A Dictionary of Art Titles

A Dictionary of Art Titles

The Origins of the Names and Titles of 3,000 Works of Art

by
ADRIAN ROOM

McFarland & Company, Inc., Publishers
Jefferson, North Carolina, and London

Library of Congress Cataloguing-in-Publication Data

Room, Adrian.
A dictionary of art titles : the origins of the names and titles
of 3,000 works of art / by Adrian Room
p. cm.
Includes bibliographical references and index.
ISBN 0-7864-0770-0 (illustrated case binding : 50# alkaline paper ∞)
1. Titles of works of art — Dictionaries. I. Title.
N33.R56 2000
703 — dc21 99-56537

British Library Cataloguing-in-Publication data are available

Manufactured in the United States of America

*McFarland & Company, Inc., Publishers
Box 611, Jefferson, North Carolina 28640
www.mcfarlandpub.com*

TABLE OF CONTENTS

Eshley had painted a successful and acceptable picture of cattle drowsing picturesquely under walnut trees, and as he had begun, so, of necessity, he went on. His "Noontide Peace," a study of two dun cows under a walnut tree, was followed by "A Mid-day Sanctuary," a study of a walnut tree, with two dun cows under it. In due succession there came "Where the Gad-Flies Cease from troubling," "The Haven of the Herd," and "A Dream in Dairyland," studies of walnut trees and dun cows. His two attempts to break away from his own tradition were signal failures: "Turtle Doves Alarmed by Sparrow-hawk" and "Wolves on the Roman Campagna" came back to his studio in the guise of abominable heresies, and Eshley climbed back into grace and the public gaze with "A Shaded Nook Where Drowsy Milkers Dream"

(Saki [Hector Hugh Munro], *Beasts and Super-Beasts*, "The Stalled Ox," 1914)

INTRODUCTION

This new dictionary seeks to explain the origins of the titles of around 3,000 works of art, mainly paintings and sculptures, but also including such modern developments as performance art and video installations. It aims to answer questions such as the following: Why is Édouard Manet's *Olympia* so called? How did Edvard Munch's *The Scream* come about? What does Paul Gauguin's *Manao Tupapau* mean? What is going on in Goya's *The Third of May, 1808*? What does Umberto Boccioni's *Unique Forms of Continuity in Space* represent? Who were Rodin's *Burghers of Calais*? Who are Poussin's *Arcadian Shepherds*? What event inspired Théodore Géricault's *The Raft of the Medusa*? Who was the *Mona Lisa* and why is she called *Mona*?

The titles may in themselves be meaningful (unless they are in an incomprehensible foreign language) but without any visual enlightenment the viewer will be often left in the dark. Even when the association is obvious, there is still a story to recount or an origin to explain. We can see the raft in Géricault's painting, but why is it so called and what are all those poor people doing on it and around it?

It has to be said that very many art titles are purely descriptive, naming a scene, a person, a place, an object, or an event. There is little mystery behind *Low Tide*, or *Italian Villa*, or *The Children of King Charles I*, or *Roses and Lilies*, or *A Boy Asleep under a Tree*, or *Troopers Watering Horses*, or *Moonlight*. (These are all genuine titles of watercolors in London's Victoria and Albert Museum.) The same is true of the hundreds of portraits that

name the subject. Bellini's *Doge Leonardo Loredan*, Van Dyck's *Lord Wharton*, Holbein's *Jane Seymour*, or Reynolds's *Countess Spencer with Her Daughter* contain no mystery and require little explanation. It is simply a matter of identity. True, one might wonder where the *Low Tide* was painted, or the *Italian Villa* located, or who exactly *The Children of King Charles I* were. But the combination of title and painting leaves little to the imagination and the viewer can simply read the title, look at the picture, and be satisfied. But if, say, *Low Tide* had been entitled *Lost*, or *Roses and Lilies* called *Deceit*, then the viewer is entitled (in the other sense) to an elucidation. Who or what was lost on the barren beach? Why name a picture of flowers by such an unexpected abstract word? *Moonlight* might equally have been called *Peace*, and the viewer would have accepted it. But what if it were *The End of Hope*? Was the artist in such deep despair? *Morning Glory*, what's the story?

There are basically four types of art titles that require an explanation.

The first are those that simply require some background knowledge. Many paintings of religious or mythological scenes are in this category, as are those of historical events. Some viewers will know the story or recall the event. But others will need to be reminded or perhaps have it explained for the first time. Typical titles of such narrative paintings are *The Adoration of the Magi*, *Bacchus and Ariadne*, *The Battle of San Romano*, *The Conversion of St. Hubert*, *Drunken Silenus Supported by Satyrs*, *The Finding of the Infant Moses*, *Mercury Piping to Argus*, *Rebecca at the Well*, *The Woman Taken in Adultery*.

1

The second type are those of works whose history, provenance, or ownership is reflected or named in their titles. Examples are *The Aldobrandini Wedding, The Aphrodite of Cnidus, The Apollo Belvedere, The Barberini Faun, The Borghese Gladiator, The Donne Triptych, The Elgin Marbles, The Farnese Hercules, The Isenheim Altarpiece, The Medici Venus, The Rokeby Venus, The Valpinçon Bather, The Venus de Milo, The Victory of Samothrace, The Wilton Diptych.* (*The Venus of Urbino* does not really belong here, however.)

The third type are the allusive titles, as distinct from those that are directly descriptive. They were beloved of Victorian artists and in many ways resemble novel titles or chapter headings, serving rather to rouse the viewer's curiosity than actually to explain the scene in question. Examples are *No Walk Today* (why not?), *Her First Letter* (to whom?), *Waiting* (for whom?), *Too Late* (for what?), *The Last Evening* (before what?), *The Escape* (from what?), *A Demurrer* (to what?), *The Discovery* (of what?), *On the Brink* (of what?). Many such titles were devised in order to attract a public that turned to art solely for diversion. They tend to be subdivided into the unashamedly or even cloyingly sentimental (*The Sick Violet*), the punning (*Sea Urchins*, with children playing on the shore), or loftily allusive (*The Wars of the Roses* not as a historical scene but as a picture of a young woman unable to decide whether to wear a white or a red rose on her ballgown). But overall such titles satisfy more than they sate, please more than they puzzle.

The fourth type of title is the one that appears inconsequential or inappropriate or that even defies any logical meaning. Who can guess the sense of Marcel Duchamp's *L.H.O.O.Q*, or Max Ernst's *Two Children Are Threatened by a Nightingale*, or Wifredo Lam's *The Somber Malembo*, or Kay Sage's *Tomorrow Is Never*, or Arshile Gorky's *The Liver Is the Cock's Comb*? What is one to think of Roberto Matta's *The Unthinkable*?

There are also the many foreign language titles that may or may not become clear once they are translated. But these embrace all ages and stages of art and form a linguistic category rather than a stylistic one.

Certain artistic schools fall fairly obviously into one or other of these four categories. Most of the Italian Renaissance painters are in the first, if only because of their subject. One need only mention Bellini's *Agony in the Garden*, Botticelli's *The Birth of Venus*, or Pollaiuolo's *Hercules and Antaeus* to illustrate the type. The authors of the second type of title are often ancient and unknown, which explains the particular formula. *The Aphrodite of Cnidus* and *The Venus de Milo* are prime examples. The first part of their titles also allies them to the first category, since knowledge of the subject's identity is necessary to appreciate the sculptures. ("Identity" is the apt word in these two cases, since the goddesses are one and the same, Aphrodite being her Greek name and Venus her Roman.)

The Pre-Raphaelites well exemplify the third category, with Ford Madox Brown's *Take Your Son, Sir!*, Arthur Hughes's *April Love*, William Holman Hunt's *The Awakening Conscience*, and Sir John Everett Millais's *Autumn Leaves* allusive or capable of figurative interpretation. At the same time many artists of this school fall firmly in the first group, with their many religious and mythological subjects. Not surprisingly, the fourth type *par excellence* are the Surrealists, some of whose typical titles are quoted above. Abstract artists are also prominent by their irrational titling. A grandiose painting by Miró has the equally grandiose title *The skylark's wing encircled by the blue of gold rejoins the heart of the poppy that sleeps on the meadow adorned with diamonds.* The weaving words of the lengthy title are artistic poetry in their own right. If one studies the work itself, however, it will be seen that the title is more meaningful than it might seem. Miró himself explained that the titles of his paintings evolved as the works themselves evolved, and that once a title had fully formed, the final painting was its realization (*XXe Siècle*, vol. x, No. 1, 1959). A somewhat different approach was adopted by the Surrealist artist René Magritte, who considered at least a dozen titles for his painting *The Glass*

Key before eventually choosing the one by which his work is now known.

Mention of "artistic poetry" in the above paragraph is a reminder that some Surrealist painters actually incorporated a title into the painting itself, not simply inscribing it at the foot of the picture but deploying it as an essential ingredient of the composition proper. This is a feature of so called "poem-paintings." A good example is Miró's *Le Corps de ma brune* (1925), where the opening words of a French poem are written across the canvas from top left to bottom right.

In considering particular artistic schools and the types of titles they favored, it must be said that the perennially popular Impressionists produced paintings with mainly descriptive titles that hardly need a commentary. Cézanne thus has *Melting Snow at L'Estaque*, Corot has *The Harbour of La Rochelle*, Degas has *The Cotton Exchange, New Orleans*, Manet has *Lady with the Fans*, Monet has *Road in the Forest with Wood Gatherers*, Pissarro has *Peasant Woman with a Donkey*, Renoir has *Skaters in the Bois de Boulogne*, Sisley has *Misty Morning*, and Van Gogh has *Interior of a Restaurant*. The titles of Monet's famous haystacks all begin with *Haystack* and simply give details of the prevailing natural conditions. But there are exceptions, one of the most notable being Gauguin, with his many Polynesian titles.

The selection of art titles for the present book was an exacting duty. In the main, there is a concentration on those titles that for one reason or another required an explanation, either in their origin or in their relationship to the work they name (or both). But any book dealing with art titles cannot overlook all that is obvious and familiar. One may exclude Monet's *Haystacks*, but surely not Constable's *Hay Wain*. There are thus many familiar titles here, ranging from Fra Angelico's *Annunciation* to Bernini's *The Ecstasy of St. Theresa*, François Boucher's *Odalisque* to Rodin's *The Kiss*, Jan Bruegel's *The Garden of Eden* to Cézanne's *Mont Saint-Victoire*, David's *The Death of Marat* to Donatello's *David*, Van Eyck's *Arnolfini Marriage* to Van Dyck's *Cupid and Psyche*, Gainsborough's *Blue Boy* to Sir Thomas Lawrence's *Pinkie*. There is also a fair showing of the many *Madonnas* of X, Y, and Z, such as the *Madonna of the Long Neck*, ... *of the Pilgrims*, ... *the Napkin*, ... *the Meadow*, ... *the Goldfinch*, ... *the Rabbit*, ... *the Grand Duke*, ... *the Book*, ... *the Fish*, ... *the Sack*, ... *the Veil*, and others like them.

It will soon be seen that some subjects have attracted many artists. This particularly applies to religious themes, such as *The Annunciation, The Nativity, The Adoration of the Magi, The Flight into Egypt* (or *The Rest on the Flight into Egypt*), *The Last Supper, The Agony in the Garden, The Crucifixion, The Deposition* (or *The Descent from the Cross*), *The Last Judgment*. Classical subjects have also long been favored, such as *The Judgement of Paris, Apollo and Daphne, The Rape of Europa* (and various other "rapes"), and the numerous depictions of *Venus*. For some of these titles a selection of artists has been given, to illustrate the range. No fewer than 20 are cited for *The Adoration of the Magi*, reflecting the popularity of the theme. This may seem generous but is hardly comprehensive and amounts to only a small proportion of the total.

The most frequently found religious subject of all is undoubtedly the Virgin Mary, usually with the infant Christ, and frequently accompanied by saints or portraits of the particular painting's donors. The titles will vary from one work to the next (many are based on *The Holy Family*), but they all belong to the same basic theme. Calvocoressi (*see* Bibliography, page 275) estimates that portrayals (painted or sculpted, and also mosaic) of Mary are numbered not in thousands but tens of thousands, and maybe even this is a conservative estimate. Many of the religious subjects quoted at the beginning of the previous paragraph also contain her, even if she is not named in the title.

But surely, it may be objected, an artistic work is complete in itself without a title. Does a title always add something to the work that it names? The answer is that it that it does, for the following reason, succinctly expressed in the words of a musical biographer:

"Why, then, bother with a title? Because an artist who has something precise to say will say it in terms of his art, but, if he is not afraid to do so, may also seize any other means of communication (of which language is the most generally used), to make sure that his audience, viewers, or readers will be prepared for it" (Robert Simpson, *Carl Nielsen*, 1952). A work of art without a title (even if that title is *Untitled*) is like a novel with a title. It has no "handle" for the viewer to approach it, nor for any reference to it to be made. And if the artist himself does not name his work, as may well happen, then someone else certainly will!

The Content of the Entries

Each entry contains two paragraphs. The first contains (1) the title, (2) the corresponding foreign title, if there is one, plus language name, (3) the name of the artist(s), (4) the date of execution of the work, and (5) the work's present location, usually by gallery and town or city.

Some details about the components of this first part may be helpful.

(1) The *title* is given in its full or familiar form, with the definite or indefinite article, in any language, ignored for purposes of alphabetization. Thus *The Call of the Night* and *Los Caprichos* are entered alphabetically under *C*, not *T* for *The* or *L* for *Los*. In cross-references, the article precedes the rest of the title in its proper place but is typographically differentiated from it. Cross-references here would thus appear as The **Call of the Night** and Los **Caprichos**. Definite and indefinite articles in the main European languages have their own entries as a reminder of this system.

(2) The *foreign title* is given wherever possible for works by a French, Spanish, Italian, German, or Russian artist. However, occasionally other languages also appear. More importantly, the title in its original foreign language is given only for works dating from or later than the 18th century. This is because titles earlier than this start running into me-

dieval or even "old" forms of the language, which even specialized sources rarely give. It is even difficult at times to ascertain what the original language actually was. Many artists moved from one country to another, and although of nationality A produced a work with a title in language B (or possibly both A *and* B). Marc Chagall is a typical example. He was born in Russia, initially moved to France, went for a time to Germany, holding his first one-man exhibition there, returned to Russia, returned to France, then in World War II was forced to flee Europe and settled in the United States before returning yet again to France. His works can thus, depending on their period of origin, be given Russian, French, German, or English titles.

In some cases a particular artist's original foreign titles are not easy to establish. This is true, for example, of Salvador Dalí, whose works in most standard sources are named by English titles, not Spanish. In a way this is understandable, since although Dalí was Spanish, he also moved to the States in World War II, although returning in 1955 to Spain. So there will be some anomalies here. Naturally, works originating from a native English-speaking artist will not normally have foreign titles. On the other hand there are works that are still better known, even in the English-speaking world, by their foreign titles. *Los Caprichos*, just mentioned, is one example. Manet's (and Monet's) *Le Déjeuner sur l'herbe* is another. Others again are Rubens's *Le Chapeau de Paille*, Renoir's *Les Parapluies*, Ingres's *La Grande Odalisque*, and Giorgione's *Fête Champêtre* (or *Concert Champêtre*). Cézanne's *Bathers*, too, is still familiar as *Les Grandes Baigneuses*, and many of the *Madonnas* cited above are still known by their Italian titles. Further, some artists bestow Latin or even occasionally Greek titles, as for Poussin's *Et in Arcadia Ego*. In such cases, the English translation is supplied. It goes without saying that titles consisting of foreign proper names remain in their native tongue, as for Monet's *La Grenouillère* or Ingres's *Mlle. Rivière*. Even here a foreign name, such as a placename, can at times be literally translated. *La Grenouillère* is

a meaningful or "transparent" name for the French, whereas for a non-French-speaker it will remain opaque.

(3) The *artist* is more straightforward, although there are works by unknown artists where naturally this information cannot be supplied. This is the case with some early works such as the Roman mural known as *The Aldobrandini Wedding*, or Greek sculptures such as *The Barberini Faun, The Borghese Warrior,* or *The Dying Gaul.* In such cases one has just "?".

(4) The *date* when a work was executed is usually known, but the further back one goes, the more likely one is to find uncertainty, and even different dates in different sources for one and the same work. Thus Botticelli's *Primavera* is dated variously between 1472 and 1486, chiefly because the true precise date is unknown. There will thus be many medieval works, and even some more recent, that will have an estimated date indicated by "*c.*" And there will be some, but not too many, that are simply "?". A date in parentheses implies a copy of an original of the stated date. Thus *The Farnese Bull* is probably a Roman copy of a Greek original dating from *c.*150 BC, so this date appears as "(*c.*150 BC)." Single titles with multiple artists, dates, and locations, such *The Adoration of the Magi,* have these three items in chronological date order.

(5) The present *location* of a work is usually well documented, but many works of art, especially paintings, are likely to pass at short notice from one gallery to another, and often even to leave the country. Sometimes works move wholesale from one gallery to another. This happens when a new gallery is built to house part of an existing collection. A notable example of this was the transformation of the Gare d'Orsay in Paris in 1986 into the Musée d'Orsay to house 19th- and early 20th-century paintings that had earlier been either in the Louvre, in the Jeu de Paume, the Impressionist museum, or in the Palais de Tokyo, the Post-Impressionist museum. Any account of these works prior to this date will thus now contain inaccurate information. It is not easy to keep abreast of the movements of modern

works of art, which can equally well be put up for sale at auction, sold following an exhibition, or pass from one owner to another. This is particularly true of paintings and other works in private hands. Any exchange of ownership or location in this way normally has little bearing on a work's title, although it is not unknown for a work to be given a new title when appearing in exhibition or sale catalog. Thus Sir George Hayter's *The Angels Ministering to Christ* (1849), now in the Victoria and Albert Museum, London, was originally listed in the catalog as *Our Saviour After the Temptation,* and John Everett Millais's *Christ in the House of His Parents* (1850), now in the Tate Gallery, London, originally appeared in the Royal Academy catalog without a title but with an appropriate biblical quotation instead.

The name of a museum or gallery is usually given in its accepted short form. Thus the Metropolitan Museum, New York, not the Metropolitan Museum of Art, the Louvre, Paris, not the Musée du Louvre, the Pitti, Milan, not the Palazzo Pitti, the Uffizi, Florence, not the Galleria degli Uffizi, the Prado, Madrid, not the Museo Nacional del Prado, the Hermitage, St. Petersburg, not the State Hermitage Museum. The names of galleries in Western European languages (but not always in Europe) are usually given in their native form, such as the Alte Pinakothek, Munich, the Museo de Bellas Artas, Seville. American galleries are located by city and state unless the city name is part of the gallery name. Thus not the Detroit Institute of Arts, Detroit, Michigan, but the Detroit Institute of Arts, Michigan, and not the Art Institute of Chicago, Chicago, Illinois, but the Art Institute of Chicago, Illinois. As with the Metropolitan Museum, New York, the National Gallery of Art, Washington, D.C., is named as the National Gallery. Its location will distinguish it from the National Gallery, London, or any other gallery of this name. British galleries and collections are mostly located just by town or city, as the Fitzwilliam Museum, Cambridge, although the county may be given for smaller places, as the Watts Gallery, Compton, Surrey. Works in churches, as often

in Italy, have the name (dedication) of the church and its location, so that the Church of St. Francis, Assisi, holding Pietro Lorenzetti's *The Deposition*, is simply S. Francesco, Assisi.

The location of a work often appears as "private collection," meaning it is not generally available for public viewing, although it may be loaned to a temporary exhibition of the artist's works. No further detail is given. The work in question may be in another country or may be the personal property of the artist.

An asterisk (*) at the end of the first paragraph denotes that the work is no longer extant, or has been destroyed, perhaps in a fire or by war. Examples are Man Ray's *Gift*, Gustav Klimt's *Girl Friends*, Kurt Schwitters's *The Cathedral of Erotic Misery*, Giovanni Pellegrini's *Rebecca at the Well*, and Gustave Courbet's *The Stonebreakers*. Sometimes the work was a display or tableau that was not expected to be permanent, as with Laurie Parson's *Stuff*. In some cases photographs, copies, or (where applicable) models exist of lost works. In others one merely has a description, as famously by the Greek satirist Lucian and later writers of Apelles' *Calumny*. The description in this instance was so detailed that it enabled Botticelli to make an accurate copy of the original.

Whereas an entry's first paragraph is succinctly factual, the second is discursive. Its main aim is to describe enough of the work in question in order to explain or if possible rationalize its title. (It should be assumed that the work is a painting unless it is stated to be otherwise.) The description may be fairly brief or rather longer and may include one or more quotations. If these are from one of the sources in the Bibliography (page 275), they are referred to author(s) and page. (Authors of more than one source have the publication year added.) If quotations are from any other source, they are followed by author(s), source title, and publication year. Some works, such as Dalí's *The Hallucinogenic Toreador*, are difficult to explain in a few words. Correggio's *The Abduction of Ganymede*, on the other hand, has just enough of the classical story to say who Ganymede was and why (and by whom) he was being abducted.

In preparing a factual, title-oriented description, there was often a strong temptation to evaluate the work in question, since some works of art provoke a keen emotional reaction. However, the temptation was equally strongly resisted, since a subjective evaluation of this kind hardly bears on the title! A reaction to the title itself, however, to its strength or weakness, relevance or irrelevance, clarity or obscurity, is another matter altogether.

And that is where this book comes in.

Adrian Room
Fall 1999

ART TITLES

A

Abbey Under Oak Trees Caspar David Friedrich, 1810, Charlottenburg Castle, Berlin.

A procession of monks carries a coffin towards a desolate Gothic ruin that stands amid barren oak trees. The ruin symbolizes the incompleteness of earthly existence, while its doorway represents the entrance to the spiritual life beyond.

The Abduction of Daniel Boone's Daughter by the Indians Carl Wimar, 1853, Washington University Gallery of Art, St. Louis, Missouri.

According to legend, Jemima, daughter of the American frontiersman Daniel Boone (*c*.1734–1820), was one day gathering flowers when she was abducted by Indians. The painting depicts her pleading for mercy as the Indians prepare to carry her off in their canoe. "Abduction" means not only "carrying off by force" but may also imply "rape," as here and probably the titles below. *Cf.* The **Rape of a Sabine**.

The Abduction of Ganymede Correggio, *c*.1531, Kunsthistorisches Museum, Vienna.

The beautiful boy Ganymede is snatched up by an eagle to serve as a cupbearer to Zeus. It is possible the eagle is Zeus himself.

The Abduction of Helen Guido Reni, 1631, Louvre, Paris.

The beautiful Helen is led away from her husband Menelaus by the Trojan prince Paris and taken down to the ships that will bear her to Troy.

Abduction of the Nymph (German, *Nymphenraub*) Franz von Stuck, *c*.1920, private collection.

A centaur, half man, half horse, lifts a nude nymph into the air, a cupid riding on his back.

Above Eternal Peace (Russian, *Nad vechnym pokoyem*) Isaak Levitan, 1894, Tretyakov Gallery, Moscow.

A tiny wooden church and cemetery stand on the edge of a vast lake beneath a sky that takes up the whole of the upper half of the picture. The title describes the scene as depicted from above, while the painting itself represents man's puny size in the face of eternal nature.

Above the Town (Russian, *Nad gorodom*; French, *Au-dessus de la ville*) Marc Chagall, 1915, private collection.

A man and a woman, presumably lovers or elopers, fly across the sky over a little town. The painting is seemingly an escapist fantasy.

Absinthe *see* The **Absinthe Drinker** (2).

The Absinthe Drinker (French, *Buveur d'absinthe*) (1) Édouard Manet, 1859, Ny Carlsberg Glyptotek, Copenhagen; (2) Edgar Degas, 1876, Musée d'Orsay, Paris.

Manet's painting depicts a dowdily dressed man in a top hat standing by a low wall, a half filled glass by his side and an empty bottle at his feet. The model was a drunken rag and bone man called Collardet. Degas shows a man and a woman side by side in a Paris café. Although at the same table, the man looks away as he draws on his pipe. The woman contemplates the glass before her that will bring oblivion. The portraits are of the Bohemian painter Marcellin Desboutin (1823–1902) and the actress Ellen Andrée (1857–*c*. 1915). The scene is the Café Guerbois, later the Café Nouvelle-Athènes, in the Place Pigalle. The latter painting is also known simply as *Absinthe*. The fuller title is said to have been first given in 1893 when the painting was exhibited in London. It may thus have originally been called *In a Café*.

An Academy by Lamplight Joseph Wright of Derby, 1769, Yale Center for British Art, New Haven, Connecticut.

A group of art students sketch the statue of a young woman, the *Nymph with a Shell*. One has laid aside his drawing and gazes into her eyes. Another has finished his work and turns away. The rest are still making their copies.

Accumulation of Sliced Teapots Arman, 1964, Walker Art Center, Minneapolis, Minnesota.

The sculpture, typically of the artist, is an assemblage of junk material that comprises the everyday items specified in the title.

Achilles Lamenting the Death of Patroclus Gavin Hamilton, 1763, National Gallery of Scotland, Edinburgh.

The scene is from Homer's *Iliad*. Patroclus, wearing the armor of his close friend Achilles, has been killed by Hector in the Trojan War.

The Acquittal *see* **Waiting for the Verdict.**

The Acrobat's Rest (French, *Le Repos de l'acrobate*) René Magritte, 1928, Galerie Isy Brachot, Brussels.

The depiction is of the fragmented parts of a nude woman's body, together with those of an amorphous figure. Presumably the woman herself is the "acrobat" of the title, who has now reassembled her body parts in such a way that they appear to rest embedded in a stone wall.

Act of Violence (French, *L'Attentat*) René Magritte, 1932, Groeningemuseum, Bruges.

The painting depicts three main objects: a "block" of blue sky with fleecy clouds, the façade of a multistory building seen through an archway, and a framed female torse. In the archway is a *grelot*, a spherical bell with a slit, the artist's trademark. The title presumably refers to the three objects, each of which has been excised from the whole of which it forms a part.

The Action and Capture of the Spanish Xebeque Frigate "El Gamo" Clarkson Stanfield, 1845, Victoria and Albert Museum, London.

The painting depicts a historical event: the capture of the named ship by the British sloop *Speedy* off Barcelona on May 6, 1801 during the Napoleonic Wars. The "action" was the chase and bombardment, the "capture" the boarding and commandeering. A "xebeque" (now usually "xebec") is a type of three-masted vessel. The name of the ship means "The Buck."

Action in Chains (French, *Action enchaînée*) Aristide Maillol, 1905, Puget-Théniers, France.

The lead statue of a full-length striding nude female figure, her head turned, her hands manacled behind her back, is a monument to the French revolutionary and socialist, Louis-Auguste Blanqui (1805–1881) and stands at his birthplace, Puget-Théniers, near Grenoble. The model for the figure was the artist's wife, a robust woman of peasant stock. A bronze cast of the original is in the Musée National d'Art Moderne, Paris. The statue is also sometimes known as *Liberty in Chains*.

Action Painting II Mark Tansey, 1984, Montreal Museum of Fine Arts.

The canvas, closely resembling a newspaper photograph, depicts a group of amateur artists by a river or lake painting the launch of a space shuttle. However, although the space shuttle can be seen rising from a cloud of billowing smoke, the artists' paintings are complete. They have already painted an event that is just taking place. The title relates not simply to the action of the launch and of the painters, but to the style of painting common in the 1950s and 1960s, in which a work could be instantly created by throwing paint on canvas. The artists in Tansey's picture have similarly "thrown" their paintings, but in time.

Adam and Eve (1) Lucas Cranachi, *c.* 1518, Kunsthistorisches Museum, Vienna; (2) Jan van Scorel, *c.*1540, private collection; (3) (French, *Adam et Ève*) Paul Gauguin, 1902, Ordrupgaard Museum, Copenhagen; (4) (French, *Adam et Ève*) Suzanne Valadon, 1909, Musée National d'Art Moderne, Paris; (5) Fernand Léger, 1935–39, Kunstsammlung Nordrhein-Westfalen, Düsseldorf.

The first three paintings depict the familiar Old Testament scene. Adam and Eve stand naked in the Garden of Eden. The serpent is coiled around the Tree of Knowledge behind them and is about to tempt Eve to eat its fruit (Genesis 3:1). The representation is thus of the final seconds before the Fall of Man. Valadon has a nude contemporary couple, although foliage masks the groin of Adam, posed by the artist's future husband, André Utter, and there is no snake. Léger's painting only nominally relates to the biblical scene. Adam and Eve are acrobats, although the serpent is now present, coiled around the rod that

Adam holds. The title here is presumably meant to denote the innocence of the two figures.

The Adoration of the Golden Calf (1) Tintoretto, c.1545, Kunsthistorisches Museum, Vienna; (2) Nicolas Poussin, 1626, M.H. de Young Memorial Museum, San Francisco, California; (3) Claude Lorrain, 1660, Manchester City Art Gallery.

The scene is from the Old Testament. The Israelites worship the idol in the form of a golden calf that has been made by Aaron at Sinai to replace Moses and God (Exodus 32). In Poussin's painting (also known as *The Worship of the Golden Calf*) they dance round the idol in poses of abandon. Their faces shine with relief, for they have escaped the austere judgment of the God of Moses. Moses himself appears as a small figure in the distance. As he descends from Mt. Sinai, he dashes down the Tables of the Law, appalled that the God who prescribed them has been rejected by his people.

The Adoration of the Magi (1) Duccio di Buoninsegna, 1308–11, Museo dell'Opera del Duomo, Siena; (2) Bartolo di Fredi, c.1390, Pinacoteca Nazionale, Siena; (3) Gentile da Fabriano, 1423, Uffizi, Florence; (4) Masaccio, 1426, Staatliche Museen, Berlin; (5) Fra Angelico and Fra Filippo Lippi, c.1445, National Gallery, Washington, D.C.; (6) Rogier van der Weyden, c.1455, Alte Pinakothek, Munich; (7) Andrea Mantegna, c.1460, Metropolitan Museum, New York; (8) Justus of Ghent, c.1460–5, Metropolitan Museum, New York; (9) Hugo van der Goes, c.1470, Staatliche Museen, Berlin; (10) Sandro Botticelli, 1475, Uffizi, Florence; (11) Leonardo da Vinci, c.1481, Uffizi, Florence; (12) Bramantino, c.1490, National Gallery, London; (13) Giorgione, c. 1502–4, National Gallery, London; (14) Albrecht Dürer, 1504, Uffizi, Florence; (15) Jacopo Bassano, c.1540, National Gallery of Scotland, Edinburgh; (16) Jacopo Bassano, c.1560, Barber Institute of Fine Arts, University of Birmingham; (17) Diego Velázquez, 1619, Prado, Madrid; (18) Francisco Rizi, 1645, Toledo Cathedral; (19) Giambattista Tiepolo, 1753, Alte Pinakothek, Munich; (20) (German, *Die Verehrung der Magier*) Johann Friedrich Overbeck, 1813, Kunsthalle, Hamburg.

The scene is from the New Testament. The Magi (Three Wise Men) offer gifts of gold, frankincense, and myrrh to the infant Jesus

(Matthew 2). The child is either in a crib or on the lap of his mother, Mary, while his father, Joseph, is near. Botticelli's painting supposedly contains portraits of members of Florence's ruling family, the Medici. Because of its potential richness, the subject is generally more popular than its more lowly counterpart, The **Adoration of the Shepherds**.

The Adoration of the Shepherds

(1) Hugo van der Goes, 1476–8, Uffizi, Florence; (2) Giorgione, c.1506, Accademia, Venice; (3) Vincenzo Catena, c.1510, private collection; (4) Giovan Gerolamo Savoldo, c.1540, Pinacoteca Tosio-Martinengo, Brescia; (5) Dirck Barendsz, c.1565, Municipal Museum, Gouda; (6) Tintoretto, 1577, Scuola Grande di S. Rocco, Venice; (7) Agostino Carracci, c.1584, Madonna della Pioggia, Bologna; (8) Rembrandt van Rijn, 1646, National Gallery, London; (9) José de Ribera, 1650, Louvre, Paris; (10) (French, *L'Adoration des bergers*) Jean Restout, 1761, St.-Louis, Versailles.

The scene is from the New Testament, and parallels that in The **Adoration of the Magi**. Shepherds have been guided by a star to the newborn Jesus and have come to worship him as he lies in a manger (Luke 2). Animals are usually depicted, although none are mentioned in the biblical account.

Advice on the Prairie William Ranney, 1853, private collection.

A buckskin-clad trapper recounts tales of frontier lore to a prosperous family of pioneers as they halt on the trek west. A smaller version of the picture is known as *The Old Scout's Tale*.

After Dinner at Ornans (French, *L'Après-dîner à Ornans*) Gustave Courbet, 1849, Musée des Beaux-Arts, Lille.

Family members and friends meet after dinner at Ornans, the artist's hometown in eastern France. In his own words: "It was in November, we were at our friend Cuénot's house, Marlet had just returned from the hunt, and we persuaded Promayet to play his violin for my father" (Gowing, p. 146). The work is unusually grandiose for such a minor social event.

After Evening Prayers (French, *Après la prière du soir*) Xavier Mellery, c.1890, Musée d'Ixelles.

A silent procession of nuns ascends the stairs after vespers.

After Muybridge: Woman Emptying a Bowl of Water and Paralytic Child on All Fours Francis Bacon, 1965, private collection.

The distorted depictions of a nude woman throwing water and a nude child crawling are based on Eadweard Muybridge's photographic studies of naked men, women, and children, *The Human Figure in Motion* (1901). The titles are those of the original studies, which usually comprise ten high-speed photographs of the motion shot from different angles.

After Prince Igor's Battle with the Polovtsy (Russian, *Posle poboishcha Igorya Svyatoslavicha s polovtsami*): Viktor Vasnetsov, 1880, Tretyakov Gallery, Moscow.

The subject of the huge painting is taken from the late 12th-century epic *The Lay of Igor's Campaign*, and depicts a battlefield strewn with corpses after the clash between Russian troops under Prince Igor Svyatoslavich and warriors of the Polovtsy tribe (1185).

After the Bath (French, *Après le bain*) (1) Pierre-Auguste Renoir, *c.* 1888, private collection; (2) Edgar Degas, 1888–92, National Gallery, London; (3) *see* **Venus Rising from the Sea**.

The artists' paintings both depict young women drying themselves after bathing. Renoir's nude is posed outdoors, by a pool. Degas's in indoors, seated next to the tub from which she has stepped.

After the Deluge George Frederic Watts, *c.*1885–91, Watts Gallery, Compton, Surrey.

The sun sets in an explosion of color and light amid swirling clouds above an empty sea. The depiction is of the imagined scene after the biblical flood described in Genesis. The picture was originally referred to as *Cessation of the Deluge*, then was retitled as now with an added subtitle, *A Reminiscence*. This in turn became *The Forty-First Day*, alluding to Genesis 7:4: "I will cause it to rain upon the earth forty days and forty nights."

After the Hunt William Harnett, 1885, California Palace of the Legion of Honor, San Francisco, California.

The artist's best known painting is a *trompe l'oeil* still life of dead game and hunting equipment hung on nails on an old iron-hinged door. They include a hare, a pheasant, a pair of antlers, a shotgun, a hunting horn, a hipflask, and a horseshoe, with a hat on a hook as the focal point. The predominance of objects beginning with "h" suggests a punning reference to "hunt" or to the artist's own name.

After the Meeting Cecilia Beaux, 1914, Toledo Museum of Art, Ohio.

An elegantly dressed young woman gestures animatedly from the armchair in which she sits. She still wears hat, scarf, and gloves and is telling a friend of the meeting she has just had. She was modeled by the artist's friend Dorothy Gilder.

After the Storm (Russian, *Posle grozy*) Arkhip Kuindzhi, 1879, Tretyakov Gallery, Moscow.

A thunderstorm has passed, and although the sky is still dark and threatening, meadows and farm buildings are suddenly illumined by a bright burst of sunlight.

An Afternoon in the Nursery Jane Bowkett, *c.*1860, present location unknown.

A young woman sits absorbed in a novel while young children create mayhem around her in the nursery. Neither the title nor the depiction itself indicates whether the woman is their mother or a governess.

Age of Apathy Peter Howson, 1992, private collection.

The scene is of a mob rule and anarchy. A crowd of thugs has bound four men and set them up on public display, as if crucifical victims. No one lifts a finger in their defense.

The Age of Bronze (French, *L'Âge d'airain*) Auguste Rodin, 1876, Minneapolis Institute of Arts, Minnesota

The bronze statue of a nude standing young man, stretching as he awakens from sleep, was sculpted with a 22-year-old Flemish soldier, Auguste Neyt, as model. The figure originally held a lance and was entitled *The Conquered* (French, *Le Vaincu*). It was later shown without a lance and was given its present title. (Any allusion to the historical era would be less apparent in the French title, since the Bronze Age is *l'Âge du bronze*.) The work itself was inspired by Michelangelo. Alternate earlier titles have been *The Man of the First Ages*, *The Awakening of Mankind*, and *Man Awakening to Nature*.

The Age of Innocence Joshua Reynolds, *c.*1788, Plymouth City Art Gallery.
A little girl sits on the ground in a wooded landscape, her hands piously clasped. She is

Theophila Gwatkin, daughter of the artist's niece, herself in childhood the subject of The **Strawberry Girl**. The title quotes one of the stock metaphors for childhood. "True to its title, the image presents an archetype of innocence. ... Also true to its title, the painting defines an age — not the child's age, but an age of childhood. *The Age of Innocence* might as well be titled the invention of innocence" (Higgonet, p. 15).

The Age of Marvels (French, *L'Âge des merveilles*) René Magritte, 1926, private collection.

Two nude women stand shrouded back to back, their abdomens replaced by a clockwork mechanism. They may be one and the same figure shown as a reflection. Whatever the case, they are certainly the "marvels" of the title.

The Age of Pleasure (French, *L'Âge du plaisir*) René Magritte, 1946, private collection.

A naked young woman with a huge frog (a prince?) on her back presses her nipple as, eyes closed and cheeks burning, she hugs a mansize bilboquet (a pillar-shaped figure like a pawn in chess). The "age of pleasure" of the title is clearly a sexual one, especially as the bilboquet evokes both a human figure and a phallus.

The Agnew Clinic Thomas Eakins, 1889, University of Pennsylvania, Philadelphia, Pennsylvania.

The painting depicts a surgical operation in progress at the Agnew Clinic, Philadelphia, with the artist himself peering intently at the proceedings. *Cf.* The **Gross Clinic**.

Agony (1) (German, *Agonie*) Egon Schiele, 1912, Neue Pinakothek, Munich; (2) Arshile Gorky, 1947, Museum of Modern Art, New York.

Schiele depicts two monks, the elder witnessing the death of the younger. The latter holds one hand to his heart while the other, bearing stigmata, is raised as if crippled with pain. The central form of Gorky's painting suggests that of a hanged man. The artist was subject to fits of despair, and the picture seems to anticipate his own suicide by hanging the following year.

The Agony in the Garden Andrea Mantegna, *c.* 1455, National Gallery, London.

The scene is from the New Testament (Matthew 26:36–46). Five angels bearing instruments of the Passion appear to Christ as he kneels in the Garden of Gethsemane, praying in anguish during the night before his crucifixion. Three of his apostles, Peter and the two sons of Zebedee, James and John, lie asleep in the foreground, unaware that Judas and a group of soldiers, seen in the background, are on their way to arrest Christ.

Agrippina Landing at Brundisium with the Ashes of Germanicus Benjamin West, 1768, Yale University Art Gallery, New Haven, Connecticut.

The scene is from Roman history, in an account by Tacitus. Agrippina the Elder (*c.*14 BC–AD 33) arrives at Brundisium (modern Brindisi, Italy) with the ashes of her husband, Germanicus Julius Caesar (*c.*15 BC–AD 19), who has died in Antioch, convinced that he has been poisoned by Cnaeus Piso, governor of Syria. Germanicus's ashes were subsequently deposited in the mausoleum of Augustus at Rome.

Aha oe feii? *see* **What! Are You Jealous?**

AIDS (Cadmium Red Light) General Idea, 1987.

The three Canadian-born artists who collaborate as General Idea (A.A. Bronson, Felix Partz, and Jorge Zontal) based their painting on Robert Indiana's **LOVE**, replacing the four letters of that word by those of *AIDS*. Love thus becomes AIDS in a possibly subversive equation. The "D" of the letters *AIDS* that fill the painting is tilted like the "O" of *LOVE* in the original. The second part of the title denotes the glowing red of the letters on their blue and green background (by comparison with the gray and green of Indiana's picture).

The Air Pump *see* The **Experiment on a Bird in the Air Pump**.

Aita tamari vahine Judith te parari ("The Child-Woman Judith Is Not Yet Breached") Paul Gauguin, 1893–4, private collection.

The nude portrait is of the artist's maid, model, and mistress in Paris at the time of its painting, 13-year-old Annah. She was actually of Indian-Malayan origin, although he liked to think of her as Javanese. The pidgin Tahitian title, which appears at the painting's top right, seems to have no relevance to the subject, and it probably refers to another nymphet, Judith Erikson-Molard, the 12-year-old Swedish stepdaughter of the artist's friend William Molard, who lived in the apartment below Gauguin's in the rue Vercingétorix. By mentioning her sexual

innocence, unlike that of Annah, Gauguin may have been poking fun at the constraints imposed on her by her bourgeois parents. There is thus a contrast between the two girls, one white and virginal, the other colored and sexual. The painting is usually known in English as *Annah the Javanese* and in French as *Annah la Javanaise*.

Ajax and Cassandra Solomon Joseph Solomon, 1886, Ballarat Fine Art Gallery, Victoria.

The painting depicts the Greek warrior, Ajax, abducting the Trojan prophetess, Cassandra, at Athena's altar after the fall of Troy. In his haste he has overturned the goddess's statue, for which personal insult she will destroy many of the homeward-bound Greek ships.

The Alba Madonna Raphael, *c*.1510, National Gallery, Washington, D.C.

The painting of the Virgin and Child with St. John was over 100 years in the collection of the Duke of Alba. Hence its name. It is also known as the *Madonna Alba*, or more fully in Italian as the *Madonna della Casa d'Alba* ("Madonna of the House of Alba").

Albanese Girl Standing in the Doorway (Russian, *Devochka-alban'ka v dveryakh*) Aleksandr Ivanov, *c*.1830, Tretyakov Gallery, Moscow.

The painting is a portrait of a young girl from the Albano region of Italy, southeast of Rome. A misreading of either the Russian or the English title could suggest that the girl is Albanian.

Albion's Dance *see* **Glad Day**.

The Alchemist (1) Adriaen van Ostade, 1661, National Gallery, London; (2) Joseph Wright of Derby, 1771, Derby Museum and Art Gallery.

Van Ostade's alchemist works a pair of bellows to fan the fire in his furnace, aiming to transmute base metals into gold by heating them. The tools of his trade lie around him. Alchemy was still practiced in this artist's day. Wright's alchemist raises his eyes from his experiment, which has just produced phosphorus, and looks up to heaven as he prays for the next stage, which he thinks will be the philosopher's stone.

The Aldobrandini Wedding ?, 1st *c*. BC, Vatican Museums.

The Roman mural, depicting the final preparations for a wedding, is named for its first modern owner, Cardinal Cinzio Aldobrandini (1560–1610).

Alenushka (Russian, *Alënushka*) Viktor Vasnetsov, 1881, Tretyakov Gallery, Moscow.

The young girl of the title, the heroine of a Russian fairy tale, sits lonely and forlorn on a stone by a pond. Her name is a diminutive of Yelena (Helen).

Alethe Edwin Long, 1888, Russell-Cotes Art Gallery, Bournemouth.

A young woman stands amid sacred ibis birds against a background of Egyptian decorative art. She is Alethe, a character from Thomas Moore's poem *Alciphron* (1839), more precisely identified in the painting's extended title: *Alethe, Attendant of the Sacred Ibis; in the Temple of Isis, Memphis, circa 255 AD*.

Alka Seltzer David Hockney, 1961, Balliol College, Oxford.

The painting depicts a nude young man in a transparent dress beneath an inverted Alka-Seltzer label. The picture is also known by its subtitle, *The Most Beautiful Boy in the World*, the wording of which runs down the figure's back. The words "D boy," standing for "doll boy," run across the figure's neck. The name "Pete" also appears near the top. The identity of "the most beautiful boy in the world" could be either the pop singer, Cliff Richard, whom the artist then idolized as a "doll boy," or "Pete," otherwise Peter Crutch, a fellow student.

All Hallow's E'en *see* The **Bridesmaid**.

"The All-Pervading" George Frederic Watts, 1887–*c*.1893, Tate Gallery, London.

A seated mystic figure holds the universe in its hands. The meaning of both subject and title is elusive. The artist himself wrote in the preface to the 1896 exhibition catalog: "The figure with the Globe of the Systems may be called the Spirit that pervades the immeasurable expanse," while the catalog description itself spoke of: "The all-pervading Spirit of the Universe represented as a winged figure, seated, holding in her lap the 'Globe of Systems'" (quoted in Wilton and Upstone, p. 268).

All the things I know but of which I am not at the moment thinking—1:36 pm; June 15, 1969 Robert Barry, 1969, private collection.

The work is a blank rectangle on which the words of the title appear in capital letters. The

aim is to indicate the interrelationship between reality and artistic representation.

Allegorical Figure *see* **Primavera** (1).

Allegory of Fertility Jacob Jordaens, *c*.1622, Musées Royaux des Beaux-Arts, Brussels.

A young woman in a red robe presents red and white grapes to a group of naked people. She is probably Pomona, the Roman gods of fruits, while the grapes themselves are the divine gift of fertility. Those to whom she offers the grapes are presumably nymphs and satyrs.

Allegory of Good and Bad Government *see* **Good and Bad Government**.

An Allegory of Love Paolo Veronese, *c*.1550, National Gallery, London.

The series of four paintings is an allegory on the pains and pleasures of love. In the first, Cupid whips a naked man while Chastity leads a woman away. In the second, Cupid leads a man to the bed of a naked (and possibly drunk) woman. In the third, a naked woman, perhaps representing Supreme Pleasure, sits between two men, who each take her hand. (The one on the right, whom she apparently restrains, is presumably her husband. The one on the left, to whom she turns her face and body, is probably her lover.) In the fourth, a couple hold out an olive branch to a naked woman, perhaps Fortune, who sits enthroned on a sphere and crowns them with a laurel wreath.

An Allegory of Love and Time Agnolo Bronzino, *c*.1545–6, National Gallery, London.

A seated nude woman turns to kiss a naked young boy, who fondles her breast. A young child to the right raises a bunch of blossoms, while an old man above them takes hold of a blue cloth as if to veil the erotic scene. Three other figures are partly hidden. The precise significance of the painting is uncertain. Its alternate title is *Venus, Cupid, Folly, and Time*, identifying the womas as Venus, the goddess of love, the boy as her son Cupid (Eros), the god of erotic love, the young child as Folly, and the old man as Time. It is also known as *An Allegory of Venus and Cupid*. The allegory may be on the lifelong "battle" between sexual love and the passage of time, while the work clearly celebrates what it supposedly condemns.

Allegory of Painting Jan Vermeer, *c*.1665, Kunsthistorisches Museum, Vienna.

An artist in historical dress is painting a portrait of a young woman wearing a laurel wreath and holding a trumpet and a book. These attributes identify her as Fama, the allegorical embodiment of fame. A map of the Netherlands hangs on the far wall, implying that the allegory relates specifically to Dutch painting. The work overall thus celebrates the fame of historical painting in the Netherlands. Vermeer took his subject from Cesare Ripa's *Iconologia* (1593). The picture is also known as *The Artist's Studio* or *A Painter in his Studio*.

Allegory of Sight Jan Bruegel, 1618, Prado, Madrid.

The painting is one of a series that portrays the five senses. In each one, Venus is surrounded by objects representing the sense in question. Here, she sits in a "cabinet of curiosities" by scientific instruments that improve the sense of sight, such as a telescope and a magnifying glass. Cupid shows Venus a painting depicting the biblical story of Jesus healing the blind man, while next to him a monkey examines a painting through a pair of spectacles.

Allegory of the Faith Jan Vermeer, *c*.1669–70, Metropolitan Museum, New York.

A young woman, her hand on her heart, sits by a table, on which are a crucifix, an open prayer book, and a chalice. Behind her hangs a painting of the Crucifixion. The work is an allegory of the Catholic faith. Vermeer took his subject from Cesare Ripa's *Iconologia* (1593), and from this source borrowed certain symbolic details in the picture, such as the chalice, the part-eaten apple at the young woman's feet, and the snake crawling across the floor.

An Allegory of Venus and Cupid *see* **An Allegory of Love and Time**.

Allegory of War Peter Paul Rubens, *c*.1638, Pitti, Florence.

Mars, the god of war, refuses to be restrained by Venus, the goddess of love, as he threatens those around him with ruin. He is dragged along by a Fury, whose companions are Pestilence and Famine. On the ground lies Concord with a broken lute. A despairing woman personifies Europe, rent by war. This was the time of the Thirty Years' War.

An Allegory with Venus and Time Giovanni Battista Tiepolo, *c*.1753–8, National Gallery, London.

The scene is from classical mythology. Venus, goddess of love, has given birth to a baby

boy (possibly Aeneas) whom she hands to Time, who has temporarily laid down the scythe with which he cuts off mortal life. Her son, Cupid, flutters beneath her, holding a quiver of arrows. When Giovanni Domenico Tiepolo, the artist's son, made an etching based on the picture, he called it *Il Parto di Venere* ("The Confinement of Venus"). The "message" of the work may be that Time is impermanent, while Love and Beauty are everlasting.

Alone (French, *Seule*) Henri de Toulouse-Lautrec, 1896, private collection.

A young prostitute has collapsed exhausted across her bed, dressed only in her stockings and a chemise. She is alone for a few moments before the next client arrives.

The Altarpiece of the Holy Lamb *see* The **Ghent Altarpiece**.

Les Alyscamps Paul Gauguin, 1888, Musée d'Orsay, Paris.

The painting is of the cypress-lined avenue of this name just outside Arles, southern France, a favorite spot for strollers. The path is on the site of a Gallo-Roman cemetery on the Roman *Via Aureliana*, and derives its own name from Latin *Elysii campi*, "Elysian Fields."

An Amateur Frederick Walker, *c.*1870, British Museum, London.

A coachman opens a clasp-knife as he selects a cabbage to cut in his garden. The title uses *amateur* in its sense of one who pursues an interest for pleasure, rather than one who is unskilful or unprofessional. The painting has the alternate title *Coachman and Cabbages*.

Ambassadeurs: Aristide Bruant Henri de Toulouse-Lautrec, 1892, Musée Toulouse-Lautrec, Albi.

The poster advertises Les Ambassadeurs, a Paris café-concert, and depicts the composer and singer, Aristide Bruant (1851–1925), who persuaded the cabaret's director to commission it.

The Ambassadors Hans Holbein II, 1533, National Gallery, London.

The double portrait depicts Jean de Dinteville, the young French ambassador to the English court of Henry VIII, and his friend Georges de Selve, bishop of Lavaur, who is known to have visited London in 1533. The two men are accompanied by symbols of the arts of learning and music in which they are versed. The foreground of the paining contains a famous distortion of a skull, while in the top left corner there is a partly hidden crucifix. Recent scholarship has revealed that the painting as a whole represents Good Friday, April 11, 1533. It is thus possible that these objects are symbolic "ambassadors" (representatives) of the Crucifixion and Resurrection, or of the triumph of death and its subsequent overthrow.

Ambush for Flamingoes George Catlin, *c.*1857, Carnegie Museum of Art, Pittsburgh, Pennsylvania.

A huge flock of flamingoes busy themselves with their nests, while a hunter and his servant lurk behind a bush to the left. They are the "ambush" of the title, and represent the ever-present threat by humankind to the natural world.

The American Dream Robert Indiana, 1961, Museum of Modern Art, New York.

The painting represents four discs of the type seen on a gaming machine or in a casino. Each has a central five-point star. The first is numbered "37, 40, 29, 66," the second has the words "TAKE ALL," the third has "TILT" surrounded by the figures 1 through 5, the fourth has the circular wording "THE AMERICAN DREAM." The implication is that "the American dream" itself, as the traditional social ambition of all Americans, can be achieved only in a game or by means of a winning gamble.

American Gothic Grant Wood, 1930, Art Institute of Chicago, Illinois.

A middle-aged Iowa farmer-preacher and his daughter stand before their farmhouse, symbolizing the God-fearing, hard-working rural dwellers of the Midwest. The "Gothic" or religious aspect of the work is implied in the cross-seaming on the farmer's shirt, the three tines of his upturned pitchfork, and especially the pointed Gothic-style window in the gable of the farmhouse, built in the style known as carpenter's Gothic. The elongated figures also evoke Gothic portraits. The artist himself commented: "I imagined American Gothic people with their faces stretched out long to go with this American Gothic house" (quoted in Chilvers 1998, p. 659). The couple portrayed are not true father and daughter but Wood's sister, Nan, and his dentist, Dr. B.H. McKeeby.

American Landscape Charles Sheeler, 1930, Museum of Modern Art, New York.

This is no rural landscape but an urban industrial scene, with a canal in the foreground. Beyond it are a railyard, loading machinery, and

a row of silos, among other buildings. A plume of smoke rises from a smokestack.

The American School Matthew Pratt, 1765, Metropolitan Museum, New York.

The painting depicts the American artist, Benjamin West, supervising other young American artists in his studio. West advised and trained Pratt himself.

American Tragedy Philip Evergood, 1937, Whitney Museum of American Art, New York.

The painting depicts, and commemorates, a police attack on striking steel workers in Chicago. The confrontation between the two groups is the "American tragedy" of the title, itself echoing Dreiser's 1925 novel and overall implying a destructive American dream.

Amore Vincitore ("Love Victorious") Caravaggio, 1597–8, Staatliche Museen, Berlin.

A young Roman boy decked out with a huge pair of wings poses as a full frontal nude Cupid. The painting is also known as *Victorious Amor*.

Amorous Dance (French, *Danse amoureuse*) Karel Appel, 1955, Tate Gallery, London.

The painting appears to depict two pairs of mating cocks and hens.

Amorous Parade (French, *Parade amoureuse*) Francis Picabia, 1917, private collection.

The painting depicts nothing more erotic than a piece of clanking machinery, complete with flywheel, hammers, and pistons. However, the erotic title tempts the viewer to see something sexual in the work. Perhaps it parodies the physical side of love-making.

Amorpha: Fugue in Two Colors Frantisek Kupka, 1912, National Gallery, Prague.

The artist's first entirely abstract work depicts a number of arabesques created by intersecting arcs. The "fugue" is formed as much by the contrasting red and blue colors as by the repeated arcing. The arabesques, as the title indicates, are randomly shaped (amorphous).

The Anatomy Lesson of Dr. Tulp Rembrandt van Rijn, 1632, Mauritshuis, The Hague.

A formally dressed surgeon displays the dissected arm of a male cadaver to a group of seven rapt onlookers. The commissioned work depicts the annual anatomical demonstration to Amsterdam's guild of surgeons by the praelector, or chief surgeon, in this case Nicolaes Tulp (1593–1674), the late owner of the arm being Aris Kindt, a well known criminal of the day. One of the onlookers holds a sheet of paper with a list of those present. A similar later commission was *The Anatomy Lesson of Dr. Deijman* (1656). The painting is also known more generally as *The Lesson in Anatomy*.

The Ancient of Days William Blake, 1794, Whitworth Art Gallery, Manchester.

In the sky, a naked, white-haired, white-bearded old man half-kneels in a break in the clouds before a huge, dark red sun. His left arm reaches down, his hand spread on the angle of a pair of compasses, measuring the depths beneath. The old man is Urizen, identified to some extent by Blake with the biblical Jehovah. The title refers to him by one of the names of God (Daniel 7:9, 13, 22). (The original Hebrew properly means "one aged in days" rather than "one living forever.") The depiction equally alludes to an Old Testament description, in which Wisdom speaks of the Lord: "When he prepared the heavens, I was there: when he set a compass upon the face of the depth" (Proverbs 8:27). Blake first used the depiction as an illustration to his poem *Europe: A Prophecy* (1794), and is said to have been inspired by "a vision which hovered over his head at the top of the staircase" (Gombrich, p. 386).

And the Gold of Their Bodies (French, *Et l'or de leur corps*) Paul Gauguin, 1901, Musée d'Orsay, Paris.

The painting depicts two nude Tahitian women, one seated on the ground, the other kneeling behind her. The allusive title, presumably a quotation, appears at the picture's bottom right. The work is also known in English as simply *Golden Bodies*.

"And the sea gave up the dead which were in it" Frederic Leighton, 1891–2, Tate Gallery, London.

The work depicts a vision of the resurrection of souls on Judgement Day. The central figures are a man supporting his wife and young son as all three rise from the sea and return to life. The title is a direct biblical quotation (Revelation 20:13), as the quote marks indicate.

And When Did You Last See Your Father? William Frederick Yeames, 1878, Walker Art Gallery, Liverpool.

The painting is an anecdotal costume piece depicting a scene is set in the English Civil War

(1642–6). A young Catholic boy stands on a footstool, about to answer the question of the title, which has been put to him by a Puritan, who leans across the table towards him. To the left, ladies of the house cling to one another in tears. They clearly dread that the child will betray his Royalist father. (The first word of the title implies that it follows on from the question before, and that the child has already given some information about his father. It should perhaps be stressed thus: "And when did you last *see* your father?")

The Andrians *see* **Bacchanal of the Andrians**.

L'Ange du foyer ("The Angel of the Hearth") Max Ernst, 1937, private collection.

A grotesquely fierce and fiery monster rants and rages as it ramps and tramps across the landscape. The painting was originally entitled *Le Triomphe du surréalisme* ("The Triumph of Surrealism"). The artist explains the work: "After the defeat of the Republicans in Spain, I painted *L'ange du foyer*. This is, of course, an ironic title for a kind of steamroller which destroys and annihilates everything that crosses its path. That was my impression at that time of what would happen in the world, and I was right" (quoted in Tesch and Holmann, p. 104).

The Angel Appearing to the Shepherds Giovanni Castiglione, *c*.1640, Birmingham City Art Gallery.

The scene is based on the New Testament story. Shepherds, surrounded by their flock, point to the sky as they tell a horseman that an angel has announced the birth of Jesus (Luke 2). *Cf.* The **Annunciation to the Shepherds**.

Angel of the North Anthony Gormley, 1998, Gateshead.

Britain's largest sculpture, of an angel with outstretched wings, stands on a hillside near Gateshead country now abolished, northeastern England. "The Angel of the North proclaims the steel and ambition of manufacturing in the North East. But it also signals that here is the boundary of different country, the lands of (the Venerable) Bede and (St.) Columba on the one hand and the largest shopping complex in Britain on the other" (*The Times*, February 16, 1998). Both title and figure are a reminder of the region's Christian heritage. They also disavow the pagan past implicit in the name of Gateshead itself, which means "Goat's Head" and refers to the goat's head displayed here at one time in connection with sacrificial rites.

Angelica (French, *Angélique*) J.-A.-D. Ingres, 1859, Museu de Arte, São Paolo.

A naked young woman is chained by the wrists to a rock. She is Angelica, the bewitching princess who is the heroine of Ariosto's *Orlando Innamorato* (1487) and *Orlando Furioso* (1516). In the latter, she flees to the island of Ebuda, where she is captured and exposed to a sea monster. The painting depicts her awaiting a rescuer, who will be Ruggiero.

The Angels Ministering to Christ Sir George Hayter, 1849, Victoria and Albert Museum, London.

The painting illustrates the event that concluded the temptation of Christ by the devil in the wilderness: "Then the devil leaveth him, and, behold, angels came and ministered unto him" (Matthew 4:11). Its original title in the catalog was *Our Saviour After the Temptation*.

The Angelus (French, *L'Angelus*) Jean-François Millet, 1859, Musée d'Orsay, Paris.

A peasant couple at work in the fields leave off their labor and bow their heads on hearing the angelus, the evening bell telling Catholics that it is time to recite three Hail Marys and repeat certain prayers. The Latin word itself begins the devotion: "*Angelus dominus nuntiavit Mariae*" ("An angel of the Lord announced to Mary"). The painting is also known in English as *The Evening Prayer*.

The Angler's Guard Sir Edwin Landseer, *c*.1824, Victoria and Albert Museum, London.

A St. Bernard dog and a white Italian greyhound guard the gear and fish basket of an angler.

Animal Destinies *see* The **Fate of Animals**.

Animal Fates *see* The **Fate of Animals**.

Anna *see* **Female Nude**.

Annabel and Rattler Lucian Freud, 1998, Tate Gallery, London.

The painting depicts a naked woman (Annabel, awake and female, "Beauty") and an Irish wolfhound (Rattler, asleep and male, "Beast") lying on a bed, the dog's pose echoing that of the woman and its legs extended similarly. The title reflects the general parallelism. The names are of identical length, contain the same vowels, and include a double consonant each.

Annah la Javanaise *see* **Aita tamari vahine Judith te parari**.

Annah the Javanese *see* **Aita tamari vahine Judith te parari**.

The Annunciation (1) Duccio di Buonin-segna, 1308, National Gallery, London; (2) Simone Martini, 1333, Uffizi, Florence; (3) Ambrogio Lorenzetti, 1344, Pinacoteca Nazionale, Siena; (4) Jan van Eyck, *c*.1434–6, National Gallery, Washington, D.C.; (5) Fra Angelico, *c*.1441–3, Museo di S. Marco, Florence; (6) Fra Filippo Lippi, *c*.1448, National Gallery, London; (7) Leonardo da Vinci, *c*.1472, Uffizi, Florence; (8) Antonello da Messina, *c*.1474, Galleria Nazionale, Palermo; (9) Carlo Crivelli, 1486, National Gallery, London; (10) Fra Bartolommeo, *c*.1500, Uffizi, Florence; (11) Pinturicchio, 1501, S. Maria Maggiore, Spello (Perugia); (12) Lorenzo Lotto, *c*.1527, Pinacoteca Comunale, Recanati (Macerata); (13) Domenico Beccafumi, *c*.1545, SS. Martino and Vittorio, Sarteano (Siena); (14) Jacopo Tintoretto, 1583–7, Scuola Grande di S. Rocco, Venice; (15) Federico Barocci, 1592–6, S. Maria degli Angeli, Perugia; (16) Orazio Gentileschi, 1623, Savoy Gallery, Turin; (17) Philippe de Champaigne, *c*.1644, Kingston upon Hull Art Gallery; (18) Bartolomé Murillo, *c*.1660–5, Prado, Madrid; (19) Edward Burne-Jones, 1876–9, Lady Lever Art Gallery, Port Sunlight; (20) John William Waterhouse, 1914, private collection; (21) (French, *L'Annonciation*) René Magritte, 1930, Tate Gallery, London; (22) see **Ecce Ancilla Domini!**

The scene is from the New Testament. The angel Gabriel announces to the Virgin Mary that she will conceive and bear Jesus (Luke 1:26–38). Messina has the Virgin alone, looking up from her reading as she sees the angel. In Crivelli's painting, Mary is seen at prayer through a doorway, while Gabriel bears a lily as a symbol of her purity. At his side is St. Emidius, the patron saint of Ascoli, the town for which the work was executed. Tintoretto has Gabriel irrupting suddenly with a cloud of cherubs upon a startled Mary. Champaigne, unusually, has both figures standing and Gabriel without a lily. Murillo has the two as little more than teenagers. Burne-Jones has Gabriel suspended upright in the air, while Mary stands by a water jar. For Waterhouse, Mary kneels on a terrace beside a garden. Magritte has no human figures in his surrealist painting. Instead, a patterned paper cut-out rises before an iron curtain with horse bells attached next to two towering bilboquets (*see* The **Age of Pleasure**). The group stands amid foliage on a rocky mount against the background of a cloudy sky. Despite the absence of the expected personages, the work's solemnity and stillness evokes something of the Renaissance paintings so titled (as those listed above). Its own title was given by the artist's friend, Belgian writer Paul Nougé, who may have seen the white paper cutout as the angel Gabriel and the double bilboquet as the Virgin.

The Annunciation to the Shepherds
Taddeo Gaddi, 1332–8, S. Croce, Florence.

The scene is from the New Testament. An angel in a cloud of light awakes a sleeping shepherd to announce the birth of the infant Jesus (Luke 2). Cf. The **Angel Appearing to the Shepherds**.

Another Bite George Smith, 1850, Victoria and Albert Museum, London.

A youthful angler tries to concentrate on his rod on feeling the soft touch of a feminine hand on his shoulder. The title puns on both kinds of "bite."

The Ansidei Madonna Raphael, *c*.1505, National Gallery, London.

The altarpiece was commissioned by Bernardino Ansidei for the family chapel in the church of S. Fiorenzo, Perugia. Hence its name (in its Italian version, *Madonna degli Ansidei*). The work also has an English title that names its four figures: *Madonna and Child with the Baptist and St. Nicholas of Bari*. The latter saint is included as the Ansidei chapel was dedicated to him.

Anthropomorphic Bread–Catalonian Bread Salvador Dalí, 1932, Salvador Dalí Museum, St. Petersburg, Florida.

A loaf of bread lies horizontally with one end wrapped and curving upwards. A melting watch is draped over this upper end, while a bottle of ink holding a quill pen stands on its lower end. A taut string extends from the center of the loaf to its upper tip. It is clear that the loaf's anthropomorphism is male and sexual, as the word indicates. Catalonia was the artist's native land, so that the painting is certainly self-referential. *Cp.* **Anthropomorphic Echo**.

Anthropomorphic Echo Salvador Dalí, 1937, Salvador Dalí Museum, St. Petersburg, Florida.

The painting represents a rocky landscape.

On the left is a town with two figures. In the center a mounted St. George fights a dragon. On the right a girl skips. As the title implies, the depiction echoes the artist's own life and experience. The (literally and figuratively) sinister figures on the left reflect his darker side, while the others express his lighter, religious side.

Antiochus and Stratonice (French, *Antiochos et Stratonice*) (1) Jacques-Louis David, 1774, École des Beaux-Arts, Paris; (2) J.-A.-D. Ingres, 1834–40, Musée Condé, Chantilly.

The works portray two figures from Greek history: the beautiful Macedonian princess Stratonice (died 254 BC), Seleucus' second wife, and her husband, crown prince Antiochus I (*c.*324–261 BC), Seleucus' eldest son.

Aphrodite Anadyomene Apelles, 4th *c.* BC.*

The painting's Greek title means "Venus rising," referring to the way in which Venus (Aphrodite) sprang full-grown from the sea foam. The long-lost portrait, showing Aphrodite wringing out her hair as she rises from the sea, was made for the temple of Asclepius at Cos. It was then taken to Rome by Augustus and set up in the temple of Caesar. The goddess is also known by other classical "surnames" or descriptive titles of this type, such as *Callipyge*, "of the beautiful buttocks" or *Epitragia*, "seated on a goat." *Cf.* The **Birth of Venus** and the many titles beginning **Venus**. *See also* **Phryne at a Celebration of Poseidon at Eleusis**.

Aphrodite of Cnidus Praxiteles, 4th *c.* BC.*

The most famous sculpture of classical times, now lost, depicted Aphrodite (Venus), the goddess of love, and was the first life-size statue to show her completely nude. (She was depicted placing her clothes on an urn before bathing.) Praxiteles made the statue for the inhabitants of the Dorian city of Cnidus. Hence its name. It is also known as the *Venus of Cnidus* or *Cnidian Venus*. *See also* **Phryne at a Celebration of Poseidon at Eleusis**.

Apolinère Enameled Marcel Duchamp, 1916–17, Philadelphia Museum of Art, Pennsylvania.

The work is an advertisement for Sapolin enamel paint, showing a small girl painting a bedstead, that the artist altered to pay a cryptic homage to the poet, Guillaume Apollinaire. (He deleted the "S" of "SAPOLIN", added "ÈRE," then added "ED" to "ENAMEL.")

Apollo and Coronis Adam Elsheimer, *c.*1607–9, Walker Art Gallery, Liverpool.

The god Apollo picks medicinal herbs in a vain attempt to revive his unfaithful lover, Coronis, whom he has shot with an arrow. The story goes that while pregnant with their child, Asclepius, god of healing, Coronis lay with a young Thessalian or Arcadian, Ischys, son of Elatus. The subject is from Book 2 of Ovid's *Metamorphoses* (1st century AD).

Apollo and Daphne Antonio Pollaiuolo, *c.*1470, National Gallery, London.

The virgin huntress of Greek mythology changes herself into a laurel tree to escape the rapacious advances of the god Apollo. *Cf.* The **Daphnephoria**.

Apollo Belvedere ?Leochares, 4th *c.* BC.*

The statue, a marble Roman copy of the lost Greek original, was discovered in the 15th century and is the most famous of the classical representations of the Greek god Apollo. It is so named for the Cortile del Belvedere, the court of the Vatican where it was set up. *Cf.* **Belvedere Torso**.

Apollo, Hyacinth, and Cyparissus (Russian, *Apollon, Giatsint i Kiparis*) Aleksandr Ivanov, 1831–4, Tretyakov Gallery, Moscow.

The mythological characters represent the three ages of man. Apollo (maturity) sits on a rock, in a royal pose. The beautiful boy, Cyparissus (youth), leans against him, while Hyacinth (childhood), kneels nearby and plays the pipes. An alternate English version of the title has *Zephyr* for *Cyparissus*, presumably following the account telling how Zephyr killed Hyacinth through jealousy of the latter's love of Apollo. The painting's full title is *Apollo, Hyacinth and Cyparissus Singing and Playing Music* (Russian, *Apollon, Giatsint i Kiparis, zanimayushchiyesya muzykoy i peniyem*).

Apollo Sauroktonos ("Apollo the Lizard-Killer") Praxiteles, *c.*350 BC, Vatican Museums.

The marble statue of the god Apollo as a boy leaning on a tree trunk, about to kill a lizard with an arrow, is a 2d-century AD Roman copy of the original. No literary reference appears to exist for the subject, although lizards were sometimes used in folk medicine as an antaphrodisiac. The lizard here could thus portray Apollo as immune to mortal sexuality.

Apotheosis of French Heroes Who Died for the Homeland during the War of Liberation (French, *Apothéose de héros français morts pour la patrie pendant la guerre de libération*): Anne-Louis Girodet de Roucy, 1802, Musée du Château Rueil-Malmaison.

The crowded painting depicts French military heroes of the Napoleonic wars, among them Jacques François Dugommier (1738–1794), Lazare Louis Hoche (1768–1797), and François Marceau (1769–1796), all dying in battle, arriving in the paradise of the Scandinavian war god, Odin, and joining the shades of the legendary Irish hero, Ossian, and his warriors. An apotheosis is literally the "making of a god."

The Apotheosis of Homer (French, *L'Apothéose d'Homère*) J.-A.-D. Ingres, 1827, Louvre, Paris.

The work, executed for a ceiling in the Louvre as a pictorial veneration of the Greek epic poet Homer, is based on Raphael's The **School of Athens**. It depicts a pyramidical grouping of famous artists and writers arranged symmetrically around Homer, the ancients near the top of the pyramid, the moderns at the base.

Apotheosis of Nelson Benjamin West, 1807, National Maritime Museum, London.

The painting depicts the sea god, Neptune, aided by Victory, presenting Britannia with the body of the English admiral, killed at the battle of Trafalgar (1805). The artist painted the work as a frontispiece for James Clarke and John McArthur's *Life of Lord Nelson* (1809).

The Apotheosis of St. Ignatius (Italian, *La gloria di Sant'Ignazio*) Andrea Pozzo, 1691–4, S. Ignazio, Rome.

The huge ceiling fresco is a pictorial glorification of St. Ignatius Loyola (1491–1556), founder of the Jesuits.

Apotheosis of War (Russian, *Apofeoz voyny*) Vasily Vereshchagin, 1870–1, Tretyakov Gallery, Moscow.

Ravens fly over or perch on a huge pyramid of skulls in a desolate plain with a ruined city in the background. The artist dedicated the painting to "all the great conquerors of the past, present, and future."

The Apparition (French, *L'Apparition*) Gustave Moreau, c.1875, Musée Gustave Moreau, Paris.

The apparition of the title is the gory, sev-

ered head of John the Baptist, surrounded by rays of light, which appears in the air before a nigh on naked Salome as she dances again before King Herod. She points imperiously to the victim whose death she has caused (Mark 6:25). The painting is sometimes known as simply *Salome*.

The Apparition of the Virgin to St. Bernard *see* The **Vision of St. Bernard**.

The Appearance of Christ to the People *see* **Christ Appears to the People**.

Apple Blossoms John Everett Millais, 1856–9, Lady Lever Art Gallery, Port Sunlight.

The painting depicts a group of young women and girls picnicking in an orchard of apple trees in full blossom. The title relates to the subjects as much as to the setting. The original title was *Spring*. The artist had at first planned to paint a woman sitting under a tree watched by a knight in the background, as a picture entitled *Faint Heart Never Won Fair Lady*.

Applicants for Admission to a Casual Ward Sir Luke Fildes, 1874, Royal Holloway College, Egham, Surrey.

A line of homeless people huddled outside a London police station on a winter's night wait for tickets to the "casual ward," the overnight lodgings of a workhouse. The painting is a version of the artist's illustration *Homeless and Hungry* published in 1869 in *The Graphic*.

Approaching Evening *see* **Taperaa mahana**.

April Love Arthur Hughes, 1856, Tate Gallery, London.

A young woman stands downcast in a bower, her eyes filling with tears following a lovers' tiff. The title seems to suggest the changing joys and sorrows of young love seen as the alternate sunshine and showers of April. The painting was more specifically inspired by Tennyson's poem *The Miller's Daughter* (1832), in which the ageing poet reminds his wife how he wooed and won her in April. This has the lines: "Love is hurt with jar and fret. / Love is made a vague regret. / Eyes with idle tears are wet."

An Arab Improvisatore Frederick Goodall, 1872, Victoria and Albert Museum, London.

An Arab improvisatore (performer who

improvises) begs for money. The title may pun on a work resulting from an improvised sketch, made on the spot during one of the artist's visits to Egypt, an Arab country.

Aramoana Nineteen Eighty-Four Ralph Hotere, 1984, Waikato Museum of Art and History, Hamilton, New Zealand.

The Maori artist's canvas has a large white cross on a black background between two vertical lines of figures, reading up 1 to 7 to the left and down 8 to 14 to the right. The title of the work is painted underneath. The cross, as the Christian symbol, represents sacrifice, in this case the sacrifice indicated by the title, which refers to the destruction of an albatross breeding colony at Aramoana, New Zealand. The figures represent the number of birds killed.

The Arcadian Shepherds *see* **Et in Arcadia Ego.**

The Architectonic Angelus of Millet Salvador Dalí, 1933, Perslys Galleries, New York.

The painting is a distorted representation of Jean-François's The **Angelus**, with the woman metamorphosed into a sort of praying mantis, as if about to devour the man, who is here a huge embryonic figure. The two together suggest prehistoric stone monuments or statues. (*See* **Atavistic Ruins After the Rain.**) Architectonics is both the scientific study of architecture and the study of the systemization of knowledge. Perhaps there is a pun on both senses here. *See also* **Gala and the Angelus of Millet Immediately Preceding the Arrival of Conical Anamorphoses.**

Are There not Twelve Hours of Daylight Colin McCahon, 1970, Waikato Museum of Art and History, Hamilton, New Zealand.

The title of the work is painted boldly in the top half of the canvas. Underneath it is a white line, representing the horizon of a landscape, and under that an elaboration of the title, reading, "Anyone can walk in daytime without stumbling because he sees the Light of this World. But if he walks after nightfall he stumbles, because the Light fails him." The message is a Christian one, and the words are a version of two New Testament verses (John 11:9–10).

Arearea ("Recreation") Paul Gauguin, 1892, Musée d'Orsay, Paris.

Two Tahitian girls sit beneath a tree beside a lagoon, one playing a flute. In the background,

worshippers pay their devotions before a carving of a Polynesian god. A red dog forages in the foreground. The native title, sometimes rendered in English as *Joyousness*, is inscribed in the bottom right corner.

Argininosuccinic Acid Damien Hirst, 1995, Saatchi Collection, London.

The work, a symmetrical arrangement of 391 colored circles painted in gloss household paint, is one of a number of randomly organized, color-spotted canvases with titles that refer to pharmaceutical chemicals.

Ariadne of Naxos (German, *Ariadne auf Naxos*) Lovis Corinth, 1913, private collection.

Ariadne, mythical daughter of the king of Crete, has landed on the island of Naxos, and lies naked in a swoon on the lap of her lover, Theseus, who is about to abandon her after vowing eternal love following her help in killing the minotaur. Bacchus, the god of wine, arrives in his chariot, and instantly falls in love with her.

Ariel Joseph Severn, 1826, Victoria and Albert Museum, London.

The painting of a naked child riding on a bat and holding a peacock's feather is a representation of Ariel, the "ayrie spirit" in Shakespeare's *The Tempest* (1611). The work was inspired by Ariel's song (V,1), which includes the line: "On a bat's back I do fly."

Ariosto *see* **Portrait of a Man.**

Aristotle Contemplating the Bust of Homer Rembrandt van Rijn, 1653, Metropolitan Museum, New York.

The great Greek philosopher and scientist contemplates the bust of the equally great poet, as if wondering which of them was the greater, or whether they complemented each other. The subject was apparently Rembrandt's own idea and not based on any classical source.

The Arming of Perseus Edward Burne-Jones, 1877, Southampton Art Gallery.

The scene is from classical mythology. The Greek hero Perseus prepares to set out to capture the head of Medusa, the Gorgon whose sight turned men to stone. Dressed in body armor, he sits on a rock while three sea nymphs give him the equipment he has asked for: a pair of winged sandals (he has put one on already), a large pouch in which to put the Gorgon's head, and the helmet of darkness, to render him invisible.

The Arnolfini Marriage Jan van Eyck, 1434, National Gallery, London.

The artist's most famous portrait shows the marriage ceremony between Giovanni Arnolfini and his wife Giovanna Cenami, the vows being taken in their own house in Bruges. Van Eyck actually witnessed the marriage, and his reflection appears in a convex mirror on the far wall. His presence is confirmed by his Latin inscription on the wall over the mirror: "*Johannes de eyck fuit hic*" ("Jan van Eyck was here"), with the date, 1434.

Arrangement in Gray and Black, No. 1: Portrait of the Painter's Mother J.A.M. Whistler, 1871, Musée d'Orsay, Paris.

The full title of the artist's most famous work, popularly known as *Whistler's Mother*, alludes to his experiment in near monochrome, the colors themselves reflecting the age and character of the old woman, who is dressed in black and sits against the background of a gray wall. The portrait was painted in London, where the artist had bought a house in 1859 and where he was joined by his long widowed mother, born Anna Matilda McNeill. She died in 1881. Whistler's painting *Arrangement in Gray and Black, No. 2* (1872) is a portrait of the Scottish historian, Thomas Carlyle.

The Arrest of a Propagandist (Russian, *Arest propagandista*) Ilya Repin, 1880–92, Tretyakov Gallery, Moscow.

A political agitator, seized by a policeman, casts an angry glance at a group by the window, among whom is the man who has denounced him.

The Arrival of St. Ursula in Rome Vittore Carpaccio, 1490, Accademia, Venice.

The work is one of a series of nine paintings by Carpaccio portraying scenes from the saint's life. This one shows her arriving in Rome on a pilgrimage made with her companions.

The Arrival of the Sorcerer at a Peasant Wedding (Russian, *Prikhod kolduna na krest'yanskuyu svad'bu*) Vasily Maksimov, 1875, Tretyakov Gallery, Moscow.

A snow-covered old sorcerer unexpectedly arrives in a candle-lit *izba* (peasant log cabin) where a marriage is being celebrated.

Art Roy Lichtenstein, 1962, Locksley Shea Gallery, Minneapolis.

The painting is simply the word "ART" in shadowed capital letters. It is thus its own title.

Art Is Useless, Go Home Ben Vautier, 1971, Galerie Bruno Bischofberger, Zürich.

The French equivalent of the English title, "*L'Art est inutile, rentrez chez vous*," is painted boldly in white capital letters on a red background. The Italian-born artist has made a career out of questioning the validity of art, and this is his graffiti-style message here.

The Art of Conversation (French, *L'Art de la conversation*) René Magritte, 1950, private collection.

The artist painted four works in 1950 with this title. Each depicts a landscape in which objects are grouped together so as to form huge words. This one has stone slabs that spell out "RÉVEIL" ("DREAM"). That is the conversation that the stones make with the viewer. Another in the series has a collaged cutout spelling "AMOUR" ("LOVE"), while a third has a cutout rising behind a dead bull reading "ESPAGNE" ("SPAIN").

The Artist and His Model (French, *Le Peintre et son modèle*) Balthus, 1980–1, Musée National d'Art Moderne, Paris.

The title leads one to expect an artist painting a model, or possibly a model examining a painting in the presence of the artist, as she does in The **Painter's Studio**. In this case the portrait is absent. The artist, his back to the model, draws back a curtain at the window. The model herself, a young girl, kneels before a chair, totally absorbed in the book she has propped on it. It is thus uncertain whether the artist is about to paint his model or has already completed her picture. The former seems more likely in view of the absence of the portrait.

The Artist and His Mother Arshile Gorky, *c*.1926–9, Whitney Museum of American Art, New York.

The Armenian-born American artist based his portrait (and self-portrait) on a photograph taken in 1912, when he was only eight.

The Artist in His Museum Charles Willson Peale, 1822, Pennsylvania Academy of the Fine Arts, Philadelphia, Pennsylvania.

Peale's self-portrait shows him in the institution that he founded in Philadelphia in 1786 as a center for studying natural law and displaying natural history objects. It is now known as the Peale Museum. In the painting, the 81-year-old artist lifts a curtain to reveal the many cabinets in the long hall beyond. The femur of a mastodon is propped behind him (*cf.* The

Exhumation of the Mastodon), and the skeleton of a prehistoric animal is partially seen.

The Artist's Family Benjamin West, 1772, Yale Center for British Art, New Haven, Connecticut.

The family portrait was painted in London and shows the artist himself, his wife, his two children, his father, and his elder brother, the latter two having come over from America.

The Artist's Halt in the Desert Richard Dadd, c.1845, private collection.

Against the background of a moonlit sky, a party of European travelers sit around a campfire close to the shores of the Dead Sea. The party is that of the Welsh lawyer Sir Thomas Phillips, whom the artist had joined in a journey to the Holy Land in 1842.

The Artist's Studio *see* (1) **Allegory of Painting**; (2) The **Painter's Studio**.

The Artist's Studio, Rue de la Condamine (French, *Mon Atelier*, "My Studio") Frédéric Bazille, 1870, Musée d'Orsay, Paris.

The artist, in his studio on the named Paris street, shows one of his paintings to Manet and Monet, while Renoir (seated) is deep in conversation with Zola (on the stairs).

"As cold waters to a thirsty soul, so is good news from a far country" George Smith, 1864, Richard Green Gallery, London.

A letter has arrived from abroad and the whole family gathers around eagerly to hear it read out. The title quotes Proverbs 25:25.

"As the twig is bent, so is the tree inclined" James Hayllar, c.1880, Christopher Wood Gallery, London.

A little girl learns to pray as she kneels beside her grandfather before a simple chair. The title quotes one of the popular proverbs that prefaced the essays in Charles Haddon Spurgeon's collection of moral lectures entitled *John Ploughman's Talk* (1869). Others were "Much cry and little wool, as the man said when he sheared the sow" (before an essay on boasting), and "There is a hole under his nose and his money runs into it" (before one on intemperance). *Cf.* The **Lesson**.

Ascanius Shooting the Stag of Silvia (French, *Ascanie tirant sur le cerf de Silvie*) Claude Lorrain, 1682, Ashmolean Museum, Oxford.

The artist's last painting takes its subject from Book 7 of Virgil's *Aeneid*. Juno has sent the Fury Alecto to stir up trouble between the Trojans and the Rutulians. She does so by making Ascanius, Aeneas' son, fire an arrow at the pet stag of the royal herdsman's daughter, Silvia.

Ashes (Norwegian, *Aske*) Edvard Munch, 1894, National Gallery, Oslo.

A dishevelled young woman stands in an anguished pose, her dress open, her hands clasped on her head. At bottom left , a young man crouches with bowed head. A log in the foreground is turning to ashes, apparently symbolizing the man's dying love for the woman. Hence the title of the painting, one of a series for the artist's *Frieze of Life* cycle, with love and death as its subject matter.

Ask Me No More Sir Lawrence Alma-Tadema, 1906, private collection.

A young Roman kisses the hand of his beloved as they sit on a terrace overlooking the sea. The title quotes the phrase that recurs in all three verses of the song added in 1850 to Tennyson's poem *The Princess* (1847), the second running: "Ask me no more: what answer should I give? / I love not hollow cheek or faded eye: / Yet, O my friend, I will not have thee die! / Ask me no more, lest I should bid thee live; / Ask me no more."

The Assembly at Wanstead House William Hogarth, 1729–31, Philadelphia Museum of Art, Pennsylvania.

The painting depicts the family and friends of Sir Richard Child, 1st Earl Tylney, who in 1715 built a grand Palladian mansion at Wanstead in what is now northeast London. The house was demolished in 1824.

The Assumption of the Virgin (1) Andrea del Sarto, c.1526, Pitti, Florence; (2) Annibale Carracci, c.1587, Prado, Madrid; (3) Giovanni Lanfranco, 1625–7, S. Andrea della Valle, Rome; (4) Gerard Seghers, 1629, Musée de Peinture et de Sculpture, Grenoble.

The works depict the Virgin Mary being "assumed" (received) into heaven on completing her earthly life. For Roman Catholics, the Assumption of the Blessed Mary is both a feastday and the fourth of the Five Glorious Mysteries of the Rosary. *See also* The **Death of the Virgin**.

Astarte Syriaca Dante Gabriel Rossetti, 1877, Manchester City Art Gallery.

The symbolic painting is a full-length portrait of Jane Morris, wife of the artist, William

Morris, as Astarte, the Semitic goddess of fertility and sexual love. The goddess was mainly associated with Syria and Palestine. Hence the title, meaning "Astarte of Syria." Rossetti wrote a sonnet to accompany the painting, beginning, "Mystery: lo! betwixt the sun and moon / Astarte of the Syrians: Venus Queen / Ere Aphrodite was."

The Asthmatic Escaped Damien Hirst, 1992, private collection.

The work consists of two large steel-framed glass cases separated by a glass partition with a narrow vertical central slit. In the first case, which has its own, smaller partition, is a heap of clothes (jeans, T-shirt, running shoes) with an inhaler, in the other a camera on a tripod. The empty clothes and inhaler seem to confirm that an asthmatic has escaped, as the title states, but the viewer is left wondering how or where to. The partition in the first case forms a cross with the steel frame, prompting the following exchange between an interviewer and the artist: "The cross is a way out, that's the escape?" "A spiritual not physical escape if you decide to choose it" (Hirst, p. 40).

At the Moulin Rouge (French, *Au Moulin Rouge*) Henri de Toulouse-Lautrec, 1892, Art Institute of Chicago, Illinois.

The painting depicts several personalities at the Moulin Rouge music hall seated around a table, while in the background La Goulue (*see* **Moulin Rouge: La Goulue**) arranges her hat.

At the Piano J.A.M. Whistler, 1859, Taft Museum, Cincinnati, Ohio.

A young girl is seated at the piano, her mother standing by. The portraits are of the artist's half-sister, Deborah Haden, and her daughter Annie.

At the School Door (Russian, *U dverey shkoly*) Nikolai Bogdanov-Belsky, 1897, Russian Museum, St. Petersburg.

A raggedly dressed peasant boy pauses at the threshold of an open schoolroom door to look longingly at the rows of boys bent over their tasks at their desks.

Atalanta and Hippomenes Guido Reni, 1625, Museo di Capodimonte, Naples.

The scene is from classical mythology. The huntress Atalanta has declared that she will marry only the man who can beat her in a race. She races against Hippomenes, but Aphrodite has given him three golden apples, which he one at a time rolls off the course. Atalanta stops each time to pick them up, so enabling him to win. (In the painting she stoops to pick up the second apple, the first already in her other hand.)

Atavistic Ruins After the Rain Salvador Dalí, 1934, Perls Gallery, New York.

The painting resembles The **Architectonic Angelus of Millet** and is probably a development of it. The woman, as a praying mantis, has now devoured the man, however, and so more obviously resembles a huge sculpture or ancient standing stone. As the title implies, the figure has reverted to an ancestral form. ("Atavistic" derives from Latin *atavus*, "great-grandfather's grandfather.") A man and a small boy survey the "ruins," and represent the artist as infant and his father.

Athlete Struggling with a Python Frederic Leighton, 1874–7, Leighton House, London.

The classically inspired sculpture is based on the **Laocoön** (1) that the artist had seen when in Rome.

The Attack on an Emigrant Train Carl Wimar, 1856, University of Michigan Museum of Art, Ann Arbor.

A group of white settlers attempt to defend themselves against a violent attack by a band of Indians on horseback.

Attempting the Impossible (French, *Tentative de l'impossible*) René Magritte, 1928, Galerie Isy Brachot, Brussels.

The painting depicts an artist bringing a nude woman into existence. She stands before him almost complete as he starts to paint her left arm from the shoulder. The artist cannot of course really create a living nude, and the fact that the picture shows him with the woman unfinished reinforces the message of the title: representational art, however faithful, is an illusion, and any artist who tries to create reality is "attempting the impossible."

The Attributes of the Arts (French, *Les Attributs des Arts*) Jean-Baptiste-Siméon Chardin, 1766, Hermitage, St. Petersburg.

The painting depicts the traditional tools of the painter and architect, such as the former's brushes and palette and the latter's measuring implements and plans. There is also a model of Jean-Baptiste Pigalle's statue *Mercury Fastening His Sandals* (1742) to symbolize sculpture.

Au Naturel Sarah Lucas, 1994, Saatchi Collection, London.

Two oranges and an upturned cucumber, representing male genitals, have been placed on one half of an old double mattress, its head raised. On the other half, representing the female, are two melons and a water bucket on its side. The title is the familiar French phrase literally meaning "in a natural state," alluding both to the representations and presumably also to the natural products that form them. *Cf.* **Two Fried Eggs and a Kebab**.

Aunt Sallys (French, *Têtes à massacre*) Georges Rouault, 1907, Tate Gallery, London.

The painting depicts three puppet-like figures, apparently a young woman between her parents. All are dressed in their finery. For this reason, the picture was originally known as *The Bride* (French, *La Mariée*), but when the artist saw a photograph of his work in 1953 he said he would like to change the title to *Têtes à massacre* (literally "Heads for Massacre"). The figures are thus Aunt Sallys at a fairground, to be dislodged by having balls thrown at them.

Aurora Guido Reni, 1613–14, Casino Rospigloso, Rome.

The famous ceiling fresco shows Aurora, Greek goddess of the dawn, flying before Apollo in his chariot. She is accompanied by the Horae (Hours), the Greek goddesses of the seasons.

Aurora Triumphans Evelyn De Morgan, 1886, Russell Cotes Art Gallery, Bournemouth.

The scene is from classical mythology. Aurora, goddess of the dawn, is released of her bonds as Nox, goddess of night, flees and three winged figures herald the triumph of dawn.

Autumn (1) Frederick Sandys, *c.*1860–2, Norwich Castle Museum, Norfolk; (2) Winslow Homer, 1877, National Gallery, Washington, D.C.; (3) (French, *L'Automne*) Natalia Goncharova, 1910, Tate Gallery, London.

Sandys depicts an old soldier reclining on the banks of a river with a young woman, either his wife or daughter, and a child. The artist probably intended the veteran to represent the autumn of life, and perhaps he now recounts past glories to the younger generation. (Sandys planned a companion picture, *Spring*, but it was never realized. A sketch for it shows a group of young children seated beneath trees.) Homer shows a solitary woman surrounded by woods in one of the many autumnal scenes he painted in the Adirondacks in upstate New York. The woman holds a spray of autumn leaves in one hand and her long skirt in the other. She is perhaps herself approaching the autumn of her life. Goncharova's semiabstract painting has three half-length female figures against a yellow and orange representation of the rays of the sun and a sandy path. The picture was painted in Russia and has also been known as *After the Storm*, *In the Park*, *The Park*, *Autumnal Park*, and simply *Three Girls*.

Autumn Cannibalism. Salvador Dalí, 1936, Tate Gallery, London.

Two figures are eating each other. The painting symbolizes the Spanish Civil War, in which family fought against family. The artist saw this as a form of cannibalism.

Autumn Leaves John Everett Millais, 1855–6, Manchester City Art Gallery.

Four young girls stand round a pile of dead leaves ready for burning. Two of the older girls add baskets of leaves to the heap. One holds an apple, a symbol of autumn (the fall) and the biblical Fall. The picture contrasts the girls' budding youth, at the springtime of their lives, with the seasonal decay of natural things in the fall, in this case leaves to be burned at dusk. The girls' reflective expressions imply their awareness of the conjunction. The subject was partly inspired by the poetry of Tennyson and William Allingham. Tennyson's poem *The Princess* (1847) includes images of autumn and dead leaves, as: "The golden Autumn woodland reels / Athwart the smoke of burning weeds." The models for the girls, all under 13, were the artist's sisters-in-law, Alice and Sophie Gray, and two Scottish girls, Matilda Proudfoot and Isabella Nicol, who also posed for The **Blind Girl**.

An Autumn Morning Henry Herbert La Thangue, 1897, private collection.

A young woman strains to snap a branch across her raised knee in a copse where she has been gathering firewood.

The Avenue, Middelharnis Meindert Hobbema, 1689, National Gallery, London.

The artist's most famous work depicts a long, straight country road flanked by lofty poplars. The avenue that immediately draws the eye is duplicated by another, smaller avenue to the right, where a nurseryman prunes young trees. Maybe one day these will supplant the older trees in the main avenue, which were themselves planted 25 years before the painting

was executed. The village of Middelharnis lies on the north coast of the island of Over Flakee in the province of South Holland at the mouth of the Maas.

Avenue Trudaine *see* The **Wafer Vendor**.

The Awakening (French, *L'Éveil*) Gustave Courbet, 1864.*

The painting, destroyed in World War II, depicted Venus looking jealously at the beautiful sleeping Psyche, both naked. The work was a version of the artist's *Venus and Psyche*, painted the previous year.

The Awakening Conscience William Holman Hunt, 1853–4, Tate Gallery, London.

A half undressed young woman rises from the lap of a lover seated at the piano to look through an open window into a sunny garden. The painting depicts her at the moment of her conversion from the dissolute life of a "fallen woman" to a state of repentance on recalling her lost childhood innocence, metaphorically represented by the garden. Her "awakening conscience" is revealed by her open lips and wide eyes, and is symbolized by the design of Cupid bound by chastity on a clock on the piano, and a knowing cat under the man's chair. The artist himself invariably referred to the painting as *The Awakened Conscience* and explained that it was a materialistic counterpart to The **Light of the World**.

The Awakening of Napoleon (French, *Napoléon s'éveillant à l'immortalité*, "Napoleon Awakening to Immortality") François Rude, 1847, Fixin, near Dijon.

The bronze sculpture is a monument to the French emperor, who had died a quarter of a century earlier, and shows him casting off his shroud. Rude was an enthusiastic Bonapartist.

The Awakening of Spring *see* The **Loss of Virginity**.

Away from the Flock Damien Hirst, 1994, Saatchi Collection, London.

The work consists of a dead sheep suspended in a tank of formaldehyde. The title relates to its isolation. One one occasion a mildly outraged fellow artist entered the gallery where the work was first shown, poured black ink into the solution, and placed his own label over the original title: "Mark Bridger, Black Sheep, May 9, 1994."

Axes Susan Rotheberg, 1978, Museum of Modern Art, New York.

An outline of a horse has a vertical axis marked through its shoulders and forelegs and an angled axis bisecting the middle of its body as it leans forward.

Azaleas Albert Joseph Moore, *c.*1868, Municipal Gallery of Modern Art, Dublin.

A young woman wearing a flowing robe stands beside a tall flowering azalea, growing in a pot of oriental design. She picks a blossom with her right hand and is about to place it in the bowl she holds in her left arm. The painting appears to have no specific mythological or other reference, and the title simply names the dominant flowers.

B

Baby Is Three Robyn Denny, 1960, Tate Gallery, London.

The abstract painting is a large tripartite picture composed of interlocking rectangles. The work itself is the artist's "baby," and its tripartition is the "three." The title was actually adopted from a science fiction story by the American writer, Theodore Sturgeon.

The Babylonian Slave Market Edwin Long, 1875, Royal Holloway College, Egham.

White-robed Egyptian slave girls sit demurely as they wait their turn to mount a platform and be offered for marriage to a crowd of male bidders. The painting, whose scene is based on a description by Herodotus, is also known as *The Babylonian Marriage Market*.

Bacchanal *see* **Bacchanal of the Andrians**.

Bacchanal of the Andrians Titian, 1518–9, Prado, Madrid.

A gathering of nude and seminude people drink wine, dance, and flirt by a clump of trees on a hillside. A nude woman lies in intoxicated abandon in the foreground, while beside her a small boy urinates next to an overturned goblet. The subject and composition of the painting recall Bellini's **Feast of the Gods**, but the actual subject is "The Stream of Wine on the Island of Andros," a tale from classical mythology. (The island of Andros had a temple to Bacchus, the god of wine, with a fountain whose water, on certain occasions, flowed with the taste of wine.)

The work is also known as *Bacchanal* (or *Bacchanalia*) or as *The Andrians*.

Bacchanalia *see* Bacchanal of the Andrians.

Bacchus (1) Michelangelo, *c*.1496–7, Bargello, Florence; (2) Jacopo Sansovino, 1511–12, Bargello, Florence.

The works specified here are both sculptures of the Roman god of wine. Michelangelo's is a convincing imitation of a classical statue. Legend has it that the model for Sansovino's Bacchus, a young nude holding a cup aloft, went mad from being made to pose for hours on end with his arm raised and that one day he was found naked on a chimney in this position.

Bacchus in India Charles Ricketts, *c*.1913, Atkinson Art Gallery, Southport.

The young Bacchus, god of wine and revelry, is depicted on his arrival in India, mounted nude on an elephant and preceded by his half-naked adherents in an orgy of abandon.

The Backwoods of America Jasper F. Cropsey, 1858, Manoogian Collection, Detroit, Michigan.

The depiction is of a pioneer settlement on the American frontier. The somewhat dilapidated state of the cabin and the tree stumps in the foreground point to the hardship and physical exertion that life in the backwoods demanded and the title pointedly centers on this word.

Bad Boy Eric Fischl, 1981, Saatchi Collection, London.

A young boy looks furtively at a sprawled naked woman on a bed, presumably his mother, while stealing from her purse which he holds behind his back. The title alludes to his double "bad boy" act.

Bad News James Tissot, 1872, National Museum of Wales, Cardiff.

A young red-coated officer sits despondently at a tea table by a window overlooking a river. A young woman has her arms around his neck, while another prepares the tea. The "bad news" is that the officer's furlough has ended, and he must rejoin his regiment. Hence the painting's subtitle, *The Parting*.

La Baignade *see* Bathers at Asnières.

The Balcony (French, *Le Balcon*) Édouard Manet, 1869, Musée d'Orsay, Paris.

Two women and a man pose on a balcony. The man is the landscape artist, Antoine Guillemet (1843–1944). The woman seated by the rail is the artist, Berthe Morisot (1841–1895), who in 1874 married Manet's brother, Eugène. The second woman is the violinist, Fanny Claus (named by some sources as Jenny Klaas).

The Baleful Head Edward Burne-Jones, 1886–7, Staatsgalerie, Stuttgart.

The painting is one of the artist's four finished pictures of a series of eight on the legend of Perseus, who here shows Andromeda the head of Medusa in the reflection of a well. "Baleful" has its original sense of "destructive," "malignant."

The Ball on Shipboard James Tissot, *c*.1874, Tate Gallery, London.

Groups of elegantly dressed young women, together with some men, stand or sit on the decorated deck of a seagoing yacht while waiting to dance. The scene may have been painted at Cowes, Isle of Wight, during Regatta Week (now known as Cowes Week).

Ballerina (French, *La Danseuse*) Henri Matisse, *c*. 1927, Hermitage, St. Petersburg.

The portrait of a seated dancer is of the ballet student and model Henriette Darricarrère, whom the artist first met in 1920, when she was 19. She posed for him until 1928 when she married, and he lost interest in her.

Ballet of the Woodpeckers Rebecca Horn, 1986, Tate Gallery, London.

A bare room is lined with mirrors which are spasmodically tapped by small electrically operated hammers, suggesting not just a "ballet" of woodpeckers but of birds that destroy themselves by flying into their own reflection.

Balls: the evening before the morning after Gilbert and George, 1972, Tate Gallery, London.

Subtitled *Drinking Sculpture*, the work comprises 114 photographs of varying sizes mounted in glass and showing the artists drinking in one of Balls Brothers chain of London wine bars. The photographs have been processed to give an increasing effect of distortion and blurring, representing the experience of increasing drunkenness, or "the evening after the night before." Near the center of the display one of the frames contains the title.

The Bank Failure (Russian, *Krakh banka*) Vladimir Makovsky, 1881, Tretyakov Gallery, Moscow.

A crowd of depositors react in different ways to the collapse of the bank to which they had entrusted their meager savings.

The Banquet of the Officers of the Civic Guard of St. George Frans Hals, 1616, Frans Hals Museum, Haarlem.

The work depicts portraits of the members of the named force as they converse with one another during their celebratory meal. The almost worshipful postures of the militiamen, together with their rapturous expressions, hints at the religious origins of their company, while the work as a whole symbolizes the strength and optimism of the men who founded the new Dutch Republic. The formal, ponderous title adds to the sense of occasion. Hals was subsequently commissioned to paint similar records, such as *The Banquet of the Officers of the Civic Guard of St. Hadrian* (*c*.1627), in the same museum.

Baptism in Kansas John Steuart Curry, 1928, Whitney Museum of American Art, New York.

A young girl is baptised by total immersion in a farmyard trough as a crowd of Baptist fundamentalists sing hymns around it.

The Baptism of Christ (1) Piero della Francesca, *c*. 1450–5, National Gallery, London; (2) Andrea del Verrocchio, *c*.1475, Uffizi, Florence; (3) Gérard David, *c*.1505, Groeninge Museum, Bruges; (4) Annibale Carracci, 1584, S. Gregorio, Bologna.

The scene is from the New Testament. John the Baptist baptises Christ, who stands by or in the Jordan River, the Holy Spirit as a white dove overhead (Mark 1:9–11). Saints or angels attend the occasion.

A Bar at the Folies-Bergère (French, *Bar aux Folies-Bergère*) Édouard Manet, 1882, Courtauld Institute, London.

A young barmaid stands at a well-stocked counter in the fashionable Paris nightclub of the title. The work is essentially a portrait of the barmaid, a young woman called Suzon.

Barbaric Tales (French, *Contes barbares*) Paul Gauguin, 1902, Folkwang Museum, Essen.

Two young Tahitian girls pose beneath a flowering tree, one kneeling, the other cross-legged. Behind them squats a devil-like figure with claw feet, his hand to his mouth as he eyes them. "The meaning of the title is not clear. In his last works, Gauguin had abandoned his ear-lier practice of naming his paintings, but he made an exception here" (Bowness, p. 126). However, the tales of the title could well be those that the girls tell of ancient Polynesian gods. The painting is equally known by its French title or by the alternate English title *Primitive Tales*.

The Barber and Others Purging Don Quixote's Library John Massey Wright, *c*.1816, Victoria and Albert Museum, London.

The painting illustrates a scene from Cervantes' *Don Quixote* (1605). The Don's housekeeper has realized that her master's excessive reading of books about knight errantry had resulted in his misadventures so far. The local barber and priest thus decide to remove and burn the offending books, with the help of the housekeeper. The artist had earlier exhibited a similarly inspired painting entitled *Don Quixote Being Fed by the High-Born Ladies*.

Barberini Faun ?, *c*. 200 BC, Glyptothek, Munich.

The work is a classical Greek marble statue of a faun (satyr) sprawled in drunken sleep. Its creator is not known, and it may be a copy. It is named for Cardinal Francesco Barberini (1597–1679), the first person recorded as possessing it (in 1628). The statue is also known as *Drunken Faun*, *Sleeping Faun*, or *Sleeping Satyr*.

The Bard (1) Thomas Jones, 1774, National Museum of Wales, Cardiff; (2) John Martin, 1817, Laing Art Gallery, Newcastle-upon-Tyne.

Both paintings depict a wild-looking old man at the edge of a precipice in a rugged landscape. In each case he is the central character of Thomas Gray's poem of the same name (1757), telling how the Celtic bards of Wales were massacred by the invading army of Edward I until one alone remained in defiance. He, too, plunged to his death from a clifftop.

Bargehaulers on the Volga (Russian, *Burlaki na Volge*) Ilya Repin, 1870–3, Russian Museum, St. Petersburg.

A gang of ten men and a boy, each distinctive and all of different nationalities, strain in their towing straps as they haul a barge up the Volga. The artist was moved to paint the picture after seeing a gang of such haulers toiling past a group of young people out on a picnic by the banks of the Neva near St. Petersburg. The painting is also known as simply *Volga Boatmen*.

Basket of Bread–Rather Death Than Shame. Salvador Dalí, 1945, Fundación Gala-Salvador Dalí, Figueras.

A half loaf lies in a bread basket. The imagery is undoubtedly religious, since bread is the staff of life and represents the body of Christ. The subtitle quotes the knightly motto "Death before dishonor," as found in the *Chanson de Roland*: "*Melz voeill murir que hunte nus seit retraite*" ("Let death be our portion sooner than shame") and also in Horace, who in his *Odes* defines a happy man as (among other things) one "who fears dishonor worse than death."

Le Bateau Ivre ("The Drunken Ship") Wols, 1945, Kunsthaus Zürich, Zürich.

A sailing ship can be made out in this modernistic painting by the German artist, who adopted for it the French title of Arthur Rimbaud's 1871 poem describing the journey of life. For Wols, the title, and thus the painting, was a poetic metaphor for his own aimless life.

The Bath (French, *La Baignoire*) Pierre Bonnard, 1925, Tate Gallery, London.

The woman lying in the bathtub is the artist's wife, Marthe, earlier his mistress and model.

The Bath of Diana *see* **Diana Bathing**.

The Bath of Psyche Frederic Leighton, *c.*1890, Tate Gallery, London.

The goddess of Greek mythology stands naked by a palace pool and gazes at her reflection in its waters as she prepares to bathe before her marriage to Eros. She is a portrait of Dorothy Dene, Leighton's favorite model.

The Bath of Venus Edward Burne-Jones, 1873–88, Calouste Gulbenkian Foundation, Lisbon.

Accompanied by musicians, the goddess Venus walks naked down steps to a bath.

The Bather (French, *La Baigneuse*) Étienne-Maurice Falconet, 1757, Louvre, Paris.

A young girl lets fall the end of her robe to enter the water. The English title of the marble statue in the Greek classical style does not reveal the bather's sex.

The Bather and the Griffon (French, *La Baigneuse au griffon*) Pierre-Auguste Renoir, 1870, Museu de Arte, São Paolo.

A young woman has disrobed preparatory to bathing in a stream and stands nude in the pose of the **Aphrodite of Cnidus**. A griffon (a small dog of the terrier breed) lies at her feet. The model for the nude was the artist's mistress, Lise Tréhot (1848–1924).

The Bathers (1) (French, *Les Baigneuses*) Gustave Courbet, 1853, Musée Fabre, Montpellier; (2) (French, *Les Baigneurs*) Frédéric Bazille, 1869, Fogg Art Museum, Cambridge, Massachusetts; (French, *Les Baigneuses*) (3) Pierre-Auguste Renoir, 1884–7, Philadelphia Museum of Art, Pennsylvania; (4) Théodore Roussel, 1887, private collection; (5) Paul Cézanne, 1900–5, National Gallery, London; (6) Pablo Picasso, 1918, Musée Picasso, Paris.

The English title does not identify the sex of the bathers in the various paintings, although the original French shows that Bazille depicts men and the other artists women. Bazille's bathers are eight young men, most in swimming trunks, in or by a pool in a woodland glade. The picture has the alternate title *Summer Scene* (French, *Scène d'été*). Courbet has one nude woman and one, presumably her servant, dressed. Renoir has five nude young women, three in the water, two by it. Roussel has one nude standing, her hands behind her head, and one seated. Cézanne has ten, none in the water. (They could almost be sunbathers, and there is no water to be seen.) Picasso has three women in brightly colored swimsuits, drying or dressing their hair. Cézanne's painting is also known as *Les Grandes Baigneuses* ("The Large Bathers"), so called because it is on a large canvas, by contrast with the smaller pictures of bathers he had painted earlier.

The Bathers Surprised William Mulready, *c.*1852–3, National Gallery of Ireland, Dublin.

The painting basically portrays a nude young woman sitting serenely by a river. But to the left a second nude hastily leaves the water, while a clothed woman behind her signals urgently. The source of the threat to the bathers is left to the viewer's imagination.

Bathhouse (Russian, *V bane*, "In the Bathhouse") Zinaida Serebryakova, 1913, Russian Museum, St. Petersburg.

Naked women are in various stages of bathing or drying themselves in a public bathhouse.

Bathing Duncan Grant, 1911, Tate Gallery, London.

A group of nude men dive, swim and clamber into a boat at sea.

Bathing at Asnières (French, *Baignade à Asnières*) Georges Seurat, 1883–4, National Gallery, London.

Young factory workers bathe or sun themselves by the bank of the Seine River at Asnières, just outside Paris. The chimneys of their factory can be made out in the distance, while to the right, across the water, lies the Île de la Grande Jatte (*see* La **Grande Jatte**). The work is also known by English speakers as *La Baignade*, a short form of its French title. The painting (but not its prosaic title) was inspired by Pierre Puvis de Chavannes's The **Happy Land**.

Bathing on a Summer Evening (French, *Baignade par un soir d'été*) Félix Vallotton, 1892, Kunsthaus Zürich, Zürich.

Women and girls of all ages in various stages of dress and undress bathe in a river or rest in the rays of the evening sun in a flowery meadow by steps that lead down to the water.

The Bathroom *see* **Nude Against the Light**.

The Baths of Caracalla Sir Lawrence Alma-Tadema, 1899, private collection.

The painting depicts the famous baths of the Roman emperor Caracalla (AD 188–217) at Rome. The emperor himself can just be made out in the background. *Cf.* **Caracalla and Geta**.

Bathtub 3 Tom Wesselmann, 1963, Museum Ludwig, Cologne.

A naked blonde woman dries herself with a red and white striped towel as she stands in a blue bathtub. Before and beside the painting are real objects, including a shower curtain, a bathmat, a laundry basket, and a bathroom door with a yellow towel on a towel rail. The work is the third by the artist on this particular subject.

A Battery Shelled Wyndham Lewis, 1919, Imperial War Museum, London.

Smoke billows from a ruined gun battery after its shelling by the enemy in World War I. Lewis was in the army and the work is one he painted following his secondment as a war artist in 1917.

Battle (German, *Schlacht*) Wassily Kandinsky, 1910, Tate Gallery, London.

The mostly abstract painting nevertheless has some representational features that enable one to make out two Cossacks dueling with sabers at top left, three more Cossacks, two of them holding lances, at bottom right, and a castle on a hill and birds in flight at top right.

The Battle Between Carnival and Lent Pieter Bruegel I, 1559, Kunsthistorisches Museum, Vienna.

The street scene represents the moment when the jollity of Shrove Tuesday reluctantly yields to the austerity of Ash Wednesday, the first day of Lent. The figures in the street are either garishly garbed and disorderly or soberly gowned and in ordered procession accordingly.

The Battle of Eylau (French, *La Bataille d'Eylau*) Antoine Gros, 1808, Louvre, Paris.

The work is a grandiose representation of the battle at Eylau (now Bagrationovsk, Russia) (1807) in which the French won a bloody but indecisive victory over the Russians and the Prussians during the Napoleonic Wars. Gros was Napoleon's official battle painter.

The Battle of the Lapiths and Centaurs Michelangelo, *c*.1491–2, Casa Buonarroti, Florence.

The marble sculptured relief, based on a similar work by Bertoldo di Giovanni, represents the famous mythological battle between the civilized Lapiths and drunken Centaurs at the marriage of Hippodamia to the Lapith king, Pirithous.

Be Loving, You Will Be Happy (French, *Soyez amoureuses vous serez heureuses*) Paul Gauguin, 1889, Museum of Fine Arts, Boston, Massachusetts.

The carving depicts a nude seated woman, her raised arm grasped by a demon. She struggles against him, despite the apparently good advice of the title. Other figures have dreary expressions, implying that the reverse of the title is true. A fox stands before the woman as a symbol of lubricity. The title is thus ironic, and echoes a sentiment expressed by the artist in a letter to his wife, demanding she reciprocate his affection: "I am to be loved if I love." (The French version of the title, seen at the top of the carving, is addressed to women only.)

The Bearded Woman José de Ribera, 1631, Tavera Hospital, Toledo.

The painting is subtitled *Magdalena Ventura with Husband and Son*, and a Latin inscription tells the story behind the portrait: "EN MAGNV NATURA / MIRACVLVM / MAGDALENA VENTVRA EX / OPPIDO ACVMVLI APVD / SAMNITES VVLGO EL A / BRUZZO REGNI NEAPOLI / TANI ANNORVN 52 ET / QVOD INSOLENS EST CV / ANNVM 37 AGERET COE / PIT PVBESCERE, EOQVE / BARBA DEMISSA AC PRO- / LIXA EXT VT POTIVS / ALICVIVS MAGISTRI BARBATI / ESSE

VIDEATVR / QVAM MV / LIERIS QVAE TRES FILIOS / ANTE AMISERIT QVOS EX / VIRO SVO FELICI DE AMICI / QVEM ADESSE VIDES HA / BVERAT. / IOSEPHVS DE RIBERA HIS / PANVS CHRISTI CRVCE / INSIGNITVS SVI TEM- / PORIS ALTER APELLES / IVSSV FERDINANDI II / DVCIS III DE ALCALA / NEAPOLI PROREGIS AD / VIVVM MIRE DEPINXIT / XIIIJ KALEND. MART. / ANNO MDCXXXI" ("The great wonder of nature, Magdalena Ventura, from the town of Accumoli among the Samnites [in central Italy], or, in the vulgar tongue, Abruzzi, in the kingdom of Naples, aged 52 years, the unusual thing about her being that when she was 37 she began to become hairy and grew a beard so long and thick that it seems more like that of any bearded gentleman than of a woman who had borne three sons by her husband, Felici de Amici, whom you see here. José de Ribera, a Spanish gentleman of the Order of the Cross of Christ, and another Apelles of his time, painted this scene marvellously from life, on the order of Ferdinand II, 3d duke of Alcalá, viceroy of Naples, on February 16, 1631").

Beata Beatrix Dante Gabriel Rossetti, c.1864–70, Tate Gallery, London.

The work is an idealized and symbolic portrait of the artist's wife and former model, Elizabeth Siddal, who had died in 1862 from narcotic abuse. She is depicted as Dante's Beatrice, in real life Beatrice Portinari, whom he first met "almost at the beginning of her ninth year" and who inspired him with a lasting love. He celebrated her in the Beatrice of *La Vita Nova* (*c.* 1294) and *La Divina Commedia* (*c.* 1307–*c.* 1321), in which she meets him on the threshold of Paradise. The Latin title thus means "Blessed Beatrice." (There is a further parallel between Rossetti's own name and that of the poet.) The painting shows Beatrice against a backdrop of 13th-century Florence, with the twin figures of Love and Dante in the foreground. A sundial marks nine o'clock, the hour Dante associated with her death. Rossetti painted a replica of the same title in 1872, now in the Art Institute of Chicago, Illinois.

beautiful, beautiful, nasty, mean, heartless but colourful, optimistic, drug induced, contentless, formless, thoughtless, uncreative, crappy but dappy, uncool, massive explosion, screaming, creamy, smooth, fill your heart with joy painting Damien Hirst, 1991, Saatchi Collection, London.

The circular painting is a centrifugal multicolored splash executed by tying the canvas to a spinning turntable and splattering it with gloss household paint. The title reflects the atmosphere in which the work was created, "less Wordsworthian emotion recollected in tranquility than kindergarten splatter fight" (Hirst, p. 10). There are similar works with similar titles, such as *beautiful, handsome, tasteless, thoughtless, amazing, spinning, cyclone good-in-bed painting* (1995), *beautiful, sharp, screaming, subtle, ice-cream-ish, yikes gosh with pinks painting* (1995), and *beautiful, shattering, slashing, violent, pinky, hacking, sphincter painting* (1995). *Cf.* the title below.

beautiful, kiss my fucking ass painting Damien Hirst, 1996, Saatchi Collection, London.

The painting is similar to the one above. The title, likewise, indicates the artist's pleasure at his creation and his doubt whether anyone else could produce anything quite like it. Taken further, the work can also be seen as a vivid depiction of the named portion of the anatomy.

The Beautiful Rosine (French, *La Belle Rosine*) Antoine Wiertz, 1847, Musée Wiertz, Brussels.

A buxom young woman stands naked face to face with a grinning skeleton. A label on its skull names it as *La belle Rosine*. It is thus her *memento mori*, her own future self.

Beauty and Barbarism Lilly Martin Spencer, c.1890, Sotheby Parke-Parke Bernet Galleries, New York.

A small girl ("beauty") perched on a chair is being dressed and coiffured for a premature introduction ("barbarism") to the world of adult fashion.

Bedtime (French, *Le Coucher*) Edgar Degas, c.1883, Tate Gallery, London.

A naked young woman sits in bed and pulls the covers up before lying down. The lighting suggests a daytime scene, however, so the painting itself hardly evokes "bedtime" in the normal sense of the word.

Before and After William Hogarth, 1730–1, J. Paul Getty Museum, Malibu, California.

The titles are those of two paintings forming a pair. In *Before*, a young woman being raped reaches out to grasp a table for support but it tilts over and the mirror that stands on it begins to

slide off. In *After*, the table is on its side and the mirror broken, like her maidenhead. Another pair of the artist's paintings with the same title and subject (1730–1, Fitzwilliam Museum, Cambridge) are set outdoors rather than indoors.

Before the Battle Dante Gabriel Rossetti, 1858, Museum of Fine Arts, Boston, Massachusetts.

A woman attaches a pennant to a knight's lance as he prepares for battle. The artist's future wife, Elizabeth Siddal, had painted a similar scene entitled *Lady Affixing a Pennant to a Knight's Spear* two years before and this almost certainly inspired the work.

Before the Caves Helen Frankenthaler, 1958, University of California Art Museum, Berkeley, California.

The abstract painting presents the viewer with what appear to be the inquisitive heads of two animals, who pause together at the entrance to caves that they may or may not enter.

Before the Mirror (Russian, *Za tualetom*, "At Her Toilet") Zinaida Serebryakova, 1909, Tretyakov Gallery, Moscow.

The painting is a self-portrait of the artist combing her hair before her dressing-table mirror. The Russian title does not specify the precise location, although it is the obvious one.

Begging for It Gary Hume, 1994, Saatchi Collection, London.

A pale blue figure is silhouetted against a lime green background with black arms and clasped hands reaching up, evidently beseeching someone for something. The title describes the action but does not elucidate it.

The Beginning of the World Constantin Brancusi, *c.*1924, Musée National d'Art Moderne, Paris.

The sculpture comprises a polished bronze egg lying on its side. The egg is a symbol of birth and beginning, and the world itself arose as an "egg" hatched by a divine or material power.

The Beguiling of Merlin Edward Burne-Jones, 1870–4, Lady Lever Art Gallery, Port Sunlight.

In a scene taken from the medieval French *Romance of Merlin*, Merlin is lulled to sleep by the enchantress Nimue in a hawthorn bush in the forest of Broceliande. The painting depicts the eternal battle of the sexes. In a reversal of the usual roles, Nimue stands erect, in a pose of strength, while Merlin lies subdued, his power ebbing away. The work is also known as *Merlin and Nimue*.

The Beheading of John the Baptist Caravaggio, 1608, Valetta Cathedral, Malta.

The scene is from the New Testament. John the Baptist has denounced Herod for marrying his sister-in-law, Herodias, and Herod has him beheaded to please his stepdaughter, Salome (Mark 6:17–29). The painting depicts the moment after the decapitation, and the artist traces his name in the blood that spurts from St John's truncated neck.

Behind the Bar John Henry Henshall, 1882, Museum of London.

The painting depicts the crowded bar of a London public house, seen from the proprietor's side of the counter.

La Bella ("The Beautiful One") Titian, *c.*1536, Pitti, Florence.

The identity of the poser for this portrait is unknown. It was formerly believed to be Eleonora Gonzaga, duchess of Urbino. Whoever she is, the title that describes her is accurate enough.

La Bella Mano ("The Beautiful Hand") Dante Gabriel Rossetti, 1875, Delaware Art Museum, Wilmington, Delaware.

A woman washes her hands in a scallop-shaped basin while an angel proffers a towel. The Italian title refers to a series of sonnets of the same name by Giusto de'Conti (1440), and Rossetti wrote his own poem on the same subject, beginning, "O lovely hand, that thy sweet self does lave."

La Belle Dame Sans Merci ("The Beautiful Lady Without Pity") (1) John William Waterhouse, 1893, Hessisches Landesmuseum, Darmstadt; (2) Sir Frank Dicksee, 1902, private collection.

Both paintings are based on Keats's poem of 1819 describing a knight enthralled by an elfin woman. Waterhouse has the knight kneeling before the nymph, who draws him down, twined in her auburn hair. Dicksee has the Belle Dame leaning down to the knight from the horse on which he has placed her. He himself, in glittering armor, strides bare-headed beside it.

La Belle Ferronnière ("The Beautiful Ironmonger's Daughter") Leonardo da Vinci, *c.* 1495–9, Louvre, Paris.

The identity of the young woman portrayed is uncertain. She may be Cecilia Gallerani, the subject of **Lady with an Ermine**. Whatever the case, she gave the word *ferronnière* in French and English for the type of ornamental frontlet that she wears, a jewel held on the forehead by a chain. The painting is also known simply as *Portrait of a Lady*.

La Belle Iseult *see* **Queen Guinevere**.

La Belle Jardinière ("The Beautiful Lady Gardener") Raphael, 1507, Louvre, Paris.

The painting depicts the Virgin and Child with St. John the Baptist in a setting that could be regarded as a conventionalized landscape or garden. The work is generally known by its French title, even in English-speaking countries.

The Belle of the Village Alice Havers, 1885, Atkinson Art Gallery, Southport.

A young washerwoman, walking along in the company of others, turns to look back at the men sprawling nearby whose lascivious gaze shows that they regard her as the local beauty.

Belles de Nuit ("Night Beauties") Paul Delvaux, 1936, private collection.

The work depicts three women: one fully nude, one seminude, and one fully dressed. The title implies that they are "ladies of the night." *Cf.* The **Call of the Night**.

The Beloved Dante Gabriel Rossetti, 1865–66, Tate Gallery, London.

A bride, about to meet her groom, is surrounded by five attendants. She is thus "The Beloved" of the title. The painting, also known as *The Bride*, is inscribed with words from the Song of Solomon beginning, "My beloved is mine, and I am his" (2:16).

Belvedere Torso Apollonius, ?, Vatican Museums.

The marble fragment of the torso of a powerful male figure (perhaps Hercules) is named for the Cortile del Belvedere, the courtyard in the Vatican in which it was formerly displayed. *Cf.* **Apollo Belvedere**.

Benches Tom Phillips, 1970–1, Tate Gallery, London.

The work is a triptych depicting photograph-like scenes of benches in public parks in various parts of Britain, framed by multicolored vertical or horizontal stripes. The first panel shows the rear view of five adults and two children on a bench in Battersea Park, London. The third depicts the same view a year later with the bench empty. The middle panel comprises six small pictures of benches elsewhere. A caption identifies all their locations.

Beneficence Charles W. Cope, 1840, Victoria and Albert Museum, London.

A young woman helps an ageing man, perhaps her father, up some steps. The painting originally appeared in the catalog without a title but with the following quotation: "Help thy father in his age, and despise him not when thou art in thy full strength." This seems biblical, although is not found as such. It may be an adaptation of a verse in the Apocrypha: "My son, help thy father in his age, and grieve him not as long as he liveth" (Ecclesiasticus 3:12).

The Benevolent Heir William Redmore Bigg, 1797, Yale Center for British Art, New Haven, Connecticut.

The painting, subtitled *The Tenant Restored to His Family*, is a pendant (companion piece) to The **Rapacious Steward**, although dated earlier. It depicts the same group as in the other work, with the farmer redeemed from prison through the intervention of the compassionate squire and his wife. The squire is of course the "benevolent heir" of the title.

Bentheim Castle Jacob von Ruisdael, 1653, Beit College, Blessington, Ireland.

The work depicts the castle at Bentheim in western Germany, near the Dutch border, which Ruisdael had recently visited. He took artistic liberties, however, so that the castle crowns the top of a steep and rugged hill instead of the slight slope on which it actually stands.

The Betrothal of the Virgin Raphael, 1504, Pinacoteca di Brera, Milan.

The scene is based on the New Testament, which states that the Virgin Mary was "espoused" (married) to Joseph (Matthew 1:18, Luke 1:27), but does not mention the actual betrothal. Before a priest, Joseph places a ring on Mary's right hand. His staff flowers at this moment, showing that God favors him to be Mary's husband. The painting is also known as *The Marriage of the Virgin* or *The Nuptials of the Madonna*, as well as by its Italian title, *Lo Spozalizio* ("The Marriage").

The Betrothed (Italian, *I promessi sposi*) Silvestro Lega, 1869, Museo della Scienza e della Tecnica, Milan.

A young engaged couple take an evening

stroll across a heath. A governess and two young girls follow behind. The title was taken from that of Alessandro Manzoni's best-known novel (1825–37), a historical study of 17th-century Italy.

The Betrothal of the Virgin *see* The **Marriage of the Virgin** (1).

Between Rounds Thomas Eakins, 1899, Philadelphia Museum of Art, Pennsylvania.

A weary boxer rests for a brief moment in his corner between rounds of a match. He is attended by two seconds, one of whom fans him with a towel to cool him.

Between the Clock and the Bed Edvard Munch, 1940, Munch Museum, Oslo.

The work is a self-portrait, depicting the old and frail artist between the clock that measures the hours of life and the bed where he will die. Munch died four years later, aged 81.

Bicycle Wheel (French, *Roue de bicyclette*) Marcel Duchamp, 1913, private collection.*

The work is a classic "readymade," a manufactured object displayed as a work of art. A (tireless) bicycle wheel is mounted on a wooden stool. The original has been lost.

Bianca William Holman Hunt, 1869, Worthing Museum and Art Gallery.

The portrait of a sumptuously costumed young woman holding a mandoline is ostensibly of Bianca, younger sister of Kate in Shakespeare's *The Taming of the Shrew*, but actually of Margaret Noyes-Bradhurst, a half–German, half–English woman whom the artist met in Florence. The subtitle is *The Patroness of Heavenly Harmony*.

Big Campbell's Soup Can, 19¢ Andy Warhol, 1962.

The depiction is of an empty Campbell's beef noodle soup can, its price of 19¢ stamped on its open lid. The first word of the descriptive title relates to the size ($72 \times 54\frac{1}{2}$") of the painting rather than to that of the original can.

The Big Dory George Bellows, 1913, New Britain Museum of American Art, New Britain.

Fisherman strain to launch their dory. The scene was painted at Monhegan Island, Maine.

Big Session with Da Wolf Vostell, 1961, Musée Départemental d'Art Ancien et Contemporain, Épinal.

The work is a décollage of scraps of German posters and newsprint, one of which reads "*Große Sitzung mit Da*," giving the title. The letter following "*Da*" may be *n* or *r*, leaving one to speculate what the compete word might be. The word fragment itself echoes the text fragments that comprise the work.

A Bigger Grand Canyon David Hockney, 1998, National Museum of American Art, Smithsonian Institution, Washington, D.C.

The vast painting consists of 60 interlocking canvases depicting the Grand Canyon, Arizona, America's greatest natural wonder. The work was inspired by Thomas Moran's *The Grand Canyon of the Yellowstone* (1893–1901). Its title relates to the latter, and also echoes the artist's famous earlier work, A **Bigger Splash**.

A Bigger Splash David Hockney, 1966–7, Tate Gallery, London.

The painting depicts the splash caused by a diver's plunge into a Californian swimpool. The title relates to two earlier paintings made shortly before. They were called *The Little Splash* and *The Splash*, but this splash is bigger than either. The title (which could also relate to the "splash" of paint needed to depict the splash) was adopted for the 1974 movie about the artist and his work, as a man who had "made a splash" through his colorful personality and equally colorful paintings.

The Billy Boy William Dobell, 1943, Australian War Memorial Collection, Canberra.

The painting is a portrait of a burly manual worker. The artist has recorded his history: "He was a Glasgow Irishman, his name was Joe Westcott. He was more interested in political argument than boiling the billy – which was his only job. … I painted him at Rathmines Air Base where I was working on camouflage" (quoted in Gleeson, pp. 98–100). A billy is a cooking pot.

The Birth of Christianity Frederick Pickersgill, 1857, Victoria and Albert Museum, London.

A young woman holding a child, presumably the Virgin Mary and the infant Christ, stands between two pagan groups. To her left, a bull on a pedestal represents an object of pagan worship in ancient Greek times. It is attended by Maenads and Corybantes with cymbals. To her right, nine figures in classical costumes flee in fear and dismay across a sea. The painting's original title was *Flight of the Pagan Deities on the Dawn of Christianity*.

The Birth of Liquid Desires Salvador Dalí, 1932, Solomon R. Guggenheim Museum, New York.

The painting was produced soon after the artist met his future wife, Gala, and is full of sexual imagery. It centers on a nude man with a loaf on his head ravishing a clothed woman. A second nude man to the left stoops to enter a cave-like aperture while to the right a woman pours water into a bowl in which the central figure has his left foot. This last is perhaps the actual "birth of liquid desires" of the title.

The Birth of the World (French, *La Naissance du monde*) Joan Miró, 1925, Museum of Modern Art, New York.

The main object in the surrealist painting is a bright orange disk with a long, thin, wavy yellow tail, like a balloon on a string. A black triangular object is to its left, while at the bottom of the "tail" is a recumbent figure. The artist has spoken of the picture as "a kind of genesis," and recalled that the title was invented by either André Breton or Paul Éluard. The tailed circle is thus presumably a single sperm, making its somewhat erratic way from the male figure at bottom left to the black triangle above it that is the female.

The Birth of Venus (1) Sandro Botticelli, *c.* 1483–4, Uffizi, Florence; (2) (French, *La Naissance de Vénus*) Alexandre Cabanel, 1863, Musée d'Orsay, Paris; (3) Adolphe-William Bouguereau, 1879, Musée d'Orsay, Paris.

Botticelli's famous painting, popularly known as *Venus on the Half-Shell,* shows Venus, the Roman god of love, rising naked and fully formed from the foam of the sea. (Strictly speaking the work does not thus depict her actual birth, but her advent into the world.) She stands on a large scallop shell and is blown ashore by Zephyr, the west wind. Flora, the goddess of flowers, stands on the shore with a rich robe ready to cover her. The painting is clearly related to the same artist's **Primavera**, in which Venus, Flora, and Zephyr also appear. Botticelli based his nude Venus on a classical prototype in the pose known as *Venus pudica*, "modest Venus," because of the position of her hands, one over her breasts, the other covering her genitals. *Cf.* **Aphrodite Anadyomene**. Cabanel has a naked Venus lying seductively on a foamy wave attended by five flying cupids, two of whom blow conches. Bouguereau has a naked Venus actually on her shell, but accompanied by conch-blowing couples and a stream of flying cupids.

The Birthday Dorothea Tanning, 1942, private collection.

A barefoot, bare-breasted woman in a Renaissance jacket and a green skirt adorned with dangling roots stands holding the knob of an open door though which a whole series of open doors stretches into the distance. Crouching on the floor before her in a sphinx-like pose is an winged creature that seems to be half bat, half griffon. The relevance of the title is uncertain. The scene is one of uneasy expectation, as there can be before a birth or a birthday.

The Birthday Party Walter Osborne, 1900, private collection.

Young children sit around a table before or after a birthday tea for one of their number.

The Black Brunswickers John Everett Millais, 1860, Lady Lever Art Gallery, Port Sunlight.

A young English woman tries to prevent her Prussian soldier sweetheart from leaving for the battle of Waterloo. She is dressed for a ball, and he wears the black uniform of the Brunswick Cavalry, known as the Brunswickers. Hence the title.

Black Iris Georgia O'Keeffe, 1926, Metropolitan Museum, New York.

The work is a near-abstract depiction of the named flower, the title emphasizing its sensuous color.

Black Magic (French, *La Magie noire*) René Magritte, 1935, private collection.

A nude woman stands by a rock on the seashore. Her lower body is pink, the color of the sand behind her. Her upper body is blue, the color of the sea and sky. Her waist, where the colors change, is on a level with the horizon. The change has been effected by "black magic."

Black Market Robert Rauschenberg, 1961, Museum Ludwig, Cologne.

The work is one of the artist's "combines," here combining a painting of random objects with a "one way" arrow leading down to a black suitcase on the ground. Four metal clipboards are suspended across the canvas. The artist intended the viewer to exchange the suitcase for some utensil of his or her own, stamp it with the number of the object removed, and record the exchange on one of the clipboards. This would constitute a "black market" deal. In the event the aim did not work, for viewers followed only the first step of the instructions and neglected to replace the components removed by others.

Black on Black Alexander Rodchenko, 1918, Metropolitan Museum, New York.

The artist's geometrical painting was a response to the **White on White** of his rival, Kasimir Malevich.

The Black Paintings (Spanish, *Los cuadros negros*) Francisco de Goya, 1820–2, Prado, Madrid.

The series of 14 large murals, depicting nightmarish scenes, originally adorned the walls of the artist's country house, the *Quinta del sordo* ("House of the Deaf Man"), outside Madrid. They include The **Dog** and **Saturn Devouring One of His Sons**. The works are so named not so much for their "black" subjects as for their dark colors. "The name Black Paintings, though it doesn't derive from the artist himself, is essentially correct, for light in these paintings is not the victorious protagonist in the drama that is played out between light and dark. Blackness is the decisive element" (Licht, p. 181).

Black Snake in My Bed Alison Saar, 1986, private collection.

The sculpture depicts a red-haired woman asleep in bed, unaware of the huge black serpent that is coiling around her, smiling.

Black Virtue (French, *Vertu noire*) Roberto Matta, 1943, Tate Gallery, London.

The surrealist painting depicts a number of biomorphic shapes against a predominantly black background. Some of the shapes evoke the female sex organs, and the overall reference is undoubtedly sexual. The artist has said that he cannot remember the exact significance of the title but it may refer to the supposed "virtue" of killing the enemy. (Matta and his friends were very anti–Nazi at this time.) The extent of black in the picture certainly suggests death. French *vertu* also means "chastity," thus reinforcing the sexual allusion.

The Blessed Damozel Dante Gabriel Rossetti, 1871–9, Lady Lever Art Gallery, Port Sunlight.

The depiction is of the subject of the artist's own poem of the same title (1850), beginning: "The blessed damozel leaned out / From the gold bar of Heaven." The "blessed damozel" herself represents an ideal platonic love, praying for union with her earthly lover. The painting shows her as she is described in the poem, with three lilies in her hand and seven stars in her hair. An earthbound figure below looks up to his departed lover. The depiction is the only one that

the artist based on one of his poems. (Usually the painting came first.)

Blessed Giles Before Pope Gregory IX Bartolomé Murillo, 1645, North Carolina Museum of Art, Raleigh, North Carolina.

The painting, one of a series the artist painted for a convent in Seville, shows the Blessed Giles (not to be confused with St. Giles, patron saint of cripples) standing in a transport of ecstasy before Pope Gregory IX, who had come to Perugia specially to consult with him. An inscription at the foot of the work reads (in translation): "There flourished in sanctity Giles, and Gregory the 9th went to Perugia to speak to him. Brother Giles visited him, being full of humility and loving obedience... Sensing the Pope's tremendous faith and love, he stood transfixed in his presence in a divine ecstasy." Giles of Assisi (*c*.1190–1260), as he is more usually known, was an intimate companion of St. Francis of Assisi and was famous not only for his mystical raptures but for his holy wisdom, preserved in his writings.

The Blessing of the Boats (French, *Baptême des bateaux*) Maurice Denis, *c*.1895, private collection.

The depiction is of a Breton religious event as typical of that region as the pardon (*cf.* **Breton Women at a Pardon**). The boats of a fishing village would be blessed to bring a good catch and to preserve the lives of the fishermen who sailed them. The French title literally translates as "Baptism of the Boats," evoking the ceremony in many countries of "christening" a ship when she is named at her launching.

The Blind Sophie Calle, 1986, private collection.

The artist met a number of blind people and asked them what their image of beauty was. For each she created a similar work, with a photograph of the person, a printed definition of their image of beauty, and a photographic interpretation of that image, each of them framed. One work thus has the definition, "The most beautiful thing I ever saw is the sea, the sea going out so far you lose sight of it." This is accompanied by a photograph of the blind man and of the sea extending to the horizon.

The Blind Girl John Everett Millais, 1854–6, Birmingham City Art Gallery.

Two young girls rest by the wayside near a village. The older of the two, the blind girl of the title, forced to earn a living as an itinerant

musician, sits expressionless, a concertina on her lap. The younger, who clasps her hand and shelters beneath her shawl, looks up at a double rainbow. The blind girl is unaware of this, as she is of the flowers beside her and the sunlit landscape behind her. The models were two Scottish girls seen also in **Autumn Leaves**.

The Blind Leading the Blind (1) Pieter Bruegel I, 1568, Museo di Capodimonte, Naples; (2) Louise Bourgeois, *c.* 1947–9, Robert Miller Gallery, New York.

The title of both works echoes the words of Jesus in the New Testament: "If the blind lead the blind, both shall fall into the ditch" (Matthew 15:14). In Bruegel's fairly literal interpretation, figures move across the picture towards a man falling into a ditch on the right. Bourgeois's abstract sculpture consists of seven pairs of painted posts, four red and three black, connected by a horizontal lintel. The red posts, which are outermost, are presumably leading the "blind" black posts, which are innermost. The sculpture itself has been interpreted as either a symbol of the artist's family or a commentary on the repressive atmosphere of the McCarthy era.

Blind Man's Buff George Morland, 1787–8, Detroit Institute of Arts, Michigan.

A young girl, blindfolded in a game of blind man's buff, reaches out to catch one of the other children who touch and tap her. The scene is out of doors, and was the first of the artist's similar depictions of children's games, with titles such as *Children Playing at Soldiers, Children Nutting, Juvenile Navigators, Children Birds'-Nesting,* and *The Kite Entangled.*

The Blinding of Samson Rembrandt van Rijn, 1636, Städelsches Kunstinstitut, Frankfurt.

A soldier gouges out Samson's eyes with a dagger as Delilah flees the grisly scene holding the mighty man's shorn locks. The depiction is the artist's interpretation of the laconic Old Testament account: "But the Philistines took him, and put out his eyes, and brought him down to Gaza" (Judges 16:21).

Blonde Odalisque *see* **Reclining Girl**.

Blue Jackson Pollock, *c.*1943, Ohara Museum of Art, Kurashiki, Japan.

The abstract painting is actually a marine scene, in which the color blue predominates. Choppy waves appear in the lower half of the canvas, and biomorphic shapes represent marine life. The painting's subtitle is *Moby Dick,* and the figure of a yellow and black and white whale flailing its flukes can indeed be made out in the center of the picture.

The Blue Bower Dante Gabriel Rossetti, 1865, Barber Institute of Fine Arts, Birmingham University.

The portrait of an auburn-haired young woman, modeled by the artist's former housekeeper and mistress, Fanny Cornforth, takes its title from the patterned background of blue hexagonal tiles decorated with prunus blossom. There are also blue cornflowers in the foreground, as a visual reference to the sitter's name.

The Blue Boy Thomas Gainsborough, 1770, Huntington Art Gallery, San Marino, California.

The portrait is that of a young boy wearing a blue satin suit in the style of Van Dyck. Its formal title, *Master Jonathan Buttall,* names the subject, the 12-year-old son of a wealthy steel merchant who was a friend of the artist. Gainsborough partly painted the portrait to confound his rival, Joshua Reynolds, who held that too much blue spoiled a picture. Its counterpart is popularly regarded as **Pinkie**, and the two portraits complement each another on opposite walls of the Main Gallery. *See also* The **Red Boy**.

Blue Movement Terry Frost, 1953, Vancouver Art Gallery.

The abstract painting depicts the harbor of the fishing village of St. Ives, Cornwall, England. In the artist's words: "On one particular blue twilit evening, I was watching what I can only describe as a synthesis of movement and counter-movement. That is to say the rise and fall of the boats, the space drawing of the mastheads, the opposing movements of the incoming sea and the outblowing off-shore wind – all this plus the predominant feel of blue in the evening. …. The subject matter is in fact the sensation evoked by the movement and the colour in the harbour" (Terry Frost in Lawrence Alloway, ed., *Nine Abstract Artists,* 1954).

Blue Poles Jackson Pollock, 1952, National Gallery, Canberra.

The huge abstract painting consists of a dense network of colors, shapes, and lines across which eight black and blue "poles" have been laid more or less vertically. They were imposed by taking pieces of timber 2 × 4 inches thick, dipping them in blue paint, and then pressing them onto the surface of the painted canvas to leave an impression.

Blumenmythos ("Floral Myth") Paul Klee, 1918, Kunstmuseum, Hanover.

The surreal work appears to represents a human torso with a flower growing out of its genitals. It is uncertain whether the title refers to any particular myth.

Boatbuilding Near Flatford Mill John Constable, 1815, Victoria and Albert Museum, London.

The work is one of many landscapes painted by the artist in his native Suffolk, in a region now known touristically as "Constable Country". As here, they usually depict a scene by water. Flatford Mill, on the Stour River, was owned by Constable's father. *Cf.* The **Hay Wain**.

Bocca Baciata ("Kissed Mouth") Dante Gabriel Rossetti, 1859, Museum of Fine Arts, Boston, Massachusetts.

The Italian title of the sensual female head-and-shoulders portrait quotes from a sonnet by Giovanni Boccaccio (1313–1375): "*Bocca baciata non perde ventura, / Anzi rinnova come fa la luna*" ("A kissed mouth does not lose its freshness; on the contrary, it renews itself as the moon does").

Böcklin's Tomb (German, *Böcklins Grab*) Ferdinand Keller, 1901–2, Staatliche Kunst- halle, Karlsruhe.

The painting is a memorial to the Swiss painter Arnold Böcklin (1827–1901). His tomb is depicted in a setting reminiscent of his own famous painting, The **Island of the Dead**.

The Body of Abel Found by Adam and Eve William Blake, *c*.1826, Tate Gallery, London.

The scene is based on the Old Testament story. Cain has murdered his brother Abel (Gen- esis 4:8) and runs from the scene of the crime. Adam, his father, looks on aghast. Eve, his mother, bends grief-stricken over Abel's body, her head on his breast, her hands cradling his head.

The Boer War John Byam Shaw, 1901, Birmingham City Art Gallery.

A young widow stands on the bank of a stream, oblivious to the beauty of nature around her. She has lost her husband in the Boer War (1899–1902) and is thinking of ending her life, which has become meaningless without him. The painting was originally exhibited with lines from Christina Rossetti's poem *A Bird Song* (1862): "Last Summer green things were greener, / Brambles fewer, the blue sky blue."

The Bogatyrs (Russian, *Bogatyri*) Viktor Vasnetsov, 1881–98, Tretyakov Gallery, Moscow.

Three doughty bogatyrs (warriors of Russ- ian folklore) sit astride their steeds on the fron- tier of their homeland as they keep watch for the approach of the enemy. They are respectively wise Ilya Muromets, impulsive Dobrynya Niki- tich, and sly Alyosha Popovich, heroes of the *byliny* (epic poems recounting their exploits).

Le Bon Bock ("The Good Glass of Beer") Édouard Manet, 1873, Philadelphia Museum of Art, Pennsylvania.

The portrait of a plump, bearded man smoking a pipe and holding a glass of beer on the table beside him is of the engraver, Émile Bel- lot, at the Café Guerbois, Paris.

Bonaparte Awakening to Immortality *see* The **Awakening of Napoleon**.

Bonaparte Crossing the St. Bernard Pass *see* **Napoleon Crossing the Alps**.

Bonjour, Monsieur Courbet *see* The **Meeting** (1).

Bonjour, Monsieur Gauguin ("Good Morning, Mr. Gauguin") Paul Gauguin, 1889, National Gallery, Prague.

The painting depicts the artist meeting an unknown Breton woman in a stormy landscape. The title obviously represents the words she ad- dresses to him. The picture was Gauguin's re- sponse to Gustave Courbet's The **Meeting**, also known as *Bonjour, Monsieur Courbet*. He would have seen the original of this, and its alternate title suggested his own.

Boredom *see* **Ennui**.

Borghese Gladiator *see* **Borghese War- rior**.

Borghese Warrior ?, *c*.2d c. BC, Louvre, Paris

The marble statue of a nude warrior in ac- tive combat was discovered in 1611 and soon after entered the collection of Cardinal Scipione Borghese (1576–1633) in Rome. (The collection, in the Villa Borghese, is now the Borghese Gallery, a state museum.) The statue is signed "Agasias, son of Dositheos, Ephesian," and is re- garded as being a copy of a Hellenistic original dating from some time after the 4th century BC. The work is also known as the *Borghese Gladia- tor* or *Fighting Gladiator*, although the warrior's sword is missing.

Bosom Friends Charles Trevor Garland, 1881, private collection.

A young girl sits at a railroad station, her hands folded around the neck of a dog seated on the bench beside her. The painting first appeared as the work of an unknown artist and as such was given the purely descriptive title *At the Railway Station*. The present owner then read the words "Manager C.T. Garland" in one of the posters in the background, and figured, correctly, that that was the name of the painter. The new title thus figuratively and literally alludes to the relationship between the girl and the dog that she clasps to her bosom.

Both Members of This Club George Bellows, 1909, National Gallery, Washington, D.C.

A white man and a black are engaged in a bloody prizefight, the latter visibly having the edge over his opponent. But they are "both members of this club," so blacks are a force in the ring to be reckoned with. The painting was originally entitled *A Nigger and a White Man*.

Boulter's Lock — Sunday Afternoon Edward J. Gregory, 1897, Lady Lever Art Gallery, Port Sunlight.

Boats of all types crowd together as they wait to pass through Boulter's Lock on the Thames River near Maidenhead, Berkshire, on a typical Victorian Sunday afternoon.

The Bower Meadow Dante Gabriel Rossetti, 1871–2, Manchester City Art Gallery.

Five young women are in a meadow. Two in the foreground play musical instruments, two in the middle distance are dancing, and one approaches in the distance. There is apparently no mythological or allegorical reference in the picture or its title, and even "bower" is purely a poetic word with vague romantic associations, here used of a meadow surrounded by trees.

Bowery Bums Duane Hanson, 1969–70, Museum Ludwig, Cologne.

The sculpture, with figures cast in fiberglass and dressed in real clothes, depicts three drunken vagrants amid a mass of scattered trash and litter. They represent the drunks and vagrants (bums, hobos) traditionally associated with the Bowery, New York City.

Boy Jennifer Bartlett, 1983, Nelson-Atkins Museum of Art, Kansas City, Missouri.

The painting is a triptych of three views of the **Manneken-Pis**, here floodlit on a low wall beside an empty swimpool. The boy is not urinating, as in the Brussels fountain, but looks as if he is about to. The swimpool will then begin to fill, in a typical small boy's fantasy.

The Boy with Many Friends Thomas Webster, 1841, Bury Art Museum, Lancashire.

A innocent new boy has arrived in school with a hamper and is instantly surrounded by "friends" eager to beg or barter for a share of its contents.

The Boy with the Cherries (French, *L'Enfant aux cerises*, "The Child with the Cherries") Édouard Manet, *c*.1858, Gulbenkian Collection, Paris.

A smiling young boy in a red cap leans on a wall holding a heap of cherries. The model was a young lad named Alexandre who helped the artist at work and sometimes posed for him. He had artistic aspirations of his own, but failing to fulfil them, hanged himself in the studio.

The Boyarina Morozova (Russian, *Boyarynya Morozova*) Vasily Surikov, 1887, Tretyakov Gallery, Moscow.

The painting's subject is the persecution of the Old Believers by the patriarch Nikon. The central character is the leading Old Believer, Feodosiya Morozova (1632–1675), in a state of ecstasy as she is borne on a sledge to her fate through the Moscow crowd. The condemned Old Believer makes the sign of the cross with two fingers in a final gesture of defiance of the church reform, which prescribed signing with three. A *boyarina* is the wife of a *boyar*, a title borne by certain Russian aristocrats. Morozova's husband was the boyar G.I. Morozov, brother of the better known boyar and statesman Boris Ivanovich Morozov (1590–1661), chief minister under Czar Alexis.

The Boyhood of Raleigh John Everett Millais, 1870, Tate Gallery, London.

The work depicts an imaginary scene from the life of the courtier and navigator Sir Walter Raleigh (1552–1618). Two boys sit at the feet of an old Genoese sailor who has returned from the Spanish main and listen intently to the strange tales he has to tell, tales that will inspire the young Walter to seek adventure on the high seas and make his own voyages of exploration. The boys were posed by the artist's two sons, Everett and George. The subject was suggested by the historian James Anthony Froude's article *England's Forgotten Worthies* in the *Westminster Review* for 1852.

Boy with a Basket of Fruit Caravaggio, *c.*1595, Borghese Gallery, Rome.

The painting is one of several of boys playing the lute, holding carafes of wine, or offering baskets of fruit, as here, that Caravaggio did for Cardinal del Monte and his household.

Boy with Squirrel John Singleton Copley, 1765, Museum of Fine Arts, Boston, Massachusetts.

The painting is also known by the name of its subject, *Henry Pelham*, the artist's 16-year-old stepbrother. (The squirrel is not an ordinary European one but an American flying squirrel.)

Boys Playing (Russian, *Igrayushchiye malʹchiki*) Kuzma Petrov-Vodkin, 1911, Russian Museum, St. Petersburg.

Two nude boys are engaged in a form of wrestling. One, half-kneeling, has grasped the hand of the other, forced it up, and caused the collapse of his opponent. "Playing" here is not simply a game but a battle of strength between two defenceless antagonists.

The Brass Handcuffs (French, *Les Menottes de cuivre*) René Magritte, 1931, private collection.

The work is a painted plaster miniature of the **Venus de Milo**. Since the statue has no arms, in can hardly have any handcuffs, brass or otherwise. The title was chosen by the artist's friend André Breton, French poet and founder of the Surrealist movement.

The Brave One Gwen Hardie, 1987, private collection.

The painting is a distorted depiction of prominent parts of the artist's body, notably breasts, buttocks, and legs (or possibly arms). As the title implies, the work is a bold feminist statement, reinventing a woman's body from the woman's point of view. Hardie used her fingers to apply and mold the paint direct onto the canvas as an integral part of the statement.

The Brazen Serpent (Russian, *Mednyy zmiy*) Fyodor Bruni, 1827–41, Russian Museum, St. Petersburg.

The painting is of an Old Testament scene. God has visited a plague of poisonous snakes on the Jews as a punishment for their rebellious spirit during their wanderings in the desert after the flight from Egypt: "And the Lord sent fiery serpents among the people, and they bit the people; and much people of Israel died" (Numbers 21:6). The title refers to the brazen serpent that

Moses made soon after at the command of God to heal those who were so troubled (Numbers 21:9), and it appears on a pillar on the left of the picture

Bread Winners Thomas Blinks, 1905, Sotheby's, London.

A team of three horses pulls a reaper through a cornfield at harvest time, while a man in the foreground gathers up the corn to bind it into sheaves. The title implies that it is the horses who are the hard-working heroes.

The Breakfast (French, *Le Déjeuner*) François Boucher, 1739, Louvre, Paris.

A family are at breakfast. The mother, spoon poised, turns to look at her young daughter playing with her dolls on the floor. The father attends to the coffee urn. A nursemaid has a young child on her lap and feeds her with a spoon. The morning sun streams through the window. Inexplicably, Laclotte and Cuzin give the title as *The Afternoon Meal* (p. 74), even though the clock on the wall clearly shows eight o'clock!

Breakfast in Fur (French, *Déjeuner en fourrure*) Meret Oppenheim, 1936, Museum of Modern Art, New York.

The famous Surrealist sculpture, with its erotic overtones, consists of a fur-lined breakfast cup, saucer, and spoon. The title was suggested by the Surrealist artist André Breton, who intended a reference both to Manet's painting Le **Déjeuner sur l'Herbe** and to Sacher-Masoch's notorious novel *Venus in Furs* (1870). Oppenheim herself originally referred to her creation simply as *Object*, and the work is popularly known as *The Fur-Lined Teacup*. Its alternate English title is *Luncheon in Fur*.

A Breed Apart Hans Haacke, 1978, Tate Gallery, London.

The work at first glance seems to be simply an advertisement for Jaguar cars. It is essentially a printed display with a heading ("Jaguar: a breed apart"), a photograph of the car's plush interior, a five-line text in smallish print, and a prominent caption: "Leyland Vehicles. Nothing can stop us now." However, the five-line text is subversive, since it is not the company's own advertising copy but an extract from a 1973 British parliamentary report on the wages of black workers, concluding: "Regardless of how uncongenial their employment or how poor their pay, they are forced to stay in their job for fear of being endorsed out of their area and back to the

homelands." The work thus parodies the advertising campaigns of those companies that proudly proclaim their sponsorship of the arts but remain silent on the conditions of employment of their immigrant workers. *They* are "a breed apart."

Breezing Up Winslow Homer, 1876, National Gallery, Washington, D.C.

Three young boys and a bearded man weigh down the starboard side of a sailboat as it tacks into the wind, which is "breezing up," or freshening into a breeze. The painting has the subtitle, or alternate title, *A Fair Wind*.

Breton Women at a Pardon (French, *Bretonnes au pardon*) Émile Bernard, 1888, private collection.

In Brittany, a pardon is the feast of the patron saint of a church at which an indulgence ("pardon") may be gained and at which national costumes are traditionally worn, as depicted here. Gauguin based his painting The **Vision after the Sermon** on Bernard's work, which has the alternate title *Breton Women in a Meadow* (French, *Bretonnes dans la prairie*).

Breton Women in a Meadow *see* **Breton Women at a Pardon**.

Bricklayers *see* The **Worker's Day**.

The Bride *see* (1) The **Beloved**; (2) The **Bridesmaid**.

The Bride at Her Toilet (French, *La Toilette de la mariée*) Gustave Courbet, 1859, Smith College Museum of Art, Northampton, Massachusetts.

A bride sits holding a mirror while her maids wash her feet, prepare her clothes, and lay a table. The figure of the bride is curiously limp, however, suggesting that the original painting may have depicted the dressing of a corpse and preparations for a wake, not a wedding. The title could have been *The Toilet of the Dead Woman* (French, *La Toilette de la femme morte*).

The Bride in Death Thomas Jones Barker, 1838–9, Victoria Art Gallery, Bath.

The artist's best known painting takes its subject from a ballad about the English Civil War. A Cavalier is prostrated with grief as he sits beside the bed of his young bride, who has died on the eve of her wedding.

The Bride of the Wind *see* The **Tempest** (2).

The Bride Stripped Bare by Her Bachelors, Even (French, *La Mariée mise à nu par ses célibataires, même*) Marcel Duchamp, 1915–23, Philadelphia Museum of Art, Pennsylvania.

The artist's most important work, executed in mixed media between two glass panels, has the alternate title *The Large Glass*. "Briefly summarized, the situation is this. A virginal bride occupies the upper half of a nine-foot-high transparent glass panel. She is for ever out of the reach of nine frustrated bachelors in the lower half of the glass. Encouraged by the bride, they attempt to strip her of her clothes by using an electrical mechanism Duchamp likens to a tiny, two-stroke engine" (Richard Dorment, reviewing Calvin Tomkins, *Duchamp*, *Times Literary Supplement*, April 4, 1997). The work thus encapsulates the artist's views on men, women, and love, the "even" of the title hinting at the ultimate frustration of the sexual quest. But the French title also contains a typical Duchampian pun, for the final "*même*" sounds the same as "*m'aime*," and thus translates: "The bride stripped bare by her bachelors loves me."

The Bride's Secret Diary Paula Rego, 1981, Rugby Art Museum.

A bride in her bridal dress is obscured by the secrets of her past life, as confided to her diary. The objects depicted are in most cases a jumble, but the presence of a skull and the arm of a skeleton implies that there are some secrets that are best kept hidden from the groom, while a shape suggesting a female sex organ alludes to this unrevealed area of the bride's past.

The Bridesmaid John Everett Millais, 1851, Fitzwilliam Museum, Cambridge.

An auburn-haired bridesmaid passes a small piece of wedding cake through a wedding ring, observing the old superstition that if she does this nine times, she will have a vision of her future lover. The painting has been incorrectly entitled *The Bride* and *All Hallow's E'en*, the latter alluding to customs observed on Halloween. The sitter for the portrait was the artist's mistress, Frances Cornforth.

The Bridge at Narni (French, *Le Pont de Narni*) J.-B.-C. Corot, 1827, National Gallery of Canada, Ottawa.

The painting depicts the broken bridge over the Nera River near the town of Narni, north of Rome.

The Bridgewater Madonna Raphael, after 1507, National Gallery of Scotland, Edinburgh.

The painting of the Virgin and Child came from the collection at Bridgewater House, London, built by Lord Francis Leveson Gower, heir to the estates of the dukes of Bridgewater. The gallery there was opened to the public in 1851.

Britomart Redeems Fair Amoret
William Etty, 1833, Tate Gallery, London.

The painting depicts a scene from Edmund Spenser's *The Faerie Queene*, III, xii (1596). Britomart, the female knight of chastity, rescues "the fair Amoret," daughter of the nymph Chrysogone, from the enchanter Busirane, who has imprisoned her.

Broadway Boogie Woogie Piet Mondrian, 1942–3, Museum of Modern Art, New York.

The work is a rectangular arrangement of intersecting red, yellow, blue, and gray lines, each line bearing a series of colored squares or "blips." Both lines and squares are spaced irregularly, suggesting the syncopated rhythms of jazz. The representation is based on the street grid of Manhattan, with the yellow "blips" suggesting cabs, as they shuttle along their own syncopated route.

The Broken Pitcher (French, *La Cruche cassée*) Jean-Baptiste Greuze, *c.* 1773, Louvre, Paris.

"It represents a little girl — simple, fresh, and charming — who has just broken her jug at the fountain. She still has it on her arm" (Mme Roland, quoted in Eliza F. Pollard, *Greuze and Boucher*, 1904). This description does not mention the young girl's dishabille (her dress has been pulled down to reveal one breast), nor her expression of sadness. These suggest that the real subject of the painting is the loss of virginity, for which the broken pitcher is a metaphor.

Bronze Ballet Edward Wadsworth, 1940, private collection.

The work depicts large bronze ships's screws (propellers) on the dockside. Their apparently carefully staged positions and their curved blades make it look as if they are dancing.

Brook Watson and the Shark John Singleton Copley, 1778, Museum of Fine Arts, Boston, Massachusetts.

Men in a rowboat beat off the shark that attacks a young lad as he swims and reach out to pull him from the water. The painting was commissioned by the subject himself, the English merchant and Lord Mayor of London, Sir Brook Watson (1735–1807), who wanted a record of the occasion in 1749 when, aged 14, he was attacked by a shark while swimming in Havana harbor. The artist based the work on the **Borghese Warrior**, but with a nude Watson, horizontal in the water, a mirror image of the Warrior.

Brother and Sister William Mulready, 1836, Victoria and Albert Museum, London.

A young woman carrying a child through a wood has stopped against a fallen tree trunk while a young boy puts his arm around her head to pinch the baby's ear. The title seems to imply that the woman is the boy's elder sister. It is possible that the painting was originally conceived as a depiction of an amorous encounter, with the young man trapping the woman against the tree and embracing her on the pretext of teasing the baby. However, no title exists to support this, although it is known that the artist sketched the picture and **First Love** on the same day. An alternate title is in fact *Pinch of the Ear*.

The Browning Readers William Rothenstein, 1900, Bradford Art Galleries.

One young woman is seated in an armchair reading the poems of Robert Browning, or of his wife Elizabeth Barrett Browning, while another woman selects a book from a bookcase. "The title of this interior … confirms its instrinsic Englishness" (Anna Gruetzner in House and Stevens, p. 205).

Brutus and His Dead Sons (French, *Licteurs portant à Brutus le corps de ses fils*, "Lictors Bearing to Brutus the Bodies of His Dead Sons") Jacques-Louis David, 1789, Louvre, Paris.

The painting's French title describes the scene more explicitly than the English. The Brutus concerned is not the one who murdered Caesar but the legendary (though probably historical) Brutus who is said to have ousted the Etruscan king Tarquinius Superbus in 509 and who executed his sons for plotting to restore the Tarquins. Lictors are magisterial attendants.

Bubbles John Everett Millais, 1886, Elida Gibbs Collection.

A curly-headed little boy in a green velvet suit sits with a bowl on his lap and watches a soap bubble float up from the pipe he has just blown. The child model was the artist's grandson and grew up to become Admiral Sir William Milbourne James (1881–1973). The picture, originally titled *A Child's World*, became widely

known through its use to advertise Pears Soap, whose manufacturers now own it.

The Buffalo Hunt Carl Wimar, 1860, Washington University Gallery of Art, St. Louis, Missouri.

American Indians armed with bows and rifles pursue a group of ferocious buffalo. The painting came to represent the standard image of the buffalo hunt and influenced subsequent depictions of the subject.

The Builders (French, *Les Constructeurs*) Fernand Léger, 1950, Musée Fernand Léger, Biot.

Robot-like construction workers carry and climb girders as they build a lofty edifice.

Bunny Sarah Lucas, 1997, Saatchi Collection, London.

The work, a female figure of stuffed kapok wearing tights and slumped on a plywood chair, is a loosely suggestive of a bunny girl.

Burd Helen William Lindsay Windus, 1856, Walker Art Gallery, Liverpool.

A young woman in male garb leads a young man on horesback across a ford. She is Burd Helen, the subject of a Scottish border ballad, who has been made pregnant by her mounted lover and is so infatuated with him that she runs by his horse as a foot page. "Burd," meaning "young lady," "maiden," is a Scottish form of *bird* (or possibly *bride*).

The Burden (French, *Le Fardeau*) Honoré Daumier, *c*.1850–3, Hermitage, St. Petersburg.

A washerwoman with a small child struggles to walk into the wind as she carries a heavy load of laundry. The painting is also known simply as *The Laundress* (French, *La Blanchisseuse*). *Cf.* The **Washerwoman**

The Burghers of Calais (French, *Les Bourgeois de Calais*) Auguste Rodin, 1885–95, Calais.

The statue was commissioned by the City of Calais in 1884 as a monument to its hero, Eustache de St. Pierre, leader of the six burghers who gave themselves as hostages to the besieging English in 1347. It was Rodin's suggestion to represent all six.

The Burial and Reception into Heaven of St. Petronilla Guercino, 1621, Palazzo dei Conservatori, Rome.

The painting depicts the burial and "assumption" of St. Petronilla, an early Roman martyr whose dates are not known.

The Burial at Ornans (French, *L'Enterrement à Ornans*) Gustave Courbet, 1849–50, Musée d'Orsay, Paris.

The huge painting of a peasant funeral includes lifesize portraits of more than 45 inhabitants of Ornans, the artist's home town, among them many of his family and friends. Courbet's grandfather had died in 1848 and the artist himself suggested that the grave depicted was his.

The Burial of Atala *see* The **Funeral of Atala**.

The Burial of Count Orgaz El Greco, 1586–8, S. Tomé, Toledo.

The work commemorates the burial in 1323 of Count Orgaz, a pious Toledan dignitary who was a benefactor of the church of S. Tomé. St. Augustine and St. Stephen lower his body into a tomb as an angel holds his soul and spirals upwards to a "an open heaven in glory." Some of the many figures present have been identified. They include the artist's young son, Jorge Manuel, and the humanist Antonio Covarrubias. The figure of the dead man may be a portrait of Alvar Pérez de Guzmán y Mendoza, the 10th Lord and the Count of Orgaz.

The Burning Bush David Salle, 1982, Saatchi Collection, London.

The canvas depicts various images of women from movie stills, advertisements, and porno magazines, with a bush-like shape in the right bottom corner. The title puns on the slang sense of "bush" (pubic hair) and the biblical story of Moses and the Burning Bush. *Cf.* The **Bush**.

The Burning Giraffe (Spanish, *La jirafa ardiendo*) Salvador Dalí, 1936, Kunstmuseum, Basel.

The central figure of the painting is not the burning giraffe of the title, which stands to the right, but that of a woman, her abdomen and right leg depicted with opened desk drawers.

The Bush (French, *Le Buisson*) Marcel Duchamp, 1910–11, Philadelphia Museum of Art, Pennsylvania.

A mother, standing, places her hand on the head of her adolescent daughter, who is kneeling. Both are nude. The figures are backed by burning bushes, suggesting the daughter's virginal rite of passage. *Cf.* The **Burning Bush**.

"But Men must work and Women must weep" Walter Langley, *c*.1882, Birmingham City Art Gallery.

A young working woman, her head bowed in grief, is comforted by her grandmother. The painting was inspired by a tragedy at sea in which fishermen lost their lives. The title quotes a line from Charles Kingsley's poem *The Three Fishers* (1858) on the same subject.

By Order of the Court Stanhope Forbes, 1890, National Museums on Merseyside, Liverpool.

An auction sale is in progress, presumably of the property of a bankrupt or other debtor.

C

C & O Franz Kline, 1958, National Gallery, Washington, D.C.

The black-and-white abstract painting takes its title from the pioneering Chesapeake & Ohio Railroad. The artist's stepfather was chief of the railway roundhouse in Wilkes-Barre, Pennsylvania, and his earliest landscapes were of the Pennsylvania railroad.

Cacodylic Eye (French, *L'Œil cacodylate*) Francis Picabia, 1921, Musée National d'Art Moderne, Paris.

The work is a collage of photographs, postcards and papers surrounding a painted human eye, the "cacodylic" eye of the title. The Greek-derived adjective means literally "stinking matter."

Cadeau/Audace ("Gift/Daring") Man Ray, 1921, private collection.

The prepared object is an iron with a row of spikes protruding from its flat bottom. The anagrammatic title alludes to the "sting in the tail" of this particular gift. If the artist had been English, he might have entitled it *Present/Serpent.*

Café ("Coffee") Cândido Portinari, 1935, Museu Nacional de Bellas Artes, Rio de Janeiro.

The painting depicts the activity on a Brazilian coffee plantation, with a large number of workers picking and bagging the beans. The artist was himself born on such a plantation.

Cage Ross Bleckner, 1986, private collection.

The work comprises a number of equally spaced blue, green, and yellow vertical stripes. Small birds of matching colors flit and perch among them, as if in a cage.

California News William S. Mount, 1850, Museums at Stony Brook, New York.

A group of men listen eagerly in the post office at Stony Brook, Long Island, as one of their number reads from the *New York Daily Tribune* the latest news on the discovery of gold in California. This famous depiction of "gold fever" is subtitled *News from the Gold Diggin's.*

The Call of the Night (French, *L'Appel de la nuit*) Paul Delvaux, 1938, private collection.

The Surrealist painting depicts three nude women, two with long hair in the form of a leafy shrub, the third holding an oil lamp and with a white sheet over her head and upper body. The title suggests that they are prostitutes, although the presence in the background of a skull, a skeleton, and a tree with lighted candles on its branches hints at the call in the night that death can make. *Cf.* **Belles de Nuit.**

Caller Herrin' John Everett Millais, 1881, private collection.

"A beautiful young fisher girl is resting for a moment as she carries home her load of fish. She is gazing over the sea, thinking perhaps of her absent lover" (1886 catalog description). The fish are herring, and *caller* is a Scottish dialect word meaning "fresh." The title is phrased in the form of a fishmonger's cry, in its full traditional version: "Wha'll buy ma caller herrin'? / They're bonnie fish an halesome farin'."

Callers Walter Ufer, *c.*1926, National Museum of American Art, Smithsonian Institution, Washington, D.C.

An Indian girl opens the gate to greet two young men on horseback who have unexpectedly called to see her. The painting has the prosaic subtitle *Indians on Horses.*

Calm Morning Frank Benson, 1904, Museum of Fine Arts, Boston, Massachusetts.

Three children, two girls and a boy, the latter standing, fish from a rowboat in a calm sea.

The Calumny of Apelles Sandro Botticelli, *c.*1496–7, Uffizi, Florence.

Pedantically punctuated, the title of this work should be *The "Calumny" of Apelles,* since it represents a version of *Calumny,* the famous allegorical painting by the 4th-century BC Greek

painter Apelles, celebrating his acquittal from a charge of political conspiracy. No copies of the original survive, but descriptions of it by Lucian and later writers enabled Botticelli to emulate it. He closely followed Leon Battista Alberti's description in *Della Pictura* ("On Painting") (1435). A judge is counseled by Ignorance and Suspicion while Calumny, led by Envy and accompanied by Treachery and Deceit, drags in naked Innocence. To the left, Remorse looks grimly at naked Truth, who points to heaven, where true justice is to be found. All the figures are female except the judge, the victim (Innocence), and Envy.

The Camden Town Affair (French, *L'Affaire de Camden Town*) Walter Richard Sickert, 1909, private collection.

A naked prostitute lies murdered on a bed, next to which stands a clothed man. The artist based his painting on a real event in September 1907, when a prostitute, Emily Dimmock, was found murdered in her lodgings in Camden Town, London. The man represents the suspected murderer, later acquitted. Both title and depiction shocked the prudish British public. Two other versions of the subject, *What Shall We Do for the Rent?* and *Summer Afternoon*, were exhibited at the first Camden Town exhibition in June 1911 as *The Camden Town Murder Series Nos. 1 and 2*. Public opinion was again outraged.

Camilla Carafa Edgar Degas, *c.*1874, Tate Gallery, London.

A young woman sits in an armchair, a shawl over her shoulders. She is Camilla Primicilio Carafa (1856–1929), younger daughter of Stéphanie de Gas and the Duke of Montejasi-Cicerale, and so a cousin of the artist (whose family name was originally de Gas). The painting is also known as *Seated Woman* (French, *Femme assise*) and (incorrectly) as *Camille Montejasi-Cicerale*.

Camille Montejasi-Cicerale *see* **Camille Carafa**.

The Campbells Are Coming *see* **The Relief of Lucknow**.

The Canon *see* **Doryphorus**.

Los Caprichos Francisco de Goya, *c.*1793–8, Metropolitan Museum, New York.

The series of 80 satirical etchings, attacking the political, social, and religious abuses of the Spanish "old order," has a title translating literally as "The Caprices," although they are also known in English as *The Follies*. Each etching has its own title and a commentary by the artist. One of the best known is No. 43, The **Sleep of Reason Produces Monsters**, which was originally planned for the title page. Others are No. 12, *Hunting for Teeth* (Spanish, *A caza de dientes*) (a woman pulls a tooth from a hanged man as a lucky charm), No. 19, *All Will Fall* (Spanish, *Todos caerán*) (bawds pluck the wings of cupids and castrate them), No. 25, *But He Broke the Pitcher* (Spanish, *Si quebró el cantaro*) (a naughty child has his bare bottom slippered), and No. 62, *Who Would Believe It!* (Spanish, *¡Quién lo creyerá!*) (fighting monsters tumble through a shadowy world). *See also* The **Disasters of War**.

A Capriote John Singer Sargent, 1878, Museum of Fine Arts, Boston, Massachusetts.

The painting is a portrait of Rosina Ferrara (*c.*1860–1928), a girl of about 17 whom the artist met on the island of Capri. She was an Anacapriote, i.e. a native of Capri of Greek origin. Hence the title.

Captain Coram William Hogarth, 1740, Coram Foundation, London.

The portrait is that of the artist's friend, the philanthropist Thomas Coram (*c.*1668–1751), a shipwright by trade, who following a period in Massachusetts colony projected and founded (1742) the famous Foundling Hospital (now demolished).

The Captain's Daughter James Tissot, 1873, Southampton Art Gallery.

On a riverside jetty, a ship's captain discusses his daughter with her sailor suitor, while the young lady herself looks out listlessly over the river as she holds a pair of binoculars.

Captive Andromache Frederic Leighton, *c.*1888, Manchester City Art Gallery.

The work depicts a scene that is suggested but not actually described in Homer's *Iliad*: the realization of Hector's prophecy that his wife Andromache would be taken captive after the fall of Troy. The painting shows Andromache imprisoned among the women of Epirus. Her figure is based on that of Dorothy Dene, the artist's model and muse in his final years.

The Captive Charger Carl Wimar, 1854, St. Louis Art Museum, Missouri.

By the waning light of sunset a group of Indians lead the white horse that they have stolen from an American cavalry officer. The sack of booty that one carries suggests they have

ambushed an army scouting party. The painting's original title was *Indians as Horse Thieves*.

Caracalla and Geta Sir Lawrence Alma-Tadema: 1907, private collection.

The painting depicts an event of Roman history in AD 195. The emperor Septimius Severus holds a gala on the occasion of his bestowing the title of Caesar on his son, Bassianus, better known as Caracalla, who stands behind him. The emperor is seated beside his second wife, Julia Domna, who is seen to be passing notes surreptitiously to an attendant, presumably to claim similar honors for her son, Geta, here depicted standing between his sisters. (Geta was later murdered by Caracalla. *Cf.* **Septimius Severus Rebuking Caracalla**.)

The Card Players (1) Lucas van Leyden, *c.*1520, Wilton House, Wiltshire; (2) Gerard Terborch, *c.*1650, Sammlung Reinhart, Winterthur; (3) Pieter de Hooch, *c.*1663–5, Louvre, Paris; (4) (French, *Les Joueurs de cartes*) Paul Cézanne, *c.*1890, Musée d'Orsay, Paris; (5) (French, *La Partie de cartes*, "The Game of Cards") Fernand Léger, 1917, Kröller-Müller Museum, Otterlo.

Lucas' painting depicts a consultation over a win (or loss) during a gambling game of cards among four players, with four onlookers and advisers, three of them women. Terborch has three players. A woman, her back to the viewer, holds a hand of cards. A man standing next to her reaches over to take one, while a man seated opposite watches attentively. De Hooch has a similar group, but the woman faces the viewer and the players sit by a fireplace, not at a table. Cézanne depicts two men, either side of a small table, playing cards. Léger's picture is quite different, and only the presence of cards in the midst of cylindrical forms at first seems to justify the title. The players here are soldiers. The artist painted the work during his convalescence from being gassed in World War I.

Carmen Henri de Toulouse-Lautrec, 1884, Clark Art Institute, Williamstown, Massachusetts.

The painting is a portrait of Carmen Gaudin, a young working woman and model from the Montmartre district of Paris whom the artist admired for her red hair.

Carnation, Lily, Lily, Rose John Singer Sargent, 1885–6, Tate Gallery, London.

Two little girls light Chinese lanterns in a garden of lilies and roses. The title comes from a line in "The Wreath" (also known as "Ye shepherds, tell me"), a once popular vocal trio by Joseph Mazzinghi (1765–1844). There are no actual carnations to be seen, but the word could apply to the girls' flesh tints. The picture was painted in Broadway, Worcestershire, and the girls are 11-year-old Polly (1874–1946) and seven-year-old Dolly (1878–1949), daughters of the artist and illustrator, Frederick Barnard. "The literary title ... invites association with a narrative tradition as well as with a genre of English garden paintings, flower symbolism and themes of childhood innocence" (Kilmurray and Ormond, p. 116).

Carnival (Italian, *Carnevale*) Guido Cadorin, 1914, private collection.

The triptych depicts a chicken hanging in a butcher's shop, four friends slumped drunk around a table, and a young woman's stockinged legs festooned in streamers. The painting interprets the title literally, and is subtitled *Flesh, Flesh, Forever Flesh* (Italian, *Carne, carne, sempre carne*).

The Carnival Winslow Homer, 1877, Metropolitan Museum, New York.

A group of American blacks prepare for a carnival. The carnival in question is the African-American festival known in the South as Jonkonnu and in the North as Pinkster.

The Carpenter's Shop *see* **Christ in the House of His Parents**.

Carte blanche (French, *Le Blanc-seing*) René Magritte, 1965, National Gallery, Washington, D.C.

A horsewoman rides through a forest, but the depiction of rider and horse is bisected by bands showing the background of trees and foliage, so that the perspective is thrown awry. The French title is the term for a signature on a blank document, and like the English title (itself also French) implies that the artist has put his name to a painting that the viewer can interpret any way he chooses.

Cashmere John Singer Sargent, *c.*1908, private collection.

Seven young girls in cashmere shawls make their way in solemn procession from left to right. They were all modeled by 11-year-old Reine Ormond, the artist's youngest niece.

The Castle Mountain of S. (German, *Der Schlossberg von S.*) Paul Klee, 1930, Tate Gallery, London.

The semiabstract painting depicts a castle on a hill or mountain. It is said the artist had no particular place in mind, so it is hard to say what or where "S." is.

The Cat Transformed into a Woman

(French, *La Chatte métamorphosée en femme*) Marc Chagall, *c*.1927–37, Tate Gallery, London.

A woman with the features of a cat sits on a chair, her arm resting on a small table nearby. The painting is an illustration for one of La Fontaine's *Fables*, here the story of a man who so adored his cat that he was able to turn it into a woman and marry her the next day.

Cat with Mirror (French, *Le Chat au miroir*) Balthus, 1989–94, private collection.

There are earlier paintings of this title, each of which depicts a young girl on a couch holding up a hand mirror to a cat, encouraging it to see its reflection. As with most of the artist's pictures, the title is baldly descriptive: "No 'storytelling' element should be derived from the works' titles, which have been given here only for the purposes of identification and rarely by Balthus himself" (de Rola, p. 24).

Catax Francis Picabia, 1929, Tate Gallery, London.

A woman's face is depicted from different angles, while a representation of her complete body is superimposed on the upper part of the canvas, together with details of her hands and eyes. The title presumably derives from Greek *kataxaino*, "I comb out," referring to the way the artist "combs out" the different images so that one is visible beneath the other.

The Cathedral of Erotic Misery (German, *Die Kathedrale des erotischen Elends*) Kurt Schwitters, 1923.*

The three-dimensional work was destroyed by an Allied bomb in 1943. A photograph survives in the Kunstmuseum, Hanover, and shows a proliferating Cubist structure. It gives a poor idea of the original, which was basically a nautilus containing various memories in its chambered, outward-growing grottoes, including (to justify the title) a Love Grotto, a Murderers' Cave, a Sex-Crime Den, and a Cavern of Hero-Worship. It is usually called the *K.d.e.E* for short, although it is also known as *Merzbau*, "Merz construction," *Merz* being a word extracted from a German printed phrase advertising the *Kommerz- und Privat-Bank*. The artist named all his work *Merz*. "That one part of the Hanover *Merz*

building was called the 'cathedral of erotic misery' should help us to understand that this work was no caprice. Indeed *Merz* also echoes *Schmerz*, pain" (Lynton, p. 144).

Catholic Mystery (French, *Mystère Catholique*) Maurice Denis, 1890, J.F. Denis Collection, Alençon.

The painting is essentially a version of The **Annunciation**, except that the angel Gabriel is replaced by a priest holding an open Gospel and preceded by two altar boys bearing candles. In the top right corner appears the Greek word ASPASMOS, meaning "loving greeting," in other words, "Hail," the angel's salutation to Mary. The title implies that the Catholic Church is continuing the mediation between God and man. (The Annunciation is itself the first of the Joyful Mysteries of the Rosary.)

Celebes *see* The **Elephant of Celebes**.

A Celebration at Least Damien Hirst, 1994, private collection.

Colored toy ballooons bob up and down above a hot air blower in each of two vertical Plexiglass containers like upended bathtubs. The wall of the left-hand container has been painted with regular vertical colored stripes, and that of the right-hand container similarly but with horizontal stripes. The title implies that the works are shallow or worth little, but that at least they display a celebration of some kind.

Celebration of a New Anthropometric Era (French, *Célébration d'une nouvelle ère anthropométrique*) Yves Klein, 1960, Galerie Karl Flinker, Paris.

The artist created a number of so called *anthropométries* (human body measurements) by using female nude models to smear a blue pigment under his direction onto prepared surfaces (*see* **IKB 79**). This one has five such "full frontal" imprints. The French title is penciled along the top, while below run the German words *Beschau als neue Art der Gestaltung* ("Inspection as new art of shaping").

Celestial Pablum Remedios Varo, 1958, private collection.

An expressionless woman sits in isolation in a lonely tower, where she mechnically grinds up stars to feed to a caged moon. The title is another way of saying "heavenly food."

A Centenary of Independence (French, *Centenaire de l'Indépendance*) Henri Rousseau, 1892, private collection.

The painting's subtitle describes the scene: *The people dance around the two republics, those of 1792 and 1892, holding hands to the tune of "Auprès de ma blonde qu'il fait bon, fait bon dormir."* The centenary is thus that of the French Revolution, and the "two republics" are the First and Third.

The Central Story (French, *L'Histoire centrale*) René Magritte, 1928, private collection.

A woman with a shrouded head stands with her hand to her neck before a tuba and an attaché case on a table. The significance of these objects is uncertain, but it is thought the painting relates to the suicide of the artist's mother when he was 12 years old. That would thus be the "central story" of the title.

The Centurion's Servant Stanley Spencer, 1914, Tate Gallery, London.

A youth lies feverish on a bed, while his parents and sister kneel anxiously beside him. The subject is biblical: "And a certain centurion's servant, who was dear unto him, was sick, and ready to die" (Luke 7: 2). He is subsequently healed by Jesus.

Cha-Hu-Ka-o Henri de Toulouse-Lautrec, 1895, Musée d'Orsay, Paris.

The painting depicts the Moulin Rouge female clown, dancer, and acrobat known as Cha-Hu-Ka-o in her dressing room. Her nickname represents French *chahut-chaos* ("hurly-burly," literally "rumpus-chaos"), a term adopted for a type of wild cancan. (*Cf.* Le **Chahut**.)

Le Chahut Georges Seurat, 1890, Kröller-Müller Museum, Otterlo.

The painting depicts a row of young women dancing the *chahut*, a type of vigorous cancan. (*Cf.* **Cha-Hu-Ka-o**.)

The Champion Sir Charles Lock Eastlake, 1824, Birmingham City Art Gallery.

A knight in armor, challenged by a Saracen, prepares to follow a herald while a young woman ties a pink sash around his shoulder. The latter presumably indicates that he is the "champion" of the title, whether in love or war.

The Champion Single Sculls *see* **Max Schmitt in a Single Scull**.

Le Chant d'Amour ("The Song of Love") Edward Burne-Jones, 1868–73, Metropolitan Museum, New York.

Henry James described the painting as "a group of three figures, seated, in a rather unexpected manner, upon the top of a garden wall." The figure to the left is a black-clad knight. In the center, a young woman plays a pipe organ. Its bellows are worked by another young woman half-kneeling behind it. Despite the title, none of the three is actually singing.

Le Chapeau de paille ("The Straw Hat") Peter Paul Rubens, *c.*1622, National Gallery, London.

The painting is a wedding portrait of a woman said to be Susanna Fourment (1599–1643), a Dutch silk merchant's daughter, who was widowed at an early age and who in 1622 married Arnold Lunden. (Her younger sister, Helena, married Rubens himself as his second wife in 1630.) Hence the painting's formal title, *Susanna Lunden*. The popular title is a misnomer, however, since the hat that she wears is made of felt, not straw. The error is explained as arising through a confusion of French *feutre*, "felt," with *feurre*, "straw."

The Charging Chasseur (French, *Officier de chasseur à cheval chargeant*) Théodore Géricault, 1812, Louvre, Paris.

A mounted army officer brandishing a saber turns in the saddle as his horse rears on hearing gunfire while charging in battle. The painting is also known as *The Charging Cuirassier* (incorrectly, since the officer wears a tunic, not a cuirass) as well as *Officer of the Imperial Guard* and *Light Cavalry Officer Charging*.

The Charging Cuirassier *see* **The Charging Chasseur**.

Charity (1) Francesco Salviati, 1543–5, Uffizi, Florence; (2) Bartolomeo Schedoni, 1611, Gallerie di Capodimonte, Naples; (3) (French, *Charité*) Adolphe-William Bouguereau, 1865, Birmingham City Art Gallery.

Salviati adopted the figure of the Virgin Mary from the **Doni Tondo** for this representation of Charity. Here, one breast bared, she is a tender mother surrounded by three loving children. Schedoni has a young woman giving bread to two ragged beggar boys, one of whom is blind. Bouguereau depicts a destitute peasant mother begging alms for her baby and two older children, a boy and a girl, on the steps of the Madeleine in Paris. The painting was originally shown with the title *The Destitute Family* (French, *La Famille indigente*). A bill on the wall in the upper right corner of the picture advertises a lecture on

the theme of charity by the radical priest and writer Père Lacordaire. Hence the title by which the work is now known.

The Charnel House Pablo Picasso, 1945, Museum of Modern Art, New York.

The grisly subject, painted when the artist was in German-occupied France, is an image of political protest.

The Chemist of Ampurdán Looking for Absolutely Nothing Salvador Dalí, 1936, private collection.

The painting shows a lifelike figure, as the chemist of the title, intently examining the ground at his feet, the picture as a whole being set in the landscape of the Ampurdán plain, in extreme northeastern Spain. The title subverts the seemingly positive research of the chemist.

Cherries *see* **Mother and Child** (3).

Cherry Ripe John Everett Millais, 1879, private collection.

The portrait is of a seated small girl dressed in white with a pink bonnet ribbon, sash, and slippers. A bunch of cherries, still on the branch, lies beside her. The title comes from Robert Herrick's poem *Cherry-Ripe* (1648), beginning "Cherry-ripe, ripe, ripe, I cry," itself the call of a street vendor. The sitter was Edie Ramage, niece of the editor of *Graphic* magazine. Although to contemporary Victorians the painting and its title would have conveyed pure English innocence, recent scholarship has surmised another interpretation. Literary historians Pamela Tamarkin Reis and Laurel Bradley, in an article in *Victorian Studies*, vol. 34, no. 2 (Winter 1991), see the title as a reference to the hymen ("cherry") that is virginal or "ripe." Support for this reading, they claim, is evident in the depiction of the child's clasped hands between her thighs, representing female genitalia. The black wristlets above her hands are thus pubic hair. But would Millais have been, or dared to be, so erotically subtle? There is also a problem with a pun on "cherry" at this date. The earliest record of the word in this originally American slang sense in the *Oxford English Dictionary* (obliquely, as thieves' cant for "young girl") is 1889, while the meaning "hymen," "virgin" emerges only in the 1920s.

Chez Mouquin William James Glackens, 1905, Art Institute of Chicago, Illinois.

The scene is set in a New York restaurant popular with artists of the realist school, the title

being its name. The work was inspired by Manet's **Bar aux Folies-Bergère**.

Chief Franz Kline, 1950, Museum of Modern Art, New York.

The abstract painting has bold swathes of black paint cutting across the canvas in all directions. Its title was taken from the name of a famous train that the artist remembered from his childhood home in the industrial part of Pennsylvania.

A Child Holding an Apple Cesar van Everdingen, 1664, Cannon Hall Museum, Barnsley.

The little girl shown holding an apple in one hand and with a goldfinch perched on the other has been identified as Maria Baert, daughter of the burgomaster of Alkmaar, the artist's native town. She died in 1689 at the early age of 28.

Child Labor Jacob Lawrence, 1940–41, Museum of Modern Art, New York.

The painting, No. 24 in a series of 60 with the overall title *The Migration*, depicts black children loading and carrying brightly colored baskets. All of the paintings in the series have didactic titles in sentence form. This one's is: *Child labor and lack of education was one of the other reasons for people wishing to leave their homes.*

The Child-Woman Judith Is Not Yet Breached *see* **Aita tamari vahine Judith te parari.**

The Childhood of Zeus (German, *Die Kindheit des Zeus*) Lovis Corinth, 1905, Kunsthalle, Bremen.

The god Zeus (Jove), as a naked young boy, is protestingly introduced to the adult pleasures of "wine, women, and song," here in the form of grapes tendered by a faun, nude women, and drunken music-making.

Children Gathering Wild Flowers George Smith, 1851, Victoria and Albert Museum, London.

Two children place garlands of flowers on their little sister, who sits in a cart that they have drawn with them to the woods. The painting was originally exhibited under the title *Spring Flowers*.

The Children of Edward Darley Boit *see* The **Daughters of Edward Darley Boit.**

Chill October John Everett Millais, 1870, private collection.

The artist's full first landscape is a bleak scene in the Scottish Highlands, which he frequently visited in the fall and winter and where he hunted and fished as well as painted. The precise setting is a backwater of the Tay River just below Kinfauns, near Perth. "Chill" is one of a number of stock epithets applied to the month of October.

Chiswick Reach Victor Pasmore, 1943, National Gallery of Canada, Ottawa.

The view is of a stretch (reach) of the Thames River in Chiswick, west London.

Choosing George Frederic Watts, 1864, National Portrait Gallery, London.

A young girl tries to decide between the merits of a showy but scentless camellia and the bunch of humble but fragrant violets that she holds close to her heart. She was modeled by the actress Ellen Terry (1847–1928), the artist's first wife. (They married in 1864 when he was 46 and she 16, but separated a year later. This gives the title a somewhat ironic touch, especially as she is shown wearing her brown silk wedding dress.)

Choosing the Wedding Gown William Mulready, 1846, Victoria and Albert Museum, London.

An elegantly dressed young woman chooses her wedding gown in a dressmaker's shop. The subject of the painting is taken from the opening sentences of Oliver Goldsmith's novel *The Vicar of Wakefield* (1766): "I had scarce taken orders a year before I began to think seriously of matrimony, and chose my wife, as she did her gown, not for a fine glossy surface, but for such qualities as would wear well." The artist based the picture on his illustration of the same passage for the frontispiece of an 1843 edition of the novel.

Christ and the Woman of Samaria (1) Alonso Cano, *c.*1650, Real Academia de San Fernando, Madrid; (2) George Richmond, 1828, Tate Gallery, London.

The scene is from the New Testament. Christ sits by Jacob's well and asks a woman of Samaria who has come to draw water to give him a drink (John 4:7). She hesitates, since Jews did not have dealings with Samaritans.

Christ Appears to Mary Magdalene After the Resurrection (Russian, *Yavleniye Khrista Marii Magdaline posle voskreseniya*) Aleksandr Ivanov, 1834–5, Russian Museum, St. Petersburg.

A tearful Mary Magdalene falls to her knees before Christ and reaches out to him, but he turns from her and makes a restraining gesture. The subject of the painting is identical to that of **Noli Me Tangere**.

Christ Appears to St. Peter Annibale Carracci, *c.*1602, National Gallery, London.

The scene is from the Acts of Peter, a book excluded from the canonical scriptures. Christ carries his cross on the Appian Way outside Rome and points ahead in response to a question put to him by a shocked St. Peter. The question, as the work's alternate title, is *Domine, quo vadis?* ("Lord, whither goest thou?"). His reply is, "To Rome to be crucified again,"

Christ Appears to the People (Russian, *Yavleniye Khrista narodu*) Aleksandr Ivanov, 1837–57, Tretyakov Gallery, Moscow.

The huge painting depicts Christ in the middle distance approaching John the Baptist who, as he raises his reed cross by the Jordan before a group of recognizable biblical characters, calls to point him out to the crowd, as the "voice of one crying in the wilderness" (Matthew 3:3). The work is also known in English as *The Appearance of Christ to the People*.

Christ Before the High Priest Gerrit van Honthorst, *c.*1617, National Gallery, London.

The scene is from the New Testament. Christ stands before a seated Caiaphas, who interrogates him about his disciples and his doctrine (Matthew 26, Luke 3, John 18).

Christ Crowned with Thorns Anthony van Dyck, *c.* 1620, Prado, Madrid.

The New Testament scene depicts the moment where Christ, after his scourging, has a crown of thorns placed on his head in a mock coronation (Matthew 27:29, Mark 15:17, John 19:2).

Christ Crucified Above Figures in Limbo Ludovico Carracci, 1614, Sta. Francesca Romana, Ferrara.

The work combines a depiction of the Crucifixion above a representation of limbo, the abode of the souls of the just who died before Christ's coming.

Christ Embracing St. Bernard Francisco Ribalta, *c.*1621, Prado, Madrid.

Christ leans down from the cross to embrace St. Bernard, who returns the embrace in ecstasy. The depiction is of one of the mystical

visions of St. Bernard of Clairvaux (1090–1153), refounder of the Cistercian order, as described in the 13th-century *Exordium Magnum* of Conrad of Eberbach.

Christ in Glory Graham Sutherland, 1962, Coventry Cathedral.

The tapestry was designed for Coventry's new cathedral, the former having been destroyed by German bombing in World War II. The huge work hangs above the high altar and represents in a neo–Byzantine style the Redeeming Savior of the World.

Christ in the House of His Parents John Everett Millais, 1850, Tate Gallery, London.

The work depicts the Holy Family. Mary kneels to kiss and comfort the young child who has wounded the palm of his hand on a nail from the table behind him where his carpenter father, Joseph, completes a length of planking. Also present are Mary's mother, Anne, and the boy who will become John the Baptist, carrying a bowl of water. The painting is also popularly known as *The Carpenter's Shop*. In the original Royal Academy catalog, instead of a title, it had a quotation from the Old Testament prefiguring Christ's passion: "What are these wounds in thine hands?" (Zechariah 13:6). The scene was inspired by Rossetti's The **Girlhood of Mary Virgin**, painted the previous year.

Christ in the Tomb Hans Holbein II, 1521 or 1522, Kunstmuseum, Basle.

The powerful work, also known as *Dead Christ*, depicts Christ's body rotting in the tomb.

Christ in the Wilderness (Russian, *Khristos v pustyne*) Ivan Kramskoy, 1872, Tretyakov Gallery, Moscow.

The subject of the painting is the temptation of Jesus in the wilderness (Matthew 4: 1–4, Mark 1: 12–13, Luke 4: 1–4). Christ is shown seated on a rock sunk deep in thought, as if searching for an answer to the most important question of his life.

Christ of St. John of the Cross Salvador Dalí, 1951, St. Mungo Museum, Glasgow.

The painting depicts the Crucifixion seen from above, looking down on the lowered head of Christ as he hangs on the Cross, itself suspended in a stormy sky over a lake. The main source of the work was a drawing made by the Spanish mystic, St. John of the Cross (1542– 1591), after a visionary experience. Hence the title.

Christ on the Cross (Spanish, *Cristo crucificado*, "Christ Crucified") Francisco de Goya, 1780, Prado, Madrid.

Christ looks up tearfully as he stands on a plinth, his hands and feet nailed to the Cross.

Christ Stripped of His Garments *see* El **Espolio**.

Christ Taking Leave of His Mother (1) Correggio, 1514–17, National Gallery, London; (2) Lorenzo Lotto, 1531, Staatliche Museen, Berlin.

Each artist, in his different way, depicts the moment when Christ bids farewell to Mary for the last time.

Christ Washing Peter's Feet Ford Madox Brown, 1851–6, Tate Gallery, London.

The scene is from the New Testament. Christ washes the disciples' feet at the Last Supper as a symbolic cleansing and lesson in humility, although Peter at first protests (John 13: 4–17).

The Christening William Hogarth, *c.*1729, private collection.

The depiction is a parody of a christening, with the parson diverted by a young woman next to him, a small girl spilling the holy water, and the father preening himself before a mirror while another man pays court to his wife. A print of the painting by Joseph Sympson was entitled by the engraver *Orator Henley Christening a Child*, casting the much derided clergyman John "Orator" Henley (1692–1756) in the role of the lecherous pastor.

Christian Allegory *see* **Earthly Paradise**.

Christians Escaping from Druid Persecution *see* **A Converted British Family Sheltering a Christian Priest from the Persecution of the Druids**.

Christina of Sweden Judy Chicago, 1972, private collection.

The painting shows more or less regular wavy lines radiating from the center of a yellow square bordered by a blue rectangle. The title refers to Christina (1626–1689), queen of Sweden for 22 years from the age of six, the colors and shapes representing her personality. The artist depicted other queens in a similar symbolic fashion, among them Marie Antoinette, Catherine the Great, and Victoria.

Christina's World Andrew Wyeth, 1948, Museum of Modern Art, New York.

A crippled woman in a cornfield in Maine pauses in her slow crawl up to her hilltop farm. The isolated setting and her condition are a study of the pain and longing that are her "world." She is Anna Christina Olson, a Swedish sailor's daughter from Cushing, Maine, who was a friend of the artist.

The Christmas of Those Left Behind
(Italian, *Il Natale dei rimasti*) Alessandro Morbelli, 1903, Galleria d'Arte Moderna, Venice.

A handful of old men sit at lonely tables in the sunlit dining hall of an old people's home, the rest of the inmates having been offered hospitality elsewhere at Christmas. The home depicted is the Pio Luogo Trivulzio, founded in Milan in 1776, which by 1900 housed over 800 old men and women.

Christ's Charge to St. Peter *see* The Delivery of the Keys to St. Peter.

Cimabue's Celebrated Madonna Frederic Leighton, 1853–5, Collection of Queen Elizabeth II, London.

The depiction of medieval Italian life shows the artist Cimabue leading the procession that took his famous painting of the Madonna to the church of Santa Maria Novella in Florence. (The work, known as the Rucellai Madonna, is now attributed to Duccio di Buoninsegna.) As he walks, Cimabue leads his young pupil Giotto by the hand while, at the extreme right, Dante looks on. The picture itself was inspired by Vasari's description of the scene.

The Cinema William Roberts, 1920, Tate Gallery, London.

Moviegoers in a picture theater intently follow the action on the screen right before them, their grimacing faces and gesticulating arms mirroring those of the actors.

Circe Invidiosa ("Jealous Circe") John William Waterhouse, 1892, Art Gallery of South Australia, Adelaide.

The seagod Glaucus has asked the sorceress Circe for a love potion to influence Scylla, the beautiful virgin with whom he is in love. Circe has wooed Glaucus herself, but he still has eyes only for Scylla. Circe now holds up a bowl and from it pours into the sea the "potion" he requested. It is a green poison, which instead of making Scylla love Glaucus, will change her into a hideous monster.

Circe Offering the Cup to Ulysses John William Waterhouse, 1891, Oldham Art Gallery.

The sorceress Circe sits on her throne on the island of Aeaea and offers a golden goblet to Ulysses, seen in the mirror behind her. She had already used her magic spells and potions to turn all Ulysses' companions into swine, but Ulysses himself had escaped by using the leaf of a herb given him by Hermes. She now tempts him with a cup containing a potion that she hopes will enchant him also. The subject is taken from Homer's *Odyssey*.

A City Atlas Sidney Starr, 1888–9, National Gallery of Canada, Ottawa.

A "city atlas" was a type of horse-drawn omnibus, here shown traveling through St. John's Wood, northwest London. The scene is depicted from a point behind a woman seated on top of the cab.

The City Rises (Italian, *La città che sale*)
Umberto Boccioni, 1910–11, Museum of Modern Art, New York.

The Futurist painting depicts the construction of a city's industrial suburbs. Two vividly colored horses toss and plunge almost out of control in the foreground, symbolizing the dynamic growth of such suburbs at this time in many Italian cities.

The Claim for Shelter *see* Fugitive Royalists.

Clairvoyance (French, *La Clairvoyance*)
René Magritte, 1936, private collection.

An artist paints a bird on a canvas while looking at an egg on a table beside him. The painting may be a self-portrait, in which case the title and depiction appear to express Magritte's conception of himself as an artist with heightened or even supernatural insight.

Claudio and Isabella William Holman Hunt, 1849, Tate Gallery, London.

The painting depicts a scene from Shakespeare's *Measure for Measure* (1604). Claudio entreats his sister Isabella to sacrifice her virginity to her captor, Angelo, so that his own life can be spared.

Cleansed Peter Howson, 1994, Imperial War Museum, London.

Muslim refugees attempt to find sanctuary by a British army camp's peripheral fence during the "ethnic cleansing" of the 1990s conflict in the former Yugoslavia.

The Clearing (French, *La Clairière*) Henri-Edmond Cross, *c.*1906–7, private collection.

A group of naked young women dance in a ring in a bright forest glade, while in the foreground two more such women languidly drape themselves around the trunk of a tree.

The Cleopatra Cylinder Vessel Edward William Cooke, 1878, Victoria and Albert Museum, London.

The painting depicts the ancient obelisk now known as Cleopatra's Needle being transported in a special vessel from Alexandria in Egypt to London, where it now stands on the Thames Embankment. The original full title of the work when first exhibited was *The "Cleopatra" in the Bay of Biscay, on the 14th October, 1877, signalling the "Olga" to cast off the tow-rope.*

Clerk Saunders Edward Burne-Jones, 1861, Tate Gallery, London.

The painting takes its subject from Sir Walter Scott's collection of ballads *Minstrelsy of the Scottish Border* (1802–3), containing the poem of the title. This tells how Clerk Saunders, exhausted and soaked from traveling in the rain, begs his lady, May Margaret, to give him a bed in her father's house. She hesitates, for if any of her seven brothers discovers him there, he will think Saunders has seduced her and will kill him. The depiction is thus of Saunders entreating May Margaret to let him into her house, and of May Margaret repelling him.

The Cloakroom of the Clifton Assembly Rooms Rolinda Sharples, 1817–18, City of Bristol Art Gallery.

Some thirty elegantly dressed ladies and gentlemen gather and genteelly gossip in the anteroom of a fashionable English social club, the Assembly Rooms at Clifton, Bristol.

The Cloister or the World? Arthur Hacker, 1896, Bradford Art Gallery.

A nun kneels in ecstasy in a convent garden before a vision of the angel of the Annunciation while a young woman accompanied by a cupid dances sensuously behind her. The painting presents the dilemma of choice between worldly delights and spiritual fulfilment.

The Clothed Maja (Spanish, *La maja vestida*) Francisco de Goya, *c.*1797, Prado, Madrid.

The portrait of a reclining *maja* (lower class Spanish belle) is said to be of the Duchess of Alba, the beautiful widow whose relationship with the artist caused a scandal in Madrid. The work is the pendant (companion piece) to The **Naked Maja**.

"Clout the Auld, the New are Dear" Erskine Nicol, 1886, Victoria and Albert Museum, London.

An old Scottish woman is mending a dress, as advised by her husband in the proverbial words of the title. "Clout the auld" is Scots for "Patch up the old."

Clytie Frederic Leighton, *c.*1890–2, Fitzwilliam Museum, Cambridge.

A diminutive and at first barely discernible figure in the bottom right corner of the painting kneels on a stone plinth beside an altar and stretches her arms out towards the sun, which sets on the horizon in a towering mass of clouds. She is Clytie, of Greek mythology. Book IV of Ovid's *Metamorphoses* (1st century AD) tells how she was abandoned by her lover, Apollo, and in her distress went out into the country daily to watch the god drive the chariot of the sun across the sky. As she watched, she was gradually turned into a heliotrope, a plant that turns to face the sun.

Cnidian Venus *see* **Aphrodite of Cnidus**.

Coachman and Cabbages *see* An **Amateur**.

A Coign of Vantage Sir Lawrence Alma-Tadema, 1895, private collection.

Three elegantly dressed young women on a Roman rooftop look down over the parapet to watch the arrival of the fleet in the Mediterranean below. A "coign" is literally a cornerstone, like the one depicted in the painting, and the title itself, though now a standard phrase, originated in Shakespeare's *Macbeth* (1605): "No jutty, frieze, / Buttress, nor coign of vantage" (I.vi).

Collage Arranged According to the Laws of Chance (French, *Collage arrangé selon les lois du hasard*) Jean Arp, 1916–17, Museum of Modern Art, New York.

The work consists of 15 rectangular pieces of torn paper pasted in the pattern in which they fell when dropped.

Collective Invention (French, *L'Invention collective*) René Magritte, 1935, private collection.

On the sandy seashore lies a creature that is the opposite of a mermaid: a fish with a

woman's lower body and legs instead of a woman with a fish's lower body and tail. The different parts (of a woman and a fish) have thus been re-ordered as a collective invention.

The Colossus (Spanish, *El coloso*) Francisco de Goya, *c*.1808–12, Prado, Madrid.

A fierce giant looms over fleeing people and animals. The grim vision is said to have been in-spired by lines written by a Spanish poet about the Napoleonic wars: "On a height above yon-der cavernous amphitheatre, a pale Colossus rises, caught by the fiery light of the setting sun" (quoted in Bragg, p. 316).

Colossus of Rhodes Chares of Lindos, *c*.280 BC.*

The original huge bronze statue of this name, one of the Seven Wonders of the World, was of Helios, the Greek sun god, which stood beside (not astride, as sometimes supposed) the harbor at Rhodes and represented the raising of a siege in 304 BC.

Comb (French, *Peigne*) Marcel Duchamp, 1916, Philadelphia Museum of Art, Pennsylva-nia.

The work is an American-made gray steel comb on the spine of which the artist has writ-ten the Surrealist sentence: "*3 ou 4 gouttes de hauteur n'ont rien à faire avec la sauvagerie*" ("3 or 4 drops of height have nothing to do with savagery").

The Comforts of Industry George Mor-land, 1790, National Gallery of Scotland, Ed-inburgh.

A frugal but clearly close and contented family are depicted in their humble cottage. The husband, a stalwart farmer, throws a guinea into his wife's lap, while their two children chat hap-pily. A large joint of meat and a plump cabbage stand on the table. The artist painted the picture following the popular plate entitled *The Fruits of Early Industry and Economy* (1789). *Cf.* The **Mis-eries of Idleness**.

Comical Dogs Sir Edwin Landseer, 1836, Victoria and Albert Museum, London.

Two dogs have been dressed up in comic costumes, one sitting in a grandmother's cap with a pipe in its mouth, the other in a shep-herd's bonnet with a snuffbox by its paws.

Coming Events William Collins, 1832, Chatsworth House, Derbyshire.

A knot of village children stand by an open gate on a woodland ride, one boy touching his forelock in deference. Who or what are the com-ing events? The answer can be seen in the long shadow on the ground at the bottom of the pic-ture, that of a gentleman on horseback. The artist painted a reduced replica of the work in 1833 (now in the Victoria and Albert Museum, London) entitled *Rustic Civility*. This predates the title of Mascagni's 1890 opera *Cavalleria rus-ticana*, the exact Italian equivalent. (The opera was based on Verga's 1884 drama of the same name, in turn based on his own story of 1880.)

The Coming of the White Man Joshua Shaw, 1850, Elisabeth Waldo-Dentzel Collec-tion, Northridge, California.

A group of Native Americans on a clifftop express their fear and awe at the sight of a Eu-ropean sailing ship on the horizon.

Commodore Keppel Joshua Reynolds, 1753–4, National Maritime Museum, Green-wich.

The heroic full-length portrait, one of sev-eral that the artist painted of his subject, is of the future British admiral Augustus Keppel, 1st Vis-count Keppel (1725–1786), who at the time of sitting had yet to see service in the Seven Years' War and fight the French at sea.

Communication with the Infinite (French, *Vers l'infini*, "Towards the Infinite"): Ferdinand Hodler, 1892, Kunstmuseum, Basel.

A naked woman stands on a length of drap-ery by a hill and raises her hands in an attitude of prayer as she looks up to the sky above, the notional location of the "infinite" of the title. The model for the painting was Augustine Dupin, mother of the artist's son, Hector.

The Communion of the Apostles Justus of Ghent, 1472–4, Galleria Nazionale delle Marche, Urbino.

The painting depicts Jesus administering communion to his apostles, two angels flying overhead. The work was produced for a confra-ternity under the patronage of Federico da Mon-tefeltro, who also appears in the picture.

The Companions of Fear (French, *Les Compagnons de la peur*) René Magritte, 1942, private collection.

A hunter with a gun slung over his shoul-der stands near the angle of a brick wall through which he has thrust his left arm. Tall trunks of closely planted trees rise above the wall. They are presumably the "companions of fear" of the

title, that of the French version of *The League of Frightened Men* (1935), a thriller by the American writer Rex Stout.

Comparisons Sir Lawrence Alma-Tadema, 1892, Cincinnati Art Museum, Ohio.

Two elegantly dressed women, one curled up on a couch, the other seated at a table, compare the books they have open before them. The woman on the couch holds a richly bound Roman codex, while the book on the table is presumably a translation of it.

Composition (French, *Composition*) Jean Arp, *c*.1920, private collection.

The composition is random, since the work was created by the artist's method of tearing up bits of paper and letting them fall arbitrarily onto a piece of colored paper.

Composition in Yellow and Blue Piet Mondrian, 1929, Boymans Museum, Rotterdam.

The prosaically descriptive title of the abstract painting with its rectangular composition is one of several executed by the artist during a period when he limited himself to the three primary colors (the pigments red, blue, and yellow) plus black, white, and gray.

The Concealed Enemy George C. Bingham, 1845, Stark Museum of Art, Orange, Texas.

A lone Indian warrior tightly grasps his rifle as he crouches on a cliff behind a rock, awaiting the (unseen) white settler who will be his victim. The title thus relates to the latter's point of view, not that of the viewer, who is in a virtual eye-to-eye confrontation with the Indian.

The Concert (1) Valentin de Boulogne, 1622, Louvre, Paris; (2) Gerrit van Honthorst, 1624, Louvre, Paris; (3) Jan Vermeer, *c*.1660–5, Isabella Stewart Gardner Museum, Boston, Massachusetts.

Valentin's painting has a group of musicians with guitar, violin, mandolin, and music score seated around a stone block with an antique relief. A young boy sings with them, and drinkers are before and behind the stone. Honthorst depicts four women in a window, singing as they accompany themselves on lutes. Vermeer's more complex work has three figures: a young woman playing the virginals, a man seated next to her, his back to the viewer, and another woman singing to his right. A painting on the wall behind the three is Dirck van Baburen's The **Pro-**

curess, owned by the artist's mother-in-law. Its presence seems to imply that there is more to "the concert" than meets the eye. (The basic sense of the word, even in English, is "plan," "design.") Vermeer had earlier painted his own picture of the same title.

Concert Champêtre *see* **Fête Champêtre**.

The Confession Sir Frank Dicksee, 1896, private collection.

A young woman in an armchair leans across to hear the words of a young man seated beside her. His anguished pose, with one hand pressed to his head, suggests that it is he who is the confessor. The woman wears a wedding ring, so presumably she is his wife. But the viewer can only guess at the precise nature of the confession.

The Conjurer Nathaniel Hone, 1775, National Gallery, Dublin.

The portrait was painted as a satire on Joshua Reynolds's practice of borrowing poses from the Old Masters. The title not only describes the subject but alludes to this "jiggery-pokery."

The Connoisseur Henry Herbert La Thangue, 1887, Bradford Art Gallery.

The painting depicts the Bradford art collector Abraham Mitchell (1828–1896) seated in the picture gallery of his house contemplating a painting. At the tea table sit his wife, Elizabeth, their son, Herbert, and one of their daughters. The eldest son, Tom, stands smoking.

The Conspiracy of Julius Civilis Rembrandt van Rijn, *c*.1661–2, National Museum, Stockholm.

The painting, also known as *The Oath of Julius Civilis*, depicts a subject from classical history. The 1st-century AD Batavian prince Gaius Julius Civilis assembles the leaders of Batavia (modern Holland) and makes them swear to rise against the occupying Romans.

Consulting the Oracle John William Waterhouse, *c*.1882, Tate Gallery, London.

A group of women seated in a semicircle seek the advice of the teraph, a household god which ancient Semitic peoples consulted as an oracle. The priestess has her ear close to the oracle's mouth and interprets its decrees with a look of terror.

Contes barbares *see* **Barbaric Tales**.

Contrary Winds Thomas Webster, 1843, Victoria and Albert Museum, London.

Four young children blow toy sailboats across a tub of water, each trying to outblow the others. A grandmother sits nearby, absorbed in her knitting. An art journal commented at the time that it was "difficult to divine the material of this work from the title."

The Contrast John Callcott Horsley, 1839, Victoria and Albert Museum, London.

An aged rustic is led into church by his little granddaughter. The painting is subtitled *Youth and Age*. The model for the child was the artist's young cousin, a clergyman's daughter.

The Convalescent James Tissot, *c*.1876, Sheffield City Art Galleries.

A sick young woman reclines in a basket chair under a tree, attended by an elderly chaperone. She is Kathleen Newton, a divorcee who had formed a secret liaison with the artist, and who died of tuberculosis in 1882 at the age of 28. To that extent the title is a misnomer, since Mrs. Newton would never recover. The setting for the picture is the garden of Tissot's house in St. John's Wood, London.

The Convalescent from Waterloo
William Mulready, 1822, Victoria and Albert Museum, London.

A uniformed soldier, wounded in the Battle of Waterloo (1815), sits with his wife and young daughter in the grounds of a seaside convalescent home, his injured arm temporarily removed from its sling. His two young sons engage in a scrap nearby, hinting at the battle.

Convent Thoughts Charles Allston Collins, 1850–1, Ashmolean Museum, Oxford.

A nun contemplates a passion flower that she has picked in her convent garden. The top of the painting's gilt frame is engraved with the Latin words "SICUT LILIUM" ("as the lily"), a quotation from the Song of Solomon: "As the lily among thorns, so is my love among the daughters" (2:2). The flower that the nun holds is not a lily, but lilies grow nearby, and their presence prompted her contemplation. A devotional book in her other hand is open at an illumination of the Crucifixion, so pointing up the reference to the Passion, for which the flower itself is named.

Conversation Feredico Zandomeneghi, *c*.1892, private collection.

Two young women on a sofa enjoy a private conversation. The title is French, although serving also in English, and the painting has the alternate French title *Causerie* ("Chat") and Italian title *Sul divano* ("On the Sofa").

Conversation Piece Vanessa Bell, 1912, University of Hull Art Collection.

The artist painted a series of interiors showing family and friends engaged in conversation, napping, taking tea, and painting in studios. This picture shows three people engaged in conversation in the sitting-room of the artist's house in Sussex. They are Adrian Stephen, her younger brother, Leonard Woolf, husband of her sister, Virginia Woolf, and Clive Bell, her husband.

A Converted British Family Sheltering a Christian Priest from the Persecution of the Druids William Holman Hunt, 1849–50, Ashmolean Museum, Oxford.

A priest is given refuge in a primitive hut by members of an early British family. The women of the family tend the exhausted priest while the men and boys keep watch for the Druids who can be glimpsed gathering before a circle of standing stones in the background. The work also has the alternate shorter titles *Christians Escaping from Druid Persecution*, *Early Britons Sheltering a Missionary from the Druids*, and simply *The Missionary*.

Cordelia Disinherited John R. Herbert, 1850, Harris Museum and Art Gallery, Preston.

The portrait of a young woman in an intricately embroided dress was inspired by Shakespeare's *King Lear* (1605), in which Cordelia, Lear's youngest daughter, is disinherited by her father when she refuses to make a public profession of her love for him.

Coresus and Callirrhoe (French, *Corésus et Callirrhoé*) Jean-Honoré Fragonard, 1765, Louvre, Paris.

Although generally known thus, the work has the full title *The High Priest Coresus Sacrificing Himself to Save Callirrhoe* (French, *Le Grand Prêtre Corésus se sacrifiant pour sauver Callirrhoé*). The classical scene is from Pausanias. Coresus, a priest of Dionysus at Calydon, falls in love with a girl named Callirrhoe, but she rejects him. In answer to Coresus' prayers, Dionysus afflicts the people of Calydon with madness. An oracle tells them that to cure their affliction they must sacrifice Callirrhoe to Dionysus unless she can find another to take her place. It is the task of Coresus, as priest, to carry out the sacrifice, but at the moment of its execution he offers himself instead and plunges the knife into his own breast. The painting depicts this moment.

Cornard Wood Thomas Gainsborough, 1748, National Gallery, London.

The scene is of the named wood (and part of the village that gave its name) just outside Sudbury, Suffolk, the artist's birthplace. The painting was also originally known as *Gainsborough's Forest*.

The Cornfield John Constable, 1826, National Gallery, London.

The painting aimed to give a visual interpretation of the lines from James Thomson's poem *Summer* (1727) in *The Seasons* that accompanied it when it was first exhibited in 1827: "A fresher gale / Begins to wave the woods and stir the streams / Sweeping with shadowy gusts the fields of corn." The artist usually referred to his work as *The Drinking Boy*, alluding to the young shepherd boy who lies drinking from a pool on the left.

Cornucopia Frank Dobson, 1925–7, University of Hull Art Collection.

The stone sculpture is of a nude young woman carrying a basket of loaves. The implication of peace and plenty in the title is represented by her fertile figure and the bread in the basket.

The Coronation of Napoleon (French, *Le Sacre de Napoléon*) Jacques-Louis David, 1805–7, Louvre, Paris.

The huge work was one of several painted by the artist between 1802 and 1807 to glorify the exploits of the French emperor. Napoleon was actually crowned (or more precisely crowned himself) on December 2, 1804 in Notre-Dame Cathedral, Paris.

The Coronation of the Virgin

(1) Lorenzo Monaco, 1414, Uffizi, Florence; (2) Fra Angelico, *c.*1430–5, Louvre, Paris; (3) Fra Filippo Lippi, 1441, Uffizi, Florence; (4) Enguerrand Charonton, 1454, Musée de l'Hospice, Villeneuve-lès-Avignon; (5) Giovanni Bellini, *c.*1471–4, Museo Civico, Pesaro; (6) Francesco di Giorgio Martini, 1472, Pinacoteca Nazionale, Siena; (7) Piero Pollaiuolo, 1483, S. Agostino, San Gimignano, (8) Carlo Crivelli, 1493, Pinacoteca di Brera, Milan; (9) Diego Velázquez, *c.*1641–2, Prado, Madrid.

All the works depict, with due ceremony, the crowning of the Virgin Mary as Queen of Heaven by her Divine Son. The Coronation of the Blessed Virgin Mary, for Roman Catholics, is the fifth of the Five Glorious Mysteries of the Rosary.

Le Corps de ma brune Joan Miró, 1925, private collection.

The work is a poem-painting, the picture itself containing symbols of breasts and hair against a brown background. The title represents the opening words of a French poem written across the painting in powerful calligraphy from top left to bottom right: "*le corps de ma brune / puisque je l'aime / comme ma chatte habillée en vert salade / comme de la grêle / c'est pareil*" ("my brown girl's body / since I love her / like my she-cat dressed in salad green / like hail / it's the same").

Corpus Delicti Jac Leirner, 1992, Galerie Lelong, New York.

The work consists of items gathered by the artist on her many international plane trips. Objects such as torn boarding passes, metal ashtrays, airsickness bags, and in-flight toiletries are strung together on a thin silver chain, mounted between two large sheets of glass, and displayed on two low plinths. The title is the legal Latin term, literally meaning "body of the offence," used to denote the concrete evidence of a crime, and especially a corpse.

The Coster Girls William Rothenstein, 1894, Sheffield City Art Galleries.

Two young women in black dresses and black hats gossip in a fishing port, one with her arms akimbo. They are the coster girls of the title, presumably selling fish or shellfish.

Country Girl with a Basket of Eggs, Crossing a Ditch, and a Youth Offering Help Norman E. Tayler, 1878, Victoria and Albert Museum, London.

The title is a straightforward description of the depiction, and is a rare exception to the sentimental or whimsical title that such a Victorian genre scene usually carried. Having seen the many examples of such titles in this book, the reader is invited to provide an apt one here!

Courbet with a Black Dog (French, *Courbet au chien noir*) Gustave Courbet, 1842, Musée du Petit Palais, Paris.

The painting is a self-portrait of the artist, seated by a rock holding a large black dog. In a rare typographical slip, the picture is named as *Combat au chien noir* ("Fight with a Black Dog") in *Le Petit Robert 2: Dictionnaire universel des noms propres* (1980).

The Course of Empire Thomas Cole, *c.*1836, New York Historical Society, New York.

The work consists of a series of five paintings depicting what the artist envisaged as "the History of a Natural Scene, as well as an Epitome of Man." The paintings are as follows: (1) *The Savage State*, depicting an Indian encampment and a hunter in skin garments; (2) *The Arcadian or Pastoral State*, an idyllic pastoral scene with a flock of sheep and girls dancing to a flute in a grove; (3) *Consummation*, showing Julius Caesar entering Rome in triumph; (4) *Destruction*, showing the sacking of ruined Rome, and (5) *Desolation*, depicting a wilderness with the remains of ruined buildings, a single column standing in the foreground.

The Course of True Love Never Did Run Smooth Jacob Thompson, 1854, private collection.

A young couple have paused in a country lane to resolve some little difference. The man pleads earnestly with the seated woman, the back of his hand on her knee, but she looks away. The title quotes the proverbial line from Shakespeare's *A Midsummer Night's Dream* (1595), where the words are spoken by Lysander to his beloved Hermia. The course of true love rarely did run smooth for Victorian couples.

A Courtesan's Palace (French, *Le Palais d'une courtisane*) René Magritte, 1928, Menil Collection, Houston, Texas.

A framed picture of a female torso hangs on a planked wall beside a passage. The title suggests that the torso is that of a royal courtesan. The framed image may be a mirror image, so that the torso is that of a person behind the viewer. This seems to be borne out by the work's original title, inscribed and deleted on the back of the canvas, as *The Living Mirror*, a title subsequently given to another painting (*see* The Living Mirror).

The Courtyard of a House in Delft Pieter de Hooch, 1658, National Gallery, London.

The painting's baldly descriptive title makes no mention of its three figures. One woman leads a small girl into a house's back yard (today we might call it a patio), while another stands in a passageway leading off it.

Covert of Roedeer (French, *Remise des chevreuils*) Gustave Courbet, 1866, Musée d'Orsay, Paris.

Roedeer rest in a wooded glade by a stream. The artist described the painting: "It is a stream shut in by rocks and big trees… This winter I hired some deer and made it into a covert: there's a little doe in the middle, like a lady receiving company in her drawing room. Her mate stands beside her" (quoted in Callen, p. 96). The covert itself was at Plaisir-Fontaine, eastern France.

The Cradle (French, *Le Berceau*) Berthe Morisot, 1872, Musée d'Orsay, Paris.

A young mother tenderly watches over her baby, asleep in a cradle. The woman depicted is the artist's younger sister, Edma Pontillon, and the baby is her second daughter, born 1871.

Cranmer, at Traitor's Gate Frederick Goodall, 1856, Victoria and Albert Museum, London.

The painting depicts the arrival of Thomas Cranmer (1489–1556), archbishop of Canterbury, at Traitor's Gate, the river entrance to the Tower of London, where he had been sent by Mary Tudor for treason on September 8, 1553. The painting was earlier listed as *Archbishop Cranmer taken to the Tower*, but was first exhibited under the title above, accompanied by lines from a poem by Samuel Rogers: "On thro' that gate misnamed, thro' which before / Went Sidney, Russell, Raleigh, Cranmer, More."

The Creation of Adam Michelangelo, 1508–12, Sistine Chapel, Vatican.

God the Father animates the languishing body of Adam as their fingertips touch. The scene, based on Genesis 1:27 ("God created Man in his own image"), may have been suggested by the Latin hymn *Veni, Creator Spiritus*, in which God restores strength to the weak by a touch of his finger. The fresco is the most famous of nine from Genesis that the artist depicted on the ceiling of the Sistine Chapel. The other eight, three preceding and five following, are: *The Separation of Light from Darkness*, *The Creation of the Sun, Moon, and Plants*, *The Separation of Land from Water*, *The Creation of Eve*, *The Temptation and Expulsion*, *The Sacrifice of Noah*, *The Deluge*, and *The Drunkenness of Noah*.

The Creation of the Birds Remedios Varo, 1958, private collection.

With the aid of pigments produced on a palette by an eccentric machine, a feathered female figure seated at a desk paints pictures of birds that come alive and fly around her studio. Their animation appears to be effected by the focussed light of a distant star shining through a window and the sound impulses from a miniature guitar strung around the figure's neck.

Crivelli's Garden Paula Rego, 1990–1, National Gallery, London.

The mural in the brasserie of the National Gallery's Sainsbury Wing was inspired by the glimpses of gardens that appear in the little paintings at the foot of Carlo Crivelli's **Madonna della Rondine**, although the depiction itself is based on the artist's own garden in Portugal.

Croatian and Muslim Peter Howson, 1994, private collection.

Two men in combat fatigues rape a woman civilian in her home while submerging her head in a toilet bowl. The painting was one of several resulting from the artist's 1992 commission to record the conflict in the former Yugoslavia. *Cf.* **Serb and Muslim**.

The Cross in the Mountains (German, *Das Kreuz in Gebirge*) Caspar David Friedrich, 1808, Staatliche Kunstsammlungen, Dresden.

The altarpiece depicts the silhouette of a tall crucifix atop a rocky summit surrounded by fir trees. Describing the work, the artist wrote that the rock symbolized unshakeable faith while the evergreen trees represented the eternal hope of humankind. But the title merely describes what the viewer sees.

The Crucifixion (1) Giotto di Bondone, 1303–5, Arena Chapel, Padua; (2) Pietro Cavallini, *c.*1308, S. Domenico Maggiore, Naples; (3) Masaccio, 1425–6, Museo di Capodimonte, Naples; (4) Andrea Mantegna, 1456–9, Louvre, Paris; (5) Antonello da Messina, *c.*1475–6, Musée des Beaux-Arts, Antwerp; (6) Gaudenzio Ferrari, 1513, S. Maria delle Grazie, Varallo Sesia (Vercelli); (7) Matthias Grünewald, *c.*1515, Musée d'Unterlinden, Colmar; (8) Pordenone, 1520–1, Cremona Cathedral; (9) Tintoretto, 1565, Scuola Grande di S. Rocco, Venice; (10) (Italian, *Crocifissione*) Renato Guttuso, 1941, Galleria Nazionale d'Arte Moderna, Rome.

The many depictions of the crucifixion of Christ usually include personages and scenes from one of the New Testament accounts (Matthew 27, Mark 15, Luke 23, John 19). Traditionally they are the Virgin Mary, Mary Magdalene, and St. John the Baptist. Mantegna's painting shows soldiers gambling for the cloak as the women grieve. Guttuso has Mary Magdalene nude. His work was seen as symbolizing the "crucifixion" of Italy under Mussolini. Grünewald's painting is the central panel, when closed, of The **Isenheim Altarpiece**.

The Crucifixion of St. John of the Cross Salvador Dalí, 1951, Glasgow Art Gallery.

The depiction is fictional, since St. John of the Cross (1542–1591), founder of the Discalced Carmelites, died a natural (if premature) death, and was crucified only in the spiritual sense.

The Crucifixion of St. Peter (1) Caravaggio, 1601, S. Maria del Popolo, Rome; (2) Guido Reni, 1603, Vatican Museums.

The scene is of the martyrdom of St. Peter, who in about AD 64 is said to have been crucified upside down in Rome during Nero's persecution of the Christians.

The Cruel Sister John Faed, 1851, Bury Art Gallery.

A young man walks between two sisters, his head turned to the younger, dressed in white, whom he favors over the elder, wearing black. The painting takes its subject from a ballad in Sir Walter Scott's *Minstrelsy of the Scottish Border* (1802–3): "There were two sisters sat in a bower, / Binnorie, O Binnorie, / There came a knight to be their wooer / By the bonny mill dams of Binnorie. / He courted the eldest with brooch and knife, / Binnorie, O Binnorie, / But he loved the younger abune (above) his life, / By the bonny mill dams of Binnorie. / The older one was vexed sair (sore), / Binnorie, O Binnorie, / And sair envied her sister fair, / By the bonny mill dams of Binnorie." The younger woman is thus the "cruel sister" of the title.

Crusaders (French, *Croisés*) Arman, 1968, private collection.

The work consists of packed rows of hundreds of paint brushes all pointing upwards. They are the crusaders of the title, apparently set on some evangelical mission.

The Cry *see* The **Scream**.

Culture-Nature Lothar Baumgarten, 1971, private collection.

The work is a color print of part of the parquet floor in the artist's studio. One of the wooden blocks has been lifted out to reveal a red feather in its space. The feather is a symbol of nature, and is contrasted with the manufactured floorboards, which are a symbol of culture, although they in turn were originally part of nature, as trees in a rainforest.

The Cumaean Sibyl Domenichino, *c.*1610, Pinacoteca Capitolina, Rome.

The portrait of a young girl holding a scroll

of music represents the Cumaean Sibyl, the most famous of the ten sibyls, or prophetesses of Greek legend, who acted as Aeneas's guide to the Underworld and who wrote down the oracles contained in the Sibylline Books preserved in the Roman temple of Capitoline Jupiter. She was associated with the colony of Cumae, near Naples.

The Cup in Benjamin's Sack Juan Antonio Escalante, 1668, Museo de Bellas Artes, La Coruña.

The painting is a complex depiction of an Old Testament scene. Benjamin, the youngest of the 12 sons of Jacob, was tested by his brother, Joseph, who had a valuable silver cup put into Benjamin's baggage on his return from Egypt to his father, sent servants after him, and accused him of theft. The picture show the moment when the cup is found in his sack (Genesis 44:12). The work is one of 17 canvases depicting episodes from the Old Testament linked in some way to the Eucharist. The collection has now been dispersed, but the titles of the other paintings are: *Abraham and Melchizedek, Abraham and the Three Angels, David and Abigail, David and the Supreme Sacrifice, Elijah in the Wilderness, Gathering Manna, The Grapepickers in the Promised Land, Moses and the Water from the Rock, Noah and His Family, The Passover of the Israelites, The Reapers in the Promised Land, The Sacrifice of Abel, The Sacrifice of Isaac, The Sacrifice of the Lamb and the Bread, Samson and the Lion*, and *Soldiers Frightened at the Miraculous Bread*. An 18th canvas is a related allegorical work similarly linked, *The Triumph of Faith over the Senses*.

The Cup of Death Elihu Vedder, 1885, Virginia Museum of Fine Arts, Richmond.

The Angel of Death places a cup to the lips of a reluctant youg woman. The painting illustrates lines from Edward Fitzgerald's 1868 version of the *Rubáiyát* of Omar Khayyám: "So when the Angel of the darker Drink / At last shall find you by the river-brink, / And, offering his Cup, invite your Soul / Forth to your Lips to quaff—you shall not shrink."

The Cup of Tea (French, *La Tasse de thé*) Maurice Denis, 1892, private collection.

The painting depicting two young women taking tea has the alternate title (or subtitle) *Mystical Allegory* (French, *Allégorie mystique*), possibly suggesting that the two are virgins making a votive offering to the patron saint of the home. The models for the women may have been the

artist's fiancée, Marthe Meunier, and her sister, Ève.

Cupid and Psyche (1) Anthony van Dyck, *c.*1639, Royal Collection, Windsor Castle; (2) (Italian, *Amore e Psiche*) Antonio Canova, 1787–93, Louvre, Paris; (3) (French, *Cupidon et Psyché*) Clodion, *c.*1798–1804, Victoria and Albert Museum, London.

Van Dyck's painting and the two sculptors' statues depict Cupid (Eros), the god of love, landing to bear off dying Psyche, the object of his love. Van Dyck and Clodion show Psyche with her eyes closed, for she was forbidden to look at her lover.

Cupid Complaining to Venus Lucas Cranach I, *c.*1530, National Gallery, London.

The subject of the painting is taken from a 3d-century BC poem by Theocritus, *Idyll XIX, The Honeycomb Stealer*, lines from which are inscribed in Latin at the top of the picture: "DVM PVER ALVEOLO FVRATUR MELLA CVPIDO / FVRANTI DIGITUM CVSPIDE FIXIT APIS / SIC ETIAM NOBIS BREVIS ET PERITVRA VOLVPTAS / QVAM PETIMVS TRISTI MIXTA DOLORE NOCET" ("While the boy Cupid was stealing honey from the hollow of a tree trunk, a bee stung the thief in the finger. Thus does the brief and transient pleasure which we seek harm us with sadness and pain"). Cupid is here shown brushing the bees off his bare body as he complainingly holds the comb out to a naked Venus, standing seductively in an elegant hat beneath an apple tree.

Cupid Sheltering His Darling from the Approaching Storm William Etty, 1822, Victoria and Albert Museum, London.

Cupid, the Roman god of love, a naked boy with wings, protects his beloved Psyche, here unusually depicted as an infant, from the gathering storm.

The Curlers Sir George Harvey, 1835, National Gallery of Scotland, Edinburgh.

The painting is an animated depiction of a curling match on the ice of a Scottish lake.

The Curvature of the Universe (French, *La Courbure de l'univers*) René Magritte, 1950, Menil Collection, Houston, Texas.

The work is a glass bottle onto which the artist has painted fleecy clouds in a blue sky. The bottle's rounded shape is its "curvature," and the sky is the "universe."

CUSeeMe Peter Halley, 1995, Goetz Collection, Munich.

Two rectangles with grid-like centers, one yellow, one blue, are superimposed on a pattern of right-angled multicolored lines. The rectangles represent prison cells, and the lines suggest secret passageways. Hence the title, to be understood as "See you, see me" (or "See you see me"), evoking clandestine meetings.

The Cut Finger David Wilkie, 1809, present location unknown.

A tearful small boy holds out a finger that he has hurt while fixing the mast in a toy boat. "This picture was, when it appeared first, called The Young Navigator by the purchaser Mr. Whitbread, who desired to see in its story the maritime glory of England in the dawn; but a boy who cries at the sight of his own blood was not considered a true representative of our conquering tars, and the picture soon took the humbler name which the great painter at first bestowed upon it" (anecdote recounted by the artist's biographer, Allan Cunningham, quoted in Johnson, p. 277).

Cymon and Iphigenia (1) John Everett Millais, 1848, private collection; (2) Frederic Leighton, *c.*1884, Art Gallery of New South Wales, Sydney.

The title of the works is misleading, since it appears to associate Iphigenia, the daughter of Agamemnon in Greek mythology, with the relatively unknown historical figure Cymon (or Cimon), son of the Athenian general Miltiades. Both artists actually took the subject from Boccaccio's *Decameron*. Cymon was a slow-witted but handsome shepherd who fell in love with the more refined and beautiful Iphigenia. Boccaccio also inspired Dryden's poem of the same title, with the lines: "Then Cymon first his rustick Voice essay'd, / With proffer'd Service to the parting Maid / To see her safe; his Hand she long deny'd, / But took at length, asham'd of such a Guide; / So Cymon led her home." Millais shows Iphigenia shyly taking Cymon's hand as she stands surrounded by her attendants. Leighton shows Cymon reflecting on his own simple existence as he admires the beauty of the sleeping Iphigenia.

D

Dali-Christ Glenn Brown, 1992, Saatchi Collection, London.

The painting is virtually indistinguishable from Dalí's **Soft Construction with Boiled Beans**. Its different title, however, seems to imply that the tortured human figure depicted is a blend of the crucified Christ and Dalí himself. The work thus identifies the two.

Dalí from the Back Painting Gala from the Back Eternalized by Six Virtual Corneas Provisionally Reflected in Six Real Mirrors Salvador Dalí, 1972–3, Fundación Gala-Salvador Dalí, Figueras.

As the title describes, albeit wordily, the painting depicts a rear view of the artist painting the rear view of his wife, Gala, sitting before a mirror, in which both of them are reflected. The work is a double portrait executed stereoscopically in two components. But the title does not relate to the actual number of eyes visible (four) or mirrors (one). Dalí enjoyed lengthy titles. Another, and even longer, was *Dalí Nude, in Contemplation before the Five Regular Bodies Metamorphosed into Corpuscles, in which Suddenly Appears the Leda of Leonardo Chromosomatized by the Visage of Gala* (1954). In this, Dalí kneels nude on the beach next to a distintegrated head of Gala.

Danaë Rembrandt van Rijn, *c.*1636, Hermitage, St. Petersburg.

A naked young woman lies on a bed, her right arm raised and her gaze fixed, as if in expectation of someone or something. The title implies that she is Danaë, the mother of Perseus, and that she is waiting for the shower of gold by which Zeus will impregnate her. However, she could equally be a biblical character, such as Sara awaiting Tobias (Tobit 3) or Leah awaiting Jacob (Genesis 29).

The Danaïdes John William Waterhouse, 1906, Aberdeen Art Gallery.

The painting shows a group of young women pouring water into a bowl from which it runs out as fast as they try to fill it. They are the Danaïdes of classical legend, the daughters of Danaüs who slayed their husbands on their wedding night in obedience to a prophecy and who were condemned to pour water endlessly in the manner depicted.

Dance (French, *La Danse*) Henri Matisse, 1909, Museum of Modern Art, New York.

Five naked women join hands in a vigorous round dance, a celebration of the "religion of happiness," as the artist called it. The painting specified here was a study for the final version of 1910 in the Hermitage, St. Petersburg.

The Dance Paula Rego, 1988, Tate Gallery, London.

Three couple and a woman on her own dance on a moonlit beach. One of the couples has allowed a small girl to join in.

Dance at the Moulin Rouge (French, *Danse au Moulin Rouge*) Henri de Toulouse-Lautrec, 1890, Philadelphia Museum of Art, Pennsylvania.

Two dancers go through their paces before a gathered company at the Moulin Rouge music hall, Paris. One is Valentin le Désossé. The other seems to be La Goulue (*see* **Moulin Rouge: La Goulue**).

The Dance of Albion *see* **Glad Day**.

The Dance of Life Edvard Munch, 1900, National Gallery, Oslo.

Three women stand against a background of dancing couples, representing the three stages of a woman's life. To the left, on her own, is the young girl, dressed in virginal white and as yet unattainable. In the center, with a man, is the brightly dressed, flirtatious young woman. To the right, in isolation, is the old woman, dressed in black, diseased, and no longer desirable. The painting is a subtler version of the earlier *Three Stages of Woman* (1894), in which the three women are stereotypes of their age: the virgin in white, turning away, the full frontal smiling nude, legs apart, hands behind head, and the raddled old woman in ghostly black.

A Dance to the Music of Time Nicolas Poussin, *c.*1639–40, Wallace Collection, London.

Four female figures, representing the four seasons, dance in an unbroken ring around an old man (Father Time) playing a lyre, while overhead the sun god Apollo drives his chariot through the sky to symbolize the cycle of days. A statue of Janus, the god of beginnings and endings (who gave the name of January), and two putti also represent the passage of time and the brevity of human life. The work was given its title by Giovanni Pietro Bellori, in full: *Le quatro stagioni che ballano al suono del tempo*, "The four seasons that danced to the music of time." Despite this well established and readily perceived origin, the 1989 Wallace Collection catalog of pictures, Volume Three, offers a different interpretation: "According to Bellori, the '*morale poesia*' which forms the subject of (the painting) was dictated by the patron Giulio Rospigliosi: 1600–69, later Pope Clement IX... The dancing group represents the perpetual cycle of the human condition: from Poverty, Labour leads to Riches and thus Pleasure which, indulged to excess, reverts to Poverty."

The Dancer, La Camargo (French, *La Danseuse: La Camargo*) Nicolas Lancret, *c.*1730, Hermitage, St. Petersburg.

A young woman dances in an open-air theater, accompanied by musicians. She is the French dancer, Marie Anne de Cupis de Camargo, known as La Camargo (1710–1770), famous for her gaiety and panache.

Dancing Class (French, *La Classe de danse*) Edgar Degas, 1875, Musée d'Orsay, Paris.

The work is one of many scenes of ballet dancers that Degas painted in the 1870s. The moment depicted appears to be a break in rehearsal, rather than an active lesson in progress.

Dancing Skeletons Edward Burra, 1934, Tate Gallery, London.

The title accurately describes the subject of the painting, but does not indicate its fantastic treatment.

Danger on the Stairs (French, *Danger dans l'escalier*) Pierre Roy, 1927–8, Museum of Modern Art, New York.

A long snake glides down the stairway of a solid-looking French apartment. The title and the depiction itself seem to hint at the danger that can arise even in the securest of surroundings.

The Dangerous Liaison (French, *La Liaison dangereuse*) René Magritte, 1966, private collection.

The Surrealist painting depicts a naked young woman holding a mirror that shows the side and rear view of her body in another pose. The "dangerous liaison" is thus apparently that between reality and its mirror image. The title may have been suggested by Pierre Choderlos de Laclos's famous novel *Les Liaisons dangereuses* (1782).

Dante and Virgil in Hell (French, *Dante et Virgile aux Enfers*) Eugène Delacroix, 1822, Louvre, Paris.

The scene, from Dante's *Divina Commedia* (*c*.1307–21), shows the Roman poet Virgil guiding the Italian poet through the descending circles of the pit of Hell (Inferno).

Dante in Exile Frederic Leighton, *c*.1864, private collection.

The poet Dante stands aloof from the crowd that ridicules him. The scene illustrates lines from his *Divina Commedia* (*c*.1307–21): "But that shall gall thee most / Will be the worthless and vile company / With whom thou must be thrown into the straits, / For all ungrateful, impious all and mad / Shall turn against thee" (*Paradiso*). The poet had been forced to leave Florence for Verona. Hence the work's alternate title, *Dante at Verona*.

Dante's Dream Dante Gabriel Rossetti, 1856, Walker Art Gallery, Liverpool.

The subject of the painting is taken from Dante's own *La Vita Nuova* (*c*.1293), celebrating his love for Beatrice, and depicts his dream of her death. The poet watches somberly as attendants prepare to cover the dead Beatrice as she lies on a couch.

Dantis Amor Dante Gabriel Rossetti, 1859–60, Tate Gallery, London.

The painting was originally the center panel of three, the other two being *Dante Meeting Beatrice in Florence* and *Dante Meeting Beatrice in Paradise*. (*Cf*. **Dante's Dream**.) It depicts a red-haired angel, symbolizing love, between two roundels, the one top left with Christ's head as the sun, the other bottom right with the head of Beatrice as the moon. The center panel thus represents the death of Beatrice, and her transition from earth (Florence) to heaven (Paradise). The Latin title means "Dante's Love."

The Daphnephoria Frederic Leighton, *c*.1874–6, Lady Lever Art Gallery, Port Sunlight.

The people of Thebes process to the tomb of the god Apollo in celebration of their victory over the Aeolians. Apollo had attempted to rape Daphne, the wild virgin huntress who was the daughter of the river god Ladon. She escaped by turning into a laurel tree, whereupon Apollo made the laurel sacred. (*Cf*. **Apollo and Daphne**.) The procession is led by the *daphnephoros*, "laurel bearer," a priest carrying a laurel branch. The title thus means "laurel-bearing ceremony."

The Daring Sleeper *see* The **Reckless Sleeper**.

The Daughter Born Without a Mother (French, *La Fille née sans mère*) Francis Picabia, 1916–17, private collection.

Ostensibly a drawing-board depiction of a machine, with crank, piston, and flywheel, the painting bears a title that denotes it to be a modern counterpart to the story of the Virgin Birth, in which Christ, the son, was born without a father.

Daughter of Eve *see* **Eve After the Fall**.

A Daughter of Soviet Kirgizia (Russian, *Doch' Sovetskoy Kirgizii*) Semyon Chuykov, 1948, Tretyakov Gallery, Moscow.

The artist's most famous work depicts a Kirgizian schoolgirl, book in hand, walking proudly through a vast landscape. "She embodies in her resolute progress across the expanse of her native land, the future hopes of a small, once backward nation" (Matthew Cullerne Bown, *Art Under Stalin*, 1991).

The Daughters of Edward Darley Boit John Singer Sargent, 1882, Museum of Fine Arts, Boston, Massachusetts.

The painting is a portrait of the four daughters of the expatriate Boston couple, Edward Darley Boit and Mary Louisa Cushing Boit, in their rented Paris apartment. The girls are respectively four-year-old Julia, the youngest, sitting on the floor, eight-year-old Mary Louisa, standing apart on the left, and the two eldest, 12-year-old Jane and 14-year-old Florence, standing in the shadows in the background. When originally exhibited in Paris, the picture was titled *Portraits d'enfants* ("Portraits of Children"), while today it has the alternate title *The Children of Edward Darley Boit*. Both this and the usual title above seem to imply that the sitters had only one parent, and the girls' mother is conspicuously absent from the portrait. Both painting and title thus seem to invite a particular psychological interpretation.

Daughters of Revolution Grant Wood, 1932, Cincinnati Art Museum, Ohio.

The satirical portrait depicts three unprepossessing women who are smug and smirking because their ancestors were heroes of the American Revolution. The three "ugly sisters" are shown standing before Emanuel Leutze's **Washington Crossing the Delaware**. The painting was prompted by the refusal of the Daughters of the American Revolution to dedicate a stained glass window Wood had designed for the Cedar Rapids Veteran Memorial because it had been made in Germany.

The Daughters of Sir William Montgomery as "The Graces Adorning a Term of Hymen" *see* The **Graces Adorning a Term of Hymen**.

David (1) Donatello, c.1433, Bargello, Florence; (2) Michelangelo, 1501–4, Accademia, Florence.

Donatello's life-size bronze sculpture represents the Old Testament hero as a nude youth standing pensively after he has killed Goliath, whose head lies at his feet (1 Samuel 17:49). Michelangelo's huge marble sculpture also depicts David nude, his left arm raised to hold the sling on his shoulder. He here expresses in visual form the power of the new Florentine republic, which is ready to challenge any bigger power, as young David did the adult Goliath. The figure itself was probably based on a classical representation of Hercules.

David's Farewell to Jonathan Rembrandt van Rijn, 1642, Hermitage, St. Petersburg.

One man embraces another in a scene of some emotion. The title implies that the depiction is of David bidding farewell to his close friend, Jonathan (1 Samuel 20), but it could equally represent the reconciliation of David and his son, Absalom (2 Samuel 14).

The Dawn of Love Thomas Brooks, 1846, Victoria and Albert Museum, London.

A young man, seated by a spring, confesses his love for the young woman who stands beside him. The painting was originally exhibited without a title but with a quotation of two verses from Robert Burns's poem "There was a Lass" (1788), the first of which ran: "O Jeanie fair, I lo'e thee dear; / O canst thou think to fancy me? / Or wilt thou leave thy mammie's cot, / And learn to tent the farms wi' me?" An article in an 1872 issue of the *Art Journal*, describing the picture, added that it "might have been called 'The Dawn of Love', for it shows Burns's 'Jeanie' with her lover."

The Day After Edvard Munch, 1894–5, National Gallery, Oslo.

A young woman wearing a skirt and an unbuttoned blouse sleeps stretched on a bed, her left arm drooping to the floor. A table with bottles and glasses stands nearby. Both she and they represent the aftermath of a Bohemian party, "the morning after the night before."

The Day Dream Dante Gabriel Rossetti, 1880, Victoria and Albert Museum, London.

A woman sits beneath a tree reflecting on what might be, a book lying open but forgotten on her lap. The painting's original title was to have been either *Vanna* (*see* **Monna Vanna**) or *Monna Primavera*, alluding to Dante's *La Vita Nuova* (c.1293). The model for the lady was Jane Morris, wife of William Morris. Rossetti later wrote a sonnet on the subject, which included the lines: "Within the branching shade of Reverie / Dreams even may spring till autumn; yet none be / Like woman's budding day-dream spirit-fann'd."

Day Dreaming *see* **Te rerioa**.

Day Dreams Sir George Clausen, 1883, private collection.

A young and an old woman rest in the shade of a tree from their hard work as farm laborers. They have time to reflect on what their life might be without such toil.

The Day of the God *see* **Mahana no atua**.

The Daydream Edward Arthur Walton, 1885, private collection.

The painting is a depiction of young love. A young peasant girl, wistful and wide-eyed, is seated on the ground, while her wordless companion lies facing her. Both are in a reverie.

The Days Thomas W. Dewing, 1887, Wadsworth Atheneum, Hartford, Connecticut.

Six virginal young women in Greek dress stand in a flowery glade holding ancient musical instruments. They represent the six days of the week, each of which when it dawns is new and virginal and plays its own tune.

Days of Delight *see* **Nave Nave Mahana**.

Dead Christ *see* **Christ in the Tomb**.

The Dead Christ Andrea Mantegna, c.1480, Pinacoteca di Brera, Milan.

Christ is portrayed as a corpse in the tomb after the Crucifixion, his mother Mary mourning by him. The figure seems to sleep on a bed, prefiguring an awakening in the Resurrection.

Dead City III (German, *Tote Stadt III*) Egon Schiele, 1911, Sammlung Rudolf Leonard, Vienna.

The picture of a cluster of houses surrounded by water is subtitled *City on the Blue River III* (German *Stadt am blauen Fluß III*), although the water is dark rather than specifically blue. The artist used the title *Dead City* for

several of his townscapes. Another is *The Small City* (German, *Die kleine Stadt I*) (1912), where it is the subtitle. The painter Albert Paris von Gütersloh commented: "Any town that he sees foreshortened, from above, he calls dead, because any town becomes dead when looked at like that. The deeper meaning of the bird's-eye view is unwittingly revealed. The title is as important, as an idea, as the picture it describes" (quoted in Fischer, p. 186).

Dead Dad Ron Mueck, 1997, Saatchi Collection, London.

The work, a lifelike three-foot-long sculpture of a naked man lying on a podium, is a likeness of the artist's father on his deathbed.

Dead Knight Robert Bateman, *c.*1870, private collection.

In a woodland glade deep in cow parsley, the body of a knight lies beside a pool fed by a spring. A faithful hound sits at the head of its dead master. The bald title does not reveal the circumstances of the failed chivalric mission and is unexpectedly devoid of emotive wording. The painting may have been inspired by Book I of Edmund Spenser's *The Faerie Queene* (1590), which tells the story of the Redcrosse Knight of Holiness.

Dead Sea *see* **Totes Meer**.

Death and Life (German, *Tod und Leben*) Gustav Klimt, 1916, Dr. Rudolf Leopold Collection, Vienna.

A group of naked human beings (five women, a man, and a child) cling to one another and ignore the figure of death in the form of a grinning skeleton that stands beside them.

Death and Maiden (German, *Tod und Mädchen*) Egon Schiele, 1915–6, Österreichische Galerie, Vienna.

Two lovers cling together in a final parting, the man (Death) wearing a penitential robe. The painting, subtitled *Man and Girl* (German, *Mann und Mädchen*), represents the artist's farewell to his mistress and model, Wally Neuzil, after their years together. The title evokes that of the poem by Matthias Claudius which served as the text of Schubert's song *Der Tod und das Mädchen* ("Death and the Maiden") (1817).

Death and the Maidens Pierre Puvis de Chavannes, 1872, Sterling and Francine Clark Art Institute, Williamstown, Massachusetts.

Four young women dance gaily in a flowery meadow in the top half of the painting, while in the foreground two maidens stand more pensively, one moving towards the figure at bottom left of an old man dressed in black lying on the grass next to his scythe. He is Death, and the picture as a whole is an allegory of man's temporal existence. The title echoes that of Matthias Claudius's poem (*see* **Death and the Maiden**), although Puvis has several maidens, not just one.

Death and the Miser Hieronymus Bosch, *c.*1490, National Gallery, Washington, D.C.

A young man sits up in bed as Death, a shrouded skeleton, comes in at the door. An angel kneels on the pillow, while an old man opens a chest at the foot of the bed. Other characters and creatures also feature. The National Gallery interprets the painting as follows: "Bosch has shown three stages in the life of a rich man. In his youth he has earned money fighting with sword and spear and guarded by armor and shield. Grown older, he tries to hoard his gains, while salamanders and rats carry away his treasure. Around his waist hangs the key to his strong box and his rosary, the key to his salvation. In the upper part of the picture, unaware of death, he makes his choice. Which key will he use?" (quoted in Morse, p. 23).

The Death of a Paralytic *see* The **Paralytic Tended by His Children**.

The Death of Actaeon Titian, *c.*1550, National Gallery, London.

The painting depicts a scene from classical mythology, as told in Ovid's *Metamorphoses*. Diana, Roman goddess of the hunt, has been seen bathing naked by the hunter, Actaeon, and is punishing him by transforming him into a stag, so that he is devoured by his own hounds.

The Death of Bara (French, *Le Jeune Bara*, "Young Bara") Jacques-Louis David, *c.*1794, Musée Calvet, Avignon.

The painting of a nude boy lying where he has fallen, modeled by one of the artist's pupils, depicts the final moments of Joseph Bara (*c.*1779–1793), a drummer boy in the Republican forces at the time of the French Revolution, in which he was killed.

The Death of Caesar (French, *La Mort de César*) Jean-Léon Gérôme, 1867, Metropolitan Museum, New York.

"Caesar's body lies at the foot of Pompey's statue; the conspirators, still holding their daggers, are grouped in the background, and all the

senators but one have fled from their seats" (*Century Cyclopedia of Names*, 1904). The Roman general and dictator Julius Caesar was assassinated by a group of senatorial conspirators in 44 BC.

The Death of Camilla, Horatio's Sister
(Russian, *Smert' Kamilly, sestry Goratsiya*)
Fyodor Bruni, 1824, Russian Museum,
St. Petersburg.

Following the battle of the Horatii against the Curiatii, in which two of the Horatii triplets were killed as well as all three Curiatii (*see* The **Oath of the Horatii**), Camilla, sister of the surviving Horatius, now lies dying, killed by her brother when she wept for one of the Curiatii, with whom she had been in love.

The Death of Cleopatra (1) Johann Liss, *c.*1622–4, Alte Pinakothek, Munich; (2) Guido Cagnacci, 1658, Kunsthistorisches Museum, Vienna.

Cleopatra, queen of Egypt, committed suicide to avoid being taken prisoner by Octavius, who had conquered Antony, Cleopatra's lover and Octavius's rival for supremacy in Rome. The method she chose was to press a snake to her breast and die from its bite. Liss depicts the moment after the bite. Cleopatra is supported by a servant woman as she collapses, her right hand across her body, while a black servant boy looks with terror at the basket he holds with the snake in it now that it has done its work. Cagnacci shows the moment just before the bite, with the snake winding its way up Cleopatra's arm as anxious maidservants look on.

The Death of General Wolfe Benjamin West, 1770, National Gallery of Canada, Ottawa.

The painting depicts the moment when the fatally wounded British army commander, James Wolfe (1727–1759), hears of victory on the Plains of Abraham during the battle of Quebec.

Death of Hyacinth (French, *Mort d'Hyacinthe*) Jean Broc, 1901, Musée des Beaux-Arts, Poitiers.

The scene is from classical mythology. Apollo supports the body of his young friend, Hyacinth, whom he has accidentally killed by a throw of the discus, seen in the foreground.

The Death of Jane McCrea John Vanderlyn, 1804, Wadsworth Atheneum, Hartford, Connecticut.

"Two Mohawks scowl and leer as they prepare to scalp their full-breasted, milk-white victim" (Richard Cork, *Sunday Times*, September 28, 1997). Jane McCrea, a young Tory, was scalped by Indians on July 27, 1777, during the Revolutionary War, when on her way to Fort Edwards, New York, to visit her English lover, serving in General Burgoyne's army. The painting is also known as *The Murder of Jane McCrea*.

The Death of Major Peirson John Singleton Copley, 1782–4, Tate Gallery, London.

The dying young English officer Francis Peirson (1757–1781) is supported by his senior officers as his black servant fires back at the enemy. The painting depicts the English repulsion of a French invasion on the island of Jersey on January 6, 1781.

The Death of Marat (French, *Marat assassiné*, "Marat Assassinated") Jacques-Louis David, 1793, Musées Royaux des Beaux-Arts, Brussels.

The French writer and revolutionary Jean-Paul Marat (1743–1793) lies on the point of death in his bath (which he had been taking to relieve a skin condition), stabbed through the heart by the young counterrevolutionary Charlotte Corday. She was guillotined four days later. He had been writing to offer money to a soldier's widow, using an upturned packing chest nearby to lean on. In his left hand, he still holds Corday's request to see him, reading, "*Du 13. juillet, 1793. Marie-Anne Charlotte Corday au citoyen Marat. Il suffit que je sois bien Malheureuse pour avoir Droit à votre bienveillance*" ("July 13, 1793. Marie-Anne Charlotte Corday to Citizen Marat. It is enough for me to be truly unhappy in order to claim your favor"). The chest has the inscription: "*À Marat David, l'an deux*" ("To Marat from David, Year 2"), the latter being the year of the republican calendar.

The Death of Procris Piero di Cosimo, *c.*1500, National Gallery, London.

The scene is from classical mythology. Jealous of her husband, Cephalus, Procris has spied on him in the woods, where he went daily to hunt. Seeing the bush stir where she was hiding, Cephalus threw a spear at what he took to be an animal. Procris now lies dead in a meadow, mourned by a satyr, while a large brown dog sits forlornly at her feet. The latter is Laelaps, a hound given to Procris by an earlier lover and given in turn by her to Cephalus. However, this account of the scene is disputed by some, and its actual reference regarded as uncertain. Hence the

work's alternate title, as simply *A Mythological Subject*.

The Death of Sardanapalus (French, *La Mort de Sardanapale*) Eugène Delacroix, 1827, Louvre, Paris.

The scene is the death of the legendary last king of Assyria, who when besieged by rebels burned himself, his treasures, and his concubines in his palace. The painting depicts Sardanapalus sitting on a bed as all his possessions, including women and horses, are gathered before him. The artist took the story from Byron's tragedy *Sardanapalus* (1821).

The Death of Socrates (French, *La Mort de Socrate*) Jacques-Louis David, 1787, Metropolitan Museum, New York.

Socrates sits on the edge of his bed surrounded by his disciples as a servant, averting his gaze, hands the philosopher a bowl of hemlock with which he will commit suicide (399 BC).

The Death of the Virgin (1) Andrea Mantegna, *c*.1465, Prado, Madrid; (2) Caravaggio, 1605–6, Louvre, Paris.

As the title implies, not all depictions of the death of the Virgin Mary are as reverential as The **Assumption of the Virgin**. Caravaggio shows the Virgin as a bloated corpse. His model is said to have been a prostitute who had drowned in the Tiber.

Death on the Pale Horse Benjamin West, 1796, Detroit Institute of Arts, Michigan.

The painting depicts the apocalyptic New Testament words: "And I looked, and behold a pale horse: and his name that sat on him was Death" (Revelation 6:8).

The Death Struggle Charles Deas, *c*.1845, Shelburne Museum, Shelburne, Vermont.

A white trapper on a white horse and an Indian on a black one plunge over the edge of an abyss as they battle with each other in a frenzy of hatred.

Declaration Philip King, 1961, Leicestershire Education Authority.

The artist explains the title of his work, an abstract but symmetrical sculpture of green concrete and marble chippings: "I called it 'Declaration' because in a sense it was a manifesto piece for me. I suddenly established new ideas about fundamental forms and sculpture being off the pedestal and extending on the ground and

stretching out. I was also interested in repetition and symmetry" (quoted in Wilson 1979, p. 179).

The Declaration of Independence John Trumbull, 1786–1824, Yale University Art Gallery, New Haven, Connecticut.

The full title of the historical painting includes the place and date of the event: *The Declaration of Independence, Philadelphia, July 4, 1776*. The depiction is of the moment just before the actual signing. The work was one of four that Congress had commissioned the artist to paint in the rotunda of the Capitol at Washington.

Decorative Figure on an Ornamental Background (French, *Figure décorative sur fond ornemental*): Henri Matisse, 1925, Musée National d'Art Moderne, Paris.

The "decorative figure" is a seated nude woman. The "ornamental background" against which she sits is a florid baroque wallpaper. A carpet of similar garish pattern is on the floor.

A Dedication to Bacchus Sir Lawrence Alma-Tadema, 1889, Hamburger Kunsthalle.

A small girl, accompanied by her mother and family, is about to be dedicated to Bacchus, the Roman god of wine.

Deep Throat Mona Hatoum, 1996, Saatchi Collection, London.

The installation is of a dining-table with a tablecloth, a setting for one, and a single chair. The scene looks unremarkable until one sees, back-projected through the plate, an endoscopic video of the artist's larynx expanding and contracting, representing the eating of a meal. The title derives from that of a famous (infamous) 1972 porno movie starring Linda Lovelace, whose clitoris is located in the back of her throat.

Deep Waters (French, *Les Eaux profondes*) René Magritte, 1941, private collection.

A young woman with a death mask for a face stands dressed in black beside a large raven on a tree stump. The painting was suggested by the death of an unknown girl by drowning in the Seine. Hence the title.

The Deer Park Michael Andrews, 1962, Tate Gallery, London.

In dreamlike fashion, the painting depicts the revellers in Normal Mailer's sensational novel about Hollywood society of the same name (1954).

Defendant and Counsel William Frederick Yeames, 1895, Bristol City Art Gallery.

A young woman sits tight-lipped as she is questioned by a lawyer. She is the defendant of the title, and he the counsel. The depiction troubled many of its viewers. What had the poor young lady done? The artist subsequently explained: "My only idea when painting the picture was to depict the eagerness of counsel to obtain from the lady defendant information on a point on which the defence depended" (quoted in Hadfield, p. 79).

The Defense of Petrograd (Russian, *Oborona Petrograda*) Aleksandr Deineka, 1928, Tretyakov Gallery, Moscow.

The artist's Symbolist-style painting shows a file of Soviet workers-turned-soldiers set to combat counterrevolutionaries in Petrograd (later Leningrad, now again St. Petersburg) in the Civil War of 1918–20.

Deianeira Evelyn De Morgan, *c.*1878, private collection.

The scene is from Greek mythology. Deianeira has inadvertently caused the death of her husband, Hercules. She now walks through a desolate landscape, her hands clasped to her head in remorse. Her suicide will follow. *Cf.* **Hercules and Deianeira**.

Le Déjeuner sur l'Herbe ("Luncheon on the Grass") (1) Édouard Manet, 1863, Musée d'Orsay, Paris; (2) Claude Monet, 1865–6, Musée d'Orsay, Paris; (3) Alain Jacquet, 1964–5, Australian National Gallery, Canberra.

Manet's painting, originally called *Le Bain* ("Bathing"), depicts a picnic party of two men and a nude woman in a forest glade, while a partially dressed woman stands in a lake in the background. The model for the nude was Victorine Meurent (1844–*c.*1885), who also posed for **Olympia**. The laconic title gives no hint of the then scandalous juxtaposition of a naked woman with two clothed men in modern dress. (The artist could have given the work an allegorical title, and so justified his choice of subject.) The work itself was inspired by Giorgione's **Fête Champêtre**. Monet's painting is based on Manet's, but with the figures in a less formal pose. Jacquet's work is a silk print on canvas depicting two men and a naked woman picnicking beside a swimpool. The title occurs for various other works, and Jean Renoir, US film director son of the French artist Pierre Auguste Renoir, adopted it for his 1959 movie about an international scientist's affair with a country housemaid.

The Delights of Landscape (French, *Les Charmes du paysage*) René Magritte, 1928, private collection.

The painting depicts an empty picture frame with a label reading "*Paysage*" ("Landscape"). The work was originally entitled *The Vanished Landscape* (French, *Le Paysage disparu*), but this rather obvious title was rejected for something more subtle and surreal.

The Delivery of Israel out of Egypt Francis Danby, 1825, Harris Museum and Art Gallery, Preston, Lancashire.

The apocalyptic painting takes its subject from the Old Testament. The Israelites (Hebrews) escape from slavery in Egypt under the leadership of Moses. The epic account is told in the book of Exodus and is the central event of the Hebrew Bible.

The Delivery of the Keys to St. Peter Pietro Perugino, 1482, Sistine Chapel, Vatican.

The subject is from the New Testament. Christ, standing, hands the keys of the kingdom of heaven to St. Peter, kneeling, the other apostles in attendance (Matthew 16:19).

The Delphic Sibyl Michelangelo, 1509, Sistine Chapel, Vatican.

The artist painted five pagan sibyls (prophetesses who foretold the coming of Christ) on the ceiling of the Sistine Chapel. The best known is the Delphic Sibyl, representing the original sibyl (named Sibylla) who lived near Troy and who gave predictions in a manner similar to that of the Pythia, the young priestess of Apollo at Delphi.

The Deluge William Etty, *c.*1835–45, Victoria and Albert Museum, London.

A young woman lies naked in the water that streams over and past her.

Démasquée ("Unmasked") Akseli Gallen-Kallela, 1888, Ateneumin Taidemuseo, Helsinki.

With a weary smile, a nude model sits on a sofa as she pauses from posing. She holds a black domino (halfmask) in her hand, as a sign that she has temporarily cast off her role. The title alludes to this, but also implies that she has been stripped of any literary or historical veil. The presence of white lilies as a symbol of chastity, and of a skull and a crucifix, suggest that she has been posing as a penitent Mary Magdalene. The picture was actually painted in Paris.

Demeter of Cnidus attributed to Leochares, *c.*330 BC, British Museum, London.

The marble statue represents a seated Demeter, the Greek goddess of agriculture. It was found at Cnidus in Asia Minor. Hence its name.

Les Demoiselles d'Avignon ("The Young Ladies of Avignon") Pablo Picasso, 1906–7, Museum of Modern Art, New York.

The semiabstract (and unfinished) painting depicts five nude women in sinister poses. The title was given some time after the work's execution by the artist's friend, André Salmon, with reference to the prostitutes at a brothel popular with sailors in the Carrer d'Avinyo (Avignon Street), Barcelona. (The subject was originally to have been a brothel scene, but Picasso abandoned this in favor of the nudes.)

Dempsey and Firpo George Bellows, 1924, Whitney Museum of American Art, New York.

The painting depicts heavyweight boxer Jack Dempsey being knocked out of the ring in the first round of the championship fight against the Argentine heavyweight Luis Firpo on September 14, 1923 at the Polo Grounds, New York. Dempsey went on to batter Firpo into defeat in the second round.

The Demurrer James Lobley, 1873, private collection.

A gamekeeper, shotgun under his arm and turnip in his hand, states his case as he stands before his master, who sits in his library with a book open on the table before him. Who is the demurrer of the title? It can hardly be the gamekeeper, who seems to be complaining that he and his wife have to live on turnips, and who now cuts off a slice to offer his master. It must thus be the squire himself, who "demurs" from taking an interest in his estate or the wellbeing of his workers. The painting is also known as *The Squire and the Gamekeeper.*

The Denial of St. Peter (French, *Le Reniement de saint Pierre*) Georges de La Tour, 1650, Musée des Beaux-Arts, Nantes.

The scene is from the New Testament. Peter denies three times that he has known Jesus. When the crowing of a cock marks his third denial, as foretold by Jesus, he weeps bitterly (Matthew 26:34, 75; Mark 14: 30, 72).

The Departure from Brighton *see* **Scene from a Camp with an Officer Buying Ribbons**.

The Departure of Hiawatha Albert Bierstadt, *c.*1868, Longfellow National Historic Site, Cambridge, Massachusetts.

An American Indian sails off into a blazing sunset watched by his fellows. He is the legendary Hiawatha, immortalized by H.W. Longfellow in his 1855 poem, which in its final part, "Hiawatha's Departure," has the lines: "Westward, westward Hiawatha / Sailed into the fiery sunset." The picture was presented to the poet at a prestigious dinner party in London.

Departure of the Volunteers in 1792 *see* **La Marseillaise**.

The Deposition (1) Benedetto Antelami, 1178, Parma Cathedral; (2) Duccio di Buoninsegna, 1308–11, Museo dell'Opera del Duomo, Siena; (3) Simone Martini, *c.*1315, Koninklijk Museum voor Schone Kunsten, Antwerp; (4) Pietro Lorenzetti, *c.*1329, S. Francesco, Assisi; (5) Rosso Fiorentino, 1521, Pinacoteca Communale, Volterra; (6) Pontormo, *c.*1526–8, S. Felicità, Florence; (7) Caravaggio, 1602–4, Vatican Museums; (8) Bartolomeo Schedoni, 1613, Galleria Nazionale, Parma; (9) Nicolas Poussin, *c.*1630, Hermitage, St. Petersburg.

The scene is from the New Testament. The body of Christ is taken down from the cross where he has been crucified (Mark 15:46, Luke 23:53). The biblical event is also known as The **Descent from the Cross**.

The Depths of the Earth (French, *Les Profondeurs de la terre*) René Magritte, 1930, private collection.

The work consists of four paintings of different sections of a single landscape framed and mounted on glass. The title seems to imply that one must consider in isolation the individual parts of what one sees in order to appreciate the "depths" of the whole.

The Derby at Epsom (French, *Le Derby d'Epsom*) Théodore Géricault, 1821, Louvre, Paris.

The painting depicts the famous annual English horserace at Epsom, Surrey, first run in 1780 and named for its founder, the twelfth Earl of Derby.

Derby Day William Powell Frith, 1856–8, Tate Gallery, London.

The panoramic scene depicts a varied crowd of spectators and entertainers at the annual Derby horserace (*see* The **Derby at Epsom**). The horses themselves are just visible in the

background. It is the social occasion, not the race, that is the main subject of the painting, whose original title was *The Humours of a Race-Course.*

The Descent from the Cross (1) Rogier van der Weyden, *c.*1435–8, Prado, Madrid; (2) Hans Memling, 1480–90, Capilla Real, Granada; (3) Il Sodoma, *c.*1505–10, Pinacoteca Nazionale, Siena; (4) Peter Paul Rubens, 1611–14, Antwerp Cathedal; (5) Rembrandt van Rijn, 1633, Alte Pinakothek, Munich, (6) Johannes Thorn Prikker, 1892, Rijksmuseum Kröller-Müller, Otterlo; (7) (German, *Kreuzabnahme*): Max Beckmann, 1917, Museum of Modern Art, New York.

The subject of the paintings is the same as that of The **Deposition from the Cross.** Rembrandt's triptych serves as one of a pair with The **Raising of the Cross,** in the same location. Thorn Prikker's depiction is in the Dutch Symbolist style.

The Despair of Achilles Angelica Kauffmann, 1789, private collection.

The scene is from classical mythology. Thetis, mother of the future great hero of the Trojan War, knows that her son will be killed if he joins the expedition to Troy. She thus hides him at the court of King Lycomedes where, disguised as a girl among the women of the court, he sits in despair, for he himself has long known that he is soon to die. Achilles is identified not only by his downcast head but by his boyish figure.

Destiny John William Waterhouse, 1900, Towneley Hall Art Gallery, Burnley, Lancashire.

A young woman in a tiled loggia raises a blue bowl to her lips as a valediction to the departing heroes in their galleons reflected in the circular mirror behind them. The painting was executed for the Artists' War Fund, and was essentially dedicated to the British forces whose destiny it was to fight for their country in the Boer War then on in South Africa.

The Destruction of the Children of Niobe Richard Wilson, 1760, Yale Center for British Art, New Haven, Connecticut.

The artist, mainly known for his landscapes, is also remembered for this depiction of a scene from classical mythology. Niobe, daughter of Tantalus, bore six sons and six daughters to her husband, Amphion, king of Thebes. But when she boasted that she was superior to Leto, who had only two children, Apollo and Artemis, Leto sent her divine pair to kill all Niobe's twelve. Niobe wept for nine days and nights afterwards, and is depicted weeping here. The painting was long known simply as *Niobe.*

Devotion Margaret Carpenter, 1821, Victoria and Albert Museum, London.

A young monk looks up to heaven, a crucifix in his right hand. The figure has traditionally been identified as St. Francis.

Dew-drenched Furze John Everett Millais, *c.*1889–90, private collection.

The painting is of firs, bracken, and gorse bushes festooned with silver webs in a Scottish wood on an early November morning. The title is not just poetically descriptive but based specifically on Tennyson's *In Memoriam* (1850), in which the second verse of section XI runs: "Calm and deep peace on this high wold, / And on these dews that drench the furze, / And all the silvery gossamers / That twinkle into green and gold."

Diadumene Sir Edward Poynter, 1884, Royal Edward Memorial Museum, Exeter.

The painting depicts a standing nude tying a fillet around her head. The title derives from *Diadumenos,* a statue by the 5th-century BC Greek sculptor Polyclitus, known only from later copies, showing a man engaged in the same action. The name represents Greek *diadoumenos,* "binding up his hair," and Poynter's title is the feminine equivalent of this. The painting's figure is based on the *Esquiline Venus,* a statue excavated in 1874 and named for the Esquiline Hill, Rome.

Diana Walter Crane, 1881, private collection.

As the Roman goddess of the hunt walks with a hound through a primeval forest, she turns and blows a blast on her horn to summon her male followers across the stream.

Diana After Her Bath (French, *Le Bain de Diane*) François Boucher, 1742, Louvre, Paris.

Two nude women sit beside a pool. The more prominent of the two, as attested by the bow and arrows, dead game, and dogs that surround her, is Diana, Roman goddess of the hunt. *Cf.* **Diana After the Hunt.**

Diana After the Hunt (French, *Diane après la chasse*) François Boucher, 1745, Musée Cognacq-Jay, Paris.

Diana, goddess of the hunt, sits to undress and rest after the chase, her spoils and weapons lying beside her. Three nymphs attend her. *Cf.* **Diana After Her Bath.**

Diana Bathing (French, *Le Bain de Diane*) François Clouet, 1550s, Musée des Beaux-Arts, Rouen.

Diana, Roman goddess of the hunt, stands naked by a forest pool, with attendants about to robe her. A man on horseback in the background wears the colors of Diane de Poitiers (1499–1566), favorite of Henry II of France, and may actually represent her royal lover. The figure of Diana may represents Diane herself, although obviously younger than her royal namesake. The painting is also known as *The Bath of Diana.*

Diana Discovers Callisto's Misdemeanor Palma Vecchio, *c.*1525, Kunsthistorisches Museum, Vienna.

The goddess Diana rests after bathing with her companions (*cf.* the two titles above). Her gaze is fixed on Callisto, however, whose demeanor she has discovered. Her crime was to have an affair with Zeus, who subsequently (according to one account) turned her into a bear.

Diana of the Hunt John Byam Shaw, 1901, Sotheby's, London.

A bare-breasted Diana, bow held high, leaps over streams and rocks as she pursues her quarry accompanied by her hounds.

Diana the Huntress (1) School of Fontainebleau, *c.*1550, Louvre, Paris; (2) Domenichino, 1614, Galleria Borghese, Rome.

In the earlier painting, Diana, Roman goddess of the hunt, walks nude and neat to the chase, a bow in her left hand, an arrow in her right, a quiver of arrows slung over her shoulder, and a dog running by her side. The identity of the artist who executed the painting is unknown. Domenichino has a clothed Diana surrounded by admiring women and young girls and triumphantly brandishing her bow after successfully shooting a bird with an arrow.

Diarchy Kenneth Armitage, 1957, Tate Gallery, London.

The semiabstract bronze sculpture represents two human figures in the form of a single flat slab from which heads, breasts, arms, and legs protrude. The title literally means "rule of two," suggesting that the figures are king and queen or some other kind of joint rulers.

A Difference of Opinion Sir Lawrence Alma-Tadema, 1896, private collection.

Two Roman lovers stand by a fountain, the woman turning tearfully away from the man as he looks keenly towards her. The depiction is that of a disagreement, but hardly a lovers' tiff.

Dignity and Impudence Sir Edwin Landseer, 1839, Tate Gallery, London.

A large and impassive bloodhound lying in his kennel ignores the cheeky little Scotch terrier who pokes his head out beside him. Both dogs, respectively named Grafton and Scratch, belonged to the artist's friend and business manager, Jacob Bell.

The Dinner (German, *Der Diner*) Franz von Stuck, 1913, Neue Pinakothek, Munich.

The painting captures the festive atmosphere of the great gala dinner held in the aristocratic artist's studio at his villa to mark his 50th birthday on February 23, 1913.

Dinner Party (German, *Tischgesellschaft*) Katharina Frisch, 1988, Museum für Moderne Kunst, Frankfurt-am-Main.

The work consists of 32 identical polyester figures of black-clothed men seated on benches either side of a long table. They all rest their hands on the red and white patterned tablecloth.

The Dinner Party Judy Chicago, 1974–9, San Francisco Museum of Modern Art, California.

The collaborative work consists of a large triangular table set with 39 places, each with a distinctive mat and plate or dish named for a particular famous woman. The artist herself referred to the work as "a sort of reinterpretation of the Last Supper from the point of view of those who'd done the cooking." Underneath the table, the porcelain floor bears the names of a further 999 women who have made significant contributions to Western civilization.

Disappointed Love Francis Danby, 1821, Victoria and Albert Museum, London.

A young woman sits desolate on a bank by a weedy pool, the fragments of a letter she has torn up scattered beside her. The inference is that she is contemplating drowning herself after being abandoned by her lover.

The Disasters of War (Spanish, *Los desastres de la guerra*) Francisco de Goya, 1810–23, Metropolitan Museum, New York.

The series of 82 aquatints comprises scenes from the French occupation of Spain and depicts atrocities committed by both the French and the Spanish as a graphic indictment of the horrors of war, some of which the artist himself witnessed. The titles are mainly laconic or ironic. No. 1 is *Sad Presentiments of What Will Happen* (Spanish, *Tristes presentimientos de lo que ha acontecer*) (a elderly man kneels and flings his arms wide in a gesture of desperation). Others include No. 14, *Hard Is the Way!* (Spanish, *¡Duro es el paso!*) (a man is forced up a ladder to be hanged), No. 15, *And It Can't Be Helped* (Spanish, *Y no hay remedio*) (men bound to stakes are shot by bands of soldiers), No. 26, *One Cannot Look at This* (Spanish, *No se puede mirar*) (women are shot), No. 32, *Why?* (Spanish, *¿Por qué?*) (a garroted man's corpse is hauled down from a tree), No. 33, *What More Can One Do?* (Spanish, *¿Que hay que hacer mas?*) (a naked man is held up by his legs and hewn in two with a sword), No. 36, *Neither Did He* (Spanish, *Tampoco*) (a soldier admires the man he has hanged), No. 37, *This Is Worse* (Spanish, *Esto es peor*) (a man's corpse has been impaled), No. 39, *Great Deeds! Against the Dead!* (Spanish, *¡Grande hazaña! ¡Con muertos!*) (men's corpses have been mutilated), No. 44, *I Saw This* (Spanish, *Yo lo vi*) (women and children are rounded up), No. 62, *The Beds of Death* (Spanish, *Las camas de la muerte*) (corpses lie in the street at night before being carted off to the communal grave), No. 69, *Nothing. The Event Will Tell* (Spanish, *Nada. Ello dirá*) (a corpse sinks into its tomb while writing the word "*Nada*" on its own sepulchral slab). *Cf.* **Great Deeds Against the Dead.**

Discobolus Myron, *c.*450 BC.*

The bronze statue is of a discus thrower, the Greek for which is *diskobolos*. The original is lost, but several marble copies exist.

Discovery (French, *Découverte*) René Magritte, 1927, private collection.

The painting depicts a seated nude whose flesh merges into heavily grained wood, much as in classical mythology the nymph Daphne was metamorphosed into a laurel or bay bush. The title alludes to the disclosure. The work was earlier entitled *The Experience of the Miracle*.

The Discovery Thomas Roberts, 1851, private collection.

A lady bends over a young woman as she lies asleep in bed and closely examines her locket. But what does the locket contain, and what does she discover in it? The answer remains uncertain.

One possibility is that the lady has discovered a lock of her husband's hair and now has the proof she sought that the young girl, who may simply be a servant, was having an affair with him. Or it could simply be that the girl is ill (she is pale and it is daytime), that her mistress has called to see how she is, and that she then notices the locket and decides to open it. Either way, the discovery is what she finds in the locket itself.

The Discovery of San Francisco Bay
William Keith, 1896, Elisabeth Waldo-Dentzel Collection, Northridge, Caifornia.

The painting re-creates the moment on November 2, 1769 when Gaspar de Portolá, Spanish governor of Baja California, ascended a commanding hill, later known as Sweeney's Ridge, pointed his sword at a cross, and in the custom of the day claimed for God and King the land overlooking what is now San Francisco Bay.

The Disintegration of the Persistence of Memory Salvador Dalí, *c.*1934, private collection.

The painting takes The **Persistence of Memory** to a logical progression. The depiction recalls that work, complete with the "soft" watches, which now gently fall apart, but the recumbent figure has become more amorphous and the memory breaks down, even introducing the figure of a fish that was not in the original.

The Dismal Sport *see* The **Lugubrious Game**.

Los Disparates ("The Follies") Francisco de Goya, *c.*1820–4, Metropolitan Museum, New York.

The 22 etchings, also known as *Los proverbios* ("The Proverbs"), are depictions of various types of human folly. Examples are No. 3, *The Dead Branch*, or *Ridiculous Folly* (Spanish, *Disparate ridiculo*) (people huddle together on a dead tree branch) and No. 13, *A Way of Flying* (Spanish, *Modo de volar*) (men holding huge wing canopies fly like modern hang-gliders).

The Disquieting Muses (Italian, *Le Muse inquietanti*) Giorgio de Chirico, 1917, private collection.

The Surrealist painting depicts a courtyard with two prominent mannequin (shop dummy) figures, one apparently a bishop, the other, seated, perhaps a woman, together with a piece of sculpture. The latter appears to represent *Apollo Musagetes*, "Apollo, Leader of the Muses." The title probably alludes to the disturbing

associations that can arise when an artist or writer is inspired by the Muses.

Dissonance (German, *Dissonanz*) Franz von Stuck, 1910, Museum Villa Stuck, Munich.

The humorous painting depicts an infant faun learning to play the pan pipes. He practices on the pipes as he sits next to his teacher, an adult faun who covers his ears and clenches his teeth on hearing the discordant sounds.

Distillation John Latham, 1967, Museum of Modern Art, New York.

The avant-garde work, a book sculpture, is a reduced and bottled copy of Clement Greenberg's *Art and Culture* (1961), an anthology of the American art critic's writings.

A Distinguished Member of the Humane Society Sir Edwin Landseer, 1838, Tate Gallery, London.

The painting depicts Paul Pry, a black and white Newfoundland dog, resting on a stone pier at high tide. Newfoundlands are known for their work in rescuing persons from the sea, and the picture was dedicated to the Royal Humane Society, a charity founded in 1774 to encourage the saving of human life. Engravings of the picture became so popular that, in honor of the artist, black and white Newfoundlands have been called Landseers ever since.

The Divers (French, *Les Plongeurs*) Fernand Léger, 1940–46, Museum of Modern Art, New York.

The painting depicts a floating tangle of arms and legs, black and gray in the center of the picture against a polychromatic background. The work was developed in many versions. The artist explains: "In 1940 I was working on my *Divers* in Marseilles. Five or six men diving. I left for the United States and one day went to a swimming pool there. The divers were no longer five or six but two hundred at once. Just try and find yourself! Whose is that head? Whose that leg? Whose those arms? I hadn't a clue. So I scattered the limbs in my picture" (quoted in Schmalenbach p. 110).

Do It Yourself Andy Warhol, 1962, Museum Ludwig, Cologne.

Subtitled *Landscape*, the work resembles a part-completed "painting-by-numbers" picture, with much of the canvas covered by faintly outlined shapes containing a number such as "1," "2," "10," or "16." The completed objects include a house, a mailbox, and a fence. There is a half-painted road, and the upper part of the picture is largely taken up by the foliage of a tree. The title is an invitation to the artistically minded viewer to complete the scene.

"Do not go gentle into that good night" Ceri Richards, 1956, Tate Gallery, London.

The Welsh artist admired the poetry of his fellow countryman Dylan Thomas and the painting is based on Thomas's poem of this title (1952), the moving tribute of a son to his gravely ill father.

The Doctor Sir Luke Fildes, 1891, Tate Gallery, London.

A country doctor sits thoughtfully beside a stricken child bedded on two chairs in the front room of a cottage. In the background, the child's farmer father rests his hand on the shoulder of the mother, her head buried in her arms, her hands clasped in hopelessness. The painting grew out of the artist's loss of his own first child on Christmas Day, 1877, watched over by the family doctor. It more generally drew attention to the literally life-or-death role played by a physician in a rural community. The work's title is thus not *The Sick Child*, but *The Doctor*.

The Dog (Spanish, *Perro semihundido*, "Half-sunken Dog") Francisco de Goya, 1820–2, Prado, Madrid.

The painting depicts just the upward-staring head of a dog that has apparently sunk to its neck in quicksand. The picture is one of the so called **Black Paintings**.

The Dog and the Shadow Sir Edwin Landseer, 1822, Victoria and Albert Museum, London.

A dog with a piece of meat in his mouth is crossing a brook by means of a fallen tree when he pauses to gaze at the reflection of himself and his booty. A cap and a pair of shoes on the bank imply that a butcher's boy has stopped to bathe or fish nearby and has been robbed of part of his charge.

Dolce Far Niente John William Waterhouse, 1880, private collection.

In a Greek setting, a young woman reclines idly on a couch as she watches a pair of pigeons at her feet. The title is the familiar Italian phrase meaning "sweet doing nothing."

The Dole James Lobley, *c*.1867, Cartwright Hall Art Gallery, Bradford.

Poor parishioners are given loaves by the vicar in his church while a prosperous-looking mother and daughter look on. The church depicted is at Stow, northwest of Lincoln.

A Doll's House William Rothenstein, 1899, Tate Gallery, London.

The painting is a portrait of the artist Augustus John and Rothenstein's wife, the actress Alice Kingsley, as characters in a performance of Ibsen's play of this title (1879).

Dolorosa Luis de Morales, *c*.1560, Toledo Cathedral.

The painting depicts the Virgin Mary mourning the death of Christ on the cross. The title comes from the medieval Latin hymn *Stabat Mater dolorosa* ("The Mother stood grieving").

The Domain of Arnheim (French, *Le Domaine d'Arnheim*) René Magritte, 1962, private collection.

A bird's nest with three eggs lies on top of a wall against a background of snowy mountains, which on closer examination take the shape of a gigantic bird with its wings spread. Both the title and the depiction were inspired by Edgar Allan Poe's story of the same name (1847), in which Arnheim is the place where a rich enthusiast of landscape gardening builds his estate.

Domine, Quo Vadis? *see* **Christ Appears to St. Peter.**

The Doni Tondo Michelangelo, *c*.1503–4, Uffizi, Florence.

The tondo (circular panel), depicting the Virgin Mary, Joseph, and the infant Jesus, with the young John the Baptist looking on from behind a wall, was probably painted to mark the marriage between Agnolo Doni and Maddalena Strozzi in Florence. Hence its name. It is also known as simply *The Holy Family. See also* **Charity.**

La Donna della Finestra ("The Woman of the Window") Dante Gabriel Rossetti, 1879, Harvard University Art Museums, Cambridge, Massachusetts.

The painting depicts the "Lady of Pity" from Dante's *La Vita Nuova* (*c*.1293) as she gazes down compassionately on Dante from a window after the death of Beatrice. The model for the lady was William Morris's wife, Jane.

La Donna velata *see* The **Lady with a Veil.**

The Donne Triptych Hans Memling, late 1470s, National Gallery, London.

The painting depicts the Virgin with the infant Christ on her lap. He blesses Sir John Donne (died 1503), the donor of the altarpiece, who is protected by St. Catherine, while his wife, kneeling opposite with their daughter, is protected by St. Barbara. As a triptych, the work is in three separate panels, the scene described occupying the center. The left wing has St. John the Baptist, and the right, St. John the Evangelist. The work's alternate title is *The Virgin and Child with Saints and Donors.*

Don't Think I'm an Amazon (German, *Glauben Sie nicht, daß ich eine Amazone bin*) Ulrike Rosenbach, 1975.

The work was a live 15-minute video action of the artist shooting 15 arrows at a reproduction of Stefan Lochner's painting *Madonna of the Rose Hedge* (1451, Wallraf Richartz Museum, Cologne), with an image of her own head superimposed on that of the Madonna. The arrows thus pierce the Virgin's head but only appear to pierce her own. Hence the title.

The Doom Fulfilled Edward Burne-Jones, 1888, Staatsgalerie, Stuttgart.

The painting is one of the artist's four finished pictures of a series of eight on the legend of Perseus, who here slays the sea monster to which Andromeda was to have been sacrificed. The doom was thus to have been that of Andromeda, but it was actually that of the monster. This work and The **Rock of Doom** were originally conceived as a single picture.

Doryphorus Polyclitus of Argos, 5th *c*.BC, Archaeological Museum, Naples.

The statue's Greek title means "spear bearer," and depicts an upright male nude figure carrying a spear. The statue (only copies survive) was long regarded as a yardstick for ideal male beauty, and hence is also sometimes known as *The Canon.*

The Doubt Henry Alexander Bowler, 1854–5, Tate Gallery, London.

A young woman leans on a headstone in a churchyard as she surveys the exhumed skull and bones in the grave below. The doubt of the title is expressed in the subtitle: "Can These Dry Bones Live?", a slightly modified biblical quotation from Ezekiel 37:3. The headstone itself has an inscription ending with the more positive words of John 11:25: "Sacred to the Memory of John Faithful. Born 1711 Died 1791. 'I am the Resurrection and the Life.'"

Downing the Nigh Leader Frederic Remington, *c*.1907, Museum of Western Art, Denver, Colorado.

A group of Indian braves have waylaid a stagecoach and now shoot arrows to "down" (kill) the front left horse, the "nigh leader," in order to bring the coach to a halt.

The Drawing Lesson (Italian, *Lezione di disegno*) Gaspare Traversi, *c*.1750, Nelson-Atkins Museum, Kansas City, Missouri.

A young woman undergoes a drawing lesson from an art teacher amidst a motley company of different ages and social classes.

The Dream (1) (German, *Der Traum*) Ferdinand Hodler, 1897, private collection; (2) (French, *Le Rêve*) Henri Rousseau, 1910, Museum of Modern Art, New York; (3) *see* **Te rerioa**.

Hodler's painting depicts a young woman with streaming red hair holding a rose, the emblem of love, as she sits in a flowery garden. She is dreaming of her lover, the young man shown lying naked in a panel at the bottom of the picture. He too is asleep and dreaming. The woman was modeled by Berthe Jacques, whom the artist married the following year. Rousseau's painting was the last of his famous jungle scenes and has the formal title *Yadwigha's Dream*. Yadwigha was a Polish schoolmistress Rousseau had known in his youth. There is also a character of this name in his play *The Vengeance of a Russian Orphan* (French, *La Vengeance d'une orpheline russe*) (1899). When first shown at the Salon des Indépendants, the painting was accompanied by the following descriptive poem, which may have been written by Guillaume Apollinaire: "Yadwigha dans un beau rêve / S'étant endormie doucement / Entendait les sons d'une musette / Dont jouait un charmeur bien pensant. / Pendant que la lune reflète, / Sur les fleurs, les arbres verdoyants, / Les fauves serpents prêtent l'oreille / Aux airs gais de l'instrument" ("Yadwigha in a beautiful dream, / While sleeping peacefully, / Heard the notes of a pipe / Played by a friendly snake charmer. / While the moonlight gleams / On the flowers and verdant trees, / The tawny snakes listen / To the gay tunes of the instrument"). The poem does not explain that Yadwigha is nude and that she rests on a sofa in the middle of a dense jungle surrounded by huge flowers. Two lions and an elephant peer from the undergrowth and a dark-skinned musician plays a flute. No "tawny snakes" are in fact visible.

Dream Caused by the Flight of a Bee Around a Pomegranate One Second Before Waking Up Salvador Dalí, 1944, Thyssen-Bornemisza Collection, Madrid.

A nude woman lies outstretched and asleep, slightly suspended over a flat rock beside the sea. Two tigers leap towards her as they erupt from a fish's mouth. Behind them, an elephant stands tall in the sky on stilt-like legs. The bee and pomegranate of the title are quite small objects, below the body of the sleeping woman. However, the fish from which the tigers erupt has itself burst from a bigger pomegranate. The "real" bee and pomegranate have thus created the dreamlike image, presumably the one that the woman sees as she sleeps.

The Dream of Antiope Correggio, *c*.1530, Louvre, Paris.

The painting depicts three nude figures: a sleeping young woman, a young child lying by her left side, and a young man standing at her right. The woman has all the attributes of Venus, the child being Cupid, but the artist apparently intended her to be Antiope, who according to Ovid was seduced by Jupiter (Zeus) in the form of a satyr (the young man). The work is also known as *Jupiter and Antiope* or *Zeus and Antiope* and in the past has also been called *The School of Love*, a title more usually given to **Mercury Instructing Cupid Before Venus**.

The Dream of Life *see* The **Knight's Dream**.

The Dream of St. Joseph (French, *Le Rêve de saint Joseph*) Georges de La Tour, *c*.1640, Musée des Beaux-Arts, Nantes.

The scene is from the New Testament. An angel tells Joseph in a dream that his wife Mary has been made pregnant by the Holy Ghost (Matthew 1:20).

The Dream of Sir Lancelot at the Chapel of the Holy Grail Edward Burne-Jones, 1896, Southampton City Art Gallery.

A young knight has dismounted from his horse and lies asleep beside a chapel. A winged figure looks down at him. The knight is Lancelot, who in Arthurian legend sought the Holy Grail. The winged figure is the Angel that guards the Grail, who visits him in his sleep and tells him that he will never find it. This is because of his adultery with Queen Guinevere.

A Dream of the Past *see* **Sir Isumbras at the Ford**.

Dreamers Albert Joseph Moore, 1882, Birmingham City Art Gallery.

Four white-robed, barefoot young women relax languidly side by side on a long couch. The heads of two are slumped to one side, their eyes closed. The head of a third is hidden behind her fan. But a fourth woman has her head tilted back and her eyes half open, her direct gaze suggesting a subtle eroticism. The "dreamers" thus seem to dream different dreams.

Dresden Venus see **Sleeping Venus**.

The Drover's Departure Sir Edwin Landseer, 1835, Victoria and Albert Museum, London.

Subtitled *A Scene in the Grampians*, the painting depicts a line of cattle winding their way down the road as they are driven south from Scotland to the English markets. As they go, an old Highlander sits helpless by his cottage door, as if doomed never to lead a drove again.

The Drowned Girl (Russian, *Utoplennitsa*) Vasily Perov, 1867, Tretyakov Gallery, Moscow.

A Moscow policeman, heavily coated against the cold, smokes his pipe as he waits for dawn while surveying the corpse of a young woman who has drowned herself in the Moskva River. The domes and turrets of the Kremlin can be made out in the fog beyond.

Drowning Girl Roy Lichtenstein, 1963, Museum of Modern Art, New York.

The head, shoulder, and hand of a despairing girl are depicted amidst a wash of waves. A thought bubble contains the words: "I don't care! I'd rather sink... than call Brad for help!" She can relate to the anguished seated girl in *I Know How You Must Feel, Brad*, 1963, Wallraf-Richartz Museum, Cologne. (In many of Lichtenstein's comic strip paintings, the speech or thought bubble serves as the title, but not in the case of *Drowning Girl*.)

Drunken Faun see **Barberini Faun**.

Dual Hamburger Claes Oldenburg, 1962, Museum of Modern Art, New York.

The artist made his name with his gigantic sculptures of foodstuffs, and this work is a "soft sculpture" of a huge hamburger, created from foam rubber covered in canvas.

Dulcinea (French, *Dulcinée*) Marcel Duchamp, 1911, Philadelphia Museum of Art, Pennsylvania.

The painting depicts a woman in five po-

sitions as she turns and her clothes are removed. The title is presumably her name. Dulcinea was also Don Quixote's beloved in Cervantes' tale. The work is also known in French as simply *Portrait. Cf.* **Dulcinea del Toboso**.

Dulcinea del Toboso Charles Robert Leslie, 1839, Victoria and Albert Museum, London.

The subject of the painting of a young woman dressing her hair is from Cervantes' *Don Quixote* (1605): "Near the place where he lived, there dwelt a very comely country lass, with whom he had formerly been in love; though, as it was supposed, she never knew it nor troubled herself about it. Her name was Aldonzo Lorenzo, and her he pitched upon to be the lady of his thoughts: then casting about for a name, which should incline towards that of a great lady or princess, he resolved to call her Dulcinea del Toboso" (Part I, Chapter 1). Critics point out that the title is inappropriate for such a good-looking woman, since in reality Don Quixote's ladylove, in the words of Sancho Panza, was a "stout-built sturdy wench."

The Duo Hendrick Terbrugghen, 1628, Louvre, Paris.

A lusty lute player sings to his instrument accompanied by a buxom young woman who claps the rhythm.

The Dustman or the Lovers Stanley Spencer, 1934, Laing Art Gallery, Newcastle upon Tyne.

A dustman (garbage collector) is carried in the arms of his long-lost wife on calling to empty her dustbin (garbage pail). The lovers are watched by the reuniting wives of other laborers.

Duty Heywood Hardy, 1888, Guildhall Art Gallery, London.

A doctor on a handsome horse has stopped to ask a young shepherd boy the way as he rides cross-country on a call of duty to a patient, perhaps in a small hamlet or on an outlying farm.

A Dwarf Sitting on the Floor Diego Velázquez, *c.*1645, Prado, Madrid.

A dwarf sits on the bare earth, his legs stretched out before him. He is Don Sebastián de Morra, the court jester. The portrait is sometimes known by his name.

The Dweller in the Innermost George Frederic Watts, *c.*1885–6, Tate Gallery, London.

The dark-toned painting depicts a seated winged female figure with a row of arrows (but no bow) and a silver trumpet on her lap. Her headdress consists of two small red wings, and a shining star of white is in the center of the fillet that encircles her head. Her identity is as mysterious as the title. The picture was originally called *The Soul's Prism*, but when exhibited in 1890 was retitled *The Dweller in the Infinite*. The former title appears to have been suggested by words in a sonnet on the painting written by Walter Crane, which began: "Star-steadfast eyes that pierce the smouldering haze / Of Life and Thought, whose fires prismatic fuse / The palpitating mists with magic hues." However, the title was seen to be inappropriate, since there is no prism in the picture. Moreover, it was frequently misread as *The Soul's Prison*. Watts then considered the title *Spirit of the Ages*, but abandoned it in favor of *The Dweller in the Infinite*. By the time the painting was exhibited in Munich in 1893, the last word of this had been altered as now. Both picture and title have led some critics to see the depicted woman as Conscience.

Dying Gaul ?, 3d c. BC, Capitoline Museum, Rome.

The marble statue, a Roman copy of a Greek work by an unknown sculptor, depicts a wounded warrior supporting himself wearily on one arm. The statue is also known as the *Dying Gladiator*, but this is clearly a misnomer, since the warrior's hairstyle and accessories are definitely Gallic. He was obviously the loser in a particular combat with the Romans.

Dying Gladiator *see* **Dying Gaul**.

Dying Slave Michelangelo, *c*.1514, Louvre, Paris.

The (unfinished) marble statue of a wounded male slave was originally carved for the tomb of Pope Julius II in the church of S. Pietro in Vincoli, Rome.

Dynamic Hieroglyphic of the Bal Tabarin (French, *Hiéroglyphe dynamique du bal Tabarin*) Gino Severini, 1912, Museum of Modern Art, New York.

The painting represents a frenzied dance and cabaret act at the Tabarin music hall, Paris. The scene is fragmented and to some extent cryptic (a nude girl descends on wires, seated astride a pair of scissors) and requires some interpretation. Hence the "hieroglyphic" of the title.

Dynamism of a Dog on a Leash (Italian, *Dinamismo d'un cane al guinzaglio*) Giacomo Balla, 1912, Albright-Knox Art Gallery, Buffalo, New York.

The "dynamism" (motion) of a dog as it walks, and of the woman who walks it, is represented by the multiple impressions of its legs and tail and the legs of its walker.

E

Ea haere ia oe? ("Where Are You Going?") Paul Gauguin, 1893, Hermitage, St. Petersburg.

A seminude Tahitian woman stands pensively holding a water gourd. The painting's native title, inscribed in its bottom left corner, is the key question a person asks about his journey through life. In this case it may additionally relate to the artist's decision to return to France.

Early Britons Sheltering a Missionary from the Druids *see* **A Converted British Family Sheltering a Christian Priest from the Persecution of the Druids**.

Early Lovers Frederick Smallfield, 1858, Manchester City Art Gallery.

A youthful swain declares his love for his maid over a country stile in a framed setting of ferns, foliage, and roses. The painting takes its title from a ballad by Thomas Hood: "It was not in the Winter / Our loving lot was cast; / It was the Time of Roses, / We pluck'd them as we pass'd! / That churlish season never frown'd / On early lovers yet: / Oh, no — the world was newly crowned / With flowers when first we met!"

Early One Morning Sir Anthony Caro, 1962, Tate Gallery, London.

The abstract metal sculpture, painted bright red, is optimistic in mood and presumably represents the glow of the dawn, perhaps as seen through the window by someone lying in bed. The title quotes the opening words of the anonymous traditional song beginning, "Early one morning, just as the sun was rising." "So confident was his position within the new idiom that he could give some of his sculptures lyrical titles such as would have signalled everything bad about British conventionalism a few years

earlier: *Month of May, Early one Morning*" (Lynton, p. 280).

Early Sunday Morning Edward Hopper, 1930, Whitney Museum of American Art, New York.

A row of offices and apartments in a city street stands deserted in bright sunlight. The title denotes the day and time, with the scene at its deadest and loneliest.

Earth Knower Maynard Dixon, *c*.1932, Oakland Museum, California.

A Native American contemplates his land. The brown-red color of his robe matches that of the mesas around him, suggesting his primeval kinship with the earth that he knows so well.

Earth-Stalker Andrzej Jackowski, 1987, Marlborough Fine Art, London.

The painting is a head-and-shoulders self-portrait, set against a broad landscape with trees and human figures. The artist seems to muse as a woman puts her arms around his neck. The title suggests he is "stalking the earth" as he recalls his past.

Earthly Paradise Giovanni Bellini, *c*.1490, Uffizi, Florence.

Young children play around an apple tree on a terrace by a lake. Adult figures to right and left include St. Sebastian, St. Paul, and the Virgin Mary. The precise intention of the depiction is uncertain, but it is almost certainly an allegory. Hence its alternate titles, *Christian Allegory* and *Sacred Allegory*.

The Earthstopper on the Banks of the Derwent Joseph Wright of Derby, 1773, Derby Museum and Art Gallery.

A hunt servant digs by moonlight and lantern light beside the Derwent River, Yorkshire, stopping up a fox's holes before the next day's hunt so that it cannot escape the hounds.

Easter Procession (Russian, *Sel'skiy krestnyy khod na Paskhe*, "Village Procession at Easter") Vasily Perov, 1861, Tretyakov Gallery, Moscow.

A drunken priest lurches down the steps of a house to join a ramshackle religious procession in which a gawping woman holds one icon and a dishevelled old man holds another upside down. The painting, with its anticlerical slant, was intended as a social indictment of its time.

Easter Procession in Kursk (Russian, *Krestnyy khod v Kurskoy gubernii*, "Festival Procession in the Kursk Province") Ilya Repin, 1880–3, Tretyakov Gallery, Moscow.

A throng of people from all layers of provincial Russian society, among them a mounted policeman and a hunchback, follow the banners of an Easter procession along a dusty road.

Eastward Ho! Henry Nelson O'Neil, 1858, private collection.

Families bid farewell to their menfolk as they embark for India, where many will lose their lives in the bitter fighting of the Indian Mutiny (1857). The title alludes to the eastward course of the ships from England. (It is also the title of a play of 1605 by George Chapman.) The picture was so popular that the following year the artist painted a pendant (companion work), *Home Again*, showing the return of the forces.

Easy Money George Morland, 1788, Huddersfield Art Gallery.

The scene is apparently of a private house that has been turned into an illegal gin parlor. The characters depicted include a highwayman and a probable receiver of stolen goods, who together with the gin sellers can all make "easy money" in their different criminal ways.

Ecce Ancilla Domini! Dante Gabriel Rossetti, 1849–50, Tate Gallery, London.

The scene is from the New Testament. The angel Gabriel announces to the Virgin Mary that she will conceive and bear Jesus (Luke 1:26–38). The title quotes the Latin Vulgate version of the words spoken by Mary (in the last verse of the passage) on learning the news: "Behold the handmaid of the Lord." The painting is also known as *The Annunciation*.

Ecce Homo (1) Correggio, 1520–6, National Gallery, London; (2) Titian, 1543, Kunsthistorisches Museum, Vienna; (3) Lovis Corinth, 1925, Kunstmuseum, Basel; (4) Sir Jacob Epstein, 1935, Coventry Cathedral.

The New Testament scene is a dramatic moment in the trial of Christ. He has been scourged and mocked and is brought before the crowd by Pilate with the words: "Behold the man!" (John 19:5). The title quotes from the Latin Vulgate version.

The Echo (French, *L'Écho*) Paul Delvaux, 1943, Claude Spaak Collection, Paris.

Three female nudes walk up a moonlit street past deserted temples. Each nude is an exact copy ("echo") of the others.

The Edge of a Forest (French, *Le Bord d'une forêt*) Max Ernst, 1926, private collection.

The title enables the viewer of the Surrealist painting to recognize it for what it is, although the trees look like meshing and the full moon overhead like a poached egg.

Ecstasy Eric Gill, 1910–11, Tate Gallery, London.

The sculpture depicts a man and a woman locked in a passionate embrace, the woman's eyes closed in ecstasy as she folds her lover to her.

Ecstasy of St. Theresa (Italian, *Estasi di S. Teresa*) Gianlorenzo Bernini, 1645–52, Sta. Maria della Vittoria, Rome.

Bernini's famous marble sculpture depicts one of the moments of ecstasy experienced by St. Theresa of Avila (1515–1582), when she received a vision of Christ and believed an angel was stabbing her through the heart with an arrow of divine love. The lifesize group includes the angel, with arrow raised. St. Theresa had been canonized in 1622. "The saint in ecstasy is also a woman in orgasm, and the arrow with which the angel is about to strike her is not merely an emblem of divine love but also a symbolic phallus" (Lucie-Smith 1991, p. 82).

The Education of Amor (French, *L'Éducation de l'Amour*) François Boucher, 1742, Staatliche Museen, Berlin.

Mercury, messenger of the gods, reclines on clouds as he holds a book for the young child Amor (Cupid) to read. Nearby is Amor's mother, Venus, who looks flirtatiously at Mercury. The large folio that Amor is learning to read bears the name of the artist and date of the painting. All three are nude, as they are in **Mercury Instructing Cupid Before Venus**.

The Education of Marie de Médicis
Peter Paul Rubens, 1622–5, Louvre, Paris.

The work is one of a cycle entitled *The Life of Marie de Médicis*, a political allegory depicting different events in the life of Marie de Médicis (Maria de' Medici) (1573–1642), queen consort of Henry IV of France. This painting depicts her education as a young girl, with classical gods and goddesses in attendance.

The Education of the Virgin (Italian, *Educazione della Vergine*) Giambattista Tiepolo, 1732, S. Maria della Fava, Venice.

The young Virgin Mary stands before a reading book between her elderly parents, Joachim and Ann, and watched by angels and cherubs.

The Effects of Intemperance Jan Steen, *c.*1663–5, National Gallery, London.

A mother slumbers in a drunken stupor while her servants take liberties and her children misbehave. The man flirting with a buxom wench in the background may be her husband.

Effie Deans John Everett Millais, 1877, Christie's, London.

The painting is based on a scene in Sir Walter Scott's novel *The Heart of Midlothian* (1818), and depicts the lovers Effie Deans and George Staunton parting in King's Park, Edinburgh. The model for Effie was Lillie Langtry (*see* A **Jersey Lilly**). Millais's wife, formerly the wife of the art critic, John Ruskin, was also named Effie, as was his daughter.

Eggs on a Dish Without the Dish Salvador Dalí, 1932, Davlyn Gallery, New York.

The painting depicts a fried egg suspended, elongated, from a line in midair, like a fish on a hook. The English title does not quite do justice to the original French, which was *Œufs sur le plat sans le plat*. *Œufs sur le plat*, although literally translating as "eggs on the dish," is standard French for "fried eggs," so that the title puns on both senses. (You can have fried eggs without a dish.) There is only one fried egg in this depiction, but another painting, identically named, has two, suggesting that there is a further pun on the slang sense of *œufs sur le plat*, "flat breasts."

L'Égypte de Mlle Cléo de Mérode ("The Egypt of Mlle Cléo de Mérode") Joseph Cornell, 1940, Leo Castelli Gallery, New York.

The American artist's French title refers to a famed French courtesan of the 1890s, said to have been promised a fabulous price by the Khedive of Egypt if she would visit his country. The work is an opened wooden cosmetic box containing a number of little flasks, each holding a different attribute of Egypt or of Cléo herself, such as sand, wheat, pearls, the Sphinx, etc. Inside the lid of the box is a picture of a pharaoh and a printed label suggesting a textbook title: "L'Égypte de Mlle de Mérode. Cours élémentaire d'Histoire Naturelle." Cléo's own name of course evokes that of the famous Egyptian queen, Cleopatra.

Eidos Willi Baumeister, 1940, Folkwang Museum, Essen.

The almost abstract painting depicts a number of nebulous shapes in a dreamlike landscape. They do not suggest a precise interpretation but

evoke a general spiritual calm. Hence the title, which is simply the Greek word for "form," "shape."

1807 Jean-Louis-Ernest Meissonier, 1876, Metropolitan Museum, New York.

The painting depicts "a regiment of cuirassiers passing at a gallop in a grain-field before Napoleon, who sits on a white horse at the left, attended by his marshals and staff" (*Century Cyclopedia of Names*, 1904). The work is also known as *Friedland*, confirming that it commemorates Napoleon's victory at the Battle of Friedland on June 14, 1807. (Friedland is now Pravdinsk, Russia.) The artist executed many paintings of the Napoleonic campaigns.

Eine Kleine Nachtmusik ("A Little Night Music") Dorothea Tanning, 1946, private collection.

The Surrealist painting depicts two young girls in a crumbling hotel corridor, one almost naked to below the waist, the other with her dress cut to ribbons, her hair streaming upwards. A giant sunflower at the top of a nearby staircase stretches its green stalks towards them. The title, clearly taken from Mozart's *Eine Kleine Nachtmusik*, suggests a child's dream that has become a nightmare, with familiar daytime sights and sounds undergoing a sinister metamorphosis. (The American artist's title is in German in the original.)

Elective Affinities (French, *Les Affinités électives*) René Magritte, 1933, private collection.

The painting, inspired by a nocturnal hallucination, is of a huge egg in a cage, and illustrates the artist's theory that certain affinities are right and natural, however absurd or unnatural they may otherwise seem. Thus the egg represents the bird that is normally found in a cage. Several of the artist's other works depict similar affinities. The title comes from that of Goethe's two-part novel *Die Wahlverwandschaften* (1808–9), which expressly refers to "elective affinity" as a chemical process and implies that the complexities of human life refuse to conform to simple mutations of chemical formulae.

Electric Chairs Suzanne Treister, 1987, Edward Totah Gallery, London.

Against a background of library shelves, the painting's four central panels each depict a different type of chair. An artery runs from a human heart on the seat of one to connect the seats of all four. The implication appears to be that the human life force, although potentially creative, as for writers, can also be a force for destruction, like the electric current that runs through the body of a human being in an electric chair.

Electric Prisms (French, *Prismes électriques*) Sonia Terk Delaunay, 1914, Musée National d'Art Moderne, Paris.

The painting, an example of so called Orphic art, depicts a complex array of multicolored interlacing arcs that suggests the intensity of artifical light.

Electrosexual Sewing Machine (French, *Machine à coudre électrosexuelle*) Oscar Domínguez, 1934, private collection.

An unrecognizable creature or object pours what appears to be blood through a funnel onto the back of a supine but headless and footless naked woman, as if "sewing" her spine. The depiction is based on the principle of combining unrelated elements, as expressed by the French poet known as the Comte de Lautréamont in his remark on the beauty of an accidental encounter between an umbrella and a sewing machine on an operating table. The umbrella here is the woman's body, and the sewing machine the funnel with its stream of blood.

The Elephant of Celebes (French, *L'Éléphant Célèbes*) Max Ernst, 1921, Tate Gallery, London.

The Surrealist painting depicts an elephant-like monster (based on a photograph of a Sudanese corn storage bin) in what looks like a deserted airfield. Before it, a headless female nude raises her red-gloved arm. The artist explained to his friend, the English painter and art collector, Roland Penrose, that the title quotes from a German schoolboy rhyme, translating as follows: "The elephant from Celebes / Has sticky yellow bottom-grease." Celebes (now better known as Sulawesi) is an Indonesian island whose outline roughly corresponds to that of an elephant. The painting is sometimes known simply as *Celebes*.

The Elevation of the Cross *see* **The Raising of the Cross**.

The Elgin Marbles ?, 5th c. BC, British Museum, London.

The collection of antique Greek sculptural remains, consisting chiefly of section of frieze and pedimental statues, came from the Acropolis, Athens, and was brought to London in 1801–3 by the British diplomat Thomas Bruce, 7th earl of Elgin (1766–1841).

Elijah and the Widow's Son Ford Madox Brown, 1864, private collection.

The scene is from the Old Testament. The prophet Elijah has brought a widow's young son back to life and now restores him to his mother (1 Kings 17:23).

Elijah in the Fiery Chariot *see* **God Judging Adam**.

Elijah in the Wilderness Frederic Leighton, 1877–8, Walker Art Gallery, Liverpool.

The scene is from the Old Testament. The prophet Elijah has escaped from the vengeful Jezebel into the desert of Judah following his revelation of the true God on Mt. Carmel. Now, as he lies prostrate, exhausted by working and fasting, he is visited by an angel, who places a cake and a cruse of water at his head (1 Kings 19:4–8). Elijah's pose in the painting is based on that of the **Barberini Faun**.

The Elphinstone Children Henry Raeburn, 1800, Cincinnati Art Museum, Ohio.

The painting is a portrait of the son and two daughters of the Scottish admiral, George Keith Elphinstone, Viscount Keith (1746–1823). The girl holding the tambourine, 12-year-old Margaret Mercer Elphinstone, was Keith's only child by his first wife, Jane. She married the Comte de Flahault, aide-de-camp to Napoleon, and was a confidante of Princess Charlotte.

The Elusive Woman (French, *La Femme introuvable*) René Magritte, 1928, private collection.

The painting is of a nude woman embedded in a stone wall. She is surrounded by four hands, similarly set. The woman is an ideal figure, a model of integration, while the hands are symbols of fragmentation. A woman is thus elusive because she is both a perfect whole yet made up of disparate parts.

Ema: Nude on a Staircase (German, *Ema: Akt auf einer Treppe*) Gerhard Richter, 1966, Museum Ludwig, Cologne.

The artist based his painting on a color photo that he took of his first wife, Ema, walking naked down a staircase. The title is similar to, and the subject directly derived from, Marcel Duchamp's **Nude Descending a Staircase**.

The Embarkation for Cythera *see* **The Pilgrimage to the Island of Cythera**.

The Embarkation of St. Ursula (French, *L'Embarquement de sainte Ursule*) Claude Lorrain, 1641, National Gallery, London.

St. Ursula departs on her pilgrimage to Rome, her companions in attendance. The painting depicts the moment when she and her baggage are being rowed out to the sailing ship anchored in the harbor.

The Embarkation of the Queen of Sheba (French, *L'Embarquement de la reine de Saba*) Claude Lorrain, 1648, National Gallery, London.

The painting depicts the preparations for the departure of the Queen of Sheba on her way to visit King Solomon, as described in the Old Testament (1 Kings 10). The artist has disguised the title as graffiti on the quay steps: "LA REINE DE SABA VA TROV(ER) SALOMON" ("The Queen of Sheba Goes to See Solomon").

Ember Kenneth Noland, 1960, private collection.

The painting consists of three concentric rings, gray, brown, and black, around a red central circle. The title seems to suggest that the image is of a dying fire which still glows red and alive in its heart but that is cold and dead on its outer edge. The black ring presumably represents unburned coal.

The Emigrant Train Bedding Down for the Night Benjamin Franklin Reinhart, 1867, Corcoran Gallery of Art, Washington, D.C.

A prosperous family of pioneers have made camp near a freshwater creek and now refresh themselves and their animals before preparing for sleep. A woman is cooking, a young girl washes clothes in a tub, a pipe-smoking man strokes a dog, and all generally gives an impression of peace and order.

L'Éminence Grise Jean-Léon Gérôme, *c.*1860, Stebbins Collection, New York.

The painting depicts "the noted confessor of Cardinal de Richelieu descending a palace staircase, feignedly oblivious of the cringing before him and the gestures of hatred behind him of a body of brilliant courtiers" (*Century Cyclopedia of Names*, 1904). *L'Éminence Grise* ("The Gray Eminence") was the nickname of François-Joseph Le Clerc du Tremblay (1577–1638), known as Père Joseph, private secretary to Cardinal de Richelieu. Du Tremblay wore the gray habit of a Capuchin monk, as depicted here.

Hence his nickname, which also alluded to his influence over Richelieu, himself known as *L'Éminence Rouge* ("The Red Eminence") for his cardinal's red robes, *Éminence* being a cardinal's title.

The Emperor Septimius Severus Reproaching His Son Caracalla for Having Plotted Against His Life *see* Septimius Severus Reproaching Caracalla.

The Empty Sleeve Thomas Roberts, 1856, private collection.

A soldier has returned home having lost his forearm in battle, and the young child seated on his knee is fascinated by his empty sleeve. The battle in question would almost certainly have been the Crimean War (1856).

The Encampment at Brighton *see* **Scene from a Camp with an Officer Buying Chickens**.

The Enchanted Castle Francis Danby, 1841, Victoria and Albert Museum, London.

The painting of a castle glimpsed behind trees was earlier known as *Calypso Grieving for her Lost Lover*. This is a misnomer, however, since Calypso, the island queen of Greek mythology with whom Odysseus was shipwrecked, has no connection with a castle. On the other hand, Eros and Psyche do, since Eros, the god of love, took his beloved princess Psyche to his castle incognito and visited her at night. While he slept, Psyche took a lamp and discovered his true identity. Eros awoke, and banished her from the castle. An alternate title *Psyche Grieving for her Lost Lover* would therefore make more sense.

The Enchanted Garden John William Waterhouse, *c.*1917, Lady Lever Art Gallery, Port Sunlight.

The (unfinished) painting was inspired by the group of young people in **A Tale from the Decameron**. The "enchanted garden," in which roses are in bloom although it is snowing outside, is the one where they have fled from the plague in Florence to tell each other tales.

The Enchanted Ones Adolph Gottlieb, 1945, Adolph and Esther Gottlieb Foundation, New York.

The painting contains a number of panels divided into compartments. Each contains a depiction of some kind, some being of a recognizable face. The work represents the victims of

World War II rising up as spirits, and these are the "enchanted ones" of the title.

Encore, Again Encore! (Russian, *Ankor, yeshchyo ankor!*) Pavel Fedotov, 1851–2, Tretyakov Gallery, Moscow.

A bored army officer, lying on a couch, holds out a poker and repeatedly orders his poodle to jump over it, using the words of the title. The Russian original, with its French *encore*, can also be understood as *Encore, Another Encore!*, as if alluding to an applauded performance.

The Encounter (French, *Le Rencontre*) Paul Delvaux, 1938, private collection.

In the setting of a courtyard among Renaissance buildings, a besuited businessman doffs his bowler hat to a classically elegant nude woman. The painting is also known in English as *The Greeting*.

The End of Her Journey Alice Havers, 1877, Rochdale Art Gallery.

A haggard working woman with a young child has collapsed by the side of a country road after days of arduous traveling. She has reached the end of her journey, which is death.

The Endless Chain (French, *La Chaîne sans fin*) René Magritte, *c.*1939, private collection.

Three men sit astride a bucking horse: a modern horseman, a medieval knight, and a classical equestrian wearing a toga. The title seems to imply that the horse and its rider are a symbol of continuity over the ages.

An English Autumn Afternoon Ford Madox Brown, 1852–4, Birmingham City Art Gallery.

The painting was the artist's largest landscape and depicts the view from the back window of his lodgings in Hampstead, near (and now in) London. He has recorded that the time was 3 p.m. and the date late October.

An Englishman in Moscow (Russian, *Anglichanin v Moskve*) Kasimir Malevich, 1914, Stedelijk Museum, Amsterdam.

The abstract painting depicts a bowler-hatted Englishman partly obscured by various objects, including a fish, a Russian church, a ladder, a candle, a sword, and an arrow. Cyrillic capital letters spell out the words PARTIAL ECLIPSE, as if an alternate title, while small letters read RACING SOCIETY.

The Enigma of Desire Salvador Dalí, 1929, private collection.

The painting depicts a typical down-facing "Dalí" head attached to a large compartmented and "holed" object bearing some resemblance to a brain. The work's subtitle is *My Mother, My Mother, My Mother*, referring to the inscription in some (but not all) of the "brain" cells, *ma mere* (with no accent). It is thus presumably the artist's mother that is the "enigma of desire" of the title, perhaps in some Freudian sense.

Ennui Walter Richard Sickert, 1914, Tate Gallery, London.

The artist's best known painting depicts the deep boredom of a Sunday afternoon in a working-class home. The husband sits listlessly smoking by a table on which a half-empty glass stands. The wife, half turned from him, stands in a corner of the room, her elbows resting on a chest of drawers, her unseeing gaze fixed on a picture on the wall that she must have seen a hundred times before. The work is also known more explicitly as *Boredom*.

The Entombment (1) Fra Angelico, 1438–43, Alte Pinakothek, Munich; (2) Rogier van der Weyden, *c*.1450, Uffizi, Florence; (3) Raphael, 1507, Galleria Borghese, Rome; (4) Michelangelo, *c*.1507, National Gallery, London; (5) Caravaggio, *c*.1602–4, Vatican Museums.

The body of Christ has been taken down from the cross and is about to be lowered, or is actually being lowered, into the tomb. Michelangelo's painting includes the three Marys, Joseph of Arimathea, and an androgynous figure who may be St. John the Baptist. The New Testament scene directly follows The **Deposition from the Cross** (Mark 15:46, Luke 23:53).

The Entombment of Atala *see* **The Funeral of Atala**.

The Entombment of Christ Caravaggio, 1602–4, Vatican Museums.

The depiction is essentially the same as The **Entombment** (above), although the actual tomb is much more prominent, and is here represented by the stone slab on which Christ's body is being laid.

The Entomologist's Dream Edmund Dulac, 1909, Victoria and Albert Museum, London.

An entomologist wakes from a nap (or in his dream does so) to see all his butterflies and moths flying free from their cases and collections. His expression of dismay suggests that a more suitable title might have been *The Entomologist's Nightmare*.

The Entry of Christ into Brussels (French, *L'Entrée du Christ à Bruxelles*) James Ensor, 1888, J. Paul Getty Museum, Malibu, California.

The Belgian artist's most important work was intended as an indictment of society. Christ, a small figure on a donkey in the center of the painting, is almost dwarfed by the angry mob before him who wave banners as he enters Brussels on Palm Sunday.

Epona-Ballade František Kupka, *c*.1900, National Gallery, Prague.

Two naked women are on horses by the sea. One, a plump blonde, sits on a great gray mare. She represents the Celtic goddess Epona (the name means "the big mare"). The other, dark-haired, stands on a piebald pony. (She was the artist's mistress at the time. The blonde was his former mistress who had died in 1898.) The painting is also known as *The Joys*.

Equivalent VIII Carl Andre, 1966, Tate Gallery, London.

The sculptor's work consists of eight groups of 120 bricks arranged two deep in a rectangle on the floor. The groups are all exactly alike. Hence the title. (The work, popularly dubbed "the Tate bricks," was vandalized in 1976 and there was an outcry about the alleged waste of public money on its purchase.)

The Ermine Sea Philip Wilson Steer, 1890, private collection.

Three young children stand on the beach at the edge of a twilight sea. The title alludes to the contrasting white waves and dark water, like heraldic ermine.

Eros *see* **Shaftesbury Memorial Fountain**.

The Escape Charles Rossiter, *c*.1860, private collection.

A husband and wife sit dejectedly on the deck of a departing ship. The title at first seems to suggest that they are emigrating. But the copy of *Bell's Life in London* on the deck below the man's knee implies that he has lost his last penny on the horses, for the book is the favorite reading of the Cockney sportsman Soapey Sponge in R.S. Surtees's *Mr. Sponge's Sporting Tour* (1853). The "escape" is thus that of the man from his creditors.

L'Escarpolette *see* The **Swing** (1).

El Espolio ("The Stripping") El Greco,
1577–9, Toledo Cathedral.

The great altarpiece is also known by the
more explicit English title *Christ Stripped of His
Garments*. It depicts the New Testament scene in
which soldiers strip Christ of his clothes after
his trial before Pilate and put a scarlet robe on
him in mockery (Matthew 27:28).

The Esterházy Madonna Raphael,
c.1505–7, Museum of Fine Arts, Budapest.

The (unfinished) painting of the Virgin and
Child with St. John was in the collection of
Prince Esterházy that formed the basis of the
museum where it is currently housed.

Esther with Flower Sir Jacob Epstein,
1949, Walsall Museum and Art Gallery.

The bronze bust is a portrait of the sculp-
tor's 20-year-old daughter, Esther, with a large
flower over her right breast.

Et in Arcadia Ego ("And I too in Arcadia")
(1) Guercino, 1618, Galleria Nazionale d'Arte
Antica, Rome; (2) Nicolas Poussin, 1638–9,
Louvre, Paris.

Guercino depicts two young shepherds
who have discovered a skull resting on a stone
plinth that bears the words of the title. Poussin
has three young shepherds and a shepherdess
making out the same words on a tomb and dis-
cussing their meaning. The words themselves,
of unknown origin, appear on tombs in other
classical paintings, including one by Joshua
Reynolds. Although Arcadia is a genuine geo-
graphical region (a mountainous district of the
central Peloponnesus in ancient Greece), its
name came to be used figuratively in Latin pas-
toral poetry, where it seems to represent a sort of
remote paradise, a scene of song and idealized
love. "I" is thus Death. Poussin's painting is also
known as *The Arcadian Shepherds*.

The Eternal Idol (French, *L'Idole éternelle*)
Auguste Rodin, 1889, Musée Rodin, Paris.

The statue depicts a nude kneeling couple,
the woman higher than the man and leaning
back, her hands behind her, while the man,
hands likewise, leans forward and into her and
kisses her breast. The "eternal idol" is thus
woman, forever worshiped by man.

The Eternally Obvious (French, *L'Évidence
éternelle*) René Magritte, 1930, Menil Collec-
tion, Houston, Texas.

The work consists of five separate framed
paintings of different sections of a lifesize stand-
ing nude (head and neck, breasts, abdomen and
pubic region, thighs and knees, ankles and feet),
the five making a complete figure when placed
one above the other. The title alludes to woman.
Whether complete or fragmented, she is "eter-
nally obvious," and here, in the words of the
French original, is "the lasting evidence."

Euclidean Walks (French, *Les Promenades
d'Euclide*) René Magritte, 1955, Minneapolis
Institute of Arts, Minnesota.

A window looks out onto a city scene with
a gray conical tower in the foreground. The cen-
tral part of the scene is blocked off by a paint-
ing on an easel which, however, depicts the part
of the view that lies behind it. This "picture
within a picture" shows the tower but next to it
has added a street in receding perspective that ex-
actly resembles it in shape and color. The 3d-
century BC Greek mathematician Euclid treated
the cone in his geometrical writings and the laws
of perspective were first set out in his *Optics*.

Europe After the Rain (French, *L'Europe
après la pluie*) Max Ernst, 1940–2,
Wadsworth Atheneum, Hartford, Connecticut.

The painting depicts a shattered landscape,
with a lone warrior standing beside his dead
steed amid the ruins. The work clearly relates to
the devastation of World War II, and the "rain"
of the title may be that of bombs and missiles.

Eurhythmy (German, *Eurhythmie*)
Ferdinand Hodler, 1895, Kunstmuseum, Berne.

Five white-robed men, their heads slightly
bowed, move slowly in the same direction. Ac-
cording to the artist, they represent the march of
humanity towards death. Their movement is
controlled and rhythmic. Hence the title, ex-
plained by Hodler as his term for the "interrela-
tionship of the harmony of the form-rhythm of
nature with the rhythm of emotion" (quoted in
House and Stevens, p. 158).

Eve After the Fall (French, *Ève après la
faute*) Jean-Baptiste Carpeaux, 1871, Tate
Gallery, London.

The terracotta statue depicts a nude young
woman seated on a tree stump ruefully survey-
ing the apple that she holds in her left hand. She
is Eve, and the apple is the fruit of the Tree of
Knowledge (Genesis 3:5–6). The work has also
been known as *Daughter of Eve* (referring to the
modern model who poses as her) and *Eve Hold-
ing the Apple*. The original French title does not

use the word for "fall" (*chute*) but that for "fault" in the sense "lapse," "sin."

Eve Holding the Apple *see* Eve After the Fall.

The Eve of St. Agnes John Everett Millais, 1862–3, Her Majesty Queen Elizabeth, The Queen Mother.

The painting depicts the scene in Keats's 1820 poem of the same name in which Madeline disrobes in the moonlight, watched secretly from a closet by her lover, Porphyro: "Of all its wreathed pearls her hair she frees; / Unclasps her warmed jewels one by one; / Loosens her fragrant boddice; by degrees / Her rich attire creeps rustling to her knees."

Evening Bells (Russian, *Vecherniy zvon*) Isaac Levitan, 1892, Tretyakov Gallery, Moscow.

The bells of a monastery ring out in the evening from across the river by which it stands. The second word of the Russian title properly means "ringing" rather than actually "bells."

Evening Falls (French, *Le Soir qui tombe*) René Magritte, 1964, private collection.

Through a shattered window the sun is seen glowing orange as it sinks down to the horizon in a summer evening sky. Fragments of an identical scene appear on the shards of glass from the broken pane as they fall inside the room. The title puns on the two senses of "fall."

The Evening Prayer *see* The Angelus.

Evening Wind Edward Hopper, 1921, Philadelphia Museum of Art, Pennsylvania.

As she climbs into into bed, a naked woman turns towards the window, drawn by the warm breeze that suddenly billows the curtains.

Everyone I Have Ever Slept With 1963–1995 Tracey Emin, 1995, Saatchi Collection, London.

The work is an igloo-shaped tent containing the embroidered or appliquéd names of the 102 people with whom the artist had slept, in either sense of the word, between the given dates. They were not all lovers: "The thing about the tent that really annoys me ... is people write it's the names of my lovers. But it's not. The tent is everyone I ever slept with from 1963 to 1994. Now, I'm 34, so how could I have had a lover in 1963? It's about conception, sleeping in the womb with my twin brother, up to my last friend or lover that I slept with in 1994. That's

what the tent's about. It's about sleep, intimacy, and moments" (interview with Waldemar Januszczak, *Sunday Times Magazine*, July 12, 1998).

Evicted William Fletcher, 1887, Queensland Art Gallery, Brisbane.

A widow and her young daughter carry their few belongings into the street following their eviction for not paying the rent. A sympathetic crowd looks on. *Cf.* **Relenting**.

Evolution Piet Mondrian, 1910–11, Gemeentemuseum, The Hague.

The triptych is effectively a theosophical altarpiece, depicting a standing nude female figure in three panels, her eyes wide and staring in the center panel as she achieves cosmic orgasm, her head raised and eyes closed in the two outer. The exact sense of the title is uncertain, although the artist throws some light on it in a 1914 notebook entry: "Two roads lead to the spiritual: the road of doctrinal teaching, of direct exercise (meditation, etc.), and the slow but certain road of evolution. One sees in art the slow growth of spirituality, of which the artists themselves are unconscious" (quoted in Bowness, p. 137). However, the painting hardly illustrates the slow road of evolution.

The Execution of Lady Jane Grey (French, *L'Exécution de lady Jeanne Grey*), Paul Delaroche, 1833, National Gallery, London.

Lady Jane Grey (1537–1554), great-granddaughter of Henry VII, reigned as queen of England for nine days in 1553. She was convicted of high treason, however, and executed at the age of 17. The painting depicts the moment before her death in the Tower of London. She kneels blindfolded before the executioner's block, supported by an officer (presumably the Lieutenant of the Tower). A lady-in-waiting who holds Lady Jane's jewels has fainted.

The Execution of the Emperor Maximilian (French, *L'Exécution de l'empereur Maximilien*) Édouard Manet, 1867, Städtische Kunsthalle, Mannheim.

The painting depicts the execution by Mexican nationalists at Querétaro on June 19, 1867 of Emperor Maximilian of Mexico (1832–1867) together with his generals, Miguel Miramón (1831–1867) and Tomás Mejía (1820–1867).

The Exhumation of the Mastodon Charles Willson Peale, 1806, Peale Museum, Baltimore, Maryland.

Men toil in and around a flooded pit to

raise the remains of a buried mastodon. One worker, stripped to the waist, triumphantly shows a bone to the artist, who stands on the edge of the pit with his children. *See also* The **Artist in His Museum**.

The Exile Thomas Cooper Gotch, *c.*1900, Alfred East Art Gallery, Kettering, Northamptonshire.

The painting is a portrait of a serious-faced young woman wearing a gown of red and gold patterned silk. The somewhat enigmatic title suggests that she has been rejected by her lover.

Expectation (German, *Erwartung*) Richard Oelze, 1935, Museum of Modern Art, New York.

The surreal painting is of a human figure represented by a ground-length coat wearing an auburn wig and holding a butterfly net. The expectation is that the figure may catch a butterfly, and presumably also that the viewer will make sense of the enigmatic picture.

An Experiment on a Bird in the Air Pump Joseph Wright of Derby, *c.*1767–8, National Gallery, London.

Many of the artist's works depicted the scientific advances of his day. This painting shows an experiment demonstrating the principle of the vacuum. A dove has been placed in a glass vessel. By using a pump, the lecturer has emptied the vessel of air, creating a vacuum in which the bird seems to be gasping its last. A scientist comforts his two young daughters, the elder weeping when told that the bird may die. But the lecturer's hand rests on a valve that readmits air to the vessel, implying that the bird will be saved from suffocation. (A boy at the window begins to lower a cage to receive it.) The painting's short title is *The Air Pump*.

Ex-Voto de 1662 Philippe de Champaigne, 1662, Louvre, Paris.

The artist's best known work is an *ex-voto* (Latin, "from a vow") for 1662, that is, a work of art made as an offering to God in gratitude for a favor granted, in this case the miraculous cure of his daughter Catherine, a nun at the Jansenist convent of Port Royal, here shown praying in bed while the prioress kneels to pray beside her. The work's alternate title is *Mother Superior Catherine-Agnès Arnauld and Sister Catherine de Sainte-Suzanne Praying*, naming the prioress and the sick girl.

F

Faa iheihe Paul Gauguin, 1898, Tate Gallery, London.

The figures of the people and animals in the painting are similar to those in **Where Do We Come From? What Are We? Where Are We Going?**, on which the artist was working at the time, although the poses are different. The Tahitian title literally means "to decorate with ornaments," so an appropriate English equivalent might be *Adornment* or simply *Decoration*. It has been suggested that the title should really be *Faa ineihe* ("Preparations for a Festival"), but the artist's inscription in the bottom right corner of the work is perfectly legible, and the second letter of the second word is clearly a capital "H," not an "N." An alternate English title is *Tahitian Pastoral*. *Cf.* **Tahitian Pastorals**.

Faaturuma ("Reverie") Paul Gauguin, 1891, Nelson-Atkins Museum of Art, Kansas City, Kansas.

The painting is a portrait of a pensive young woman in a red dress seated in a rocker. She may be Teha'amana, the artist's *vahine* (woman) in Mataiea, Tahiti.

The Face of War Salvador Dalí, 1940, Boymans-van Beuningen Museum, Rotterdam.

The painting is symbolic rather than surreal. It depicts an anguished face with skulls in the place of the eyes and mouth and with further skulls in the eyes and mouths of those skulls. The face is thus "full of death," and symbolizes the age of concentration camps and mass murders.

The Faery Feller's Master-Stroke Richard Dadd, 1855–64, Tate Gallery, London.

The enigmatic painting depicts human or humanoid figures seen in various poses through a network of grasses and flowers. The figures all watch the fairy woodman ("feller") with ax raised high as he aims at a hazelnut in his "master-stroke." The significance of the key moment is unexplained.

The Fair Oysterinda *see* The **Oyster Girl**.

The Fair Toxophilites William Powell Frith, 1872, Royal Albert Memorial Museum, Exeter.

Three elegantly dressed young women practice archery. They were modeled by the artist's daughters, Alice, Fanny, and Louisa. The painting was originally exhibited under the title *English Archers, 19th Century.* "Toxophilite" ("lover of the bow") has a more romantic ring.

A Fair Wind *see* **Breezing Up**.

Fairy Dance in the Alder Grove Moritz von Schwind, *c.*1844, Städelsches Kunstinstitut, Frankfurt am Main.

Lightly robed young women and children, most naked to the waist, represent a group of dancing elves.

Faithful Charles Edward Perugini, *c.*1890, Walker Art Gallery, Liverpool.

A widow in black satin and bombazine grieves over her husband's grave in a typical example of the Victorian preoccupation with death.

The Faithful Colt William Harnett, 1890, Wadsworth Atheneum, Hartford, Connecticut.

A glance at the painting will show that the title does not allude to a a young horse but to a depiction of a Colt 45 pistol hanging from a nail.

Faithful Unto Death Sir Edward Poynter, 1865, Walker Art Gallery, Liverpool.

A Roman sentry stands loyally at his post while Pompeii and its inhabitants are destroyed by the eruption of Vesuvius. The title quotes a biblical phrase: "Be thou faithful unto death, and I will give thee a crown of life" (Revelation 2:10).

Fall Bridget Riley, 1963, Tate Gallery, London.

The painting comprises a mass of vertical wavy lines. The "waves" are more marked toward the bottom of the picture, giving the illusion of falling water or perhaps tumbling hair.

The Fall of Icarus Pieter Bruegel I, *c.*1554–58, Musées Royaux des Beaux-Arts, Brussels.

The painting depicts the culminating moment of the Greek myth of Daedalus and Icarus. The craftsman Daedalus built a wooden cow in which Queen Pasiphaë of Greece could meet her lover, a sacred bull. He then built a labyrinth to hide the monster offspring of their union, the Minotaur, part man, part bull. Furious that Daedalus aided his wife, King Minos banished Daedalus and his son Icarus to the labyrinth. The two prepared their escape, flying free on

wings made of wax and feathers. Daedalus advised Icarus not to fly too near the sun lest the max melt. In his excitement, however, he forgot this counsel. He flew high, the wax melted, and he now plunges headfirst into the sea. But a plowman, a shepherd, and a fisherman continue in their daily labor, seemingly unaware of the hapless Icarus. Their presence refers to an old German proverb: "No plow comes to a standstill because a man dies." The painting is described in W.H. Auden's poem, *Musée des Beaux Arts* (1940).

The Fall of Man Hugo van der Goes, *c.*1467–77, Kunsthistorisches Museum, Vienna.

The scene is the biblical Garden of Eden. Adam and Eve stand beneath the Tree of Knowledge, from which Eve is plucking a second fruit to give to Adam, while a humanoid serpent looks on. They are still naked, so at the moment depicted have not yet "fallen."

The Fall of Phaeton Sebastiano Ricci, 1703–4, Museo Civico, Belluno.

Phaeton, the headstrong son of Apollo, tumbles from the chariot of the sun after losing control when driving it and letting it come too close to earth. At the top of the painting, Zeus is about to kill him with a thunderbolt.

The Fall of the Cowboy Frederic Remington, 1895, Amon Carter Museum, Fort Worth, Texas.

Two cowboys return to the ranch after a day's work, one dismounting to open the gate through a barbed-wire fence. This sign of the end of the open range combines with the weary men and horses, the snow-covered ground, and the leaden sky over all to create a sense of depression that the cowboy's way of life is drawing to a close.

The Fall of the Rebel Angels Frans Floris, 1554, Koninklijk Museum, Antwerp.

The painting, as the central panel of a triptych, depicts the (literal) fall of those angels of God that became rebel spirits. The fall of rebel angels is referred to several times in the Bible, both in the Old Testament (*e.g.* Isaiah 14:12–15) and the New Testament (*e.g.* 2 Peter 2:4).

Falling Warrior Henry Moore, 1956–7, Huddersfield Art Gallery.

The semiabstract bronze sculpture is of a collapsed and dying warrior. The artist explained: "In the Falling Warrior sculpture, I

wanted a figure that was still alive. The pose in the first maquette was that of a completely dead figure so I altered it to make the action that of a figure falling, and the shield became a support for the warrior, emphasizing the dramatic moment that precedes death."

The False Mirror (French, *Le Faux Miroir*) René Magritte, 1929, Museum of Modern Art, New York.

The Surrealist painting is a close-up of a lashless eye, its iris a blue sky with fleecy clouds. The eye is held to reflect the soul of its owner. Here it is a false mirror.

The Family (1) Arthur Boyd Houghton, *c.*1862, private collection; (2) William Roberts, 1935, Leeds City Art Gallery; (3) Paula Rego, 1988, Saatchi Collection, London.

Houghton depicts his young wife Susan seated in an armchair with her two baby children, Arthur and Georgina, on her lap. Arthur is playing "coach and horses" with two long locks of his mother's hair, watched by his infant sister. Roberts depicts a peasant family, painted on a visit to Spain in 1934. (On reproducing the painting in 1964 he retitled it *The Peasants*.) Rego shows a woman, two young girls, and a man in a bedroom. The man sits on the end of the bed, apparently unable to move. The woman, presumably his wife, stands behind him and tugs at the sleeve of his jacket. The older of the girls faces him and presses close to him as she pulls at his trousers. The younger girl stands with her back to the window, her hands clasped. The man is the artist's husband, Victor Willing, who died in 1988 after suffering for 20 years with multiple sclerosis. The painting was begun when he was still alive, and was at first optimistically titled *The Raising of Lazarus*.

A Family Group Augustus John, *c.*1908, Hugh Lane Municipal Gallery of Modern Art, Dublin.

Two women and four young children, one a babe in arms, are in a meadow. The painting is an idealization of family life and depicts the artist's two wives, Ida (who died in 1907) and Dorelia, and their respective children.

The Family of Ferdinand IV Angelica Kauffmann, *c.*1782–84, Museo Nazionale di Capodimonte, Naples.

Ferdinand IV of Naples (later Ferdinand I of the Two Sicilies) (1751–1825) poses in a neo-classical setting for a group portrait with his wife, Maria Carolina of Austria (1752–1814), his six children, and two of his dogs.

The Family of Philip IV *see* Las **Meninas**.

The Family of the President Fernando Botero, 1967, Museum of Modern Art, New York.

The painting is a fairly free parody of Goya's *The Family of Charles IV* (1800), but with only seven figures, including a plump bishop and a saluting general, instead of the original 14 members of the house of Bourbon. The unspecific title seems to imply that the artist's grotesque, doll-like "family" could be that of the president of any country.

Family Portrait (1) Maerten van Heemskerk, *c.*1530, Staatliche Gemäldegalerie, Cassel; (2) Georg Baselitz, 1975, Staatliche Gemäldegalerie, Cassel.

The identity of the first family, mother and father with three young children, is unknown, but the painting is one of the most important in 16th-century Dutch portraiture. The second family is also anonymous. However, the viewer is disoriented to see that its members, a seated naked couple, are portrayed upside down.

Family Reunion (French, *Réunion de famille*) Frédéric Bazille, 1867, Musée d'Orsay, Paris.

Eleven members of the artist's family, including his parents, pose formally on the terrace at Méric, the family residence near Castelnau in the Lez valley.

Farewell, Farewell Peter Howson, 1995, Angela Flowers Gallery, London.

The painting is the first of a set of seven inspired by Stravinsky's opera *The Rake's Progress* (1951), itself based on Hogarth's A **Rake's Progress**. In this first scene, Tom Rake bids farewell to Anne Truelove, his proposed wife, having rejected a job offer from her father. The title quotes a phrase from the libretto (by W.H. Auden and Chester Kallman).

Farmers Nooning William S. Mount, 1836, Museums at Stony Brook, New York.

Farmworkers take their noonday rest under a tree. A youth sharpens his scythe while a young boy tickles the ear of a black man asprawl on a heap of hay.

Farnese Bull ?, (*c.*150 BC), Archaeological Museum, Naples.

The marble sculpture group, believed to be a Roman copy of a Greek original, depicts the punishment of Dirce, who in Greek legend was tied to the horns of a bull for her cruelty to

Antiope and trampled to death. The statue was found in Rome in 1545 and was part of the collection of antiquities built up by Cardinal Alessandro Farnese (1520–1589). Hence its name. (*Cf.* **Farnese Hercules**.)

Farnese Hercules Glycon, (4th c. BC), Archaeological Museum, Naples.

The gigantic marble statue depicts Hercules leaning on his club to rest after his labors. It is signed by an Athenian sculptor named Glycon and is a copy of an original probably by Lysippus. It was discovered in Rome in *c.*1546 and is so called because it was part of the Farnese collection (*see* **Farnese Bull**).

Fascination (French, *Fascination*) Victor Brauner, 1939, private collection.

The Surrealist painting centers on a table with the head of a wolf at one end and its tail and genitals at the other. A nude woman sits unconcernedly at the table, her hair curling up and over into a bird with a swan-like neck that mesmerizes the snarling wolf's head by its stare.

The Fastidious Bride (Russian, *Razborchivaya nevesta*) Pavel Fedotov, 1847, Tretyakov Gallery, Moscow.

A hunchbacked aristocrat goes down on one knee to propose to a middle-aged woman, while her father listens at the door. The artist took his subject from one of the fables of Ivan Krylov (1769–1844), in which an elderly bride, having refused all suitors in her youth, is finally obliged to marry a hunchback. The title is thus ironic.

Fatagaga Max Ernst and Jean Arp, 1920, private collection.

The Surrealist collage depicts a man's body with a bird for a head and bird's claws for feet and a woman with one arm awkwardly upraised. A bird perches on a branch nearby. The artists used this title for a number of collages of this type, as an abbreviation of French *Fabrication de tableaux garantis gazométriques* ("Manufacture of paintings guaranteed to be gasometric"), a phrase that may or may not have had some significance for the inventors.

Fatata te miti ("Near the Sea") Paul Gauguin, 1892, National Gallery, Washington, D.C.

Two naked Tahitian women bathe in the sea, apparently unconcerned by a fisherman in the background. One of the women is based on that in **Ondine**. Variants of the English title are *By the Sea* and *The Sea Is Near*.

The Fate of Animals (German, *Tierschicksale*) Franz Marc, 1913, Kunstmuseum, Basel.

The painting depicts a cataclysmic destruction of animal life. A blue deer raises its head as a tree falls. To the right are red foxes, and at top left, green horses. The artist wrote on the back of the picture, as what may be regarded as the original title: "*Und alles Sein ist flammend Leid*" ("And all being is flaming suffering"). He saw the picture as a premonition of war, and himself died in combat at Verdun in World War I. The work is also known in English as *Animal Fates* or *Animal Destinies*, more closely reflecting the German original, in which *Schicksale* is plural.

The Father Reading the Bible to His Family (French, *Le Père lisant la Bible à sa famille*) Jean-Baptiste Greuze, 1755, Louvre, Paris.

The title accurately describes the painting's subject, although the father is not simply reading the Bible but expounding it to his offspring. Hence the work's alternate French title: *Un père de famille expliquant la Bible à ses enfants* ("A Father Explaining the Bible to His Children").

Fatherly Advice Gerard Terborch, 1654–5, Staatliche Museen, Berlin.

A father gives friendly advice to his daughter. Or so it seems, and the title implies. But the depiction was originally of a soldier propositioning a courtesan in a brothel. The artist later painted out the coin that he offered her. The work is also known as *Parental Admonition*.

Fatidica Frederic Leighton, *c.*1894, Lady Lever Art Gallery, Port Sunlight.

A young woman in a white robe leans back serenely but pensively in a throne-like chair. She is Fatidica ("fate-teller"), a prophetess who foretold the future to women.

A Favorite Custom Sir Lawrence Alma-Tadema, 1909, Tate Gallery, London.

In a neoclassical setting, two naked young women play in the water of a marble palace pool, their game (splashing each other) being the "favorite custom" of the title. Other bathers stand or sit in various stages of undress in the background.

The Favorites of the Emperor Honorius John William Waterhouse, 1883, Art Gallery of South Australia, Adelaide.

Seated on his throne, a Roman emperor scatters grain from a golden salver on his lap to

the birds at his feet as priests bow humbly before him while waiting for an audience. He is Honorius (AD 384–423), famous for his weakness, and the birds are his "favorites." (The servile priests may also be.) The subject for the painting was apparently suggested by a passage in Wilkie Collins's *Antonina* (1850), a historical novel about the fall of Rome.

Fazio's Mistress Dante Gabriel Rossetti, 1863, Tate Gallery, London.

The portrait of an auburn-haired woman is that of the mistress of the Italian poet Fazio degli Uberti (*c*.1305–*c*.1367), described in his verses, which Rossetti had translated and included in his *Early Italian Poets* (1861). The picture's subtitle is *Aurelia*, but the actual name of Fazio's mistress was Agniola di Verona. She is also the subject of **Woman Combing Her Hair**. The model for the painting was the artist's own mistress, Frances Cornforth.

The Feast in the House of Levi Paolo Veronese, 1573, Accademia, Venice.

The scene is from the New Testament: "And Levi made (Jesus) a great feast in his own house: and there was a great company of publicans and of others that sat down with them" (Luke 5:29). The painting's original title was *The Last Supper*, but when the many drunkards and other dubious characters depicted led to the artist's being examined by the Inquisition on a charge of heresy, he simply changed the title to *The Feast in the House of Levi*. As this feast was attended by publicans and sinners, as well as Christ, the unacceptable elements in the work could be allowed.

The Feast of the Ascension (Italian, *La festa della Sensa*) Francesco Guardi, *c*.1775, Gulbenkian Foundation, Lisbon.

A crowd of people throngs around the pavilions that have been erected in Venice for the Feast of the Ascension, known in the Venetian dialect as *Sensa* (a corruption of Italian *Ascensione*).

The Feast of the Gods Giovanni Bellini, 1514, National Gallery, Washington, D.C.

The depiction of classical gods and goddesses feasting is an overpainting by Titian of Bellini's original landscape.

The Feast of the Rose Garlands Albrecht Dürer, 1506, National Gallery, Prague.

The painting depicts Pope Julius II and the Emperor Maximilian, representing the spiritual and temporal worlds respectively, leading a large crowd of worshippers in adoration of the Virgin and Child and of St. Dominic, the founder of the cult of the rosary. Humankind thus receives from these three the blessing of the rosary in the form of rose garlands.

The Feast of Venus Peter Paul Rubens, *c*.1630–40, Kunsthistorisches Museum, Vienna.

The painting centers on a nude statue of Venus, the goddess of love, around which naked men, women, and children dance, kiss, and generally enjoy life, transported by the sensual pleasures of love. The "feast" is also represented by the bunches of grapes and other fruit that hang from the branches above.

Feathered Damien Hirst, 1983–5, private collection.

The title of the abstract mixed media collage presumably refers to the bird's feather that is tucked away in the bottom center. It could also allude to the way the paint has been applied to the right-hand panel, using a "feathering" technique.

February Azure (Russian, *Fevral'skaya lazur'*) Igor Grabar, 1904, Tretyakov Gallery, Moscow.

The sky shines bright blue through the bare branches of a group of silver birches, their shadows casting a deeper blue on the snow beneath. These "blues" are the azure of the title.

February Fill Dyke Benjamin William Leader, 1881, Birmingham City Art Gallery.

The painting depicts a bleak winter scene in the country near a small village. Leafless tress stand bare against a sunset sky while below the ruts of a cart track are filled with pools. The title quotes from the old country rhyme about February as a wet month of rain or snow: "February fill the dyke, / Be it black or be it white, / But if it be white / It's the better to like."

Feeding the Birds *see* **In the Peristyle**.

Feeding the Swans Edith Hayllar, 1889, Sotheby's, London.

Women and girls of different ages and generations sit or stand on the riverside steps of a garden pavilion. Only the two youngest feed the swans of the title, which may be intended to imply that they alone are at the stage of growing into similarly beautiful and graceful beings.

Feeling Much Better George Bernard O'Neill, 1901, Ackermann & Johnson, Ltd., London.

A fresh-faced young invalid reclining on a sofa gazes adoringly at the pretty young girl who sits on the couch beside him and who has presented him with a posy of roses. A pet dog with his paws up on the sickbed wags his tail happily: his master is clearly "feeling much better."

The Female Contains All Qualities Ceri Richards, 1937, Tate Gallery, London.

The painting depicts biomorphic forms representing a generously endowed female towering over an admiring male. Her figure is "fuller" than that of the male to represent her repleteness of attributes, as the title implies.

Female Fig Leaf (French, *Feuille de vigne femelle*) Marcel Duchamp, 1950, private collection.

The sculpture is a concave mold of the female pubic region in galvanized plaster. The title thus deliberately misleads, since the work does not conceal the area but reveals it.

Female Nude (French, *Nue*) Pierre-Auguste Renoir, 1876, Pushkin Museum, Moscow.

The portrait of a seated nude is also known as *Anna*. The model is the woman also depicted in **Nana**. Other alternate titles are *The Nude* and *Nude Woman Sitting*, and the painting has also been known as *The Pearl* "because of the preciousness of the presentation" (Gruitrooy).

Ferdinand Lured by Ariel John Everett Millais, 1849–50, private collection.

The painting depicts a scene from Shakespeare's *The Tempest* (1611). Prospero's servant, the sprite Ariel, leads Ferdinand to his master, teasing him as he goes about the death in a shipwreck of his father, the King of Naples.

Fête Champêtre ("Country Party") (1) Giorgione, *c*.1510, Louvre, Paris; (2) Jean-Baptiste Pater, *c*.1730, National Gallery, Washington, D.C.

The title is used for a romantic depiction of an outdoor entertainment, usually centering on a meal, and often with music, dancing, and flirting. (From the 18th century the term specifically applied to a party of this kind at which members of the French aristocracy were dressed as shepherds and shepherdesses.) Giorgione's painting, which depicts two seated men engaged in conversation between two nude women, one of whom fills a jug from a well, was largely the work of Titian. It is also known as *Concert Champêtre*. It was this work that probably inspired Manet's Le **Déjeuner sur l'Herbe**.

Les Fêtes Vénitiennes ("The Venetian Parties") Antoine Watteau, *c*.1718–19, National Gallery of Scotland, Edinburgh.

The painting depicts a *fête galante* ("courtship party"), a variant on the traditional **Fête Champêtre**, with figures in ball dress dancing and generally disporting themselves amorously in a parkland setting.

Fiammetta Singing Marie Spartali, 1879, private collection.

A young woman sings in a garden in an Italian Renaissance setting. She is Fiammetta, the name used by Boccaccio for his lover, Maria d'Aquino, and the subject of his romance *Fiammetta amorosa* (1343). When first exhibited, the painting was accompanied by a five-line quotation from Dante Gabriel Rossetti's translation of Boccaccio's poem. The artist herself sat to Rossetti as Fiammetta in A **Vision of Fiammetta**.

Fidelity Briton Rivière, 1869, Lady Lever Art Gallery, Port Sunlight.

The painting shows a poacher and his dog locked up awaiting trial. The man sits dejectedly, one arm in a sling, the other covering his face, while his loyal companion rests his head on his master's knee and looks up sorrowfully. The original title was *Prisoners*, describing the state in which the two now find themselves, but this was changed by Lord Leverhulme when he bought the painting in 1903 to promote Sunlight Soap by offering color reproductions of the picture in exchange for a particular number of soap wrappers or coupons.

Field Hand Andrew Wyeth, 1985, National Gallery, Washington, D.C.

A black farm laborer rests from his work beside a fallen tree trunk. On it lies his prosthetic arm, in the form of a hook. The false limb is the "field hand" of the title, as more obviously is the laborer himself.

Fiercely the Red Sun Descending Burned His Way Across the Heavens Thomas Moran, 1875–6, North Carolina Museum of Art, Raleigh.

The painting depicts a fiery sunset (borrowed from J.M.W. Turner's The **Slave Ship**) over a stormy sea with a menacing group of rocks and caves. The picture illustrates the title, which quotes two lines from Part IX ("Hiawatha and the Pearl-Feather") of H.W. Longfellow's *The Song of Hiawatha* (1855) (although the text itself has "along," not "across").

The Fifer (French, *Le Fifre*) Édouard Manet, 1866, Musée d'Orsay, Paris.

The portrait of a uniformed boy fife player was posed by a young member of the Imperial Guard.

The Fight Interrupted William Mulready, 1816, Victoria and Albert Museum, London.

A schoolmaster intervenes to halt a fist fight between two of his pupils.

Fighting for the Woman (German, *Kampf ums Weib*) Franz von Stuck, 1927, private collection.

Two naked men wrestle for a naked young woman, who watches anxiously, half turning from the scene.

Fighting Forms Franz Marc, 1914, Neue Pinakothek, Munich.

The abstract painting, which has virtually no representational content, depicts an expression of convulsive fury. The artist painted other works with similar titles, such as *Struggling Forms*, *Broken Forms*, and *Cheerful Forms*.

Fighting Gladiator *see* **Borghese Warrior**.

The Fighting Temeraire J.M.W. Turner, 1838, National Gallery, London.

The warship *Fighting Temeraire*, which had fought at the Battle of Trafalgar (1805), is being towed by a steamer up the Thames to London and the wrecker's yard. The artist witnessed the sight in 1838, and painted it against the red sunset that had been its original backdrop. The ship herself was named for the *Téméraire* ("Daring"), a French ship captured in 1759 at Lagos Bay. Following her Trafalgar victory, she was known as the *Fighting Temeraire*. The painting's full formal title is *The "Fighting Temeraire" Tugged to Her Last Berth to Be Broken Up*.

Figure in Flenite Sir Jacob Epstein, 1913, Tate Gallery, London.

The serpentine sculpture of a figure with bowed head, reminiscent of African art, takes its title from its material. Flenite is more commonly known as serpentine, but the artist may have been attracted by the alliterative euphony.

The Figure on the Beach Nicolas de Staël, 1952, Kunstsammlung Nordrhein-Westfalen, Düsseldorf.

The abstract painting is entirely non-figurative, with a patchwork of rectangular forms on a red background, and thus can only be interpreted in terms of its title.

Figures of Night (French, *Les Figures de la nuit*) René Magritte, 1927, Sprengel Museum, Hanover.

Four cutout figures walk along a corridor inside a building. The figures are essentially silhouettes, and the area of each is entirely covered by the depiction of a cloudy night sky.

The Finding of Don Juan by Haidee
Ford Madox Brown, 1878, Musée d'Orsay, Paris.

The naked and apparently lifeless body of Don Juan is found washed up on the shore of a Greek island by Haydee, a Greek pirate's daughter. (She revives him and they fall in love.) The scene is from Byron's *Don Juan* (1818–19), Canto II, verses 110–112, with its last two lines: "And slowly by his swimming eyes was seen / A lovely female face of seventeen."

The Finding of Moses (1) Paolo Veronese, *c.*1580, Prado, Madrid; (2) Sébastien Bourdon, *c.*1650, National Gallery, Washington, D.C.; (3) Giovanni Battista Tiepolo, *c.*1730, National Gallery of Scotland, Edinburgh; (4) Sir Lawrence Alma-Tadema, 1904, private collection.

All four paintings depict versions of the Old Testament story telling how Pharaoh's daughter finds the baby Moses in "an ark of bulrushes" in the Nile (Exodus 2:5). In Veronese's picture, she looks on as the baby is held by an attendant. In Bourdon's, two men have recovered the basket and hand it to the servant women while she looks on. In Tiepolo's, she stands among a group of servants and entrusts the baby to a nurse. In Alma-Tadema's, both she in her litter and the baby in his basket are being carried to Pharaoh's palace. The title is thus not strictly accurate, since in each case the depiction is not actually that of the discovery.

The Finding of the Laocoön (French, *La Découverte du Laocoon*) Hubert Robert, 1773, Virginia Museum of Fine Arts, Richmond, Virginia.

The painting is a romantic depiction of the rediscovery of the **Laocoön** in Rome in 1506.

The Finding of the Saviour in the Temple William Holman Hunt, 1854–60, Birmingham City Art Gallery.

The scene is from the New Testament. Joseph and Mary find their 12-year-old son Jesus in the Temple at Jerusalem, "sitting in the midst of the doctors, both hearing them and asking

them questions" (Luke 2:46). (In the picture he is standing, not sitting.) The work is said to be the first religious picture to be painted in the location where the event took place.

Finishing Touches Jessica Hayllar, 1887, present location unknown.

The picture shows the artist's younger sister, Edith Hayllar, putting the finishing touches to a painting she is working on at the family home at Castle Priory, Wallingford, Berkshire (now Oxfordshire).

The Fire Engine Ernest Opper, *c*.1900, Museum of Art, Providence, Rhode Island.

An old-fashioned red "pumper" engine, drawn by a pair of fire horses, races down Main Street, Elizabeth, New Jersey, which is where the artist painted it.

A Fireside Party Sir Edwin Landseer, 1829, Victoria and Albert Museum, London.

A group of dogs stand, sit or lie drowsily in front of an open fire. The painting was originally exhibited with the title *Conversazione*.

First Class: The Meeting Abraham Solomon, 1854, Southampton Art Gallery.

A father, his daughter, and the latter's admirer, a young naval officer, travel in comfort in a first-class railroad carriage as they engage in pleasant conversation and wordless dalliance. An attractive pastoral scene is seen through the window. The painting is a depiction of upper-middle-class life, and is a pendant (companion picture) to **Second Class: The Parting.**

The First Cloud Sir William Quiller Orchardson, 1887, Tate Gallery, London.

A glaring husband, hands thrust into his pockets as he stands with his back to the fireplace in a spacious drawing room, watches his young wife flounce out. The depiction is one of domestic discord. The couple have already had a tiff, and "the first cloud" has appeared in the hitherto unbroken sky of their marriage.

First Communion of Anemic Young Girls in the Snow (French, *Première communion de jeunes filles chlorotiques par un temps de neige*) Alphonse Allais, 1883, Musée des Arts Décoratifs, Paris.

The "painting" is simply a sheet of pristine white Bristol board. Young girls making their first communion wear white robes that show only their pale anemic faces. If they then stand in the snow they will be invisible against the

white background. The artist "painted" similar burlesque pieces the following year, such as *Apoplectic Cardinals Harvesting Tomatoes on the Shore of the Red Sea (Study of the Aurora Borealis)*, an all-red variant of the above.

The First Earring David Wilkie, 1835, Tate Gallery, London.

A young girl sits apprehensively before her mother as a maid fastens on her first earring.

The First Letter (Italian, *La primera lettera*) Alessandro Morbelli, 1890, private collection.

A young woman stands by a railing reading a letter, presumably the first from her sweetheart. The woman was modeled by the artist's young wife, Maria Pagni.

First Love William Mulready, 1840, Victoria and Albert Museum, London.

A young mother with her baby and lover whispering sweet nothings behind a tree are rudely interrupted when the girl's mother and younger brother run out of a nearby cottage to call her in to supper. A description of the painting in the 1986 catalog points to the complex layers of meaning implicit in the title: "Is 'First Love' the love of the child for its mother or of the youth for the young woman? If this is 'First Love' what is second love?"

The First Morning (French, *Le Premier Matin*) Égide Rombaux, 1913, Tate Gallery, London.

The marble statue depicts a nude young woman sleepily sitting up. She is Eve, waking from sleep after the Creation.

The First of October Edith Hayllar, 1888, Sotheby's, London.

Three Victorian sportsmen relax over an outdoor lunch table after a morning's pheasant shooting, the dead birds lying beside them. The date of the title is the first day following the end of the close season for pheasant shooting on September 30, a date still in force today.

The First Outing (French, *La Première Sortie*) Pierre-Auguste Renoir, *c*.1875–6, Tate Gallery, London.

Two young women, one holding a nosegay of flowers, make their first visit to a café concert. The present title may not have been the original one. The picture was entered in an 1899 sale as *Café-Concert* and was reproduced in 1918 as *At the Theatre*.

A First Rate Man of War Driving on a Reef of Rocks and Floundering in a

Gale George Philip Reinagle, 1826, Royal Albert Memorial Museum, Exeter.

The title is an accurate description of the scene, in which a man of war flies the union flag while braving storm and waves with broken mast and torn sails. The depiction may be allegorical, alluding to the ship of state weathering what was then a stormy period in British history, in which case the title is metaphorical also.

The First Reading Lesson (Italian, *Prime lettere*) Plinio Nomellini, *c.*1905, Civica Galleria d'Arte Moderna, Milan.

Seated at a table on a shady terrace, a mother teaches her young child to read. The woman is the artist's wife and the child their own. The Italian title literally means "First Letters."

The First Real Target? Peter Blake, 1961, Robert Fraser Gallery, London.

The title of the conventional depiction of a target probably refers to Jasper Johns's target paintings of the late 1950s. This would thus be the first "real" one.

Fish Out of Water Richard Deacon, 1987, Saatchi Collection, London.

The sculpture is a representation of a stranded fish, made of laminated hardboard. The title works two ways, for it both describes the object represented and alludes to its unique form and appearance. The work is a "fish out of water," different from others. "Much of Deacon's sculpture 'refers' to the human or animal body, yet without courting an unambiguous or non-ironic relation between the sculpture's form and its title" (Taylor, p. 85).

The Fisherman and the Siren Frederic Leighton, 1858, Bristol City Art Gallery.

A naked mermaid reaches up to embrace a half-drowned fisherman on a rock by the sea. The painting's original full title was *The Fisherman and the Syren—from a Ballad by Goethe*. The reference is to Goethe's ballad *Der Fischer* ("The Fisherman") (1779) telling of a nymph who entices a fisherman into the depths of the ocean. The picture was later retitled *The Mermaid*, but even so is still better known by the (slightly modernized) original title.

Fishermen at Sea J.M.W. Turner, 1796, Tate Gallery, London.

The artist's first oil painting is a moonlit scene depicting fishermen struggling in a gale off The Needles, Isle of Wight.

The Fitting Paula Rego, 1990, Saatchi Collection, London.

A statuesque debutante is being fitted for a dress for her "coming-out" ball. Her plump flesh and the full folds of the dress evoke more a calf being fatted for the meat market, or an offering made for the sacrificial altar of marriage, than a butterfly emerging from a chrysalis.

Five Feet of Colored Tools Jim Dine, 1962, Museum of Modern Art, New York.

A number of tools such as hammers, drills, pliers, and saws have been dipped in paint of different colors and suspended in a row across the top of an otherwise empty canvas. The "five feet" of the title is the height of the canvas.

Flag Jasper Johns, 1954–5, Museum of Modern Art, New York.

The art object is an exact reproduction of the American flag in its pre–1960 form. The artist aimed to create a familiar object in an unfamiliar medium, in this case encaustic, oil, and collage on fabric mounted on plywood. The title states that the result is a flag. But is it?

The Flagellation of Christ (1) Piero della Francesca, late 1450s, Galleria Nazionale delle Marche, Urbino; (2) Jörg Ratgeb, 1518–19, Staatsgalerie, Stuttgart; (3) Caravaggio, 1606, Mueso di Capodimonte, Naples.

The scene is from the New Testament. Having tried Jesus, Pontius Pilate has him scourged before sending him to be crucified (Matthew 27:26, Mark 15:15, John 19:1).

Flaming June Frederic Leighton, *c.*1895, Museo de Arte de Ponce, Puerto Rico.

Clad in bright orange drapery, a sleeping young woman is bathed in golden sunlight. (She is Dorothy Dene, the artist's model in his latter years.) The words of the title traditionally apply to one of the warmest months of the year.

The Flea Giuseppe Maria Crespi, *c.*1707–9, Uffizi, Florence.

A servant girl sits on her bed wearing only a shift and searches inside it for the flea that she can thinks she can feel on her breast. The painting's Italian title is *Donna che si spulcia*, "Woman searching herself for fleas."

Flight and Pursuit William Rimmer, 1872, Museum of Fine Arts, Boston, Massachusetts.

The artist's best known painting is a nightmarish depiction of a man endlessly pursuing his

own shadow. It thus represents the classic doppelgänger image of the paranoid schizophrenic.

The Flight into Egypt (1) Gaudenzio Ferrari, *c*.1511–13, Sta. Maria delle Grazie, Varallo; (2) Giovanni Battista Crespi, *c*.1600–10, Bristol Museums and Art Gallery; (3) Annibale Carracci, *c*.1604, Doria Gallery, Rome; (4) Adam Elsheimer, 1609, Alte Pinakothek, Munich; (5) Domenico Feti, *c*.1621–3, Kunsthistorisches Museum, Vienna.

The scene is from the New Testament. Joseph and Mary flee with the infant Jesus to Egypt to escape the wrath of Herod, who vows to kill him as a rival to the throne (Matthew 2:14).

Flora and the Zephyrs John William Waterhouse, *c*.1898, private collection.

Flora, the Roman goddess of flowering plants, sits garlanded among girls and young women who pick and carry flowers as zephyrs, gods of the west wind, gently blow on her.

Florence Triumphant Over Pisa Giambologna, *c*.1575, Bargello, Florence.

The sculpture symbolizes the reconquering of the city-state of Pisa in 1509 by Florence, its age-old Tuscan rival.

The Flower Vendor Diego Rivera, 1935, Museum of Modern Art, San Francisco, California.

A peon waits patiently on hands and knees while his wife adjusts a huge basket of flowers bound to his back.

The Folk Song (Italian, *Canto dello stornello*) Silvestro Lega, 1867, Pitti, Florence.

Three young women genteelly make music, one playing the piano while the two others sing. A stornello is a traditional type of Tuscan folk song.

The Follies *see* Los **Caprichos**.

F-111 James Rosenquist, 1964–5, Museum of Modern Art, New York.

The huge multipanel painting, 86 feet long, is a fantasy about the consequences of a nuclear catastrophe, which at the time seemed very real. The title is the designation of the fighter-bomber that was the latest American weapon in Vietnam. Its fuselage form the background of the depiction, which comprises a host of contemporary images, all of them significant. (An angel-food ring cake is a missile silo, the hairdryer under which a little girl sits is a pilot's

combat helmet, a beach umbrella is a "nuclear umbrella.")

For Better, for Worse William Powell Frith, 1881, Forbes Magazine Collection.

A middle-class couple board a coach in a London square after their wedding reception. The words of the title are at one level taken from the marriage service ("To have and to hold from this day forward, for better for worse, for richer for poorer, in sickness and in health"). But a poor woman carrying a baby in her arms stands in the foreground, out of sight of the couple, and the implication seems to be that the child is the bridegroom's, and that the woman has come to see what sort of a bride he has. This possibility gives the title a whole new import. The artist's depiction may even have been autobiographical.

For Eighty Cents? (Italian, *Per ottanta centesimi?*) Angelo Morbelli, 1895, Civico Museo Antonio Borgogna, Vercelli.

A row of women bend down to weed a rice paddy, their bare feet embedded in the soggy soil. The title points to the pitifully low wage they received for this long, back-breaking work. Italy suffered a grave agricultural crisis in the early 1890s, with wages dropping sharply.

"For Only One Short Hour" Anna Blunden, 1854, Christopher Wood, London.

Her hands clasped as if in prayer, a seamstress pauses in her work at dawn in an attic room by an open window. The painting was originally exhibited with a quotation of four lines from Thomas Hood's poem *The Song of the Shirt* (1843), the first of which gave the title: "For only one short hour / To feel as I used to feel, / Before I knew the woes of want / And the walk that costs a meal!"

Foreign Body Mona Hatoum, 1994, Musée National d'Art Moderne, Paris.

The work is a videofilm of the interior of the artist's body, created by means of a microscopic camera inserted in the body's different orifices and passed along internal tubes. The title puns on the well known phrase, but also serves as a reminder that a person's familiar exterior conceals a quite alien interior. The work is additionally a self-portrait, since the artist became a stranger (a "foreign body") when isolated from her Lebanese homeland.

The Forest Fire Piero di Cosimo, *c*.1487–9, Ashmolean Museum, Oxford.

Animals and birds flee or wait in fear as a

forest fire rages in the background of the painting.

Forging the Anchor Stanhope Forbes, 1892, Ipswich Art Galleries.

A ship's anchor is being hammered into shape in a forge. The subject was presumably intended to symbolize Britain's maritime might at this time.

La Fornarina (1) Raphael, *c*.1518, Palazzo Barberini, Rome; (2) *see* **Portrait of a Woman**.

The portrait of a seminude young woman seated in a wood is reputedly that of the artist's mistress, said to have been a baker's daughter (Italian, *fornarina*) named Margherita. The bracelet on her arm has the inscription *Raphael Urbinas*. (The artist was originally named Raffaello Sanzio but was also known as *Raffaello da Urbino*, "Raphael of Urbino," for his birthplace.) The title dates from about 1750. The same woman is portrayed in The **Lady with a Veil**. The painting has also been known as *Raphael's Mistress*.

The Fortune Teller Caravaggio, *c*.1594–5, Louvre, Paris.

A foppishly dressed youth holds out his hand to a young gypsy girl for her to read his palm. The painting is also known by its Italian title, *La Zingara*, "The Gypsy". *Cf.* The **Young Fortune Teller**.

42 Kids George Bellows, 1907, Corcoran Gallery, Washington, D.C.

Naked working-class boys gather on a crumbling wooden pier to dive and swim in the nearby river. As only 21 can be individually counted, the title suggests that they seem to be twice as many, or that each has a "double" of some kind. They are "kids," not boys or children, implying they are truants or mischief-makers.

Found Dante Gabriel Rossetti, 1854, Delaware Art Museum, Wilmington, Delaware.

A young woman collapses (as a "fallen woman") by a churchyard wall as she recognizes the farmer who has found her as her former lover. The calf in the farmer's cart nearby tries to escape from the net that holds it. The painting remained unfinished.

Found Drowned George Frederic Watts, *c*.1849, Watts Gallery, Compton, Surrey.

The body of a young woman lies under the dark arch of the London bridge from whose parapet she has thrown herself into the Thames. The depiction is said to be based on an incident witnessed by the artist. The title echoes a police description of a suicide.

Fountain Marcel Duchamp, 1917, Philadelphia Museum of Art, Pennsylvania.

The work is a porcelain urinal which the artist bought in 1917 from a New York plumbing firm. He signed it "R. Mutt" to dissociate himself from it (the name is that of a firm of sanitaryware manufacturers) then set it on its back and presented it as a "ready-made," an everyday manufactured object elevated to the status of a work of art. "The urinal's new title, *Fountain*, and also its position demonstrate an inversion of the object's intended function" (Lynton, p. 131). The original has been lost.

Fountain of Neptune Giambologna, 1563–6, Bologna.

The bronze sculpture, originally designed for a fountain in Florence, emulated Michelangelo's *Victory* and centers on a nude figure of Neptune. (A full-scale plaster model of the work was set up with the *Victory* in the Palazzo Vecchio, but was replaced in 1570 by the marble version, now in the Museo Nazionale.)

The Fountain of Youth (1) Lucas Cranach I (or II), 1546, Staatliche Museen, Berlin; (2) *see* **Love at the Source of Life**.

The fountain of youth was a mythical pool believed to preserve or restore the youth of any who bathed in it. In this painting it takes the form of a swimpool, in which young women (no men) are bathing. Elderly women are being carried to one side of the pool and can be seen emerging rejuvenated on the other, where they are sent by a nobleman into a tent to dress. A meal is in progress in the middle distance, depicting the youthful pleasures of food, drink, music, and love. Some men who have not been rejuvenated look on in envy.

Four basic kinds of straight lines and their combinations Sol LeWitt, 1969, Lisson Gallery, London.

The deadpan title describes the work, which consists of 15 squares containing different types of straight lines, either singly or in combination: (1) vertical, (2) horizontal, (3) diagonal left to right, and (4) diagonal right to left. The squares are numbered with the type or types of line. Thus the first square, numbered 1, has just vertical lines. The square numbered 23 combines

horizontal and left-to-right diagonal lines, and the last and densest square, numbered 1234, combines all four types. The 16th square of the display defines the types of line. The whole is in black and white. The artist created an identical work but with the four types color-coded: yellow for vertical, black for horizontal, red for left-to-right diagonal, and blue for right-to-left diagonal. Its title: *Four basic colors and their combinations* (1971).

Four Knights Gilbert and George, 1980, Southampton City Art Gallery.

The work comrpises a set of full-length black and white photo portraits of four teenage youths below a row of color-tinted head shots of each, respectively green, blue, yellow, and red, but with each different from the portrait below. Since the colors of the upper row suggest the jewels of a crown, the title may have a royal reference, such as to the four poursuivants of the College of Arms: Portcullis, Bluemantle, Rouge Croix, and Rouge Dragon.

Four Lane Road Edward Hopper, 1956, private collection.

The owner of a rural gas station sits patiently in a folding chair, waiting in vain for traffic to turn in from the road that has now presumably been bypassed by a four-lane highway. His wife hurls abuse at his back as she leans from a window.

Four Rahsbs 4 Barry Flanagan, 1967, Solomon R. Guggenheim Museum, New York.

The work consists of four standing objects tapering towards the top. They are "rahsbs," a word denoting the materials from which they are made: *r*esin *a*nd *h*essian *s*and*b*ags.

The Four Seasons (French, *Les Quatre Saisons*) Nicolas Poussin, 1660–4, Louvre, Paris.

The artist painted four historical episodes combined with biblical references to depict each of the four seasons. Winter, for example, is represented by the Deluge.

The Four Stages of Cruelty William Hogarth, 1751.

The set of four engravings charts the descent of Tom Nero from torturing animals (*The First Stage of Cruelty*) to murdering a maidservant after forcing her to steal her mistress's plate (*Cruelty in Perfection*). He meets his end in the fourth print (*The Reward of Cruelty*), where he is shown being disembowelled and having his eyes cut out in the dissecting room of the Barber-Surgeons'

Company. The set is also known as simply *Stages of Cruelty*.

Four Times of the Day Francis Wheatley, 1799, Yale Center for British Art, New Haven, Connecticut.

The series of four paintings, respectively entitled *Morning*, *Noon*, *Evening*, and *Night*, purports to present a typical day in the life of an English yeoman's family. The overall impression is of a life of domestic delight and bucolic bliss. *Noon*, for example, depicts the whole family gathered for an alfresco picnic in the fields.

The Fourth Estate (Italian, *Il quarto stato*) Giuseppe Pellizza da Volpedo, 1901, Civica Galleria d'Arte Moderna, Milan.

A crowd of workers advances, headed by a young couple and their child. They are the Fourth Estate, the working classes advancing towards social justice. (The first three estates are the clergy, nobility, and commons, the fourth estate being any new group that wields political power.) Pellizza intended the painting to be his political and artistic manifesto. The first version of the work, executed *c*.1892 and depicting three spokesmen for a distant crowd of striking agricultural workers, was entitled *Ambassadors of Hunger* (Italian, *Ambasciatori della fama*). By 1895 the artist had sketched out a new version, entitled *The Flood* (Italian, *Fiumana*). He then abandoned this and by mid–1898 began another work entitled *The Worker's Progress* (Italian, *Il progresso dell'operaio*), and this was initially the title of the present work. The current title, adopted in 1902, may have been taken from Jean Jaurès's *Histoire socialiste de la Révolution française* (1901–7), which Pellizza had read as it was published. Jaurès in turn may well have taken up the term from earlier writers such as Carlyle, Hazlitt, and Macaulay.

Fox Hunt Winslow Homer, 1893, Pennsylvania Academy of the Fine Arts, Philadelphia, Pennsylvania.

A starving fox struggles through deep snow, harassed by the crows who will hasten his death.

Fragments Lisa Milroy, 1987, Jack Shainman Gallery, New York.

The painting, done from memory, depicts twenty individual pieces of Greek pottery, arranged in rows of five. If assembled, they would not create a complete item.

Franz West Mary Heilmann, 1995, private collection.

The painting is not a portrait but an arrangement of different colored patches that evokes the outdoor installation of colorfully carpeted chairs created by the named Austrian artist.

Frari Triptych Giovanni Bellini, 1488, S. Maria Gloriosa dei Frari, Venice.

The altarpiece, alternately known simply as *Madonna and Child with Saints*, takes its distinguishing name from the dedication of the church in which it stands.

Freedom from Want Norman Rockwell, 1943, Norman Rockwell Museum, Stockbridge, Massachusetts.

A mother places a mountainous Thanksgiving turkey on the family table. The title implies that the diners are reaping the rewards of their labor and virtuous living, an impression confirmed by the sober glasses of water that they have before them. The title itself quotes from F.D. Roosevelt's Message to Congress of January 6, 1941: "We must look forward to a world founded upon four essential human freedoms… The third is freedom from want."

Freight Cars in March Charles Burchfield, 1933, Tate Gallery, London.

The painting of two freight cars in a bleak landscape was originally known as *Railway Trucks*. But the American artist wrote as follows in a letter of May 17, 1953: "The picture which you call 'Railway Trucks' … went out under the title 'Freight Cars in March.' I prefer my title because season is important to me in all my work, and in this painting I have tried to give the feeling of March, which in our locality (Gardenville, New York) is very cold and bleak" (quoted in Alley, p. 20).

Fresh from the Altar Jessica Hayllar, 1890, Christie's, London.

A wedding has just taken place, and the bride is greeted by an older woman in the room where the reception will be held. On the wall above the bride is an engraving of the coronation of Queen Victoria at the moment when she, too, was "fresh from the altar."

Fresh Widow Marcel Duchamp, 1920, Museum of Modern Art, New York.

The work consists of a miniature window, painted green and with glass panes covered with squares of black polished leather. The black panes denote mourning for a recent death, although the title is, predictably, a pun on "French window."

A Freshet William Stott of Oldham, *c.*1885, Oldham Art Gallery.

A freshet is a rush of water resulting from heavy rain or melting snow, and this is the subject of the painting, which depicts an icy torrent tumbling down into a fast-flowing river.

Friedland *see* **1807**.

The Friends *see* **Women Asleep**.

From Hand to Mouth Bruce Nauman, 1967, Hirshhorn Museum, Washington, D.C.

The work is a model hand and arm made of wax covered in cloth. At the top of the arm, above the shoulder and part of the neck, is just the mouth and chin of a face. The piece and title pun on the familiar phrase, turning the metaphorical into a representation of the literal.

From the Faraway Nearby Georgia O'Keeffe, 1937, Metropolitan Museum of Art, New York.

An animal's skull with huge branching antlers is set in a mountainous landscape as a representation of the reality and spirit of New Mexico. The artist is said to have based the almost Surrealist image on D.H. Lawrence's tale *St. Mawr* (1925), telling of an outlander, like herself, who faces the reality of life in the desolate landscapes of New Mexico. Lawrence's text provides a near perfect interpretation of the picture: "But even a woman cannot live only into the distance, the beyond. Willy-nilly she finds herself juxtaposed to the near things … and willy-nilly, she is caught up into the fight with the immediate object. The New England woman had fought to make the nearness as perfect as the distance." As its title implies, the painting thus merges the near and the far, as well as the real and the unreal.

The Frugal Meal *see* The **Potato Eaters**.

Fugitive Royalists Rebecca Solomon, 1862, present location unknown.

The painting depicts a scene from the English Civil War. A Royalist woman and her son are being offered refuge by a Puritan woman whose sick child lies asleep, a Bible open on her knee. The picture has the alternate title *The Claim for Shelter*.

Full Cry Thomas Blinks, *c.*1900, Richard Green Gallery, London.

A hunt in full cry scatters a flock of geese, who cackle in turn in full cry as they flee the advancing hounds and horses.

Fumée d'ambre gris John Singer Sargent, 1880, Sterling and Francine Clark Art Institute, Williamstown, Massachusetts.

The artist sometimes gave his paintings French titles. This one, meaning "Ambergris smoke," is used to describe a picture of a young woman standing in a trance-like state and holding up the hood of her robe to trap the smoke from an incense burner at her feet. Ambergris is a waxlike substance secreted by sperm whales and associated with perfumes. It is used for the rite of inhalation by Jews and Muslims, usually in connection with religious festivals, and is also said to have aphrodisiac powers. The painting was executed in Morocco.

The Funeral of Atala (French, *Les Funérailles d'Atala*) Girodet-Trioson, 1808, Louvre, Paris.

The artist greatly admired Chateaubriand's novel *Atala* (1801), in which the Christian Indian maiden of that name, unable to fulfil her vow to become a nun because of her love for a brave, kills herself. The painting depicts the novel's famous passage in which Atala is buried by a mountain stream. The English title, although corresponding semantically to the French, is somewhat misleading, and would be better as *The Burial of Atala* or *The Entombment of Atala*, as which the work is in fact sometimes known.

The Funeral of the Anarchist Galli (Italian, *I funerali dell'anarchico Galli*) Carlo Carrà, 1911, Museum of Modern Art, New York.

The Futurist artist's best known painting depicts ranks of anarchists advancing with lances and banners as they challenge the police at the funeral of one Galli, killed in a demonstration in 1904. Carrà had himself been present.

The Funeral of the First Born *see* **Her Firstborn**.

The Fur-Lined Teacup *see* **Breakfast in Fur**.

Fur Traders Descending the Missouri George C. Bingham, *c.*1845, Metropolitan Museum, New York.

Two trappers, father and son, calmly paddle their canoe down the Missouri. A bear cub sits tethered in the prow, presumably to be sold in St. Louis as a gourmet delicacy. The painting was originally called *French Trapper and His Half-Breed Son*, but this was altered to the present title by the American Art Union, partly to avoid objections to the mention of miscegenation, partly to include a frontier reference to the Missouri.

The Fury of Athamas John Flaxman, 1790–4, Ickworth House, Suffolk.

The artist's greatest Roman statue is a marble group of four figures depicting a scene from Ovid's *Metamorphoses*. King Athamas incurs the wrath of the goddess Hera because his wife Ino has nursed the god Dionysus. He goes mad and kills one of his sons, Learchus. Ino, to escape his wrath, throws herself into the sea with the other son, Melicertes.

G

Gabrielle with Jewels (French, *Gabrielle aux bijoux*) Pierre-Auguste Renoir, *c.*1910, private collection.

A young woman in a revealing négligée admires her jewelry in the mirror of an 18th-century dressing table. The portrait is of Gabrielle Renard (1879–1959), a cousin of the artist's wife, Aline, who joined the Renoir household in 1894 as nanny to their young son, Jean, born the previous year. She did not leave until she married an American painter in 1914.

Gainsborough's Forest *see* **Cornard Wood**.

Gala and the Angelus of Millet Immediately Preceding the Arrival of the Conical Anamorphoses Salvador Dalí, 1933, National Gallery of Canada, Ottawa.

There is almost as much to savor in this painting as in there is in the lengthy title. Gala, the artist's wife and model, is seated against a wall facing a distorted figure of Lenin, seated at a table, his back to an open door. Behind the door is a figure of the Russian revolutionary, Maxim Gorki, here shown eavesdropping with a lobster on his head. In a panel over the door is a more or less faithful reproduction of Jean-François Millet's painting The **Angelus**. The final part of the title implies the latter is about to undergo some major reshaping, as it fact does in The **Architectonic Angelus of Millet**.

Galatea (French, *Galatée*) Gustave Moreau, 1880, private collection.

A naked nymph sits languidly in an under-

water grotto, watched by a sinister, one-eyed monster. She is the Nereid (sea nymph) Galatea, who in Greek mythology was the object of the unrequited love of the monster, the Cyclops Polyphemus.

Galatea of the Spheres Salvador Dalí, 1952, Fundación Gala-Salvador Dalí, Figueras.

The painting, with its quasiastronomical title, depicts a bust of his wife, Gala, composed of exploding spheres.

The Gallery of H.M.S. "Calcutta"
James Tissot, c.1877, Tate Gallery, London.

A sailor stands on the gallery of the named ship with two young ladies, clearly unable to choose between them (as in **My Heart Is Poised Between the Two**). The prominent posterior of the nearer lady as she leans on the rail has prompted some to suggest that the ship's name was chosen as a pun on French *Quel cul t'as* ("What an ass you have"), in the manner of **L.H.O.O.Q**.

The Game of Skittles Pieter de Hooch, c.1665, Cincinnati Art Museum, Ohio.

A man and a young woman converse by a statue of Cupid next to the nine wooden pins that have been set up on the ground for a game of skittles, or as it would now be called, ninepins. (The Dutch brought this game to America as the ancestor of modern American bowling.) To the left, a young man waits for the woman to break from the conversation and join him in a game. The game itself may stand as a metaphor for the unpredictable course of love.

Ganymede Feeding the Eagle Richard Evans, 1822, Victoria and Albert Museum, London.

The beautiful boy Ganymede, of Greek mythology, feeds the eagle that has borne him to Zeus, to whom he will serve as cup bearer and lover. In most accounts of the story the eagle is equated with Zeus himself. *Cf.* The **Abduction of Ganymede**.

Ganymede on the Eagle Benvenuto Cellini, 1545–7, Museo Nazionale, Florence.

The bronze statue depicts the beautiful boy Ganymede seated naked astride the eagle that will bear him to Zeus. *Cf.* **Ganymede Feeding the Eagle**.

The Garden of Ariosto Anselm Feuerbach, 1863, Schack-Galerie, Munich.

The great Renaissance poet Ariosto strolls in his magnificent garden among intellectuals and beautiful women. According to the artist, the painting was entitled *Ariosto at the Court of Ferrara* when it was acquired by its original purchaser, Count von Schack. The Prince of Ferrara was one of the first to stage Ariosto's plays.

The Garden of Earthly Delights
Hieronymus Bosch, c.1500, Prado, Madrid.

The complex triptych is believed to have the deadly sin of Lust as its subject. The title properly applies to the central panel, set between depictions of the Garden of Eden and Hell. It shows a fantastic garden landscape in which groups of small nude figures, entwined with giant birds, engage in every kind of sexual activity. The garden itself may have been inspired by the allegorical Garden of Delight in the 13th-century *Roman de la Rose*.

The Garden of Eden Hugh Goldwin Riviere, 1900, City of London Art Gallery.

A happy young couple look into each other's eyes as they walk hand in hand in a London park. The park is thus their private "Garden of Eden," as the gently ironic title indicates.

The Garden of Pan Edward Burne-Jones, 1886–7, National Gallery of Victoria, Melbourne.

The painting is the only one to be completed of a set of four on the subject of Edmund Spenser's *The Faerie Queene* (1590, 1596). It shows a nude youth playing on Pan pipes to a seated nude couple. The artist originally envisioned the work as "a picture of the world — with Pan and Echo and sylvan gods, and a forest full of centaurs, and a wild background of woods, mountains and rivers" (quoted in Wood 1998), although the setting is romantic rather than classical and there are no centaurs.

The Garden of the Hesperides Frederic Leighton, c.1892, Lady Lever Art Gallery, Port Sunlight.

Three young women recline in lethargy beneath an apple tree. They are the Hesperides, the daughters of Hesperus, and are guarding the golden apples that grow on the tree. The dragon, Ladon, coils itself in the form of a snake around the tree and the women themselves.

A Garden Scene Charles Robert Leslie, 1840, Victoria and Albert Museum, London.

A small child stands with his little toy horse and cart in a garden. The painting is a portrait of the artist's youngest son, George Dunlop

Leslie (1835–1921), and the garden was his at 12 Pine Apple Place, Edgware Road, London.

Garrick Between Comedy and Tragedy
Joshua Reynolds, 1761, private collection.

The actor and theater manager David Garrick (1717–79) is portrayed between two female figures, Comedy and Tragedy, respectively playing Pleasure and Virtue. Garrick himself, playing Hercules, is clearly charmed by both women but, unlike the Hercules of classical legend, who chose Virtue, his parted arms indicate that he is unable to choose between them.

Gassed John Singer Sargent, 1918, Imperial War Museum, London.

Eyes and lungs damaged by German mustard gas, and leaning on one another's shoulders for guidance and support, nine blindfolded British soldiers stumble towards a dressing station. Sargent was a war artist towards the end of World War I and in this capacity visited combat zones in France. The painting depicts what he had witnessed on August 21, 1918 near Arras following an attack by the British Army.

The Gates of Hell (French, *La Porte d'Enfer*)
Auguste Rodin, 1880–1917, Musée Rodin, Paris.

The huge, unfinished work is a bronze door commissioned for a proposed Musée des Arts Décoratifs, which in the event was never realized as originally planned. The figures on it were inspired by Dante's *Inferno*, and the work as a whole is effectually a recasting of Ghiberti's *Gates of Paradise* (1401–24) for the Florence Baptistery. *Cf.* The **Kiss**. *See also* The **Thinker**.

The Gates to Times Square Chryssa
(born Chryssa Vardea Mavromichaeli), 1964–6, Albright-Knox Art Gallery, Buffalo, New York.

The sculpture consists of neon tubing in the shape of a giant letter "A" symbolizing America. The Greek-born sculptor had become fascinated with the bright lights of Times Square in her early years in New York and they were thus the inspiration for this work.

Gather Ye Rosebuds While Ye May
John William Waterhouse, 1908, private collection.

When put up for sale by Christie's in 1943, the painting was titled *A Lady, in a Green Dress, Holding a Bowl of Roses*, a fair enough description of the subject. The present title quotes the familiar line from Robert Herrick's poem, "To the Virgins, To Make Much of Time" (1648).

Gattamelata Donatello, 1446–53, Piazza del Santo, Padua.

The work is a bronze equestrian statue of the great Venetian *condottiere* Erasmo da Narni (*c.*1370–1443), popularly known as Gattamelata ("honeyed cat").

Gelmeroda Lyonel Feininger, 1926, Folkwang Museum, Essen.

The painting is a semiabstract depiction of the parish church at Gelmeroda, Germany.

The General Dealer James McNeill Whistler, *c.*1888, Museum of Art, Rhode Island School of Design, Providence.

The painting depicts the front of a general store in Chelsea, the artist's home territory in London.

The General Post Office: One Minute to 6 George Elgar Hicks, 1859–60, private collection.

The scene is the rush at closing time at London's central post office, St. Martin's–le-Grand.

Genesis (1) (French, *Genèse*) Yves Tanguy, 1926, private collection; (2) Sir Jacob Epstein, 1931, Whitworth Art Gallery, Manchester.

Tanguy's Surrealist painting shows various objects that seem to represent the Old Testament book. A branch (of the Tree of Knowledge?) rises from a rocky hill next to a tower (of Babel?) to the summit of which a woman (Eve?) ascends a tightrope. A snake crawls towards the foot of the hill, from the top of which projects a man's hand (Noah's?) holding a nail. Epstein's marble sculpture depicts the torso of a pregnant woman, one arm across her swollen belly. Greek *genesis* literally means "generation," "creation," "birth."

The Genius of Greek Poetry George Frederic Watts, late 1850s–*c.*1878, Harris Art Gallery, Preston.

A naked male figure is seated on a rock while other naked (perhaps female) figures float, dive, and swim around him. He represents the genius of the Greek poets, rather than a Greek man, while the surrounding figures represent the natural phenomena, such as the winds and the waves, to which the poet gives human characteristics. The painting was inspired by the artist's own travels around the Greek islands.

The Gentle Art Joseph Kirkpatrick, 1898, private collection.

A young girl sits with rod and line by a

river on a summer's day. The "gentle art" is thus angling, and she is the gentle practitioner of it. The phrase is hardly likely to have become associated with fishing because anglers use gentles (maggots) as bait, as sometimes claimed.

Gentle Spring Frederick Augustus Sandys, c.1863–5, Ashmolean Museum, Oxford.

A white-robed, bare-footed, full-bosomed young woman stands in a flowery meadow beneath a rainbow and fluttering butterflies, blossoms gathered in the fold of her dress. She is an obvious personification of spring, even without the words of the title, which presumably come from James Thomson's *The Seasons*, "Spring" (1728): "Come, gentle Spring! ethereal mildness, come." The painting was exhibited together with a poem by A.G. Swinburne, written in response to the picture but not containing the words of the title. (It begins: "O virgin mother! of gentle days and nights, / Spring of fresh buds and spring of swift delights.")

Geopolitical Child Watching the Birth of the New Man Salvador Dalí, 1943, private collection.

A grown man breaks out of a soft but cracking egg which bears the outlines of the continents of the world. An emaciated woman watches this birth, with a young child at her feet. The title hints at the "new man" that all hoped to see after the defeat of fascism in World War II. Geopolitics was a study, fashionable in the 1930s, of the geographical factors that influenced the destinies of nations, and especially their particular location on the globe.

Gersaint's Shop Sign (French, *L'Enseigne de Gersaint*) Antoine Watteau, 1721, Staatliche Museen, Berlin.

A number of fashionable clients inspect pictures and *objets d'art* in the shop of Watteau's friend, the art dealer Edmé Gersaint (died 1750). Watteau painted the picture as an actual sign for the shop, designed to be displayed outside over the entrance. Most of the paintings depicted inside the shop cannot be identified, although one woman is seen to be carrying off a portrait of Louis XV based on a version by Hyacinthe Rigaud.

The Ghent Altarpiece Jan van Eyck, 1432, St. Bavo Cathedral, Ghent.

The great altarpiece, named for the town of its location, is a polyptych composed of many panels. The upper row (from outer to inner panels) depicts Adam and Eve, musical angels, the Virgin Mary and St. John the Baptist, and God the Father. The lower left-side panels depict the Just Judges and the Warriors of Christ, while the lower-right panels show Holy Hermits and Holy Pilgrims. Between them, as the central panel, is a depiction of the Adoration of the Lamb. Hence the work's alternate title, *The Altarpiece of the Holy Lamb*.

La Ghirlandata Dante Gabriel Rossetti, 1873, Guildhall Art Gallery, London.

The painting, its Italian title meaning "The Garlanded One," depicts a languid young woman playing a harp whose upper strings are decked with a garland of roses. Two angels look down from above. The model for the harpist was Alexa Wilding.

Ghost (1) Rachel Whiteread, 1990, Saatchi Collection, London; (2) Ron Mueck, 1998, Anthony d'Offay Gallery, London.

Whiteread's work is a mausoleum-like plaster cast of a Victorian room, evoking collective memories from the past. Hence the title. Mueck's work is a lifelike sculpture of a lanky teenage girl in a swimsuit leaning against a wall, her legs unnaturally long and thin. She could be anorexic, and the title seems to imply that she is the ghost of what she should be at her age or stage of physical development.

Ghost of Vermeer van Delft, Which Can Be Used as a Table Salvador Dalí, 1934, Salvador Dalí Museum, St. Petersburg, Florida.

Dalí greatly admired the work of the Dutch artist, Vermeer, and this picture shows a typical male character from one of his paintings with a bottle of beer and a glass on his abnormally extended leg as he kneels in a deserted landscape.

Gift (1) (French, *Cadeau*) Man Ray, 1921;* (2) Kenneth Noland, 1961–2, Tate Gallery, London.

Ray's work, no longer extant but with a reconstruction in the Museum of Modern Art, New York, is a flatiron with a row of tacks embedded in its sole, making it an aggressive gift. Noland's painting depicts an apparently spinning "target" as a series of concentric rings in unlikely color combinations. The title may allude to the "hit" that is the viewer's reward.

Gilbert à Becket's Troth George John Pinwell, 1872, Lady Lever Art Gallery, Port Sunlight.

The painting takes its subject from the

story of the Saracen maiden who fell in love with the captive crusader Gilbert à Becket. After helping him escape from the Holy Land, she followed him to England, but met with hostility and indifference from the native populace. This is the scene shown here as she walks up a path from the ship where she has landed. An alternate title is *The Saracen Maid*.

Gilles Antoine Watteau, 1721, Louvre, Paris.

The portrait is that of a Pierrot or clown in white, which the artist probably executed as a placard for the Théâtre de la Foire or some other theater. The identity of the clown is not known.

La Gioconda *see* **Mona Lisa**.

Girl Arranging Flowers *see* The **Trellis**.

The Girl at the Gate Sir George Clausen, 1889, Tate Gallery, London.

A sad, lonely-looking young woman stands at the entrance to a country garden. The artist had considered calling the picture *Marguerite* but in the end opted for the present title, which he may have taken from a popular story by Wilkie Collins.

The Girl Friends (German, *Die Freundinnen*) Gustav Klimt, 1916–17.*

Two young lesbian lovers, one robed in red, the other nude, stand close, the nude leaning on her friend's shoulder. The painting, together with many others by the artist, was destroyed by fire in the Schloss Immendorf in 1945.

Girl in Sunlight (Russian, *Devushka, osveshchyonnaya solntsem*, "Girl Illumined by the Sun") Valentin Serov, 1888, Tretyakov Gallery, Moscow.

A young woman sits beneath a tree in an orchard. She is Masha Simonovich, a cousin of the artist. He did not name the painting for her because he saw it as a rural scene rather than a portrait. *Cf.* **Girl with Peaches**.

Girl in the East Wind with Ravens Passing the Moon *see* **Ill Omen**.

Girl Reading (French, *La Liseuse*) Pierre-Auguste Renoir, 1875–6, Musée d'Orsay, Paris.

A young woman smiles gently with pleasure as she sits reading an absorbing book. The French title, meaning literally "The Female Reader," has caused the painting's English title to appear in other versions such as *A Young Woman Reading* or simply *Woman Reading*.

Girl Standing at a Window Salvador Dalí, 1925, Museo Español de Arte Contemporáneo, Madrid.

A young woman, her back to the viewer, stands at an open window looking out onto a river. The painting is a rear portrait of the artist's sister, Ana Maria, who was effectively his only model until he met and married Gala Eluard.

Girl Table Allen Jones, 1969, private collection.

A lifesize model of a young woman in black boots, black arm-length gloves and black and yellow corset stands on hands and knees, supporting a glass plate on her back to form a table.

Girl with a White Dog Lucian Freud, 1951, Tate Gallery, London.

The painting depicts the artist's first wife, Kathleen, one breast exposed, seated on a sofa with their pet dog, an English bull terrier, resting its head on her lap. She is hardly a "girl" in the normal sense of the word.

Girl with Peaches (Russian, *Devochka s persikami*) Valentin Serov, 1887, Tretyakov Gallery, Moscow.

A young girl sits at a table on which peaches lie. She is Vera Mamontova, 12-year-old daughter of the arts patron, Savva Mamontov (1841–1918). Serov did not name the painting for her because he regarded it as an interior rather than a portrait. *Cf.* **Girl in Sunlight**.

The Girlhood of Mary Virgin Dante Gabriel Rossetti, 1849, Tate Gallery, London.

An adolescent Virgin Mary practices embroidery under the watchful eye of her mother, St. Anne, while her father, St. Joachim, trims vines in the background. The model for Mary was the artist's sister, Christina, while his mother was Anne and a family handyman known as Old Williams posed for Joachim. (The identities of the three characters are inscribed in halos above their heads.) The painting inspired Millais' **Christ in the House of His Parents**.

Girls on the Banks of the Seine *see* **Young Women on the Banks of the Seine**.

Girls Singing Music by Gabriel Fabre Louis Welden Hawkins, *c.*1903, private collection.

Three girls are seen singing from a page of music by Gabriel Fabre, and the signature of the composer can be read in mirror image through the transparent sheet that the middle girl holds. The music itself seems to come from Fabre's *Sonatines sentimentales* (1894–1902), which significantly include a *Ronde: Trois Filles*.

Giudetta Pasta Joseph Cornell, 1950, Tate Gallery, London.

A wooden box displays two loose balls above a row of six wine glasses, one containing rock crystals, another a blue ball, and the third a smaller transparent ball. The back of the box is covered with charts of the northern and southern celestial hemispheres. The box is a metaphor for a world in time and space, while the two hemispheres represent another world. The rock crystals and balls symbolize air, water, and ice. The whole mixed media work is dedicated to, and named for, the famous Italian opera singer Giuditta Pasta (1797–1865).

Given: 1. the waterfall 2. the illuminating gas (French, *Étant donnés: 1. la chute d'eau 2. le gaz d'éclairage*) Marchel Duchamp, 1946–66, Philadelphia Museum of Art, Pennsylvania.

The construction is a development of The **Bride Stripped Bare by Her Bachelors, Even**, and is displayed nearby. "We enter an alcove which seems to contain nothing more interesting than a rough wooden door surmounted by a brick arch. But the door has two peep-holes through which we look…. The scene shows a naked woman lying on her back in an autumn landscape with a *trompe l'oeil* waterfall flickering in the background. We cannot see her face, but in one hand she holds aloft an illuminated lamp. Clearly, this is the bride, stripped bare at last. And just as clearly, we have become the bachelors forever denied access to her" (Richard Dorment, review of Calvin Tomkins, *Duchamp*, *Times Literary Supplement*, April 4, 1997).

Giving a Bite William Mulready, 1834, Victoria and Albert Museum, London.

A young boy has been cowed into sharing his apple with another, who now leans forward to take a big bite from it. Below, a monkey freezes in terror before a dog, and the title could equally refer to the sharp nip that the dog may be about to give the other animal.

Glad Day William Blake, *c.*1795, British Museum, London.

A nude youth stands on a mountainside with arms outstretched against the background of a bright and radiant sun. The inspiration of the work is uncertain. "The sunburst effect of the picture gave it early the title of 'Glad Day,' on the erroneous assumption that it was inspired by lines in *Romeo and Juliet* (III.v.9–10): 'Night's candles are burnt out, and jocund day / Stands

tiptoe on the misty mountain tops.' But there are no candles and no mist, nor does the figure stand on tiptoe" (S. Foster Damon, *A Blake Dictionary*, 1965). The painting is also known as *Albion's Dance* or *The Dance of Albion*, suggesting that the youth is a symbolic figure representing England, here rising spiritually above the Industrial Revolution.

The Glass Key (French, *La Clef de verre*) René Magritte, 1959, Menil Collection, Houston, Texas.

In a cold mountainous landscape, a huge boulder stands balanced on the edge of an abyss. A suitable title was found with difficulty. The work has ten deleted titles on its verso: *The Metronome* (French, *Le Métronome*), *The Lucky Charm* (French, *Le Porte-bonheur*), *The Keystone* (French, *La Clef de voûte*), *Perfect Harmony* (French, *L'Accord parfait*), *Life Together* (French, *La Vie à deux*), *Gold and Silver* (French, *L'Or et l'Argent*), *Fine Words* (French, *Les Belles Paroles*), *Clear Ideas* (French, *Les Idées claires*), *La gaia scienza* (French, *Le Gai Savoir*, "the gay science," *i.e.* the poetry of the troubadours), and *Representation* (French, *La Représentation*). Nor were these the only titles considered. Others proposed were *Page 88* (French, *Page 88*), *The Sash Cords* (French, *Les Cordes d'une vitre*) (rejected because cords suggested mountaineering), and *Night and Day* (French, *La Nuit et le Jour*). The artist also considered *The Keystone*, which he regarded as "apt but a bit 'heavy'," but finally settled for *The Glass Key*, the title of a Dashiell Hammett novel and of the movie with Veronica Lake and Alan Ladd based on it. Many of Magritte's titles are allusive in this way.

The Gleaners (1) (French, *Les Glaneuses*) Jean-François Millet, 1857, Musée d'Orsay, Paris; (2) (Italian, *Le macchiaiole*) Giovanni Fattori, 1865, private collection.

In Millet's painting, three women stoop to gather the scanty remains of the harvest, while in the background the harvesters themselves are seen loading up the plentiful crop. The depiction and title have a political message: the poor must often exist on the slim pickings left over by the rich. Fattori's picture has a similar message, although no harvesters are seen behind the few women gleaners. (The French and Italian titles are both grammatically feminine.) In Fattori's case, the title additionally puns on his artistic group, the Macchiaioli, so called as its members emphasized painterly freshness through the use of blots or patches (*macchie*) of color.

Glenrowan Sir Sidney Nolan, 1956–7, Tate Gallery, London.

A semi-abstract figure with a square head brandishes a long club against the background of a hut and a dark blue sky. He represents the Australian outlaw Ned Kelly (1855–1880), here depicted in the village of Glenrowan where he took his last stand.

Glide Path Peter Lanyon, 1964, Whitworth Art Gallery, University of Manchester.

The abstract painting has a length of black plastic stretched across it, suggesting the path of a glider out over the edge of the cliffs on the coast of the artist's native Cornwall. Lanyon took up gliding in 1959 and died following a gliding accident in the year of this work aged 46.

God Is a Lily of the Valley Robert Indiana, 1961, private collection.

The work is a geometrical composition of four circles within a larger circle. Each circle has a inscription in capital letters, so that together they spell out the full text of the title: "God is a Lily of the Valley, He is a Tiger, He is a Star, He is a Ruby, He is a King, He can do Everything but Fail." The words come from a Negro spiritual.

God Judging Adam William Blake, 1795, Tate Gallery, London.

The scene is from the Old Testament. God, an old man seated in a chariot, points an accusing finger at Adam, standing naked and bowed before him. He charges him with having eaten the forbidden fruit in the Garden of Eden, and condemns him to hard labor for the rest of his life (Genesis 3:17–19). The painting was long wrongly known as *Elijah in the Fiery Chariot*, but a faint pencil inscription discovered in 1965 revealed the true subject.

The God Look-Alike Contest Adam Chodzko, 1992–3, Saatchi Collection, London.

The artist placed a notice in magazines worldwide looking for people who believed they resembled God. The work is the result: a display of 12 framed images (plus one of the announcement). The photographs received ranged from a naked woman and a couple from Minsk to a woman from Ghana standing in front of a car.

"God Save the Queen" Henrietta Ward, 1857, present location unknown.

A mother at the piano teaches her three young children to sing the national anthem, while a nursemaid takes charge of a younger child. The queen then was Victoria.

The Godhead Fires Edward Burne-Jones, 1868–70, private collection.

For the story behind this third painting in the set of four in the artist's *Pygmalion* series, see The **Heart Desires**.

Going to Service Richard Redgrave, 1843, private collection.

A middle-class young woman bids farewell to her old mother, her brother, and her little sister as she leaves home to "go to service" (we would now say "into service") as a lady's maid or seamstress in some richer person's household.

Golconda (French, *Golconde*) René Magritte, 1953, Menil Collection, Houston, Texas.

Hundreds of dark-coated bowler-hatted men float in rows above and around houses. They may not be static, but rising like balloons or falling like raindrops. The artist, possibly tongue in cheek, explains: "Golconda was a ruined city (in southern India) in antiquity. This picture represents a ruined city. All the people are rising because they are ruined and are building castles in Spain" (quoted in Sylvester, p. 296).

The Golden Age (1) (French, *L'Âge d'or*) J.-A.-D. Ingres, 1862, Fogg Art Museum, Cambridge, Massachusetts; (2) Charles Shannon, 1921–2, private collection.

Ingres's (almost) incomplete painting depicts the mythical Golden Age, the classical counterpart of the biblical Garden of Eden. To the left, the naked populace gather round the robed figure of Astraea (the personification of Justice). In the center, a priest presides over a ceremony at a stone altar, encircled by a ring of dancing maidens, clothed and nude. (They represent the Three Hours, the Three Graces, Venus, the goddess of love, and Hebe, the personification of youth.) To the right, seated nude figures eat fruit, drink milk, and are strewn with flowers. Saturn stands in the upper middle distance, surveying the people in his happy domain. Shannon depicts a similar scene, with naked men and women living like gods.

Golden Bodies *see* **And the Gold of Their Bodies**.

A Golden Dream Thomas Cooper Gotch, 1893, Harris Art Gallery, Preston, Lancashire.

A girl stands in an orchard, her hand raised to pluck a golden apple from the tree above her. It is the fall, the time of harvest and fruition,

when the yield of the three preceding seasons of work and preparation is disclosed for good or ill. For the girl, the season is a time of adventure and discovery, the apple representing her golden dream of the future now that she has reached maturity and so attained her own fruition.

The Golden Isles (French, *Les Îles d'or*) Henri-Edmond Cross, 1891–2, Musée d'Orsay, Paris.

The pointillist painting depicts the Îles d'Hyères, a Mediterranean island group off the French Riviera. It is possible the name of the islands may have suggested the poetic title.

The Golden Legend (French, *La Légende dorée*) René Magritte, 1958, private collection.

Through an opening in a wall, long French loaves are seen hovering in or drifting across a starry sky. Whatever their motion, the scene is unsettling. The title is presumably adopted from that of *The Golden Legend*, the account of the lives of the saints by Jacobus de Voragine compiled around 1260. The loaves are golden, and here at least are also legendary.

The Golden Stairs Edward Burne-Jones, 1872–80, Tate Gallery, London.

Eighteen young women hold a variety of musical instruments as, barefoot in flowing white robes, they descend a curved stone staircase. The picture apparently has no allegorical content, and the title is both descriptive, referring to the golden glow of the stonework and the golden hair of the women, and perhaps also metaphorical, alluding to the golden classical age that they appear to represent. Various alternate titles were originally considered for the work, including *Music on the Stairs* and *The King's Wedding*. The latter seems to imply that all the women are bridesmaids. All the figures were painted from an Italian model, Antonia Caiva. It has been suggested that the painting, or an etching of it, as well as possibly its title, may have been the inspiration for Marcel Duchamp's **Nude Descending a Staircase**.

Gone Frank Holl, *c.*1877, Geffrye Museum, London.

A family group has just bid farewell to the husband (or son) on his way to emigration.

Gone! Gone! Thomas Charles Farrer, 1860, private collection.

A young woman, perhaps a widow, stands by a darkening window, her face buried in her hands. The artist gave no explanation for his subject's distress, although the title suggests the recent death or departure of a husband or lover. The frame of the painting has a biblical inscription: "Come unto me, all ye that labor and are heavy laden, and I will give you rest. Take my yoke upon you and learn of me; for I am meek and lowly in heart: and ye shall find rest unto your souls" (Matthew 11:28–29).

Good and Bad Government Ambrogio Lorenzetti, 1338–9, Palazzo Publico, Siena.

The artist's best known work, a contemporary political allegory, is a fresco series depicting a panorama of society in and around Siena, interlarded with classical references. The panels show the respective types of government. One scene of Good Government, for example, depicts an enthroned personification of Good Government himself, dressed as a judge in black and white (the colors of Siena). At his feet the mythological twins Senius and Ascanius feed from a she-wolf, symbolizing Siena's ancient origins, while a figure of Peace sits to the left and members of the Sienese community crowd round the platform. The work is also known as *Allegory of Good and Bad Government*.

The Good Example (French, *Le Bon Exemple*) René Magritte, 1953, Musée National d'Art Moderne, Paris.

The painting depicts a man standing with a folded umbrella, as a portrait of the artist's dealer, Alexander Iolas. Below him are the words "*Personnage assis*" ("Seated person"). The caption puns on the notice printed on the interior walls of the coaches of the Paris Métro: "*Voyageurs assis, Voyageurs debout*" ("Seated passengers, Standing passengers"), together with the number permitted in each category. The title perhaps means that the work is a good example of the artist's "word pictures," where the subject is labeled with a contrary caption.

The Good Harvest of 1854 Charles Allston Collins, 1854, Victoria and Albert Museum, London.

A young girl holds a generous sheaf of corn. The 1850s in England saw a series of bountiful harvests following the "Hungry Forties" and they inspired several landscape paintings.

Goodnight Thomas Webster, 1846, Bristol City Art Gallery

The scene is of a family group in a farmworker's home, and can be "read" from left to right, like a frieze. Grandfather sits at the head

of the supper table next to his eldest grandson, waiting while the three younger children say goodnight (hence the title) to their father and a fifth says his prayers at his grandmother's knee. There seems little doubt that the whole happy family will indeed have a "good night."

Gordon's Gin Richard Estate, 1968, private collection.

The painting is of an American city street with all its billboards, the most prominent of which is for Gordon's Gin. The artist photographed the scene, then reproduced it exactly it as it appeared in the photograph.

Got a Girl Peter Blake, 1960–1, Whitworth Art Gallery, University of Manchester,

The Pop Art painting depicts a row of five pop icons (Fabian, Frankie Avalon, Ricky Nelson, Bobby Rydell, and Elvis Presley) above a red, white, and blue chevron design. A vinyl disk in the top left corner gave the work its title, that of a song by the Four Preps, released in 1960. It bemoans the girlfriend who thinks only of her idols, not of her real-life sweetheart.

The Governess (1) Richard Redgrave, 1844, Victoria and Albert Museum, London; (2) Rebecca Solomon, 1854, Sotheby's, New York.

In Redgrave's painting, a young governess dressed in mourning black sits sorrowing over a letter while her pupil day-dreams over her assigned task. Two little girls skip happily outside. The artist's best known painting was originally exhibited as *The Poor Teacher*, since the governess herself, although from a good family, has been reduced to drudgery by misfortune. Solomon depicts a governess plodding wearily through a lesson with an inattentive pupil while glancing reproachfully at a young man and young woman who flirt at a piano nearby.

The Graces Adorning a Term of Hymen
Joshua Reynolds, 1774, Tate Gallery, London.

Three young women pose theatrically as the Three Graces before a term (bust on a pedestal) of Hymen, the Greek god of marriage. They are the amateur actress daughters of Sir William Montgomery. Hence the alternate fuller title, *The Daughters of Sir William Montgomery as "The Graces Adorning a Term of Hymen."* The painting was originally exhibited as *Three Ladies Adorning a Term of Hymen*, and today is also known as simply The **Three Graces**.

Gradiva André Masson, 1939, G.J. Nellens Collection, Knokke-le-Zoute.

At first sight the painting is a surreal assemblage of the internal and external parts of a woman's body. It in fact represents the death of Gradiva, the leading character in a story by the German novelist Wilhelm Jensen (1837–1911). The story is about an archaeologist, Norbert Hanold, who buys a plaster cast of a statue he has seen in Rome, that of a young woman in midstride named Gradiva. One night he has a dream, in which he finds himself in ancient Pompeii in the year 79 and sees Gradiva by the Temple of Jupiter. He knows that the town is about to be destroyed by the eruption of Vesuvius and wants to warn her, but it is too late, she sinks down, suffocated by the sulfur vapors, and turns into a stone image of herself. This is the scene that Masson depicts. Gradiva was also the nickname of Dalí's wife, Gala (*see* **Gradiva Rediscovers the Anthropomorphic Ruins — Retrospective Fantasy**), as well as the name of André Breton's Surrealist gallery in Paris before World War II.

Gradiva Rediscovers the Anthropomorphic Ruins — Retrospective Fantasy
Salvador Dalí, 1931, Colección Thyssen-Bornemisza, Madrid.

The surreal painting depicts a female figure wrapped in a stone ruin, with a castle in the background. "Gradiva" was the artist's nickname for his wife, Gala, meaning "she who advances." *See also* **Gradiva**.

A Grammar of Essence Sarah Charlesworth, 1990, private collection.

The Cibachrome photograph depicts a display of nine fertility figures (representations of goddesses from Minoan culture). The title seems to echo that of some former treatise in which "grammar" meant the fundamental principles of an art or science, as in Edward Newman's *The Grammar of Entomology* (1835), or Owen Jones's *The Grammar of Ornament* (1856). Here perhaps the figures represent the "grammar" of femininity.

Grande Arabesque Edgar Degas, *c.*1885–90, Tate Gallery, London.

The bronze statue is of a nude ballet dancer in the position of the title, *viz.* supported on one leg with the other extended back at an angle, torso extended forward, and arms outstretched. She thus produces the longest line from her fingertips to her toes. The artist executed a number of statues of nude dancers in the positions described by their titles. They could be quite

detailed, such as *Dancer at Rest, Her Hands Behind Her Back, Right Leg Forward* (French, *Danseuse au repos, les mains sur les reins, la jambe droite en avant*) (*c*.1890).

La Grande Baigneuse *see* The **Valpinçon Bather**.

La Grande Jatte Georges Seurat, 1884–86, Art Institute of Chicago, Illinois.

The painting's full title is *Sunday Afternoon on the Island of La Grande Jatte* (French, *Un dimanche d'été à la Grande Jatte*). It depicts strollers with their children and pets (including a tame monkey) on a sunny Sunday afternoon on the small island of the name in the Seine, northwest of the center of Paris. The canvas is also seen in the background of The **Models**.

La Grande Odalisque ("The Great Odalisque") J.-A.-D. Ingres, 1814, Louvre, Paris.

A nude odalisque (female slave in the Turkish sultan's harem) reclines with her back to the viewer but with her head turned to face him.

Les Grandes Baigneuses *see* The **Bathers** (5).

Gran's Treasures *see* The **Jewel Casket**.

Graves of Ancient Heroes (German, *Graben alten Helden*) Caspar David Friedrich, 1812, Kunsthalle, Hamburg.

Tombs of heroes of old are depicted in a broken mountain meadow before the entrance to a cave at the foot of a rocky cliff. The names on some of them can be made out. One is that of Arminius (died 19 BC), the German tribal leader who fought against the Romans. The most prominent monument is an obelisk decorated with a winged figure, a pair of crossed swords, the initials "G.A.F.", and an inscription which reads, in translation, "To the Youth Fallen for the Fatherland." The identity of the particular individual is unknown.

Gravy for the Navy Peter Phillips, 1963, Oldham Art Gallery.

The painting, with inserts of wood and glass, depicts four stereotyped pinups or movie stars, each within a star-shaped border. Geometric forms at the top derive from the decorative motifs associated with movie theaters. "Gravy" has its slang sense "extras," "perquisites," while the rest of the title is simply a rhyming jingle.

Gray Sick Sir Sidney Nolan, 1949, private collection.

A bearded, anxious-looking man is tied to the rear end of a camel as it stands in a hot desert beneath a fierce blue sky. He is Charles Gray, one of the explorers who attempted to cross Australia in 1818. The expedition was badly organized and ended in failure. Gray suffered from headaches and dysentery and had to be lashed to the side of his camel. He died in 1861.

The Great Bear Simon Patterson, 1992, Saatchi Collection, London.

The work is an accurate redrawing of the official London Underground (subway) map, but with the station names replaced by the names of celebrities and the lines renamed after their occupations or vocations. Thus Victoria becomes Raphael on the Italian Artists Line, Leicester Square becomes Laurence Olivier on the Film Actors Line, Paddington is Pythagoras on the Philosophers Line, and Holborn is St. Neri on the Saints Line. Passengers traveling south on the District Line to Wimbledon now ride on the Explorers Line to their destination at Columbus. Other lines are Engineers, Louis (for the French kings), Explorers, Planets, Journalists, Footballers, Musicians, Thirty Comedians, and, incongruously, on the Docklands Light Railway, Sinologues. The title alludes to the astronomical constellation, for the stations have now become "stars."

The Great Day of His Wrath John Martin, *c*.1853, Tate Gallery, London.

In an apocalyptic scene, a landscape lies beneath a louring sky while lightning flashes amidst the gathering thunderclouds. The title quotes a phrase from the New Testament: "For the great day of his wrath is come, and who shall be able to stand?" (Revelation 6:17).

Great Deeds Against the Dead Jake and Dinos Chapman, 1994, Saatchi Collection, London.

The sculpture depicts the naked bodies of three castrated soldiers tied to a tree in various degrees of mutilation. The subject and title were closely based on etching No. 39, *Great Deeds! Against the Dead!*, in Goya's The **Disasters of War**.

Great Expectations Eric Forbes-Robertson, 1894, Northampton Art Gallery.

A mysterious and melancholy young girl and a wistful young boy are depicted in a room in which the sole item of furniture is a table with a bowl of fruit and carafe of wine. The title is obviously borrowed from Charles Dickens's

famous novel (1860), although the expectations here are not financial but undefined or at best generalized. The fruit and wine may represent the ripened realization of the boy's hopes and dreams.

Great Journeys (French, *Les Grands Voyages*) René Magritte, 1926, private collection.

Against a mountainous background, the branch of a tree merges into the body of a nude which in turn dissolves into an urban landscape. The eye of the viewer travels from one object to the next, and these are presumably the "great journeys" of the title, which may also pun on the French expression *le grand voyage* to mean the last great journey (of life).

The Great Masturbator Salvador Dalí, 1929, Museo Centro Nacional, Centro de Arte Reina Sofia, Madrid.

The main object in the painting is a typical face-down "Dalí" head, its mouth covered by a grasshopper whose abdomen is being devoured by ants. A similar head appears in The **Lugubrious Game**, and represents the artist himself, who had an intense fear of grasshoppers. The title thus also applies to the artist, who was still a virgin at the time of painting. A woman's head and shoulders arise from the neck of the head and approach the genitals of a nude male figure with bloodied knees. The subject of the work is heightened by a small lone figure to the left and a similar figure of a man attempting intercourse with a rock shaped like a woman.

The Great Parade (French, *La Grande Parade*) Fernand Léger, 1954, Solomon R. Guggenheim Museum, New York.

The crowded painting depicts a grand circus parade, with acrobats, riders, aerialists, and clowns clearly represented. A large capital letter "C" in the center of the picture stands for "Circus" (French, *Cirque*) itself.

The Great Paranoic Salvador Dalí, 1936, private collection.

The painting depicts a head composed of human figures. The title alludes to the mental derangement and delusion that this represents.

The Great Picture attrib. Jan van Belcamp, 1646, Abbot Hall Art Gallery, Kendal.

The content and composition of the triptych were decided by Lady Anne Clifford (1590–1676) in celebration of her family and life. The left-hand panel depicts her at the age of 15. The central panel shows her parents and her elder brothers, with portraits of her four aunts on the walls. The right-hand panel shows her in her fifties. All three make a "great picture." The title is unusual in giving no indication of its subject, especially as it is particularly specific.

The Great War (French, *La Grande Guerre*) René Magritte, 1964, Saatchi Collection, London.

The painting is a self-portrait of the artist with an apple in front of his face, so that his features are hidden. The title is obscure. As it stands, it is the alternate name for World War I. Perhaps the "great war" is the battle between the surreal Magritte and his true identity.

The Great Way Fritz Hundertwasser, 1955, Österreichische Galerie, Vienna.

The painting consists of a roughly rectangular spiral that leads from the edge to the center (or from the center to the edge) in a single line, changing color as it goes. This labyrinthine route is thus the "great way" of the title.

Greek Dance in a Landscape (French, *Danse grecque dans un paysage*) André Bauchant, 1937, Tate Gallery, London.

The naïve painting depicts several young women in identical stylized Greek dress dancing in a grove. The artist based his picture, at one time known simply as *Landscape*, on an old book illustration.

The Greek Slave Hiram Powers, *c.*1843, Yale University Art Gallery, New Haven, Connecticut.

The marble statue in the neoclassical style depicts a naked Greek slave girl chained by the wrists after her capture by the Turks. The figure was based on the **Aphrodite of Cnidus** and itself inspired The **White Captive**.

Green Summer Edward Burne-Jones, 1864, private collection.

A group of eight women, all but one dressed in green, sit on the grass beside a pool against a background of green trees. The figures are loosely based on the artist's wife Georgiana, her sisters, and other friends of theirs.

Greeting the Icon (Russian, *Vstrecha ikony*) Konstantin Savitsky, 1878, Tretyakov Gallery, Moscow.

A crowd of adults and children gather in a meadow around a wagon bearing a holy icon. Some pray passionately, while others are more restrained and others again do not pray at all.

La Grenouillère (1) Claude Monet, 1869, Metropolitan Museum, New York; (2) Pierre-Auguste Renoir, 1869, National Museum, Stockholm.

Both artists depict a relaxed social scene at La Grenouillère, a popular bathing place with a restaurant at Croissy on the Seine near Paris. The name itself means "the froggery."

The Gross Clinic Thomas Eakins, 1875, Jefferson Medical College, Thomas Jefferson University, Philadelphia, Pennsylvania.

The artist's well known painting depicts the famous surgeon and teacher of medicine Samuel Gross (1805–1884) of Jefferson Medical College operating in his clinic before his students.

Guardian Angels Dorothea Tanning, 1946, New Orleans Museum of Art, Louisiana.

The title is ironic. Far from protecting young children, the guardian angels of the painting are evil-looking winged creatures that pluck them from their beds and fly off with them to some unknown destination.

The Guardian of Paradise (German, *Der Wächter des Paradieses*) Franz von Stuck, 1889, Museum Villa Stuck, Munich.

A winged and elegantly robed young man holds a fiery sword at the entrance to paradise.

Guardians of the Secret Jackson Pollock, 1943, Museum of Modern Art, San Francisco, California.

Two standing figures flank a central gray rectangle, perhaps an altar or a sarcophagus. They are clearly the guardians, but the nature of the object they guard, or of its contents, is a secret. The title may well have been influenced by the artist's theosophical interests. *See* **Lucifer**.

The Gueridon (French, *Le Guéridon*) Georges Braque, 1912, Musée National d'Art Moderne, Paris.

The painting is of a gueridon, a small table for objects such as lamps and vases that formerly stood on the mantelpiece. The artist painted the subject many times in the 1920s.

Guernica Pablo Picasso, 1937, Centro Cultural Reina Sofía, Madrid.

The great mural, generally regarded as the artist's masterpiece, depicts the devastation caused in the ancient Basque capital of Guernica by prolonged heavy bombing on April 26, 1937 during the Spanish Civil War. It so happens that the name of the village itself evokes its subject:

Spanish *guerra* and French *guerre* both mean "war."

A Gust of Wind John Singer Sargent, *c.*1883–5, private collection.

The painting is a portrait sketch of a young woman holding on to her broad-brimmed hat in the "gust of wind" of the title. She is the French writer and critic, Judith Gautier (1850–1918), daughter of the novelist Théophile Gautier.

Gyntiana Jörg Immendorff, 1992–3, Galerie Michael Werner, Cologne.

The painting depicts a kind of Boschian bar for lost souls, peopled with lonely or anxious individuals. The title is the name of a character from Henrik Ibsen's verse drama *Peer Gynt* (1867), based on Norse folklore, and the work itself is part of a cycle entitled *Café de Flore*, an allegory of the abuse of power and evils of oppression.

H

Hadleigh Castle John Constable, 1829, Yale Center for British Art, New Haven, Connecticut.

The painting depicts the ruins of the Norman castle in the named Essex town (not to be confused with the town of the same name in the neighboring county of Suffolk).

Hagar and Ishmael in the Wilderness Andrea Sacchi, *c.*1630, National Gallery of Wales, Cardiff.

The scene is from the Old Testament. Hagar, a servant of Sarah, Abraham's wife, is given to Abraham as a concubine. Her change of status and abuse by Sarah prompts her to run away. In the wilderness she is comforted by an angel and gives birth to Ishmael (Genesis 16). The painting depicts all three, the angel indicating that it is safe for Hagar to return.

Hail Mary *see* **Ia Orana Maria**.

The Hallucinogenic Toreador Salvador Dalí, 1968–70, Salvador Dalí Museum, St. Petersburg, Florida.

The painting was suggested by a box of Venus pencils and is full of Dalíesque images. In the top left corner is a spiritualized head of the artist, and in the bottom right corner he appears

as a six-year-old boy in a sailor suit (exactly as in The **Specter of Sex Appeal**). The main part of the picture is occupied by a series of **Venus de Milo** figures. The toreador of the title is at first hard to detect, but can eventually be made out in the outline of the bare torso of one of the Venuses, which turns into a face (her right breast as a nose, the shadow across her midriff as a mouth). To the left is a bullfighter's glittering suit, merging into rocks that can also be seen as the head of a dying bull, whose eye is a blue-bottle that is repeated to give the illusion of the sequins on the toreador's costume. Hallucinogenic indeed!

A Hamadryad John William Waterhouse, 1893, Plymouth Art Gallery.

A naked hamadryad, or wood nymph, looks down from the tree that she embodies as a faun play pan pipes seated at its foot.

Hambletonian: Rubbing Down George Stubbs, 1799, National Trust, Mount Stewart, Northern Ireland.

The famous English racehorse Hambletonian, 1795 St. Leger winner, is depicted being rubbed down (dried and cleaned) after winning an exhausting race in which it was "much cut with the whip" and "shockingly goaded" with the spur.

The Hand Refrains Edward Burne-Jones, 1868–70, private collection.

For the story behind this second painting in the set of four in the artist's *Pygmalion* series, see The **Heart Desires**.

The Hands (French, *Les Mains*) Paul Delvaux, 1941, Claude Spaak Collection, Paris.

Two nude women stand with hands posed in elaborate gestures. To the left, a formally dressed man with a seminude woman holds out his left hand, while in the middle distance a nude couple lie in an embrace, their hands around each other. The artist himself half appears from the left edge of the picture, a paintbrush in his hand. A man and a seminude woman on the right have their backs to the viewer, however, and their hands are not seen.

Hang-Up Eva Hesse, 1965–6, Art Institute of Chicago, Illinois.

The work is an empty picture frame hanging on a wall. A thin but flexible rod loops out from the top left part of the frame then back to the bottom right. Both tube and frame are wrapped in cloth, as if bandaged. The title ob-viously refers to the suspension of the work. But it also seems to allude to the "hang-up" (neurosis) that the work in some way represents, that prevents it from making a satisfactory statement.

Happy Charles Dillem Lauderdale, 1869, Christopher Wood Gallery, London.

A young mother sits before the fireplace of her farm cottage while her daughter plays happily with her baby on the rug. The depiction implies "poor but happy" rather than just "happy."

Happy as a King William Collins, 1836, Tate Gallery, London.

A young boy perches on the top bar of a field gate, his arms happily upraised, as his friends swing it open. The title quotes the stock metaphor. According to the artist, the subject was suggested by "the story of a country boy whose ideal of happiness was swinging upon a gate and eating fat bacon" (quoted in Johnson, p. 174).

Happy Frolics (French, *Joyeux ébats*) Paul Chabas, 1899, Musée des Beaux-Arts, Nantes.

Nude and lightly draped young women splash and frolic in the shallow water by a river's edge in the evening light. The river depicted is the Erdre, near Nantes.

Happy Hour Patrick Caulfield, 1996, Tate Gallery, London.

The painting is a semiabstract, semirealist depiction of the interior of a winebar, executed almost entirely in light and dark shades of red. A table of wine bottles can be made out, and in the center of the picture is a perfectly painted glass of wine. An "EXIT" sign is seen through one window. The title is ironic, and the "happy hour" is that of the wine imbiber, who after too many glasses sees everything through, as it were, "rosé-colored spectacles." "Happy hour" is also the slang term for the hour or period when a bar offers drinks at half price, the theory being that the drinker will become sufficiently "happy" to stay on when the charge reverts to normal.

The Happy Land (French, *Le Doux Pays*) Pierre Puvis de Chavannes, 1882, Yale University Art Gallery, New Haven, Connecticut.

Naked women and children rest and play on a river bank in an imaginary scene of idyllic bliss. It was this painting (but not its biblically poetic title) that inspired Georges Seurat's **Bathing at Asnières**.

The Happy Warrior George Frederic Watts, *c.*1884, Neue Pinakothek, Munich.

A knight in armor is depicted at his moment of death. Behind him is the vision of a beautiful woman, representing the ideal he sought in life. The title derives from Wordsworth's poem "Character of the Happy Warrior" (1807) in *Poems of Sentiment and Reflection*, beginning: "Who is the happy Warrior? Who is he / That every man in arms should wish to be?"

The Harbour of Refuge Frederick Walker, 1872, Tate Gallery, London.

A group of old folk sit in an almshouse garden, quietly living out the last days of their lives. The presence of death is indicated by a man mowing the grass with a scythe.

"Hard at It" Sir James Guthrie, 1883, Glasgow Art Gallery.

Shaded by a large parasol, an artist is busy painting on a beach.

Hard Times (1) Sir Hubert von Herkomer, 1885, Manchester City Art Gallery; (2) Frederick Brown, 1886, National Museums on Merseyside, Liverpool.

Von Herkomer depicts a weary family pausing for rest while wandering country lanes in search of work. The father, an agricultural laborer, stands with his tools at his feet. His wife, a baby at her breast, sits slumped by the wayside. Her young son leans on her. The artist noted in his auobiography that he had painted the group in a lane known locally as "Hard Times Lane" near his home at Bushey, Hertfordshire. Brown has a working man and young woman, perhaps father and daughter, in what appears to be an inn. The man sits at a small table before a mug of beer. The woman kneels to warm her hands at the fire. The title in each case would have been familiar from Charles Dickens's novel of the same name (1854).

A Harlot's Progress William Hogarth, *c.*1731.*

The artist's first public success was this series of six paintings (the originals were destroyed by fire and only the engravings survive) depicting the tragic story of a country girl, Moll Hackabout, who falls for the temptations of city life. She is taken in by a procuress providing prostitutes for the aristocracy, becomes a "kept woman" and street prostitute, enters a house of correction, and finally dies. Her "progress" is thus downwards and ultimately fatal. The plates do not have individual titles. The work was followed by its male counterpart, the similarly titled The **Rake's Progress**.

The Harnessing of the Horses of the Sun Giambattista Tiepolo, *c.*1733–6, Bowes Museum, Barnard Castle, County Durham.

The scene is from classical mythology. The sun god Apollo presses his hand against the cheek of his half-mortal son, Phaeton, as he is urged towards the chariot of the sun, and his subsequent death, by the bearded figure of Time. Below, a cupid and the Hours harness the impatient horses.

The Hat Makes the Man (French, *C'est le chapeau qui fait l'homme*) Max Ernst, 1920, Museum of Modern Art, New York.

The depiction is of four humanoid creatures fashioned out of hats balancing on cylindrical casings of different colors. The French title has the subtitle: *Le style c'est le tailleur* ("The Style is the Tailor"). The title as a whole obviously puns on Georges Louis de Buffon's famous statement, *"Le style c'est l'homme même"* ("Style is the man himself") (1753). It also happens to echo the English proverb popularized in the 14th century by William of Wykeham, "Manners maketh man."

The Hay Wain (1) Hieronymus Bosch, *c.*1500, Prado, Madrid; (2) John Constable, 1821, National Gallery, London.

The identically titled paintings are quite different. Bosch's work is a triptych, the inner and outer wings of which respectively depict the Creation and Fall of Man (inner) and Hell (outer). The center panel shows a crowd of demons pulling a haycart with two lovers atop towards Hell. Church and state dignitaries ride behind, and an unruly mob fights over handfuls of hay, itself symbolizing the worthlessness of material gain. Constable depicts a peaceful, rural scene on a summer's day. An empty farm waggon halts in a shallow stream to allow the horses to cool off. The scene is near Flatford Mill, Suffolk. (*See also* **Boatbuilding near Flatford Mill**.) The painting's full formal title is *Landscape: Noon, the Hay Wain*.

The Haymakers (French, *Les Foins*) Jules Bastien-Lepage, 1877, Louvre, Paris.

Two weary peasants, a man and a woman, rest in a hayfield after their labors, the man lying flat, his hat over his face, the woman seated on the ground, her face a mask of exhaustion, her arms slumped on her parted legs. (She was modeled by the artist's sister.) The painting is also

known in English as *The Hayfield* or as *Hay-making*. The latter is closer to the French.

Haystack in the Snow: Morning (French, *Meule, effet de neige, le matin*) Claude Monet, 1890, Museum of Fine Arts, Boston, Massachusetts.

No work on art can overlook Monet's famous haystacks. Over the two years 1890–91 he painted a series of 18 pictures, standing at the selfsame spot morning and evening, summer and winter, rain or shine. The titles all begin *Haystack* (French, *Meule*) and contain a brief indication of the prevailing natural conditions. Another is *Haystack in the Snow: Overcast Weather* (French, *Meule, effet de neige, temps couvert*), 1891, Art Institute of Chicago, Illinois.

Head of a Boy Pifferaro (Russian, *Golova mal'chika-pifferaro*) Aleksandr Ivanov, *c.*1830, Tretyakov Gallery, Moscow.

The serious-looking boy in the broad-brimmed hat is a young Italian shepherd and *pifferaro*, or player on a *piffero*, a type of bagpipe.

Head of a Bull: Metamorphosis (French, *Tête de taureau: Métamorphose*) Pablo Picasso, 1943, Musée Picasso, Paris.

The witty sculpture uses *objets trouvés* (found objects), here the saddle and handlebars of a bicycle, to create a bull's head, the transformation being the "metamorphosis" of the title.

The Healer (French, *Le Thérapeute*) René Magritte, 1937, private collection.

The upper half of the figure of a seated traveler is represented by a bird cage. The cloth over the cage has been drawn back and the cage door opened, so that the two white birds inside are free to fly. The title gives the clue to the meaning of the painting: a healer can free us from our pains and woes, just as birds can be released from the cage that confines them.

The Health of the Bride Stanhope Forbes, 1889, Tate Gallery, London.

A wedding breakfast is in progress, and a man at the head of the table has risen to propose a toast to the bride. The bride and groom sit quietly as all those present raise their glasses.

The Heart Desires Edward Burne-Jones, 1868–70, private collection.

The painting is the first of a set of four depicting the story of Pygmalion, the sculptor of classical mythology whose statue of a beautiful girl comes to life as a real girl, Galatea. Here Pygmalion, against a background of young women and a statue of The **Three Graces**, is inspired to create his work. The series as a whole originated from drawings made as part of a proposed illustrated version of William Morris's cycle of poems, *The Earthly Paradise*, in the event published without illustrations in 1868. The four titles form a quatrain written by Morris himself: "The heart desires, / The hand refrains, / The godhead fires, / The soul attains." *The Hand Refrains* thus depicts Pygmalion resisting the temptation to pray to Venus to bring his sculpture to life, *The Godhead Fires* shows Venus doing just that, and *The Soul Attains* shows Pygmalion on bended knee before the nude and newly created Galatea.

Heart of the Andes Frederick Edwin Church, 1859, Metropolitan Museum, New York.

The artist had traveled widely in South America, making sketches of scenes on the spot. The present painting is an assemblage of his impressions, rather than an actual single landscape. The depiction is of a wooded plain with a waterfall against a mountainous background.

The Heart of the Matter (French, *L'Histoire centrale*) René Magritte, 1928, private collection.

A woman with a cloth over her head stands before a table on which are an upturned tuba and a suitcase. The woman probably represents the artist's mother, who had drowned with her nightgown wrapped around her face. The title implies that this was a central event in the artist's life.

Hearts Are Trumps John Everett Millais, 1872, Tate Gallery, London.

The painting depicts three young ladies playing cards. The punning title alludes both to the cards themselves (the viewer, as "dummy," is shown the hearts in the good hand of the player on the right) and to the romantic power of the heart. The latter sense contrasts with the proverb "Clubs are trumps," meaning that physical force is needed to decide an issue. The title is found earlier as that of James Hannay's 1849 novel, *Hearts Are Trumps*.

Hearts of Oak James Clarke Hook, 1875, University of Warwick.

In a seaside setting, a small boy has abandoned his toy truck to watch a sailor carve a model ship. The title puns on vessels made of oak (the ship) manned by men with hearts of

oak (the sailor), as in David Garrick's familiar song *Heart of Oak* (1759) with the lines: "Heart of oak are our ships, / Heart of oak are our men." The painting was originally shown with the following lines from Shakespeare's *King John* (1596): "That England, hedged in with the main, / That water-walled bulwark, still secure / And confident from foreign purposes."

A Hearty Welcome Sir Lawrence Alma-Tadema, 1878, Ashmolean Museum, Oxford.

A young girl embraces her mother in a Roman courtyard, while her sister crouches behind to welcome the pet dog that bounds towards her. The woman is the artist's wife, Laura, the girls her two stepdaughters, Laurence and Anna. Alma-Tadema himself is seen descending the staircase to the courtyard. The artist painted the picture for his friend Sir Henry Thompson (*see* **Ninety-four Degrees in the Shade**).

Hegel's Holiday (French, *Les Vacances de Hegel*) René Magritte, 1958, William M. Copley Collection, New York.

A glass of water stands on top of an opened umbrella. The depiction illustrates the two opposing functions of a glass of water, which admits water, since it contains it, but equally does not admit it, since it repels it. The umbrella emphasizes the latter function. The artist felt that the duality would have amused the German philosopher, G.W.F. Hegel (1770–1831), who conceived of mind and nature as two abstractions of an indivisible whole.

The Heir George Goodwin Kilburne, 1890, Richard Green Gallery, London.

A bumptious little boy in a tweed suit and bowler hat struts importantly in a stable yard as a groom holding a horse's head looks on indulgently. The lad is the heir to his father's estate.

Held Up Newbold Trotter, 1897, National Museum of American History, Smithsonian Institution, Washington, D.C.

A train crossing the prairie is brought to a halt on the track as a vast herd of buffalo passes.

Helen (German, *Helena*) Franz von Stuck, *c.*1925, private collection.

The portrait of a woman in Greek profile depicts Helen of Troy, described by Homer as the most beautiful of all women. She stands on a plinth within the painting bearing three lines in Roman script from the German version of Homer's *Iliad*: "TADELT NICHT DIE TROER VND HELLVMSCHIENTEN ACHAEER / DIE VM EIN SOLCHES WEIB SO LANG AVSHARREN IM ELEND! / EINER VNSTERBLICHEN GOETTIN FVERWAHR GLEICHT JENE VON ANSEHN!" ("Do not blame the Trojans or the helmeted Achaeans / Who waited so long in such misery for such a woman! / The one we see indeed resembles an immortal goddess!").

Helios and Rhodos Frederic Leighton, *c.*1869, Tate Gallery, London.

The sun god Helion leans to embrace and draw to himself the naked nymph Rhodos, who would be the mother by him of seven sons, the Heliades.

Henrietta Maria with Her Dwarf Anthony Van Dyck, *c.*1633, National Gallery, Washington, D.C.

The painting is a portrait of Queen Henrietta Maria (1609–1669), wife of Charles I, with her teenage dwarf, Jeffrey Hudson (1619–1682), shown here holding her pet monkey, Pug.

Henry Pelham *see* **Boy with Squirrel**.

Her First Letter R.W. Chapman, 1857, private collection.

A young girl raises herself on tiptoe to peer through the narrow opening of a public mailbox as she prepares to drop in her first letter.

Her First Place Alfred Elmore, *c.*1860, private collection.

A young housemaid pauses with dustpan and brush in a middle-class drawing room to dry her eyes as she is overwhelmed by a wave of homesickness in her first post.

Her Firstborn Frank Holl, 1876, Dundee Art Gallery.

Grieving parents and grandparents walk through a graveyard behind four young girls who carry the tiny coffin of the mother's first baby, which died soon after it was born. The painting is also known as *The Funeral of the First Born*. The titles of many of the artist's works reflect his attraction to somber subjects, especially those shadowed by death. Others include *The Lord Giveth and the Lord Hath Taken Away* (1869), *No Tidings from the Sea* (1871), *I am the Resurrection and the Life* (1872), *Deserted—A Foundling* (1874), *The Village Funeral* (1874), and *Widowed* (1879).

Her Mother's Voice Sir William Quiller Orchardson, 1888, Tate Gallery, London.

A widower sits sadly in a drawing room,

listening to his daughter singing her late mother's favorite songs at the piano. The title alludes not only to the similarity of her voice to that of her mother, but to the mother's role that she has now taken over.

Hercules and Deianeira Jan Gossaert, 1517, Barber Institute of Fine Arts, University of Birmingham.

Seated nude in a niche, Hercules and his wife Deianeira embrace. He holds a club, while she sits on the cloak given her by the centaur Nessus, who had claimed it would secure Hercules' love and fidelity for her. Instead, when Hercules put it on, it enveloped his body in flames and killed him. *Cf.* **Deianeira**.

Hercules Taming the Thracian Horses William Theed, *c.*1816, Royal Mews, London.

The sculpture is a pediment group depicting the mythical hero Hercules capturing the man-eating mares of the King of Thrace as the eighth of his Twelve Labors.

Hercules Wrestling with Death for the Body of Alcestis Frederic Leighton, 1869–71, Wadsworth Atheneum, Hartford, Connecticut.

The scene is from classical mythology. Admetus, king of Pherae, has been assured by the Fates that he will not die if someone else consents to die in his place. His wife Alcestis agrees to do so. As her body lies awaiting burial, Hercules passes by and wrestles with Thanatos (Death) to rescue Alcestis from Death's clutches. The painting depicts this moment, itself described in Euripides' *Alcestis*, as well as later poems by Robert Browning and William Morris.

Here I Am, Here I Stay (French, *J'y suis, j'y reste*) Louise Bourgeois, 1990, Galerie Karsten Greve, Cologne.

Within a glass casket, a pair of truncated human feet stand firmly on a roughly hewn block of marble. The allusion may be to the order that humankind has created out of the chaos of nature. The French title quotes the French military commander, the Comte de Mac-Mahon, who said these words in 1855 on capturing the Malakoff fortress in the Crimean War.

Here, This Is Stieglitz Here (French, *Ici, c'est ici Stieglitz*) Francis Picabia, 1915, Metropolitan Museum, New York.

The artist created "object portraits" of his friends. The drawing of an unworkable camera is a portrait of the American photographer, Alfred Stieglitz (1864–1946). The title suggests a guide explaining a painting.

The Hermit Sir Edwin Landseer, *c.*1841, Victoria and Albert Museum, London.

An elderly hermit sits in his cell reading holy scripture. A quotation from Thomas Parnell's narrative poem *The Hermit* (1721) accompanied the catalog description of the painting on its original exhibition at the Royal Academy.

The Hermits (German, *Die Eremiten*) Egon Schiele, 1912, Rudolf Leopold Collection, Vienna.

The painting depicts 22-year-old Schiele and his 50-year-old mentor, the painter Gustav Klimt, robed in religious habits. They are "hermits" in their isolated artistic experience.

Hero and Leander William Etty, 1828–9, private collection.

The scene is from Greek mythology. Every night Leander swam across a stretch of sea to his lover, Hero, a priestess of Aphrodite. One night, during a storm, he drowned. Hero, grief-stricken, threw herself to her death from a tower. The painting depicts the two dead lovers in their final embrace at the edge of the sea beneath the tower.

Hesperus *see* **Vesper**.

The Hidden Woman (French, *La Femme cachée*) René Magritte, 1929, private collection.

The center of the painting is taken up by a nude in classical pose with wording above "*Je ne vois pas la*" ("I do not see the") and below "*cachée dans la forêt*" ("hidden in the forest"). The missing word is obviously "*femme*" ("woman"), which she herself represents. Her figure is surrounded by head-and-shoulder photographs of 16 men, including the artist himself, all with their eyes closed. That is why they do not see the woman, who is supposedly hidden in the forest. The men are all members of the Surrealist movement, and include Louis Aragon, André Breton, Luis Buñuel, Salvador Dalí, Paul Éluard, and Max Ernst. The work is based on a photomontage in the journal *La Révolution surréaliste* No. 12, 1929, in which a photograph of the anarchist Germaine Berton is surrounded by portraits of 28 devotees, including de Chirico, Freud, and Picasso.

Hide and Seek (French, *Cache-cache*) Pavel Tchelitchew, 1942, Museum of Modern Art, New York.

Children in their hiding places encircle the girl who seeks them, her back to the viewer. The children's heads metamorphose into vegetable forms, so giving a secondary sense to the title. The artist was interested in the occult and believed he had magical powers.

High Noon Edward Hopper, 1949, Dayton Art Institute, Dayton, Ohio.

A blonde woman in an open blue robe allows the sun and air to caress her naked body as she stands in the dark doorway of her house. The title implies a maximum gratification or zenith.

High Priestess Anselm Kiefer, 1985–9, Anthony d'Offay Gallery, London.

Massive books bound in lead stand on huge steel shelves as a symbol of human achievement. The title refers to the Tarot, the second Arcanum of which is "the Door of the Sanctuary." The image of this is of a robed woman seated between two columns, with a book in her lap, and she is the "High Priestess." The German title of the work is *Zweistromland*, "Mesopotamia" (literally "Two-Streams-Land"), *i.e.* the land between the Tigris and the Euphrates, the cradle of civilization and the site of the first great library (at Nippur). Lead pipes full of water rise up the steel frame to represents the two streams of the German title.

A Highland Breakfast Sir Edwin Landseer, 1834, Victoria and Albert Museum, London.

A group of terriers and hounds feed from a bowl as a young mother seated nearby gives her child the breast. The pups of one of the dogs similarly suckle as their mother feeds.

A Highland Landscape Sir Edwin Landseer, *c*.1824–35, Yale Center for British Art, Nw Haven, Connecticut.

Many of the artist's paintings are devoted to animals, but this has not a single animal or human figure. The title declares it to be a Scottish Highland scene, but the precise location remains unidentified. It may be somewhere in or near the Cairngorms, where Landseer often stayed from 1825 as a guest of the Duchess of Bedford.

Hilly Landscape with a Cornfield George Lambert, 1733, Tate Gallery, London.

The view of the rolling English countryside is believed to show Dunstable Downs at the northern end of the Chiltern Hills, Bedfordshire.

Hina Tefatou ("Hina and Fatou") Paul Gauguin, 1893, Museum of Modern Art, New York.

A nude Tahitian woman, her back to the viewer, stands with upraised arms before the image of a stern male figure. She is Hina, the spirit of the Moon, who engages in legendary dialogue with Fatou, the spirit of the Earth. The painting's English title is *The Moon and the Earth*.

Hindering the Artist Is a Crime, It Is Murdering Life in the Bud! (German, *Den Künstler hemmen ist ein Verbrechen, es heißt keimendes Leben morden!*) Egon Schiele, 1912, Graphische Sammlung Albertina, Vienna.

The watercolor is a self-portrait, depicting the artist huddling in a coat on his bed in jail, where he had been sent for distributing immoral drawings. The title is neatly written in the bottom right corner of the picture. Other paintings done at this time include *For Art and for My Loved Ones I Will Gladly Endure to the End!* (German, *Ich werde für die Kunst und für meine Geliebten gerne ausharren*) and *I Feel Not Punished but Cleansed!* (German, *Nicht gestraft, sondern gereinigt fühle ich mich!*).

A Hind's Daughter Sir James Guthrie, 1883, National Gallery of Scotland, Edinburgh.

A young girl stands alone in a cabbage patch. She is the hind's daughter of the title, a hind being a farm worker. The picture was painted in Perthshire, Scotland.

Hip Hip Hooray! (Da. *Hip, hip, hurråa!*) Peder Severin Krøyer, *c*.1884–8, Göteborgs Konstmuseum, Gothenburg.

Artists raise their champagne glasses in a toast at a party in Skagen, on the northern coast of Denmark. The party was held in the garden of the Anchers, husband and wife artists.

The Hireling Shepherd William Holman Hunt, 1851–2, Manchester City Art Gallery.

A shepherd neglects his flock to flirt with a shepherdess. He puts his arm round her as she sits on the ground, ostensibly to look at the little lamb on her lap, but really to tease her with a death's-head moth. The landscape depicted is near Ewell, Surrey, and the work itself was partly suggested by the pastoral imagery of John Ruskin's *Notes on the Construction of Sheepfolds* (1851). The painting is symbolic, warning the clergy against neglecting their flocks while they

devote themselves to esoteric theological issues. Asked why he called his shepherd a hireling, the artist explained that the word "in its proper suggestion represents a man neglecting his duties for selfish and idle fancies" (quoted in Johnson, p. 241). The title and subject also evoke a biblical verse: "The hireling fleeth, because he is an hireling, and careth not for the sheep" (John 10:13).

His First Lesson Frederic Remington, 1903, Amon Carter Museum, Fort Worth, Texas.

Two cowboys are about to attempt to break in a hobbled pony who is unaccustomed to having a saddle on his back. One wrangler gingerly reaches out to tighten the cinch, while the other holds the reins apprehensively. Whose first lesson is it? It may be the cowboy's first ride on a raw bronco, but the pony's fearful look suggests that the title really applies to him.

Hist!—said Kate the Queen Dante Gabriel Rossetti, 1851, Eton College, Berkshire.

A young woman turns her head to listen as, surrounded by attendants, a maid dresses her hair. The painting depicts a minor incident from Part II ("Noon") of Robert Browning's poem *Pippa Passes* (1841): "('Hist!'—said Kate the Queen; / But 'Oh!'—cried the maiden, binding her tresses, / 'Tis only a page that carols unseen, / 'Crumbling your hounds their messes!')."

The History of the True Cross *see* **The Legend of the True Cross**.

The Hold Up. Charles M. Russell, 1899, Amon Carter Museum, Fort Worth, Texas.

The painting offers a familiar image of the Old West. The Deadwood stagecoach has been brought to a halt by the notorious highwayman Big Nose George (real name George Parrott) (died 1881) and a group of passengers stand before it, hands up, as the hold-up victims.

The Holy Family. (1) Bernaert van Orley, 1522, Prado, Madrid; (2) *see* The **Doni Tondo**.

The child Jesus stands before his mother Mary while his father Joseph looks on. Two angels approach from the left, one carrying a basket of flowers, the other bearing a golden crown. The child looks up to the crown, with which he will one day make his mother Queen of Heaven, while with his right hand he points to the apple that Joseph holds, a symbol of the sin he has been born to conquer. The three members of the

Holy Family are sometimes joined by other saintly figures, as in the titles below.

Holy Family with St. Anne and St. John El Greco, *c*.1594–1604, Prado, Madrid.

The painting depicts the Holy Family (Mary, Joseph and the child Jesus) with St. Anne, Mary's mother, and a young St. John the Baptist.

The Holy Family with St. John Andrea del Sarto, *c*.1530, Metropolitan Museum, New York.

The painting depicts the Holy Family with a young St. John the Baptist, here given a prominent position in his role as patron saint of Florence, the artist's native city.

Holyday James Tissot, *c*.1876, Tate Gallery, London.

An elegant picnic party is in progress by a garden pool. (The painting's alternate title is actually *The Picnic*, and it may have originally been simply *Teatime*.) The two young men present, one reclining, one standing, both wear cricket caps, ringed with the I Zingari colors. Hence the punning title, referring both to the "holiday" and to the halo-like rings on the caps, which make their wearers look "holy." The actual setting for the picture is the artist's garden at his home in St. John's Wood, London, to which he moved in 1873.

Homage to Blériot (French, *Hommage à Blériot*) Robert Delaunay, 1914, Musée Moderne de la Ville de Paris, Paris.

The brightly colored semiabstract painting contains images of the propeller and wings of an airplane, the Eiffel Tower, and floating forms in the sky, some of them recognizably aircraft. They combine to pay tribute to Louis Blériot, the French aviator and aircraft builder who was the first to fly the English Channel in 1909.

Homage to Cézanne (French, *Hommage à Cézanne*) Maurice Denis, 1900, Musée d'Orsay, Paris.

The artist was a member of the Nabis, a group of French painters whose work was inspired by Gauguin's use of color and rhythmic patterns. The picture depicts identifiable members of the Nabis paying tribute to a framed still-life painting by Cézanne. Among those represented are Odilon Redon, Édouard Vuillard, Pierre Bonnard, and the artist himself.

Homage to Delacroix (French, *Hommage à Delacroix*) Henri Fantin-Latour, 1864, Musée d'Orsay, Paris.

The painting depicts the artist himself, together with Baudelaire, Manet, Whistler and others, grouped around a portrait of the artist Eugène Delacroix. The same artist's A **Studio at Batignolles** pays similar homage to Manet, and his **Immortality** is another tribute to Delacroix.

Homage to Louis David (French, *Hommage à Louis David*)

Fernand Léger, 1948–49, Musée National d'Art Moderne, Paris.

A group of cyclists pose for the viewer as if in a family photograph. A woman seated on the ground in the foreground holds a sheet of paper with the French title. There is no particular connection between the picture and any of those by the great classical painter, and Léger's tribute is made generally to the other artist's clear and simple depictions. He explains: "I loved David because he is anti-impressionistic. ... I feel David, particularly in his portraits, far closer to me than Michelangelo. I love the dryness in David's work and in Ingres's too" (quoted in Schmalenbach, p. 118).

Homage to Manet

(1) Sir William Orpen, 1909, Manchester City Art Gallery; (2) *See* A **Studio at Batignolles**.

The painting depicts George Moore reading his reminiscences of the English Impressionists to five leading figures in the art world: Philip Wilson Steer, Walter Richard Sickert, D.S. MacColl, Henry Tonks, and Hugh Lane. They are informally grouped around a tea table beneath Manet's 1870 portrait of his pupil and model, Eva Gonzalès (1849–1883), which Orpen had recently acquired.

Home Again *see* Eastward Ho!

Home Fields

John Singer Sargent, *c*.1885, Detroit Institute of Arts, Michigan.

The painting depicts an orchard divided from a field by a ramshackle wooden fence. It was probably executed in the fields behind Farnham House in Broadway, Worcestershire, the home of the American artist Frank Millet and his wife Lily and the social center of the colony of Anglo-American artists who gathered each summer at Broadway during the 1880s.

Home from Sea

Arthur Hughes, 1856–62, Ashmolean Museum, Oxford.

A young brother and sister mourn in a country churchyard, the girl kneeling, the boy prostrate. The boy's naval dress shows him to be a sailor lad. He is the one who is thus "home from sea" to grieve beside the freshly turfed grave where his mother has been buried in his absence. The title predates R.L. Stevenson's famous line, "Home is the sailor, home from sea" (*Underwoods*, 1887), and was given the painting in 1863 on its first showing at the Royal Academy. It was originally entitled simply *A Mother's Grave*, and included only the figure of the young boy.

Home from Work

Arthur Hughes, 1861, private collection.

A laborer has returned home from work and kisses his small daughter, already in her nightdress for bed, outside his cottage. Her older sister looks on.

A Home in the Wilderness

Sanford R. Gifford, 1866, Cleveland Museum of Art, Ohio.

The log cabin that is the home of the title looks small and even intrusive in the panoramic view of the golden lake and mountain scenery that is the wilderness of the American frontier. The specific setting of the location remains unidentified and it is almost certainly idealized.

Home Thoughts

Emily Mary Osborn, 1856, private collection.

A school for young ladies is breaking up for vacation. A pampered little miss in the center of the picture is being readied for departure, while in the window corner, concealed by a curtain, another girl listens miserably to these preparations. Her black dress suggests that she may have recently been orphaned, and that she is therefore doomed to spend the holiday in loneliness at the school. The "home thoughts" of each child are thus quite different. The painting's subtitle is *One Heart Heavy, One Heart Light*.

Homesickness (French, *Le Mal du pays*)

René Magritte, 1941, private collection.

A lion lies on a terrace behind a man with long wings who looks out over a wall. The picture was painted during the German occupation of Belgium, the artist's native country. The lion represents the Belgian coat-of-arms and the winged man a nostalgic memory of freedom. Magritte was at first unsure what to call the work: "I am hesitating between two titles: (1) *The Spleen of Paris or Philadelphia* (this is a complete title) and (2) *Pea Soup*." (The latter refers to the fog, based on a London "peasouper.") He eventually chose the present title.

Hommage à Chrysler Corp.

Richard Hamilton, 1957, private collection.

The semiabstract painting depicts a Chrysler auto with a female "sex symbol" to advertise it. The artist based his work on a compilation of themes derived from glossy magazines, including advertisements for Chrysler's Plymouth and Imperial models. The title evokes the tributes by French painters to fellow artists, such as **Homage to Cézanne**.

Hon Niki de Saint Phalle, 1966, Moderna Museet, Stockholm.

The huge sculpture was in the form of a reclining woman, with an "interior" resembling a funfair that the visitor entered through her vagina. The Swedish title means simply "she."

Honey Is Sweeter Than Blood Salvador Dalí, 1941, Santa Barbara Museum of Art, California.

A naked but headless woman, seated among clouds with her right armpit supported by a crutch, presses her left breast. A centaur in the sky with two trees growing from his rump holds a long rod in his right hand. The statement of the title presumably has a sexual allusion.

The Hop Garland William Frederick Witherington, 1834, Victoria and Albert Museum, London.

A young girl decorates a younger one with a chaplet of golden flowers from the hop vines nearby that adults and children are engaged in picking. The title is sometimes given as *The Hop Garden*, perhaps by confusion with a similar picture of this name that the artist painted.

Hope (1) (French, *L'Espérance*) Pierre Puvis de Chavannes, *c*.1872, Musée d'Orsay, Paris; (2) George Frederic Watts, 1886, Tate Gallery, London.

Puvis depicts a naked young girl seated on a white drape against a background of ruins and death, her left arm holding a green branch. She represents Hope, and symbolizes the desire of the French for peace after the trauma of the Franco-Prussian War. Watts has Hope as a blindfolded young woman seated bowed on a globe and trying to play a broken lyre. Many felt that the painting should have been called *Despair*. But a single string on the lyre remains unbroken, and a sole star shines in the dark sky above. These justify the title. "No one can name this picture properly, but Watts who painted it, has named it *Hope*. But the point is that this title is not (as those think who call it "literary") the reality behind the symbol, but another symbol for the same thing. ... The title is therefore not

so much the substance of one of Watts' pictures, it is rather an epigram upon it. ... He calls it *Hope* and that is perhaps the best title" (G.K. Chesterton, *G.F. Watts*, 1904).

A Hopeless Dawn Frank Bramley, 1888, Tate Gallery, London.

In a dawn-lit cottage room looking out on a stormy sea, two women keep vigil for the son and husband who has not returned from the fishing grounds. Dawn is often a sign of hope, but not this one.

The Horse Dealers William S. Mount, 1835, New York Historical Society.

Two men strike a deal on a brown horse, which waits patiently, saddled, in a farmyard. The artist's own farm of Stony Brook, Long Island, is depicted in the background.

The Horse Fair Rosa Bonheur, 1853, Metropolitan Museum, New York.

The artist, whose specialty was painting horses, disguised herself as a man to obtain the "local color" necessary for this depiction of a horse market that she had begun visiting two years earlier.

The Horse Tamers (French, *Les Chevaux de Marly*, "The Marly Horses") Guillaume Coustou I, 1745, Place de la Concorde, Paris.

The two great marble sculptures of horse tamers were originally erected in the park at Marly-le-Roi, west of Paris. Hence their French name. They were subsequently removed to their present site at the entrance to the Champs-Élysées.

The Horses of Neptune Walter Crane, 1892, Neue Pinakothek, Munich.

Neptune, god of the sea, drives his wild white horses before him as they leap from a curling breaker onto the shore. The painting is a visual realization of the "white horses" that are the powerful foam-crested waves of the sea.

The Horsewoman (Russian, *Vsadnitsa*) Karl Bryullov, 1832, Tretyakov Gallery, Moscow.

The young lady portrayed on horseback is Giovannina Pacini, the Italian ward of Countess Samoylova, a noted patroness of music and the arts and a friend of the artist himself.

House Rachel Whiteread, 1993, London.*

The sculpture, erected on a derelict site in London's East End, was a plaster cast of a house interior, created by spraying the inside of an

abandoned three-story row house with concrete, then removing the exterior walls to expose the cast. The work was a social and political statement, partly representing the kind of Victorian house that many people in England have lived in, partly symbolizing government housing policy in England, in which houses such as this have been demolished (as the cast itself was in 1994) and replaced by tower blocks.

The House of Cards (1) William Hogarth, 1730, private collection; (2) (French, *Le Château de cartes*): J.-B.-S. Chardin, *c*.1735, National Gallery, Washington, D.C.

Hogarth's work comprises a pair of paintings showing children aping their elders, in each case the image being one of collapse. The first centers on a house of cards, still standing at the moment of depiction, while the second has a doll's table, which a dog is upsetting. The title is conventionally applied to both works even though cards appear only in the first. Chardin shows a composed young boy starting to build a house of playing cards on a table.

The Household Angel (French, *L'Ange du foyer*) Max Ernst, 1937, private collection.

The depiction of a hideous monster rampaging across the land with outstretched arms was painted when the artist was suffering from the shock of the Spanish Civil War and the threat of Nazism. He commented: "After the defeat of the Republicans in Spain, I painted *L'Ange du foyer*. This is, of course, an ironic title for a kind of steamroller which destroys and annihilates everything that crosses its path" (quoted in Tesch and Hollmann, p. 104). The work was originally shown under the title *The Triumph of Surrealism* (French, *Le triomphe du surréalisme*), and this is frequently given as the subtitle today.

How Kola! Charles Schreyvogel, 1901, Buffalo Bill Historical Center, Cody, Wyoming.

An American trooper leading a cavalry charge is about to shoot an Indian whose horse has fallen. The artist is said to have based the painting on a story he heard from a soldier who had served in General Crooks's army during the Indian Wars of the 1870s and 1880s. A trooper had fallen behind the main company of soldiers during a winter march and lost his way on the snow-covered prairie. He was rescued by an Indian. Later, the same trooper was leading a cavalry charge in the Battle of the Rosebud, when he found himself about to kill a "redskin." Sud-

denly the Indian called out, "How, kola," or "Hello, friend." Recognizing the brave as the man who had saved him from freezing, the soldier spared him.

How Many Pictures Louise Lawler, 1989, private collection.

The work is a Cibachrome print of the reflection of a Frank Stella painting in a gallery's highly polished floor. His picture has thus created another. But, as the title implies, it remains debatable how many pictures can be formed from a single original.

The Huguenot John Everett Millais, 1851–2, private collection.

The painting depicts an incident from the 1572 St. Bartholomew's Day Massacre in Paris, when French Catholics, led by the Duc de Guise, murdered thousands of Protestants, known as the Huguenots. A Catholic girl here attempts to prevent the death of her Huguenot lover by begging him to wear the white armband used to identify Catholics, but he gently rebuffs her, unwilling to compromise his principles.

Hullo, Largess! William Maw Egley, 1862, private collection.

Subtitled *A Harvest Scene in Norfolk*, the painting depicts the enaction of an East Anglian harvest custom. The farmer has had a visitor, and the head man of the laborers has asked for a largess. The men and women now join hands in a circle and call "Hullo, Largess!" One of the worker's children holds her hand out to the farmer and his daughters for the largess itself.

Human Concretion (French, *Concrétion humaine*) Jean Arp, 1934, Musée National d'Art Moderne, Paris.

The white marble statue is one of a number so named evoking a human figure, with smoothed and rounded projections to represent limbs, breasts, or head. The artist insisted they were not meant to be abstract, and that they were actually concrete, as the title implies.

The Human Condition (French, *La Condition humaine*) René Magritte, 1933, private collection.

A canvas on an easel exactly reproduces the "real" landscape beyond the window. Such is the paradox of the human condition, in which we see the world as being outside ourselves even though it is actually a mental image within ourselves. The artist may well have adopted the title from that of André Malraux's novel, published the same year.

The Humours of May Day *see* The Milkmaid's Garland.

A Hundred Ardent Lovers Fell into Eternal Sleep Simon Edmondson, 1987, Stephen A. Solovy Art Foundation, Chicago, Illinois.

As a couple make love, they are surrounded by a crowd of lovers of the past. The title implies that such lovers lie dormant in the subconscious until aroused by an act of love in the present.

Hung Up Damien Hirst, 1983–5, private collection.

An abstract mixed media collage with a punning title, since the work includes a suspended open book and coat hanger, among other objects.

The Hungry Lion (French, *Le Lion ayant faim*) Henri Rousseau, 1905, private collection.

The painting's full lengthy title (here in its English translation) describes the scene depicted: *The Lion being hungry throws itself on to the Antelope, devours it; the Panther anxiously awaits the moment when it, too, can have its share. Some carnivorous birds have slashed a morsel of flesh from the upper parts of the animal which is shedding a tear! Setting Sun.*

A Hunt in a Forest Paolo Uccello, *c.*1468, Ashmolean Museum, Oxford.

A hunting party in a forest is depicted in a somewhat stylized manner, all the animals having their front legs raised and their back legs on the ground.

The Hunters at the Edge of Night (French, *Les Chasseurs aux bords de la nuit*) René Magritte, 1928, private collection.

Two hunters, guns over their shoulders, struggle to free themselves from the end of a wall beyond which lies a darkening sky. The latter is the threat which they are desperate to escape.

Hunters in the Snow Pieter Bruegel I, *c.*1565, Kunsthistorisches Museum, Vienna.

Hunters and their dogs look down from a hilltop to skaters on the frozen ponds below. The painting is one of a series representing the months, in this case probably January. Others in the series include *The Gloomy Day* (February), *Haymaking* (July), *The Corn Harvest* (August), and *The Return of the Herd* (October or November).

The Hunter's Return Thomas Cole, 1845, Amon Carter Museum, Fort Worth, Texas.

The painting is an idyllic and idealized depiction of pioneer life on the American frontier. Preceded by a boy, a hunter returns from the forest with the deer he has killed to the neat log cabin and carefully tended garden in the mountains where his wife and children wait.

Hurray, the Butter Is All Gone! (German, *Hurrah, die Butter ist alle!*) John Heartfield (born Helmut Herzfelde), 1935, Akademie der Künste, Berlin.

The work is a surreal photomontage on the lines of a Nazi propaganda poster. A German family at dinner is eating the parts of a bicycle. A baby cuts its teeth on an ax, a dog licks a huge nut and bolt. The words of the German title appear below the depiction, and at the foot is a quotation from Hermann Goering: "*Erz hat stets ein Reich stark gemacht, Butter und Schmalz haben höchstens ein Volk fett gemacht*" ("Iron ore has always made the Reich strong, butter and lard have at best made the people fat"). The family thus take the words literally: having finished the butter they can start on the iron.

Hush! James Tissot, *c.*1875, Manchester City Art Gallery.

Elegantly dressed guests have assembled in a drawing room for a concert and chat together as they wait for it to start. This must be any second now, for a young lady stands by the piano, her violin already in position under her chin. So *Hush!*

Hylas and the Nymphs John William Waterhouse, 1896, Manchester City Art Gallery.

The scene is from classical mythology. The young and handsome Hylas kneels to draw water from the spring Pegae, where a nymph who dwells in the spring falls in love with him and draws him into the depths. The painting represents the moment when she clasps his arm while six other nymphs, naked among the water lilies, look on. (*Nymphaea* is the botanical name of the white water-lily genus.)

I

"I Am Half Sick of Shadows," said the Lady of Shalott John William Waterhouse, 1915, Art Gallery of Ontario, Toronto.

The painting is the third in the artist's **Lady of Shalott** trilogy, based on Tennyson's 1821 poem of this title. Here the Lady sits relaxed but somehow restless before her loom, while "many-towered Camelot" can be seen through the window arches. The title quotes two lines from Part 2 of the poem, which concludes: "Or when the moon was overhead, / Came two young lovers lately wed./ 'I am half sick of shadows,' said / The Lady of Shalott."

I Am Not Jasper Johns (Russian, *Ya ne Dzhasper Dzhons*) Yurii Albert, 1981, private collection.

The work is a duplication of a painting by Johns, but with the letters of its title in Cyrillic letters. It thus deploys the style of Jasper Johns to says that its author is not Jasper Johns.

I and the Village (Russian, *Ya i derevnya*; French, *Moi et le Village*) Marc Chagall, 1911, Museum of Modern Art, New York.

The artist depicts disparate images from his native Russian village of Liozno, near Vitebsk, including a priest in the door of his church, a laborer with a scythe, and a farmgirl milking a cow. A large human face in the foreground ("I") faces a sheep's head ("the village").

I Lock My Door Upon Myself Fernand Khnopff, 1891, Neue Pinakothek, Munich.

A young woman dreamily rests her head on her hands at the edge of a stage. To the right, a monastery garden can be seen, while behind her is a locked door. A bust of Hypnos, god of sleep, stands on a shelf behind her. The title quotes the first line of the third verse of Christina Rossetti's poem *Who Shall Deliver Me?* (1864), in which the poet tells how she can lock out the "turmoil, tedium, gad-about" of life but not her own self, with all its cares. The painting is subtitled *Christina Georgina Rossetti*. A revised version of 1900 was titled *A Recluse*. *Cf.* **Who Shall Deliver Me?**

I May Not Be a Ruralist Anymore but I Saw a Fairy at the Bottom of My Garden This Morning Peter Blake, *c.*1990, private collection.

In a clump of ferns growing by a brick wall a whitish form may or may not represent a fairy. The artist was one of a group of seven British painters who in 1975 formed the Brotherhood of Ruralists, so called as they saw the countryside as a source of inspiration and imagery. Blake later became known for his paintings of fairies. The title evokes the opening line of Rose Fyleman's poem "Fairies": "There are fairies at the bottom of our garden!" (1917).

I Saw the Figure 5 in Gold Charles Demuth, 1928, Metropolitan Museum, New York.

The painting depicts a huge "figure 5 in gold" over two smaller figures superimposed on images of streetlights and a red firetruck. Both title and depiction were inspired by William Carlos Williams's poem *The Great Figure*: "Among the rain / and light, / I saw the figure 5 / in gold / on a red / firetruck / moving / tense / unheeded / to gong clangs / siren howls / and wheels rumbling / through the dark city." The figure 5 is the firetruck company number. The work is effectively dedicated to the poet, whose name appears in the word "BILL" at the top of the picture, "CARLOS" in the middle, and his initials "W.C.W." at the bottom.

I See Again in Memory My Dear Udnie (French, *Je revois en mémoire ma chère Udnie*) Francis Picabia, 1914, Museum of Modern Art, New York.

The abstract painting depicts a number of blossoming, petal-like forms evoking sexual pleasure. The work pays personal homage to a ballet dancer named Udnie Napierkowska, whom the artist had encountered on a transatlantic liner. At the same time the name *Udnie* hints at his association with the American dancer Isadora Duncan, since it contains a combination of her initials and French *nue*, "naked."

I Wanna Be Me Damien Hirst, 1990–1, private collection.

The work consists of rows of old drug bottles in a cabinet. The title seems to imply that an individual's inner and private life, however apparently degrading, is more important than any outward or public persona, however apparently ennobling.

I Want to Spend the Rest of My Life Everywhere, with Everyone, One to One, Always, Forever, Now Damien Hirst, 1991, private collection.

A table tennis ball bobs on a thin column of air above a spraygun to which a supply of compressed air leads at the top end of an elongated plinth formed by two glass uprights. The title and the work itself are an autobiographical statement on the part of the artist, who used the title again for his first book (*see* **Bibliography**, p. 278).

I Was a Rich Man's Plaything Eduardo Paolozzi, 1947, Tate Gallery, London.

The central feature of the collage is a cover of the 1940s women's magazine *Intimate Confessions,* depicting a seductive brunette. Printed beside her in a column are the words of the title and other luring contents: "Ex-Mistress," "I Confess," "If This Be Sin," "Woman of the Streets," and "Daughter of Sin." The artist has added items epitomizing American popular culture, such as a picture of a bomber worded "Keep 'Em Flying!", a Coca-Cola bottle, a cherry pie, and a gun firing the word "Pop!", perhaps its first appearance in art.

I Will Fight Philip Simpson, 1824, Victoria and Albert Museum, London.

A young boy of about ten determinedly squares up to an older one, who amiably attempts to dissuade him from the fight.

Ia Orana Maria ("Hail Mary") Paul Gauguin, 1891, Metropolitan Museum, New York.

The artist describes his painting: "An angel with yellow wings reveals Mary and Jesus, Tahitians just the same, to two Tahitian women — nudes dressed in *pareus,* a sort of cotton cloth printed with flowers that can be draped as one likes from the waist" (quoted in Vance, p. 106). The painting's title, inscribed at bottom left, represents the words of the reverent women and is the opening of the Tahitian version of the *Ave Maria.* The subject suggests a blend of The **Annunciation** and The **Adoration of the Shepherds.**

Ibayé Wifredo Lam, 1950, Tate Gallery, London.

The Surrealist painting depicts a female figure. According to the Cuban artist, *Ibayé* is her name.

Idleness and Lust *see* **Women Asleep.**

Idyll (1) Frederic Leighton, *c.*1880–1, private collection; (2) (Italian, *Idillio*) Giovanni Segantini, 1882–5, Aberdeen Art Gallery.

In Leighton's painting a seated shepherd, his back to the viewer, plays his pipes, while to his right two dryads (forest nymphs) lie beneath an oak tree listening to his music. Segantini has two shepherd boys, one lying, the other seated and playing his pipes. In both cases the title evokes the *Idylls* of the Greek poet Theocritus, themselves models for later pastoral poetry.

If Not, Not Ron B. Kitaj, 1975–6, Scottish National Gallery of Modern Art, Edinburgh.

The painting, with the gatehouse at Auschwitz dominating the scene, has the genocide of European Jews as its subject. A medley of people and objects fills the rest of the picture, including a self-portrait of the artist. The title seems to imply that if the Holocaust had not occurred, the artist would not have had to depict it.

If the Shoe Fits Eileen Cooper, 1987, Benjamin Rhodes Gallery, London.

A seated naked woman raises her right leg to try on a shoe. Other shoes surround her figure, one containing a child. The title adapts the proverbial "If the cap fits…" as part of the painting's aim to demystify womanhood and motherhood.

Ignis Fatuus Henry Pegram, 1889, Tate Gallery, London.

The bronze relief shows a woman sitting on a throne, her head supported on her arm in a gesture of despair or resignation. She has been forsaken by the warrior beside her, who reaches up towards a group of strange creatures with human heads and the bodies of birds, animals, and insects. These are the fancies of his imaginations and desires, otherwise the *ignis fatuus* of the title. The Latin phrase literally means "foolish fire," and is specifically used to describe the phenomenon of marsh gas combustion, producing a flame-like phosphorescence that flits over marshy ground and that is followed at one's peril. Hence the more general use of the phrase for a foolish or deluded venture.

IKB 79 Yves Klein, 1959, Tate Gallery, London.

The canvas comprises a rectangle of monochrome mauvish-blue, representing the shade that the artist called International Klein Blue. Hence the title of the work, the 79th in a series. *See also* **Celebration of a New Anthropometric Era.**

Ill Omen Frances Macdonald, 1893, Hunterian Art Gallery, Glasgow.

Four ravens, birds of ill omen, fly behind a standing female figure, her long hair streaming in the wind. The title seems to imply that she is no simple maiden or innocent virgin and that perhaps she is even dangerous. The general atmosphere is one of premonition. The painting is also known more prosaically as *Girl in the East Wind with Ravens Passing the Moon.*

Illumined Pleasures Salvador Dalí, 1929, Museum of Modern Art, New York.

The painting is effectively an illumined display of the artist's obsessions, the "pleasures" (in some cases intended ironically) of the title. They include a group of cyclists (presumably representing masturbators), a man addressing an amorphous shape before a church, a man grasping a woman with bloodstained hands, a grasshopper in the sky, and a hand seizing another that holds a bloodstained knife.

I'm Dreaming of a White Christmas
Richard Hamilton, 1967, private collection.

The Pop Art painting, in black, white, and gray tones, resembles the negative of a photograph of Bing Crosby in a hotel lobby, but is actually a watercolor. Its title comes from Crosby's familiar hit song, but at the same time suggests the picture's pale, dreamlike quality.

The Immaculate Conception Diego
Velázquez, c.1618, National Gallery, London.

The painting is one of several portraying the Virgin Mary as a young woman who, from the moment of her conception, was free from all stain of original sin. (The religious doctrine of the title relates to her own birth, and not to the Virgin Birth of Christ.) She here stands pure and holy in glory, her hands reverently clasped, her head encircled by stars.

Immaculate Conception with Miguel Cid Francisco Pacheco, 1621, Seville Cathedral.

The painting depicts the Virgin Mary as a young girl standing in glory surrounded by angels. A portrait of the popular Seville poet, Miguel Cid (died 1617), appears at bottom left.

Immortality (French, L'Immortalité) Henri
Fantin-Latour, 1889, National Museum of Wales, Cardiff.

A winged young woman, the Muse of Immortality, is poised over the tombstone of the painter Eugène Delacroix in the Père Lachaise cemetery, Paris. Cf. Homage to Delacroix.

The Imp of the Perverse (French, Le
Démon de la perversité) René Magritte, 1927, Musées Royaux des Beaux-Arts, Brussels.

The outlines of four biomorphic shapes appear against a background of wooden boarding. It is not clear what they represent, and the title hardly elucidates. The artist himself, in painting such a picture and giving it such a title, is perhaps himself the "imp of the perverse."

Implement Blue Margaret Preston, 1927,
Art Gallery of New South Wales, Sydney.

The still-life painting shows a collection of crockery and other tableware (the "implements" of the title) casting dense blue shadows.

The Importance of Marvels (French, L'Importance des merveilles) René Magritte, 1927, private collection.

In a version of Botticelli's The Birth of Venus, a nude woman rises from the sea, hair flying in the wind, each part of her emerging from a larger part in the manner of a Russian doll. The bottom part, her lower abdomen and legs, is a hollow shell corresponding to the scallop from which Venus emerges. The title presumably alludes to the miraculous event that inspired the earlier work. In admiring the painting, the viewer must not overlook the marvel of its subject.

L'Impression ("The Impression") Ed
Paschke, 1981, private collection.

A man holding a lighted match peers at his reflection in a mirror. The multicolored image is indistinct, and the match has an elongated flame as in a photograph of light in motion. "The title … refers perhaps to the effect of personality, and it is also a play both on the mirror's reflective capacity and the Impressionist painting style" (Yenawine, p. 80).

Impression: Sunrise (French, Impression,
soleil levant) Claude Monet, 1872, Musée Marmottan, Paris.

The painting depicts an early morning view of the harbor at Le Havre. The artist called it Impression to indicate that it was only a sketch. It was this work that gave the name of the Impressionists as a whole following its inclusion in the exhibition of April 15–May 15, 1874, at 35, Boulevard des Capucines, Paris. The artist and critic Louis Leroy coined the word when sarcastically attacking the picture in an article headed "Exposition des impressionnistes" in the April 25, 1874 issue of the satirical magazine Le Charivari.

An Impromptu Ball Eva Roos, 1899,
Christie's, London.

Little girls in ragged pinafores dance in the street to the music from an unseen barrel organ.

In a Café see The Absinthe Drinker (2).

In a Quandary George C. Bingham,
1851, Huntington Art Gallery, San Marino, California.

The painting's alternate title sets the scene and reveals the nature of the "quandary":

Mississippi Raftsmen at Cards. The game of the two riverboat men reaches a sticking point as their raft drifts slowly downstream.

In & Out of Love Damien Hirst, 1991, private collection.

The title is that of the artist's first solo exhibition and also of the work exhibited. It was arranged on two floors, one above the other. "Upstairs, exotic butterflies emerged from pupae attached to white painted canvases, fed themselves from flowers and bowls of sugar water, mated, laid eggs and, in due course, died. Downstairs, dead butterflies were displayed, wings oustretched, embedded or swamped in the greasy surfaces of monochrome paintings. Instead of sugar water, the tables contained ashtrays full of dead ends" (Hirst, p. 12). The title summarizes the cycle of birth, mating and death, and to some extent is represented by a butterfly's constant opening and closing of its wings, as if "in love" and "out of love." More generally, there is an allusion to the appearance and disappearance of an object of affection, as one experiences in childhood and youth.

In Arcadia Alexander Harrison, 1866, Musée d'Orsay, Paris.

Naked young women stand, sit, or lie in a golden grove, representing the Arcadia of Greek legend that was the home of pastoral simplicity and happiness. *Cf.* **Et in Arcadia Ego.**

In Bed (French, *Le Lit,* "The Bed") Henri de Toulouse-Lautrec, 1892–95, Musée d'Orsay, Paris.

Two lesbians embrace as they lie together in bed.

In Blue Space (Russian, *V golubom prostore*) Arkady Rylov, 1918, Tretyakov Gallery, Moscow.

The painting depicts seven swans flying in a blue but cloudy sky over a dark blue sea, and was intended to express the sense of joy and freedom engendered by the recent Revolution.

In Early Spring John Inchbold, 1855, Ashmolean Museum, Oxford.

The inspiration for the country scene came from William Wordsworth's poem *The Excursion* (1814): "When the primrose flower / Peeped forth, to give an earnest of the Spring." These words accompanied the painting's original exhibition under the title *A Study in March.*

In Memoriam Sir Joseph Noel Paton,* engraved by William Henry Simmons, 1862, Victoria and Albert Museum, London.

The painting (original untraced) depicts a group of women and children prisoners and was "Designed to Commemorate the Christian Heroism of the British Ladies in India during the Mutiny of 1857, and their Ultimate Deliverance by British Prowess." Hence the title. (In the original version the prisoners were shown at the mercy of invading sepoys with fixed bayonets, but the horrors of the Cawnpore massacre were so fresh in the public memory that the artist replaced the mutineers by Scottish Highlanders coming to the relief of Lucknow.)

In Memory of Mack Sennett (French, *In memoriam Mack Sennett*) René Magritte, 1936, private collection.

A nightdress with prominent red-nippled breasts is shown hanging on its own in a wardrobe. The title clearly announces the artist's comic intention. The famous movie comedian Mack Sennett (1880–1960) was himself something of a surrealist, his slapstick humor involving him with gorgeous girls as well as pursuing cops. Although not dead when this painting was done, the "king of comedy" had effectively already retired from the screen.

In Praise of the Dialectic (French, *L'Éloge de la dialectique*) René Magritte, 1936, Musée d'Ixelles, Brussels.

A closeup of an upper corner of a house shows an open window through which can be seen a room containing a complete house. The part thus represents the whole, and the whole is contained in its parts. This is the neat dialectic or reasoning depicted here.

In That Moment Bernard Cohen, 1965, Tate Gallery, London.

The abstract painting consists of a single line starting from the bottom edge of the canvas and simply extended, crossing and recrossing itself until the whole surface is covered and the background obliterated. At this point the line is brought back down to the base again and the painting is finished. The color of the line is mainly red but is changed at intervals. The title presumably refers to the line either as a "moment" of time, linking seamlessly with the past (its start point) and the future (its end point), or to the "moment" where it starts back down.

In the Doctor's Waiting Room (Russian, *V priyomnoy u doktora*) Vladimir Makovsky, 1870, Tretyakov Gallery, Moscow.

As they wait their turn to see the doctor, patients give one another "medical" advice.

In the Garden (French, *Dans le jardin*)
Pierre-Auguste Renoir, 1885, Hermitage,
St. Petersburg.

A young man and young woman, obviously in love, sit at a small table in a garden, the woman facing the viewer, the man looking expectantly at the woman. He is presumably depicted at the moment when he asks for her hand and heart. The model for the man was the 21-year-old artist Henri Laurent, and that for the woman 26-year-old Aline Charigot, Renoir's model and future wife. (She is also in The **Luncheon of the Boating Party**.)

In the Hands of the Dilettanti Mark Wallinger, 1986, Anthony Reynolds Gallery, London.

The painting is based on Sir Joshua Reynolds's group portrait of the Society of Dilettanti, of which he was a member. In the foreground is a toby jug in the form of the death mask of William Blake (who had called Reynolds and the Society "Sir Sloshua and his gang of hired knaves"). Three hands are prominently seen in different poses.

In the Hold David Bomberg, *c.*1913–14, Tate Gallery, London.

The colored abstraction of fragmented geometric forms is based on the subject of men working in the hold of a ship in dock.

In the Hood David Hammons, 1993, Jack Tilton Gallery, New York.

The work displays a discarded sweatshirt hood found in the street, evoking the poor and homeless person who probably owned it. The title both relates to the particular piece of clothing and puns on the black slang word for "neighborhood."

In the Land of the Germans (German, *Im Land der Deutschen*) Franz Radziwill, 1947, private collection.

Ruined and desolate buildings are set against a flower-studded sky containing symbols of redemption. (An angel flies down and a red carnation falls to earth.) The title relates directly to the devastation of the artist's homeland in World War II.

In the Land of Weissnichtwo George Frederic Watts, 1894, Watts Gallery, Compton, Surrey.

The allegorical painting has a title that alludes to Thomas Carlyle's philosophical satire *Sartor Resartus* (1832), the narrative of which is set in a fictitious place named Weissnichtwo, German for "I know not where."

In the Peristyle John William Waterhouse, 1874, Rochdale Art Gallery.

In the peristyle (area surrounded by columns) of a Greek temple, a young girl scatters grain from her basket for the birds. Until 1977 the painting was known as *Feeding the Pigeons*.

In the Spring Harold Knight, 1908–9, Tyne & Wear Museums, Newcastle upon Tyne.

A young couple take tea out of doors at a table set under a blossoming tree.

In the Spring Time Eleanor Fortescue-Brickdale, 1901, private collection.

A young woman wearing a flowing silk dress sits, eyes closed, amid woodland bluebells.

In the Tepidarium Sir Lawrence Alma-Tadema, 1881, Lady Lever Art Gallery, Port Sunlight.

A tepidarium is a room between the cold and hot rooms in a Roman bath. In this one, a nude female bather lies sensuously on a bearskin rug, her eyes closed, her right hand clasping a strigil (*see* **Strigils and Sponges**), her left holding an ostrich feather at a strategic angle. *Cf.* The **Tepidarium**.

In Without Knocking Charles M. Russell, 1909, Amon Carter Museum, Fort Worth, Texas.

A group of drunken cowboys enter a saloon through the front door without dismounting from their horses. "The titles of Charles M. Russell's paintings often reflected the artist's rough and occasionally raucous western sense of humor" (Sweeney, p. 193). This is an example. The scene depicts an actual event that occurred in Stanford, Montana, in 1881, when a group of cowboys rode into town to celebrate before setting off on a long cattle drive.

Inasmuch as It Is Always Already Taking Place Gary Hill, 1990, private collection.

The work consists of 16 television screens that transmit images of different parts of the artist's body. The viewer is unable to form a unified picture of the disparate depictions, but is prompted by the title to appreciate that the work as a whole represents a living entity.

Inconsolable Grief (Russian, *Neuteshnoye gore*) Ivan Kramskoy, 1884, Tretyakov Gallery, Moscow.

A woman stands numb with grief by flowers prepared for a funeral, a handkerchief pressed to her lips. The painting was directly connected with the grief of the artist and his wife at the death of their son.

Indecision attrib. Andrea Landini, *c.*1880, Plymouth City Museum and Art Gallery.

Subtitled *Conversation Piece*, the painting depicts a cardinal and his companion playing chess. The indecision of the title is that of the cardinal's opponent over his next move.

Indian Rescue Asher B. Durand, 1846, Anschutz Collection, Denver, Colorado.

A group of Indian holds a white woman and child captive. One raises a tomahawk, another, armed with a bow, gestures to an Indian woman as if offering to kill the two. But to the left a band of rescuers can be seen advancing through the trees. They move stealthily, like Indians, and the title presumably refers to this rather than simply denoting a rescue from Indians.

Indian Telegraph John M. Stanley, 1860, Detroit Institute of Arts, Michigan.

An American Indian stands on a rock and holds a smoking brand aloft to signal a message to a distant tribesman. The title combines the contrasting notions of pretechnological simplicity ("Indian") and the invention of Samuel Morse ("telegraph"), thus subtly emphasizing the white man's superiority.

Indians as Horse Thieves *see* The **Captive Charger**.

The Indiscretion Antoine Watteau, 1717, Louvre, Paris.

A young couple are seated on the ground in a country setting, the man supporting the woman who begins to lean back. A red cloak lies on the grass, indicating that the act of undressing has begun. The "indiscretion" of the title implies that the man is taking liberties.

Industry Charles Baxter, 1867, Victoria and Albert Museum, London.

The painting is a portrait of a young girl knitting, not particularly industriously.

Industry and Idleness William Hogarth, 1747.

The series of 12 engravings tells the story of two apprentices, Francis Goodchild and Tom Idle, representing the respective attributes of the title. Each plate has a caption, as follows: (1) *The*

Fellow 'Prentices INDUSTRY and IDLENESS at their Looms; (2) *The INDUSTRIOUS 'PRENTICE performing the Duty of a Christian*; (3) *The IDLE 'PRENTICE at Play in the Church Yard during Divine Service*; (4) *The INDUSTRIOUS 'PRENTICE a Favourite and entrusted by his Master*; (5) *The IDLE 'PRENTICE turn'd away and sent to Sea*; (6) *The INDUSTRIOUS 'PRENTICE out of his Time, & Married to his Master's Daughter*; (7) *The IDLE 'PRENTICE return'd from Sea, & in a Garret with a common Prostitute*; (8) *The INDUSTRIOUS 'PRENTICE grown rich, & Sheriff of London*; (9) *The IDLE 'PRENTICE betrayed, and taken in a Night-Cellar with his Accomplice*; (10) *The INDUSTRIOUS 'PRENTICE Alderman of London, the Idle one brought before him & Impeach'd by his Accomplice*; (11) *The IDLE 'PRENTICE Executed at Tyburn*; (12) *The INDUSTRIOUS 'PRENTICE Lord-Mayor of London*. The "accomplice" of Plates 9 and 10 is the prostitute of Plate 7.

Inheritance (Norwegian, *Arv*) Edvard Munch, 1897–9, Munch Museum, Oslo.

A distressed woman sits with a desperately sick infant on her lap. The child has inherited syphilis from its father. Hence the title. The subject of the painting was suggested to the artist by a scene witnessed at the St. Louis Hospital in Paris.

Innocence Preferring Love to Riches (French, *L'Innocence préfère l'amour à la richesse*) Pierre-Paul Prud'hon, *c.*1809–10, Ashmolean Museum, Oxford.

A young woman, personifying Innocence, resists the temptation of an open casket of jewels offered by an older woman, Riches, and prefers instead the embrace of a winged young man. The child Cupid dances happily nearby.

Innocentia Franz von Stuck, 1889, private collection.

A white-robed androgynous (but actually female) figure stands as a personification of innocence holding a giant lily, a symbol of that virtue. The painting is a reinterpretation of the Christian representation of the Virgin Mary in this role.

Inside Out Amanda Faulkner, 1985, private collection.

The painting is essentially a double portrait of a single woman, but with her internal organs floating outside her. Chief among them is a fetus in the form of a demon, still attached by its umbilical cord. The work is clearly a feminist state-

ment, and the artist appears to be subverting the traditional **Madonna and Child** fantasy of the male artist.

Inspecting His Estate (Russian, *Ob'yezd vladeniy*) Nikolai Kuznetsov, 1879, Tretyakov Gallery, Moscow.

A local landowner pauses on his horse-drawn cart to wave his whip angrily at a poacher who has just shot a young animal on his estate.

The Institution of the Eucharist *see* The Communion of the Apostles.

The Intercepted Billet William Mulready, 1844, Victoria and Albert Museum, London.

An Italian nobleman has just been handed a bouquet and a billet (message) by his servant. They are clearly intended for hands other than his, and his eye is fixed in a look of vengeance as he clenches the flowers.

Interior with Two Figures (French, *Intérieur avec deux personnages*) Edgar Degas, *c*.1869, Hermitage, St. Petersburg.

A husband and wife, each dressed ready to go out, stand with backs turned to each other in the boudoir of an apparently wealthy household. The title offers no explanation for the scene.

An Interesting Story James Tissot, *c*.1872, National Gallery of Victoria, Melbourne.

It is the 18th century. A red-coated officer pores over a map by a window overlooking a harbor and relates a story to two young women who barely disguise their boredom: one looks away, the other stifles a yawn. The story is thus interesting only to the teller. The artist subsequently painted *The Tedious Story* (*c*.1872) on the same theme but with just one girl.

The Interpretation of Dreams (French, *La Clef des songes*) René Magritte, 1927, private collection.

The artist's first "word picture," depicting objects that are labeled with misnomers, has an apt title alluding to the illogicality of dreams. The painting, something in the manner of a school reading primer, comprises four equal compartments each containing a captioned picture: a portmanteau labeled "*Le ciel*" ("The sky"), a penknife labeled "*L'oiseau*" ("The bird"), a leaf labeled "*La table*" ("The table"), and (or but) a sponge labeled "*L'éponge*" ("The sponge"). A later version of 1930 with the same title, now in the Staatsgalerie Moderner Kunst, Munich, has six compartments: an egg as "*l'Acacia*" ("The

Acacia"), a shoe as "*la Lune*" ("The Moon"), a hat as "*la Neige*" ("The Snow"), a candle as "*le Plafond*" ("The Ceiling"), a glass as "*l'Orage*" ("The Storm"), and a mallet as "*le Désert*" ("The Desert"). A third one of 1935, in a private collection, has four compartments with English captions: a horse's head as "the door," a clock as "the wind," a jug as "the bird," and (but) a suitcase as "the valise." The French title is more literally rendered in English as *The Key of Dreams*. Lynton names the work thus and with regard to the "sponge" in the original version comments: "This last disconcerts us more than the others, and makes us wonder about names and titling. A picture of a naked woman may have a label 'Nude'. Why? Magritte's title for that four-part picture suggests that wonder and fantasy, and also perplexity, arise out of naming and out of our trust in names. Perhaps, after all, that leather container with handles should be called 'sky'. Words are arbitrary, unreliable things, yet we tend to put more trust in them than in images even though we would agree that images can approximate to visual facts" (pp. 181–2).

The Intervention of the Sabine Women Jacques-Louis David, 1794–9, Louvre, Paris.

The painting depicts the sequel to The **Rape of the Sabine Women.** The Sabines subsequently attacked the Romans with the aim of avenging the abduction. Hersilia, daughter of the Sabine leader Tatius, has married Romulus, the Roman leader, and has had two children by him. In the picture, she bravely stands between her father and her husband as they are about to attack each other, thus bringing peace between the two communities. In a booklet written for the painting's original exhibition (1799–1805), David himself explained: "Romulus holds back the javelin which he was about to hurl at Tatius. The general of the cavalry puts his sword back into its sheath. Soldiers raise their helmets as a sign of peace. The feelings of conjugal, fatherly, and brotherly love spread through the ranks of both armies. Soon the Romans and the Sabines embrace to form one single people." The association with the abduction has led the picture to be popularly mistitled *The Rape of the Sabines*. The connection is reinforced by further confusion with other works so titled, such as those by Pietro da Cortona or Poussin.

The Invention of Fire (French, *Invention du feu*) René Magritte, 1946, private collection.

A naked girl on all fours has a mansize bilboquet standing behind her, between her feet.

The artist glossed the title as follows: "The astonishing invention of fire. Thanks to the friction of two bodies, reminiscent of the physical mechanics of pleasure" (quoted in Sylvester, p. 264).

The Invention of Life (French, *L'Invention de la vie*) René Magritte, 1928, private collection.

Against a landscape background, a dark-haired woman stands next to a figure shrouded in a sheet, as if a character playing a ghost. The title and depiction seems to hint at the mysterious life that potentially lies in every woman and that cannot be realized unless she "invents" it.

The Invention of Monsters Salvador Dalí, 1937, Art Institute of Chicago, Illinois.

A rocky landscape contains many of the "monsters" that the artist had introduced in earlier works, such as a woman with a horse's head, transparent nudes, and a burning giraffe. Dalí claimed that the only "non-monster" was the ghostly dog in the bottom right corner.

Inverse Reverse Perverse Cerith Wyn Evans, 1996, Saatchi Collection, London.

The work is a large concave mirror hung on the gallery wall that inverts and distorts the reflection of the viewer, thus creating a disturbing (perverse) self-portrait, the opposite (reverse) of what one expects when looking in a mirror.

The Invisibles Yves Tanguy, 1951, Tate Gallery, London.

The Surrealist painting depicts biomorphic shapes ascending pointed objects against the background of a gray sky. They are the "invisibles" of the title, as creatures that cannot be seen by humans because they have adopted a disguise.

Io *see* **Jupiter and Io**.

Iridescent Interpenetrations (Italian, *Compenetrazioni iridescenti*) Giacomo Balla, 1912–14, private collection.

The Futurist artist painted a number of works with this title, each representing a pattern of intersecting prismatic forms in alternating colors.

The Irish Famine George Frederic Watts, 1848–9, Watts Gallery, Compton, Surrey.

A weary and hungry Irish family, the mother nursing a young child, sit despairingly in a bleak landscape. They have been evicted from their home following the failure of the Irish potato crop in the 1840s. The painting's original title actually was *The Irish Eviction*.

Iron and Coal William Bell Scott, 1861, private collection.

The painting depicts an industrial scene on Tyneside in northeastern England. Three muscular "strikers" are hammering out molten iron in an engineering workshop. Below them, a coal barge passes on the river. The picture's caption proudly proclaims: "In the Nineteenth Century the Northumbrians show the World what can be done with Iron and Coal."

Isaac Blessing Jacob Matthias Stomer, *c*.1635, Barber Institute of Fine Arts, University of Birmingham.

The scene is from the Old Testament. The aged and almost blind Isaac has summoned his eldest son, Esau, to prepare him a meal and receive his blessing. Isaac's wife, Rebecca, has substituted her own favorite son, Jacob, putting goatskin gloves on his hands so that he resembles the hairy Esau. Isaac now reaches out to bless Jacob, while the latter cautiously offers his father a dish of meat. The story is told in Genesis 27:1–29.

Isabel and the Pot of Basil John White Alexander, 1897, Museum of Fine Arts, Boston, Massachusetts.

The painting depicts a scene from Keats's narrative poem *Isabella; or the Pot of Basil* (1818), itself based on a story in Boccaccio's *Decameron* that tells of the ill-fated love affair between Isabella and Lorenzo, leading to his death and ultimately to hers. Isabella finds the spot where the murdered Lorenzo lies buried, cuts off his head, places it in a jar, and covers it with mold and basil. She now stands beside the jar and mourns her lover. *Cp.* **Isabella and the Pot of Basil**.

Isabella John Everett Millais, 1848–9, Walker Art Gallery, Liverpool.

The painting is based on Keats's poem *Isabella; or the Pot of Basil* (1818) (see **Isabel and the Pot of Basil**). A meal is in progress. Isabella fondles a dog with one hand while symbolically accepting half a blood orange from Lorenzo with the other. Opposite her sit her two brothers, one kicking the dog. (It is they who will murder Lorenzo.) The work has the alternate title *Lorenzo and Isabella*.

Isabella and the Pot of Basil (1) William Holman Hunt, 1866–8, Laing Art Gallery, Newcastle upon Tyne; (2) John William Waterhouse, 1907, private collection.

Both paintings are based on the same source as **Isabel and the Pot of Basil**. Hunt has

the bereaved Isabella leaning against the plinth that supports the pot of basil as she embraces it and rests her head sorrowfully on it. Waterhouse has her kneeling with closed eyes as she clasps the pot on its plinth in a garden setting. His picture was originally titled simply *Isabella*. The extended title first appeared in 1922.

Isabella Stewart Gardner John Singer Sargent, 1888, Isabella Stewart Gardner Museum, Boston, Massachusetts.

The full-length portrait of the American art collector, Isabella Stewart Gardner (1840–1924), popularly known as "Mrs. Jack," from the first name of her husband, John Lowell Gardner, was first shown under the title *Woman: An Enigma*.

The Isenheim Altarpiece Matthias Grünewald, *c*.1515, Musée d'Unterlinden, Colmar.

The altarpiece, painted for the Monastery of St. Anthony in Isenheim, opens out in three stages and comprises eight large panels. When fully closed it shows the artist's **Crucifixion**, with panels either side depicting, respectively, *St. Sebastian* and *St. Anthony Abbot*. When opened out, it shows The **Annunciation**, *The Allegory of the Nativity*, and The **Resurrection**. The final innermost panels are The **Temptation of St. Anthony** and *St.Anthony and St.Paul in the Wilderness*.

The Island of Cythera *see* The **Pilgrimage to the Island of Cythera**.

The Isle of the Dead (German, *Toteninsel*) Arnold Böcklin, 1880, Metropolitan Museum, New York.

The Swiss artist's best known painting depicts a sinister-looking island with a cliff-like fortress extending either side of tall, dark cypresses. A shrouded figure in a boat is about to land. The title was invented by an art dealer, not the artist himself, who called the work *A Tranquil Place*. The new title was suggested by the white-draped coffin on the boat, the funereal trees, and the general atmosphere of stillness and silence. *See also* The **True Picture of the Isle of the Dead by Arnold Böcklin at the Hour of the Angelus**.

Isolated Elements Swimming in the Same Direction for the Purpose of Understanding Damien Hirst, 1991, Saatchi Collection, London.

The work is a steel-framed glass cabinet containing individual perspex cases of 38 different fish preserved in formaldehyde and all facing the same way. The title, hinting at metaphors such as "swimming with the tide", seems to imply that individuals, however disparate, best achieve understanding through unity of purpose and direction. The artist commented: "The fish pieces came first because you have to take them out of their element (the sea) and put them into formaldehyde. It preserves them in a very similar state to their natural one, only they're dead. I used 'swimming' in the title because they're not" (Hirst, p. 298).

An Italian Contadina and Her Children Sir Charles Lock Eastlake, 1824, Victoria and Albert Museum, London.

An Italian peasant woman (*contadina*) in traditional costume sits under a tree with her two childen, one behind her, the other leaning on her lap. The painting was originally exhibited as *An Italian Scene; a contadina and her children*. The artist was living in Rome at the time.

Italy (Italian, *Italia*) Luciano Fabro, 1968, private collection.

The work consists of a large road map of Italy molded in anodized iron and suspended upside down from a noose. The display not only inverts the viewer's traditional concept of the country, but (perhaps intentionally) evokes the familiar news photograph of the dead Mussolini, strung up by his heels in a public square.

It's Happening To Me Damien Hirst, 1983–5, private collection.

The artist has shed light on the title of his abstract mixed media collage: "One day I had a horrifying thought. It changed everything. I was looking at my collages, all these rotten little bits of wood, these decaying discarded bits of rubbish on the floor, very close to death, I felt, in the formal arrangements I'd made, with bits of plastic and dirty tissues almost breaking apart. 'This is happening to me,' I thought. It changed everything" (Hirst, p. 72).

Ivan the Terrible and His Son Ivan (Russian, *Ivan Groznyy i syn yego Ivan*) Ilya Repin, 1885, Tretyakov Gallery, Moscow.

Russia's first czar, Ivan the Terrible (1530–1584), kneels in distraction to clasp his dying son Ivan (1554–1582), whom he has mortally wounded in a quarrel.

Ivrea Langlands & Bell (Ben Langlands and Nikki Bell), 1991, Saatchi Collection, London.

The work is a white-framed, three-dimenstional cross-section of Ivrea, the utopian urban complex built for their headquarters by the Olivetti company outside Turin, Italy.

IXI Susan Rothenberg, 1977, private collection.

The painting, heavily impastoed in red, depicts the outline of a leaping horse. The two letters "I" of the title represent two vertical white lines overpainted near the picture's left and right borders through the neck and rump of the horse. The "X" represents the black diagonal lines that run from its muzzle to its hock and from its knee to its croup, intersecting below its abdomen at the point where its girth would pass.

J

A Jack in Office Sir Edwin Landseer, 1833, Victoria and Albert Museum, London.

A Jack Russell terrier sits with an air of lordly authority atop a wheelbarrow, while other dogs whine and watch below. The title puns on the breed of dog (established by the Revd. John Russell, the "sporting parson"), a "jack in office" being an expression for a self-important minor official. A famous political cartoon by "HB" (John Doyle) was based on the painting, depicting Lord John ("Jack") Russell, Home Secretary and Leader of the House of Commons after the fall of Sir Robert Peel's Tory administration, as the "jack in office" surrounded by other dogs: Joseph Hume sitting quietly on the left, Lord Brougham, Lord Chancellor, as the whining pointer bitch, Daniel O'Connell as a poodle sitting up and begging (for Irish claims), and Lord Durham as the alert terrier in the background.

Jacob and the Angel Sir Jacob Epstein, 1941, Tate Gallery, London.

The grand alabaster sculpture depicts a naked man in the embrace of a half-crouching winged figure. The representation is of the events of Genesis 32:24–30, recounting how Jacob wrestles all night with a mysterious man (traditionally regarded as an angel but not actually named as such) and realizes he has been combating God. The sculptor would have been aware that he shared his name with Jacob, whom the angel significantly renames Israel ("he who strives with God"). The work and its title must surely therefore allude to this identity.

Jacob Wrestling with the Angel *see* **The Vision After the Sermon**.

Jaguar Devouring a Hare (French, *Jaguar dévorant un lièvre*) Antoine-Louis Barye, 1852, Louvre, Paris.

The sculpture is one of a number of violent animal scenes created by the artist. Others include *Tiger Devouring a Gavial* (1831) and **Lion Crushing a Snake**.

El Jaleo John Singer Sargent, 1880, Isabella Stewart Gardner Museum, Boston, Massachusetts.

The painting depicts a Spanish Gypsy dancer at the height of her dance. "The title word means, in Spanish, the rush of spontaneous clapping, finger-snapping, and *olés* that flamenceros break into to encourage the single dancer" (Hughes, p. 251). (The word, pronounced "ha-*ley*-o," is related to English *halloo*.)

Jane Avril Leaving the Moulin Rouge (French, *Jeanne Avril sortant du Moulin Rouge*) Henri de Toulouse-Lautrec, 1893, Wadsworth Atheneum, Hartford, Connecticut.

The dancer Jane Avril (1868–1943), who appears in a number of the artist's paintings, is here shown leaving the Moulin Rouge, the famous Paris music hall.

Jasper's Dilemma Frank Stella, 1962–3, private collection.

The work represents two juxtaposed rectangular figures. They are equally symmetrical and identical in structure, except that the one on the left is in bright colors while the other is in white, black, and gray. The title refers to the artist Jasper Johns's practice of working with similar schemes in color and black and white, the choice between the two being the dilemma.

Je t'aime ("I Love You") Robert Motherwell, 1955, Sidney Janis Gallery, New York.

The Abstract Expressionist painting depicts a pen that has just written the words of the title in black on a broad band of orange.

Jealousy (Norwegian, *Sjalusi*) Edvard Munch, 1895, Rasmus Meyers Collection, Bergen.

A young man stares out of the shadows with an expression of acute melancholy while behind him a couple assume an Adam-and-Eve pose under a tree, the woman about to pluck an

apple. The painting represents the three-cornered relationship of the artist himself and the Norwegian student Dagny Juell, as Adam and Eve, and the Polish writer Stanislaw Przybyszewski (1868–1927), whom Juell would subsequently marry.

Jekyll and Hyde Peter Howson, 1995, private collection.

The painting is a double self-portrait, one face looking at the viewer, the other turned to the first, as if challenging it. The title comes from R.L. Stevenson's 1886 story, in which the good Dr. Jekyll takes on an evil personality as Mr. Hyde. The phrase was subsequently adopted for a person (or thing) with two opposed aspects, as literally here.

Jephthah and His Daughter Hezekiah Augur, 1828–32, Yale University Art Gallery, New Haven, Connecticut.

The two separate sculptures are of the Old Testament judge, Jephthah, and his daughter. In return for God's promise to defeat the Amorites, Jephthah vowed that he would sacrifice the first creature to appear from his tent. It was his daughter and only child (Judges 11:29–40).

Jeroboam Sacrificing to the Idols (French, *Jéroboam sacrifiant aux idoles*) Jean-Honoré Fragonard, 1752, École des Beaux-Arts, Paris.

The scene is from the Old Testament. Jeroboam, first king of Israel, sets up golden calves at Bethel and Dan to discourage people from worshipping in Jerusalem (1 Kings 12:28–33).

A Jersey Lilly John Everett Millais, 1878, Jersey Museum, St. Helier, Jersey.

The painting is a portrait of the actress and society beauty Lillie Langtry (1853–1929), nicknamed "Jersey Lily" for her name and the island of her birth. (She was born Emilie Charlotte Le Breton but married Edward Langtry in 1874.) Millais depicts her holding a Jersey lily (*Amaryllis belladonna*). (Significantly, its specific name means "beautiful lady.") The title has "Lilly" both as an 18th-century spelling of *lily* and as a blend of *Lillie* and *Lily*.

Jesse's Dream *see* The **Relief of Lucknow**.

The Jewel Casket George Bernard O'Neill, 1866, private collection.

A grandmother shows the treasures of her jewel casket to her young granddaughters. A smaller version of the painting in the City of London Guildhall Art Gallery is more explicitly titled *Gran's Treasures*. The girls were probably modeled by the artist's daughters.

The Jewish Bride Rembrandt van Rijn, c.1665, Rijksmuseum, Amsterdam.

A husband tenderly embraces his new young wife, his left hand around her shoulder, his right on her breast. The painting is possibly intended to be a biblical portrait of Isaac and Rebecca (Genesis 24).

The Jewish Cemetery Jacob von Ruisdael, c.1660, Gemäldegalerie, Dresden.

Ruins and dead trees surround a lonely cemetery amid mountains. A rainbow and new foliage contrast with them to emphasize the transitoriness of life. The landscape is fictional, and the tombstones were originally sketched by the artist at Ouderkerk, near Amsterdam.

Jo Sketching on the Beach Edward Hopper, 1923–34, Whitney Museum of American Art, New York.

A young woman sits sketching on a sandy beach. She is Josephine Nivison, the artist's wife, whom he married in 1924. They had met as students of Robert Henri.

Jo, the Beautiful Irish Girl (French, *La Belle Irlandaise*) Gustave Courbet, 1865–6, National Museum, Stockholm.

The sitter for the portrait was Joanna Hiffernan, the Irish mistress of J.A.M. Whistler in the early 1960s. She is also the subject of the latter's **Symphony in White No. 1** and **Symphony in White No. 2**.

Job Francis Gruber, 1944, Tate Gallery, London.

A naked man sits on a stool, his hand to his head, and contemplates a paper on the floor bearing the French words: "*Maintenant encore, ma plainte est un révolte, et pourtant ma main comprime mes soupirs*" ("Now again my lament is a revolt, yet my hand restrains my sighs"). The French artist painted the picture to symbolize the oppressed peoples of the world, who like Job in the Old Testament had undergone much suffering. The quotation is not from the Book of Job, however, but appears to be from some 19th-century writer such as Baudelaire or Verlaine.

John Deth Edward Burra, 1932, private collection.

A personification of death (John Deth), a

figure with a skull head holding a scythe in skeleton hands, intrudes into a decadent party and embraces a merrymaking woman, so turning the celebration into a macabre masquerade.

John Donne Arriving in Heaven Stanley Spencer, 1911, private collection.

A bearded young man with a staff walks along a road as four robed figures in a meadow nearby pray in different directions. The walker is the metaphysical poet John Donne (1572–1631) and the painting was inspired by one of his sermons.

Join Elizabeth Murray, 1980, Security Pacific Corporation, Los Angeles, California.

The abstract painting depicts two large forms in green and red that resemble the heads of two people about to kiss. But the undulations at the near edge of each do not entirely match, suggesting that the forms, although close to each other, will not actually be able to join. However, two thin vertical lines, one white and one black, interweave between the rounded projections, implying that the forms do after all have a common bond.

Jonathan's Token to David Frederic Leighton, c.1868, Minneapolis Institute of Arts, Minnesota.

The scene is taken from the Old Testament. Jonathan looks out into the field as he prepares to fire three arrows. A boy stands beside him, waiting to retrieve them. David, unseen, is somewhere in the surrounding landscape and waits for Jonathan's "token" (coded signal) that it it is safe to come out of hiding from King Saul (1 Samuel 20:18–24, 35–42).

Joseph in Egypt Pontormo, c.1515, National Gallery, London.

Joseph, son of Jacob, is shown in all his power and opulence as a great lord in Egypt.

Joseph Stalin Gazing Enigmatically at the Body of V.I. Lenin as It Lies in State in Moscow in the Style of Jackson Pollock Art & Language (real names Michael Baldwin and Mel Ramsden), 1979, private collection.

The painting by the two British artists superficially resembles a canvas by the American Abstract Expressionist Jackson Pollock. The viewer should be grateful for this interpretation while "gazing enigmatically" at what is otherwise an inchoate network of black on gray and white interspersed with splashes of green and yellow and spots of red.

Josephine and the Story Teller David Wilkie, 1837, National Gallery of Scotland, Edinburgh.

A young woman has her future told by fortune teller. She is the Empress Josephine, future wife of Napoleon, who is said to have her fate foretold when a girl.

Joshua Commanding the Sun to Stand Still John Martin, 1816, United Grand Lodge of Great Britain, London.

The scene is from the Old Testament. Joshua wins extra time in his battle against the league of five kings led by Adoni-zedek by commanding the sun to stand still (Joshua 10:12–14).

The Journey of the Magi Benozzo Gozzoli, c.1459, Palazzo Medici-Riccardi, Florence.

The artist's most famous work, in the form of frescoes on all four walls of the tiny chapel, depicts the Magi (Three Wise Men) on their journey to present gifts to the infant Jesus.

The Joy of Life (French, *La Joie de vivre*) Henri Matisse, 1905–6, Barnes Foundation, Merion.

The painting depicts an Arcadian scene with naked nymphs and shepherds exhibiting a true *joie de vivre*.

Joy of Living (French, *Joie de vivre*) Max Ernst, 1936, private collection.

The depiction of lush vegetation and dense foliage appears at first to justify the idyllic title until the viewer sees that the plants are in the process of metamorphosing into animals and monsters that will surely devour each other. The title is thus ironic.

Juan de Pareja Diego Velázquez, 1649–50, Metropolitan Museum, New York.

The half-length portrait is of the artist's mulatto slave, Juan de Pareja (c.1610–c.1670), himself also a painter.

The Judgement of Paris (1) Niklaus Manuel, c.1517–18, Kunstmuseum, Basel; (2) Lucas Cranach I, 1530, Staatliche Kunsthalle, Karlsruhe; (3) Peter Paul Rubens, 1632–5, National Gallery, London.

The scene is from classical mythology. Paris, son of King Priam, must judge which of the three goddesses, Hera (Juno), Aphrodite (Venus), and Athena, is the most beautiful, the prize being a golden apple. In Manuel's painting he has already presented the apple to a nude Aphrodite, while a clothed Hera and a nude

Athena turn away following their defeat. From a tree overhead, a blindfolded Cupid, god of love, shoots an arrow at Paris. In Rubens's depiction, Mercury, wearing his winged helmet and cloak, has led the goddesses to Paris and all three stand nude before him as he holds the apple while making his judgement.

Judith I Gustav Klimt, 1901, Österreichische Galerie, Vienna.

The painting is a portrait of the biblical Judith holding the head of Nebuchadnezzar's general, Holofernes, whom she has decapitated to save her compatriots (Judith 2–7, 10–15). As the title implies, this is the first version of the subject. The second, *Judith II*, was painted in 1909 and is in the Museo d'Arte Moderne, Venice. *Cf.* **Judith Beheading Holofernes**.

Judith Beheading Holofernes Artemisia Gentileschi, *c.*1620, Uffizi, Florence.

The scene is from the Apocrypha. The Jewish heroine Judith decapitates Nebuchadnezzar's general, Holofernes, in order to save her compatriots (Judith 2–7, 10–15). *Cf.* **Judith with the Head of Holofernes**.

Judith with the Head of Holofernes Cristofano Allori, 1613, Pitti, Florence.

The artist's best known painting depicts Judith holding the head of Holofernes by the hair after decapitating him. (*Cf.* **Judith Beheading Holofernes**.) An elderly servant woman looks on. It is said that Judith is a portrait of Allori's mistress, Mazzafirra, that the servant woman is her mother, and that the face of Holofernes is his own.

Juju as a Wave Philip Evergood, 1935–42, Hirshhorn Museum and Sculpture Garden, Smithsonian Institution, Washington, D.C.

A juju (spirit of a West African fetish) emerges wave-like from the sea to enter a tree.

Jumps Out at You, No? Jim Dine, 1993, private collection.

The etching depicts two bathrobes, almost identical in shape and size but each having different colors for its component parts (lapels, sleeves, upper and lower body panels). The colors thus clearly distinguish the robes, so that they "jump out at you."

The Jungle Wifredo Lam, 1943, Museum of Modern Art, New York.

The Surrealistic painting depicts a number of strange but humanoid creatures gathered at the edge of a jungle, their long limbs merging with the stems and stalks of the trees.

Juno Receives the Head of Argus Jacopo Amigoni, 1730–2, Moor Park, Hertfordshire.

The scene is from classical mythology. Juno (Hera) has set the many-eyed Argus to watch the cow Io, but Hermes kills him, whereupon Juno places his eyes in the tail of her bird, the peacock. The painting depicts Hermes presenting the head of Argus to Juno as she sits on a cloud next to her peacock.

Jupiter and Antiope *see* The **Dream of Antiope**.

Jupiter and Io Correggio, *c.*1531, Kunsthistorisches Museum, Vienna.

The painting depicts the nymph Io, daughter of the river god Iachus, being seduced by Jupiter (Zeus) in the form of a cloud. The work is also known as *Zeus and Io* or simply as *Io*.

Jupiter and Thetis (French, *Jupiter et Thétis*) J.-A.-D. Ingres, 1811, Musée Granet, Aix-en-Provence.

The scene is from Greek mythology. Having comforted her son Achilles after the death of his close friend Patroclus, the Nereid (sea nymph) Thetis goes to Mt. Olympus to beg Zeus for new armor. Now, kneeling nude before him as he sits impassive on his throne, she stares up at him imploringly while coquettishly stroking his bearded chin.

Just Harbouring a Grid Damien Hirst, 1983–5, private collection.

Parts of a grid are clearly visible in this abstract mixed media collage, whose title seems to pun on "harboring a grudge."

Justice and Divine Vengeance Pursuing Crime (French, *La Justice et la Vengeance divine poursuivant le Crime*) Pierre-Paul Prud'hon, 1808, Louvre, Paris.

The artist's masterpiece is an allegorical moonlit scene in which the figures of Justice and Vengeance fly to catch Crime, who flees from the naked corpse of the youth he has just murdered.

Just What Is It that Makes Today's Homes So Different, So Appealing? Richard Hamilton, 1956, Kunsthalle, Tübingen.

The photomontage, which heralded the start of Pop Art in Britain, is a satire on

consumerism and suburbia, and is made up of advertising images. The key human figures in a living room are a near-nude muscle man and a wholly nude girl either side of a poster advertising the magazine *Young Romance*. Also present are collaged images of a tape recorder, a can of ham, and a vacuum cleaner. Above is a moon ceiling. All these thus provide a visual answer to the question of the title, which has become a slogan of the period. (The word "POP" on a large lollipop held by the muscle man is said to be the earliest visual reference to Pop Art, although it also appears in **I Was a Rich Man's Plaything**.)

K

Keith Arnatt Is an Artist Keith Arnatt, 1972, Tate Gallery, London.

The work simply consists of the words "KEITH ARNATT IS AN ARTIST" painted on the white wall of an otherwise bare space. The inscription is thus its own title, which itself poses the two old questions: what is an artist, what is a work of art?

The Key of Dreams *see* The **Interpretation of Dreams**.

Kindred Spirits Asher B. Durand, 1849, New York Public Library.

The artist's most famous work was painted as a memorial to the American landscape painter Thomas Cole (1801–1848) and depicts Cole and the poet William Cullen Bryant on a rock above a deep gorge admiring the scenery in the Catskill Mountains, New York State.

King Cophetua and the Beggar Maid Edward Burne-Jones, 1884, Tate Gallery, London.

A king has finally found his ideal woman. King Cophetua has stepped down from his throne to sit and gaze up at the poorly clad, sweet-faced maiden. The subject is from Tennyson's short poem *The Beggar Maid* (1842), which has the lines: "Bare-footed came the beggar maid / Before the king Cophetua. / In robe and crown the king stept down, / To meet and greet her on her way." (Cophetua was a legendary African king who had no time for women until he saw a beggar maid "all in gray," fell in love with her, and made her his queen.)

The Kiss (1) (Italian, *Il bacio*) Francesco Hayez, 1859, Pinacoteca di Brera, Milan; (2) (French, *Le Baiser*) Auguste Rodin, 1886, Tate Gallery, London; (3) (German, *Der Kuß*) Gustav Klimt, 1907–8, Österreichische Galerie, Vienna; (4) (French, *Le Baiser*) Constantin Brancusi, 1908, Musée National d'Art Moderne, Paris; (5) (French, *Le Baiser*) Pablo Picasso, 1925, Musée Picasso, Paris.

All five works show a pair of lovers kissing in a close embrace. Hayez has a couple at the foot of some stone steps in what appears to be operatic costume. Rodin's marble sculpture, depicting a nude young couple, was originally conceived as a representation of Paolo and Francesca (condemned to Hell in Dante's *La Divina Commedia*) for The **Gates of Hell**. The man is an 18-year-old model, Liberio Nardone. The woman, also a model, is named Carmen.

Klimt's painting depicts the artist himself, holding his beloved Emilie Flöge in his arms.

The Kiss of the Sphinx (German, *Der Kuß der Sphinx*) Franz von Stuck, 1895, Museum of Fine Arts, Budapest.

The Sphinx, half woman, half bird and beast, crouches on a rocky ledge and embraces her victim, a naked young man whom she suffocates with her kiss of death. He is presumably a young Theban who has been unable to answer her riddle. *Cf.* **Oedipus and the Sphinx**.

Kitty's Breakfast Emily Farmer, 1883, Victoria and Albert Museum, London.

A young girl pours milk into a saucer to give to a kitten peeping out of a basket on the floor.

The Knight and the Women (German, *Der Ritter und die Frauen*) Max Slevogt, 1903, Gemäldegalerie, Dresden.

A knight clad in medieval armor is preparing to leave his tent, presumably for battle. Three naked women cling to him, two rolling on the floor and clutching at his leg, one gripping him by the arm. A fourth woman lies exhausted in the background.

The Knight Errant John Everett Millais, 1870, Tate Gallery, London.

Robbers have stripped a young woman of her valuables and left her tied naked to a tree. A knight in armor has found her, seen her plight, and with his sword now cuts the cords that bind her. A "knight errant" is one who travels about seeking adventure. Here he is the proverbial

"knight in shining armor" who has come to the rescue of a "maiden in distress."

The Knight of the Sun Arthur Hughes, 1860, private collection.

A dying knight is carried tenderly to his rest by a river in the glow of the (symbolically) setting sun. A page bears his sword and his shield emblazoned with his device of the sun.

The Knight's Dream Antonio Pereda, c.1665, Real Academia de San Fernando, Madrid.

A knight sits dreaming by a table on which lie a wealth of objects, including a purse, a tiara, flowers in a vase, a gun, books, a globe, skulls, and a clock. These are worldly goods that represent coveted human possessions: riches, power, beauty, glory, knowledge, and the like, in the face of death (the skulls) to which time leads (the clock). An angel by the knight holds a banner with the Latin inscription: "AETERNE PVNGT — CITO VOLAT ET OCCIDIT" ("It pierces perpetually — flies quickly and kills"). (The dash is represented by an arrow poised to be loosed from a drawn bow.) The present title is purely descriptive. Past titles include *Life is a Dream*, *The Dream of Life*, and *Disillusionment with Life*, while the painting was originally called *The Pleasures of Man Passing Like a Dream*. A better title would be *Allegory of the Vanity of Worldly Goods*.

Knowledge of the Natural (French, *La Connaissance naturelle*) René Magritte, 1941, private collection.

A nubile young woman with voluptuous golden tresses stands as a full frontal nude. The "knowledge" must be hers, and she displays and imparts it in her naked and natural presence.

Knucklebones, Walberswick Philip Wilson Steer, c.1888, Christchurch Mansion, Ipswich.

Knucklebones, an old English game involving tossing and catching the bones of animals, is shown being played by children with pebbles on the beach at Walberswick, Suffolk. It may be pure coincidence that the two awkward words of the title balance each other in sound and meter as well as evoking a primitive game in an elemental setting.

Kouros Isami Noguchi, 1944–5, Metropolitan Museum, New York.

The abstract sculpture is a modern equivalent of the classical Greek *kouros*, a statue of a nude youth, here presented in stylized anatomical form.

Kunst Kick Chris Burden, 1974, Basel Art Fair, Switzerland.

The work comprises photographs of the artist being kicked down a flight of steps: "At the public opening (of the Art Fair) … at twelve noon (on June 19, 1974), I laid down [*sic*] at the top of two flights of stairs in the Munstermesse. Charles Hill repeatedly kicked my body down the stairs, two or three steps at a time" (quoted in Taylor, p. 28). Hence the title, which means "art kick" (German *Kunst*, "art").

L

La La at the Cirque Fernando, Paris (French, *La La au Cirque Fernando, Paris*) Edgar Degas, 1879, National Gallery, London.

An acrobat is suspended by her teeth from a rope high in a circus ring. She is "a dusky lady known as La La" (as a contemporary English reviewer described her), here performing at the Cirque Fernando on the Boulevard Rochechouart, Paris.

Labor (Spanish, *Labor*) Joan Brossa, 1978, private collection.

The work consists of a red letter "A" knitted in wool and still attached to the needles and ball of wool with which it was made. The letter represents either the beginning of the alphabet, indicating the great labor that lies ahead, or else the second letter of "labor" itself. In addition, the Spanish word *labor* means not only "labor" but "knitting," "embroidery."

Lachrymae Frederic Leighton, c.1895, Metropolitan Museum, New York.

The painting's Latin title means "Tears," and as such has classical overtones. ("*Lacrymae rerum*," "tears of things," a phrase from Virgil's *Aeneid*, is an expression sometimes used in English to imply the innate sadness of human life.) The work depicts a grieving young woman, draped in black, resting her arm on a Doric column atop which stands a funerary urn. There appears to be no specific mythological or historical reference.

Ladies' Concert at the Philharmonic Hall (Italian, *Concerto di dame al casino dei*

Filarmonici) Francesco Guardi, 1782, Alte Pinakothek, Munich.

The painting depicts a specific occasion, the celebrations arranged in honor of the Russian "Counts of the North" when they visited Venice in 1782. Music was provided by a chorus of orphan girls assembled from the Conservatorio della Pietà, in its day one of the most famous vocal and instrumental ensembles in Europe.

The Ladies of the Chariots (French, *Les Dames des chars*) James Tissot, 1883–5, Museum of Art, Rhode Island School of Design, Providence.

The painting depicts the Hippodrome de l'Alma, Paris, and the Roman chariot race with female charioteers which was at one time mounted there.

Lady and Gentleman in a Landscape Thomas Gainsborough, *c.*1746–7, Louvre, Paris.

An elegant young couple are seated on a bench in a glade or garden before a classical rotunda. It is known that the depiction is of the artist himself, aged 19, and his wife Margaret Burr, his junior by a year, whom he had just married.

A Lady as Lucretia Lorenzo Lotto, *c.*1530, National Gallery, London.

In classical legend, Lucretia was a virtuous Roman wife who was raped by a prince and who then stabbed herself from shame. The lady representing her here is probably Lucrezia Valier, who married Benedetto Pesaro in 1533. She displays a portrait of her Roman namesake in her left hand, and a Latin inscription on the table by her reads: "NEC VLLA IMPVDICA LVCRETIAE EXEMPLO VIVET" ("Let no unchaste woman live after Lucretia's example"). The word "IMPVDICA" may allude to the fact that the drawing of Lucretia shows her in the pose of *Venus pudica* (*see* The **Birth of Venus**), while the lady Lucrezia echoes the gesture. The painting is also known as *A Lady with a Drawing of Lucretia*.

Lady Blessington's Dog — The Barrier Sir Edwin Landseer, 1832, Victoria and Albert Museum, London.

A large dog lies across the bottom step of a staircase, preventing a mother cat from reaching her kittens on the stairs higher up. Lady Blessington was the Irish writer born Marguerite Power (1789–1849). She married Charles Gardiner, 1st Earl of Blessington, in 1818 and established a brilliant salon in London. The dog, a gift to her from the King of Naples, also appears in the artist's later painting, *Waiting for the Countess* (1833).

The Lady Clare John William Waterhouse, 1900, private collection.

A serious-faced young woman walks through a glade followed by a doe. She is Lady Clare from Tennyson's poem of the same name (1842), who when she was told the secret of her humble birth "clad herself in a russet gown" and, accompanied by "the lily-white doe (her betrothed) Lord Ronald had brought" went sadly to offer him his freedom.

Lady in a White Dress *see* **Woman Combing Her Hair**.

Lady in Her Bath (French, *Dame au bain*) François Clouet, *c.*1570, National Gallery, Washington, D.C.

The aristocratic young lady sitting up in her bath was long said to be a portrait of Diane de Poitiers (1499–1566), mistress of Henry II of France, but is now thought to be of Marie Touchet (1549–1638), mistress of Charles IX.

Lady in White (French, *Dame en blanc*) Marie Bracquemond, 1880, Musée de la Ville de Cambrai.

The lady in a flowing white dress seated in a garden is a portrait of the artist's sister, Louise Quiveron, her constant companion and regular model.

Lady in White at Her Toilet *see* **Woman Combing Her Hair**.

Lady Lilith Dante Gabriel Rossetti, 1868, Delaware Art Museum, Wilmington, Delaware.

The painting is a portrait of the legendary Lilith, the beautiful yet evil wife of Adam before Eve, here depicted combing her long red hair as she looks into a hand mirror. The artist's own poem *Lilith* (1860) explains the subject and begins: "Of Adam's first wife, Lilith, it is told / (The witch he loved before the gift of Eve) / That, ere the snake's, her sweet tongue could deceive, / And her enchanted hair was the first gold." Lilith was modeled by Frances Cornforth but the face is that of Alexa Wilding. (*Cf.* **Lilith**).

The Lady of Shalott (1) William Holman Hunt, 1886–1905, Wadsworth Atheneum, Hartford, Connecticut; (2) John William

Waterhouse (a) 1888, Tate Gallery, London; (b) 1894, Leeds City Art Gallery.

Both artists depict the central figure of Tennyson's poem of the same name (1821), the princess who falls in love with Lancelot and who dies of unrequited love while floating down to Camelot. She originally appears in the Arthurian romances, and is Elaine, "the fair maid of Astolat" (the same name as Shalott), in Thomas Malory's *Le Morte d'Arthur* (*c*.1470). The model for Waterhouse's Lady is believed to be his wife. His first painting depicts the latter part of the poem, with the boat and its tragic burden floating into Camelot. The second has the Lady at the earlier moment of crisis when the mirror cracks from side to side as she whirls away from it, her broken threads twined around her knees. *See also* **"I Am Half Sick of Shadows," said the Lady of Shalott.**

The Lady Prays Desire Marie Spartali, 1867, Sotheby's, London.

A young woman looks wistfully at the viewer, her left hand resting on a half-opened book. She is the allegorical figure who "by well doing sought honor to aspire" in Spenser's *The Faerie Queene* (1590), and two lines from Book 2, Canto 9 of this work were quoted in the catalog of the painting's first exhibition: "Pensive I am and sad of mien, / Thro' great desire of glory and of fame."

Lady Reading a Letter at an Open Window Jan Vermeer, *c*.1658, Gemäldegalerie, Dresden.

The young woman reading the letter is believed to be a portrait of the artist's wife, Catharina Bolnes, whom he married in 1653.

A Lady with a Drawing of Lucretia *see* **A Lady as Lucretia.**

The Lady with a Veil Raphael, *c*.1515, Pitti, Florence.

The portrait is of the artist's mistress, better known as the subject of La **Fornarina**. The picture is also known by its equivalent Italian title, *La donna velata*.

Lady with an Ermine Leonardo da Vinci, *c*. 1490, Czartoryski Museum, Kraków.

The lady holding the ermine (white weasel) is a portrait of Cecilia Gallerani, mistress of Ludovico Sforza (1452–1508), Duke of Milan, who had commissioned it.

The Lady's Last Stake William Hogarth, 1759, Albright-Knox Art Gallery, Buffalo, New York.

A virtuous married lady has lost all her cards in a game with a young officer. She now faces the dilemma whether to lose her honor to him in order to recover her loss.

The Lament Edward Burne-Jones, 1864–6, William Morris Gallery, Waltham Forest, London.

The painting shows two figures seated on the stone benches of a castle chamber. A young woman robed in red holds a dulcimer, while a young man in blue rests his head on his hands in a gesture of sorrow or exhaustion. The depiction apparently has no specific narrative reference, so that "its title must be taken to indicate that the state of mind of the figures is one of grief and despair" (Wilton and Upstone, p. 127). The reason for the lament is thus unclear. Perhaps the two have ended a love affair, or the woman has lost her virginity.

The Lamentation of Christ Fra Angelico, 1436, Museo di S.Marco, Florence.

Christ has been taken down from the cross and as he lies on the ground is mourned by his mother, Mary, at his head, by St. John the Evangelist, next to her, and by Mary Magdalene, at his feet, as well as by other holy figures, including here St. Catherine and St. Dominic.

Laments Jenny Holzer, 1989, Dia Art Foundation, New York.

The installation comprises a row of black granite sarcophagi with neatly engraved inscriptions in capital letters. These are poetic "laments" on political, environmental, and feminist issues. One runs: "IT BECAME TOO HOT. THE BLACK DIRT'S HEAT MADE THE AIR WRIGGLE. NEW WEATHER WOULD NOT ENTER. FIRES COULD NOT STOP. I COULD NOT SEE MY NEIGHBOR. I TUNNEL FOR RELIEF. I DIG WATER AND PUT IT IN AN EGG. I BREAK INTO OTHER BURROWS BECAUSE YOU CANNOT ENJOY RUNNING IN A TUBE OF YOUR MAKING. I SHOULD FALL IN FREEZING WATER TO SAVE MY PARTS. I CANNOT GO WHERE IT IS COOLER BECAUSE PEOPLE THERE ARE AWAKE AND ARMED."

Lamia John William Waterhouse, 1905, private collection.

A maiden kneels before a knight in armor

in a wood. She is Lamia, originally a legendary monster, half woman and half serpent, that lured and devoured its victims, but here the young woman of Keats's poem so named (1820). Soon after, the artist painted two further versions of the picture, each with the specifically modified title *Lamia—Keats*. A later painting *Lamia* (1909) has the nymph seated alone on the edge of a rock-bound pool. *Cf.* **Lilith**.

Lampwick's Dilemma David Salle, 1989, Waddington Galleries, London.

The painting depicts a number of disparate but generally recognizable images, most of them superimposed on a horizontally oriented reproduction of a historical figure holding a staff. "The 'dilemma' of Salle's title seems to refer to the classic children's tale by C. Collodi, in which Pinocchio's errant schoolfriend Lampwick suggests a journey to the Land of Fun, where there are no schools or books and the days are spent in play. Once there, however, they discover that those who engage in endless fun turn into donkeys" (Taylor, p. 60). The work is thus a "play" of images.

Landscape: Noon, the Hay Wain *see* The **Hay Wain**.

Landscape with a City Francisco Collantes, 1634, Real Academia de San Fernando, Madrid.

A shepherd sits guarding his sheep against the background of a turreted city. It is suggested that the city is Toledo, since the central pointed Gothic tower resembles the spire of Toledo Cathedral. But if so, the artist has taken liberties with the true locations of the buildings.

Landscape with St. Jerome attrib. Joachim Patenier, *c*.1520, National Gallery, London.

The painting is a fantastical depiction of St. Jerome as a hermit in the desert of Chalcis in Syria. The landscape, with its towering crags and steep precipices, dwarfs the saint, seated in the foreground.

Landscape with the Ashes of Phocion Collected by His Widow Nicolas Poussin, 1648, Walker Art Gallery, Liverpool.

The painting depicts a scene from Plutarch's *Life of Phocion* (1st century AD). Phocion (402–318 BC) was an Athenian general condemned to death by his enemies and forced to drink hemlock. His body was refused burial within the city walls and was carried to the out-skirts of Megara, where it was cremated. His widow gathered his ashes (shown here) and took them back to Athens, where they were later accorded an honorable burial. The painting's pendant (companion picture) is *Landscape with the Body of Phocion Carried out of Athens* (1648).

Laocoön (1) ?, 2d or 1st c. BC, Vatican Museums, Rome; (2) El Greco, *c*.1610, National Gallery, Washington, D.C.

The Trojan priest of Apollo and his two sons struggle in vain against the snakes sent either by Apollo or Athene as a penalty for warning the Trojans against the wooden horse of the Greeks. The story is told in Virgil's *Aeneid*, 2:264–295. The antique marble group was carved some time BC and brought to Rome by the Emperor Titus in AD 69. It was rediscovered in a vineyard in Rome in 1506 and bought by Pope Julius VI for the Vatican Museum, where it is now. Its creator remains uncertain, and it may even be a Roman copy of a Hellenistic original. El Greco's painting includes the wooden horse trotting towards the Visagra Gate in Toledo, presumably with reference to the local tradition that the city had been founded by descendants of the Trojans. The figure of Laocoön is believed to be a portrait of the former archbishop of Toledo, Bartolomé Carranza.

Large and Small Form Barbara Hepworth, 1934, Piers Arts Centre Trust, Orkney.

The semiabstract sculpture of white alabaster is recognizably a mother and child, although the forms themselves suggest amoeba-like creatures from which all life on earth originated.

The Large Cowper Madonna *see* The **Niccolini-Cowper Madonna**.

The Large Glass *see* The **Bride Stripped Bare by Her Bachelors, Even**.

Large Trademark with Eight Spotlights Edward Ruscha, 1962, Whitney Museum of American Art, New York.

The "large trademark" is that of 20th Century Fox, and the "eight spotlights" are those seen playing above the wording in the familiar movie credit.

The Last Communion of St. Jerome (1) Agostino Carracci, *c*.1593, Pinacoteca Nazionale, Bologna; (2) Domenichino, 1614, Vatican Museums, Rome.

Both paintings depict the elderly saint

receiving his last communion. St. Jerome died at Bethlehem at the age of about 80.

The Last Day in the Old Home Robert Braithwaite Martineau, 1862, Tate Gallery, London.

A family has gathered in a room of a well-appointed house on the day before they leave. All the objects in the room have been numbered for sale, and the owner's mother exchanges a banknote for the keys surrendered by the elderly retainer. In the father's hand, draped over his young son's shoulder, is a racing notebook, representing his fatal weakness and so the reason for the enforced sale and their departure. The Christie's catalog on the floor gives the name of the owner and his house as Sir Charles Pulleyne, Bart., of Hardham Court.

The Last Day of Pompeii (Russian, *Posledniy den' Pompei*) Karl Bryullov, 1830–3, Russian Museum, St. Petersburg.

The huge painting depicts the destruction of Pompei by the eruption of Vesuvius on August 24, AD 79, and may have been intended to evoke the (unsuccessful) Decembrist uprising of 1825. It was inspired by Giovanni Pacini's opera *L'ultimo giorno di Pompei* (1825), and in turn was the inspiration for Edward Bulwer-Lytton's novel, *The Last Days of Pompeii* (1834).

The Last Evening James Tissot, 1873, Guildhall Art Gallery, London.

On the deck of a sailing ship, a young woman leans back pensively in a bentwood rocking chair, while her sailor suitor sits beside her and gazes at her intently. It is the unhappy couple's last evening together before the ship sets sail. The woman seems frail, and is perhaps an invalid, so it could quite literally be their "last evening." The young man is a portrait of the artist himself, while the lady is his mistress, Kathleen Newton.

The Last Furrow Henry Herbert La Thangue, 1895, Oldham Art Gallery.

An old plowman has died at his work in the field, and has slumped over the handle of the plow just as it was turning to make the last furrow. The horses have stopped, and one looks round inquiringly to see what has happened. The furrow is an obvious metaphor for the course of a working life.

The Last Gleam Walter F. Stocks, 1866, Victoria and Albert Museum, London.

The setting sun sheds a last gleam of light on a ruined castle. The title probably also alludes to the castle itself, remaining as the "last gleam" of its former full glory.

The Last Inn by the Town Gate (Russian, *Posledniy kabak u zastavy*) Vasily Perov, 1868, Tretyakov Gallery, Moscow.

In a scene of typical "Russian melancholy," two horsedrawn sledges wait in the snow at the entrance to a dimly lit inn. An old woman sits huddled on one sledge and a dog is tethered to the horse's harness.

The Last Judgment Michelangelo, 1536–41, Sistine Chapel, Vatican.

The gigantic fresco, the artist's first work in Rome, depicts the biblical day of judgment when the righteous and the wicked are accorded their deserts in the life to come after death.

Last Muster Sir Hubert von Herkomer, 1875, Lady Lever Art Gallery, Port Sunlight.

War veterans attend a final parade at the Royal Chelsea Hospital, London, the charitable institution that is their home. The painting's full title is *Last Muster: Sunday at the Royal Hospital, Chelsea*.

The Last of England Ford Madox Brown, 1855, Birmingham City Art Gallery.

An emigrant family sets out from Dover, England, for a new life elsewhere in the Commonwealth. As the boat departs, the young couple take a last look at their native land. The two pictured are the artist and his wife Emma, but the painting was inspired by the departure of the sculptor Thomas Woolner for Australia in July 1852.

The Last of the Buffalo Albert Bierstadt, 1888, Corcoran Gallery of Art, Washington, D.C.

Buffalo lie dead and dying as they are hunted down to near extinction by Indians. In the foreground the body of an Indian brave lies almost hidden among the dying forms of the animals. The artist stated that his aim in painting the picture was "to show the buffalo in all his aspects and depict the cruel slaughter of a noble animal now almost extinct" (quoted in Sweeney, p. 198). By "cruel slaughter," however, Bierstadt did not mean the Indian buffalo hunt, but the senseless extermination of the once vast herds by white settlers.

The Last of the Race Tompkins H. Matteson, 1847, New York Historical Society, New York.

An old chief, a younger man, and two women, the remnants of an Indian tribe, gather on a clifftop to contemplate the sunset over the ocean. The fact that the sun sets over the sea means that the location is the Pacific coast. This, for them, is thus the end of the line, and they have been "driven into the western sea" (W.C. Bryant, 1824) as the last of their race.

The Last Sleep of Arthur in Avalon
Edward Burne-Jones, 1881–98, Museo de Arte de Ponce, Puerto Rico.

King Arthur lies on his deathbed in Avalon, surrounded by maidens playing musical instruments and other attendants. Above him is a golden canopy with twelve reliefs depicting scenes from the Quest for the Holy Grail. The painting takes its subject from the Arthurian legends as told in Thomas Malory's *Le Morte Darthur* (printed 1485) and later by Tennyson.

The Last Spike
Thomas Hill, 1877–81, California State Railroad Museum, Sacramento.

The painting depicts the historic moment on May 10, 1869 when a golden spike was driven into the wooden ties at Promontory Point, Utah, to mark the meeting of the Union Pacific and Central Pacific railroads and thus the completion of the first transcontinental railroad.

The Last Supper
(1) Pietro Lorenzetti, *c.*1329, S. Francesco, Assisi; (2) Andrea del Castagno, 1447, S. Apollonia, Florence; (3) Dirk Bouts, 1464–7, St. Pierre, Louvain; (4) Domenico Ghirlandaio, 1480, S. Marco Convent, Florence, (5) Leonardo da Vinci, *c.*1495, S. Maria delle Grazie, Milan; (6) Andrea del Sarto, 1519, Monastery of S. Salvi, Florence; (7) Tintoretto *c.*1592, S. Giorgio Maggiore, Venice; (8) Daniele Crespi, *c.*1624–5, Pinacoteca di Brera, Milan; (9) Philippe de Champaigne, *c.*1652, Louvre, Paris; (10) (Russian, *Taynaya vecherya*) Nikolai Ge, 1863, Russian Museum, St. Petersburg; (11) Emil Nolde, 1909, Statensmuseum for Kunst, Copenhagen; (12) Stanley Spencer, 1920, Stanley Spencer Gallery, Cookham; (13) Salvador Dalí, 1955, National Gallery, Washington, D.C.

The depiction, one of the most frequently favored biblical subjects, is of the last meal before his trial and crucifixion that Christ held with his disciples in the Upper Room. The occasion instituted the Eucharist (the Lord's Supper). Most artists depict the breaking of the bread and blessing of the wine, but Leonardo concentrates on the moment when Jesus announces his forthcoming betrayal (Matthew 26:21–25, Mark 14:17–21, Luke 22:21–23, John 13:18–26). Ghirlandaio's fresco has a Latin text from Luke 22:29–30 running behind the figures of Christ and the disciples as they sit on a podium at table: "EGO DISPONO VOBIS SICVT DISPOSVIT MIHI PATER MEVS REGNVM. VT EDATIS ET BIBATIS SVPER MENSAM MEAM IN REGNO MEO" ("I appoint unto you a kingdom, as my Father hath appointed unto me; That ye may eat and drink at my table in my kingdom"). Ge places the depiction not at the moment of Christ's prophecy of his imminent betrayal but immediately after, as Judas leaves the room (John 13:30). Nolde portrays Christ and his disciples as German peasants. Spencer clothes the twelve disciples in monks' habits. Dalí has the company inside a modernistic, glass-encased room. The disciples bow their heads as they kneel around the table. Christ points towards heaven and the upper torso of a male figure overhead, presumably the Holy Spirit, that extends its arms to embrace the company. The supper itself is represented by the two halves of a broken loaf and a half-drunk glass of wine.

The Last Token
(German, *Das letzte Zeichen*) Cornelius Gabriel Max, 1874, Metropolitan Museum, New York.

"A beautiful young girl in the Roman arena (is) exposed to wild beasts. Some spectator has thrown her down a rose. She stands over it, resting her hand against the wall, and, looking up, tries to distinguish the one who has pitied her" (*The Century Cyclopedia of Names*, 1904). The rose is thus her last token of admiration.

Late Afternoon
see **Taperaa mahana**.

Late Morning
Bridget Riley, 1967–8, Tate Gallery, London.

The Op art painting consists of narrow vertical bands of gray bordered alternately with red and green. The overall effect is perhaps that of a late morning townscape, with its gray sky, red brick buildings, and green trees and gardens.

The Laughing Cavalier
Frans Hals, 1624, Wallace Collection, London.

The title of the artist's most famous painting is inaccurate, for the cavalier is not laughing but smiling. An inscription in the top right corner records that the sitter was aged 26 at the time.

The Laundress
see The **Burden**.

The Laundry (French, *Le Linge*) Natalia Goncharova, 1912, Tate Gallery, London.

Linen, a washboard, and a smoothing iron are three of the main objects discernible in this picture, which was painted in Russia. Five Russian letters transliterating as *prache* appear horizontally, presumably standing for *prachechnaya*, "laundry," "washhouse."

Laura Giorgione, 1506, Kunsthistorisches Museum, Vienna.

The best documented of the artist's works is this female portrait, whose subject even so remains unidentified. Her name is identifiable, however, from the laurel branch behind her.

Laus Veneris ("Praise of Venus") Edward Burne-Jones, 1873–8, Laing Art Gallery, Newcastle upon Tyne.

A queen and her attendants sit in a close group before a tapestry. Through a window a line of knights are seen riding by. The painting takes its subject from A.C. Swinburne's poem of the same title in the volume *Poems and Ballads* (1866), itself dedicated to Burne-Jones. Its own subject comes from the medieval legend of Tannhäuser, on which Wagner based his 1845 opera. The story centers on the Wartburg, where the landgraves of the Thuringian valley preside over contests between the Minnesingers. Near the castle is the Venusberg, inhabited by Holda, the goddess of spring, later identified with Venus, the goddess of love, who seduced the knights of the Wartburg and held them captive.

Lavender Mist Number I Jackson Pollock, 1950, National Gallery, Washington, D.C.

The entire surface of the abstract painting is a fine maze of blues, lilac-grays, white, and silver. There are so few contrasts of light and dark that the surface is essentially the "mist" of the title, with lavender the predominant shade. Lavender mist is itself a standard term for a pale purple that is paler than average lavender.

Leaning, Clear, Glass, Square Joseph Kosuth, 1965, Panza di Biumo Collection, Varese.

The work consists of four panes of glass, each 100 x 100 centimeters. They stand next to one another leaning against a wall. The first has the word "LEANING" in the center, the second has "CLEAR," the third "GLASS," and the fourth, predictably, "CLEAR." The four words of the title apply to each, since they are all leaning, all are clear or transparent, all are square, as stated, and all are panes of glass.

The Leaping Horse John Constable, 1825, Royal Academy of Arts, London.

A horse and his young barefoot rider leap a sluicegate on the Stour River, Suffolk. The painting was inspired by the practice of training the horses that towed the canal barges to leap over the barriers erected along the towpath to prevent cattle from straying.

Leaves and Shell (French, *Feuilles et coquillage*) Fernand Léger, 1927, Tate Gallery, London.

The painting shows four leaves and a shell against a stylized background. The work is sometimes wrongly referred to as *Leaves and Shells*, although there is clearly only one shell.

Leaves and Shells *see* **Leaves and Shell.**

Leda Peter Paul Rubens, *c.*1601–2, Gemäldegalerie, Dresden.

The scene is from classical mythology. Leda, here naked, is seduced by Zeus (Jupiter), disguised as a swan. As a result of the union she bore the twins Castor and Pollux and Helen. *Cf.* **Leda and the Swan.**

Leda and the Swan Correggio, *c.*1531–2, Staatliche Museen, Berlin.

The scene is similar to that above. Leda is seduced by Zeus in the form of swan. To the left, Cupid plays a harp. To the right, nymphs bathe in a pool, where there is a second swan. (A third flies overhead.) All the human figures are naked except two female attendants, who hold the robes of the bathing nymphs.

Leda Atomica Salvador Dalí, 1949, Fundación Gala-Salvador Dalí, Figueras.

The painting is a nude study of the artist's wife, Gala, being attacked by an angry swan. (*Cf.* **Leda.**) The work is a reaction to the destructive power of the atomic bomb, as demonstrated in Japan in 1945. Dalí now saw all matter as atomic particles, and began to paint accordingly.

The Leg of Mutton Nude Stanley Spencer, 1937, Tate Gallery, London.

The painting is a double nude portrait of the artist and his second wife, Patricia Preece. The title alludes to the leg of mutton that the artist added to the explicit depiction of the fleshy figures, whose limbs uncannily resemble this cut of meat in shape and coloring. Spencer himself referred to the painting as *Double Nude and Stove*, a title drawing the viewer's attention to the stove burning in the top right corner.

The Legend of St. Francis attrib. Giotto di Bondone, c.1298–1300, S. Francesco, Assisi.

Whether actually by Giotto or by the unidentified painter known as the Master of the St. Francis Cycle, the frescos on the nave walls of the Upper Church of S. Francesco in Assisi depict scenes from the life of the named saint, including his famous preaching to the birds.

The Legend of the True Cross: Piero della Francesca, c.1452–c.1465, S. Francesco, Arezzo.

The fresco cycle, also known as *The History* (or *Story*) *of the True Cross*, illustrates the named myth, and begins with the death of Adam, fallen at the foot of the tree that provides wood for the crucifix on which Jesus is slain. It includes battle pieces and courtly scenes.

Leisure William Merritt Chase, 1894, Amon Carter Museum, Fort Worth, Texas.

Two women and two children sit or lie on grassy dunes by the sea on a warm summer's day. The actual setting is of Long Island.

Leisure Hours John Everett Millais, 1864, Detroit Institute of Arts, Michigan.

Two small girls sit idly on the floor by a bowl of goldfish. The double portrait is of the sisters Anne (1852–1902) and Marion (1856–1955), daughters of Sir John Pender, a Scottish laird. The title seems to imply that the girls' leisure hours were as monotonous as the life of the goldfish, whose own "leisure hours" are spent swimming endlessly in their restrictive home.

Lending a Bite William Mulready, c.1815, private collection.

A boy holding an apple watches apprehensively as his friend takes a bite from it. Has his offer been over-generous? In the background, a girl munches an apple while a dog sniffs the ground hopefully for her own "lendings."

The Lesson William Mulready, c.1859, Victoria and Albert Museum, London.

A mother teaches a (rather large) naked boy on her knee how to say his prayers. The painting has the subtitle *"Just as the twig is bent, the tree's inclined"*, a quotation from Alexander Pope's *Epistles to Several Persons*, "To Lord Cobham" (1734), itself the variant of a proverb often cited as "Best to bend while it is a twig." *Cf.* **As the twig is bent, so is the tree inclined**".

The Lesson in Anatomy *see* The **Anatomy Lesson of Dr. Tulp**.

Let's Not Be Stupid Richard Deacon, 1991, University of Warwick.

The outdoor sculpture consists of two undulating steel forms, one apparently escaping from a cage to join another outside it. A horizontal framework of twisted stainless steel connects the two like an electric discharge. The theme of the work seems to be the duality of captivity and freedom. The title presumably sounds a note of caution: true freedom can never be fully realized, for there will always be a dependent link. It is perhaps equally a cautionary message (or rallying call) to the university students at its location.

The Letter Gerard Terborch, c.1655, Alte Pinakothek, Munich.

A young man dressed as a cavalier has entered the living room of an elegantly dressed lady to hand her a letter. She does not reach out her hand to take the letter, however, but withdraws it under her cloak. The depiction of this action makes it clear that the letter of the title is a love letter, and that the lady does not wish to accept it.

The Letter of Introduction David Wilkie, 1813, National Gallery of Scotland, Edinburgh.

In the library of a country house, a youth presents a letter of introduction to an elderly eccentric who, seated by his desk in nightcap and carpet slippers, regards him sceptically. The man's dog also approaches the youth suspiciously. The contrast is implicit between the fresh-faced "country bumpkin" and the cynical landowner.

L.H.O.O.Q. Marcel Duchamp, 1919, Mary Sisler Collection, New York.

The (in)famous painting is a reproduction of the **Mona Lisa** with a mustache added. The letters of the punning title give the French words *"Elle a chaud au cul,"* "She has a hot ass."

The Liberation of St. Peter Raphael, 1513–14, Stanza d'Eliodoro, Vatican.

The scene is from the New Testament. St. Peter, imprisoned by Herod Agrippa, is released from his chains by an angel (Acts 12:7).

Liberty in Chains *see* **Action in Chains**.

Liberty Leading the People (French, *La Liberté guidant le peuple*) Eugène Delacroix, 1831, Louvre, Paris.

A bare-breasted young woman, personifying Liberty, brandishes the French tricolor as she leads on the citizens of Paris over the bodies of

those killed in insurrection. The painting was inspired by the Revolution of 1830. The figure of Liberty is allegorical, but those with her are portraits of historical participants. The work is also known as *Liberty on the Barricades*.

Liberty on the Barricades *see* **Liberty Leading the People**.

Lieder ohne Worte ("Songs without Words") Frederic Leighton, *c*.1860–1, Tate Gallery, London.

A young woman sits by a fountain listening to the ripple of the water and the song of a bird. The title echoes that of Mendelssohn's well known piano pieces (1834–43), the "songs without words" being those of the running water and the bird.

Life at the Seaside *see* **Ramsgate Sands**.

Life Death, Knows Doesn't Know Bruce Nauman, 1983, Anthony d'Offay Gallery, London.

Flickering neon lights flash words in capital letters in the form of a cross superimposed on a circle. "Knows Doesn't Know" thus crosses "Cares Doesn't Care," while around the circle run the words, "Pleasure," "Pain," "Life," "Death," "Love," "Hate." The words flash on and off in arbitrary sequences and presumably represent the ambiguities of life. The title quotes what the artist regards as the key contrasts.

Life in London *see* **Punch**.

Life Is Everywhere (Russian, *Vsyudu zhizn'*) Nikolai Yaroshenko, 1888, Tretyakov Gallery, Moscow.

Convicts, among them a mother and her young child, feed pigeons through the barred window of a railroad prison wagon. The convicts still have their life, even though it is restricted, unlike that of the pigeons, which is unconfined. The painting was inspired by Leo Tolstoy's story *What People Live By* (1881).

The Life Line Winslow Homer, 1884, Philadelphia Museum of Art, Pennsylvania.

A lifeguard rescues a woman from a shipwreck by means of a breeches buoy. The artist had witnessed such a rescue on the New Jersey coast. The title may additionally hint at the vital link between the guard and the woman whom he tightly clasps.

Life's Illusions George Frederic Watts, 1848–9, Tate Gallery, London.

"Let us turn to an earlier work, '*Life's Illusions*'. Here there is no room for doubt as to the painter's meaning. He himself furnished an explanation which occupies nearly a page of the catalogue. The 'design' is 'allegorical', 'typifying the march of human life'. To the left is a swirl of upfloating figures, of flesh and drapery and garlanded flowers. These are 'fair visions of beauty, the abstract embodiments of divers forms of hope and ambition' that 'hover high in the air above the gulf which stands as the goal of all men's lives'. To the right, 'upon the narrow space of earth that overhangs the deep abyss' … are a 'knight in armour' who 'pricks on his horse in quick pursuit' of a bubble, 'an aged student' who is so absorbed in his book that the next step will take him over the edge of the precipice, a pair of lovers, a child pursuing a butterfly. The ground is all bestrewn with bones, and scattered gold, and sceptres and crowns" (*London Quarterly Review*, quoted in Blunt, p. 64). All the named objects and actions are examples of life's illusory aims and pleasures, as the title implies.

Ligeia Siren Dante Gabriel Rossetti, 1873, private collection.

In 1869 the artist drafted a libretto for an opera called *The Doom of the Sirens*. It was never performed, but it described the journey by sea of a Christian prince and his encounter with three Sirens, Thelxiope, Thelxinoë, and Ligeia, who try to lure him to destruction. The nude young woman holding a stringed musical instrument in the painting is thus Ligeia, her name deriving from Greek *ligys*, "clear-toned," "sweet." This refers to her beautiful voice and music-making, designed to entrance men and destroy them.

Light Cavalry Officer Charging *see* **The Charging Chasseur**.

The Light of Coincidence (French, *La Lumière des coïncidences*) René Magritte, 1933, Dallas Museum of Art, Texas.

The painting is of a sculptured female torso on the lines of the **Venus de Milo**. The torso is depicted in a case and is lit by the flame of a candle on a nearby table. The "coincidence" is presumably between the torso itself and the Greek sculpture that recognizably inspired it

Light of the Harem Frederic Leighton, *c*.1880, private collection.

A young girl holds up a mirror in which an exotically draped concubine in a Turkish harem admires herself. Her figure is that of Dorothy

Dene (real name Ada Alice Pullan), the artist's favorite model.

Light of the World Peter Blume, 1932, Whitney Museum of American Art, New York.

Three people on a terrace look up uncomprehendingly at a brightly shining electric street lamp. A church stands in darkness to the left. Modern technology is thus the "light of the world," although few understand it as yet. *Cf.* The **Light of the World**.

The Light of the World William Holman Hunt, 1854, Keble College, Oxford.

Christ, holding a lantern, knocks on a disused and overgrown door. The light from the lantern symbolizes the human conscience. The door is a symbol of the human soul, ignorant of or impervious to Christ's teaching. (It has no handle, so can be opened only from the inside.) Both the title and the depiction represent Christ's words: "I am the light of the world" (John 8:12), "Behold, I stand at the door and knock" (Revelation 3:20). The latter quotation is inscribed on the frame.

Light Sentence Mona Hatoum, 1992, Museum of Modern Art, New York.

The environmental installation was created from metal cages with a swinging light hung at its center, evoking a feeling of imprisonment. Hence the title, punning on the legal phrase.

The Lightning Field Walter De Maria, 1977, Catron County, New Mexico.

The outdoor installation consists of 400 stainless-steel poles in a rectangular grid array, one mile long and one kilometer wide. The poles attract lightning strikes, although this rarely happens. "Field" here has both the usual sense and the scientific one, as an area where a force is effective (as a magnetic field).

Lilith John Collier, 1887, Atkinson Art Gallery, Southport, Lancashire.

A young woman stands naked with a huge snake entwined around her. She is Lilith, said to be the wife of Adam before Eve (*cf.* **Lady Lilith**). Lilith is also known as Lamia (*see* **Lamia**), and the artist appears to have based his depiction on Keats's description of her in his poem of that name ("a palpitating snake" … "a gordian shape of dazzling hue, / Vermilion-spotted, golden, green, and blue").

Lion Comique Walter Richard Sickert, 1887, private collection.

A music hall singer is on the stage in full flow while a violinist saws away in the orchestra pit below him. The performer is the "lion comique" ("comic lion") of the title, otherwise Alfred Peck Stevens (1840–1889), also known as "The Great Vance". Any successful comic singer on the music hall stage was popularly known as a "comic lion" at this time, a famous earlier example being George Leybourne (1826–1882), familiar as "Champagne Charlie." The nickname itself apparently originated with John Reeve (1799–1838), who according to Pierce Egan's *Book of Sports* (1832) was the great comic lion after his success in the burlesque *The Lions of Mysore*. Leybourne may have gained the name because of his parody of a social lion. As Stevens habitually sported tails and a top hat, he was clearly cast in the same image.

Lion Crushing a Serpent (French, *Lion écrasant un serpent*) Antoine-Louis Barye, 1833, Louvre, Paris.

A snarling lion pins down a snake with its left front paw and crushes it with its right. The sculpture is based on drawings that the artist made in the Jardin des Plantes zoo, Paris.

The Listening-Room (French, *La Chambre d'écoute*) René Magritte, 1952, Menil Collection, Houston, Texas.

A huge green apple fills the whole of an otherwise empty room. The title appears to bear no relevance to the depiction. Perhaps this was the intention, so that it adds to the surreal scene.

The Literal Meaning (French, *Le sens propre*) René Magritte, 1929, Menil Collection, Houston, Texas.

Magritte painted more than one work of this title, each similar in subject. This one shows two framed shapes, one oval, one round, standing against a wooden wall. The first has the word "*salon*" ("drawing room") inscribed neatly inside it, the second has "*forêt*" ("forest"). Another painting has a single round shape inscribed "*femme triste*" ("sad woman"). Each of these wordings is thus the "literal sense" (but not the true sense) of what is depicted.

The Little Flowers of the Field Sir George Clausen, 1893, private collection.

A young woman lying prone in a meadow studies a small flower that she has picked. The title has a biblical ring (Psalm 13:15 tells how man is "as a flower of the field") and is perhaps intended to imply that the woman herself is one of the "little flowers" depicted.

The Little Fourteen-Year-Old Dancer

(French, *La Petite Danseuse de quatorze ans*)
Edgar Degas, 1881, Musée d'Orsay, Paris.

The bronze statue of a young ballet dancer, wearing a cotton skirt and pink satin hair ribbon, is a model of a girl from the children's ballet class at the Opéra, Paris. The original wax statue wore not only a muslin tutu but a linen bodice and satin shoes lightly covered in wax.

A Little Girl Jan Gossaert, *c.* 1520, National Gallery, London.

The subject of the portrait is traditionally identified as Jacqueline de Bourgogne, daughter of Adolphe de Bourgogne, a patron of the artist, and Anne de Bergues, whom Gossaert is known to have painted. Her date of birth is unknown, but she was probably around ten years old at the time of this depiction.

The Little Mermaid (Dan. *Den lille havfrue*) Edvard Eriksen, 1913, Copenhagen.

The bronze statue of a kneeling mermaid on a rock by Copenhagen's harbor is based on Hans Christian Andersen's 1836 fairy story of the same name in which she figures as the Sea King's daughter. According to local tradition, she is destined to wait on her rock for 300 years before entering the world of humans and gaining the possibility of life after death.

Little Pleasures Wassily Kandinsky, 1913, Solomon R. Guggenheim Museum, New York.

The semiabstract painting depicts a landscape with a rider on horseback galloping over a distant hill. Recent scholarship has revealed that the work is a theosophical reinterpretation of the Apocalypse of St. John, in which the things of this world, the "small pleasures" of the title, are seen to be passing away before the arrival of the new heaven and earth promised by Revelation. The distant rider is thus one of the Four Horsemen of the Apocalypse.

The Little Roamer Richard Rothwell, 1843, Victoria and Albert Museum, London.

A little bare-legged girl has been gathering flowers and now rests, standing, against a bank. On its first exhibition at the Royal Academy the painting had the unattributed quotation "her path 'mid flowers" added in parenthesis after the title.

A Little Solitude Amidst the Suns

(French, *Petite solitude au milieu des soleils*)
Francis Picabia, 1919, private collection.

The depiction of a pump-like mechanism superimposed on a diagram with five numbered circles has the subtitle: *A Picture Painted to Tell And Not to Prove* (French, *Tableau peint pour raconter non pour prouver*). The "suns" of the main title are presumably the circles, while the "solitude" must be the mechanism itself.

The Liver Is the Cock's Comb Arshile Gorky, 1944, Albright-Knox Art Gallery, Buffalo, New York.

The painting is a mass of brightly colored biomorphic forms suggesting birds, animals, plants, and human body parts. "The title has always baffled and annoyed me; somehow it seems too redolent of Surrealist re-creations — combining words never before joined to form near-nonsensical expressions" (Arthur C. Danto, review of Nouritza Matossian, *Black Angel: A Life of Arshile Gorky*, *Times Literary Supplement*, January 22, 1999). Many would agree. "The title defies easy comprehension despite the precise meaning — or meanings — of each word. The 'liver' might be an internal organ or 'one who lives,' for example, and the differences conjure up distinct images, none of which might seem illustrated in any literal sense by the painting" (Yenawine, p. 81). This is a reasonable conclusion, since the title is in English in the original. One might further suggest that as the liver as body organ is traditionally regarded as the seat of love and of violent passion, it may well be represented here as a flaming cockscomb. The riddle appears to be solved by Matossian, Armenian like the artist, who explains in her book: "'My liver' is an Armenian term of endearment. The cockscomb, or crown, denotes masculine pride." If this is so, the painting does not necessarily contain a depiction of either a liver or a cockscomb, and the title could even have a personal reference, so that "my liver" is Gorky's term of endearment for his young wife, the cockscomb being the artist himself, glorying in the birth of his first child.

The Living Mirror (French, *Le Miroir vivant*)
René Magritte, 1928, private collection.

Four pale biomorphic shapes are linked together against a black background. Inside each is a phrase or word, respectively "*personnage éclatant de rire*" ("person bursting out laughing"), "*horizon*" ("horizon"), "*armoire*" ("cupboard"), and "*cris d'oiseaux*" ("bird calls"). The title seems to imply that they mirror the named objects, none of which is actually depicted. The artist had considered using the same title for A **Courtesan's Palace**.

LNAPRK Jean-Michel Basquiat, 1982, Whitney Museum of American Art, New York.

The crayon-and-paint canvas is filled with graffiti and simple drawings. The words "ITALY IN THE 1500'S" appear at the top of the picture, as if ironically indicating *cinquecento*, referring to 16th-century Italian art. Immediately below this is a scrawled "LUNAPRK." This is a slightly more literate version of the title, which represents *Luna Park*, the famous Coney Island amusement park. The overall image is of a disadvantaged society and its associated undemanding lifestyle and materialistic pleasures.

La Loge ("The Box") Pierre-Auguste Renoir, 1874, Courtauld Institute, London.

An aristocratic young man and a wealthy young woman sit in their finery in a box at the opera. The posers for the painting were the artist's brother, Edmond, and a model called Nini.

Lola de Valence ("Lola of Valencia") Édouard Manet, 1862, Musée d'Orsay, Paris.

The portrayed Spanish dancer was the *première danseuse* of Camprubi's ballet company.

London Visitors James Tissot, 1874, Toledo Museum of Art, Ohio.

With the aid of a guidebook, a prosperous-looking gentleman explains the local sights to his female companion as both stand on the steps of the National Gallery, London. She does not share his interest, however, and looks directly at the viewer. Boys in the uniform of Christ's Hospital public school, then located in London, act as guides.

The Long Engagement Arthur Hughes, 1853–9, Birmingham City Art Gallery.

An impoverished young parson embraces his fiancée, agonizing when he will be able to afford to marry her. (Victorian engagements could last up to ten years until the families of both parties felt financially secure enough to proceed.) The scene is set in a forest, and the painting was originally conceived as a Shakespearean subject entitled *Orlando in the Forest of Arden*, depicting the hero of *As You Like It* and the girl he loves, Rosalind. This girl is not Rosalind but Amy, however, and her lover has waited so long that the ivy has grown over her name where he carved it on the bark of the beech under which they stand. The picture was originally exhibited untitled with a quotation from Chaucer's *Troilus and Criseyde* (*c*.1385): "For how myght sweetnesse ever hav be known / For hym that never tastyd bitternesse."

The Long Leg Edward Hopper, 1935, Huntington Art Gallery, San Marino, California.

A lone sailboat tacks into the wind on a "long leg" of its haul off the New England coast.

Looking Back Paula Rego, 1987, Saatchi Collection, London.

The painting depicts two women and a little girl. One of the women lies prone on a bed under a blanket while the other raises a leg as if to climb on to it. The small girl crouches below the bed, as if eavesdropping, and looks back knowingly at the viewer. The title seems to imply that the depiction is of a childhood experience to which the artist herself now looks back.

Loop My Loop Helen Chadwick, 1991, private collection.

The work is a photograph of a long lock of golden hair looped around a sow's intestine in shocking juxtaposition as a simultaneous evocation of intimacy and revulsion. (The hair represents female purity and innocence; the pig's gut stands for the animalistic side of human nature.) The title plays on the phrase "loop the loop," the aerobatics maneuver.

Lorenzo and Isabella *see* **Isabella**.

The Loss of Virginity (French, *Perte de virginité*) Paul Gauguin, 1890–1, Chrysler Museum, Norfolk, Virginia.

A naked young woman lies on the ground, one hand holding a red-tipped cyclamen to denote her recent defloration, the other resting on a fox which places its paw on her breast. In the background, a Breton wedding procession wends its way along a narrow path. The woman is the artist's mistress, 20-year-old Juliette Huet, who soon after bore him a daughter. Gauguin based the painting on Émile Bernard's portrait of his 19-year-old sister Madeleine in identical pose, but fully clothed (*Madeleine in the Bois d'Amour*, 1888, Musée d'Orsay, Paris). The fox is the demon of physical desire and a symbol of lasciviousness, as in **Be Loving, You Will Be Happy**. The work is also known as *The Awakening of Spring*. "The title, *The Loss of Virginity*, makes the meaning of the picture obvious — too obvious perhaps, because the painting is exceptional in Gauguin's oeuvre for the explicit nature of its symbolism" (Bowness 1991, p. 18).

Lost (German, *Verirrt*) Franz von Stuck, 1901, Österreichische Galerie Wien, Vienna.

A shivering faun, half man, half goat, is

lost in the snow, far from his usual pastoral warmth.

The Lost Change William Henry Knight, 1859, private collection.

An elderly gentleman, on his way home from church with his wife and daughter, has dropped (or thrown down as a gift) the change that he was carrying and village children now search for it in the muddy stream that runs through the street.

Lost in the Woods Edmund George Warren, 1859, private collection.

A small child has fallen asleep under a bramble bush in the woods after losing her way. The artist himself must have been "lost in the woods" to paint such a meticulous leafy scene.

The Lost Jockey (French, *Le Jockey perdu*) René Magritte, 1940, William N. Copley Collection, New York.

A jockey rides a race in a forest of trees whose trunks are giant bilboquets (balusters or chessmen). He is clearly well off course, but continues to urge his mount onwards. He may represent the artist himself, in pursuit of the unknown. There are several painting of this title with similar depictions.

The Lost Path Frederick Walker, 1863, private collection.

A young mother stumbles blindly through the snow carrying the bundle that is her tiny baby. She has lost her way, and one or both of them may perish. The artist painted the picture as an illustration for Dora Greenwell's long descriptive poem *Love and Death*, based on an actual reported occurrence. The mother died in the storm, but the child lived.

Lost Record Kay Sage, 1940, Indiana University Art Museum, Bloomington, Indiana.

A dead tree and two unidentifiable objects are depicted in a desert landscape. The title seems to imply that they formerly had a purpose, but that the record of what it was has been lost.

Louise O'Murphy *see* **Reclining Girl**.

LOVE Robert Indiana, 1966, Indianapolis Museum of Art, Indiana.

The four red letters of the word *LOVE* fill the canvas against a gray and green background. The "O" that occupies the top right quarter is tilted askew. The depiction and title encapsulate the popular culture of the 1960s. *See also* **AIDS (Cadmium Red Light)**.

Love Among the Nations Stanley Spencer, 1935, Fitzwilliam Museum, Cambridge.

Races and creeds of all nations meet to reconcile their differences in acts of erotic love. The artist originally titled the painting *Humanity*.

Love Among the Ruins Edward Burne-Jones, 1893–4, Wightwick Manor, West Midlands.

Two lovers embrace among briars that grow by ruined castle walls, each aware of the ephemerality of love and youth. The title was adopted from that of Robert Browning's poem (1855) although the painting is not an illustration of this but more the evocation of a mood.

Love and Death George Frederic Watts, *c*.1874–7, Whitworth Art Gallery, University of Manchester.

"Love — the chubby, manly boy — hearing the sweep of Death's garments and her stealthy footfall outside the door rushes impetuously forward, and with outstretched arm pushes against the strong white-robed figure. It is of no avail. Death conquers" (Charles T. Bateman, *G.F. Watts, R.A.*, 1901). The painting, a companion work to **Love and Life**, was suggested by the incurable illness of William Schomberg Kerr, 8th Marquess of Lothian (1832–1870), whose wife was a close friend of the artist.

Love and Life George Frederic Watts, 1884, Watts Gallery, Compton, Surrey.

"Love guides and aids Life, a fair young girl, undraped, up a rough ascent, while flowers spring up in his footsteps" (*The Century Cyclopedia of Names*, 1904). The painting is a companion to **Love and Death**. (In the former picture, Love is a naked young boy, a vainly struggling Eros. In the latter he is a nude young man, a handsome winged angel.) The artist himself commented: "Life, represented by the female figure, could never have reached such heights unless protected and guided by Love" (quoted in Charles T. Bateman, *G.F. Watts, R.A.*, 1901). The title links the two in a familiar alliterative association.

Love and the Pilgrim Edward Burne-Jones, 1896–7, Tate Gallery, London.

The painting is one of three illustrating Chaucer's *The Romaunt of the Rose* (*c*.1240–80), itself a translation of the French allegorical romance *Roman de la Rose* (*c*.1230), which tells of the encounters of the narrator in his endeavors to reach the rose that symbolizes his lady's love.

Here a winged Love holding an arrow leads the Pilgrim through a tangle of thorns.

Love at the Source of Life (Italian, *L'amore alla fonte della vita*) Giovanni Segantini, 1896, Civica Galleria d'Arte Moderna, Milan.

Two young lovers dressed in white walk along a narrow path past rhododendrons and privet towards a seated angel, who extends one of his great wings over a pool that is the "source of life." The artist has explained the color symbolism: the white-clad lovers are lilies, the red rhododendrons are "love eternal," the green privet is "hope eternal." An alternate title is *The Fountain of Youth* (Italian, *La fontana della giovinezza*), referring to the same pool. *Cf.* The **Fountain of Youth**.

Love in Autumn Simeon Solomon, 1866, private collection.

Cupid in the form of young winged boy, naked except for a red drapery with which he attempt to shield himself, is buffeted by the cold winds of autumn. The subject and title emphasize the transience of love, which is normally associated with spring, not the fall.

The Love Letter Margaret Carpenter, *c.*1840, private collection.

A young girl stands wistfully beneath a flowering may tree as she lowers the letter a lover has sent. The words of its writing cannot be made out.

Love on the Beach Philip Evergood, 1937, Hunter Gallery, Chattanooga, Tennessee.

Three couples dance or embrace in happy abandon on the beach. They are joined by a fourth couple: two crabs, who face each other claw to claw, also seemingly dancing.

Love on the Moor Stanley Spencer, 1937–55, Fitzwilliam Museum, Cambridge.

Crowds converge in various rituals of love-making upon a statue of a naked Venus, representing the artist's first wife, Hilda Carline (1889–1950), whom he had married in 1925 and whom he divorced in 1937, the year he began the painting. The artist himself is entwined around her legs, as if a Pygmalion endeavoring to bring his creation to life. The whole scene takes place on Cookham Moor near the Spencers' home at Cookham-on-Thames, Berkshire.

Love Song (French, *Le Chant d'amour*) Giorgio de Chirico, 1914, Museum of Modern Art, New York.

The three main objects in the Futurist painting are a plaster cast of the head of the **Apollo Belvedere**, a floppy rubber glove, and a ball. A locomotive puffs past in the background. The subject was inspired by the title of a poem by Guillaume Apollinaire.

The Lovesick Woman Jan Steen, *c.*1660, Alte Pinakothek, Munich.

A doleful-faced lady sits on the edge of her bed while a doctor feels her pulse. She is sick, but with love, not a physical malady. In the lady's other hand is a note reading: "*Daar baat gen medesyn want het is mine peyn*" ("No medicine can cure the pain of love").

Lucifer Jackson Pollock, 1947, private collection.

The abstract artist was influenced by the teachings of the Russian-born American theosophist Helena Blavatsky (1831–1891), and "as late as 1947, Pollock gave one of his most beautiful drip paintings the name of the infamous cultural pamphlet with which Blavatsky had tried to propagate her weird ideas: Lucifer" (*Sunday Times Magazine*, January 31, 1999).

The Lugubrious Game Salvador Dalí, 1929, private collection.

The painting is filled with sexual and scatological images, but a statue to the left of a man with an outstretched giant hand makes it clear that the "lugubrious game" of the title is masturbation. The work is also known as *The Dismal Sport*. *Cf.* The **Great Masturbator**.

Luncheon in Fur *see* **Breakfast in Fur**.

The Luncheon of the Boating Party (French, *Le Déjeuner des canotiers*) Pierre-Auguste Renoir, 1881, Phillips Collection, Washington, D.C.

A group of friends enjoy an alfresco meal on the upstairs terrace of the Restaurant Fournaise on an island opposite the village of Chatou on the Seine River, just outside Paris. Those depicted include the restaurant proprietor, M. Fournaise, his daughter, Alphonsine, Renoir's future wife, Aline Charigot, the party's organizer, Baron Barbier, the painter and boating enthusiast, Gustave Caillebotte, and two actresses, Jeanne Samary and Ellen Andrée. The English version of the title sounds as awkward as the original French is euphonious.

Luncheon on the Grass *see* Le **Déjeuner sur l'Herbe**.

Luxe, Calme, et Volupté ("Luxury, Calm, and Voluptuousness") Henri Matisse, 1904, Musée d'Orsay, Paris.

Nude figures rest on a beach after a swim in a scene of idyllic fantasy. The artist took the title from the repeated couplet in Charles Baudelaire's poem *L'Invitation au voyage* in *Les Fleurs du mal* (1857), in which a loved one is invited to a dreamland where all is harmony and beauty: "*Là, tout n'est qu'ordre et beauté, / Luxe, calme et volupté*" ("There, all is simply order and beauty, / Luxury, peace, and sensual pleasure").

Lydia in a Loge, Wearing a Peal Necklace Mary Cassatt, 1879, Philadelphia Museum of Art, Pennsylvania.

A young woman sits in a relaxed pose in a theater loge, light playing on her bare shoulders and golden hair. She is the painter's elder sister, who along with their parents had come to live with her in Paris.

M

Ma Jolie ("My Pretty One") Pablo Picasso, 1914, private collection.

The painting is a still life of a guitar, a die, a playing card, and other objects related to playing or leisure. The title is that of a popular song, and appears on a music sheet at the top of the picture. It was also the artist's pet name for his new mistress in 1912, Marcelle Humbert.

Machine Turn Quickly (French, *Machine tournez vite*) Francis Picabia, 1916–18, National Gallery, Washington, D.C.

The painting, like an engineering drawing, depicts a large cogwheel engaging with a smaller below it. The small wheel is labeled "*Femme*" ("Woman"), the large one "*Homme*" ("Man"). Over both is a network of fine lines and circles. The title mocks the glorification of the machine that arose during World War I. It is the engagement of the sexes that matters, not the engagement of one wheel with another to make the machine run faster.

Madame Récamier Jacques-Louis David, 1800, Louvre, Paris.

Madame Récamier, originally Jeanne Françoise Julie Adélaïde Bernard (1777–1849), ran a noted Paris salon that was a regular meet-ing place for royalists and opponents of Napoleon's government. Aged 23, she here reclines elegantly on the type of sofa or chaise longue that from this painting became known as a *récamier*. *See also* **Perspective: Madame Récamier by David**.

Madame X John Singer Sargent, 1884, Metropolitan Museum, New York.

The artist's best known portrait is actually of Madame Gautreau, née Virginie Avegno (1859–1915), an American from New Orleans who married a French banker, Pierre Gautreau, and became a Parisian society beauty. The portrait was originally exhibited at the Paris Salon as *Portrait de Mme****, the sitter not being identified to preserve her anonymity.

Mademoiselle Murphy *see* **Reclining Girl**.

Mlle. Rivière. J.-A.-D. Ingres, 1805, Louvre, Paris.

The artist painted portraits of three members of the wealthy Rivière family, the others being *M. Philibert Rivière* and *Mme. Philibert Rivière*. (All were painted in 1805 and all are in the Louvre.) The father, a court official, married Marie-Françoise Beauregard. Their daughter was aged 15 at the time of her own portrait, and died only a few months later.

The Madhouse (Spanish, *Casa de locos*) Francisco de Goya, 1794, Virginia Meadows Museum, Dallas, Texas.

Male inmates of a lunatic asylum, many of them naked, rage and rant in grotesque poses. One is a megalomaniac with a crown on his head and a scepter in his hand.

The Madness of Sir Tristram Edward Burne-Jones, 1862, private collection.

The painting takes its subject from Book IX, chapter iv, "Tristram's Madness and Exile," of "The Book of Sir Tristram de Lyones," which forms the fifth part of Thomas Malory's *Le Morte Darthur* (1485). Sir Tristram, misled by false tales of Iseult's love for another, leaves his castle in a wild frenzy and rushes into a wood, tearing down trees and bushes as he goes. He there finds the harp that Iseult gave him, and is shown weeping as he plays and sings to it.

The Madonna Alba *see* The **Alba Madonna**.

The Madonna Albertina Raphael, *c.*1509, Albertina, Vienna.

The pen and ink drawing of the Virgin reading a book to which the Child extends his hand is named for the museum where it is housed. The museum, located in the Archducal Palace, takes its own name from Archduke Albert of Sachsen-Teschen (1738–1822), founder of the collection of Old Master drawings from Dürer onwards.

Madonna and Child Guido da Siena, c.1280, Palazzo Pubblico, Siena.

The depiction of the Virgin Mary with the infant Jesus is one of hundreds. Here they are alone, but in some representations they are accompanied by other figures, as in those below.

Madonna and Child Enthroned with Sts. Peter and Mark and a Donor
Giovanni Bellini, 1505, Birmingham City Art Gallery.

The Virgin Mary sits with the Child on her lap and the named saints either side of her. The unidentified donor (who will have commissioned the painting) kneels before her.

Madonna and Child with Angel and St. Jerome see **Madonna of the Long Neck**.

Madonna and Child with Four Saints
Rogier van der Weyden, c.1450–1, Städelisches Kunstinstitut, Frankfurt am Main.

The Virgin Mary holds the infant Jesus to her breast, with St. Peter and St. John the Baptist to the right and St. Cosmas and St. Damian to the left. The work was probably painted in Florence for the Medici family. Not only does it bear the arms of Florence but Cosmas and Damian were the Medici patron saints while Peter and John bear the names of Cosimo de'Medici's two sons.

Madonna and Child with St. Catherine and a Rabbit see **The Madonna of the Rabbit**.

Madonna and Child with St. Jerome and St. Louis of Toulouse Cima da Conegliano, c.1495, Accademia, Venice.

The Virgin Mary is seated on a rock before an open landscape with the infant Jesus on her knee. To her left stands the Franciscan friar and bishop, St. Louis of Toulouse (1274–1297), and to her right St. Jerome.

The Madonna and Child with St. John see **The Madonna of the Meadow** (1).

Madonna and Child with Saints (1) Domenico Veneziano, c.1442–8, Uffizi,

Florence; (2) Alesso Baldovinetti, c.1454, Uffizi, Florence.

Domenico's painting depicts the Virgin Mary, holding the infant Jesus, enthroned between St. Francis and St. John the Baptist, on the left, and St. Zenobius and St. Lucy, on the right. The presence of the latter has caused the work to be alternately known as the *St. Lucy Altarpiece*. Alesso has the Virgin with the Child lying on her lap. To one side of her stand St. Julian and St. Lawrence, to the other are the doctor saints, Cosmas and Damian.

Madonna and Child with Sts. John the Baptist and Jerome Parmigianino, 1527, National Gallery, London.

The Virgin sits enthroned on a crescent moon with the infant Christ standing between her knees. Below, St. John the Baptist, half kneeling, faces the viewer and points back and up at the infant, while behind him, on his back in the undergrowth, lies St. Jerome, apparently having a vision. The title dates from no earlier than the 19th century.

Madonna and Child with the Baptist and St. Nicholas of Bari see The **Ansidei Madonna**.

Madonna and Saints Pietro da Cortona, 1626–8, Museo dell'Accademia Etrusca, Cortona.

The painting was commissioned by the Passerini family, some of whom were members of chivalrous orders. The Virgin and Child are thus accompanied by figures representing Knights of St. Stephen (in the person of St. Stephen), the Knights of Malta (St. John the Baptist), and the Order of Calatrava (St. James the Great).

Madonna Benois Leonardo da Vinci, c.1478, Hermitage, St. Petersburg.

The portrait of the Madonna and Child was acquired for the museum in 1914 from the widow of the Russian painter Léon Benois. Hence the name.

Madonna Conestabile Raphael, c.1500–2, Hermitage, St. Petersburg.

The painting of the Madonna and Child was purchased for the museum in 1875 from the collection of the Conte Conestabile in Perugia. Hence the name.

Madonna dal Collo Lungo see The **Madonna of the Long Neck**.

Madonna dei Pellegrini see The **Madonna of the Pilgrims**.

Madonna de la Servilleta *see* The **Madonna of the Napkin**.

Madonna degli Ansidei *see* The **Ansidei Madonna**.

Madonna del Belvedere *see* The **Madonna of the Meadow** (1).

Madonna del Cardellino *see* The **Madonna of the Goldfinch**.

Madonna del Coniglio *see* The **Madonna of the Rabbit**.

Madonna del Granduca *see* The **Madonna of the Grand Duke**.

Madonna del Libro *see* The **Madonna of the Book**.

Madonna del Pesce *see* The **Madonna of the Fish**.

Madonna del Prato *see* The **Madonna of the Meadow**.

Madonna del Sacco *see* The **Madonna of the Sack**.

Madonna del Velo *see* The **Madonna of the Veil**.

Madonna dell'Arancio *see* The **Madonna of the Orange Tree**.

Madonna della Candeletta *see* The **Madonna of the Taper**.

Madonna della Casa d'Alba *see* The **Alba Madonna**.

Madonna della Cesta *see* The **Madonna of the Basket**.

Madonna della Gatta *see* The **Madonna with the Cat**.

Madonna della Melagrana *see* The **Madonna of the Pomegranate**.

Madonna della Quaglia *see* The **Madonna of the Quail**.

Madonna della Rondine (1) Carlo Crivelli, *c.*1475–9, National Gallery, London; (2) *see* The **Madonna of the Swallow**.
The painting is an altarpiece formally named *The Virgin and Child with St. Jerome and St. Sebastian*, but which is known as *Madonna della Rondine* ("Madonna of the Swallow") from the swallow perched on the Virgin's throne. *See also* **Crivelli's Garden**.

Madonna della Rosa *see* The **Madonna of the Rose**.

Madonna della Scala *see* The **Madonna of the Stairs**.

Madonna della Sedia *see* The **Madonna of the Chair**.

Madonna della Verdura *see* The **Madonna of the Meadow** (1).

Madonna della Vittoria Andrea Mantegna, 1495, Louvre, Paris.
The portrait of the Virgin and Child was originally painted for the church of Sta. Maria della Vittoria ("St. Mary of the Victory"), Mantua, "a church built after the direction and design of Andrea by the Marquis Francesco (II Gonzaga), in memory of the victory that he gained (at the battle of Fornovo) on the River Taro, when he was general of the Venetian forces against the French" (Vasari I, p. 563).

Madonna delle Arpie *see* The **Madonna of the Harpies**.

Madonna delle Ombre *see* The **Madonna of the Shadows**.

Madonna in Glory with Saints and Angels *see* **Ognissanti Madonna**.

Madonna in the Rose Garden *see* **Madonna of the Rose Bower**.

Madonna Litta Leonardo da Vinci, *c.*1490, Hermitage, St. Petersburg.
The portrait of the Madonna and Child was purchased in 1865 for the museum by Czar Alexander II from the collection of the Counts Litta in Milan. Hence the name.

The Madonna Niccolini *see* The **Niccolini-Cowper Madonna**.

Madonna of Burgomaster Meyer Hans Holbein II, 1526, Schlossmuseum, Darmstadt.
The Virgin Mary is accompanied by portraits of the work's commissioner, Burgomaster Meyer of Basel, and his family (his first and second wives, his daughter, and a boy carrying a naked child).

Madonna of Humility Jacopo della Quercia, *c.*1400, National Gallery, Washington, D.C.

The marble sculpture depicts the Virgin and Child seated on the ground rather than enthroned as the Queen of Heaven. Hence the title.

The Madonna of Port Lligat Salvador Dalí, 1949, Marquette University, Haggerty Museum of Art, Milwaukee, Wisconsin.

The painting is a recognizable, if fragmented, Madonna and Child, the Virgin being posed by the artist's wife, Gala. She sits against a background of the coast off Port Lligat, Dalí's home village on the Costa Brava in northeast Spain.

The Madonna of St. Francis Correggio, 1514, Gemäldegalerie, Dresden.

The Virgin Mary is enthroned beneath a canopy. Before the throne are St. Francis, St. Antony of Padua, St. John, and St. Catherine. The artist painted the work for the church of S. Francesco in Correggio, his home town.

The Madonna of the Basket Correggio, 1520–6, National Gallery, London.

A simply dressed Virgin Mary with the infant Christ on her lap is seated on the ground. Beside her on the grass is a workbasket with cotton and scissors. Hence the title. The work is also known by its Italian title, *Madonna della Cesta*.

The Madonna of the Book Vincenzo Foppa, 1460–8, Sforza Castle, Milan.

The Virgin supports a standing infant Jesus with one hand while holding a prayer book in the other. The painting is also known by its Italian title, *Madonna del Libro*.

The Madonna of the Cat *see* **The Madonna with the Cat**.

The Madonna of the Caves Andrea Mantegna, *c.*1481, Uffizi, Florence.

The Virgin and Child are in a landscape with caves: "(Mantegna) painted ... a little picture of the Madonna with the Child sleeping in her arms; and within certain caverns in the landscape, which is a mountain, he made some stonecutters quarrying stone for various purposes" (Vasari I, p. 562). The painting is also known as *The Madonna of the Quarries*.

The Madonna of the Chair Raphael, *c.*1514–15, Pitti, Florence.

The Virgin Mary, with the Child on her lap and St. John the Baptist standing by, is seated on an ornate chair. The painting is also known by its Italian title, *Madonna della Sedia*.

The Madonna of the Fish Raphael, *c.*1514, Prado, Madrid.

The painting's full formal title is *Madonna Enthroned Between St. Hieronymus and the Archangel Raphael with the Little Tobit*. The latter, as the biblical character more usually known as Tobias, is shown holding a fish. Hence the title. (For the story, *see* **Tobias and the Angel**.) The painting is also known by the Italian title, *Madonna del Pesce*.

The Madonna of the Franciscans Duccio di Buoninsegna, *c.*1300, Pinacoteca Nazionale, Siena.

The Virgin Mary is worshiped by three kneeling Franciscan monks who are sheltered by her blue mantle. Hence the name of this depiction of the Virgin of the Protecting Cloak.

Madonna of the Goldfinch Raphael, *c.*1505, Uffizi, Florence.

The Virgin Mary is seated on a mossy bank before an open landscape. At her knee stand the infant Jesus and the child St. John, the one tenderly holding a goldfinch that the other gently strokes. The work is also known by its Italian title, *Madonna del Cardellino*.

The Madonna of the Grand Duke Raphael, *c.*1506, Pitti, Florence.

The painting of the Virgin and Child was bought in 1799 by Ferdinand III, Grand Duke of Tuscany (1769–1824). Hence the title. The picture is also known by the Italian form of the title, *Madonna del Granduca*.

The Madonna of the Harpies Andrea del Sarto, 1517, Uffizi, Florence.

The Virgin Mary, standing on a pedestal, just manages to hold on to the infant Jesus as he climbs up her to escape the two winged children (the "Harpies") who clutch at her legs. The painting is also known by its Italian title, *Madonna delle Arpie*.

The Madonna of the Lilies (Italian, *La Madonna dei gigli*) Gaetano Previati, 1893–4, Civica Galleria d'Arte Moderna, Milan.

The Virgin sits in a field of lilies with the infant Jesus on her lap. The artist aimed to evoke a late medieval image and originally planned to call the painting *Light* (Italian, *Luce*): "'If I manage to achieve the pictorial effect I am seeking it would be the most suitable title, nor would it be unfitting in the allegorical sense'" (quoted by Sandra Berresford in House and Stevens, p. 247, from F. Bellonzi and T. Fiori, *Archivi del Divisionismo*, Vol. I, 1968).

Madonna of the Long Neck Parmigianino, *c.*1535, Uffizi, Florence.

The Virgin Mary, portrayed with a stalklike neck, sinuous body, and elongated limbs, supports with one arm an outsized infant Jesus as he perches precariously on her knees. The painting is also known as *Madonna and Child with Angel and St. Jerome* or by its Italian title, *Madonna dal Collo Lungo.*

The Madonna of the Magnificat Sandro Botticelli, *c.*1480–5, Uffizi, Florence.

The tondo (circular painting) depicts the Virgin Mary with the infant Jesus on her lap surrounded by angels. His hand rests on her arm as she writes the Latin hymn known as the Magnificat in the book open before her. It begins: "*Magnificat anima mea Dominum,*" "My soul doth magnify the Lord" (Luke 1:46).

The Madonna of the Meadow (1) Raphael, 1505–6, Kunsthistorisches Museum, Vienna; (2) Giovanni Bellini, *c.*1510, National Gallery, London.

Raphael depicts the Virgin Mary seated in a flowery landscape. The infant Jesus stands before her with his hand on a cross that the infant St. John presents him. Hence the painting's formal title, *The Madonna and Child with St. John.* Bellini has the Virgin seated similarly, the Child asleep on her lap. Both paintings are also known by the Italian title, *Madonna del Prato,* while Raphael's is alternately either *Madonna della Verdura,* essentially the equivalent, or *Madonna del Belvedere,* "Madonna of the View."

The Madonna of the Napkin Bartolomé Murillo, *c.*1676, Museo de Bellas Artes, Seville.

The artist is said to have painted the portrait of the Virgin and Child on a table napkin supplied by the cook because no canvas was available. Hence the title. The work is also known by the Spanish equivalent, *Madonna de la Servilleta.*

The Madonna of the Orange Tree Cima da Conegliano, *c.*1495–7, Accademia, Venice.

The Virgin and Child sit beneath an orange tree. Hence the title of the painting, which is also known in Italian as *Madonna dell'Arancio.*

The Madonna of the Quarries *see* The **Madonna of the Caves.**

The Madonna of the Pilgrims Caravaggio, 1603–5, S. Agostino, Rome.

The Virgin holds the Child in her arms as she stands at the front door of an ordinary house and looks down at two pilgrims kneeling before her in grimy rags. The painting is also known by its Italian title, *Madona dei Pellegrini.*

The Madonna of the Rabbit Titian, *c.*1530, Louvre, Paris.

"The Virgin is seated on the ground with her hand on a white rabbit, to the delight of the infant Christ, who is held by St. Catherine" (*The Century Cyclopedia of Names,* 1904). The painting is known formally as *Madonna and Child with St. Catherine and a Rabbit,* or by its equivalent Italian title, *Madonna del Coniglio.*

The Madonna of the Pomegranate Sandro Botticelli, 1487, Uffizi, Florence.

The Child on the Virgin Mary's lap rests his left hand on the pomegranate that she holds to his body. The painting is also known by its Italian title, *Madonna della Melagrana.*

The Madonna of the Quail Pisanello, 1420–2, Museo di Castelvecchio, Verona.

The title derives from the quail that creeps from beneath the hem of the Virgin's gown as she holds the Child on her lap. The painting's Italian title, *Madonna della Quaglia,* is also used.

Madonna of the Rocks *see* The **Virgin of the Rocks.**

The Madonna of the Rose Parmigianino, *c.* 1530, Gemäldegalerie Alte Meister, Dresden.

"The Virgin has given the Child a rose, which he holds as he lies with one hand resting on a globe typifying the earth" (*The Century Cyclopedia of Names,* 1904). The painting is also known by its Italian title, *Madonna della Rosa.*

Madonna of the Rose Bower Martin Schongauer, 1473, St. Martin, Colmar.

The Virgin Mary is seated holding the infant Jesus against a background of a trained rose hedge, above which two angels hold her crown. The altarpiece is also known as *Madonna in the Rose Garden* or *Madonna of the Rose Hedge. Cf.* The **Virgin in the Rose Bower.**

Madonna of the Rose Garden *see* The **Virgin in the Rose Bower.**

Madonna of the Rose Hedge *see* **Madonna of the Rose Bower.**

The Madonna of the Sack Andrea del Sarto, 1525, S. Annunziata, Florence.

The fresco depicting the Holy Family is named for the sack against which Joseph is lean

ing reading. The painting is also known by its Italian title, *Madonna del Sacco.*

The Madonna of the Shadows Fra Angelico, *c.*1450, Convento di S. Marco, Florence.

The Virgin sits enthroned with the Child on her knee and four saints either side of her. The depiction is sidelit, so that the capitals of the classical columns behind her cast long shadows. Hence the title. The painting is also known by its Italian title, *Madonna delle Ombre*, or simply as a **Sacra Conversazione.**

The Madonna of the Stairs Andrea del Sarto, *c.*1522, Prado, Madrid.

The Virgin sits on the top of a short flight of stone steps as she holds the Child standing beside her. Hence the title of the painting, also known in Italian as *Madonna della Scala.*

The Madonna of the Swallow Guercino, *c.*1620, Pitti, Florence.

The painting of the Virgin and Child shows the latter with a swallow perched on his hand. Hence the title. The work is also known by its Italian equivalent, *Madonna della Rondine.*

The Madonna of the Taper Carlo Crivelli, *c.*1490, Pinacoteca di Brera, Milan.

The painting of the Virgin and Child, the centerpiece of a dismantled polyptych, takes its title from the slender candle seen in the bottom left of the picture. The work is also known by its Italian title, *Madonna della Candelleta.*

The Madonna of the Veil Raphael, *c.*1510, Louvre, Paris.

The Virgin kneels beside the sleeping Child and raises the veil over him. The young St. John kneels beside her. The Virgin wears a coronet, giving the alternate title *The Madonna of the Diadem*. The painting is also known as *The Virgin with the Veil*, *The Virgin with the Diadem*, or the latter's French equivalent, *Vierge au diadème.*

The Madonna with the Cat Giulio Romano, *c.*1530, Museo di Capodimonte, Naples.

"Having withdrawn to work by himself, Giulio painted a picture of Our Lady, with a cat that was so natural that it appeared to be truly alive; whence that picture was called the Picture of the Cat" (Vasari II, p. 123). The painting is also known as *The Madonna of the Cat* or, as its Italian equivalent, *Madonna della Gatta.*

The Madonna with the Green Cushion Andrea Solario, *c.*1507, Louvre, Paris.

The Virgin Mary suckles the infant Jesus, who lies on a plump green cushion.

Mae West's Face Which May Be Used as a Surrealist Apartment Salvador Dalí, 1934–5, Art Institute of Chicago, Illinois.

As the title implies, the painting is a depiction of the named actress's face. But she has been converted into an apartment ready for occupation. Her tumbling locks of hair are the curtains at its entrance, her chin is the steps that lead in, her lips are a sofa, her nose is a fireplace and mantelpiece, and her eyes are two pictures on the wall.

Maestà Duccio di Buoninsegna, 1308–11, Museo dell'Opera del Duomo, Siena.

The Italian title, meaning "Majesty," came to be used for a depiction of the Madonna and Child in which Mary is enthroned as the Queen of Heaven, surrounded by a "court" of saints and angels. The central panel of Duccio's altarpiece, originally painted for Siena Cathedral, is one of the most famous examples.

The Magic Circle John William Waterhouse, 1886, Tate Gallery, London.

A sorceress traces a circle on the ground around her bubbling cauldron as she casts her spell.

The Magician (French, *Le Sorcier*) René Magritte, 1951, Galerie Isy Brachot, Brussels.

A man sits at a table eating a meal. Closer inspection reveals that he has two pairs of arms: one pair of hands cuts up the food on his plate, while the right hand of the second pair pours a glass of wine as the left raises a pieces of bread roll to his mouth. He is clearly a magician!

Mahana no atua ("The Day of the God") Paul Gauguin, 1894, Art Institute of Chicago, Illinois.

Clothed and naked Tahitian women stand, sit, and lie on a beach. They are presided over by an idol of the god of the title. He is Taaroa, creator of the universe in Polynesian mythology. The painting's native title is inscribed at bottom left.

The Maid and the Magpie William Henry Hunt, 1838, Cecil Higgins Art Gallery, Bedford.

A kitchenmaid pauses in her chore of peeling apples in a simple cottage outhouse to turn and look at the viewer. A magpie in a cage is seen through the window. The title seems to

suggest a story or allegory, but is apparently purely descriptive.

Maiden Meditation Charles W. Cope, 1847, Victoria and Albert Museum, London.

A young woman reads a prayer book while kneeling in meditation. The painting was suggested by biblical words: "I will greatly rejoice in the Lord, my soul shall be joyful in my God; for he hath clothed me with the garments of salvation, he hath covered me with the robe of righteousness" (Isaiah 61:10). A figure behind the maiden is about to cast the "robe of righteousness" over her.

The Maids Paula Rego, 1987, Saatchi Collection, London.

Two chambermaids play some prank or prepare to enact some deed in their mistress's room. One approaches her mistress from behind as she sits in her chair and seems to be feeling her neck. The other clasps a young girl to her as if to stop her seeing what is about to happen. The title derives from Jean Genet's play of the same name (1947) in which the maids murder their mistress, so the suggestion is that these two may do likewise, or at least pretend to.

Majas on the Balcony (Spanish, *Majas en el balcón*) Francisco de Goya, *c.*1812, Metropolitan Museum, New York.

Two *majas* (lower class Spanish belles) are seated on a balcony attended by their beaux. *Cf.* The **Clothed Maja**, The **Naked Maja**.

The Major's Courtship (Russian, *Svatovstvo mayora*) Pavel Fedotov, 1848, Tretyakov Gallery, Moscow.

An impoverished army officer stands at the door of a room awaiting a response after asking a merchant for the hand of his daughter, who herself makes to rush from the room altogether.

Making a Doll's House Harry Brookner, 1897, private collection.

A young boy saws a plank of wood to make a doll's house for his little sister. The title may have additionally been intended to imply that the girl herself is the "doll."

Making a Train Seymour Joseph Guy, 1867, Philadelphia Museum of Art, Pennsylvania.

A young girl dresses up in the privacy of her attic bedroom, imagining the quilt she trails behind her to be the train of a fine lady's dress.

Mama, Papa Is Wounded! (French, *Maman! Papa est blessé!*) Yves Tanguy, 1927, Museum of Modern Art, New York.

The Surrealist painting depicts a barren beach setting with various biomorphic objects. The largest of these is a huge hairy antenna to the right. This emits a gray cloud, like a wounded sea creature, and is presumably the father. A green figure to the left is perhaps the mother, while a small yellow object like a jumping bean in the center could be the child who cries the words of the title. This was itself adopted from the notes of a psychiatric case history.

Mamba Mambo Alison Saar, 1985, private collection.

The sculpture of a nude woman represents a mambo, or Haitian voodoo princess. She is presumably also intended to be a striptease dancer who uses a boa constrictor in her act. Hence the first word of the title, relating to the mamba, a venomous African snake.

Mammon George Frederic Watts, 1884–5, Tate Gallery, London.

Mammon, as a personification of wealth and covetousness, is depicted enthroned like an ancient king, moneybags filling his lap. His left foot crushes a nude youth, while his massive fist bears down on the head of a naked girl. The painting's somewhat unusual subtitle is *Dedicated to his Worshipers*, almost as if the artist regarded his portrait as an "icon" of Mammon that those who are greedy should be honest enough to bow to or acknowledge.

Man and Woman Gazing at the Moon Caspar David Friedrich, 1830–5, Nationalgalerie, Berlin.

A couple stand by a rock near a dead tree, gazing at the waxing moon. As with other of the artist's paintings, the objects depicted have a religious symbolism. The couple are engaged in spiritual contemplation. The rock is the rock of faith. The crescent moon is Christ. A ridge of evergreen trees beyond the dead tree represents humankind's eternal hope of salvation.

Man in a Red Turban Jan van Eyck, 1433, National Gallery, London.

Also known as *A Man in a Turban*, the painting is generally considered to be a self-portrait. An inscription at the top of the frame reads in Middle Dutch, "ALC IXH XAN" ("As I can"), perhaps punning on the artist's name ("As Eyck can"). But the words are actually the first half of an old Flemish proverb, "As I can, but not as I would."

A Man in a Turban *see* **Man in a Red Turban**.

Man in the Open Air Elie Nadelman, 1915, Museum of Modern Art, New York.

The sculpture is of a bowler-hatted man standing nonchalantly, legs crossed, by a tapering shrub.

Man of Saint-Denis (French, *L'Homme de Saint-Denis*) César, 1958, Tate Gallery, London.

The manlike winged creature, sculpted from welded iron, was made in the French artist's workshop at Saint-Denis, Paris. Hence the name. (The artist named many of his sculptures for the places where they were made. Others are *Nude of Saint-Denis*, *Insect of Épinay*, and *Man of Villetaneuse*.)

Man on a Stair (French, *L'Homme sur un escalier*) Pierre-Auguste Renoir, *c.*1876, Hermitage, St. Petersburg.

The elegant young man posing on a staircase is the publisher Georges Charpentier (1846–1905). He and his wife (*see* **Woman on a Stair**) ran a famous artistic salon in their mansion on the rue de Grenelle, Paris, and the staircase depicted was in it.

Man Proposes, God Disposes Sir Edwin Landseer, 1864, Royal Holloway College, Egham, Surrey.

In the Arctic Circle, polar bears rapaciously destroy the remains of Sir John Franklin's ill-fated expedition of 1845 to find the Northwest Passage, in which he and his crew of 138 men perished. The title quotes from Thomas à Kempis's *The Imitation of Christ* (*c.*1415–24).

The Man with the Ax (French, *L'Homme à la hache*) Paul Gauguin, 1891, private collection.

A seminaked, somewhat androgynous Tahitian wields an ax on the beach while behind him a woman, presumably his wife, stows nets in a dugout canoe. The ax may represent the artist's exorcism of sexual impulses that he considered undesirable.

The Man with the Scythe Henry Herbert La Thangue, *c.*1896, Tate Gallery, London.

A mother who has been cutting cabbages in her garden bends over her invalid daughter slumped in a chair before their cottage and realizes with dawning incredulity that she has just died. At the end of the path, a man with a scythe over his shoulder is about to come through the gate. He symbolizes the "grim reaper" who has already mown down the little girl's life.

Man Woman Allen Jones, 1963, Tate Gallery, London.

The Pop Art painting depicts a closely seated couple, their (headless) bodies and limbs melting into each other in a multicolored blur. The work is one of a series entitled *Hermaphrodite*, and the male figure, with its brightly striped tie, is a self-portrait of the artist.

Manao tupapau ("Thought Spirit") Paul Gauguin, 1892, Albright-Knox Art Gallery, Buffalo, New York.

A nude Tahitian girl lies face down on a bed. She is the artist's young *vahine* (woman), Teha'amana (called by him Tehura), whom he found petrified with terror one evening on his return to the hut where they lived. Gauguin explained that Teha'amana's living spirit contrasts with the spirit of the dead (the *tupapau*, in the form of an old woman) who sits by the foot of the bed, so that she is "Day" to the spirit's "Night." The Tahitian title appears at top left. Gauguin interpreted this not quite accurately as "She thinks of the spirit of the dead." The painting's usual English title is *The Spirit of the Dead Keeps Watch*. *See also* **Merahi metua no Teha'amana**.

Mankind Eric Gill, 1927–8, Tate Gallery, London.

The sculpture, of a nude woman's torso and thighs, accentuates her breasts, belly, and genitals, and thus her role as generator and nourisher of the human race ("mankind").

Manneken-Pis Jérôme Duquesnoy I, 1619, Brussels.

The famous fountain of a small boy urinating has a Flemish name meaning literally "Little Man Piss." See also **Boy**.

Many Happy Returns of the Day William Powell Frith, 1854, Harrogate Art Gallery, Yorkshire.

A child's birthday party is about to begin. The celebrant is one of the artist's daughters, while the artist himself sits at the end of the dining-room table. The elderly lady at the far end was posed by his mother. The familiar wish of the title dates from at least the 18th century.

Map Jasper Johns, 1961, Museum of Modern Art, New York.

The brightly colored painting is a recognizable map of the United States, each state duly named in pseudo-stenciled lettering. A question arises: has the artist painted a map or a painting

of a map? Johns himself felt it was the former, and the title seems to confirm this. (He did not title it *United States*. Nor does the title hint at the painting's significant date, when John F. Kennedy took office and the civil rights movement was just beginning.)

Map to not indicate Terry Atkinson and Michael Baldwin, 1967, Tate Gallery, London.

The work is a rectangle containing the outlines of the states of Iowa and Kentucky. Below it is a list of all the surrounding states and other geographical areas which are not shown.

Marathon Nicolas de Staël, 1948, Tate Gallery, London.

The abstract painting comprises a display of oblong colored patches more or less angled towards the center. But why *Marathon*? "The title, unfortunately, remains somewhat of an enigma, as none of the people who might have been in a position to know ... can remember exactly what the artist had in mind" (Alley, p. 252). But the patches do suggest a certain dynamism, even if not exactly a marathon.

March, 1961 Roger Hilton, 1961, Whitworth Art Gallery, University of Manchester.

In a deliberate attempt to distance his abstract painting from any kind of representational reference, the artist gave it a title that simply denoted the month and year of its completion.

Maria Charles Landseer, 1836, Victoria and Albert Museum, London.

The painting depicts the pathetic, deranged Maria in Laurence Sterne's *A Sentimental Journey through France and Italy* (1768), where she is described as dressed in white sitting under a poplar with her elbow in her lap, her head to one side, and her little pet dog nearby.

Mariage de Convenance ("Marriage of Convenience") Sir William Quiller Orchardson, 1883, Glasgow Art Gallery.

A husband and wife sit at opposite ends of a dining table in a cavernous dining room. He is middle-aged and disillusioned, she is young and bored. The marriage that resulted from practical considerations has not worked out. The artist subsequently painted a pendant (companion picture), *Mariage de Convenance—After!* (1886), showing the same man seated by the fireside alone, the table now laid for one. He had planned to call it *Ichabod*, with its biblical connotation of "the glory is departed" (1 Samuel 4:21), but then decided to repeat the earlier title with the added significant word.

Mariamne John William Waterhouse, 1887, Forbes Magazine Collection.

The painting depicts Mariamne (c. 57–29 BC), queen of Herod the Great, falsely accused and unjustly condemned, descending the steps of the courthouse on her way to her execution. (Herod had been passionately attached to his wife and was moved to commute the sentence to life imprisonment, but was persuaded by his sister Salome to maintain the judgement.)

Mariana (1) John Everett Millais, 1851, private collection; (2) Dante Gabriel Rossetti, 1868–70, Aberdeen Art Gallery.

Millais's Mariana was suggested by Tennyson's 1830 poem of the name, itself inspired by Shakespeare's *Measure for Measure* (1604), in which Mariana has spent five years alone in a moated grange following the loss of her marriage dowry in a shipwreck. Rossetti's Mariana was taken more directly from Shakespeare. Millais has her in a blue dress stretching wearily by an embroidery table before a stained glass window. The painting was originally exhibited untitled but accompanied by the following lines from Tennyson's poem: "She only said, 'My life is dreary, / He cometh not,' she said; / She said, 'I am aweary, aweary, / I would that I were dead!'" Rossetti's Mariana dreamily works at a piece of embroidery while a boy sings her a melancholy song. (Act IV of the play opens with a boy singing: "Take, O take those lips away, / That so sweetly were forsworn.") The model for Rossetti's Mariana was Jane Morris, wife of William Morris. *Cp.* **Mariana in the South**.

Mariana in the South John William Waterhouse, *c.*1897, private collection.

A young woman stretches wearily before a mirror as she broods on the lover whose letters lie scattered at her feet. The title is that of Tennyson's 1832 poem, itself based on Shakespeare's Mariana "of the moated grange" (see **Mariana**), and the painting depicts its lines: "And, rising, from her bosom drew / Old letters, breathing of her worth."

The Market *see* **Ta matete**.

Marooning Edward J. Gregory, 1887, Tate Gallery, London.

A young woman reclines languidly beneath a parasol in a canoe that drifts slowly by a river bank. Another girl stands on the bank and looks enviously at her companion, as if marooned.

Marriage A-la-Mode William Hogarth, 1743–5, National Gallery, London.

The six engraved plates tell the story of two young persons forced into marriage by their greedy families, recording their boredom and adultery. The husband is finally killed in a duel with his wife's lover, while the wife herself commits suicide. The title comes from John Dryden's identically named tragicomedy of 1673. The individual titles of the engravings are: *The Marriage Contract, Shortly After the Marriage, The Visit to the Quack Doctor, The Countess's Morning Levée, The Killing of the Earl,* and *The Suicide of the Countess.*

The Marriage Contract William Hogarth, *c.*1732, Ashmolean Museum, Oxford.

A decadent aristocrat is about to sign a marriage contract with an ugly spinster but is deflected from the business by his jockey. The work is an oil sketch that probably represents the artist's early idea for The **Rake's Progress**.

Marriage of Alexander and Roxane
Il Sodoma, 1516–17, Villa Farnesina, Rome.

The fresco, regarded as the artist's finest work, depicts the marriage in AD 327 between Alexander the Great and Roxana, daughter of King Oxyartes.

The Marriage of Peleus and Thetis
Abraham Bloemart, 1638, Mauritshuis, The Hague.

The painting depicts the mythological marriage between Peleus, son of King Aeacus of Aegina, and the nereid Thetis.

The Marriage of Poseidon and Amphitrite (Italian, *Nozze di Poseidone e Anfitrite*) Felice Giani, 1802–5, Palazzo Milzetti, Faenza.

In a stormy, sea-sprayed scene, the oval fresco (on a wall in an antechamber leading to a bathroom) depicts the marriage of Poseidon, Greek god of the sea, to the goddess Amphitrite.

The Marriage of the Virgin *see* The **Betrothal of the Virgin**.

Married Couple in a Garden Frans Hals, *c.*1622, Rijksmuseum, Amsterdam.

The husband and wife beneath the oak tree are probably portraits of the merchant and explorer, Isaac Massa (1587–1635), and his first wife, Beatrix van der Laen. The work would have been executed to commemorate the couple's marriage, on April 25, 1622. (It is certainly a marriage portrait for the woman wears a wedding ring.)

La Marseillaise François Rude, 1833–6, Arc de Triomphe, Paris.

The stone relief has the alternate title *Departure of the Volunteers of 1792* (French, *Le Départ des volontaires de 1792*), and depicts a group of French volunteers departing for the Revolutionary campaign of 1792. It gained its popular title by association with the French national anthem, itself composed in 1792 as a marching song for French troops and adopted with enthusiasm by volunteer forces from Marseille.

Marsh Plant George Rockey, 1962, Hirshhorn Museum and Sculpture Garden, Smithsonian Institution, Washington, D.C.

The "marsh plant" is formed by a metal sculpture with thin blades that oscillate in the wind, like long reeds.

The Martyr of the Solway John Everett Millais, 1871, Walker Art Gallery, Liverpool.

The young woman bound in chains is a depiction of Margaret Wilson (1667–1685), a Scottish Covenanter who refused to acknowledge the episcopacy and was sentenced to death by drowning in the Solway River.

Martyrdom of St. Agatha Sebastiano del Piombo, 1520, Pitti, Florence.

Attempts to seduce the virtuous Agnes have failed, and two torturers now grip her nipples in iron pincers preparatory to severing her breasts with the knife that lies in the foreground.

Martyrdom of St. Andrew Bartolomé Murillo, *c.* 1680, Prado, Madrid.

The painting depicts the crucifixion of St. Andrew on a saltire (X-shaped) cross. Hence the modern St. Andrew's cross of this shape.

The Martyrdom of St. Clement
Bernardino Fungai, 1498–1501, York City Art Gallery.

The painting, originally one of five panels forming a large altarpiece, depicts the martyrdom of St Clement, pope from *c.*91 to *c.*101. According to legend, he was exiled from Rome by the Emperor Trajan, sent to Chersonesus in the Crimea, and killed by being thrown overboard lashed to an anchor, as shown here.

Martyrdom of St. John the Evangelist at the Porta Latina Charles Le Brun, *c.*1641–2, St. Nicolas du Chardonnet, Paris.

According to legend, St. John the Evangelist was arrested under Trajan at the Porta Latina in Rome and thrown into a barrel of burning

oil. The painting shows the saint being winched up by a crane to be deposited in the fiery cauldron with its billowing black smoke.

The Martyrdom of St. Margaret
Ludovico Carracci, 1616, S. Maurizio, Mantua.

St. Margaret, a model of Christian virtues, bares her neck for the executioner's sword. The painting hangs in the chapel dedicated to her in the named church.

The Martyrdom of St. Matthew
Caravaggio, 1599–1602, S. Luigi dei Francesi, Rome.

A frenzied killer, a hired assassin, rushes in to slay the apostle and evangelist St. Matthew as he lies wounded on the ground.

The Martyrdom of St. Sebastian
(1) Antonio Pollaiuolo, c.1475, National Gallery, London; (2) Hans Holbein I, c.1515–17, Alte Pinakothek, Munich.

These works represent just two of the representations of St. Sebastian being shot to death by arrows by his own archers on the orders of the emperor Diocletian. (The title is strictly speaking inaccurate, since according to early accounts he recovered after being left for dead.)

The Martyrdom of St. Stephen (1) Il
Cigoli, c.1597, Pitti, Florence; (2) Annibale Carracci, c.1603–4, Louvre, Paris.

The depictions are two of several showing the first Christian martyr, St. Stephen, being stoned to death (Acts 7:54–60).

The Martyrdom of St. Symphorian
(French, *Le Martyre de saint Symphorien*) J.-A.-D. Ingres, 1834, Autun Cathedral.

The painting depicts the martyrdom in AD 200 of Symphorian, a Christian beheaded for refusing to worship pagan gods. The cathedral at Autun stands on the site of his place of burial.

The Massacre of Chios (French, *Les Massacres de Scio*) Eugène Delacroix, 1824, Louvre, Paris.

The depiction of dead and dying men, women, and children was based on the 1822 massacre or selling into slavery of around 20,000 inhabitants of the Greek islands, including Chios, during the Greek struggle for independence from Turkish rule. The traditional French title uses the Italian name of Chios rather than the French.

The Massacre of the Innocents Guido
Reni, c.1612, Pinacoteca Nazionale, Bologna.

The scene is from the New Testament. King Herod orders the murder of all children aged under two in Bethlehem in a vain attempt to destroy the infant Jesus (Matthew 2:16). The painting depicts the actual frenzied slaughter.

Master Jonathan Buttall *see* The **Blue Boy**.

Master Lambton *see* The **Red Boy**.

Maternity (1) (Spanish, *Maternidad*) Joan Miró, 1924, private collection; (2) *see* **Mother and Child** (4).

A thin line joins a bulbous object surmounted by wavy feelers at top left with a large quadrant having a hole in it at bottom right. It is crossed by another line, joining a solid hemisphere with a cone on it at bottom left and a circular outline with a central dark ring at top right. From each of the latter dangle two plant-like objects. The Surrealist painting is an exercise in the artist's "biomorphic" symbols. The bulbous object is a woman's head, the feelers being her hair. The quadrant is her fan-shaped skirt. The hemisphere and circle are her breasts, the cone and the ring being nipples, while the plant-like objects suspended from them are her babies. (The upper one has feelers on its head like its mother, so must be a girl.)

The Mathematical Mind (French, *L'Esprit de géométrie*) René Magritte, 1936, Tate Gallery, London.

A mother holds her baby in her arms, but the head of the baby has been exchanged for that of the mother, and that of the mother for the head of the baby. The representation is thus that of a huge baby cradling its dwarfish mother. The title (in French literally "The Spirit of Geometry") appears to denote a mathematical equation, "Let the mother equal the baby."

Mathematics Takes a Holiday. Scholastic Designation: The Physics of Relative Motion Brings the Victim to the Bullet as the Ratio of Abstraction Is Always Altered in Favour of Those Who Find It to Their Advantage to Judge the Moon as a Hole in the Sky. Remedial Title: Piss-Pot Pete's Daughter Soils Apache Loincloths on a Jabberwocky Trajectory
Robert Williams, 1991, Robert and Tamara Bane Collection, Los Angeles, California.

The work, which reflects the artist's former interest in hot-rod customizing and comic book art, depicts a naked girl standing on the footrest

of a motorcycle that zooms upward from a cityscape. As she flies up, she shoots at the Apaches who pursue her. Both the depiction and the title are a deliberate "overload," and are intended to counterbalance the exoticism and minimal narrative verbalism normally associated with West Coast artists.

Mavourneen James Tissot, 1877, Owen Edgar Gallery, London.

The painting is a portrait of the artist's mistress, Kathleen Newton, née Kelly (1854–1882), the daughter of an Irish army officer. Hence the title, an English form of Irish *mo mhurnín*, "my dear one," here with particular reference to her name, in allusion to Julia Crawford's poem *Kathleen Mavourneen* (1835) and the popular song of 1839 based on it.

Max Schmitt in a Single Scull Thomas Eakins, 1871, Metropolitan Museum, New York.

The artist's friend, Max Schmitt, turns round in his scull in the foreground to face the viewer, while in the background Eakins himself is seen sculling. The painting is also known as *The Champion Single Sculls*.

May Day *see* **Punch**.

May Morning on Magdalen Tower William Holman Hunt, 1890, Lady Lever Art Gallery, Port Sunlight.

In a tradition observed since the 16th century, the choirboys and men of Magdalen College, Oxford, sing their annual invocation to summer atop the college tower early on the morning of May 1. This painting helped to popularize the event, which is today attended in the street and on the bridge below by crowds of university students.

May 23, 1953 (French, *23 mai 1953*) Pierre Soulages, 1953, Tate Gallery, London.

The abstract painting, a canvas of intersecting brushstrokes, is named for the date on which it was completed. The artist named many of his pictures thus, or simply called them *Painting*.

Mazeppa Horace Vernet, 1826, Musée Calvet, Avignon.

A naked youth is strapped to a running horse. He is the Polish page Mazeppa, who legend tells was discovered by a jealous fellow countryman in the act of committing adultery with his queen and punished by being tied to a horse

that carried him to the Ukraine, or according to another account, that ran until it fell dead, killing its rider.

Me in Germany (West) (German, *Ich in Deutschland (West)*) A.R. Penck, 1984, Museum Ludwig, Cologne.

The painting consists of a number of figures and pictograms representing episodes from the artist's life. He was born (in 1935) in East Germany, but settled in West Germany in 1980. His original name was Ralf Winkler, but out of fear of government repression he adopted the name of a geologist and ice age expert who lived from 1858 to 1949. Some of the figures in the painting seem to reflect the specialty of his historical *alter ego*.

The Meager Company Frans Hals, 1633–36, Rijksmuseum, Amsterdam.

The painting, with its eleven figures, depicts a thinly represented Amsterdam militia company.

Measurement of the Stones in the Wolf's Belly and the Subsequent Grinding of the Stones into Cultural Rubbish Sigmar Polke, 1980–1, Art Gallery of Ontario, Toronto.

The semiabstract painting depicts two human figures about to climb a ladder to a four-sailed windmill that another figure loads with stones. The title alludes to the old belief that the wolf filled its belly with stones to stave off hunger.

Medea Frederick Sandys, 1866–8, Birmingham City Art Gallery.

Medea, the sorceress of Greek mythology, loved Jason, but when he fell in love with and married Glauce, daughter of King Creon, she took her revenge by making a magic garment that would cause Glauce to be consumed by flame when she put it on. The painting shows Medea treating the threads from which the garment is to be woven with fire.

Medici Franz Gertsch, 1971, Ludwig Forum, Aachen.

The photographically realistic painting depicts five casually dressed young people standing by or leaning on a red and white wooden barrier. The title, presumably intentionally recalling the famous Italian family and its art patronage, is simply a name that can be seen (upside down) on one of the white sections of the barrier.

Medici Venus attrib. Praxiteles, 4th c. BC, Uffizi, Florence.

The marble statue of the naked Venus, regarded as a model of female beauty, was first recorded for certain in 1638 in the Villa Medici in Rome. Hence its name. It is signed by "Cleomenes, son of Apollodorus," but is now generally regarded as being a copy of *c*.100 BC of an original of the time of Praxiteles. It is also known as the *Venus de' Medici*.

The Meeting (1) (French, *La Rencontre*) Gustave Courbet, 1854, Musée Fabre, Montpellier; (2) (French, *Le Meeting*) Marie Bashkirtseff, 1884, Musée d'Orsay, Paris; (3) Richard Lindner, 1953, Museum of Modern Art, New York; (4) *see* The **Progress of Love**.

Courbet's painting was commissioned by a rich eccentric, Alfred Bruyas, and shows the artist arrogantly confronting Bruyas and his servant, Calas, who doff their hats to him on his arrival outside Montpellier in 1854. The picture's alternate title is *Bonjour, Monsieur Courbet* ("Good Morning, Mr. Courbet"), a pun on the words of the Fox to the Crow in Lafontaine's *Fables* (1668): "Bonjour, Monsieur Corbeau" ("Good morning, Mr. Crow"). The work was parodied in Gauguin's **Bonjour, Monsieur Gauguin**. Bashkirtseff shows a group of street urchins meeting for a "parley" on a street corner. (The English word in French use implies a meeting for purposes of serious discussion.) Lindner's painting depicts a meeting of utterly dissimilar people, none of whom acknowledges the presence of any of the others. They are King Ludwig II of Bavaria, a prim lady in a gray coat, a young woman showing her leg, a woman in a tightly laced corset and suspenders, an old-fashioned couple with the man in a sailor suit, a lady in a red dress, and a casually dressed man. A huge ginger cat sits among them. The meeting is thus of past and present, dream and reality.

The Meeting of David and Abigail
Peter Paul Rubens, *c*.1618, Detroit Institute of Arts, Michigan.

The biblical painting depicts Abigail, wife of Nabal, kneeling to placate David, who had been offended by her husband (1 Samuel 25). She later became his wife.

Melampus and the Centaur Glyn Warren Philpot, 1919, Glasgow Art Gallery.

In Greek mythology, Melampus was the first physician, and he is here depicted as a seated nude youth being taught his art by Chiron the centaur.

Melancholy Domenico Feti, *c*.1622, Gallerie dell'Academia, Venice.

A woman sits contemplating a skull, her head resting wearily in her hand. A plaster torso and a book lie abandoned at her feet as unused attributes of art and science. The somber tones of the painting contribute to the overall depiction of melancholy (literally, "black bile") as the bodily humor associated with all things dry, cold, and heavy.

The Mellow Pad Stuart Davis, 1945–51, Edith and Milton Lowenthal Collection, New York.

Ostensibly a view of the street from a New York window, the painting is essentially an abstract "representation" of syncopated jazz music, with brightly colored dancing forms and figures. The title, itself written among the shapes, is period jazz slang meaning the pleasant place, "the laid-back scene."

Meltdown Morning Neil Jenney, 1975, Philadelphia Museum of Art, Pennsylvania.

The painting is a narrow and heavily framed horizontal view of the trunk of a pine tree, on which green leaves are beginning to unfold. The title runs along the lower edge of the frame. The scene through the letter-box opening seems serene and springlike, until one detects sinisters clouds spreading upwards from the bottom of the picture. Nature has been violated.

Memories (French, *Mémoires*) Fernand Khnopff, 1889, Musées Royaux des Beaux-Arts, Brussels.

The painting depicts a study of seven women standing on a lawn, all holding a tennis racket. They are in fact one and the same woman, the artist's sister, Marguerite Khnopff, whom he lovingly recalled and re-created from photographs in this multiple pastel portrait.

Memory (1) Elihu Vedder, 1870, Los Angeles County Museum of Art, California; (2) René Magritte, *c*.1942, private collection.

At first sight, Vedder's painting appears simply to depict a lowering sky over a barren beach. But then one makes out the face of a woman in the clouds. She is the artist's wife, Carrie, whom he married in 1869. It is believed that the picture is based on a drawing that he made on her birthday, March 17, in 1867. Magritte's canvas centers on a pale plaster cast of a pensive woman's head with a splash of red paint on one cheek. The implication is that this is the "memory" that has suddenly struck her.

Men Without Women Stuart Davis, 1932, Radio City Music Hall, New York.

The mural in the men's lounge (smoking room) of the Radio City Music Hall is a painted assemblage of male- and masculine-associated objects, such as a yacht, an automobile, a gas pump, a barber's pole, a cigarette pack, a pipe, a Havana cigar, matches, and a playing card (the ace of hearts). The title was adopted from Ernest Hemingway's collection of short stories of the same name (1927).

The Menaced Assassin (French, *L'Assassin menacé*) René Magritte, 1926, Museum of Modern Art, New York.

A man stands listening to a phonograph while the corpse of a naked woman lies behind him on a couch. Her throat has been cut and blood streams from her mouth. In the left foreground, hidden from his view, stands a man with a club, while to the right, also unseen, is a man with a net. In the background the heads of three men watch over a balcony railing. The phonograph listener is thus the "menaced assassin" of the title, and the woman his victim. The title here logically explains the scene, unlike in many of the artist's later works, where the titles were often added later and had no rational connection with the depiction.

Mendicants of the Campagna Edward Villiers Rippingille, 1840–4, Victoria and Albert Museum, London.

Two young women lie resting with their children as they await gifts of food and money from sympathetic strangers in the Campagna Romana, Italy.

Las Meninas ("The Maids of Honor") Diego Velázquez, *c.*1656, Prado, Madrid.

The painting portrays the five-year-old Spanish infanta, Margarita Maria, with two maids of honor. A key element in the composition is a self-portrait of the artist, who stares at the viewer from a large canvas on which he is painting the king and queen, Philip IV and Mariana of Austria. (They are themselves unseen, as they are in the same location as the viewer, but their reflection appears in a mirror in the background.) The title was given only in the 19th century. The work's formal alternate title is simply *The Family of Philip IV.*

Menshikov in Berezovo (Russian, *Menshikov v Beryozove*) Vasily Surikov, 1883, Tretyakov Gallery, Moscow.

The painting depicts Aleksandr Menshikov (1673–1729), imperial chancellor and favorite of Peter the Great, shortly before his death in the Siberian village to which he was exiled as a traitor and embezzler in 1727. With his son and two daughters, he sits deep in thought in the tiny log cabin that he built himself.

Mental Arithmetic (Russian, *Ustnyy schyot*) Nikolai Bogdanov-Belsky, 1895, Tretyakov Gallery, Moscow.

In a provincial schoolroom, keen-faced peasant boys rack their brains to solve the calculation on the blackboard while the kindly teacher sits waiting for their individual answers. The boys look no older than twelve or thirteen, but the sum is fairly demanding for mental solution: $(10^2 + 11^2 + 12^2 + 13^2 + 14^2) \div 365$. (Figurewise readers may well be familiar with this one!)

Merahi metua no Teha'amana ("The Ancestors of Teha'amana") Paul Gauguin, 1893, Art Institute of Chicago, Illinois.

The painting is a portrait of the artist's 13-year-old Tahitian wife, Teha'amana, whom he called Tehura. She poses against a background of Polynesian gods and symbols to represent her heritage and ancestry. (The god depicted is Hina, also in **Hina Tefatou**.) *See also* **Manao tupapau**.

The Merciful Knight Edward Burne-Jones, 1863, Birmingham City Art Gallery.

A wooden figure of the crucified Christ leans down to embrace a knight in black armor who kneels before him. The knight is St. John Gualbert (died 1073), founder of the Vallumbrosan order near Florence in *c.*1040, who is said to have been miraculously embraced in this way when praying at a wayside shrine after forgiving the murder of a kinsman.

Mercury Instructing Cupid Before Venus Correggio, *c.*1520–5, National Gallery, London.

Venus has brought her son, Cupid, to be taught reading by Mercury, and the child Cupid is depicted studying at Mercury's knee while Venus looks on protectively. All three are nude, as they are in The **Education of Amor**. A popular title for the work is *The School of Love*.

Mercy's Dream Daniel Huntington, 1841, Pennsylvania Academy of the Fine Arts, Philadelphia, Pennsylvania.

The painting illustrates the episode from Part II of John Bunyan's *Pilgrim's Progress* (1684)

in which an angel reveals in a dream to Mercy, companion of Christiana, Christian's wife, that their pilgrimage will eventually bring them to their goal, Heaven.

Merlin and Nimue *see* The **Beguiling of Merlin**.

The Mermaid *see* The **Fisherman and the Siren**.

The Mermaids' Haunt Julius Caesar Ibbetson, 1804, Victoria and Albert Museum, London.

Some two dozen naked young women bathe or dry themselves in and around a pool in a pastoral setting. They are more naiads (river nymphs) than nereids (sea nymphs).

Merry Company Frans Hals, *c.*1615–17, Metropolitan Museum, New York.

The painting depicts a group of musicians, drinkers, and harlots celebrating Shrove Tuesday. Hence the work's alternate title, *The Shrovetide Revelers*. Two of the figures represent the stock theater characters Hans Wurst and Pickle Herring.

The Merry-Go-Round Mark Gertler, 1916, Tate Gallery, London.

Wooden-looking, open-mouthed figures sit stiffly on their horses in a fairground roundabout. As some of them wear military uniforms, the painting is presumably a satire on the futility of war. Its title further suggests this, for war involves advances and retreats, losses and gains, like the motion of a merry-go-round, which gives movement but no ultimate gain.

Merry Jesters (French, *Joyeux farceurs*) Henri Rousseau, 1906, Philadelphia Museum of Art, Pennsylvania.

A group of monkeys in a jungle setting appear to be playing with a bottle of milk and a back-scratcher, while one tickles another with a reed.

Merzbau *see* **Cathedral of Erotic Misery**.

The Message Henry Scott Tuke, 1890, Falmouth Art Gallery, Cornwall.

A mother sits in her humble breakfast parlor with her young sons and reads a telegram that has just been delivered by the post office messenger who stands awaiting her reply in the doorway. The implication is that it announces the loss of her husband at sea.

Le Métafisyx Jean Dubuffet, 1950, Musée National d'Art Moderne, Paris.

The painting is a crude representation of a massive human figure. Its title, a distorted spelling of French *métaphysique*, "metaphysics," denotes both its nonconformist nature and incorporeal, nonphysical content. (It hints at the literal meaning of "metaphysics" as "things after the physics.")

Metal Shutter and Violin (Catalan, *Porta metál.lica i violí*) Antoni Tàpies, 1956, Fundación Antoni Tàpies, Barcelona.

The work is what it says it is: an old, slightly rusty and dented metal shutter on which is fixed a violin with only two strings, its fingerboard projecting horizontally over the edge. The Catalan title is bisected in midword to evoke the distorted music produced by the squeak of the shutter and scrape of the violin's sole strings. The artist at this time was an enthusiast for *musique concrète*, in which sounds are produced by ordinary objects rather than instruments.

Metamorphosis of Narcissus Salvador Dalí, 1937, Tate Gallery, London.

The painting depicts the Narcissus of classical mythology, as the beautiful youth who sees his own reflection in a pool and falls in love with it, until he eventually pines away and is transformed by the gods into the flower that bears his name. Here, in one half of the picture, he is shown nude gazing into the pool as he sits beside it. The other half of the picture shows his "metamorphosis," in the form of a figure that resembles him quite closely in shape and outline but that is actually a giant hand holding up an egg from which a narcissus is growing. Before either event, he also appears in the background as a nude figure posing on a pedestal.

The Metaphysical Muse (Italian, *La musa metafisica*) Carlo Carrà, 1917, Pinacoteca di Brera, Milan.

A plaster-cast figure of a female tennis player with a mannequin head stands next to a map of Greece. In the background, a brightly-colored geometric cone stands beside a painting of factories. The figure is the "metaphysical muse" of the title. Carrà and his fellow Italian artist de Chirico were founders of so called "metaphysical painting" (*pittura metafisica*), in which disparate objects are depicted in combination to give a disconcerting, dreamlike atmosphere.

Midday Sir Anthony Caro, 1960, private collection.

The semiabstract steel sculpture, radiant in bright yellow-orange paint, suggests a sunbathing figure reading a book. Hence the title.

Midsummer Sir James Guthrie, 1892, Royal Scottish Academy, Edinburgh.

Three elegant young ladies take tea in a garden under the shade of a flowery tree.

A Mighty Blow for Freedom Michael Sandie, 1988, Gallery of Modern Art, Glasgow.

The sculpture shows a powerful figure smashing a television set, so freeing himself from its tyranny and the voice of authority that it represents. The title, almost a cliché, echoes words from Viscount Montgomery's 1944 message to his troops on the eve of the Allied invasion of Europe: "To us is given the honor of striking a blow for freedom which will live in history."

Mile Long Drawing Walter De Maria, 1968, Mojave Desert, California.

The work consists of two parallel chalk lines, 12 feet apart, running straight for a mile through the desert.

The Milkmaid's Garland Francis Hayman, *c.*1740, Victoria and Albert Museum, London.

The painting, subtitled *The Humours of May Day*, depicts a former English custom. On May first, London milkmaids declared a holiday, donned fancy costumes, and rented silver plates and mugs which they arranged into a kind of pyramid and carried on their heads in the manner of their usual daily milkpails. They then went the rounds of their customers, dancing to the music of fiddles and bagpipes and soliciting contributions.

The Mill Edward Burne-Jones, 1882, Victoria and Albert Museum, London.

Three young women stand in a pose reminiscent of the **Three Graces** (although they are clothed, not nude) before a mill while a fourth plays a musical instrument. No particular mill seems to be represented, and the title is not intended in any allegorical sense.

Milo of Crotona (French, *Milone de Crotone*) Pierre Puget, 1671–82, Louvre, Paris.

The marble sculpture group represents the moment when wolves attack the 6th-century BC Greek athlete, Milo, after he has become caught in the cleft of a tree while attempting to rend it

asunder. Milo came from the Achaean colony of Crotona, in southern Italy. Hence the title.

Minerva Protects Pax from Mars *see* **Peace and War**.

The Miracle of St. Mark Freeing the Slave *see* The **Miracle of the Slave**.

The Miracle of the Loaves and Fishes Giovanni Lanfranco, *c.*1620–3, National Gallery of Ireland, Dublin.

The scene, from the New Testament, depicts the miracle of the Feeding of the Five Thousand (Mark 6:35–44).

The Miracle of the Slave Tintoretto, 1548, Accademia, Venice.

The painting with which the artist made his name has the fuller alternate title of *The Miracle of St. Mark Freeing the Slave*, and is one of a series depicting legends of the martyred saint. Here St. Mark swoops down from the sky to break the hammer with which the executioner is about to strike the condemned slave.

The Miracle of the True Cross Gentile Bellini, 1496–1500, Gallerie dell'Academia, Venice.

The painting is one of a series of scenes dedicated to the cult of the True Cross, a sacred fragment believed to be a relic of the cross on which Christ was crucified. The depiction shows the recovery of the relic from the canal into which it had fallen.

The Miraculating Machine in the Garden Alice Aycock, 1982, Rutgers University, New Brunswick, New Jersey.

The complex and cumbersome structure with motor-driven parts represents the more playful aspect of modern technology, which can create similar "miraculating machines," produced as if by means of a miracle. The construction's subtitle is *Tower of the Winds*, where "winds" presumably puns on the two senses of the word.

The Miraculous Draft of Fishes Konrad Witz, 1444, Musée d'Art et d'Histoire, Geneva.

The scene is from the New Testament. The disciples net a huge haul of fish in the Sea of Galilee on the command of Jesus, who stands on the shore (Luke 5:1–11). Instead of the Lake of Gennesaret (Sea of Galilee), however, the artist has depicted a recognizable Lake Geneva.

Mirr Jean Arp, 1936–60, National Gallery, Washington, D.C.

The surreal marble sculpture appears to represent an as yet unborn form. "Its title is poetic but nonsensical, echoing the expressive sounds of Dada" (Richler, p. 183).

The Mirror Fairfield Porter, 1966, Nelson-Atkins Museum of Art, Kansas City, Missouri.

The painting is effectively a portrait of the artist's young daughter. She sits on a stool before a large mirror which reflects her back view and also her father as he paints her.

The Mirror of Life (Italian, *Lo specchio della vita*) Giuseppe Pellizza da Volpedo, 1895–8, Civica Galleria d'Arte Moderna, Turin.

The picture of a line of sheep following one another was painted from life and has a subtitle: *That Which the First One Does, the Others Follow* (Italian, *E ciò che fa la prima, e l'altre fanno*), a quotation from Dante's *Divine Comedy*, "Purgatory," Canto III (*c*.1308–21). The implication is that every life follows a course or pattern laid down by earlier lives.

The Mirror of Venus Edward Burne-Jones, 1873–7, private collection.

Venus, goddess of love, stands by a pool in which maidens look longingly at their own reflections. The inspiration for the painting was William Morris's poem *The Earthly Paradise* (1868–70), a series of 24 tales modeled on Chaucer's *Canterbury Tales* and Boccaccio's *Decameron*. The artist based his picture on his illustration for "The Hill of Venus" in Morris's work, itself a version of the Tannhäuser legend, like **Laus Veneris**.

The Miseries of Idleness George Morland, 1790, National Gallery of Scotland, Edinburgh.

The depiction is of a poorly clad family in their wretched housing. The feckless husband sleeps while the wife and two children sit listlessly, the boy gnawing a bone. A neglected baby howls on its pallet. The artist painted the picture following a popular plate entitled *The Effects of Youthful Extravagance and Idleness* (1789). *Cf.* The **Comforts of Industry**.

Misses Kate Greenaway, *c*.1879, Walker Art Gallery, Liverpool.

Two young girls in bonnets and bows, fur-trimmed coats, and fur muffs stand before a wooden fence. The title points to their pretentious middle-class status, confirmed by their fussy dress and prim poses.

The Missionary *see* A **Converted British Family Sheltering a Christian Priest from the Persecution of the Druids**.

Mississippi Raftsmen at Cards *see* **In a Quandary**.

Mr. and Mrs. Andrews Thomas Gainsborough, *c*.1749, National Gallery, London.

An elegant young country squire and his wife pose with gun and dog under an oak beside the rolling fields and woods that are part of their estate. Sheaves of ripe corn stand before them, denoting their wealth. The painting is also known as *Robert Andrews and His Wife*. The sitters are traditionally identified as a gentleman farmer, Robert Andrews (?1726–1806), and his wife Frances Mary, née Carter (*c*.1723–1780), who married in 1748. They are depicted on their farm, Auberies, near Sudbury, Suffolk. (The church in the background is St. Peter's, Sudbury, and the tower to the left is Lavenham church.)

Mr. and Mrs. Clark and Percy David Hockney, 1970–1, Tate Gallery, London.

The artist's best known double portrait depicts the named young couple, one standing, the other seated, at home in their sitting room. They are the fashion designers, Ossie Clark (1942–1996) and Celia Birtwell, married in 1969. Percy the white cat sits on Ossie's lap.

The Mitherless Bairn Thomas Faed, 1855, National Gallery of Victoria, Melbourne.

A sad little orphan boy is taken in by a poor but pitying family. He is the "mitherless bairn" (motherless child) of the title. The artist, a Scot, often used titles taken from Scottish folklore or vernacular poetry.

M-Maybe (A Girl's Picture) Roy Lichtenstein, 1965, Museum Ludwig, Cologne.

As with many of the artist's Pop Art paintings, the work is an enlarged frame of a typical comic strip, complete with uppercase wording. Here the depiction is of a blonde pensive-looking girl with a thought bubble: "M-maybe he became ill and couldn't leave the studio!"

The Mocking of Christ Matthias Grünewald, *c*.1503, Alte Pinakothek, Munich.

The scene is from the New Testament. Christ is mocked by the soldiers before his crucifixion (Matthew 27:29–31, Mark 15:17–20, Luke 22:63–65). Here, as in Luke's description, Christ is seated blindfolded while the soldiers strike him.

The Models (French, *Les Poseuses*) Georges-Pierre Seurat, 1888, Artemis, Luxembourg.

The painting should really be called *The Model* (*La Poseuse*), since although it contains three figures, they are front, side, and back views of one and the same nude model, posing in the artist's studio before his canvas of La **Grande Jatte**.

Modern Art (German, *Moderne Kunst*) Sigmar Polke, 1968, private collection.

The painting depicts the clichés both of a regular picture and of a modern work of art. Within a white border, the canvas is dominated by a large splash of mauve paint over broad and fine brush strokes, some straight, some curved or curled. The German title appears boldly below.

A Modern Olympia *see* The **New Olympia**.

Molly Longlegs George Stubbs, 1762, Walker Art Gallery, Liverpool.

A jockey holds the bridle of the racehorse named in the title, a bay mare who won 200 guinea prizes at Newmarket.

Mon Brave William John Hennessy, 1870, Brooklyn Museum, New York.

A young woman kisses the framed portrait of her dead lover, killed in the 1870 Franco-Prussian War. The title adopts the French phrase meaning "my good man," but here is perhaps better interpreted as "my hero."

Mona Lisa Leonardo da Vinci, *c.*1503, Louvre, Paris.

The famous portrait is of an otherwise obscure Florentine lady named Lisa Gerhardini, wife of the merchant Francesco di Zanobi del Giocondo. Her husband's name gave the painting's alternate Italian title, *La Gioconda*, i.e., wife of (Francesco del) Giocondo. *Mona* means "Lady," as a form of *monna*, modern Italian *madonna*, "my lady." *La Gioconda* happens to translate as "The Merry One," but this is hardly apt for the enigmatically smiling lady.

Mona Lisa with Keys (French, *La Joconde aux clés*) Fernand Léger, 1930, Musée Léger, Biot.

The title accurately describes the painting, in which a bunch of keys dominates the center foreground, with a reproduction of the **Mona Lisa** floating to the right. (There are also a tin of sardines, a circular form, and a winding black ribbon.) The artist explains the origin of the work: "One day, after drawing a bunch of keys, I asked myself what element was furthest removed from the bunch of keys, and I said to myself: 'It's the human face.' I went out into the street and saw in a shop window the portrait of Mona Lisa. That is how I did the picture *Mona Lisa with Keys*" (quoted in Schmalenbach, p. 100).

The Monarch of the Glen Sir Edwin Landseer, 1850, John Dewar and Sons, Ltd.

A stag stands proud and untamed in a Scottish valley against a background of misty peaks. The painting personifies the Victorian virtues of nobleness and heroism. The title evokes the association between royalty and the Scottish highlands, as well as between royalty and deerhunting. Queen Victoria's residence was in the highlands, so she was also "monarch of the glen."

Monna Vanna (1) Dante Gabriel Rossetti, 1866, Tate Gallery, London; (2) Franz von Stuck, *c.*1920, private collection.

Rossetti's painting is a portrait, modeled by Alexa Wilding, of an ideal Venetian beauty. It was originally entitled *Venus Veneta* ("Venetian Venus") but was renamed to evoke a specifically Italian connection. Monna Vanna ("Lady Vanna") is a character in both Boccaccio and Dante's *La Vita Nuova* (*c.*1293). Von Stuck depicts her as a standing figure opening her gown to reveal her naked body.

Monogram Robert Rauschenberg, 1955–9, Moderna Museet, Stockholm.

The freestanding combine (painting that includes real objects) comprises a stuffed goat girdled with a tire. This represents the artist's monogram, the sign by which he is best known. (Monograms are drawn with the letters interlacing each other, as the goat laces through the tire.) The symbol itself is a sexual fetish: the goat represents lust, and this one, halfway through the tire, is an image of anal sex and so an icon of male homosexual love.

Mont Sainte-Victoire Paul Cézanne, 1885–95, Barnes Foundation, Merion, Pennsylvania.

The painting depicts the artist's favorite subject, the mountain known as Mont Sainte-Victoire, near his hometown of Aix-en-Provence.

Montserrat Julio González, 1937, Stedelijk Museum, Amsterdam.

The artist's best known work, a lifesize

sculpture of a peasant woman with a child in her arms, commemorates the suffering of the Spanish people in the Civil War of 1936–9. Mt. Monserrat, northwest of Barcelona, is Spain's holy mountain.

Monuments at G Paul Klee, 1929, Metropolitan Museum, New York.

The painting consists of thin horizontal bands of green, gray, brown, and red, with occasional yellow, broken by angular lines that suggest the shapes of pyramids and other "monuments." The artist had recently visited Egypt, and had seen the pyramids at Gaza, the "G" of the title.

The Moon and the Earth *see* **Hina te Fatou**.

Moonrise by the Sea Caspar David Friedrich, 1822, Nationalgalerie, Berlin.

Three elegantly dressed young women sit on a rock and look out to sea as the moon rises and ships sail back to their home port. The artist painted the picture as a companion piece to *The Solitary Tree* (*Village Landscape in Morning Light*), intending they be viewed together.

Morgan-le-Fay Frederick Sandys, 1864, Birmingham City Art Gallery.

Morgan-le-Fay (Morgan the Fairy) was the half-sister of King Arthur. She was jealous of his goodness and power to inspire love and so plotted to kill him. She is here depicted beside the loom on which she has woven an enchanted garment for Arthur, a mantle that will consume his body with fire.

Morning (1) (German, *Morgen*) Philipp Otto Runge, 1809, Kunsthalle, Hamburg; (2) Dod Procter, 1926, Tate Gallery London.

Runge's painting centers on a nude female figure walking in a blaze of light towards the viewer. She is the Morning Star. She is also apparently Venus, goddess of love, Aurora, goddess of the dawn, and even the Virgin Mary, for below her lies a newborn babe, reminiscent of the Christ Child. The infant also represents the painting's title, the morning not just of day but also of life, of spring (cherubs pick and proffer flowers), and of the creation of the world. Procter's painting, the one for which she is best known, shows Cissie Barnes, a fish merchant's 16-year-old daughter, lying sleeping on her bed in the dawn light.

Morning in the Riesengebirge (German, *Morgen im Riesengebirge*) Caspar David Friedrich, 1811, Schloss Charlottenburg, Berlin.

Two people stand at the foot of a crucifix atop a rocky peak in a mountainous landscape. One, a woman who clings to the Cross, helps the other, a man in city clothes, climb the last few steps to the summit. The Riesengebirge (Giant Mountains) are on the border between Poland and the Czech Republic.

Morning News Helen M. Turner, 1915, Jersey City Museum, New Jersey.

A young woman sits beside the breakfast table and leisurely scans the pages of the morning newspaper.

The Morning of a Landowner's Wife (Russian, *Utro pomeshchitsy*) Alexei Venetsianov, 1823, Russian Museum, St. Petersburg.

Seated at a table, a country landowner's wife gives her serf girls their orders for the day.

Morning of a New Day Henry Farny, 1907, National Cowboy Hall of Fame and Western Heritage Center, Oklahoma City.

Native Americans watch silently from a snowy precipice as a locomotive chugs through the valley below. The title is ironic, since for them this particular morning brings loss, not the renewal that is normally associated with the dawning of a new day. The settlers arriving on the train will set up homesteads, fence in lands, graze cattle in pastures, and generally occupy the lands over which the Native Americans formerly roamed freely. They will also destroy the game that they hunted.

A Morning Walk John Singer Sargent, 1888, private collection.

A young woman in white holding a white parasol walks beside a river in the morning sun. She is the artist's 18-year-old sister, Violet, and the river is the Kennet, near Reading, Berkshire.

The Morning Walk Thomas Gainsborough, 1785, National Gallery, London.

Arm in arm, an elegantly dressed married couple and their dog go for a morning walk. The strollers are William Hallett (1764–1842) and his wife Elizabeth, née Stephen (1763–1833), who had been married on July 30, 1785. The picture must have been painted soon after, as it was described in the *Morning Herald* of March 30, 1786, as having "*promenaded* from Gainsborough's gallery where it was no longer on view." The present poetically descriptive title, however, probably dates from no earlier than the late 19th century.

Mors Janua Vitae ("Death the Gateway to Life") Harry Bates, 1899, Sudley Gallery, Liverpool.

The bronze statue depicts a naked young woman being raised away from the world by the Angel of Death. The title comes from the familiar Latin tag, sometimes found in the form *"Mors janua vitae novae"* ("Death the gateway to a new life").

Mortlake Terrace J.M.W. Turner, *c.*1826, National Gallery, Washington, D.C.

The scene depicted is the terrace by the Thames in Mortlake, west of (but now in) London, outside the home of the painting's commissioner, William Moffat.

Moscow Courtyard (Russian, *Moskovskiy dvorik*) Vasily Polenov, 1878, Tretyakov Gallery, Moscow.

The scene is a typical Moscow courtyard, meaning an unkempt grassy area among houses. A horse waits harnessed to a cart, a woman carries a bucket of water, children play, hens peck around, a baby sits howling.

Moses and the Daughters of Jethro
Giovanni Battista Rosso, *c.*1523, Uffizi, Florence.

The painting, a vigorous (and nude) depiction of an Old Testament scene, is also known as *Moses Defending the Daughters of Jethro*, which more precisely indicates its subject. Moses meets the seven daughters of Jethro, his future father-in-law, at a well, and defends them from the shepherds who try to drive them away (Exodus 2:16–21).

Moses Defending the Daughters of Jethro *see* **Moses and the Daughters of Jethro**.

Mosquito Nets John Singer Sargent, 1908, Detroit Institute of Arts, Michigan.

Two women relax in their chairs beneath large black mosquito nets, one reading, the other dozing. They are the artist's sister, Emily, and their friend, Eliza Wedgwood, a descendant of the famous 18th-century potter, Josiah Wedgwood. The painting was executed in Majorca.

The Most Beautiful Boy in the World *see* **Alka Seltzer**.

Mother and Child (1) Charles W. Cope, 1852, Victoria and Albert Museum, London; (2) Frederick George Stephens, 1854–6, Tate

Gallery, London; (3) Frederic Leighton, *c.*1864–5, Blackburn Museum and Art Gallery; (4) (French, *Mère et enfant*) Pierre-Auguste Renoir, *c.*1915, Tate Gallery, London; (5) Kevin Sinnott, 1987, Bernard Jacobson Gallery, London.

These are just five works with the familiar title. Cope depicts a young mother holding her baby in her arms. Stephens has a young child extending a comforting hand out to her mother, who sits bowed in a chair beside her, a letter clasped on her lap. Presumably it announces the infidelity or even death of her husband. Lord Leighton shows a small girl about to place a cherry from the basket she holds in the mouth of her mother as she reclines on a sofa. The painting has the alternate title *Cherries*. Renoir's bronze sculpture is a memorial to his wife, Aline, who died in 1915. She is depicted as she was in 1885, nursing her first baby, Pierre. The work, also known as *Maternity*, is based on a painting of Aline with the baby on her lap that the artist made then. Sinnott's painting, of an anguished mother clasping her baby to her, is based on the classical legend of the Sabine women (*see* The **Rape of the Sabines**).

Mother and Sick Child Gabriel Metsu, *c.*1660, Rijksmuseum, Amsterdam.

Sometimes known as simply *The Sick Child*, the painting depicts a mother seated with an ailing child asprawl on her lap.

Mother Superior Catherine-Agnès Arnauld and Sister Catherine de Sainte-Suzanne Praying *see* **Ex-Voto de 1662**.

Le Moulin de la Galette Pierre-Auguste Renoir, 1876, Musée d'Orsay, Paris.

The painting depicts a convivial scene of dancing, drinking, and dining at the Paris café and dance hall known as Le Moulin de la Galette, "The Pancake Mill," so called from a defunct windmill at the top of Montmartre.

Moulin Rouge: La Goulue Henri de Toulouse-Lautrec, 1891, Musée Toulouse-Lautrec, Albi.

The poster was commissioned to advertise the Moulin Rouge music hall, Paris, and depicts the dancer Louise Weber (1870–1929), known as La Goulue ("The Glutton"). In the foreground is the silhouetted figure of the dancer Valentin le Désossé (real name Jacques Renaudin). Weber gained her nickname "because, ever since her adolescence, she had been in the habit of draining the glasses dry in bars" (Jacques Pessis and

Jacques Crépineau, *Le Moulin Rouge*, translated by Malcolm Hall, 1990).

La Mousmé Vincent van Gogh, 1888, National Gallery, Washington, D.C.

The painting is of a seated young woman. A *mousmé* (the word also exists in English, from the French) is an unmarried Japanese girl (Japanese *musume*, "daughter," "girl").

The Mower Sir Hamo Thornycroft, 1894, Walker Art Gallery, Liverpool.

The bronze statue is of an athletic-looking young man holding a scythe. The sculpture was suggested by the following lines from Matthew Arnold's poem *Thyrsis* (1867): "Where are the mowers, who, as the tiny swell / Of our boat passing heav'd the river-grass, / Stood with suspended scythe to see us pass?" The figure was based on a drawing the artist had made of an agricultural worker at rest on a riverbank.

The Mud Bath David Bomberg, 1914, Tate Gallery, London.

The apparently abstract painting in fact depicts a vapor bath used by the Jewish community in Whitechapel, London. Angular blue and white figures leap around the red, rectangular bath as they circle a central, dark-colored pillar.

The Murder of Jane McCrea *see* **The Death of Jane McCrea**.

The Muse Inspiring the Poet (French, *La Muse inspirant le poète*) Henri Rousseau, 1909, Pushkin Museum, Moscow.

The painting depicts the French poet Guillaume Apollinaire (1880–1918), a scroll in one hand and a quill pen in the other, standing next to his muse and mistress, Marie Laurencin, who raises one hand in a sort of poetic invocation.

Music in the Tuileries Gardens (French, *La Musique aux Tuileries*) Édouard Manet, 1863, National Gallery, London.

The painting depicts a crowded fashionable gathering in the Tuileries Gardens, Paris, many of the figures being recognizable portraits of friends of the artist, including one of himself. The title indicates that a band must be playing somewhere, but it remains unseen.

The Music Lesson (French, *La Leçon de musique*) Jean-Honoré Fragonard, *c.*1770–2, Louvre, Paris.

A young girl plays the harpsichord under the approving eye of her teacher, his approval clearly directed more at her décolleté than her

digital dexterity. The "lesson" of the title thus works both ways: he teaches her, but she in turn has something to show him.

Musical Erratum (French, *Erratum musical*) Marcel Duchamp, 1913, private collection.

The work consists of three short "musical" pieces, in ink on music paper, headed respectively "Marcel," "Yvonne," and "Magdeleine," the latter for the artist's two sisters. The "music" itself consists of notes drawn at random from a hat, while the accompanying text is composed of unpunctuated dictionary definitions of the word *imprimer* ("to print"): "*Faire une empreinte marquer des traits une figure sur une surface imprimer un sceau sur cire*" ("To make an impression to mark lines a figure on a surface to print a seal on wax"). An "erratum" here is a printing error.

My Bunkie Charles Schreyvogel, 1899, Metropolitan Museum of Art, New York.

A galloping American trooper hauls up to safety a fallen comrade whose horse has been shot from under him. The comrade is his barracks bunkmate or "bunkie."

My Calling (Card) #1 Adrian Piper, 1986, John Weber Gallery, New York.

The work is a fullsize (2 × 3½ ˝) business card with what the artist describes as a "reactive guerilla performance (for dinners and cocktail parties)." The text on the card is an open letter, beginning, "Dear Friend, I am black. I am sure you did not realize this when you made/laughed at/agreed with that racist remark." It concludes, "I regret any discomfort my presence is causing you, just as I am sure you regret the discomfort your racism is causing me. Sincerely yours, Adrian Margaret Smith Piper." The parentheses in the title point up the two senses of "calling."

My Egypt Charles Demuth, 1927, Whitney Museum of American Art, New York.

The painting depicts a huge grain elevator in Lancaster, Pennsylvania, the artist's hometown. "Demuth's title whimsically refers to the mania for Egyptology planted in American popular culture in 1922, when Howard Carter discovered Tutankhamen's tomb" (Hughes, p. 382). Egypt has been famous for its grain since biblical times (Genesis 42:2).

My First Sermon John Everett Millais, 1862–3, Guildhall Art Gallery, London.

A small girl in a red cape, her hands in a muff, her feet on a hassock, sits in church dwarfed in a box pew and listens gravely to her

first sermon, a picture of innocent piety. The model was the artist's five-year-old daughter, Effie. The following year he painted a pendant (companion picture), *My Second Sermon*, showing the same girl asleep during a long sermon.

My Front Garden Frederick Walker, 1864, Harris Museum and Art Gallery, Preston.

The painting depicts the arrival of a postman at the gate of the artist's house in Bayswater, London. Much of the garden is seen, with a circular flower bed in the middle of the lawn.

My Heart Is Poised Between the Two (French, *Entre les deux mon cœur balance*) James Tissot, *c*.1877, Tate Gallery, London.

A Scottish soldier in dress uniform sits in the prow of a boat between two elegant young ladies, unable to decide which of the two has the greater charm. The title is the artist's own, although the picture was put up for sale in 1937 as *Divided Attention*. It is also known as *Portsmouth Dockyard*, referring to the actual setting. *Cf.* The **Gallery of H.M.S. "Calcutta."**

My Second Sermon *see* **My First Sermon**.

My Tale Shall Be Told Peter Howson, 1995, Angela Flowers Gallery, London.

The painting is the third in the series of seven based on Stravinsky's opera *The Rake's Progress* (*see* **Farewell, Farewell**). Here Tom Rake is attracted to the fantastic bearded lady, Baba the Turk, depicted astride a giant dog while her young child plays on the floor. As for all the depictions, the title quotes from the libretto.

My Thoughts Are My Children George Frampton, *c*.1900, Walker Art Gallery, Liverpool.

The artist exhibited the original plaster of this title in 1894. It is now untraced, but he had the present bronze relief cast from it. It depicts a young woman holding a lily, while above her, and less distinct, a male (or possibly female) figure has his arms around two young women, one of whom kisses the head of the baby she holds. At the top of the composition the sun shines in a burst of rays. The words of the title presumably relate to the main figure, whose lily denotes that she is chaste, pure, and innocent. (She does not appear to represent the Virgin Mary, however.) She thus aspires to motherhood, as represented by the figures above. The actual wording of the title suggests a possible source in some poem.

Myra Marcus Harvey, 1995, Saatchi Collection, London.

The work, resembling the blowup of a police "mug shot," is a head-and-shoulders portrait of the British child murderer Myra Hindley (born 1942). The dotted paint marks that comprise the sinister image are in fact children's handprints.

Myrtle Albert Joseph Moore, *c*.1886, Fogg Art Museum, Cambridge, Massachusetts.

A nude young woman is portrayed seated, her arms raised and behind her head, her lap and legs concealed by flowing draperies. On the floor beside her stands a vase with a spray of myrtle leaves and berries. The precise import of the title is uncertain. The girl's name may be Myrtle. More likely, the plant is singled out in a symbolic sense. In antiquity, the myrtle was sacred to Venus, and was both her attribute and that of her handmaidens, The **Three Graces**. The girl may therefore represent one of the Graces or even a blend of all three. Again, as it was forever green, the myrtle stood for everlasting love. That too would suit, for the girl's pose promises open devotion. Finally, the artist may have intended an association with weddings, for Queen Victoria carried myrtle in her bouquet when she married in 1840.

Myself: Portrait-Landscape (French, *Moi-même: portrait-paysage*) Henri Rousseau, 1890, National Gallery, Prague.

The painting depicts the artist holding in one hand a palette inscribed with the names of his first and second wives, Clémence and Joséphine, and in the other a paintbrush. He himself is thus the "portrait," while the "landscape" behind him is of Paris, with the newly-constructed (1889) Eiffel Tower and a ship dressed in colorful flags on the Seine.

Mysteriarch George Frampton, 1892, Walker Art Gallery, Liverpool.

The head-and-shoulder sculture of a woman depicts a mysteriarch, one who presides over mysteries. Her precise identity is uncertain. She may be intended to represent one of the priestesses who presided over the "Mysteries" of the secret cults of ancient Greece. She appears to be in a trance-like state, which suits such a figure. Or she may simply represent woman, as both an object of mystery in herself and presiding as priestess over life's enigma.

The Mystery and Melancholy of a Street (Italian, *Il mistero e la malinconia di una*

strada) Giorgio de Chirico, 1914, private collection.

A young girl bowls a hoop across a sunlit street past a carriage with open doors that waits in the shade of a dark building. The long shadow of a statue is cast in the street from behind the building. The mystery must first and foremost be the identity of the unseen statue as well as the purpose of the carriage, while the melancholy is the viewer's regret that he will never learn the identity of the figure or even discover whether the girl with the hoop reaches it.

The Mystic Marriage of St. Catherine
(1) Michelino da Besozzo, *c.*1410–20, Pinacoteca Nazionale, Siena; (2) Gérard David, *c.*1505–10, National Gallery, London; (3) Correggio, 1510–14, Detroit Institute of Arts, Michigan; (4) Fra Bartolommeo, 1511, Louvre, Paris; (5) Parmigianino, *c.*1526, National Gallery, London; (6) Annibale Carracci, 1585–7, Gallerie di Capodimonte, Naples.

These and similar paintings of the Italian Renaissance depict the mystic marriage of St. Catherine of Alexandria to Christ, as related in Jacobus de Voragine's *The Golden Legend* (*c.*1260). (About to be tortured, she cries, "He is my God, my lover, my shepherd, and my one and only spouse.")

The Mystic Nativity Sandro Botticelli, 1500, National Gallery, London.

The artist's last major work is an ornate depiction of the birth of Christ, which includes not only Mary and Joseph (and an ox and ass) but the shepherds, the Magi, and, overhead, an angelic choir, while three pairs of men and angels embrace in the foreground.

A Mythological Subject *see* The **Death of Procris**.

N

Nafea faa ipoipo? ("When Will You Marry?") Paul Gauguin, 1892, Kunstmuseum, Basel.

The painting depicts two young Tahitian women, one crouching before the other, who kneels. It is not certain who is addressing the question of the title to whom, even though the front girl wears a magnolia behind her ear to show that she is looking for a husband. It may have been put by a third person to both women, who look askance and appear nervous or threatened. The Tahitian title appears at bottom right. When the artist exhibited his Tahitian paintings in 1893 he provided French translations for those titled in Tahitian. This work was thus *Quand te maries-tu?*

A Naiad John William Waterhouse, *c.*1893, private collection.

"The Naiad (water nymph) has just risen, nude, from the stream, and peers between the willow stems at a sleeping youth, who lies half covered with a leopard skin on the bank" (catalog notes, quoted in Hobson, p. 185).

The Naked Maja (Spanish, *La maja desnuda*) Francisco de Goya, *c.*1797, Prado, Madrid.

The portrait of a reclining naked *maja* (lower class Spanish belle) is said to be of the Duchess of Alba, the beautiful widow whose relationship with the artist caused a scandal in Madrid. The work is one of a pair, the other being The **Clothed Maja**.

Naked Portrait with Reflection Lucian Freud, 1980, private collection.

A naked woman lies on a tattered couch before a mirror, in which a reflection of the artist's feet can be seen.

Nameless and Friendless Emily Mary Osborn, 1857, private collection.

An art dealer looks with disdain at the paintings a young woman tries to sell him in his shop. She is "nameless and friendless," for if her work is not accepted she will remain unknown and unappreciated. The painting was inspired by Mary Brunton's novel *Self Control* (1811), about a young woman painter who finds it hard to make a living. (According to some, the paintings the woman offers are those of her late lover, while the small boy who stands by her is their son. In this interpretation, the title gains a different significance, for the woman does not wear a wedding ring.) "The *Art Journal* expressed concern for the woman's plight, her destitution, her distress... The title too encourages this interpretation, signalling the artist, habited in deep mourning, as an orphan with no family or protector. It does more, however, calling up a plethora of meanings, and implying that the central figure has no guardians in this dangerous territory in which her name and reputation are at risk — as a woman and an artist" (Cherry, p. 80).

Nana Édouard Manet, 1877, Kunsthalle, Hamburg.

The half-dressed young woman in her boudoir is Henriette Hauser, known as Citron, mistress of the Prince of Orange. "The title, as with **Olympia** merely a woman's name (but an eloquent one), establishes a literary link that has been much debated in recent scholarship" (Walther 1997). The link is that she represents Nana, the courtesan Anna Coupeau in Émile Zola's novel *L'Assommoir* (1877). Zola's later novel *Nana* (1880), in which she is the title character, was influenced by Manet's portrait. Hauser also appears in Renoir's **Female Nude**, where an alternate title names her (again with reference to Zola's character) as *Anna*.

Napoleon Crossing the Alps (French, *Le Passage du Grand-Saint-Bernard*, "The Crossing of the Great St. Bernard Pass") Jacques-Louis David, 1800, Kunsthistorisches Museum, Vienna.

The painting depicts Napoleon crossing the Great St. Bernard Pass from Switzerland to Italy in the winter of 1799–1800 in his campaign against the Austrian army. The alternate English title *Bonaparte Crossing the St. Bernard Pass* is also found.

The Nativity Konrad of Soest, 1403, St. Nikolaus, Bad Wildungen.

The Virgin Mary sits up in bed and holds the infant Jesus, to whom she has just given birth. Cattle munch hay from a manger in a nearby stable, a shepherd with his sheep looks up at an angel, and St. Joseph kneels to blow on the flames of a fire over which he cooks a meal. The scene is more domesticated than many other depictions with this title.

Natural Knowledge (French, *La Connaissance naturelle*) René Magritte, c.1938, private collection.

The depiction is of a full frontal female nude, her long and luxuriant hair reaching to below her waist as if now parted to reveal the "natural knowledge" of what is normally concealed.

A Naughty Child Sir Edwin Landseer, 1834, Victoria and Albert Museum, London.

A small boy of about five stands sulkily defiant in the corner where he has been sent after misbehaving.

Nave nave fenua *see* **Te nave nave fenua**.

Nave nave mahana ("Day of Delight") Paul Gauguin, 1898, Musée des Beaux Arts, Lyon.

A group of Tahitian women stand or sit in an idyllic pose among fruit trees.

Nave nave moe ("Spring of Delight") Paul Gauguin, c. 1894, Hermitage, St. Petersburg.

Two Tahitian women sit meditatively before the spring, next to which are two more, one being the seated nude in **What, Are You Jealous?** In the distance, women dance before statues of the moon gods.

Near the Sea *see* **Fatata te miti**.

NELRI Cornelis Troost, 1740, Mauritshuis, The Hague.

The series of five pictures depicts the debauchery that accompanies a reunion dinner party. The five letters of the title are the initials of the Latin words that accompany the five views.

Nevermore Paul Gauguin, 1897, Courtauld Institute, London

The painting was inspired by an incident that took place when Gauguin first visited Tahiti. He returned home one evening to find his 14-year-old *vahine* (woman), Pahura, lying naked on the bed, fearful of the *tupapaus*, the legendary spirits of the dead who were said to walk by night. Sobbing, she exclaimed, "Never again leave me alone like this without a light." The picture shows her on the bed, a raven perched behind her. In a letter to a friend the artist explained: "As a title, *Nevermore*; not exactly the raven of Edgar (Allan) Poe, but the bird of the devil who keeps watch" (Vance, p. 130).

The New Lazarus Philip Evergood, 1954, Whitney Museum of American Art, New York.

The allegorical religious painting depicts a grotesque Crucifixion set amidst the figures of starving children. The title suggests that only a Christian revival, however imperfectly realized, can solve the troubles of the world.

The New Olympia (French, *La Nouvelle Olympia*) Paul Cézanne, 1872–3, Musée d'Orsay, Paris.

As its title suggests, the painting is a parody of Manet's **Olympia**. It shows the black servant stripping off the sheet to expose the naked Olympia cowering before the gaze of a clothed male viewer, recognizably the artist himself. An alternate title is *A Modern Olympia* (French, *Une moderne Olympia*).

New York Movie Edward Hopper, 1939, Museum of Modern Art, New York.

The painting depicts the auditorium of a half empty motion picture theater. The movie of the title is only partly and vaguely visible. The picture's real subject is the lonely figure of an usherette who stands, not watching the movie, at the foot of the curtained stairs to the right.

Newgate — Committed for Trial Frank Holl, 1878, Royal Holloway College, Egham, Surrey.

The artist's masterpiece was based on a scene he had witnessed. A bank clerk had embezzled funds and was shortly to be sentenced to five years' imprisonment. The scene depicts the so called "cage" at Newgate Prison, London, where the family and friends of prisoners were allowed to have brief conversations with them through two sets of bars, separated by a walkway for the warder (jailer) in charge. A working-class woman with her two young daughters now speaks in this manner with her husband, who has been committed for trial.

The Newly Decorated Civil Servant (Russian, *Svezhiy kavaler*) Pavel Fedotov, 1846, Tretyakov Gallery, Moscow.

A newly-decorated civil servant, in the pose of a Roman orator, proudly displays his medal, pinned on his dressing gown, to his cook, who responds by thrusting an old boot at him. Bottles are scattered nearby. The Russian title contains a pun, since *svezhiy* means literally "fresh," and the official is clearly far from "fresh" after the previous evening's indulgence.

News from My Lad James Campbell, 1859, Walker Art Gallery, Liverpool.

An old locksmith is reading a letter from his son serving in India. The letter is headed Lucknow and dated 1858, so the son must be fighting in the Indian Mutiny. The father has turned the sheet to read the second page, so that the viewer can read some of the first, beginning: "My dear old Daddy, I daresay you will read this in the old Shop."

The Niccolini-Cowper Madonna Raphael, 1508, National Gallery, Washington, D.C.

The painting of the Virgin and Child was in the Casa Niccolini, Florence, from 1677 until 1780, when it passed to Earl Cowper of Panshanger, Hertfordshire, England, where it remained until 1918. The two family names combine to give the work's title. The picture was also formerly known as *The Large Cowper Madonna*. *Cf.* The **Small Cowper Madonna**.

Night (1) Edward Burne-Jones, 1860, private collection; (2) (German, *Die Nacht*) Ferdinand Hodler, 1890, Kunstmuseum, Berne.

Burne-Jones depicts a draped female figure floating in a starry sky, her arms stretched before her in the manner of a somnambulist. She is obviously a personification of Night, bringing darkness and sleep. Hodler shows six men and women lying peacefully asleep. In their midst, a man lies awake, his face a mask of fear as he grapples with a sinister figure in black kneeling on his chest. It is a nightmare.

The Night (German, *Die Nacht*) Max Beckmann, 1918–19, Kunstsammlung Nordrhein-Westfalen, Düsseldorf.

The scene is of the terrors of the night, or of a nightmare. A family is being attacked and tortured in their home. The father is being strangled on a table. The mother, her clothes stripped, her hands tied to the window frame, sinks to the floor with legs spread wide. A man wearing a cap that hides half his face pulls down a curtain as he drags the daughter in.

Night Portrait Lucian Freud, 1976–7, private collection.

A naked woman sprawls on the cover of a double bed. The title presumably denotes the time when the portrait was painted.

A Night That Never Ends Peter Howson, 1995, Angela Flowers Gallery, London.

The painting is the last in the series of seven based on Stravinsky's opera *The Rake's Progress* (see **Farewell, Farewell**). Tom Rake is now insane in Bedlam, surrounded by madmen. As with all the other depictions, the title quotes from the libretto.

The Night Train (French, *Le Train de nuit*) Paul Delvaux, 1947, private collection.

Two naked young women are in an elegant railroad waiting room, one standing, her hands cupping her breasts, the other stretched full length on a seat. A (dressed) barmaid stands at a counter. Through the open doors a freight train can be seen waiting in the station. A clock shows the time to be ten past midnight. The French title may pun on *train de vie*, "lifestyle."

The Night Watch Rembrandt van Rijn, 1642, Rijksmuseum, Amsterdam.

The artist's most famous painting, showing a militia company about to form ranks, has an erroneous title that dates from the late 18th century. Its correct title is *The Militia Company of Captain Frans Banning Cocq and Lieutenant Willem van Ruytenburch Readying to March*. The false title came to be given because the original canvas was so discolored with dirty varnish that it looked like a night scene. Successive cleanings have now established that the scene takes place in daylight.

Nighthawks Edward Hopper, 1942, Art Institute of Chicago, Illinois.

Through the lighted window of a late-night diner on the corner of a deserted New York street, a bartender is seen bending down to prepare a drink for a man and woman at the bar while a lone drinker sits impassively, his back to the viewer. The impression is of isolation. The depicted establishment is one in Greenwich Avenue at the junction of two roads. The artist explained: "I simplified the scene and made the restaurant bigger. Unconsciously, probably, I was painting the loneliness of a big city" (quoted in Tesch and Hollmann, p. 110). The three customers are the "nighthawks" of the title, people who stay up late at night.

The Nightmare (German, *Der Alp*) Henry Fuseli, 1782, Detroit Institute of Arts, Michigan.

A demon crouches on the body of a sleeping woman, while a ghostly mare's head gleams in the background. Both are the stock ingredients of a nightmare. (German *Alp* is the incubus, the demon of folklore who squats on a sleeper's stomach and induces a sense of anxiety.)

Ninety-four Degrees in the Shade Sir Lawrence Alma-Tadema, 1876, Fitzwilliam Museum, Cambridge.

In 1869 the artist had been operated on by the surgeon Sir Henry Thompson, himself an amateur painter. Alma-Tadema became his teacher and friend, and painted portraits of him and his son Herbert. In the present picture, 17-year-old Herbert, a budding lepidopterist, lies at the edge of a cornfield on a hot summer's day studying a book on butterflies, his net by his side. The field depicted is one near Godstone, Surrey. The title refers to the sweltering Fahrenheit temperature. (Its Celsius equivalent would be almost 35 degrees.)

The Ninth Wave (Russian, *Devyatyy val*) Ivan Ayvazovsky, 1850, Russian Museum, St. Petersburg.

Survivors of a shipwreck cling to a piece of wreckage in a stormy sea. The title refers to the superstition among Russian sailors that the ninth wave is the most powerful and destructive.

Niobe *see* The **Destruction of the Children of Niobe**.

No Man's Land Jankel Adler, 1943, Tate Gallery, London.

A singing bird perches on a thorn bush under a dark blue night sky. The artist painted the picture after an evening walk, when the solitary bird seemed the sole life in the otherwise empty landscape.

No te aha oe riri? *see* **Why Are You Angry?**

No Walk Today Sophie Anderson, *c.*1856, private collection.

Dressed in her best hat and coat, a small girl looks out sadly through a firmly shut window. There will be no walk for her today even though the sun is shining, for there are raindrops on the pane and more may follow.

The Nocturnal Kind (French, *Le Genre nocturne*) René Magritte, 1928, location unknown.

A nude woman stands next to a cracked mirror, her hands covering her head, or rather, the space where her head would be. The title presumably alludes to the fantasy world of dreams and the horrors of nightmares.

Nocturne in Black and Gold J.A.M. Whistler, *c.*1875, Detroit Institute of Arts, Michigan.

The painting's full title is *Nocturne in Black and Gold: The Falling Rocket*. It depicts fireworks exploding in the night sky over Cremorne Gardens, Battersea, London. The work was one of several "nocturnes" (night scenes). Others were *Nocturne: Blue and Silver — Chelsea* (1871) and *Nocturne: Blue and Silver — Cremorne Lights* (1872). The use of the musical term was not the artist's own, but was suggested to him by the pianist Frederick Leyland, who was presumably prompted by Whistler's earlier adoption of "symphony," as in **Symphony in White No. 1**.

Noli Me Tangere (1) Fra Angelico, *c.*1442, Museo di S. Marco dell'Angelico, Florence; (2) Titian, *c.*1508, National Gallery, London; (3) Correggio, 1520–6, Prado, Madrid.

All three paintings, and others identically titled, depict Christ's appearance to Mary

Magdalene after the Resurrection. The Latin words are those he addresses to her, "Touch me not" (John 20:17). *Cf.* **Christ Appearing to Mary Magdalene After the Resurrection**.

The Nominal Three (To William of Ockham) Dan Flavin, 1963, Solomon R. Guggenheim Museum, New York.

The work consists of six vertical neon tubes against the far wall of an empty room, one in the left corner, two together in the middle, and three together in the right corner. The subtitle's dedication to the 14th-century philosopher William of Ockham implies a reference to his famous "razor," stating that "entities are not to be multiplied beyond necessity," that is, that a theory should not propose the existence of anything more than is needed for its explanation. That in turn is why Flavin's threefold display is "nominal": the tubes simply display color.

Nonchaloir John Singer Sargent, 1911, National Gallery, Washington, D.C.

A young woman has fallen asleep on a sofa in an elegant interior. She is Rose-Marie Ormond (1893–1918), the artist's niece and favorite model. (She married the French art historian Robert André-Michel and both were killed in World War I.) The painting has the English subtitle *Repose*, which is not really an accurate translation of the French, for *nonchaloir* properly means "listlessness" or "sluggishness" rather than "repose."

Noon (Italian, *Mezzogiorno*) Felice Casorati, 1922, Galleria d'Arte Moderna, Trieste.

Two young girls sleep naked on the ground in the glare of the sun, one on her side, the other on her back. Behind them, in the shade, a third nude figure is seated reading. In the foreground are a pair of scarlet slippers and a priest's hat.

Noonday Edward Stott, 1895, Manchester City Art Gallery.

Young farm children bathe naked in a pond in the heat of a summer's day.

The North-West Passage John Everett Millais, 1874, Tate Gallery, London.

An aged mariner sits surrounded by nautical objects, a chart spread before him, while his daughter sits at his feet and, holding his hand, reads aloud from one of his accounts of his expeditions. The painting was executed at a time when the search was on for a "northwest passage," or safe shipping route from the Atlantic to the Pacific through the Arctic archipelago north

of mainland Canada. (The route was eventually won through by Roald Amundsen in 1906.) The work was subtitled *It might be done and England should do it.*

Nostalgia of the Infinite (French, *La Nostalgie de l'infini*) Giorgio de Chirico, 1913, Museum of Modern Art, New York.

Two dark figures stand in sunlight at the base of a tall tower on which flags are flying. A dark building to the right casts a black shadow. The title suggests the artist's intention to depict a scene whose simple content evokes a sense of something intangible and awesome.

Not Forgotten George Bernard O'Neill, 1882, Wolverhampton Art Gallery, West Midlands.

A young girl sits demurely at the entrance to a churchyard holding a wreath of primroses. In view of the type of flower, it may not be a family wreath but one commemorating the former British prime minister, Benjamin Disraeli, who had died the year before the picture was painted, and whose death was long commemorated by Primrose Day, for his favorite flower. He would thus have been the one who was "not forgotten."

Not Guilty *see* Waiting for the Verdict.

Not to Be Reproduced (French, *La Reproduction interdite*) René Magritte, 1937, Museum Bymans-van Beuningen, Rotterdam.

The painting depicts the rear view of a man standing before a wall mirror, in which his identical rear view is seen rather than the expected reflection of his face. The title indicates that the latter view, as a conventional portrait, is "not to be reproduced," so that the man (in fact British art collector, Edward James) is denied the right to see himself as a human being.

Nourish Boyd Webb, 1984, Southampton City Art Gallery.

The work is a color photograph of a clothed man under water sucking at the nipple of a whale. The "skin" of the whale is made of rubber sheeting, while the nipple is apparently a vegetable of some kind.

The Novel Reader (French, *La Liseuse de romans*) Antoine Wiertz, 1853, Musée Wiertz, Brussels.

A naked young woman lies on her bed reading a novel. A glance at the titles of the novels lying beside her shows that they are nothing more sinful than the works of Alexandre Dumas.

The Novice (Russian, *Novichok*) Ivan Bogdanov, 1893, Tretyakov Gallery, Moscow.

A tearful young boy, his hands and bare feet grimy with coaldust, is berated by his drunken peasant father for his bungling attempts to light the stove in the room.

Novitiate Mendicants Richard Rothwell, 1837, Victoria and Albert Museum, London.

A young girl and her small brother pose as beggars. It is possible the two were members of an actual mendicant family in Ireland.

Nuclear Fission Adrian Wiszniewski, 1985, Collection Susan Kasen and Robert D. Summer, New York.

A half-kneeling youth with one arm behind his back holds up a fish in his other hand. The title appears to allude to the typical "split personality" of adolescence, while simultanously punning on "fishin'." It may even further pun on "no clear vision."

Nuda Veritas ("Naked Truth") Gustav Klimt, 1899, Theatersammlung der National Bibliothek, Vienna.

The painting is a portrait of a standing redheaded nude with red-haired pubis, a snake coiling around her ankles. The Latin title appears below the picture, while above it is a German quotation from Schiller: "*Kannst du nicht allen gefallen durch deine That und deine Kunstwerk, mach es wenigen recht. Vielen gefallen ist schlimm*" ("Though you cannot please everyone with your deeds and your art, try to please a few. To please many is not good").

The Nude *see* **Female Nude**.

Nude Against the Light (French, *Nu à contre-jour*) Pierre Bonnard, 1908, Musées Royaux des Beaux-Arts, Brussels.

The artist's wife, Marthe, sprays herself with perfume after her bath as she stands nude and half turned from the viewer towards the window. The painting is also known in English as *The Bathroom* and simply *Standing Nude*.

Nude Descending a Staircase (French, *Nu descendant un escalier*) Marcel Duchamp, 1912, Philadelphia Museum of Art, Pennsylvania.

The painting, combining the techniques of Cubism and Futurism, depicts the successive "freeze-frame" images of a nude woman walking down a staircase. The title was regarded as provocative in its day, for a nude should be posing motionless, not actively moving.

Nude from the Back *see* The **Valpinçon Bather**.

Nude on a Cushion *see* **Red Nude**.

Nude on a Staircase *see* **Ema**.

Nude Woman Sitting *see* **Female Nude**.

Nudes in the Forest (French, *Nus dans la forêt*) Fernand Léger, 1909–10, Kröller-Müller Museum, Otterlo.

The title suggests an idyllic pastoral scene. But this is no *fête champêtre*, for the nudes in this cubist painting are woodcutters, at work felling trees in the forest. The artist may well have chosen a poetic title for an everyday scene in order to draw attention to his prosaic subject.

The Nuptials of the Madonna *see* The **Betrothal of the Virgin**.

Nydia, the Blind Girl of Pompeii Randolph Rogers, *c.*1856, Brooklyn Museum, New York.

The marble statue represents Nydia, the blind flower girl and street singer in Edward Bulwer-Lytton's novel *The Last Days of Pompeii* (1834).

The Nymph of the Fountain Lucas Cranach I, 1534, Walker Art Gallery, Liverpool.

A nude nymph reclines by the fountain that she guards. The Latin inscription on the fountain represents her words as she smiles seductively at the viewer through half-closed eyes: "*Fontis nympha sacri somnum ne rumpe quiesco*" ("I, the nymph of the sacred fountain, am resting; do not disturb me").

O

O Miracle! Peter Howson, 1995, Angela Flowers Gallery, London.

The painting is the fourth in the series of seven inspired by Stravinsky's opera *The Rake's Progress* (see **Farewell, Farewell**). Here, Nick Shadow, later revealed as an agent of the devil, demonstrates to Tom Rake a fantastic machine for turning stones into bread.

O the Roast Beef of Old England William Hogarth, 1748, Tate Gallery, London.

The painting, subtitled *The Gate of Calais*,

depicts a cook holding a succulent sirloin of beef and contrasts the hearty fare of the English with the meager rations of the French. The latter are represented by two ragged soldiers holding bowls of thin soup. The scene is depicted before the gate named in the subtitle. The artist painted the picture on his return from Calais, where he had been arrested as a suspected spy while sketching the drawbridge and gate of the ancient English fortifications. The title is based on lines from a song in Henry Fielding's *The Grub Street Opera* (1731): "Oh! the roast beef of England, / And old England's roast beef."

The Oak and the Reed (French, *Le Chêne et le Roseau*) Achille-Etna Michallon, 1816, Fitzwilliam Museum, Cambridge.

A mighty oak splits in two in a storm while the clump of reeds beside it merely bends before the gale. The subject is taken from one of La Fontaine's *Fables* (1668–93), telling how the oak mocks the reed until a storm arises and it suffers the fate shown here.

Oak Tree in the Snow (German, *Eiche im Schnee*) Caspar David Friedrich, 1829, Charlottenburg Castle, Berlin.

A leafless oak tree stands alone in the snow. The artist often used natural objects as religious symbols. Here, the tree represents both death and resurrection. The dead branch on the ground before it resembles the crucified Christ.

The Oath of Julius Civilis *see* The Conspiracy of Julius Civilis.

The Oath of the Horatii (French, *Le Serment des Horaces*) Jacques-Louis David, 1784, Louvre, Paris.

The painting depicts an event from Roman history. To settle a border dispute, the triplet Horatii brothers of Rome have agreed to fight the Curiatii, also triplets, of neighboring Alba Longa. They now swear themselves to combat, extending their arms to their father, who raises three swords in his fist in return. Behind them, the women of the family weep and comfort one another. The outcome was tragic: two of the Horatii and all three Curiatii were killed, and on returning home the surviving Horatius killed his sister. (*See* The **Death of Camilla, Horatio's Sister**.) The painting's title is thus portentous.

Object *see* Breakfast in Fur.

Object to Be Destroyed Man Ray, 1923.*

The artist's best known object was a metronome with an engraving of an eye impaled in its wand. The origin of the image was the Great Seal of the United States graven on the back of every dollar bill, itself representing the eye of Authority hovering over the pyramid of History. Hence the anarchist message of the title. The work was duly destroyed in 1957 by rioters protesting against Dada art.

Observed in a Dream (German, *Die Traum-Beschaute*) Egon Schiele, 1911, Metropolitan Museum, New York.

Legs apart, a naked woman lies on her back and pulls her labia wide open with her fingers. The erotic scene is presumably one that the artist himself "observed in a dream." The depiction is as explicit as the title is implicit. Most of Schiele's erotic paintings have directly descriptive titles, as *Seated Nude Girl with Arms Raised over Head* (German, *Sitzendes nacktes Mädchen mit über dem Kopf verschränkten Armen*) (1911) or *Reclining Nude with Legs Spread Apart* (German, *Liegender weiblicher Akt mit gespreizten Beinen*) (1914).

The Ocean (French, *L'Océan*) René Magritte, 1943, private collection.

A reclining sea god poses naked with an erection metamorphosed into a nude Venus. The painting is a novel interpretation of the mythical event depicted in The **Birth of Venus**.

October Gold John Atkinson Grimshaw, 1889, Christopher Wood Gallery, London.

A lone cart passes down an empty street between lines of leaf-shedding trees lit by the golden glow of the setting sun. The poetic association between gold and October is common.

Odalisque (French, *Odalisque*) (1) Pierre-Auguste Renoir, 1870, National Gallery, Washington, D.C.; (2) Robert Rauschenberg, 1955–8, Museum Ludwig, Cologne; (3) *see* Reclining Girl.

Renoir's luxuriously reclining eastern concubine was based on Ingres's La **Grande Odalisque** and other depictions of the harem. Rauschenberg's freestanding combine (painting combined with real objects) consists of a box with painted sides on a post with a stuffed rooster atop, the whole resembling a totem. The title equally evokes the exotic female slaves and concubines of Ingres' work and implies that the combine is a human figure. The post is its "foot," planted firmly on a cushion, suggesting the lush draperies in Ingres's paintings. The sides of the box are covered in pin-ups and reproductions of

Old Master nudes, while the dominant rooster is a symbol of overweening masculinity.

Odalisque with Slave (French, *L'Odalisque à l'esclave*) J.-A.-D. Ingres, 1839, Fogg Art Museum, Cambridge, Massachusetts.

A naked eastern concubine reclines indolently on a bed while a (female) slave sings to a tar (an oriental lute). A Negro eunuch stands in the background. *Cf.* La **Grande Odalisque**.

Oedipus and the Sphinx (French, *Œdipe et le Sphinx*) Gustave Moreau, 1869, Metropolitan Museum, New York.

The scene is from classical mythology. A naked Oedipus holds a spear as he is assailed by the Sphinx, who clings to his body as she asks him her riddle, unaware that he can answer it.

Of This Men Shall Know Nothing
(French, *Les hommes n'en sauront rien*) Max Ernst, 1923, Tate Gallery, London.

The Surrealist painting depicts a number of objects, the most prominent being a whistle suspended from a yellow crescent serving as the canopy of a parachute. Under the crescent are two pairs of widely parted legs, while below them is a hand in a circle. Overhead is the sun, and below, circling the hand, the moon. An inscription on the reverse of the work reveals that it was presented by the artist to the poet, André Breton. The title in French (as above) here heads a prose poem which to some extent explains the imagery and the title itself: "*Le croissant (jaune et parachute) empêche que le petit sifflet tombe par terre. Celui-ci, parce qu'on s'occupe de lui, s'imagine monter au soleil. Le soleil est divisé en deux pour mieux tourner. Le modèle est étendu dans une pose de rêve. La jambe droite est repliée (mouvement agréable et exact). La main cache la terre. Par ce mouvement la terre prend l'importance d'un sexe. La lune parcourt à toute vitesse ses phases et éclipses. Le tableau est curieux par sa symmétrie. Les deux sexes se font équilibre*": "The crescent (yellow and parachute-like) prevents the little whistle from falling to the ground. The whistle, because it is the object of attention, thinks it is rising to the sun. The sun is divided into two to turn better. The model is extended in a dreamlike pose. The right leg is bent (a precise and pleasant movement). The hand hides the earth. Through this movement the earth gains the importance of a female sex organ. The moon runs though its phases and eclipses at top speed. The painting has an odd symmetry. The two sexes balance each other". The "model" (the two pairs of legs) is in fact a copulating couple, but if one turns the picture sideways, the two pairs of legs become a single pair of legs with its mirror image. The overall title thus seems to imply that the artist is privy to arcane knowledge that eludes the ordinary mortal.

Ognissanti Madonna Giotto di Bondone, *c.*1307, Uffizi, Florence.

The altarpiece was painted for the Umiliati friars of Ognissanti ("All Saints") at Florence, and this gave its popular title. It is formally known as *Madonna in Glory with Saints and Angels*, which describes its content more precisely. The Virgin Mary is seated on a throne with the Child on her lap. Two angels kneel at her feet, and six saints stand each side of her.

OH! Joe Tilson, 1963, The 180 Beacon Collection, Boston, Massachusetts.

The painting depicts two large exclamation marks above the three characters of the title. The work is thus its own exclamation.

Oh! Calcutta! Calcutta! Clovis Trouille, 1946, private collection.

The depiction is of a reclining nude woman with an exaggerated and decorated backside. The title puns on French, "*Oh, quel cul t'as!*" ("Oh, what an ass you have!"). It was this painting that inspired the title of Kenneth Tynan's 1969 sex revue *Oh! Calcutta!*, with its notorious nudity. *See also* The **Gallery of H.M.S. "Calcutta."**

Oh! One of Those Men Who's Done All That (French, *Oh! un de ces messieurs qui a fait tout ça*) Joan Miró, 1925, private collection.

The work juxtaposes (and superimposes) the title with (and on) the bare outlines of female figures. The title itself perhaps refers to the artist and implies that he needs a mere sketch to depict his subject. He has done enough "real" painting. Now all he needs is the suggestion of one, with a proper inscription to complete it. There may also be an implicit sexual message.

Oh Swallow, Swallow John Melhuish Strudwick, 1894, Sudley House, Liverpool.

A young woman sits on a window seat holding a golden chain given her by her lover. The song of the swallow seen flying past the window is a message from him. The title quotes from Tennyson's poem *The Princess* (1847): "O Swallow, Swallow, flying, flying South, / Fly to her, and fall upon her gilded eaves, / And tell her, tell her, what I tell to thee."

The Ohio Gang Ron B. Kitaj, 1964, Museum of Modern Art, New York.

The Pop Art painting depicts a naked young woman apparently being interrogated by a man and a woman, the latter holding a yellow ribbon that she either unwinds from the girl's hair or that she is about to tie around her. A small naked figure in the foreground sits upright in a baby carriage pushed by a specter-like figure. Whatever the intended depiction, the title alludes to the historical Ohio Gang, the group of politicians who achieved high office during the administration of Warren G. Harding (1921–3) and who betrayed their public trust through various scandals.

Oi, Yoi, Yoi Roger Hilton, 1963, Tate Gallery, London.

The semiabstract painting depicts a nude dancing woman, her legs, arms, and breasts flying in all directions. The title is an exclamation of enthusiasm appropriate for her erotic abandon.

Un Oiseau poursuit une abeille et la baisse ("A bird pursues a bee and lowers it") Joan Miró, 1926, private collection.

The French title is an integral part of the painting, which depicts a bird chasing a bee. The bird, at the top of the picture, is labeled "*Un oiseau*." Below it is the word "*poursuit*," its letters following a straggling course to represent the erratic flight of the bird. The bee, at the bottom of the picture, is labeled "*une abeille*," and underneath it, in larger writing, are the remaining three words. French "*baisse*" ("lowers"), while describing how the bird's pursuit makes the bee fly lower, also puns on "*baise*" ("ravishes").

The Old Cupboard Door William Harnett, 1889, Sheffield Art Gallery.

The *trompe l'œil* painting depicts the cracked and splintered planks and broken hinges of a green-painted door hung with various musical, literary, and artistic objects. They include a violin and bow, a worn tambourine, torn and faded musical scores, a manuscript poem, and, on the ledge below, old books, a small bronze statue of an athlete, and a dying rose in a vase. A key hangs on a nail above the lock.

The Old Hunting Grounds Thomas W. Whittredge, 1864, Museum of American Art, Winston-Salem, North Carolina.

Tall trees form an arch over a tranquil but forlorn forest pool where a lone deer drinks. The skeleton of an Indian birch-bark canoe lies at the pool's edge. This is all that remains of a tribe that once hunted in the woods, and the deer need no longer fear the arrows that at one time would have felled it. The painting represents the decimation of the Native American population and the demise of its culture.

The Old King (French, *Le Vieux Roi*) Georges Rouault, 1937, Carnegie Museum of Art, Pittsburgh.

The portrait of a (not obviously old) king suggests some Old Testament ruler. (Hence perhaps "Old.") The king's robes, however, do not suggest any particular historical era.

The Old Scout's Tale *see* **Advice on the Prairie**.

The Old Shepherd's Chief Mourner Sir Edwin Landseer, 1837, Victoria and Albert Museum, London.

A grieving collie rests his head pathetically on his master's draped coffin as it waits in the old shepherd's humble dwelling. He is the old man's chief and perhaps only mourner.

Olympia Édouard Manet, 1863, Musée d'Orsay, Paris.

A naked prostitute reclines on a bed in the pose of Giorgione's **Sleeping Venus**. A black maid offers her a bouquet, presumably a gift from one of her clients. The title is taken from the subject of Zacharie Astruc's poem *La Fille des îles*, in which Olympia symbolizes the dawn and spring, while the painting itself was suggested by Titian's **Venus of Urbino** and Goya's The **Naked Maja**. Olympia was posed by a professional model, Victorine Meurent (1844–c.1885), who is the nude in Le **Déjeuner sur l'Herbe**. *See also* The **New Olympia**.

Officer of the Imperial Guard *see* The **Charging Chasseur**.

Omnibus Life in London William Maw Egley, 1859, Tate Gallery, London.

The scene is of the crowded interior of a London horsedrawn omnibus. Passengers from all walks of life are jostled together as they sit opposite one another on the benches, while others seek to enter at the rear.

On His Holidays John Singer Sargent, 1901, Lady Lever Art Gallery, Port Sunlight.

A young boy rests by a fast-flowing stream after fishing, the two salmon he has netted lying on the rocks beside him. He is Alexander McCulloch (1887–1951), the son of an Australian

sheep farmer. The artist painted the picture during a fishing expedition in Norway.

On the Balcony Peter Blake, 1955–7, Tate Gallery, London.

Four figures sit on a park bench, surrounded by (and displaying) four paintings executed by the artist's fellow students. Various other everyday objects, such as cigarette packs, magazines, and food wrappers, combine to give an image of contemporary popular culture. One of the objects, in the center of the picture, is a photograph of the British royal family on the balcony at Buckingham Palace. This gave the title of the work, which thus equates the people and objects it presents with the royal "show."

On the Beach (1) Winslow Homer, 1870, Canajoharie Library and Art Gallery, Canajoharie, New York; (2) Édouard Manet, 1873, Musée d'Orsay, Paris.

Homer's painting was originally part of a larger canvas titled *On the Beach, Long Branch*, depicting a seaside scene at the then popular New Jersey resort of this name. The present picture, with its off-center group of bathers, is the central section only of the original. Manet's work portrays his wife, Suzanne, seated reading on the beach, and his brother, Eugène, reclining at her feet. The picture was painted in the summer of 1873 during a family stay at the French resort of Berck-sur-Mer, on the Picardy coast.

On the Brink Alfred Elmore, 1865, Fitzwilliam Museum, Cambridge.

A young woman collapses in distress below an open window that reveals the social gathering within. The painting was described in the following terms by *The Art Journal* at the time of its first exhibition: "'On the Brink' is a misadventure wrought by the gambling table. … The title, which is intentionally vague, suggests a sequence. A lady who in high play has sustained fatal loss rushes with empty purse from the scene of disaster and is here seen on the brink of certain ruin and possible suicide" (quoted in Hadfield, p. 131). This could well be so, but it does not explain the sinister figure of a man leaning out of the window behind the lady. Perhaps he is her husband, pleading for her to pull herself back from "the brink"? She is more likely to be "on the brink" of some sexual consequence rather than a financial one.

On the Coast of the Bay of Naples (Russian, *Na beregu Neapolitanskogo zaliva*) Aleksandr Ivanov, late 1840s, Tretyakov Gallery, Moscow.

Three naked boys, one standing, one sitting, one lying, are depicted in the morning light against a background of the Bay of Naples.

On the Oka River (Russian, *Po reke Oke*) Abram Arkhipov, 1890, Tretyakov Gallery, Moscow.

A ferryman's boat, its stern in the foreground, carries a silent group of peasants across the named Siberian river.

On the Road Thomas Otter, 1860, Nelson-Atkins Museum of Art, Kansas City, Missouri.

A Conestoga wagon lumbers west along a road that leads to a bridge across which a steam train runs. The title alludes both to the old wagon road and to the contrasting new railroad.

On the Temple Steps Sir Edward Poynter, 1889, Towneley Art Gallery, Burnley.

A flimsily dressed and seriously expressioned young girl sits by the steps of an ancient temple amid bowls of flowers and baskets of fruit.

On the Threshold of Liberty (French, *Au seuil de la liberté*) René Magritte, 1930, Museum Boymans-van Beuningen, Rotterdam.

A cannon is set to fire in a room whose walls are paneled with depictions of familiar art subjects, such as a forest, a skyscape, a nude, and various decorative designs. We thus stand on the threshold of liberty, for these conventions will be destroyed when the gun goes off, leaving the artist free to express himself in an entirely different way (as he does here).

Ondine Paul Gauguin, 1890, Cleveland Museum of Art, Ohio.

The painting depicts a naked woman in the waves of the sea. The title, which may have been given by the auctioneer at the sale of the work in 1891, presumably derives from Friedrich La Motte-Fouqué's popular fairy tale *Undine* (French, *Ondine*) (1811), about a woman who enticed men to their deaths. (French *onde* means "wave.")

One and Eight: A Description Joseph Kosuth, 1965, Leo Castelli Gallery, New York.

The following eight words are illuminated in neon lights along a wall and serve as their own description of the one art object: "NEON ELECTRICAL LIGHT ENGLISH GLASS LETTERS WHITE EIGHT."

One and Three Chairs Joseph Kosuth, 1965, Museum of Modern Art, New York.

The artist's best known work presents a wooden folding chair alongside a fullsize photograph of a chair and an enlarged dictionary definition of a chair. The work as a whole thus presents three concepts of a single object: its reality, its representation, and its description.

One Ball Total Equilibrium Tank Jeff Koons, 1985, Saatchi Collection, London.

A sealed glass tank containing a basketball sits atop a metal stand. The salt solution in the tank allows the ball to rest suspended in the exact center of its container. The overall effect is one of complete balance. Hence the title.

190 × 60 × 11, 190 × 60 × 11 Miroslaw Balka, 1992–3, Lannan Foundation, Los Angeles, California.

The sculpture comprises two identical marble slabs of the dimensions stated (in centimeters) laid side by side on a metal base and connected to heating cables. The suggestion is of twin beds, especially as the slabs bear traces of some kind of activity or wear.

190 × 30 × 7, 190 × 30 × 7, 50 × 42 × 1 Miroslaw Balka, 1993, London Projects, London.

The partly abstract sculpture consists of two tall steel plates of identical height and width on which strong-smelling soap has been smeared. A carpet lies on the floor before them. The dimensions in the title are the artist's own measurements: height, weight, and foot size. (The figures are metric, so his height, for example, is 6ft 2in.) The plates, with the same dimensions as his own, represent his body in a shower bath, while the carpet is the bath mat.

One of Our Breadwatchers Frederick James Shields, 1866, Manchester City Art Gallery.

A young girl sits huddled in a crudely constructed shelter by a snow-covered field to scare the birds off the newly sown corn. A *Times* reviewer thought the title "of questionable taste" but praised the picture.

One of the Family George Frederick Cotman, 1880, Walker Art Gallery, Liverpool.

A horse pokes his head through the door of a family at dinner to be given something to eat.

One Touch of Nature Makes the Whole World Kin Thomas P. Hall, 1867, N.R. Omell Gallery, London.

A small group of spectators respond animatedly to the painting they see in an art dealer's window. All classes and ages are represented. Hence the apt title, which quotes from Shakespeare's *Troilus and Cressida* (1602).

1 2 3 4 5 6 … B Keith Milow, 1970, Tate Gallery, London.

The work is a series of representations of a sculpture by Anthony Caro arranged in a parabolic curve. The title is purely a reference. The figure 6 is enclosed in a box to denote that the work is the sixth and last in a group called "Improved Reproductions." It comes from the second of the two series, A and B, within the group. Hence the final "B."

One Year the Milkweed Arshile Gorky, 1944, National Gallery, Washington, D.C.

The abstract expressionist painting, one of Gorky's so called "inscapes," depicts a mass of drifting corpuscular forms. The title appears to have no immediate relation to the work, and is perhaps simply a nostalgic phrase recalled from a folk poem of the artist's native Armenia.

Onement I Barnett Newman, 1948, Museum of Modern Art, New York.

The painting is a monochromatic canvas of dark red with a single stripe of lighter red running as a "zip" down the middle. It was the first of the artist's mystical works of this type. Hence its title. (A "onement" is a union, or in mystical terms an "atonement.")

The Only Good One Is a Dead One Willie Doherty, 1993, Matt's Gallery, London.

The installation consists of two videofilms projected side by side. One shows a night-time car journey along country roads. The other is a night-time street scene, filmed from inside a stationary car. The films are accompanied by an Irish voice uttering phrases and sentences implying that the second film is of an assassin waiting for his victim and that the first is of the victim being pursued. The title echoes the cynical World War II saying, "The only good German is a dead German."

Open Your Mouth and Shut Your Eyes William Mulready, 1838, Victoria and Albert Museum, London.

A young man accompanied by a baby reclines on the ground by a décolletée young woman and dangles a cherry before her as she kneels with mouth open and eyes shut. The title quotes from an old nursery saying. (The full version is traditionally: "Open your mouth and shut your eyes, and see what Providence will send you.")

Opened by Customs (German, *Zollamtlich geöffnet*) Kurt Schwitters, *c*.1937–9, Tate Gallery, London.

The work is a collage including various kinds of wrapping papers and fragments of German and Norwegian newspapers. The title was suggested by a couple of German customs labels printed "*zollamtlich geöffnet*" and stamped with the place and date "Hannover 3.8.37."

Ophelia (1) John Everett Millais, 1851–2, Tate Gallery, London; (2) Arthur Hughes, 1859, Birmingham City Art Gallery; (3) John William Waterhouse, (a) 1889, private collection; (b) 1894, private collection; (c) 1910, private collection.

All five paintings depict the innocent Ophelia of Shakespeare's *Hamlet* (1601) who is humiliated by Hamlet when she falls in love with him, loses her reason, and drowns. Millais has her singing as she lies in the stream, the depiction closely following Shakespeare's lines: "Her clothes spread wide, / And, mermaid-like, awhile they bore her up; / Which time she chanted snatches of old tunes, / As one incapable of her own distress." (She was modeled for this by Elizabeth Siddal, Dante Gabriel Rossetti's future wife, immersed in a tub of water.) For Hughes, Ophelia sits by the stream as a woodland sprite. For Waterhouse, she first lies distractedly in a flowery meadow, then stands mad-eyed by a tree with a bouquet of flowers gathered in the folds of her dress, and finally "sits by the margin of a lily-strewn pool" (catalog description, quoted in Hobson, p. 186).

Optophone Francis Picabia, *c*.1918, Mme. Henry Collection, Paris.

The painting depicts naked human figures and other objects revolving on a pattern of concentric circles, suggesting an irradiating sound. An optophone is "an instrument by which light variations are converted into sound variations so that a blind person is enabled by its use to locate and estimate varying degrees of light through the ear and thus even to read printed matter" (*Webster's Third New International Dictionary*, 1971). The instrument must have been a novelty at the time the artist painted his picture.

The Order of Release John Everett Millais, 1852–3, Tate Gallery, London.

The painting, set in a prison waiting room, has a general historical background but was probably actually inspired by the novels of Sir Walter Scott. A rebel Scottish clansman, imprisoned after the defeat of Bonnie Prince Charlie at Culloden in 1746, is led by the jailer to his wife, child, and pet collie dog. The wife hands the jailer the order that she has obtained for her husband's release, the expression on her face suggesting that she prostituted herself to gain the necessary funds. The picture was originally entitled *The Ransom*.

Organic Movement of Chair and Pitcher (German, *Organische Bewegung des Sessels und des Kruges*) Egon Schiele, 1912, Graphische Sammlung Albertina, Vienna.

The watercolor was made when the artist was in jail for disseminating immoral drawings. It is thus part of that experience, and shows a chair and a jug apparently moving through the air. The sense of the first word is uncertain. "Does the adjective 'organic' in the title have an exact meaning, or is it mere wordplay? Does Schiele mean 'natural'?" (Fischer, p. 55).

The Origin of the Milky Way
Tintoretto, *c*.1582, National Gallery, London.

The scene is from classical mythology. Jupiter, wishing to immortalize the baby Hercules, whose mother was the mortal Alcmene, feeds him at the breast of the goddess Juno as she sleeps. The droplets of milk that spirt into the heavens as he suckles form the stars of the Milky Way.

The Origin of the World (French, *L'Origine du monde*) Gustave Courbet, 1866, Musée d'Orsay, Paris.

The painting focuses on a woman's genital area, the source of new life in the world.

The Origins of Language (French, *Les Origines du langage*) René Magritte, 1955, Menil Collection, Houston, Texas.

The tip of a rock is seen against a background of sea and cloudy sky. The rock represents a basic "statement," although as yet it is rudimentary and, like primitive language, open to varying interpretations.

The Orphan Grace Carpenter Hudson, *c*.1898, California Historical Society, San Francisco.

An old Pomo Indian woman stands with her hand on the head of a forlorn-looking young girl, the orphan of the title.

Orpheus Roelandt Savery, 1628, National Gallery, London.

Orpheus was the great poet and musician

of classical mythology who could charm the beasts to stillness with his music. He here plays a violin in a wooded glade, enticing all kinds of exotic birds and animals.

The Orrery *see* **A Philosopher Giving a Lecture on the Orrery**.

Orthodox Boys　Bernard Perlin, 1948, Tate Gallery, London.

Two Orthodox Jewish boys stand on the platform at Canal Street subway stop, New York City. The graffiti-covered green wall behind them is the back of a newspaper kiosk.

Ossian's Dream (French, *Les Songes d'Ossian*) J.-A.-D. Ingres, 1813, Musée Ingres, Montauban.

As the Gaelic bard Ossian sleeps, slumped over his harp, he dreams of the romances and deeds of valor that await him in the sagas ahead, as narrated (and fabricated) by the Scottish writer and forger James Macpherson.

Otahi ("Solitude")　Paul Gauguin, 1893, private collection.

A kneeling Tahitian woman leans forward on her elbows, cupping her face in her hands. The picture's title is inscribed at bottom left.

Our Days Were a Joy and Our Paths Through Flowers　David Inshaw, *c.* 1980, City Art Gallery, Bristol.

The enigmatic landscape with figures has an evocative title described by Michael Jacobs in *The Mitchell Beazley Traveller's Guide to Art: Britain & Ireland* (1984) as "a typically silly Ruralist title." (The Brotherhood of Ruralists was formed by seven British painters in 1975 in the rural west of England, their definition of "rural" being "someone who is from the city who moves to the country.")

Our English Coasts　William Holman Hunt, 1852, Tate Gallery, London.

Sheep, including two black sheep, gather in confusion on a clifftop by the sea. One sheep is caught in brambles, while another lies dead. The depiction almost certainly has a biblical allusion. The painting is popularly known as *Strayed Sheep*, a title not given by the artist but having the right religious overtones: "All we like sheep have gone astray" (Isaiah 53:6), "We have erred, and strayed from thy ways like lost sheep" (Book of Common Prayer).

The Outcast　Richard Redgrave, 1851, Royal Academy, London.

An errant daughter, carrying her illegitimate child, is banished from her home by her stern father, despite the desperate pleas of her mother for him to show mercy.

The Outhouse　William Henry Hunt, 1838, Fitzwilliam Museum, Cambridge.

A woman stands with a jaunty air in the doorway of a shed, the outhouse of the title. She is a portrait of the artist's wife, Sarah.

The Outlaw　William Lindsay Windus, 1861, Manchester City Art Gallery.

A woman crouches in the undergrowth against a background of fields and trees, cradling a man's head in her arms. He is the outlaw of the title. He has been shot by an arrow, which he limply holds in his right hand. A bloodhound races over the heath in the middle distance, presumably having picked up the outlaw's scent.

Outside (French, *Dehors*)　Yves Tanguy, 1929, private collection.

The Surrealist work depicts a dreamlike scene in which biomorphic objects float in a sky or sea or stand or crawl on the ground or seabed below. The title may simply denote an outdoor setting, although the original could allude to the French saying, *Les dehors sont trompeux*, "Appearances are deceptive."

The Oval of the Apparitions (Italian, *L'ovale delle apparizioni*)　Carlo Carrà, 1918, Galleria Nazionale d'Arte Moderna, Rome.

The oval-shaped painting depicts a mixed collection of characters and objects, the most prominent being a tall building, a dead fish, a tailor's dummy, and a female figure holding a tennis racket and ball. They are all "apparitions" in this example of Metaphysical art.

Over the Square　James Rosenquist, 1963, private collection.

The Pop Art painting is of a woman's stockinged legs below the knee, her hand resting on the left leg, which is raised to one side. The depiction represents part of an advertising poster, and the title refers to the artist's experience painting billboards over Times Square.

Over the Town (Russian, *Nad Vitebskom*, "Over Vitebsk")　Marc Chagall, 1914–18, Tretyakov Gallery, Moscow.

Two lovers embrace as they fly horizontally over Vitebsk, the artist's native town.

The Oyster Girl　Philip Mercier, *c.*1745–50, private collection.

The portrait of a young woman with a plate of oysters is also known as *The Fair Oysterinda*. The latter somewhat unusual appellation appears to combine *oyster* with a name such as *Linda* or *Belinda*. More likely, it was based on *Orinda*, the pseudonym adopted by the English poet Kathleen Philips (1631–1664), also known as *The Matchless Orinda*.

P

The Painter and His Pug William Hogarth, 1745, Tate Gallery, London.

The artist's self-portrait gives prominence to his pet pug, named Trump. The resemblance between the pug's face and that of his master is slyly suggested. (It was taken up by caricaturists, who dubbed Hogarth "Painter-Pugg" in consequence.)

A Painter in His Studio *see* **Allegory of Painting**.

The Painter's Studio (French, *L'Atelier du peintre*) Gustave Courbet, 1854–5, Musée d'Orsay, Paris.

The subtitle of the vast and detailed canvas, known alternately in English as *The Artist's Studio*, is *A Real Allegory Determining a Phase of Seven Years of My Artistic and Moral Life* (French, *Allégorie réelle, déterminant une phase de sept ans de ma vie artistique et morale*), the seven years in question being 1848–54. It depicts the artist's Paris studio, with Courbet himself at work on a landscape, watched by a life model (female nude) and a small boy. He is surrounded by 27 other figures. To the right are his friends, including the writers Charles Baudelaire, Pierre Joseph Proudhon, and Champfleury (Jules Husson). To the left are "the others, the world of trivialities: the common people ... those who thrive on death."

Painting (1) (French, *La Peinture*) René Magritte, 1945, private collection; (2) Francis Bacon, 1946, Museum of Modern Art, New York.

Magritte's work is a plaster cast of a woman's torso that the artist has delicately painted in more or less natural colors. Hence the wittily misleading but entirely accurate title. Bacon's painting (which has no other title) is of

an anguished, isolated human figure whose mortality is represented by the sides of meat that surround him.

Painting No. 5 Marsden Hartley, 1914–15, Whitney Museum of American Art, New York.

The abstract painting, incorporating military emblems and decorations of wartime Germany, is so titled as it was the fifth of its series.

The Palace at 4 a.m. (Italian, *Il palazzo alle quattro*) Alberto Giacometti, 1933, Museum of Modern Art, New York.

The Surrealist plastic sculpture represents the framework of a palace with a chesslike queen figure walking toward what could be a bathroom while a bird hovers over the roof.

Palace of Curtains III (French, *Palais de rideaux III*) René Magritte, c.1928–9, Museum of Modern Art, New York.

Two irregularly-shaped framed panels lean side by side against the paneling of a room. The first contains a depiction of the sky. The second contains the French word *ciel*, "sky." The title is perhaps intended to suggest that the second panel is an obscured or "curtained" image of the first. The serial number indicates its order.

Palaestra Dorothea Tanning, 1947, private collection.

A number of young girls in various stages of undress climb on one another's shoulders to form a human pyramid up to the ceiling. The title is the Latin word for a wrestling school or gymnasium.

Palagonia Izhar Patkin, 1990, Holly Solomon Gallery, New York.

The multiple sculpture takes its inspiration, in a pop-culture idiom, from Bernini's **Ecstasy of St. Theresa** and the Baroque grotesques of the Villa Palagonia in Sicily. Hence the title.

La Palermitana George Clint, 1834, Victoria and Albert Museum, London.

The painting is a portrait of a young woman from Palermo, Italy, in local costume. One might pedantically translate the title as "A Palermitan," but this would not indicate the sex.

Pallas and the Centaur Sandro Botticelli, c.1485, Uffizi, Florence.

Pallas (Athene), the Greek goddess of wisdom, tames a centaur, a half-man, half-horse figure who here represents the bestial side of human nature.

Pallas Athene Franz von Stuck, 1898, George Schäfer Collection, Schweinfurt.

The depiction of the Greek goddess, Pallas Athene, is really a portrait of the artist's American wife, Mary Lindpainter, whom he had just married.

Palpitation Charles W. Cope, 1844, Victoria and Albert Museum, London.

A young lady stands anxiously by the open front door, where a servant of the house gossips with the postman (mailman) who just has arrived with a letter. It is uncertain whether the palpitation she experiences is caused by the prospect of a letter from a suitor or by the possibility of one from an illicit lover which she was hoping to intercept. The latter interpretation is suggested by a whip hanging from stag's antlers on the wall and a hat on the table below, indicating a man already in the household.

Pamela Duncan Grant, 1911, private collection.

A young girl is seated on a rug in a garden. She is the daughter of the English art critic and painter Roger Fry (1866–1934) and the garden is that of his home near Guildford, Surrey.

Pan and Syrinx Paul Bril, *c*.1620, Louvre, Paris.

The depiction is essentially of an impressive landscape. But then the god Pan can be seen in the bottom left corner, pursuing the Arcadian nymph Syrinx, who is about to ask the Earth to help her. (She will be changed into a bed of reeds, from which Pan will make his pipes.)

Panatella Richard Smith, 1961, Tate Gallery, London.

The huge painting is based on the band of a panatella cigar as it might be seen on a gigantic billboard. The image is so large that it has become abstracted, and the title alone serves as an indication of the actual subject.

Pandora (1) Sir Lawrence Alma-Tadema, *c*.1880, Bankside Gallery, London; (2) Harry Bates, *c*.1890, Tate Gallery, London; (3) John William Waterhouse, 1896, private collection.

Alma-Tadema has a nude young woman with a wreath of bluebells in her red hair holding a curious casket decorated with a sculpted sphinx and gazing at it intently. Bates has a marble statue of a nude kneeling young woman holding an ivory box and about to open it. Waterhouse has a kneeling maiden tentatively opening the lid of a similar chest. In each case the woman is Pandora, who in Greek legend was given a box and told never to open it. But curiosity overcame her caution. She did so, and released all the ills and woes of human life.

Panic in the Middle Ages (French, *Une panique au moyen âge*) René Magritte, 1927, Musées Royaux des Beaux-Arts, Brussels.

The painting, based on an illustration to a novel by Jules Verne, depicts three headless men in medieval costume. One gestures wildly, another leaps out of a window. The title describes the scene but the men's identity has been concealed by the radical expedient of removing their heads. They are panicking, and have literally "lost their head."

Paolo and Francesca George Frederic Watts, 1872–5, Watts Gallery, Compton, Surrey.

The depiction is of the tragic lovers immortalized in Dante's *Divina commedia* (*c*.1308–21). Historically, Francesca da Rimini (died 1283), married to Gianciotto Malatesta, engaged in adulterous affairs with her brother-in-law, Paolo. The two were discovered by her husband and slain. They are now shown embraced in death in the second circle of Dante's Hell, buffeted by the "warring wings" of hurricanes on tempestuous seas. Watts based Francesca's portrait on Lady Virginia Somers, née Pattle (1826–1910), with whom he had been in love.

Pape moe ("Mysterious Water") Paul Gauguin, 1893, private collection.

A Tahitian youth drinks from a stream of water as it flows into a well. The artist based the painting on a photograph by Charles Spitz, the only professional photographer living on Tahiti at the time.

The Paralytic Tended by His Children (French, *Le Paralytique soigné par ses enfants*) Jean-Baptiste Greuze, 1763, Hermitage, St. Petersburg.

A sick old man on the point of death is lovingly cared for by his children and grandchildren. Even the family dog looks on solicitously. The painting, a visual object lesson, is also known in English as *The Death of a Paralytic* and was originally entitled *The Fruits of a Good Education*.

Les Parapluies ("The Umbrellas") Pierre-Auguste Renoir, *c*. 1881–6, National Gallery, London.

A Paris crowd braves a shower under a

canopy of open umbrellas. The artist was probably influenced in his choice of subject by a print of Japanese ladies with parasols. Hence perhaps the English preference for the French title, with the French elegant *parapluie*, keeping off the rain, implicitly contrasted with the English fashionable *parasol*, protecting from the sun.

The Parasol (Spanish, *El quitasol*) Francisco de Goya, 1777, Prado, Madrid.

A young man patiently holds a parasol over his lady love to shield her from the sun.

Parau na te Varua ino ("Words of the Devil") Paul Gauguin, 1892, National Gallery, Washington, D.C.

A naked Tahitian woman stands beneath a tree and glances back fearfully at the squatting figure of an evil spirit behind her as she covers herself with one hand. She is Eve, and the evil spirit (the "Devil") is the serpent who has told her of the sexual power she possesses.

Parau parau ("Whispered Words") Paul Gauguin, 1891, Hermitage, St. Petersburg.

A circle of Tahitian women sit under a tree to gossip. The artist himself translated the title more accurately as *Conversation*, since the repeated *parau* ("words") serves as an intensive.

Parental Admonition *see* **Fatherly Advice**.

The Parting Robert Farrier, 1844, Victoria and Albert Museum, London.

A newly enlisted soldier bids farewell to his mother and sisters. The painting has the (hardly necessary) explanatory subtitle *A Recruit Taking Leave of his Family*.

Parting at Morning William Rothenstein, 1891, private collection.

A partly dressed young woman stands dejectedly, her hands limp at her sides. It is clear her lover has departed. The title is that of a four-line poem of 1849 by Robert Browning: "Round the cape of a sudden came the sea, / And the sun looked over the mountain's rim: / And straight was a path of gold for him, / And the need of a world of men for me." The poem is inscribed on the painting but misquotes the opening words ("Round the cliff on a sudden").

The Parting Kiss Sir Lawrence Alma-Tadema, 1882, private collection.

A Roman mother tenderly kisses her young daughter's brow as she leaves for the amphitheater seen in the painting's background.

Party in the Country at Berneval (French, *Paysage à Berneval avec personnages*) Pierre-Auguste Renoir, 1898, Hermitage, St. Petersburg.

A small group of young women and children sit in the shade in a meadow while a boy stands nearby. They are Julie Manet, daughter of the artist Berthe Morisot and niece of Édouard Manet, Paule and Jeannie Gobillard, Julie's cousins, four-year-old Jean Renoir, the future film director, and 13-year-old Pierre Renoir, the artist's eldest son, later an actor. Berneval is on the Normandy coast in northern France. The French title literally translates as "Landscape at Berneval with Figures," as if the latter were decorative adjuncts to the main subject.

Pasiphaë Jackson Pollock, 1943, Metropolitan Museum, New York.

Three figures can be made out in the otherwise inchoate mass of colored forms that comprise the painting. Two, like sentinels, stand either side of a recumbent body. They are presumably male, and the lying figure female, especially as it appears to have dugs. The work's original title was *Moby Dick*, for the whale of Herman Melville's novel, but the painting was retitled after a friend told the artist about the Greek myth of Pasiphaë, wife of King Minos, who disguised herself as a cow to mate with a bull and so give birth to the Minotaur.

The Passage of Fortune (French, *La Fortune passe*) Albert Maignan, *c.*1895, Musée St.-Denis, Reims.

The specter of a nude young woman holding a torch floats down the steps of the Paris Stock Exchange, unseen by the speculators who study market prices. Fortune has passed them by.

A Passing Storm James Tissot, *c.*1876, Beaverbrook Art Gallery, Fredericton, New Brunswick.

A young woman faces the viewer as she reclines on a couch by a window overlooking a harbor. Outside on the balcony stands the semi-obscured figure of her lover, gazing dully in at another part of the room. Gray clouds almost cover the sky over the harbor. But the storm will soon pass, as will the lovers' tiff. The young woman is a portrait of the artist's mistress, Kathleen Newton.

Past and Present Augustus Egg, 1858, Tate Gallery, London.

The work is a series of three paintings

depicting the break-up of a typical Victorian middle-class family. In I, the unfaithful wife has collapsed on the floor beside her husband, who has just read the incriminating letter and who grinds the portrait of the betrayer underfoot. Two young children play with a tumbling house of cards. In II, some years later, the two daughters are alone in an attic, one burying her head in the other's lap. In III, the outcast mother crouches beneath riverside arches. The child in her arms is clearly the result of her illicit passion. When originally shown at the Royal Academy, the sequence was untitled, but bore a caption as follows: "August the 4th. Have just heard that B– has been dead more than a fortnight, so her poor children have now lost both their parents. I hear she was seen on Friday last near the Strand, evidently without a place to lay her head — What a fall her's has been!"

The Past and the Present William Mc-Taggart, 1860, Sotheby's, London.

A group of five children make a structure of bricks beside chapel ruins on a Scottish coast. The ruins are the past, and the children use its stones to build the present. The painting was originally called *The Builders*.

The Path of Enigmas Salvador Dalí, 1981, Fundación Gala-Salvador Dalí, Figueras.

The painting depicts a straight road lined by flying moneybags. The "enigmas" are perhaps the two slashed bags that lie on the road. One spills golden coins but the other spouts water. The moneybags themselves may refer to Dalí's time in the United States, when the artist André Breton nicknamed him anagrammatically as "Avida Dollars."

La Patrie ("The Homeland") Christopher Nevinson, 1916, Birmingham City Art Gallery.

The painting, based on the artist's experiences working with a Red Cross unit in northern France, depicts wounded soldiers on stretchers next to their dead comrades in a makeshift hospital set up in a railroad shed. The French title is intended ironically, but could also be interpreted positively as an allusion to the noble sacrifice of life and limb for one's country.

The Patrol (Italian, *In vendetta*) Giovanni Fattori, 1872, private collection.

Three light cavalrymen patrol the outer wall of a fortification under the scorching sun.

Paul Sean Scully, 1984, Tate Gallery, London.

The Irish artist's abstract work, comprising three contiguous striped canvases, is dedicated to his son, who died in 1983.

Pavonia Frederic Leighton, 1859, private collection.

The painting is a portrait of the model Anna (known as Nanna) Risi. Her head is framed by a spray of peacock feathers. Hence the title of the work, from Latin *pavo, pavonis*, "peacock."

Peace Edward Onslow Ford, 1887–9, Walker Art Gallery, Liverpool.

Peace is represented by a lifesize bronze statue of a nude adolescent girl standing on the armor of war as she holds a dove in one hand and a palm branch of victory in the other.

Peace and Plenty (1) George Inness, 1865, Metropolitan Museum, New York; (2) Oscar E. Berninghaus, 1925, St. Louis Art Museum, Missouri.

Inness has painted a panoramic view of well watered pastures and cornfields, representing the agrarian utopia that many hoped would succeed the Civil War (1861–5). Berninghaus depicts an old Indian and a young Indian woman surrounded by pumpkins and corn, symbols of the land's fertility. A crucifix above the woman's head indicates that she and her husband have been converted to Christianity, a religion offering peace of soul and mind.

Peace and Plenty Binding the Arrows of War Abraham van Janssens, 1614, Wolverhampton Art Gallery.

The painting centers on three young women. The first, to the left, holds a cornucopia in one hand and a bundle of arrows in the other. The two others, one with a dove, representing Peace, the other with a young child, symbolizing Plenty, bind the arrows of war together so that they cannot be used as weapons. A cupid flies above bearing a wreath of victory.

Peace and War Peter Paul Rubens, *c.*1629, National Gallery, London.

The naked figure of Peace (Pax) squirts milk from her breast to feed a small child who is Plutus, the god of wealth. Minerva, the goddess of wisdom, protects her from the attack of Mars, the god of war. Cupid, the god of love, and Hymen, the god of marriage, lead two young girls toward a cornucopia. The depiction is thus allegorical, teaching that Wisdom must protect Peace from War so that wealth can increase and marriage flourish. The painting's formal title is

Minerva Protects Pax from Mars. Rubens completed it when he was in England on a diplomatic peacekeeping mission

Peace: Burial at Sea J.M.W. Turner, 1842, Tate Gallery, London.

Two ships have anchored next to each other as a corpse is lowered into the water by the light of flaming torches. The painting is a tribute to the Scottish painter Sir David Wilkie (1785–1841), who died on board a steamer while returning from Palestine and who had to be buried at sea the same evening because the port authorities at nearby Gibraltar had closed the harbor for fear of the plague then prevalent in the Middle East. The title refers to the peaceful summer evening, to the calm sea, and to the peace that the Scottish artist had finally found.

Peace Concluded John Everett Millais, 1856, Minneapolis Institute of Arts, Minnesota.

A wounded British officer sits with his wife and daughters following his return home after a military campaign. His wife holds a copy of *The Times* with the news that peace has been concluded. Millais' wife, Effie, posed for the officer's fond spouse, while the officer himself is a portrait of the artist's friend, Colonel Malcolm. The daughters are unidentified, but one holds out a dove, signifying peace, and the other grasps a medal awarded her father for valor.

Peaceable Kingdom Edward Hicks, *c.*1834, National Gallery, Washington, D.C.

The scene is that of a utopia, in which colonizers and native Americans, wild and domestic animals, coexist in peaceful harmony. A young child stands amid the animal grouping, in which a wolf lies quietly beside a lamb. Their presence is a clue to the work's biblical inspiration: "The wolf also shall dwell with the lamb, and the leopard with the young kid; … and a little child shall lead them" (Isaiah 11:6). The title itself hints at words from the same Old Testament book: "My people shall dwell in a peaceable habitation" (Isaiah 32:18).

The Pearl see Female Nude.

Pearls Rolled Across the Floor Lawrence Weiner, 1994, private collection.

Five statements slant up in uniform capital letters on a wall. The first is the title. The others are: "Cannonballs stacked as high as they will go," "Burnt cork rubbed upon the garden wall," "Concrete pummeled to sand underfoot," and

"Glass scratched by diamonds." The statements replace the expected visual depiction and create associated mental images. Thus the pearls are perhaps also the cannonballs.

Peasant Girl Gathering Faggots in a Wood see Peasant Girl Gathering Sticks.

Peasant Girl Gathering Sticks Thomas Gainsborough, 1782, Manchester City Art Gallery.

The painting, also known as *Peasant Girl Gathering Faggots in a Wood*, is a simple pastoral scene, quite unlike the artist's rich society portraits. A young country girl stands before a sparsely leaved oak tree with a bundle of sticks to be used as kindling or firewood.

Peasant Wedding Pieter Bruegel I, *c.*1567, Kunsthistorisches Museum, Vienna.

Two servants carry bowls of food to a long table where a wedding breakfast is in full swing. The title thus alludes to the materialistic celebration of the spiritual event, not the wedding itself, and the painting may well be a representation of the sin of gluttony.

A Peasant Woman Fainting from the Bite of a Serpent Sir Charles Lock Eastlake, 1831, Victoria and Albert Museum, London.

A young woman is supported by a friend after falling unconscious. The painting was based on an actual incident in Italy, when a young peasant woman named Nina Ranieri was bitten by a snake while kneeling in a chapel of the Virgin Mary and died soon after.

The Pebble (French, *Le Galet*) René Magritte, 1948, Musées Royaux des Beaux-Arts, Brussels.

A woman naked to the waist places a hand on her breast as she turns her head to lick her shoulder. The latter is the pebble of the title, as a stone rounded and smoothed by the action of water. The painting evokes The **Venus de Milo**.

Peep-bo Joanna Boyce, 1861.*

A young mother plays peep-bo (peekaboo) with her baby from behind a curtain as the child sits on the nursemaid's lap. The painting was destroyed in World War II.

Pegwell Bay, Kent William Dyce, 1859–60, Tate Gallery, London.

The painting's full title is *Pegwell Bay, Kent: A Recollection of October 5th, 1858*, naming not only the location depicted but the day of its depiction. The scene is of a mostly deserted

seashore below the cliffs at the named bay, now a district of Ramsgate. The picture is essentially a family portrait, as the four figures in the foreground are the artist's wife, Jane, his wife's sisters, Grace and Isabella, and one of his sons, while the artist himself, carrying a paintbox, appears at the extreme right in the middle distance. The full title implies that the artist regarded the work as a souvenir of the family visit.

Penelope Leandro Bassano, *c*.1575–85, Musée des Beaux-Arts et d'Archéologie, Rennes.

To stave off the importunate suitors who urge her to remarry, Penelope, wife of Odysseus, tells them she must first finish weaving a shroud for her father-in-law, Laertes. The painting shows her wearily unraveling by night what she has woven by day in order to prolong the process. The story is told in Homer's *Odyssey*.

Penelope and the Suitors John William Waterhouse, 1912, Aberdeen Art Gallery.

Penelope, wife of Odysseus (*see* **Penelope**), sits at her spinning-loom while impatient suitors look in at the window and try to entice her with flowers, jewels, and music.

The Penitent Magdalene José de Ribera, *c*. 1640, Prado, Madrid.

Mary Magdalene is depicted as a sinner kneeling in repentance (Luke 7:37–38), her hands folded in prayer.

Penn's Treaty with the Indians Benjamin West, 1771, Pennsylvania Academy of the Fine Arts, Philadelphia.

The painting depicts William Penn's historic interview with the Indians in November, 1682, on the site of the future Philadelphia.

The Penny Wedding Alexander Carse, 1819, private collection.

Guests at a Scottish wedding dance, drink, and dine after the ceremony. The title refers to a practice at country weddings by which each guest makes a small donation towards the cost of the celebration, any remainder being given to the couple to help them set up home. The subject was a favorite one with Scottish genre artists down to the middle of the 19th century.

People in the Sun Edward Hopper, 1960, Smithsonian Institution, Washington, D.C.

Five fully-dressed people, silent and motionless, sit on wooden chairs in the sun. The title implies a scene of warmth and conviviality,

but the painting conveys coldness and isolation.

Peppermint Tower in Honor of Greedy Little Girls (French *Tour menthe poivrée à la louange des petites filles goulues*) Hans Bellmer, 1942, private collection.

The depiction is of a recognizable male phallus in the guise of a stick of peppermint rock greedily grasped by the hands and arms of young girls. The artist produced his first version of the painting in 1936, the same year that he made a doll with identical breasts and buttocks so that it looked the same upside down as right side up.

Perfect Content Erskine Nicol, 1856, Victoria and Albert Museum, London.

A middle-aged man leans back in his chair and closes his eyes in contentment as he puffs on his pipe. The painting has the subtitle *A man smoking* and was exhibited in 1857 under the proverbial title *A Contented Mind's a Continual Feast*. (*Cf.* Proverbs 15:15: "He that is of a merry heart hath a continual feast.")

The Perfect Image (French, *L'Image parfaite*) René Magritte, 1928, private collection.

A woman looks at a picture frame that contain no picture, or else at a mirror that has no reflection. The title refers ambiguously to either. An earlier but rejected title was *The Lost World* (French, *Le Monde perdu*), implying that it is the picture that is missing.

The Pergola (Italian, *Il pergolato*) Silvestro Lega, 1868, Pinacoteca di Brera, Milan.

A thickly-growing pergola protects three women and a little girl from the oppressive heat of a summer afternoon.

La Perla ("The Pearl") Raphael, 1518–20, Prado, Madrid.

The painting, formally known as *The Holy Family*, was apparently so named by Philip IV of Spain on purchasing it from the collection of Charles I of England after the latter's execution in 1649. On seeing the picture, the Spanish king allegedly exclaimed, "This is the pearl of my pictures!" The king's judgement overrates its artistic merit.

Perseus and Andromeda (1) François Lemoyne, 1723, Wallace Collection, London; (2) Frederic Leighton, *c*.1891, Walker Art Gallery, Liverpool.

The two paintings depict the same mytho-

logical rescue of Andromeda by Perseus but from a different perspective. In Lemoyne's interpretation, Perseus zooms down from the sky with his shield to release a nude Andromeda chained by arm and leg to a rock. In Leighton's, a naked Andromeda cowers beneath a huge sea monster, its scaly wings forming a canopy over her. A nude Perseus here rides high in a golden glow on Pegasus, and an arrow that he has loosed at the monster already protrudes from its back. (The model for Andromeda was Dorothy Dene, while Leighton based the mounted Perseus on a print by the Dutch artist Hendrik Goltzius.) *See also* **Perseus Freeing Andromeda**, **Perseus on Pegasus Hastening to the Rescue of Andromeda**.

Perseus Arming Sir Alfred Gilbert, 1881, Bradford Art Galleries and Museums.

The bronze statue of Perseus, rescuer of Andromeda in Greek mythology, depicts him as a nude figure balancing awkwardly as he glances down to check the fit of his winged sandal.

Perseus Freeing Andromeda Piero di Cosimo, *c*.1515, Uffizi, Florence.

The subject of the painting is as for **Perseus and Andromeda**. Here, however, Perseus appears twice: first flying through the air, then standing on the back of the monster ready to slay it with his sword as it nears the hapless Andromeda. Various other figures adorn the lower foreground.

Perseus on Pegasus Hastening to the Rescue of Andromeda Frederic Leighton, *c*.1895–6, Leicester Museum and Art Gallery.

From a narrative point of view, this mythological depiction chronologically precedes the one above, although painted after it. A nude Perseus rides the winged horse Pegasus on his mission to rescue Andromeda. Pegasus has sprung from the bloody neck of Medusa, whose decapitated head Perseus now carries in his flight.

The Persistence of Memory (Spanish, *La persistencia de la memoria*) Salvador Dalí, 1931, Museum of Modern Art, New York.

Memory outlasts time, and distorts it in the process. That is the implication of the famous Surrealist painting, which depicts three "soft" (melting) fob watches, one on a table, one on a dead branch, and the third on a rock that has metamorphosed into the artist's face. A fourth watch is being devoured by ants. The scene as a whole is set by the sea in a location recalling the artist's native Costa Brava. (The artist

claimed the melting watches were inspired by an over-ripe Camembert cheese.) *Cf.* The **Disintegration of the Persistence of Memory**.

Personal Values (French, *Les Valeurs personnelles*) René Magritte, 1952, private collection.

A hugely enlarged comb, match, wineglass, soap tablet, and shaving brush stand or lie in a normal-sized bedroom whose walls are a cloudy sky. The title alludes to the importance that such otherwise insignificant objects assume in our everyday lives.

Perspective: Madame Récamier by David (French *Perspective: Madame Récamier de David*) René Magritte, 1951, Saatchi Collection, London.

As the title indicates, the painting is based on Jacques-Louis David's **Madame Récamier**, but with a coffin bent at an angle on the couch instead of the reclining young lady. The title seems to imply that her youth, or youth in general, can be viewed in the perspective of death. The word also alludes to the picture's artistic perspective, which is that of the original.

The Pesaro Madonna Titian, 1519–26, S. Maria Gloriosa dei Frari, Venice.

The altarpiece, with its Virgin and Child and saints, was painted for the Pesaro family. Hence its name. The work includes portraits of the family in all its generations as its donors.

A Pet Walter Howell Deverell, *c*.1853, Tate Gallery, London.

A young woman stands in the entrance to a conservatory that leads into a summer garden. A cage with a songbird hangs by the door and she brings her face up to it as if proffering a kiss. A shaggy dog lies on the tiled floor. The title seems to imply that he is "the" pet but that the bird is "a" pet, or at any rate the one of the moment. The painting was first exhibited with the following unidentified quotation: "But, after all, it is only questionable kindness to make a pet of a creature so essentially volatile."

Peter Getting Out of Nick's Pool David Hockney, 1966, Walker Art Gallery, Liverpool.

A naked young man, seen from behind, raises himself on his hands and looks to the right as he climbs out of a swimpool. He is Peter Schlesinger, an art student with whom Hockney had become romantically involved in California. The pool belongs to Nick Wilder, a Los Angeles art dealer.

Peter the Great Interrogating the Czarevich Alexis (Russian, *Pëtr I doprashivayet tsarevicha Alekseya Petrovicha*) Nikolai Ge, 1871, Tretyakov Gallery, Moscow.

The Russian czar interrogates his son and heir, Aleksei Petrovich (1690–1718), whom he suspects of plotting to overthrow him.

The Phantom Landscape (French, *Le Paysage fantôme*) René Magritte, 1928, private collection.

A head-and-shoulders portrait of a woman has the word "*montagne*" ("mountain") written across her face. This is the "phantom landscape" of the title, named but not actually seen.

Phantom Wagon Salvador Dalí, 1933, Yale National Gallery, New Haven, Connecticut.

The painting is at first glance simply a depiction of a horse-drawn wagon crossing a plain. But the wagon is a phantom. Look more closely, and the two people sitting in the wagon become two towers of a distant town, while the wagon's wheels are stakes in the ground.

Pharmacy (French, *Pharmacie*) Marcel Duchamp, 1914, private collection.

The artist created the work by purchasing a commercial print of a landscape and painting two luminous dots on it, one red and the other green, like the colored glass jars in a pharmacy. Hence the title. He is said to have had the idea when he was looking out of a train window at the dreary countryside and saw two small lights in the distance.

A Philosopher Giving a Lecture on the Orrery Joseph Wright of Derby, 1766, Derby Art Gallery.

A lecturer explains the workings of an orrery (a clockwork model of the solar system) to a group of seven men, women, and children. The painting, one of a number depicting scientific experiments, is also known by the short title, *The Orrery*.

The Philosopher's Lamp (French, *La Lampe philosophique*) René Magritte, 1936, private collection.

A man smoking a pipe has a nose that enters the bowl of his pipe to reemerge as a lighted candle on a stand before him. Smoking and the scent of tobacco are traditionally associated with pondering and philosophizing, and the fire that smolders in the bowl of the pipe here transmutes into the flame of the candle that illuminates the smoker's face (a self-portrait).

Philosophical Reflection *see* The **Present and the Past**.

Philosophy in the Boudoir (French, *La Philosophie dans le boudoir*) René Magritte, 1947, private collection.

A nightdress with a pair of glowing breasts hangs on a rail before a table with a pair of women's high-heeled shoes in which the toes are shown as actual feet. The title implies that the painting evokes other works, in particular **In Memory of Mack Sennett**, The **Rape**, and The **Red Model**. More generally it implies the mental associations that everyday objects can make, and that lead one to ponder on the cause of a particular association.

Photo: This Is the Color of My Dreams (French, *Photo: Ceci est la couleur de mes rêves*) Joan Miró, 1925, private collection.

The Surrealist painting consists of a single blue amorphous shape against a pale pink background. The work is unusual in that the title is more prominent than the depiction. The first word, "Photo," occupies the top left corner of the picture, while the remaining words are written under the blue shape, at bottom right. The title itself appears to represent a one-line prose poem, with "Photo" its own title. The words obviously refer to the artist's dreams, and so presumably to the color blue. Perhaps the depiction is thus a "photo" of an actual dream.

The Phrenologist William Henry Knight, *c.*1860, Wolverhampton Art Gallery.

Phrenology, the so called science of "reading" the prominences on a person's skull, was a fashionable Victorian craze. Here a practitioner of the art palpates the head of a smirking little darling while his mother and sister await the great man's verdict.

Phryne at a Celebration of Poseidon at Eleusis (Russian, *Frina na prazdnike Poseydona v Elevsine*) Genrikh Semiradsky, 1889, Russian Museum, St. Petersburg.

Phryne, an Athenian courtesan of the 4th century BC, was the mistress of the sculptor, Praxiteles, and is said to have been the inspiration for Apelles's **Aphrodite Anadyomene** after the artist saw her naked on the seashore with disheveled hair. She was also the model for Praxiteles's own **Aphrodite of Cnidus.** She is naked by the bay in Semiradsky's painting, showing her as the center of attraction at the festival of the god of the sea.

Phyllis and Demophoon Edward Burne-Jones, 1870, Birmingham City Art Gallery.

The depiction of Phyllis and Demophoon is based on Ovid's *Heroides*, which tells how Phyllis, queen of Thrace, fell in love with Demophoon when he stayed at her court. He then left Thrace and did not return within a month, despite his promise to do so. Pitying the distraught queen, the gods turned her into an almond tree. Demophoon finally returned and embraced the tree, which burst into blossom and turned back into Phyllis. The painting depicts the moment. Phyllis now embraces Demophoon, who starts from her in wonder.

Physical Energy George Frederic Watts, 1883–1904, Watts Gallery, Compton, Surrey.

The bronze sculpture is of a horse and heroic nude rider, the muscles of both taut and quivering. The title applies to both man and mount.

The Physical Impossibility of Death in the Mind of Someone Living Damien Hirst, 1991, Saatchi Collection, London.

The sculpture consists of the body of a tiger shark suspended in formaldehyde in a glass tank. Confronted with the fearsome creature, the viewer is forced to reflect on his own mortality. The title thus repeats the familiar truth, that death seems impossible to those who are alive. The work itself is visual proof that the reverse is the case, as we know but are loath to admit. "The title ... resonated with high-cultural associations, such as Le Rochefoucauld ('Neither the sun, nor death, can be looked at steadily') and Wittgenstein in the *Tractatus* ('Death is not an event in life. Our life has no end in just the way in which our visual field has no limits') and the *Mahabharata* (Lake: 'What is the greatest wonder'? Arunya: 'Every day Death strikes everywhere, yet we live as though we were immortal. This is the greatest wonder')" (Gordon Burn, "Is Mr. Death In?", in Hirst, p. 7).

The Piano Lesson (French, *Leçon de piano*) Henri Matisse, 1916, Museum of Modern Art, New York.

A young boy's head appears over the music book open on the stand of the grand piano at which he sits. He is the artist's son, Pierre, who was made to study music against his wishes.

The Picnic *see* **Holyday.**

Pietà (1) Enguerrand Charonton, *c.*1460, Louvre, Paris; (2) Giovanni Bellini, *c.*1465,

Pinacoteca di Brera, Milan; (3) Sandro Botticelli, after 1490, Alte Pinakothek, Munich, (4) Ercole de' Roberti, *c.*1495, Walker Art Gallery, Liverpool; (5) Michelangelo, 1498–9, St. Peter's, Rome; (6) Giovanni Bellini, *c.*1505, Accademia, Venice; (7) Fra Bartolommeo, *c.*1516–17, Pitti, Florence; (8) Titian, *c.*1573, Accademia, Venice; (9) Pietro da Cortona, 1620–5, S. Chiara, Cortona; (10) Eugène Delacroix, 1843, Louvre, Paris; (11) Max Ernst, 1923, Tate Gallery, London; (12) Salvador Dalí, 1982–3, Fundación Gala-Salvador Dalí, Figueras.

The Italian word, meaning "pity" (from Latin *pietas*, originally "piety"), is applied to a painting or sculpture depicting the Virgin Mary supporting the body of the dead Christ on her lap. Other figures, such as St. John the Evangelist or Mary Magdalene, may also be present, as they are in the School of Avignon painting (now generally attributed to Enguerrand Charonton). The "pity" is the grief of Mary for her dead son. The subject is not of biblical origin and but was established early in the Christian narrative. Michelangelo's marble sculpture is probably the best known example. Ernst's Surrealist painting, however, offers a different interpretation, and depicts a kneeling father holding his fully grown son. The artist may have chosen the traditional religious title as an attack on religion, or even intended a personal attack on his father, a devout Catholic. Dalí's *Pietà*, despite its surreal touches, is a recognizable depiction of the dead Christ and his mother.

The Pilgrimage to the Island of Cythera (French, *Le Pèlerinage à l'île de Cythère*) Antoine Watteau, 1717, Louvre, Paris.

One by one, pairs of lovers sadly depart from the island of Cythera, the haven of love devoted to Aphrodite, and a symbol of human life. The painting is alternately known as *The Embarkation for Cythera* (French, *L'Embarquement pour Cythère*). Both titles are somewhat misleading, since the pilgrim lovers have already paid their vows at the shrine of Venus, and are now leaving the island. On the other hand, the title could relate to the completed pilgrimage. A third title, *The Island of Cythera*, is also found. The subject is said to have been suggested to the artist by Florent Dancourt's play *Les Trois Cousines* (1700), in the final act of which a group of country youths, disguised as pilgrims of love, prepare to embark on the voyage to Cythera. (Cythera is now Kythira, northwest of Crete in the Peloponnese.)

Pillars of Society (German, *Stützen der Gesellschaft*) George Grosz, 1926, National-galerie, Berlin.

The painting is a censurious depiction of contemporary German society. There are four main figures. One is a beer-drinking National-ist with monocle, scar, and swastika. A warhorse rides out of his opened skull. Another is a Social Democrat holding a German flag and displaying a slogan reading "*Sozialismus ist Arbeit*" ("Socialism is work"). He also has an open skull. A third is a journalist with a palm branch in his hand and a chamber pot on his head, denoting his limited intelligence. The fourth is a unctuous clergyman who turns his back on the bloodshed behind him. The military, the political, the press, and the clergy are thus the "pillars of society." The title was ironically adopted from that of Ibsen's play (1877).

Pinch of the Ear *see* **Brother and Sister**.

Pink Morning (French, *Matin rose*) Eva Gonzalès, 1874, Louvre, Paris.

The portrait of a seated young woman in a flowing pink dress looking tenderly down at a litter of puppies in a basket is probably of the artist's sister, Jeanne Gonzalès. The painting was originally exhibited under the title *La Nichée* ("The Brood"), referring to the puppies.

Pinkie Sir Thomas Lawrence, 1795, Hunt-ington Art Gallery, San Marino, California.

The painting is a portrait of Sarah Barrett Moulton (1783–1795), daughter of an English planter in Jamaica, and nicknamed Pinkie for her rosy complexion. When she was sent to England at the age of ten to be educated, her grandmother wrote to a niece in Richmond Hill, near London: "I become every day more desirous to see my dear little Pinkey; but as I cannot gratify myself with the Original, I must beg this favor of You to have her picture drawn at full length by one of the best Masters in an easy Careless attitude" (quoted in Morse, p. 191). Lawrence began the portrait soon after, depicting the pink-cheeked little girl wearing a pink bonnet with pink ribbons and with a pink sash around her waist. She died of tuberculosis, aged 12, within a few months of the completion of the portrait, which now hangs in the same gallery as her "opposite number," The **Blue Boy**. The pair attractively illustrate the popular saying, "Blue for a boy, pink for a girl."

Pisces Man Ray, 1938, Tate Gallery, London.

The Surrealist painting juxtaposes an elongated reclining female nude with a mackerel. The title represents either the zodiac sign or else the plural form of Latin *piscis*, "fish." The model's body curves reflect those of the fish, her nipple suggests its eye, her ribs its stripes, and her two feet its parted tail fin. The painting is based on a drawing made in 1936 called *Woman with Her Fish* (French, *La femme et son poisson*).

Piss Christ Andres Serrano, 1987, Paula Cooper Gallery, New York.

The glowing image of Christ on the Cross was made by photographing a small plastic crucifix in a glass of urine. Understandably, the representation upset many. But as the critic David Levi Strauss suggested, it was probably not so much the image itself that offended (he called it "really quite beautiful") but the particular juxtaposition of the words in the title.

Piti teina ("Two Sisters") Paul Gauguin, 1892, Hermitage, St. Petersburg.

The painting is a portrait of Tetua and her younger sister, Tehapai, two young Tahitian girls.

Pity William Blake, *c*.1795, Tate Gallery, London.

A woman lies on the ground, apparently lifeless. Above her, two female figures race through the air on horses, one of them holding a tiny child and looking down. The painting is based on the passage from Shakespeare's *Macbeth* in which Macbeth ponders the consequences of murdering Duncan: "And pity, like a naked new-born babe, / Striding the blast, or heaven's cherubim, hors'd / Upon the sightless couriers of the air, / Shall blow the horrid deed in every eye" (I.vii).

Pizarro Seizing the Inca of Peru John Everett Millais, 1846, Victoria and Albert Museum, London.

The painting depicts the Spanish conquest of Peru at the moment on November 16, 1532, when Francisco Pizarro, the Spanish leader, seizes the Inca emperor Atahualpa at Cajamarca.

Pizza Eater Eric Fischl, 1948, Mary Boone Gallery, New York.

A naked young girl on the verge of puberty picks her way over the beach, a pizza in one hand, a bottle of cola in the other. Two young men watch her somewhat salaciously. She is so preoccupied with the pizza, the title implies, that she is innocent of any sexual provocation. But

since the subject is sexuality, it is possible the title was meant to suggest *peter-eater*, slang for a fellator (fellatrix).

Place de la Concorde Edgar Degas, 1875, Hermitage, St. Petersburg.

The painting depicts a well-to-do gentleman walking with his two young daughters and a pedigree dog across a Paris square. The main title is the name of the square. But the picture is really a family portrait set against a background of this square Hence its alternate title, *Viscount Lepic and His Daughters Crossing the Place de la Concorde* (French, *Vicomte Lepic et ses filles traversant la Place de la Concorde*). There is reason to believe that the artist himself used the first title. Viscount Ludovic-Napoléon Lepic (1839–1889) was an aristocratic artist whose work is now all but forgotten. His two daughters are Eylau (named for the 1807 battle), born 1868, so here aged 12, and Janine, born 1869, so 11. The dog is Lepic's borzoi, Albrecht.

Plan Jenny Saville, 1993, Saatchi Collection, London.

The painting is a portrait of a naked woman, her body seen from below and filling the canvas. Contour lines, like those indicating the different altitudes of a landmass on a map, are drawn across the surface of the woman's skin. The title thus alludes to this feature.

Playing at Doctors Frederick Daniel Hardy, 1863, Victoria and Albert Museum, London.

"Doctors and nurses" has long been a stock children's game. In this painting, a healthy little girl "patient" giggles as the "doctor" solemnly takes her pulse. Two budding apothecaries make pills of breadcrumbs while two more mites raid a medicine cupboard. Their mother and infirm grandmother (who may have inspired the game) are about to enter the room.

Playtime William Jabez Muckley, *c.*1865, Albion Fine Art, London.

The painting depicts a violent scene of children at play. Two young boys hold flintlock rifles and one aims his at a child's doll on a chair, resisting the attempts of a girl to restrain him. The doll's owner weeps as her baby faces the firing squad.

The Plea Rebecca Solomon, *c.*1880, Geffrye Museum, London.

A young sailor stands with lowered eyes before the family head in a country house. The fa-

ther's daughter pleads with him to have mercy on the handsome lad. What is his crime? A gamekeeper beside him holds the evidence: the rabbit that he has poached from the estate.

Please Touch (French, *Prière de toucher*) Marcel Duchamp, 1947, private collection.

Created for the cover of the catalog of the Paris exhibition *Le Surréalisme en 1947,* the work consists of a foam-rubber breast with a red nipple mounted on black velvet. The title is an invitation that is the exact opposite of the expected caution, "Please do not touch" (French, *Prière de ne pas toucher*), applied to art objects. It also suggests a lifting of the normal taboo on touching the object actually represented.

Pleasure Palette Jim Dine, 1969, Museum Ludwig, Cologne.

The work is a representation of an artist's palette on which a number of different-colored bright blobs of paint have been applied. In the center is a heart-shaped form. The sight, though abstract, is cheerful, and the title puns on "palate-pleasure" as a tasty tidbit.

PLIGHT Joseph Beuys, 1958–85, Anthony d'Offay Gallery, London.

The two spaces of the gallery are lined with rolls of gray felt and are empty except for a grand piano with a closed lid on which lie a blackboard and a thermometer. The evocation is of oppression and frustration, since the piano is not prepared for playing, the blackboard is blank, and the purpose of the thermometer remains unknown. Hence the title, which also evokes the German artist's related native word *Pflicht*, "duty." Together, the two words are perhaps intended to epitomize the artist's view of the human condition.

The Plum (French, *La Prune*) Édouard Manet, 1877, private collection.

A young woman sits in a café, an unlit cigarette in her hand. She has ordered a plum in brandy, which stands on the table before her.

Plum Grove Peter Howson, 1994, Tate Gallery, London.

The painting depicts an incident during the 1990s conflict in the former Yugoslavia. Children play alongside the hanging figure of a castrated soldier. The title perhaps translates the name of the nearby village. But it could also refer to the grove where the children play, with "plum" alluding to the "fruit" now hanging from one of the trees as a prize trophy.

The Poet Vladimir Mayakovsky Invites the Sun to Tea Ken Kiff, 1985–7, private collection.

The painting is an imaginary portrait of the great Russian poet of the Revolution and illustrates his poem *Sun*, in which, abandoning for once his socially charged subjects, he notes the sun's easy daily round and cheekily invites him down to come to tea and talk with him. The poem ends with the the the poet accepting that both have their allotted tasks, and each must shine in his particular way.

The Poet Reclining (French, *Le Poète allongé*) Marc Chagall, 1915, Tate Gallery, London.

The artist (here regarding himself as a poet) lies on the grass in front of his house. Behind him, in a field, a horse grazes and a pig stands before a shed containing their respective stable and sty. The picture was painted in Russia during the honeymoon following the artist's first marriage. Hence no doubt the lyrical title.

The Policeman's Daughter Paula Rego, 1987, Saatchi Collection, London.

A young woman pettishly polishes her policeman father's jackboot by the light of the streetlamp that shines brightly into the room. The painting depicts a state of subservience that is already hinted at in the title.

Political Drama (French, *Drame politique*) Robert Delaunay, 1914, National Gallery, Washington, D.C.

A man and a woman dance in and out of the multicolored rings of a giant disk. The title suggests they are leading characters in some sort of play, although its stated political nature is not immediately apparent.

The Pond with Water-Lilies *see* The **Water-Lily Pond**.

The Pool of Bethesda Robert Bateman, 1877, private collection.

The scene is from the New Testament. An angel walks down steps to touch the waters of the pool of Bethesda, which will then have healing powers (John 5:4).

A Poor Aristocrat's Breakfast (Russian, *Zavtrak aristokrata*) Pavel Fedotov, 1849, Tretyakov Gallery, Moscow.

An impoverished aristocrat snatches a meager breakfast in his dingy apartment. An advertisement for oysters lies on a chair to the left.

The word "poor" does not appear in the Russian title.

Poor Fauvette (French, *Pauvre Fauvette*) Jules Bastien-Lepage, 1881, Glasgow Art Gallery.

A little peasant girl wrapped in a shawl is dwarfed by a tall thistle and a barren tree as she stands in rough pastureland. A cow grazes beyond. She is the "poor Fauvette" of the title, her name presumably intended to mean "little wild girl."

The Poor Fisherman (French, *Le Pauvre Pêcheur*) Pierre Puvis de Chavannes, 1881, Musée d'Orsay, Paris.

A fisherman stands dejectedly in his boat, waiting for a catch. On the grassy bank nearby, his wife picks flowers and his young child lies sleeping. The painting has religious overtones.

The Poor Poet (German, *Der arme Poet*) Carl Spitzweg, 1839, Nationalgalerie, Berlin.

A poet seeks a rhyme or a meter as he sits in a makeshift bed under a suspended umbrella in a dilapidated attic with a leaky ceiling. Heavy tomes lie on the floor beside him and pages from *Gradus ad Parnassum* ("The Road to Parnassus") wait beside the stove for use as fuel. The poet may be poor, but he can pursue the lofty poetic art, however unattainable it may be.

The Poor Teacher *see* The **Governess**.

Pop Gavin Turk, 1993, Saatchi Collection, London.

The piece is a lifesize waxwork portrait in a case of the artist as Sex Pistol Sid Vicious in the pose of Warhol's painting of Elvis as an armed cowboy. The title alludes to the "pop" that is about to erupt from the gun while also serving as a visual pun on the artist as pop icon.

Porcia Wounding Her Thigh Elisabetta Siran, 1664, Spencer A. Samuels & Company, New York.

A seated young woman holding a dagger aloft extends her bared right leg and looks down at the bloody gash in her thigh. She is Porcia (Portia), wife of Brutus, who has stabbed herself to prove to her husband that she can keep his secret: the plot to assassinate Julius Caesar. The incident is described in Plutarch's *Life of Brutus* (1st c. AD).

Pornokrates Félicien Rops, 1878, Musée Félicien Rops, Namur.

The painting depicts a young woman,

naked but for black stockings, black gloves, and a black hat, walking blindfold along a marble pavement led by a pig. Three flying cherubs recoil in horror. Below her are figurines of Sculpture, Music, Poetry, and Painting. The woman is Pornocrates, the personification of harlotry.

Portinari Altarpiece Hugo van der Goes, *c.*1475, Uffizi, Florence.

The triptych of the Nativity was commissioned by Tommaso Portinari, the Medici representative in Bruges, for the family chapel in the church of Sta. Maria Novella, Florence, founded in 1285 by his ancestor, Folco Portinari. The left-side panel shows Tommaso Portinari kneeling in prayer. His two sons, Antonio and Pigello, stand behind him. The right-side panel shows Portinari's wife, Maria, and their daughter, Margaret, kneeling similarly.

Portrait of a Bearded Man *see* **Portrait of a Man** (1).

Portrait of a Boy (1) Rembrandt van Rijn, *c.*1645–50, Norton Simon Foundation Collection, Los Angeles, California; (2) Jacques van Oost, 1650, National Gallery, London.

Rembrandt's painting was long known as *Portrait of the Artist's Son Titus*, but recent research has established that Titus was older than the subject at the time he was painted. The title has been adjusted accordingly. Van Oost's young boy half turns from the viewer, his hands in a fur muff. His identity is unknown, but an inscription reveals that he is aged 11.

Portrait of a Clergyman Albrecht Dürer, 1516, National Gallery, Washington, D.C.

The identity of the young clergyman in the portrait is unknown.

Portrait of a Dog Eric Fischl, 1987, Museum of Modern Art, New York.

The four-part painting is a study of privacy invaded. In gray-green tones, the depictions from left to right are of a naked woman washing her hair in a tub, a dog on a lead, a man in a bathroom holding the end of the dog's lead, and a toothbrush in a glass with a tube of toothpaste beside it on a shelf. The dog looks keenly at the woman as she kneels by the tub. The title seems to imply that the viewer is also a "dog" for spying on these domestic scenes.

Portrait of a Lady (1) Domenico Ghirlandaio, 1488, Thyssen-Bornemisza Collection, Lugano; (2) *see* La **Belle Ferronnière**.

The profile portrait is of Giovanna Tornabuoni, a daughter of the family (related to the Medici) who were the donors of the frescoes that the artist painted in their chapel, in the church of Sta. Maria Novella, Florence.

Portrait of a Man (1) Titian, *c.*1512, National Gallery, London; (2) *see* The **Young Englishman**.

A bearded man in a blue quilted costume turns to face the viewer. His identity is uncertain, although the painting may be a self-portrait. In the 17th century it was believed to be a portrait of the Italian poet, Ludovico Ariosto (1474–1533), author of *Orlando Furioso* (*c.*1502), and is still named as *Ariosto* in some modern sources. An alternate English title is *Portrait of a Bearded Man.*

Portrait of a Musician Leonardo da Vinci, 1485–90, Pinacoteca Ambrosiana, Milan.

The identity of the sitter is uncertain. He is obviously a musician since he holds a musical score in his right hand. He may be the composer Franchino Gaffurio (1451–1522), chapelmaster at Milan cathedral and a prominent writer of treatises on music

Portrait of a Young Gentleman Juan Bautista Martínez del Mazo, *c.*1660, Banco Exterior de España, Madrid.

The young man is stated at top right of his portrait to be "ETATIS SUAE 16 ANOS" ("aged 16 years"), but his name is not given. He may have been the son of Don Juan González Unzqueta, whose portrait came from the same Carmelite convent in Madrid, as did a *Portrait of a Lady*, perhaps that of his mother. The family may thus have supported the convent.

Portrait of a Young Man Andrea del Sarto, *c.*1517, National Gallery, London.

A young man holding a piece of clay or marble, or possibly a book, turns to face the viewer. His identity is unknown, but he may be a sculptor or writer.

Portrait of a Young Woman Sebastiano del Piombo, 1512, Uffizi, Florence.

The portrait was originally believed to be by Raphael and in the 19th century was stated to be of his mistress, La **Fornarina**. Hence it still appears in some sources (such as Rossi) as *The So Called Fornarina*. The subject's true identity is unknown, however.

Portrait of Felix (French, *Portrait de Félix*) Camille Pissarro, 1881, Tate Gallery, London.

A dark-haired young boy wearing a beret looks somewhat nervously at the viewer. He is the artist's third son, Félix-Camille Pissarro (1874–1897), aged seven. He became a painter and engraver under the pseudonym Jean Roch and died of tuberculosis at the early age of 23.

Portrait of Félix Fénéon (French, *Portrait de Félix Fénéon*) Paul Signac, 1890, Museum of Modern Art, New York.

The full title of the poster-like portrait of the French writer and art critic Félix Fénéon (1861–1944) is *Portrait of Félix Fénéon on the Enamel of a Rhythmic Background of Measures and Angles, Shades and Colors* (French, *Portrait de Félix Fénéon sur l'émail d'un fond rythmique de mesures et d'angles, de tons et de teintes*). The "enamel" background, with its dynamic curves, is based on the design on a Japanese kimono.

Portrait of Gala Salvador Dalí, 1935, Museum of Modern Art, New York.

The painting depicts a rear and front view of the artist's wife, Gala, facing each other like mirror images. In her front view, Gala sits below a picture on the wall that is a variation on Jean-François Millet's The **Angelus**. Dalí's work is subtitled *The Angelus of Gala*, stressing the interrelationship between his painting and Millet's, and the front-view Gala (but not the rear-view) sits on a wheelbarrow, like the female figure in Dalí's version of Millet's picture.

Portrait of Ida Rubinstein (Russian, *Portret Idy Rubinshteyn*) Valentin Serov, 1910, Russian Museum, St. Petersburg.

The Russian ballerina, Ida Rubinstein (1885–1960), famous for her oriental roles, adopts a delicate, angular pose as she sits naked on drapery against a gray background.

Portrait of Kitty Sir Jacob Epstein, 1937, Walsall Museum and Art Gallery.

The drawing is of the artist's 10-year-old daughter, Kathleen (Kitty), who married the painter Lucian Freud in 1948 (they divorced four years later).

Portrait of Madame de Staël as Corinne (French, *Portrait de Mme de Staël comme Corinne*) Élisabeth Vigée-Lebrun, *c.*1807–8, Musée d'Art et d'Histoire, Geneva.

The French writer Madame de Staël, otherwise Germaine Necker, baronne de Staël-Holstein (1766–1817), is here depicted seated with a lyre on her lap as Corinne, the fictitious Italian poet who is the heroine of her own novel *Corinne ou l'Italie* ("Corinne, or Italy") (1807).

Portrait of My Sister, Madeleine (French, *Portrait de ma sœur Madeleine*) Émile Bernard, 1888, Musée Toulouse-Lautrec, Albi.

The artist has portrayed his saintly but sickly sister, Madeleine Bernard (1871–1895), who died of tuberculosis at the age of 24. Gauguin's painting The **Loss of Virginity** was based on another of Bernard's portraits of Madeleine made at about this time.

Portrait of Valentine *see* **Winged Domino**.

Portrait of Whistler's Mother *see* **Arrangement in Gray and Black, No. 1: Portrait of the Painter's Mother**.

Portsmouth Dockyard *see* **My Heart Is Poised Between the Two**.

Post-Partum Document VIa Mary Kelly, 1978–9, Arts Council, London.

The work, in slate and resin, is one of a series executed by the artist over a period of six years. The series explores the relationship between mother and child, and specifically between herself and her infant son. This particular work resembles the Rosetta Stone, with three types of inscription. The top reproduces the barely formed letters of a child learning to write. The center, in cursive writing, begins "(age 3.10)" and comments on the child's progress in writing. The bottom is a typewritten text dated "December 6, 1977" and commenting on infant schools the artist visited for her son, with her views on their method of teaching reading and writing. "Post-partum" is the Latin medical term for "after childbirth."

The Potato Eaters Vincent van Gogh, 1885, Rijksmuseum Vincent van Gogh, Amsterdam.

A peasant family of five sit around the table and by the dim light of an old oil lamp eat the potatoes they have sown and dug. The painting was popular with other Dutch artists of the period, who alternately titled it *The Frugal Meal*.

The Precious Book Gwen John, *c.*1920, private collection.

A young girl reads a book. She holds it carefully, almost reverently, in a white handkerchief, implying that the book is a special favorite. The painting's title confirms this.

Prehistory Julian Schnabel, 1981, Saatchi Collection, London.

The full title of the semiabstract work, which includes images of apparently dead or decaying human figures and real antlers mounted on a "canvas" of pony skin, is *Prehistory: Glory, Honor, Privilege, Poverty*, an uneasy combination of abstract nouns. "The title and scale of this work evoke epic yet conflicting narratives of claustrophobic density" (Taylor, p. 58).

Preparing Tea Jane Bowkett, *c*.1860.*

A mother and her two young daughters prepare tea. The mother cuts toast at the table while watching out of the window, one daughter toasts bread before the fire, and the other brings in her father's slippers. He himself is presumably arriving in the train seen through the window. The painting was lost at sea.

The Present and the Past (French, *Le Présent et le Passé*) Henri Rousseau, *c*.1889, Barnes Foundation, Merion, Pennsylvania.

The painting depicts the artist and his second wife, Joséphine, holding a posy of flowers between them in a spring-like landscape. That is the "present." The "past" is represented by two heads, of a man and a woman, floating in the sky above. The identity of the two is uncertain. They may be Joséphine's previous husband, Le Tensorer; and the artist's first wife, Clémence, but the man could equally represent Rousseau's younger self. The overall intention was certainly to commemorate his first and second marriage. The picture was exhibited in 1907 under the new title *Philosophical Reflection* (French, *La Pensée philosophique*).

The Presentation in the Temple

(1) Ambrogio Lorenzetti, 1342, Uffizi, Florence; (2) Stefan Lochner, 1447, Hessisches Landesmuseum, Darmstadt; (3) Hans Memling, *c*.1463, Kress Collection, Washington, D.C.; (4) Lorenzo Lotto, *c*.1555, Palazzo Apostolico, Loreto.

The scene is from the New Testament. The infant Christ is presented by his parents in the temple at Jerusalem 40 days after his birth, as prescribed by Mosaic law (Luke 2:22–39). The ceremony marked the purification (cleansing) of the mother, who had to remain in confinement for this period following a birth. *See also* **The Presentation of Christ in the Temple**.

The Presentation of Christ in the Temple (1) Bartolo di Fredi, *c*.1390, Louvre,

Paris; (2) Fra Bartolommeo, *c*.1516, Kunsthistorisches Museum, Vienna.

The New Testament subject is the same as that above. *Cf.* the next entry below.

The Presentation of the Virgin Eustache Le Sueur, *c*.1640, Hermitage, St. Petersburg.

The three-year-old Virgin Mary is brought to the temple at Jerusalem by her aged parents, St. Joachim and St. Anne. The event is not biblical, but is described in the apocryphal Book of James (Protevangelion) and also in Jacobus de Voragine's *The Golden Legend* (*c*.1260).

The Pretty Baa-Lambs Ford Madox Brown, 1852, Birmingham City Art Gallery.

A young mother holds her baby in her arms as she feeds the lambs in the open air on a sunny spring day, a maid picking flowers behind them. The painting was at first held to have a religious content, as if the mother were the Virgin Mary. The artist later explained it was simply "a lady, a baby, two lambs, a servant girl, and some grass" (quoted in Sunderland, p. 220). The title represents the babyish words of the mother to the infant.

Priam Begging Achilles for Hector's Body (Russian, *Priam, isprashivayushchiy u Akhillesa telo Gektora*) Aleksandr Ivanov, 1824, Tretyakov Gallery, Moscow.

The artist's first painting depicts a scene from classical mythology. King Priam has penetrated the enemy's camp in order to beg Achilles, murderer of his son, Hector, to return his body, but now finds Achilles mourning his friend, Patrocles, killed by Hector.

Primavera (1) Cosmè Tura, *c*.1460, National Gallery, London; (2) Sandro Botticelli, *c*.1478, Uffizi, Florence.

The Italian title of both paintings means "Spring," and they are sometimes known by this English name. The title seems to have little to do with the young woman seated on a throne in Tura's work. She may represent one of the Muses. The mystery of her identity and fascination of her portrayal have caused the picture to be alternately known as simply *Allegorical Figure*. The identity of the six young women and two young men portrayed in a flowering grove is equally problematical in Botticelli's painting. Giorgio Vasari, in his *Lives of the Artists* (1550), identified the central figure as Venus, a symbol of spring, here being decorated with flowers by the Graces. But he did not account for the others. It is now thought that, from left to right, the figures

actually are: Mercury, the messenger of the gods; the three Graces, handmaidens of Venus; Venus herself (with Cupid flying above); Flora, the goddess of flowers (she alone wears a flower-patterned dress); Chloris, the nymph who, according to Ovid, was transformed into Flora (her name means "green," the color of spring); and Zephyr, the west wind, who married Flora. Taken allegorically, the transformation of Chloris into Flora could be seen as the transformation of Love into Beauty. (The conjunction of the two appears to be further represented by the fact that the figure of Cupid is blind.) The painting is clearly related to The **Birth of Venus**, in which Venus, Flora, and Zephyr also appear.

Primitive Tales *see* **Barbaric Tales**.

Prince and Princess Ben Nicholson, 1932, Walker Art Gallery, Liverpool.

The semiabstract painting depicts three playing cards on a table. The profiles on two of them are those of the artist and the sculptor Barbara Hepworth, with whom he was was sharing a studio at the time. They are thus the "prince and princess" of the title, as a paler image of the standard king and queen. The third card, between them, is (punningly) the two of clubs.

The Princes in the Tower (1) (French, *Les Petits Princes à la tour de Londres*) Paul Delaroche, 1831, Louvre, Paris; (2) John Everett Millais, 1878, Royal Holloway College, Egham, Surrey.

Both paintings depict the two young princes, Edward V, the rightful heir to the English throne, and Richard, Duke of York, sons of Edward IV, who are said to have been suffocated in their sleep in the Tower of London in 1483, aged respectively 13 and 11. Delaroche shows them huddled together in a room in the Tower. A pet dog pricks up its ears on hearing a step at the door. It is that of their uncle, the Duke of Gloucester, who has ordered their imprisonment and murder so he can seize the throne as Richard III. Millais has the boys standing fearfully hand in hand on a staircase shortly before their death. *Cf.* The **Two Princes in the Tower**.

Princess Elizabeth in Prison at St. James's John Everett Millais, 1879, Royal Holloway College, Egham, Surrey.

The painting depicts the second daughter of Charles I and Henrietta Maria, who spent most of her short life imprisoned in St. James's Palace, London. She is shown writing a letter to Parliament requesting she be reunited with her servants. She was moved to Carisbrooke Castle, Isle of Wight, where she died in 1650, aged 15. *Cf.* The **Princes in the Tower**.

The Princess Royal Charles Roberts Leslie, 1841, Victoria and Albert Museum, London.

The portrait of a baby girl is of Queen Victoria's first child, Victoria Adelaide Mary Louisa (1840–1901), then just three months old. Princess Royal is the title of a British sovereign's eldest daughter.

Prisoners from the Front Winslow Homer, 1866, Metropolitan Museum, New York.

The painting depicts a Union officer, General Francis Barlow, receiving three Confederate soldiers captured at the battle of Spotsylvania Court House (1864).

The Procession (Italian, *La processione*) Giuseppe Pellizza da Volpedo, 1892–6, Museo Nazionale della Scienza e Tecnica, Milan.

The picture of a religious procession approaching up a poplar-lined avenue was painted from life at Volpedo. The original title was *Mysticism* (Italian, *Mistica*), since the work was intended to evoke a religious sense of peace.

The Procuress (1) Dirck van Baburen, 1622, Museum of Fine Arts, Boston, Massachusetts; (2) Jan Vermeer, 1656, Gemäldegalerie, Dresden.

The two depictions of a procuress are linked through their artists as well as their subjects. Van Baburen's procuress, a turbaned hag, counts out on her wrinkled hands the cost of hiring the plump whore who leers at her ogling client. The painting appears in the background of two of Vermeer's works: The **Concert** and *Lady Seated at the Virginals* (*c.*1670). Apparently Vermeer's mother-in-law actually owned it.

The Prodigal Daughter John Collier, 1903, Usher Art Gallery, Lincoln.

A variation on the more usual theme of The **Prodigal Son**. A daughter, already a middle-aged woman, returns to her elderly parents after defiantly going her own way. Her showy finery, in contrast to their somber dress, symbolizes the life of pleasure she has been leading.

The Prodigal Son (1) Peter Paul Rubens, *c.*1618, Musée des Beaux-Arts, Antwerp; (2) Constantin Brancusi, *c.*1915, Philadelphia Museum of Art, Pennsylvania; (3) (Italian, *Il figliol*

prodigo), Giorgio de Unirico 1922, Museo d'Arte Contemporanea, Milan.

Although separated by three centuries, and utterly different in style, the three works were inspired by the same New Testament subject, the parable of the prodigal son (Luke 15:11–32). Brancusi's avant-garde sculpture rests almost entirely on its title for its appropriate appreciation, and even Rubens's painting, set in a contemporary farmyard dominated by animals, requires the title for its correct interpretation. (The young man depicted is clearly agitated, but only the title properly identifies him.) De Chirico's painting, however, lacks all the pathos of the original story of the repentant wastrel who is welcomed home by his father. (*Cf.* The **Return of the Prodigal Son**.) His prodigal son is portrayed as a featureless doll or puppet, while the father is a stony statue.

The Profligate Punished by Neglect and Contempt Edward Penny, 1774, Yale Center for British Art, New Haven, Connecticut.

A gout-ridden old reprobate, his leg supported on a cushioned stool, is callously ignored by a pair of flirting servants. The subject and title of the painting are in pointed contrast to those of its pendant (companion piece), The **Virtuous Comforted by Sympathy and Attention**.

The Progress of Love (French, *Les Progrès de l'amour*) Jean-Honoré Fragonard, 1771–3, Frick Collection, New York.

The set of four amorous scenes, generally regarded as the artist's masterpiece, were painted for Madame du Barry, mistress of Louis XV, although she rejected them on grounds of frivolity. The individual titles (French originals in brackets) are: *The Assault* (*L'Escalade*), *The Pursuit* (*La Poursuite*), *The Declaration* (*La Déclaration*), and *The Lover Crowned* (*L'Amant couronné*). *The Assault*, which shows the young lover scaling a balcony wall to reach his beloved, is also known less graphically as *The Meeting*.

The Proles' Wall Paula Rego, 1984, Gulbenkian Foundation, Lisbon.

The wall-length painting was commissioned for a London exhibition commemorating George Orwell's novel *Nineteen Eighty-Four* (1949) and depicts characters from this, mostly in caricature form. The title refers to the proles or dispossessed class who feature in the novel.

Promise of Spring Sir Lawrence Alma-Tadema, 1890, Museum of Fine Arts, Boston.

A young man takes the hand of the woman he loves as she sits on a marble bench beneath a blossoming tree. The title may mean simply "spring is in the air," but could also allude more specifically to the lovers' vows, or to the promise that the man makes as he looks down at the young woman beside him.

The Proposition Judith Leyster, 1631, Mauritshuis, The Hague.

A young man leans over the shoulder of a young woman deeply absorbed in her sewing. With one hand on her arm, he holds out the other, filled with coins. That is his sexual inducement, the proposition of the title, which she entirely ignores.

The Proscribed Royalist John Everett Millais, 1852–3, private collection.

The painting depicts a scene from Vincenzo Bellini's opera *I Puritani* (1835). Elvira, a Roundhead, hides her Royalist (Cavalier) lover, Arturo (Lord Arthur Talbot), in an oak tree.

The Prose of Life (Russian, *Zhiteyskaya proza*) Vasily Baksheyev, 1892–3, Tretyakov Gallery, Moscow.

A provincial middle-class family of three sit somber and silent at the breakfast table, each absorbed in his or her own thoughts. At this moment for them, life has lost its poetry.

Protect Me from What I Want Jenny Holzer, 1988, Piccadilly Circus, London.

The work consists of the words of the title displayed on a huge electronic advertising billboard above London's Piccadilly Circus, the popular hub of the capital. The message is thus conveyed directly or subliminally to the passing crowds below. The words themselves quote one of the artist's own "Truisms," a series of short statements commenting on various public and personal matters and on society generally. (Two others are, "Abuse of power comes as no surprise" and "Money creates taste.")

Proud of His Wife Marcus Harvey, 1994, Saatchi Collection, London.

The painting is a "reader's wife" portrait of a squatting naked woman, her legs spread apart.

Proun 19D El Lissitzky, *c.*1922, Museum of Modern Art, New York.

The abstract geometric painting is one of a number that the artist called *prouns*, from the abbreviation either of Russian *proyekt utverzhdeniya novogo*, "project for the affirmation of the new," or of *proyekt Unovisa*, "Unovis project,"

from the abbreviated name of *Utverditeli novogo iskusstva*, "Affirmers of new art," a grouping of innovative artists led by Malevich.

Los Proverbios *see* Los **Disparates**.

The P.S. Wings in the O.P. Mirror Walter Richard Sickert, 1888–9, Musée des Beaux-Arts, Rouen.

The painting depicts the reflected image of a singer on the stage of the Old Bedford Hall, London, together with the (unreflected) heads of the audience. The abbreviations in the title stand for "prompt side" (the side where the prompter sits, in the UK to the actor's left) and "opposite prompt" (to the actor's right).

Psyche Before the Throne of Venus Henrietta Rae, 1894, present location unknown.

Searching for her son, Cupid, Psyche has come to the palace of Venus and lies prostrate before her throne. The goddess has admitted her but, jealous of her beauty, will make her a slave and give her impossible tasks to perform. The artist based her depiction on the retelling of this story in William Morris's poem *The Earthly Paradise* (1868–70). *Cf.* The **Awakening**.

Puberty (Norwegian, *Pubertet*) Edvard Munch, 1894, National Gallery, Oslo.

A naked adolescent girl crosses her lanky arms to cover her lap as she sits on the edge of a bed. Her figure and pose epitomize the awkward stage of her development named by the title. The picture was painted from a young model while the artist was living in Berlin.

Public Opinion George Bernard O'Neill, 1863, Leeds City Art Gallery.

The depiction is of a scene at the annual exhibition of the Royal Acadamy, then held in a wing of the National Gallery, London. Viewers are seen approving a particular picture. It is protected by a rail, implying that the "public opinion" of the title is unanimously favorable.

The Public Voice (French, *La Voix publique*) Paul Delvaux, 1948, Musées Royaux des Beaux-Arts, Brussels.

In a city setting, a naked young woman lies on a couch, her right hand resting at the top of a sheet that has been pulled down to expose her pubic area. Behind her sit or stand three more young women, all in identical long black dresses and with a large mauve bow in their hair. A lighted streetcar approaches in the middle distance. The French title seems to suggest a pun on *voix publique*, "public voice," and *voie publique*, "public highway."

Punch Benjamin Robert Haydon, 1829, Tate Gallery, London.

The artist's masterpiece depicts a Punch and Judy puppet show as a popular form of street entertainment. The painting's alternate title is *May Day*, as the scene takes place on the traditional festive holiday of this name. Its original title was simply *Life in London*, and the canvas, with its many and varied characters, is in fact a microcosm of the subject.

The Punished Son (French, *Le Mauvais Fils puni*, "The Wicked Son Punished") Jean-Baptiste Greuze, 1778, Louvre, Paris.

Family members gather around the death bed of its head. The mother points out her late husband to one of the sons, who weeps bitterly for his part in causing his father's death.

The Punishment of Cupid Sebastiano Ricci, 1706–7, Palazzo Marucelli-Fenzi, Florence.

Cupid, the Roman god of love, is having his wings clipped for playing pranks on mortals.

Pygmalion (1) Franz von Stuck, 1926, private collection; (2) Paul Delvaux, 1939, Musées Royaux des Beaux-Arts, Brussels.

Both works are based on the story from classical mythology telling how the sculptor, Pygmalion, falls in love with a statue he has made and prays to Venus, goddess of love, for a woman like her. She brings the statue to life as Galatea. Von Stuck depicts this moment. A kneeling Pygmalion raises his arms to embrace his creation as the nude Galatea extends her own arms down to him from her plinth. Delvaux, as a Surrealist, inverts the story: Pygmalion is now the statue, and is being embraced by his creation who is alive and very much "in the flesh" (*i.e.* nude). Also present are Venus herself, with a flower climbing her naked body, and a clothed gentleman in a bowler hat.

Q

Quand te maries-tu? *see* **Nafea faa ipoipo**.

Queen Guinevere William Morris, 1858, Tate Gallery, London.

The artist's only extant painting (eventually abandoned, and completed by Dante Gabriel Rossetti and Ford Madox Brown) is a portrait of Jane Burden as King Arthur's wife. Its alternate title is *La Belle Iseult* ("The Beautiful Isolda"), taking the subject as the Irish princess who was betrothed to King Mark but tragically loved by the knight Tristram. (Thomas Malory's *Le Morte d'Arthur* tells both their stories.) If she is Guinevere, the crumpled bed by which she stands alludes to her adulterous affair with Sir Lancelot.

The Queen of Hell Peter Howson, 1995, private collection.

The painting is the sixth in the series inspired by Stravinsky's opera *The Rake's Progress* (*see* **Farewell, Farewell**). Here, Tom Rake is slumped in a churchyard. Nick Shadow has revealed himself as an agent of the devil and has invited Tom to play cards in a last attempt to save himself from hell. Tom wins, but is condemned by Nick to insanity. As always, the title quotes from the libretto.

The Queen of Sheba Mark Gertler, 1922, Tate Gallery, London.

A voluptuous nude represents the Old Testament queen of great wealth who brought lavish gifts to Solomon (1 Kings 10).

The Queen of Spades John Byam Shaw, 1898, private collection.

A Madonna-like Queen of Spades sits enthroned while a lady-in-waiting sings to a stringed instrument. Black on red playing-card spades appear above her, on the carpet before her, and on two long poles held by attendant knights either side of her.

Queen Riqui (Spanish, *La Reina Riqui*) Alberto Gironella, 1974, Museo de Arte Moderno, Mexico City.

The near abstract painting is based on Velázquez's *Queen Mariana of Austria* (1652) and serves as a metaphor for Mexico's colonial past and present. The title refers to the artist's former wife, Carmen Parra, nicknamed Riqui.

The Questioner of the Sphinx Elihu Vedder, 1863, Museum of Fine Arts, Boston, Massachusetts.

An Egyptian crouches before the silent lips of a carved sphinx in the desert, questioning its secrets. The artist commented, "My idea in the sphinx was the hopelessness of man before the immutable laws of nature" (quoted in Baigell, p. 171).

A Quiet Afternoon James Tissot, *c.*1879, private collection.

An elderly man dozes under the shade of a garden tree while a young lady in a hammock reads a novel. She was modeled by the artist's mistress, Kathleen Newton, a married woman with children, which led a *Punch* reviewer of the painting to rename it *The Naughty Old Man; or I'll Tell Your Wife How You Spend Your Afternoons in Fair Rosamund's Bower-Villa N.W.* ("Fair Rosamund's Bower" was the hidden home of Rosamond Clifford, Henry II's mistress. The initials are for London's chic North-West district, where the artist lived.)

R

Race Class Sex Mark Wallinger, 1992, Saatchi Collection, London.

The work comprises four paintings of racehorses. The title primarily alludes to their attributes, as an epitome of each, but it also states the three main categories into which human beings are divided and by which they are subjectively or objectively assessed.

Race Track Malcolm Morley, 1970, Neue Galerie, Aachen.

The work is a sunny color photograph of a racetrack in South Africa over which the artist has painted a large, blood-red cross. The title thus puns on the scene depicted and the artist's anti-apartheid statement effected through his superimposed "race track" of paint.

Radisson and Groseilliers Frederic Remington, 1906, Buffalo Bill Historical Center, Cody, Wyoming,

The French explorers Pierre Esprit Radisson (*c.*1636–*c.*1710) and Seigneur Médard Chouart des Groseilliers (1625–1698) travel down the St. Lawrence River in a large Indian birchbark canoe, paddled by a crew of Native Americans.

The Raft of the Medusa (French, *Le Radeau de la Méduse*) Théodore Géricault, 1819, Louvre, Paris.

A raft of dead and dying shipwrecked passengers drifts helplessly in a stormy sea, a Negro desperately waving a rag in the direction of a rescue ship, just visible on the horizon. The artist

based his painting on a real event. The *Medusa* was one of four government ships that set sail from France for Senegal on June 17, 1816, following the treaty of 1815 which proclaimed that country a French colony. The shipwreck occurred on July 2 on a sandbank some 135 miles off the African coast. A raft only 60 feet long by 21 feet wide picked up 149 survivors who existed together for 12 days. Only 15 remained alive when they were rescued by the brig *Argus*, the others having either been thrown overboard or eaten by their fellows.

The Railway Station William Powell Frith, 1862, Royal Holloway College, Egham, Surrey.

The bustling scene, with its arrivals and departures, greetings and farewells, loadings and unloadings, is set at Paddington Station, a London mainline terminus.

Railway Train Attacked by Indians Theodore Kaufmann, 1867, John F. Eulich Collection, Dallas, Texas.

A train rushes through the night towards the point in the foreground where a group of Indians have removed a rail from the track. The Indians have not exactly "attacked" the train in the direct sense of the word, though they have certainly ambushed it.

Rain, Steam, and Speed J.M.W. Turner, 1844, National Gallery, London.

The artist was one of the first to depict the (then) modernity of the steamer and railroad. His painting's full title is *Rain, Steam, and Speed: The Great Western Railway*. A train, its firebox glowing, battles bravely against the wind and rain as it steams across a river bridge. The location of the scene is Brunel's rail bridge over the Thames at Maidenhead, west of London, and the train depicted is an express bound for Exeter in the West Country. The title implies that technology (producing steam and speed) can overcome the force of nature (rain). The subject of the picture sometimes causes the title to be misquoted by a single letter: "Where hangs Turner's Rail, Steam and Speed?" (*The Times*, February 9, 1999).

The Rainbow (French, *L'Arc-en-ciel*) René Magritte, 1948, private collection.

The title of the painting refers to its bright colors, not to the five figures that it depicts in compartments respectively labeled "*Le Journalier*" ("The Day-Laborer"), "*L'Avarié*" ("The Syphilitic"), "*L'Apôtre*" ("The Apostle"), "*Le Sybarite*" ("The Hedonist"), and "*Le Dévot*" ("The Believer"). It is uncertain whether these are the "real" descriptions of the figures.

The Raising of Jairus's Daughter (Russian, *Voskresheniye docheri Iaira*) Ilya Repin, 1871, Russian Museum. St. Petersburg.

Christ takes the wrist of a young girl on her deathbed while her anxious family looks on. He will bring her back to life. The story of the miracle is told in Mark 5:38–43 and Luke 8:49–56.

The Raising of Lazarus (1) Nicolas Froment, 1461, Uffizi, Florence; (2) Rembrandt van Rijn, *c.*1630, Los Angeles County Museum of Art, California; (3) Carel Fabritius, *c.*1645, National Museum, Warsaw; (4) Vincent van Gogh, 1890, Rijksmuseum Vincent van Gogh, Amsterdam.

The scene is from the New Testament. Lazarus, the brother of Martha and Mary, has died. Four days after his death, Jesus removes the stone at the mouth of his tomb and he walks out (John 11). (This Lazarus should not be confused with the beggar of the name in Luke 16, contrasted with the rich man Dives.)

The Raising of the Cross Peter Paul Rubens, 1610–11, Antwerp Cathedral.

The central panel of the triptych depicts the erection of the cross to which Christ has been nailed for his crucifixion. The scene is the converse of the artist's other great work in the same location, The **Descent from the Cross**. Its alternate title is *The Elevation of the Cross*.

A Rake's Progress William Hogarth, *c.*1735, Sir John Soane's Museum, London.

The artist followed A **Harlot's Progress** with its male counterpart. The eight plates depict the decline and fall of a rake, or dissolute man of fashion, who rejects a life of work and squanders his inherited wealth on the trappings of a luxurious existence in high society. He is finally arrested for debt and leaves the debtor's prison only to end his days in a madhouse.

A Rally Sir John Lavery, 1885, Glasgow Art Gallery.

A young woman, dressed in the restricting costume of her day, stretches to reach and return a ball in a game of tennis.

Il Ramoscello Dante Gabriel Rossetti, 1865, Harvard University Art Museums, Cambridge, Massachusetts.

The painting, a portrait of Amy Graham, later Lady Muir MacKenzie, was originally entitled *Belle e Buona* ("Beautiful and Good"), but in 1873 was renamed *Il Ramoscello*, Italian for "The Spray," referring to the oak spray that the lady holds.

Ramsgate Sands William Powell Frith, 1854, Royal Collection, London.

The Victorian social scene depicts the English by the sea on the sands of Ramsgate, Kent. The original title was more generally *Life at the Seaside*.

Random Acts of Kindness James Rielly, 1996, Saatchi Collection, London.

The work is a display of 40 small canvases. Their subjects are all human but unconventionally so, and include a man with an almost severed head, a hand holding out a cocktail of pills, a family portrait with children exposing their underpants, and an exhibitionist in a park. The title seems to indicate the artist's plea on behalf of all these victims of society.

The Ransom *see* The **Order of Release**.

The Rapacious Steward William Redmore Bigg, 1801, Yale Center for British Art, New Haven, Connecticut.

Subtitled *The Unfortunate Tenant*, the painting depicts a hard-hearted overseer evicting a tenant farmer who has fallen behind with his rent. The title has echoes of the biblical "unjust steward" (Luke 16:8). The pendant (companion piece) to the picture is The **Benevolent Heir**.

The Rape (French, *Le Viol*) René Magritte, 1934, Menil Collection, Houston, Texas.

The painting is of a woman's head but with the eyes replaced by breasts, the nose by the navel, and the mouth by the sex organ. The hair of the head is pubic hair, and can be seen as being penetrated by the torso-head on its tumescent neck. The conventional head-and-shoulders portrait has thus itself been violated or "raped." The title may in fact introduce a further meaning through a pun, as French *Le Viol* suggests *Le Viole*, "The Viol," a medieval stringed musical instrument that sometimes had a face or a female torso carved on its back.

The Rape of a Sabine Giambologna, 1581–2, Loggia dei Lanzi, Florence.

The marble sculpture depicts a young Roman abducting a Sabine woman while an older Roman, his rival for the prize, crouches defeated below. *Cf.* The **Rape of the Sabines**.

("Rape" in titles of this type usually means "abduction," "carrying off by force," but can also imply the modern sense of the word.)

The Rape of Europa (1) Titian, *c*.1559–62, Isabella Stewart Gardner Museum, Boston, Massachusetts; (2) Paolo Veronese, *c*.1580, Palazzo Ducale, Venice; (3) (Russian, *Pokhishcheniye Yevropy*) Valentin Serov, 1910, Tretyakov Gallery, Moscow.

According to ancient Greek myth, as retold by Ovid in the *Metamorphoses*, Europa was the beautiful daughter of Agenor, king of Tyre. She was desired by Zeus who disguised himself as a white bull to abduct her. Titian depicts her seminude on the swimming bull's back. Veronese shows her being lifted on to the bull by her attendants, while the bull itself licks her foot in anticipation of the seduction. The presence of Cupid in both paintings indicates that consummation will follow. Serov's bull glances back lasciviously at Europa kneeling on its back as it ploughs through the waves.

The Rape of Helen Francesco Primaticcio, *c*.1530–9, Bowes Museum, Barnard Castle, Co. Durham.

The legendary daughter of Leda and Zeus, said to be the most beautiful woman in the world, is carried off by Proteus to Egypt. (She is the same character as Helen of Troy, but according to Euripides' play *Helen*, from which this scene is taken, she was never at Troy.)

The Rape of the Daughters of Leucippus Peter Paul Rubens, *c*.1618, Alte Pinakothek, Munich.

Two horsemen are forcibly lifting two naked young women onto their horses. The subject matter of the painting was not recognized until 1777 when the German poet Wilhelm Heinse pointed out that a scene in the *Idylls* of Theocritus exactly corresponded with the depiction. The two young men are the twins Castor and Pollux, Leda's sons, and the women are Phoebe and Hilaria, daughters of Leucippus of Argus. They were abducted during a wedding ceremony (not shown here) although already betrothed to the twins Lynceus and Idas.

The Rape of the Sabines (1) Pietro da Cortona, 1627–9, Pinacoteca Capitolina, Rome; (2) Nicolas Poussin, *c*.1635, Metropolitan Museum, New York; (3) Peter Paul Rubens, *c*.1635–40, National Gallery, London.

All three paintings depict the abduction of

the Sabine women by Romulus and his followers, who sought women to bear the children they needed in order to preserve the continuance of their people. The abduction itself took place during a festival to which the Romans invited neighboring tribes, including the Sabines. At a prearranged signal, the Roman men broke into the crowd and forcibly carried off as many Sabine women as they could. *See also* The **Intervention of the Sabine Women**.

Raphael's Mistress *see* La **Fornarina**.

A Rare Old Vintage Picasso (French, *Un Picasso de derrière les fagots*) René Magritte, 1950, Menil Collection, Houston, Texas.

The work is a wine bottle painted with a parody of a Picasso-style cubist composition. The French expression *de derrière les fagots*, literally "from behind the firewood," is a stock phrase for what English-speaking oenophiles might call "an extra-special little wine."

A Reading Thomas W. Dewing, 1897, National Museum of American Art, Smithsonian Institution, Washington, D.C.

Two elegantly dressed young women are seated at a table. One is reading aloud from a novel while the other listens impassively.

The Reading Girl Théodore Roussel, 1887, Tate Gallery, London.

The title does not reveal that the young woman reading a magazine as she reclines in a campaign chair is entirely nude. Her discarded kimono is draped over the back of the chair.

Reading the Scriptures Thomas Webster, 1835, Victoria and Albert Museum, London.

A little girl spells out a text from the Bible at her grandmother's knee. The title itself has a biblical ring.

Reading the Will David Wilkie, 1820, Neue Pinakothek, Munich.

A crowd of relatives has gathered in a dead man's study to hear the lawyer read out his last will and testament. The subject for the painting was suggested to the artist by the English actor Charles Bannister.

The Ready-Made Bouquet (French *Le Bouquet tout fait*) René Magritte, 1956, private collection.

The painting shows the rear view of a black-coated, bowler-hatted man looking into a forest over a stone balustrade with the figure of Flora from Botticelli's **Primavera** on his back.

She is thus the "ready-made bouquet" of the title.

A Real Work of Art Mark Wallinger, 1995, private collection.

The subject of the work is a racehorse formerly owned by the artist and some friends. The title is its actual name, given ironically by Wallinger with the aim of challenging the viewer's perception of a work of art. The horse raced under the colors of the suffragette movement (violet, green, and white), each race being recorded as an individual work of art. Its career ended when it was injured, and it was sold off to an art collector. *Cf.* **Race Class Sex**.

Rebecca at the Well Giovanni Pellegrini, *c.*1715, Kress Foundation, New York.*

The painting, now destroyed, represents an Old Testament scene. Rebecca, drawing water at a well, is chosen by Abraham's eldest servant, Eliezer, as a wife for Abraham's son Isaac.

Recalling the Past Carlton Alfred Smith, 1888, Victoria and Albert Museum, London.

A young woman recoils from a writing desk, her head bowed in misery. She has been tearing up letters and throwing them in a wastepaper basket, but cannot help reading them.

The Reckless Sleeper (French, *Le Dormeur téméraire*) René Magritte, 1928, Philadelphia Museum of Art, Pennsylvania.

A sleeping man lies on a shelf above the objects that presumably appear in his dreams. The objects are very mundane (a hand mirror, a bird, a bowler hat, a bow, a lighted candle, an apple), so that either the sleeper is reckless only in his imagination, or else the objects are not what they seem. The artist enjoyed the idea of ambiguity. (The title may, of course, simply mean that we are reckless each time we go to sleep, since we are vulnerable, open to attack and to the strange and unpredictable world of our dreams.) The painting's English title does not precisely render the French, as *téméraire* means "daring" rather than "reckless." (*Cf.* The **Fighting Temeraire**.) Hence the work's more faithful alternate title, *The Daring Sleeper*.

Reclining Girl (French, *Odalisque*, "Odalisque") François Boucher, 1751, Alte Pinakothek, Munich.

The young girl sprawling naked on a couch amid lavish draperies is Marie Louise Murphy (1737–1814), a 14-year-old French-born Irish girl

who posed for the artist and who for a time in 1753 was the mistress of Louis XV. The portrait is also known as *Mademoiselle Murphy, Mademoiselle O'Murphy*, or *Louise O'Murphy*, as well as *Blonde Odalisque* or *Odalisque*. (*Cf.* La **Grande Odalisque**.) The title *Reclining Girl* can mislead, since "recline" implies leaning back or lying supine, not prone, as the model is. (Her froglike pose has been shown to derive from that of a swimming nymph in The **Triumph of Venus**.)

Reclining Woman (French, *Femme couchée*) Gustave Courbet, *c.*1865–6, Hermitage, St. Petersburg.

A nude young woman lies asleep at the edge of a forest. She presumably represents a nymph of classical mythology, but the prosaic title gives no clue that this was the artist's intention. *Cf.* **Woman with a Parrot**.

A Recluse *see* **I Lock my Door Upon Myself**.

Le Recueillement ("Reminiscence") Pierre Puvis de Chavannes, 1867, private collection.

A young woman dressed in white stands beside a tree in a forest, her eyes closed, the fingers of one hand lightly touching her brow, as if absorbed in her own thoughts. The painting is one of four panels evoking the source and process of artistic creation. The others are: *L'Histoire* ("History"), *Fantaisie* ("Imagination"), and *La Vigilance* ("Vigilance").

The Red Boy Sir Thomas Lawrence, 1825, private collection.

The formal title of the portrait of a young boy in a red velvet suit is *The Son of J.G. Lambton, Esq*, that is, the son of John George Lambton, 1st Earl of Durham (1792–1840). He was Charles William Lambton, who died in 1831 aged only 13. The popular title was probably suggested by The **Blue Boy**. The painting has also been known as simply *Master Lambton*.

The Red Garters (French, *Les Jarretières rouges*) Pierre Bonnard, *c.*1904, private collection.

A model has undressed almost completely except for her stockings and red garters before posing nude in the artist's studio.

Red Horse Swimming (Russian, *Kupaniye krasnogo konya*) Kuzma Petrov-Vodkin, 1912, Tretyakov Gallery, Moscow.

A naked boy rides a red horse into a river, while other boys and other horses are seen in the background. The painting represents the past, in the form of the horse, and the future, the young rider. The horse, as the Russian hero's traditional friend, is not brown, black, or white but red, the color of the historical era to come. The Russian title more precisely means "The Bathing of the Red Horse," implying a quasireligious baptismal act, not simply a swim.

The Red Host (German, *Die rote Hostie*) Egon Schiele, 1911, private collection.

The title of the painting is almost as shocking as that of its subject, a self-portrait, with a naked young woman holding the red-robed artist's outsize phallus, as if presenting a cultic object. The title relates to the host that is the consecrated bread of the Eucharist. When immersed in the consecrated wine (in the practice known as intinction) the host becomes red.

Red Model (French, *Le Modèle rouge*) René Magritte, 1934, Boymans-van Beiningen Museum, Rotterdam.

The painting is of an upright pair of boots whose lower half are human feet. The depiction is unsettling, and its mystery is enhanced by the apparently quite irrelevant title. The artist painted several versions of the picture.

Red Nude (Italian, *Nudo rosso*) Amedeo Modigliani, 1917, private collection.

A naked young woman lies full length on a red coverlet, her head and back resting on a blue cushion. The former, pointed up by her scarlet lips, gave the present title, the latter an alternate title, *Nude on a Cushion*.

The Red Sea (German, *Rotes Meer*) Anselm Kiefer, 1984–5, Museum of Modern Art, New York.

A coffin-like boat lies in a murky sea amidst a mass of discarded or discarded objects. The artist titled the painting after the Red Sea that separated the Jews from their homeland when they were exiled from Egypt, but which then parted to allow them to escape slavery. The title reminds the viewer of the Jews in World War II for whom the waters did not part.

Red Vision Leonor Fini, 1984, private collection.

A little girl in a nightdress, painted in pale tones in a bare room, looks up fearfully at a red-colored amorphous apparition that, genie-like, hovers near the ceiling.

Regentesses of the Old Men's Alms House
Frans Hals, c.1664, Frans Hals Museum, Haarlem.

The painting, portraying four elderly governesses and their servant, is a companion piece to the artist's **Regents of the Old Men's Alms House**. The almshouse was in the artist's hometown of Haarlem.

Regents of the Old Men's Alm House
Frans Hals, c.1664, Frans Hals Museum, Haarlem.

The group portrait of the elderly governors of a Haarlem armshouse is a companion canvas to the **Regentesses of the Old Men's Alms House**, painted the same year.

Regents of the St. Elizabeth Hospital
Frans Hals, 1641, Frans Hals Museum, Haarlem.

The group portrait is of the elderly governors of the St.Elizabeth Hospital, a Haarlem almshouse.

Regina Cordium
Dante Gabriel Rossetti, 1866, Glasgow Art Gallery.

The painting is a bust-length portrait of the artist's model, Alexa Wilding, as *Regina Cordium*, the "Queen of Hearts." The subject is surrounded by emblems of love, such as roses, and she wears a gold pendant with a heart at its center. To her left there is also a heart-shaped medallion depicting a blindfolded Cupid. The title is inscribed in the lower part of the picture.

Relenting
Thomas Brooks, 1855, private collection.

A landlord sits in the poorly furnished room of a widow and her four young children. The title implies that he is taking pity on her and will not evict her. *Cf.* **Evicted**.

The Relief of Lucknow
Frederick Goodall, 1858, Sheffield Art Galleries.

The painting, also known as *Jessie's Dream*, depicts an incident in the Indian Mutiny (1857) when sepoys of the Bengal army shot their British officers and marched on Delhi to restore their emperor. The mutiny spread to other cities, including Lucknow, where a siege was first relieved in September. Jessie Brown, a Scottish corporal's wife, then dreamed that she heard the sound of the bagpipes of the second relieving force approaching under the command of Sir Colin Campbell, who in fact relieved the siege in November. The painting, which shows her pointing from the fort on discovering her dream to be correct, was exhibited at the British Institution in 1858 under the title *The Campbells Are Coming; Lucknow, September 1857*.

Remembering Joys That Have Passed Away
Augustus Edwin Mulready, 1873, Guildhall Art Gallery, City of London.

A little girl matchseller and a small boy crossing sweeper stand oblivious of the swirling snow as they stare at the bill for a Christmas pantomime that has already ended its run. The title, with its biblical ring, expresses a notion found often in poetry, as in Robert Burns's "Thou minds me o' departed joys" in *The Banks o' Doon* (1792).

Remingtons Museums-Traum ist des Besuchers Schaum
Sigmar Polke, 1979, Städtisches Kunstmuseum, Bonn.

The outlines of two male heads, taken from a shaving cream advertisement, have been transferred as stencils onto a background of pink synthetic fur. Much of the depiction is covered with drips and daubs of colored paint. The German title, which sounds like an advertising jingle, literally means "The Remington Museum Dream is the Visitor's Foam." However, *Schaum*, "foam," also means "hot air," "hype," and surely has that sense here.

Reminiscences of 1865
John F. Peto, 1897, Wadsworth Atheneum, Hartford, Connecticut.

The painting is a memorial to Abraham Lincoln, assassinated in 1865. An oval photograph of the president is shown pinned to a board beneath an old bowie knife hanging from a hook. Its blade obscures the word "Head" in the inscription "Head of the House" on the card behind it.

Rendezvous of Friends
(French, *Rendezvous d'amis*) Max Ernst, 1922, Wallraf-Richartz Museum, Cologne.

The painting is a group portrait of Surrealist poets and painters, many of them in the circle of friends that surrounded André Breton. They include the artist himself, seated like a baby on the knee of Dostoevsky (one of the "adopted fathers" of Surrealism), and 16 others, identified by numbers in two lists. Breton, in a cloak, stands in the center.

Rendezvous of Sunday, February 6, 1916...
(French, *Rendez-vous du dimanche 6 février 1916...*) Marchel Duchamp, 1916, Philadelphia Museum of Art, Pennsylvania.

The work consists of typewritten French text on four postcards placed together as a square. The date is that of the work's creation, but the words of the text form meaningless sentences.

Repairing the Railroad (Russian, *Remontnyye raboty na zheleznoy doroge*) Konstantin Savitsky, 1874, Tretyakov Gallery, Moscow.

Gangs of laborers doggedly wheel earth and ballast in wooden barrows to shore up a railroad line that has subsided.

Res Ipsa Francesco Clemente, 1983, private collection.

A green circle, representing the wheel of life, connects a human head, arm, and feet through radial tree branches and flower stems. The Latin title, meaning "the thing itself," indicates the basic principles that the painting depicts. It equally suggests the Latin tag, "*Res ipsa loquitur,*" "The matter speaks for itself," implying that what is shown is obvious.

The Rescue John Everett Millais, 1855, National Gallery of Victoria, Melbourne.

A fireman safely carries out two young children from a burning building and delivers them to their overjoyed mother. The painting paid tribute to the bravery of two firemen whose death the artist had witnessed a few months earlier.

The Reservoir (Russian, *Vodoyom*) Viktor Borisov-Musatov, 1902, Tretyakov Gallery, Moscow.

Two women repose beside a round pond in an ancient park, one seated, the other standing and looking back. A better English title might in fact be *The Pond*, since *The Reservoir* implies a much larger expanse of water than that shown here.

Rest in the Shade (Italian, *Riposo all'ombra*) Giovanni Segantini, 1892, Villa Hügel, Essen.

A young woman lies prone in the shade of a cool garden, her face buried in her arms. She is "Baba" (the model for The **Return to the Sheepfold**) and the garden is that of the artist's house at Savognin in the Swiss Alps.

The Rest on the Flight into Egypt
(1) Lucas Cranach I, 1504, Staatliche Museen, Berlin; (2) Jacopo Bassano, 1550, Pinacoteca Ambrosiana, Milan; (3) Federico Barocci, 1570–5, Vatican Museums; (4) Caravaggio, 1594–6, Galleria Doria Pamphili, Rome;

(5) Orazio Gentileschi, *c*.1615–20, Birmingham City Art Gallery; (6) Anthony van Dyck, *c*.1630, Alte Pinakothek, Munich; (7) (German, *Ruhe auf der Flucht nach Ägypten*) Philipp Otto Runge, 1805–6, Kunsthalle, Hamburg.

The Holy Family (Mary, Joseph, and the infant Jesus) break their journey during The **Flight into Egypt**, in a medieval addition to the brief biblical account (Matthew 2:13–14).

The Resurrection (1) Piero della Francesca, 1463, Pinacoteca Comunale, Sansepolcro; (2) Annibale Carracci, 1593, Louvre, Paris.

Both these and other works of this title obviously depict the Resurrection of Christ, whom Piero della Francesca shows stepping solemnly up from the tomb.

The Resurrection, Cookham Stanley Spencer, 1924–6, Tate Gallery, London.

The dead rise from their tombs and graves in the churchyard of the parish church at Cookham, Berkshire, Spencer's native village. The central nude figure is a self-portrait. The painting is probably the best known of the artist's many Resurrections.

The Return Philip Guston, 1956–8, Tate Gallery, London.

The "abstract impressionist" painting can be taken to represent the return of human figures to their place of departure, such as vacationers returning home from a holiday.

The Return of Persephone Frederic Leighton, *c*.1891, Leeds City Art Gallery.

The mythological scene is taken from Ovid's *Metamorphoses*. A pale and frail Persephone, goddess of the Underworld and wife of Hades, is carried by Hermes, messenger of the gods, up and out of the entrance of the Underworld to the outstretched arms of her mother, the earth goddess Demeter, with whom the gods have permitted her to spend part of every year.

The Return of Rip Van Winkle John Quidor, 1829, National Gallery, Washington, D.C.

The painting depicts the moment in Washington Irving's tale of the same name (1819–20) when Rip returns to his altered village as an old man after a 20-year absence and is bewildered to see his younger self leaning against a tree.

The Return of the Dove to the Ark
John Everett Millais, 1851, Ashmolean Museum, Oxford.

Two young women stand amid hay in what must taken for a ship's hold. One supports a dove on her right hand while holding an olive spray in her left. The other bends to kiss the bird's breast, resting her left hand on the first woman's arm as she does so. The painting is based on the well known Old Testament story telling how the dove returned to Noah's ark with an olive leaf in its beak, so proving that the flood had abated (Genesis 8:11).

The Return of the Poet (French, *Le Retour du poète*) Giorgio de Chirico, *c.*1911, private collection.

A tower and a chimney stand in the middle ground between two façades like the wings of a theater stage. A train runs across in the foreground. The artist painted the picture after a visit to Turin, so presumably the title refers to himself, back in creative action in Paris after his absence and "on display" to the public.

The Return of the Prodigal Son
(1) Guercino, 1619, Kunsthistorisches Museum, Vienna; (2) Rembrandt van Rijn, *c.*1669, Hermitage, St. Petersburg; (3) (French, *Le Retour de l'enfant prodigue*) James Tissot, 1862, private collection.

Guercino depicts the moment in the biblical parable when the wastrel's father has welcomed his son home and gives him fine robes to wear instead of his swineherd's rags (Luke 15:22). Rembrandt's painting of the welcome is generally regarded as much more expressive than his earlier depiction of the subject, The **Prodigal Son**. Tissot depicts the return in a medieval courtyard.

The Return to the Sheepfold (Italian, *Ritorno all'ovile*) Giovanni Segantini, 1888, private collection.

A young shepherdess leads sheep back to their pen. The painting depicts Barbara ("Baba") Uffer, a local girl from Savognin in the Swiss Alps whom the artist often used as a model. The work was the last of a series of Millet-inspired pictures by this title. An earlier painting was *Return from the Sheepfold* (Italian, *Ritorno dell'ovile*) (private collection, 1882).

The Revenge George De Forest Bush, 1882, Philadelphia Museum of Art, Pennsylvania.

As a mounted Indian warrior gallops towards the viewer, he triumphantly brandishes his trophy, a freshly cut scalp. He has had his bloody revenge on the enemy.

The Reverend Robert Walker Skating
Sir Henry Raeburn, *c.*1784, National Gallery of Scotland, Edinburgh.

The named clergyman is depicted skating composedly on Duddingston Loch, just outside Edinburgh.

Reverie (1) Edmund C.Tarbell, 1913, Museum of Fine Arts, Boston, Massachusetts; (2) *see* **Faaturuma**.

An elegantly dressed young woman turns in her chair to rest her chin on her hands and contemplate what might have been (or what could be).

The Rhinoceros (Italian, *Il rinoceronte*)
Pietro Longhi, *c.*1751, Museo del Settecento Veneziano, Venice.

A dark-skinned rhinoceros stands in a stall watched by a small group of curious onlookers. The depiction is of an actual event, as testified by a notice on a wall in the painting that dates the episode in question. The exotic beast's horn has been excised and is brandished by one of the spectators.

The Ride (German, *Spazierritt*) Franz von Stuck, 1903, Georg Schäfer Collection, Schweinfurt.

Three naked girls, garlands in their hair, ride somewhat precariously on the back of a pipe-playing centaur, its rear half a horse, its front half a man.

The Rider on the Pale Horse George Frederic Watts, *c.*1882, Walker Art Gallery, Liverpool.

A rider on a rearing horse scythes his way grimly through humanity against the background of a fiery sky. He is one of the four horsemen of the Apocalypse: "Behold a pale horse: and his name that sat on him was Death" (Revelation 6:8).

The Rift in the Lute Arthur Hughes, 1862, City Museum and Art Gallery, Carlisle.

A young woman lies pensively on the ground among bluebells beside a discarded lute. The painting is loosely based on Vivien's song in Tennyson's *Merlin and Vivien* from his *Idylls of the King* (1859): "It is the little rift within the lute, / That by and by will make the music mute, / And ever widening slowly silence all. / The little rift within the lover's lute / Or little pitted speck in garnered fruit, / That rotting inward slowly molders all."

Rinaldo and Armida (1) (French, *Renaud et Armide*) François Boucher, 1734, Louvre, Paris; (2) (Italian, *Rinaldo ed Armida*) Giambattista Tiepolo, 1753, Bayerische Staatsgemäldesammlungen, Munich; (3) Francesco Hayez, 1812–3, Accademia, Venice.

The paintings depict the two main characters of Torquato Tasso's *Jerusalem Delivered* (1581), the magician Armida and her captive and lover, the French knight Rinaldo, victor of the battle for Jerusalem.

The Rival Performers John Callcott Horsley, 1839, Victoria and Albert Museum, London.

A young musician playing a pipe is silenced by his female companion so that they may hear the song of a bird in a cage on the wall opposite. It is not clear whether the two are brother and sister or a young couple, or what kind of songbird it is. There is an old folktale of a nightingale that strove to outdo the song of a minstrel.

The River of Life William Blake, *c.*1805, Tate Gallery, London.

A mother and her children swim in the river that flows through paradise: "And he shewed me a pure river of water of life… In the midst of the street of it, and on either side of the river, was there the tree of life, which bare twelve manner of fruits, and yielded her fruit every month: and the leaves of the tree were for the healing of the nations" (Revelation 22:1–2).

Robert Andrews and His Wife *see* **Mr. and Mrs. Andrews**.

The Robing of the Bride Max Ernst, 1939, Peggy Guggenheim Collection, Venice.

A nude female figure is being dressed as a bird in a robe of red feathers. She is attended by another nude but unrobed female and by a green and apparently male bird figure with human legs and arms holding the upper half of a broken lance. The robed figure must be the bride. But why is she dressed as a bird? Could the title perhaps pun on English "bride" and "bird"?

The Rock Drill Sir Jacob Epstein, 1913–14, Tate Gallery, London.

The modernistic sculpture integrates a robot-like figure with a real rock drill. Hence its name.

The Rock of Doom Edward Burne-Jones, 1885–6, Staatsgalerie, Stuttgart.

A young man in black armor is poised by a rock to which a naked young woman is chained. He is Perseus, who has found and killed the Medusa, and who has now come across Andromeda, daughter of Cepheus, chained to a rock as a sacrifice to appease the gods. The doom of the title was thus to have been her fate. But after rescuing Andromeda, Perseus went on to slay the sea monster to which she was to have been sacrificed. The scene is depicted in The **Doom Fulfilled**, showing that the doom was actually the monster's, not Andromeda's. The two paintings were originally to have formed a single composition but they were later separated to avoid having two figures of Andromeda side by side.

The Rokeby Venus Diego Velázquez, *c.*1651, National Gallery, London.

A young nude woman reclines on her bed and looks at a mirror held by a winged child. She is Venus, and he is Cupid. The painting is formally known as *The Toilet of Venus*, while its popular title relates to its history. The work is first recorded in 1651, when it hung in the Madrid palace of the Marqués del Carpio, son of Philip IV's first minister. In 1813 it went to England, and was sold soon after to John Morritt of Rokeby Park, Yorkshire. Further alternate titles for the painting are *Venus and Cupid* and *Venus at Her Mirror*.

The Roll-Call Elizabeth Butler, 1874, Royal Collection, Windsor Castle.

The painting depicts "the calling of the roll of the Grenadier Guards, in the presence of the colonel, after a battle in the Crimea, in winter" (*Century Cyclopedia of Names*, 1904).

The Roll Call of the Last Victims of the Terror (French, *L'Appel des derniers victimes de la Terreur*) Charles Louis Müller, 1850, Metropolitan Museum, New York.

The scene is "the calling of the names, in the Conciergerie prison, of the last detail of victims for the guillotine, in July, 1794. The Princesse de Chimay is in the tumbril, which is seen through the open door; the Princesse de Monaco rises upon hearing her name. André Chénier, the poet, sits in a chair in the foreground" (*Century Cyclopedia of Names*, 1904).

The Romans of the Decadence (French, *Les Romains de la décadence*) Thomas Couture, 1847, Musée d'Orsay, Paris.

The painting, also known as *The Romans in Their Decadence*, depicts "a wild debauch in the

later days of the empire, in the court of a splendid house. The statues of dignified ancestors contrast with the scene of unbridled license before them" (*Century Cyclopedia of Names*, 1904). The classical subject had a contemporary political relevance.

Rome Elihu Vedder, 1894, Bowdoin College Museum of Art, Brunswick, Maine.

The large lunette mural, subtitled *The Art Idea*, is an allegorical depiction of Roman culture. The central figure is a nude Nature, her right hand resting on the Tree of Life, her left holding a branch with its fruit, symbolizing the seeds of the future. Below the painting run the Italian words: "SAPIENZA PENSIERO ANIMA VITA NATVRA ARMONIA AMORE COLORE FORMA" ("Wisdom Thought Soul Life Nature Harmony Love Color Form"). The mural is one of four installed at Bowdoin College. The others are Abbott Thayer's *Florence* (1894), Kenyon Cox's *Venice* (1894), and John La Farge's *Athens* (1898).

The Rooks Have Arrived (Russian, *Grachi prileteli*) Alexei Savrasov, 1871, Tretyakov Gallery, Moscow.

Against the background of a gray and chilly sky, rooks are building their nests in the barebranched trees of a remote Russian village. The snow is already beginning to melt, and the arrival of the birds is welcome proof that spring cannot be far off.

Room in New York Edward Hopper, 1932, Sheldon Memorial Art Gallery, University of Nebraska, Lincoln, Nebraska.

It is night. In a lighted room, a man in shirtsleeves reads a newspaper, leaning forward before a round table. A woman in a red dress sits at a piano, her finger resting on a single key. The title does not reveal that the subject of the painting is boredom and alienation.

Rose-Garden Madonna *see* The **Virgin in the Rose Bower**.

The Roses of Heliogabalus Sir Lawrence Alma-Tadema, 1888, private collection.

The painting depicts the moment when the Roman emperor Heliogabalus asphyxiates his guests by showering rose petals on them as they revel. They do not yet realize their fate, and delight in the decadent indulgence.

The Rout of San Romano Paolo Uccello, *c.*1456, National Gallery, London, / Uffizi, Florence, / Louvre, Paris.

The work was commissioned by Cosimo de'Medici to commemorate the victory of the Florentine army in 1432 over that of Siena at San Romano in the valley of the Arno River. The three panels of the original, now in different galleries, depict, respectively, the Florentine general Niccolò de Tolentino leading the attack, the unhorsing of the Sienese general Bernardino della Carda, and the counterattack of the Florentine leader Michelotto da Cotignola.

The Rugged Path Paul Falconer Poole, 1851, Victoria and Albert Museum, London.

A smiling country girl takes a young child on her back to carry her over a rocky stream.

Ruin, Disaster, Shame Peter Howson, 1995, Angela Flowers Gallery, London.

The painting is the fifth in the series of seven based on scenes in Stravinsky's opera *The Rake's Progress* (*see* **Farewell, Farewell**). Tom Rake is now bankrupt, and all his property is about to be sold by auction. Baba, the bearded lady whom Tom has married, stands in an empty packing crate. The title quotes from the auction scene in Act III.

The Ruling Passion John Everett Millais, 1885, Glasgow Art Gallery.

An aged but bedridden ornithologist pursues his life's interest surrounded by young members of his family. The artist was inspired to paint the work after visiting the home of John Gould (1804–1881), an ornithologist notorious for being an awkward invalid. The subtitle is *The Ornithologist*.

Russian Music (French, *La Musique russe*) James Ensor, 1881, Musées Royaux des Beaux-Arts, Brussels.

A young woman plays the piano as a young man sits behind her listening attentively. The title evokes a mood of musicality, and the reference to Russian music relates to the general interest in Russian culture in western Europe in the 1880s, when it was regarded as a welcome antidote to the dominant Naturalist and Decadent schools of art. The model for the pianist was the artist's younger sister, Mariette ("Mitche"), while that for the listener was his fellow student at the Académie Royale in Brussels, Willy Finch.

Rustic Civility *see* **Coming Events**.

S

Sacking and Red Alberto Burri, 1954, Tate Gallery, London.

The painting, or collage, consists of strips of sacking glued to a canvas covered in red plastic paint. The sacking itself is also partly painted red, giving an overall effect of a blood-stained bandage. The Italian artist, formerly a doctor, began painting in 1944 when a prisoner of war in Texas.

Sacra Conversazione (1) Alvise Vivarini, 1480, Accademia, Venice; (2) Giovanni Bellini, 1505, S. Zaccaria, Vicenza; (3) Giorgione, *c*.1505, Accademia, Venice; (4) Palma Vecchio, 1521, S. Stefano, Vicenza; (5) *see* The **Madonna of the Shadows**.

All five altarpieces could equally be entitled *Madonna and Child with Saints*. Whereas earlier saints occupied separate panels, they now appeared in a unified grouping known as a *Sacra Conversazione*, literally "Holy Conversation," in which they not only attend the Virgin but usually have a specific reference, such as to the patron of the church for which the work was commissioned or to the founder of a particular monastic order. They may equally personify some moral or intellectual quality. They are often portrayed talking or gesturing. Hence "Holy Conversation."

Sacred Allegory *see* **Earthly Paradise**.

Sacred and Profane Love Titian, *c*.1516, Villa Borghese, Rome.

The painting is an enigmatic allegory, depicting two women, one clothed, the other naked, by a fountain. The work has been variously interpreted. The most widely held theory explains the subject as an allegory of earthly and spiritual love, so that the two women represent the respective terrestial and celestial aspects of Venus. (The rich clothing represents profanity, while nudity stands for purity.) But there may be a much simpler origin. The painting was commissioned in about 1514 by Niccolò Aurelio, a senior government official in Venice, and as he married that year, the work may have commemorated the event. The clothed woman wears white, the traditional color of Venetian bridal gowns, and could thus be his bride, Laura Bagarotto. She is thus perhaps being initiated into the mysteries of sexual love by the naked Venus. Cupid is seen stirring the waters of the fountain, as if to aid his mistress in her task. But this "marriage picture" theory hardly justifies the title.

Sacred Conversation Lorenzo Lotto, 1534, Uffizi, Florence.

The painting depicts the Virgin Mary and infant Jesus with St. Anne (Mary's mother), St. Joachim (her father), and St. Jerome. Such a group came to be known as in the 14th and 15th centuries as a "holy conversation." *See Sacra Conversazione*.

The Sacred Wood (French, *Le Bois sacré*) Pierre Puvis de Chavannes, 1884–6, Musée des Beaux-Arts, Lyons.

Twelve female figures, draped or seminude, are disposed in various groups and attitudes in a clearing by a grove. (Six are standing, three are seated, one is reclining, and two are flying.) The painting appears to have a classical reference, although its title remains general rather than specific.

The Sacrifice of Isaac (1) Caravaggio, 1598–9, Wadsworth Atheneum, Hartford, Connecticut; (2) Caravaggio, *c*.1603, Uffizi, Florence; (3) Domenichino, *c*.1620–1, Prado, Madrid.

The scene is from the Old Testament. When Isaac, son of Abraham, was still young, God demanded that his father sacrifice him as a test of his faith. Abraham prepared to do so, but the boy was saved when at the last moment God sent a ram to be sacrificed in his place. The paintings shows an angel staying Abraham's hand as he is about to cut his son's throat. The ram is nearby in all three pictures.

Sacrilegious Robbery (Italian, *Furto sacrilegio*) Alessandro Magnasco, 1731, Quadreria arcivescovile, Milan.

The painting illustrates a crime committed on January 6, 1731, when thieves forced an entry into the church of Sta. Maria in Campomorto at Siziano, Pavia, to steal the holy vessels used for mass. They were seen off by skeletons from the graves in the surrounding cemetery. The work really belongs to the church where the attempted robbery took place, but for safety reasons it is kept in the Diocesan Museum in Milan.

The Sad Hour (Italian, *L'ora mesta*) Giovanni Segantini, 1892, private collection.

As evening falls over the fields a woman sits with bowed head by a cooking pot over a fire while a cow looks mournfully on.

Saddle-My-Nag William Dobell, 1941, Art Gallery of New South Wales, Sydney.

A group of young people are engaged in a lively game. "(Dobell) had seen a group of Irish servant-girls and their boy-friends playing the game in (London's) Hyde Park. As a schoolboy he too had played the game, in which the players divided themselves into two teams, one of which becomes the 'nag' and the other the 'riders.' The object of the game is for the riders to attempt to make the 'nag' collapse" (Gleeson, p. 77).

The Sailor's Orphans William Ward, 1799, mezzotint after painting by William Redmore Bigg.

The headmistress of a girls' seminary has brought her genteel charges to the home of a widow of a sailor, whose death has left his family in reduced circumstances. The picture has the alternate title *The Young Ladies' Subscription*. The theme of charity was clearly one close to Bigg's heart, as other paintings exhibited by him at the Royal Academy bore the titles: *Schoolboys Giving Charity to a Blind Man* (1780), *A Lady and her Children Relieving a Distressed Cottager* (1781), and *Generous Schoolboys, or the Collection for a Soldier's Widow* (1798). This last is set in a cricket ground.

St. Augustine as Founder of Military and Religious Orders Juan Pantoja de la Cruz, 1606, Toledo Cathedral.

St. Augustine is depicted as founder of a monastic rule in the habit of his order, with the addition of a bishop's cloak, miter, and crozier. To his left stand St. Nicholas of Tolentino, the Blessed Juan Bono, and St. Monica (Augustine's mother). To his right are St. Clare of Montefalco, the Blessed Juan de Reate, and St. John of Sahagún. All these are Augustinians, so represent the saint. The military orders of the title, kneeling on the right, are represented by knights of the orders of St. Stephen of Malta, the Hospitalers of the Holy Sepulcher of Jerusalem, and Order of Santiago. The religious orders, kneeling on the left, are represented by a Mercedarian, a Trinitarian, a Dominican, and a member of the lesser clergy.

St. Cecilia (1) Guido Reni, 1606, Norton Simon Museum, Pasadena, California; (2) John William Waterhouse, 1895, private collection.

Reno shows St. Cecilia, the patron saint of music, with a violin and bow in her hands as she looks up for divine inspiration. Waterhouse has her asleep in a chair with a book on her lap while two angels play on stringed instruments. His work is based on lines from Tennyson's poem *The Palace of Art* (1832): "Or in a clear-wall'd city on the sea, / Near gilded organ-pipes, her hair / Wound with white roses, slept St. Cecily; / An angel look'd at her."

St. Eulalia John William Waterhouse, 1885, Tate Gallery, London.

A young woman, naked to the waist, lies dead in the snow in a Roman street. She is St. Eulalia of Merida (Spain), martyred in the early 4th century. Legend tells how she opposed the edicts of Diocletian obliging everyone to offer sacrifice to the gods and was subsequently tortured and burnt alive. Snow then covered her body until it was buried by Christians.

St. George and the Dragon (1) Paolo Uccello, *c.*1460, National Gallery, London; (2) Cosmè Tura, *c.*1470, Museo del Duomo, Ferrara; (3) Carlo Crivelli, *c.*1476, Isabella Stewart Gardner Museum, Boston, Massachusetts; (4) Il Sodoma, *c.*1516, National Gallery, Washington, D.C.; (5) Tintoretto, *c.*1558, National Gallery, London; (6) Peter Paul Rubens, *c.*1606–10, Prado, Madrid.

The paintings all center on the familiar story of how St. George saved the king's daughter, chained to a rock, by conquering and killing the dragon that was about to devour her. In each case the warrior saint is on a warhorse, armed with a sword or lance. The fullest account is in Jacobus de Voragine's *The Golden Legend* (*c.*1260). Tura's painting, with St. George and the Dragon on one panel and the princess on another, is also known as *St. George and the Dragon and The Princess*, as two distinct depictions. (The panels open out to reveal an *Annunciation* on the reverse.)

St. George and the Dragon and the Princess *see* **St. George and the Dragon** (2).

St. James of Alcalá Feeding the Poor Bartolomé Murillo, *c.*1645, Real Academia de San Fernando, Madrid.

The painting depicts the Spanish monk, St. James of Alcalá (1400–1463), kneeling in prayer before distributing food to the poor men, women, and children who stand or sit around him.

St. John of Mata Renouncing the Degree of Doctor, but Then Accepting

It on Divine Inspiration Francisco Ribalta, *c*.1632, Prado, Madrid.

St. John of Mata (1160–1213), French founder of the Trinitarian Order, is depicted twice in the one painting. First he declines the doctorate of theology on the grounds of his humility and scorn for human honors, then he accepts it after a night of prayer. The former scene is the larger.

St. Lucy Altarpiece *see* **Madonna and Child with Saints**.

St. Margaret Francisco de Zurbarán, *c*.1653, National Gallery, London.

The young woman in a wide-brimmed straw hat with a woven saddlebag on her arm is accompanied by a sinister dragon, which curls menacingly around her feet. St. Margaret is said to have been swallowed by a dragon which then burst, leaving her unharmed.

St. Martin's Summer John Singer Sargent, 1888, private collection.

Two young women in white dresses reclining in a boat on a river are illumined by a flourish of sunlight on St. Martin's Day (November 11).

St. Nicholas Reviving the Little Children (French, *Saint Nicolas ressuscitant les petits enfants*) Gustave Courbet, 1847, Église de Saules, Ornans.

St. Nicholas, here depicted as a bishop (and posed by the artist's friend, Urbain Cuénot), raises three little boys to life from the brine tub in which they were murdered by a butcher.

St. Paul on Malta Adam Elsheimer, *c*.1600, National Gallery, London.

The scene is a depiction of St. Paul's shipwreck on Malta, as described in the New Testament (Acts 28:1–6). St. Paul shakes the viper from his hand into the fire, while shipwrecked travelers huddle around it for warmth and try to dry their clothes.

St. Veronica Hans Memling, *c*.1480, National Gallery, Washington, D.C.

St. Veronica kneels as she holds up a kerchief with a depiction of the head of Christ. According to legend, Veronica, a pious woman of Jerusalem, gave Christ her kerchief to wipe his brow when he was on the road to Calvary. When he returned it, an impression of his face was miraculously imprinted on it. Veronica's name is thus popularly derived from Latin *vera*, "true,"

and Greek *icon*, "image." The painting shows the saint surrounded by veronica (speedwell), the flower said to be named for her.

Sts. Justa and Rufina (Spanish, *Santas Justa y Rufina*) Francisco de Goya, 1817, Seville Cathedral.

The painting depicts the two young sisters, Justa and Rufina, martyred for their faith in AD 287. They are said to have been spared by the lions to which they were thrown, and the painting shows a lion licking Rufina's feet. They are now the patron saints of Seville.

Salmacis and Hermaphroditus Bartholomeus Spranger, *c*.1590, Kunsthistorisches Museum, Vienna.

The scene is from classical mythology. The Naiad (water nymph) Salmacis disrobes before joining Hermaphroditus, son of Hermes and Aphrodite, in her spring. (Their bodies then blended together as one, becoming a hermaphrodite, but the painting does not show this.)

Salome (1) Franz von Stuck, 1906, private collection; (2) *see* The **Apparition**.

The painting depicts Salome, the daughter of Herodias who so pleased Herod with her dancing that he said he would give her anything she wished. She asked for, and got, the head of John the Baptist. (She is not named in the biblical account: Matthew 14:6–11.) She is here shown dancing with raised arms, naked from the waist up. To the right, a servant bows and grins as he offers his mistress the head of John the Baptist on a dish.

A Salty Tale Steven Campbell, 1985, Collection Susan Kasen and Robert D. Summer, New York.

The painting's subtitle describes the surreal scene: *In a Drought a Man Saves a Whale by his Perspiration and Tears*. The lengthy title, as surreal as the depiction, is typical of the artist, and springs from his interest in myths and scientific (or pseudoscientific) experiments. Others are *'Twas Once an Architect's Office in Wee Nook* (1984) (Wee Nook is a cottage owned by Bertie Wooster in the stories by P.G. Wodehouse) and *The Man who Gave his Legs to God and God Did not Want them* (1987).

Sam with Sam Chifney, Jr., Up Benjamin Marshall, 1818, Huntington Art Gallery, San Marino, California.

The painting depicts the English jockey Samuel Chifney, Jr., (1786–1854) seated on

"Sam" in the year that the two won the Derby. Rather unusually, the horse was named for his rider.

The Sampling Officers of the Cloth-makers' Guild *see* The **Syndics of the Drapers' Guild**.

Sam's Spoon Avigdor Arikha, 1990, private collection.

The painting depicts a solitary silver tea-spoon on a white napkin, the name "Sam" just visible on its handle. The work is a tribute to the artist's friend, the writer Samuel Beckett (1906–1989), and was painted on the first an-niversary of Beckett's death. The christening spoon is Beckett's own, which he had given to the artist's daughter on her birth.

Samson Solomon Joseph Solomon, *c.*1886–7, Walker Art Gallery, Liverpool.

The scene is from the Old Testament. Sam-son has had his hair cut off (*see* **Samson and Delilah**) and is being bound by the Philistines while a bare-breasted Delilah mocks him.

Samson and Delilah Peter Paul Rubens, *c.*1613, National Gallery, London.

Delilah has lured from Samson the secret of his extraordinary strength, which lay in his hair. After lulling him to sleep, she had the seven locks from his head cut off and delivered him to the Philistines for 1100 pieces of silver (Judges 16: 4–19). The painting shows Samson asleep in Delilah's lap while a man delicately, so as not to wake him, cuts the locks from his head.

San Giobbe Altarpiece Giovanni Bellini, *c.*1480, Accademia, Venice.

The painting of the Madonna and Child enthroned, surrounded by saints, was commis-sioned for the church of S. Giobbe (St. Job), Venice. The saint himself is shown nearest the throne.

Sancta Lilias ("Holy Lilies") Dante Gabriel Rossetti, 1874, Tate Gallery, London.

The painting is an abandoned and cut-down version of the artist's The **Blessed Damozel**, here showing simply the head and shoulders of the Damozel and her right hand holding the three holy lilies of the title. (They are actually irises, but these are members of the lily family.) In Christian art the lily symbolizes purity, chastity, and innocence, and in paintings of The **Annunciation** the angel Gabriel presents Mary with a lily. The Latin title should properly

have no final *-s*. Perhaps one was added to stress the plural sense.

Sand of the Marches (German, *Märkischer Sand*) Anselm Kiefer, 1982, Stedelijk Museum, Amsterdam.

The work is blend of oil and sand on paper with labels affixed to show the names of places such as Oranienburg in the historic area of the title, the Brandenburg Marches, as the margra-vate in northeastern Germany that was the nu-cleus of the kingdom of Prussia and that came to have Berlin as its capital.

Sappho and Alcaeus Sir Lawrence Alma-Tadema, 1881, Walters Art Gallery, Baltimore, Maryland.

The painting depicts two famous Greek lyric poets and friends, Sappho and Alcaeus, both of the 7th century BC. Sappho looks and listens intently as Alcaeus accompanies his song on a *kithara* (a stringed instrument).

The Saracen Maid *see* **Gilbert à Becket's Troth**.

Sarah Tubb and the Heavenly Visitors Stanley Spencer, 1933, Stanley Spencer Gallery, Cookham, Berkshire

The painting is based on a story recounted to the artist by his father, in which the appear-ance of Halley's comet in 1910 so scared old Sally Tubb that she feared the end of the world. Spencer shows her with the face of her daugh-ter, Sarah, kneeling on the sidewalk in Cookham High Street, surrounded by angels and village folk.

Saskia as Flora Rembrandt van Rijn, 1634, Hermitage, St. Petersburg.

The portrait of the artist's pregnant wife, *née* Saskia van Uylenborch, dressed as Flora, the Roman goddess of flowers and fertility, was painted in the year of their marriage.

Satire Sat Here Mark Wallinger, 1986, Anthony Reynolds Gallery, London.

The painting is divided centrally into mir-ror images. In each, a toilet bowl is metamor-phosed into an artist painting a self-portrait. The opposing artists-cum-toilet bowls also serve as the eyes of the mask created by the painting as a whole. (The mouth is made up of the word "GAG" split in two, with the last letter a mirror image of the first.) The work is a lampoon on 18th-century English "nonconformist" painters, and is based on William Hogarth's *Comic Muse*

(*c*.1758) also a self-portrait in the act of being painted. The title is not just a punning jingle, but a gibe at Hogarth's socially critical art: it is now clear where "Satire sat."

Saturday Night in the Vale Henry Tonks, 1928–9, Tate Gallery, London.

The artist's best known work is a conversation piece showing the writer and painter, George Moore, reading aloud to a gathering at Tonks's studio in The Vale, Chelsea, London.

Saturn Devouring One of His Sons

(Spanish, *Saturno*) Francisco de Goya, 1820–2, Prado, Madrid.

According to Roman mythology, the Roman god Saturn devoured his sons because he was afraid they might usurp him. The picture, one of the so called **Black Paintings**, depicts the god in the gruesome act. The Spanish title is laconic, simply naming the god.

The Satyr and the Farmer's Family

Jacob Jordaens, after 1620, Alte Pinakothek, Munich.

A naked satyr rises from the table where he has been sharing the supper of a farmer and his family. The scene is taken from one of Aesop's fables. A farmer invites a satyr into his home. The satyr sees the farmer blowing on his hands to warm them, then blowing on his soup to cool it. Feeling he is being made fun of, he jumps up from the table.

The Savage Sparkler Alice Aycock, 1981, Plattsburgh State Art Galleries, New York.

The sculpture is an imposing-looking electrical machine that basically comprises a motorized fan in a cylindrical housing with an antenna-like array of fluorescent lights. If empowered, the construction would function as the "savage sparkler" of the title.

The Savoyard Alexander Moses, *c*.1832, Walker Art Gallery, Liverpool.

An itinerant boy musician with dog and monkey entertains a group of country children. Such musicians were so called as they originally came from Savoy in southeastern France.

The Scapegoat William Holman Hunt, 1854–5, Lady Lever Art Gallery, Port Sunlight.

The painting of a goat by the sea has its source in the Old Testament. It refers to the Hebraic custom whereby two goats are selected as penitential symbols of human sin. On the Day of Atonement, one goat is presented to the temple while the other is driven into the wilderness (Leviticus 16:5–10). The depiction is of the second goat. It stands against a background of the Dead Sea, on a site believed to be the location of the city of Sodom. The artist actually painted the picture there.

Scene from a Camp with an Officer Buying Chickens Francis Wheatley, 1788, Royal Pavilion Art Gallery, Brighton.

The depiction is exactly as the title states, showing the military camp at Bagshot, Surrey, with an officer bargaining for chickens. Yet when this picture was mezzotinted in 1796 it was retitled *The Encampment at Brighton*. This was probably because the annual assembling of militia at Brighton attracted more public attention. The work's companion piece, **Scene from a Camp with an Officer Buying Ribbons**, was similarly rechristened.

Scene from a Camp with an Officer Buying Ribbons Francis Wheatley, 1788, Royal Pavilion Art Gallery, Brighton.

As with the painting's twin, **Scene from a Camp with an Officer Buying Chickens**, the title is a bald factual description of the scene in the military camp at Bagshot, Surrey. When mezzotinted in 1796, however, the picture was retitled *The Departure from Brighton*.

Schokko Alexei von Jawlensky, 1910, private collection.

A fashionable woman in a flowery hat poses reflectively. The title is the young model's nickname, given her when she asked for a cup of hot chocolate (German *Schokolade*).

Scenes from the Life of Aeneas Sylvius Piccolimini Pinturicchio, 1503, Piccolimini Library, Siena.

Aeneas Sylvius Piccolimini was the original name of Pope Pius II (1405–1464). The painting is in the library founded in 1495 by his nephew, Francesco Piccolimini, later Pius III.

School Is Out Elizabeth Adela Armstrong Forbes, 1889, Penlee House Gallery, Penzance, Cornwall.

Children prepare to leave their rural schoolroom after the day's lessons, some pausing to look gleefully at a small boy who sits crying on the end of a bench and who must stay behind.

The School of Athens Raphael, 1508–11, Stanza della Segnatura, Vatican.

The famous fresco depicts Plato and Aris-

totle surrounded by a number of other philosophers, past and present, engaged in discussion or contemplation. The title dates only from the 17th century, and was coined by a French travel guide with the aim of identifying the subject, which properly is Philosophy. The fresco is one of four, the others representing Poetry (the *Parnassus*), Law (the *Wall of Justice*, or *Wisdom, Temperance, Strength*), and Theology (the *Disputà*, or *Disputation Concerning the Holy Sacrament*).

The School of Love *see* (1) The **Dream of Antiope**; (2) **Mercury Instructing Cupid Before Venus**.

"Scotland for Ever!" Elizabeth Butler, 1881, Leeds City Art Gallery.

The artist's best known painting shows the charge of the Royal Scots Greys at the Battle of Waterloo (1815), when that heavy cavalry regiment suffered severe casualties.

The Scream (Norwegian, *Skriket*) Edvard Munch, 1893, National Gallery, Oslo.

The painting, an icon of human anguish, depicts a figure on a pier beneath a vivid red sunset, his hands clapped to his ears, his eyes and mouth wide open. The painting sprang from a personal experience in 1890 when the artist was walking with two friends by Oslofjord: "One evening, I was walking along a path, the city was on one side and the fjord below. I felt tired and ill. I stopped and looked out over the fjord — the sun was setting, and the clouds turning blood red. I sensed a scream passing through nature; it seemed to me that I heard the scream. I painted this picture, painted the clouds as actual blood. The color shrieked. This became *The Scream*" (*Diary*, Saint-Cloud, 1898) (quoted in Hodin, p. 48). The work is also known in English as *The Cry* and *The Shriek*.

The Sea Maiden Herbert James Draper, 1894, Royal Cornwall Museum, Truro.

Bewildered fishermen find they have caught a siren in their nets. The painting was inspired by lines from Algernon Charles Swinburne's poem *Chastelard* (1865): "A song of dragnets hauled across thwart seas / And plucked up with rent sides and caught therein / A strange-haired woman with sad singing lips."

A Sea Spell Dante Gabriel Rossetti, 1877, Harvard University Art Museums, Cambridge, Massachusetts.

A woman sits dreamily plucking the strings of a dulcimer. The painting was originally in-tended to illustrate a couplet from Coleridge's *Kubla Khan* (1816): "A damsel with a dulcimer / In a vision once I saw." It later became a pendant (companion picture) for **Veronica Veronese**. The model in both cases was Alexa Wilding. The artist later described the imagery in a sonnet, beginning: "Her lute hangs shadowed in the apple-tree, / While flashing fingers weave the sweet-strung spell / Between its chords; and as the wild notes swell, / The sea-bird for those branches leaves the sea." A "sea spell" is one cast by a real or fancied sea-dweller, such as a seabird or siren.

Seated Woman *see* **Camille Carafa**.

The Seaweed Gatherers (French, *Ramasseuses d'algues*) Paul Gauguin, 1889, Folkwang Museum, Essen.

The artist wrote in a letter to Vincent van Gogh: "At the moment, I am working on a painting of women gathering seaweed on the beach. ... I see this scene every day and it is like a gust of wind, a sudden awareness of the struggle for life, of sadness, and of our obedience to the harsh laws of nature" (quoted in Jennifer Bright, *At the Sea*, 1996).

Second Class: The Parting Abraham Solomon, 1854, Southampton Art Gallery.

A young lad is about to take leave of his sorrowing mother and sister as all three travel in a second-class railroad carriage. The bills on the wall advertise job opportunities in Australia, and it is clear that the youth is about to emigrate to that far continent, so that the parting will be a long one. The painting's subtitle is *Thus part we rich in sorrow, parting poor*, hinting at the work's pendant (companion picture), **First Class: The Meeting**.

The Second of May, 1808 (Spanish, *El dos de Mayo, 1808*) Francisco de Goya, 1814, Prado, Madrid.

The painting depicts the uprising of the people of Madrid against Napoleon's cavalry on May 2, 1808, during the Peninsular War. Its full title is *The Second of May, 1808: The Charge of the Mamelukes*. The grim events of the next day are depicted in The **Third of May, 1808**.

The Secret Double (French, *Le Double secret*) René Magritte, 1927, Musée National d'Art Moderne, Paris.

The painting depicts two identical head-and-shoulder portraits, one of which has had most of its face, neck, and breast peeled away to

form the other. The title implies that all individuals are secretly doubles of themselves.

security and serenity Haim Steinbach, 1985, private collection.

The work, with its modest and satisfyingly balanced lowercase title, comprises two plastic laminated wood shelves each holding two "Gem-Lites" and two plastic toilet brushes in their holders. Such homely objects are reassuring, especially when arranged in pairs, like the title.

The Seeds and Fruits of English Poetry
Ford Madox Brown, 1845–51, Ashmolean Museum, Oxford.

The painting, in form suggesting an Italian triptych, shows Chaucer reading his poetry to Edward the Black Prince surrounded by courtiers and flanked by a pantheon of British poets, including Milton, Spenser, Shakespeare, Byron, Pope, Burns, Goldsmith and James Thomson. Putti lined along the base of the picture carry cartouches bearing the names of further poets: Campbell, Moore, Shelley, Keats, Chatterton, Kirke White, Coleridge, and Wordsworth. Sleeping in the spandrels between the three arches are the Norman Troubadour and the Saxon Bard, the two sources of inspiration behind British poetry and thus its "seeds."

The Seesaw (German, *Die Wippe*) Franz von Stuck, 1898, Museum Villa Stuck, Munich.

Two young women, one blonde and nude, the other dark-haired and in a red dress but with bared breasts, improvise a game of seesaw on a wooden pole balanced in the fork of a tree. The title implies a balance between man and nature, now one ascendant, now the other.

The Seine Boat Stanhope Forbes, 1904, private collection.

A group of fishermen in a rowboat seek the best place to cast their nets off the coast. The title does not refer to the French river but to the type of net used. (A seine is designed to encircle fish and has floats at the top and weights at the bottom edge.)

A Select Committee Henry Stacy Marks, 1891, Walker Art Gallery, Liverpool.

As it was described by one reviewer when first exhibited, the humorous painting shows "a council, board and congress ... of blue, white and black parrots and cockatoos perched in an aviary and gravely discussing the affairs of birdland." The "select committee" is presided over by a Hyacinthine Macaw, which raises a claw to address the group.

Selene and Endymion (French, *Séléné et Endymion*) Nicolas Poussin, 1635, Detroit Institute of Arts, Michigan.

The painting depicts the moon goddess, Selene, taking her early morning leave of the shepherd, Endymion, after one of her nightly visits of love to him on the mountainside.

Self Marc Quinn, 1991, Saatchi Collection, London.

The work is a three-dimensional self-portrait head made of the artist's own frozen blood.

Self-Portrait with Cropped Hair (Spanish, *Autorretrato con pelo cortado*) Frida Kahlo, 1940, Museum of Modern Art, New York.

The artist, wearing a man's baggy gray suit, sits on a chair surrounded by locks and strands of her hair that seem to wriggle like snakes. Above her over a line of music are bitter words from the lyric of a popular song: "*Mira que si te quise, fué por el pelo, / Ahora que estás pelona, ya no te quiero*" ("Remember that if I loved you, it was for your hair, / Now that you are bald, I do not love you"). The reference is autobiographical. The artist married the famous Mexican muralist Diego Rivera in 1929, but their stormy relationship led to a divorce in 1939. The painting dates from just after this, when Kahlo was in the depths of despair.

Self-Portrait with Dr. Arrieta (Spanish, *Autorretrato con el doctor Arrieto*) Francisco de Goya, 1820, Minneapolis Institute of Arts, Minnesota.

The sick artist sits up in bed as his friend, Dr. Arrieta, tries to persuade his patient to take a sip of medicine from the glass that he holds. The following words are inscribed at the base of the painting: "*Goya agradecido, a su amigo Arrieta: por el acierto y esmero con que le salvó la vida en su aguda y peligrosa enfermedad, padecida a fines del año 1819 a los setenta y tres de su edad. Lo pintó en 1820*" ("From a grateful Goya to his friend Arrieta: for the compassion and care with which he saved his life during the acute and dangerous illness he suffered toward the end of the year 1819 in his seventy-third year. He painted this in 1820").

Self-Portrait with Patricia Preece
Stanley Spencer, 1936, Fitzwilliam Museum, Cambridge.

The double nude portrait is of the artist and his second wife, Patricia Preece (1900–1971), whom he first met in 1929 and whom he married in 1937, five days after divorcing his first wife, Hilda Carline, the central subject of **Love on the Moor**.

The Self-Seers (German, *Die Selbstseher*) Egon Schiele, 1910, location unknown.

The painting is a kind of dual self-portrait, showing one Schiele looking over the other's shoulder. A second work of the same title (1911) is apparently not a self-portrait but shows a man staring into a mirror. Behind him is a shimmering copy of himself as Death.

The Sempstress Richard Redgrave, 1846, Forbes Magazine Collection, New York.

A weary woman sews by lamplight, a clock showing the time as 2.30 in the morning. The artist was prompted to paint the subject after reading Thomas Hood's poem *The Song of the Shirt* (1843): "With fingers weary and worn, / With eyelids heavy and red, / A woman sat in unwomanly rags, / Plying her needle and thread—/ Stitch! Stitch! Stitch! / In poverty, hunger and dirt, / And still with a voice of dolorous pitch / She sang 'The Song of the Shirt.'"

A Sense of Reality (French, *Le Sens des réalités*) René Magritte, 1963, private collection.

A large rock floats over a valley in a blue but cloudy sky. The depiction is realistic, but at the same time unreal. The image provides a "sense of reality" but not a true representation of it..

Septimius Severus Reproaching Caracalla (French, *Septime Sévère et Caracalla*) Jean-Baptiste Greuze, 1769, Louvre, Paris.

The painting depicts a scene from Roman history. The emperor Septimius Severus (145–211), seated on a couch, rebukes his elder son, Caracalla (188–217). The reason for the reproach is supplied by the work's full and formal title: *The Emperor Septimius Severus Reproaching His Son Caracalla for Having Plotted Against His Life*. Caracalla (originally Marcus Aurelius Antoninus) succeeded his father as emperor on the latter's death. *Cf.* **Caracalla and Geta**. (The emperor's name is misprinted in some sources as Septimus.)

The Sepulcher Marshall Claxton, 1843, Victoria and Albert Museum, London.

The painting depicts Christ in the tomb, his body in a half-recumbent position, his head resting on a block of stone. Two angels fly down to take their place as watchers in the tomb.

Serb and Muslim Peter Howson, 1994, City of Aberdeen Art Gallery.

Two soldiers rape a civilian woman in the 1990s conflict in the former Yugoslavia. The painting's complement is **Croatian and Muslim**, showing that atrocities were not restricted to one side alone.

La Servante de Bocks *see* La **Serveuse de Bocks**.

La Serveuse de Bocks ("The Waitress Serving Bocks") Édouard Manet, 1878–9, National Gallery, London.

A waitress serves bocks (glasses of beer) in a Paris café. The painting's alternate English title is usually simply *The Waitress*. The French title is given in many sources as *La Servante de Bocks*, although *servante* means "servant," not "server."

The Seven Ages of Man William Mulready, *c.*1836, Victoria and Albert Museum, London.

The painting is based on Jaques' soliloquy in Shakespeare's *As You Like It* (1599) and depicts the seven characters mentioned, among others. The subtitle is *All the World's a Stage*, Jaques' opening words.

The Shadow of Death William Holman Hunt, 1869–73, Manchester City Art Gallery.

On completing a long day's work in the carpenter's shop, Christ stretches his arms out in relaxation, as he does so casting a shadow of his crucified figure. The depiction is not based on any biblical scene, although the title is a phrase found in both the Old and the New Testament, as "He brought them out of the shadow of death" (Psalm 107:14), "To give light to them that sit in darkness and in the shadow of death" (Luke 1:79).

Shaftesbury, or Lost and Found William Macduff, 1863, private collection.

In a city street, a young chimney sweep and a shoeshine boy gaze gratefully into a printseller's window at an engraved portrait of the philanthropist, Lord Shaftesbury (*see* **Shaftesbury Memorial Fountain**), whose social reforms did much to improve their lot. They had lost hope, and thanks to him have found it again.

Shaftesbury Memorial Fountain Sir Alfred Gilbert, 1887–93, Piccadilly Circus, London.

The statue atop a fountain in London's Piccadilly Circus is popularly known as *Eros*, since the figure is that of an archer and his bow. But the fountain was erected in memory of the philanthropic 7th Earl of Shaftesbury (died 1885) and the figure is not Eros, the Greek god of love, but the Angel of Christian Charity.

Shakespeare's House, Stratford-Upon-Avon Henry Wallis, 1854, Victoria and Albert Museum, London.

The painting is a straightforward view of the staircase leading up to the room where Shakespeare is supposed to have been born in his house in Stratford-upon-Avon, Warwickshire. The animal painter Sir Edwin Landseer subsequently added some embellishments, including a terrier by the door at the foot of the stairs sensing someone's arrival (Shakespeare's?).

$he Richard Hamilton, 1958–61, Tate Gallery, London.

The Pop Art painting has as its main theme the image of woman in advertising. Hence the title, with the dollar sign as its first letter. The main source of the work was an advertisement for an American RCA Whirlpool fridge/freezer, and the image of the woman is based on a photograph of a model called Vikky Dougan, known as "Vikky the Back" because she modelled daringly lowcut backless dresses.

"She shall be called Woman" George Frederic Watts, *c.*1888–1892, Tate Gallery, London.

The painting shows Eve after her creation, rising upward in an explosion of light and color. The title is a direct quotation from Genesis 2:23: "She shall be called Woman, because she was taken out of Man." The painting was originally entitled *The Newly Created Eve*. The artist intended it to be the first of a series of three, the others to be *After the Transgression* and *Cain*.

The Shepherdess Sir George Clausen, 1885, Walker Art Gallery, Liverpool.

A young peasant girl stands in a springtime orchard guarding a flock of sheep. The brief, factual title suggests that the depiction is not intended to be symbolic.

The Ship of Fools Hieronymus Bosch, after 1490, Louvre, Paris.

A group of people are drinking, eating, and making music in a boat, their company including a monk and a nun. The painting is a literal representation of the allegory told in Sebastian Brant's *The Ship of Fools* (German, *Das Narrenschiff*) (1494). In this, a ship laden with fools and steered by fools sets sail for Narragonia, the "fools' paradise."

Ships of the Plains Samuel Colman, 1872, Union League Club, New York.

A covered wagon train heads west, the foremost wagon being drawn by a team of eight oxen. The title sees the ox as the "ship of the plain" just as the camel is the "ship of the desert." Both animals have to be "navigated," in this case by the teamster.

Showing a Preference John Callcott Horsley, 1850, private collection.

A young naval lieutenant devotes his exclusive attention to one of two young women as they walk through a cornfield, leaving the rejected girl to follow unhappily behind. The magazine *Punch* commented that the officer "was showing a preference in a very indiscreet and decided manner. The very poppies hide their heads in shame" (quoted in Wood 1988, p. 196).

The Shriek *see* The Scream.

The Shrimp Girl William Hogarth, *c.*1740, National Gallery, London.

The painting is a portrait of a cheery young Cockney fisherwoman carrying a basket of shrimps on her head. The artist's wife called it *The Market Wench*.

The Shrovetide Revelers *see* Merry Company.

Sibylla Fatidica Henry Pegram, 1904, Tate Gallery, London.

The marble statue is of a nude young woman draped in despair over the lap of the Sibyl, the enigmatic prophet of classical mythology. The second word of the title is Latin for "predicting fate," otherwise foreseeing the future. The young woman has thus collapsed on learning the Sibyl's decree.

Sibylla Palmifera Dante Gabriel Rossetti, 1866–70, Lady Lever Art Gallery, Port Sunlight.

The painting is a portrait of the model Alexa Wilding as *Sibylla Palmifera*, "Palm-Bearing Sibyl," referring to the palm branch that the subject holds in her right hand. The depiction was originally called simply *Palmifera*, but the artist later added *Sibylla*. He explained in a letter to his brother William: "The title Palmifera was adopted to mark the leading place which I

intend her to hold among my beauties." He added that the beauty for which she bore the palm was the beauty of the soul, as distinct from the beauty of the body in **Lady Lilith**, modeled by the same sitter (Ash, n.p.).

"Sic Transit"　George Frederic Watts, 1890–2, Tate Gallery, London.

A shrouded corpse lies on a bier beside the relics of a life of glory, among them a sword, a gauntlet, a spear, a plumed casque, a lute, a cup, and an open book. A wreath stands at the head of the bier, above which are the words: "What I spent, I had; What I saved, I lost; What I gave, I have." The title quotes the familiar words from Thomas à Kempis's *Imitation of Christ* (*c.*1420): "*Sic transit gloria mundi*" ("So passes the glory of the world"). "'Sic Transit' is the title of this picture, not the full motto 'Sic transit gloria mundi.' 'My husband,' Mrs. Watts writes, 'particularly wished the title to be "Sic transit." It was not the glory of the world he wished to draw attention to, but the possibilities and opportunities of life'" (H.W. Shrewsbury, *The Visions of an Artist: Studies in G.F. Watts, R.A., O.M.*, 1918).

The Sick Child *see* **Mother and Sick Child**.

Sickness and Health　Thomas Webster, 1843, Victoria and Albert Museum, London.

A sick child watches from her chair in a courtyard while two rosy-cheeked little girls dance to the music of an Italian organ-grinder to cheer her up. A benevolent grandmother looks on.

Sidonia von Bork 1560　Edward Burne-Jones, 1860–1, Tate Gallery, London.

The portrait of a lady in a flowing gown with a pattern of branching and intertwined snakes was inspired by Johannes Wilhelm Meinhold's novel *Sidonia von Bork, die Klosterhexe* ("Sidonia von Bork, the Convent Witch") (1847) translated by Speranza Wilde as *Sidonia the Sorceress* (1849). Meinhold's story, set in 1560, tells how the beautiful Sidonia used her powers of sorcery to destroy innocent lives, and who was particularly vicious to the men who could not help falling in love with her. Burne-Jones painted an accompanying picture, *Clara von Bork* (1860), as a portrait of Sidonia's virtuous cousin-in-law.

Sigismonda Mourning Over the Heart of Guiscardo　William Hogarth, 1759, Tate Gallery, London.

The subject is from Boccaccio's *Decameron* (1348–53). Sigismonda, a princess of Salerno, contemplates a golden cup containing the heart of her lover, Guiscardo, a family retainer who had been brutally murdered by her father, Tancred. She subsequently poisoned herself.

Silence　(1) Henry Fuseli, *c.*1800, private collection; (2) Fernand Khnopff, 1890, Musées Royaux des Beaux-Arts, Brussels.

Fuseli's painting shows a woman sitting cross-legged, her head bowed, her arms crossed over her feet, her long hair hiding her face as it falls into her lap. She is a personification of grief or sorrow, in which there are often no words to be said. Khnopff has a standing white-robed female figure, her finger laid to her lips as a sign of silence. The source for the pastel was a posed photograph of his sister, Marguerite.

Silent Pleading　Marcus Stone, 1859, Calderdale Museums, Halifax.

In a winter scene, a laborer who has clearly fallen on hard times slumps asleep on a bench with a child in his arms. A policeman is about to arrest him, but is deterred from doing so by a country gentleman who lays a restraining hand on his arm, the "silent pleading" of the title.

Silver Dollar Bar　Edward Burra, 1955, York City Art Gallery.

The painting depicts a scene in the Silver Dollar Bar, Boston, a nightclub the artist first visited in 1937.

Silver Favorites　Sir Lawrence Alma-Tadema, 1903, Manchester City Art Gallery.

Three young Roman women are by a fish pool. One reclines, the second is seated, and the third, standing, feeds the fish, which are carp, and the "silver favorites" of the title.

Silver Morning　Arnesby Brown, 1910, Tate Gallery, London.

A herd of cattle stands in the morning sun. The title refers to the bright silver clouds in the sky and perhaps also to the white hide of the foremost bullock.

Sin (German, *Die Sünde*)　Franz von Stuck, 1893, Neue Pinakothek, Munich.

The painting is a depiction of Eve, her naked upper body entwined by a massive serpent, its head resting on her shoulder. The artist designed the altar-like gilt frame of the painting, and its base panel is engraved with the title "DIE SUENDE" in prominent capital letters.

Sir Isumbras at the Ford John Everett Millais, 1856–7, Lady Lever Art Gallery, Port Sunlight.

Two children, a young girl and a small boy, cling to an aged knight as he crosses a ford on his horse. Or, as a more romantic account has it: "In the June twilight the old knight with the golden armour is riding home, dusty with his day's work. At the ford he has found the wood-cutter's children, wishful to cross. Like a true gentleman of chivalry … he has taken them on his saddle" (*Bibby's Annual*, 1913). The picture, originally entitled *A Dream of the Past*, has no particular literary or mythical source, although it was accompanied by a pseudomedieval poem by Thomas Taylor that sought to explain it. *Sir Isumbras* is the title of a (real) medieval verse romance in which the character of the name, a young and handsome warrior, loses his wife, children, and possessions and suffers for 21 years among the Saracens.

The Sisters Margaret Carpenter, 1839, Victoria and Albert Museum, London.

The portrait of two young girls is traditionally said to be of the artist's daughters, Henrietta and Jane, although a listing in an 1866 publication identifies the pair as the Misses Brandling.

The Sisters of the Artist *see* **Two Sisters**.

Sistine Madonna Raphael, *c.*1512–14, Gemäldegalerie, Dresden.

The artist's most famous painting of the Virgin and Child is named for the church of S. Sisto (St. Sixtus), Piacenza, its original location. The church was named for Pope Sixtus II (died 258), who with St. Barbara also appears in the picture. The work is thus not named for the Sistine Chapel in the Vatican, which was built by (and named for) Pope Sixtus IV (1414–1484), although Raphael was involved in decorating it and was commissioned to produce cartoons for tapestries portraying scenes from the Acts of the Apostles.

Sixtus IV Appointing Platina Prefect of the Vatican Library Melozzo da Forlì, 1477, Vatican Museums.

The courtly scene depicts Pope Sixtus IV (*see* **Sistine Madonna**) apppointing Platina librarian of the Vatican in 1475. Platina was the humanist scholar Bartolomeo Sacchi (1421–1481), so called because he was born in Piadena, the Latin name of which was *Platina*.

The Skater Gilbert Stuart, 1782, National Gallery, Washington, D.C.

The full-length portrait is of one William Grant, here shown skating in St. James's Park, London.

Skeleton Studying Chinoiseries (French, *Squelette regardant les chinoiseries*) James Ensor, 1885, private collection.

A skeleton is glimpsed through an open door as it sits inspecting what appears to be an album of Japanese prints. The painting summarizes the world of fantasy inhabited by the artist in his attic studio in his birth town of Ostend, Belgium.

The Skylark's wing encircled by the blue of gold rejoins the heart of the poppy that sleeps on the meadow adorned with diamonds Joan Miró, 1967, private collection.

At first sight the painting appears to be nothing more than a black oval surrounded by a mauve halo against a yellow background with, below, on a green background, a small red blob with a white aura. The two fields of yellow and green are separated by a fairly thin black strip. The title, however, indicates what the artist intended the viewer to perceive. "The lark's wing has acquired a blue aura from the sky, and we now realize that we are enveloped in golden light, looking down from a height at a small scarlet poppy which illuminates the space round it like the sparkle of diamonds. The title becomes a poetic accompaniment to the painting and also supplies an interpretation of colour and space that extends and completes their effect" (Penrose, p. 177).

The Slave Market (French, *Le Marché d'esclaves*) Jean-Léon Gérôme, 1867, Sterling and Francine Clark Art Institute, Williamstown, Massachusetts.

A young white slave stands stripped and submissive as her teeth are examined by a potential purchaser in an oriental market.

The Slave Ship J.M.W. Turner, 1840, Museum of Fine Arts, Boston, Massachusetts.

A ship heads away through a stormy sea, while the chained limbs of abandoned bodies flail in the water, surrounded by sharks and seabirds. The painting was inspired by a real event. When the slave ship *Zong* was struck by plague in 1783, her captain had the diseased slaves thrown overboard, knowing he could

claim insurance on those "lost at sea" but not on any who died of disease. The full title is: *Slavers Throwing Overboard the Dead and the Dying— Typhon Coming On.* The artist attached lines of his own poetry to the painting: "Aloft all hands, strike the top masts and belay; / Yon angry setting sun and fierce edged clouds / Declare the Typhon's coming. / Before it sweep your decks, throw overboard / The dead and dying — n'er heed their chains. / Hope, Hope, fallacious Hope! / Where is thy market now?"

Sleep (1) (Russian, *Son*) Kuzma Petrov-Vodkin, 1911, Russian Museum, St. Petersburg; (2) (Spanish, *Sueño*) Salvador Dalí, 1937, private collection.

Petrov-Vodkin shows a naked youth, slumped asleep against a rock, watched by two equally naked women, one young and one older, presumably mother and daughter. Dalí's Surrealist painting depicts a sleeper's head supported on crutches against a background of dream-like images. The implication is that if one of the crutches should break, the sleeper will wake.

Sleep and His Half-Brother Death
John William Waterhouse, 1874, private collection.

Two youths recline side by side on a couch. The foremost, who is Sleep, has his eyes closed and rests his head on the shoulder of the other, who lies with head thrown back as Death. The metaphor of Death as the brother of Sleep is an old one, dating from classical times. Homer's *Iliad* has "Sleep, brother of Death" and Pope's 1718 version of this work has "Death's half-brother, Sleep." The incentive for the painting must have been the deaths of two of the artist's brothers from tuberculosis.

The Sleep of Endymion (French, *Le Sommeil d'Endymion*) Anne-Louis Girodet de Roucy, 1792, Louvre, Paris.

In Greek mythology, the shepherd Endymion was loved by Selene (the Moon), who persuaded Zeus to grant him eternal sleep so she could visit him each night in a cave without waking him. The painting does not depict the person of Selene, however, but Cupid, who parts the leaves of a tree so that Selene's beams fall on the nude Endymion as he sleeps.

The Sleep of Reason Produces Monsters
(Spanish, *El sueño de la razón produce monstruos*) Francisco de Goya, c.1798, Metropolitan Museum, New York.

The title is that of Plate 43 of Los **Capri-**chos. It depicts the artist, his head in his arms, sleeping at a desk. Behind him hover monstrous owls, bats, and a huge cat. The title itself is inscribed on the desk. The artist's commentary reads: "Imagination abandoned by reason produces impossible monsters: united with her, she is the mother of the arts and the source of their wonders." The plate was originally intended to preface *Los Caprichos* and to carry the explanation: "The artist dreaming. His only purpose is to banish harmful, vulgar beliefs and to perpetuate in this work of caprices the solid testimony of truth."

The Sleepers, and the One That Watcheth Simeon Solomon, 1870, Leamington Spa Art Gallery.

The painting is of the heads of three young people side by side, arms and hands embracing or holding one another. Two of the figures have their eyes closed in sleep, while the third, a woman, seems to stare into space with unseeing eyes. The picture appears to have no obvious subject or allusion, and the title merely describes the three in quasibiblical terms.

The Sleeping Beauty Edward Burne-Jones, 1871, Manchester City Art Gallery.

A young woman lies languidly asleep on a couch, one hand resting on her neck, the other behind her head. She is the "The Sleeping Beauty" of Charles Perrault's *Histoires et contes du temps passé*, also known as *Contes de ma Mère l'Oye* ("Mother Goose Tales") (1697), or more precisely Tennyson's reincarnation of her in his poem "The Day-Dream" (1842).

Sleeping Faun *see* **Barberini Faun**.

The Sleeping Gypsy (French, *La Bohémienne endormie*) Henri Rousseau, 1897, Museum of Modern Art, New York.

The artist described the painting as follows: "A wandering negress, playing the mandolin, with her jar beside her (vase containing drinking water), sleeps deeply worn out by fatigue. A lion wanders by, detects her and doesn't devour her. There is an effect of moonlight, very poetic.The scene takes place in a completely arid desert. The gipsy is dressed in oriental fashion" (quoted in Alley 1978, p. 45).

Sleeping Nymphs Peter Lely, 1650–60, Dulwich College Picture Gallery, London.

Five nude nymphs lie, recline, or sit asleep in a shady bower.

Sleeping Satyr *see* **Barberini Faun**.

The Sleeping Town (French, *La Ville endormie*) Paul Delvaux, 1938, private collection.

Four nude women pose in a classical townscape by moonlight, one covered in leaves (perhaps symbolizing birth), another shrouded in drapery (perhaps representing death). The artist himself looks on from a doorway to the left. The title seems to imply that the scene as a whole is that of a dream.

Sleeping Venus (1) Giorgione, *c.*1510, Gemäldegalerie, Dresden; (2) (French, *La Vénus endormie*) Paul Delvaux, 1944, Tate Gallery, London.

Her left hand cupping her genitals, her right arm raised behind her head, Giorgione's nude Venus lies peacefully asleep in a cloudy landscape that may have been completed by Titian. The painting's location has given it the alternate title of *Dresden Venus*. Delvaux's Venus, also nude, her hands behind her head, her body fully exposed, sleeps in a Roman setting on a couch suggesting a sacrificial altar. At her head stands another, gesticulating nude, while at her feet a lady in Edwardian dress (or possibly a dressmaker's dummy) is greeted by a skeleton. Further nudes in the background adopt attitudes of despair. *Cf.* **Venus of Urbino**.

The Small Cowper Madonna Raphael, *c.*1505, National Gallery, Washington, D.C.

The painting of the Virgin and Child was purchased in the late 18th century by Lord Cowper for his collection at Panshanger, Hertfordshire, England. Hence its name. It is "small" because not as large as the later **Niccolini-Cowper Madonna**.

The Snail (French, *L'Escargot*) Henri Matisse, 1953, Tate Gallery, London.

The work consists of individual pieces of colored paper arranged in a spiral shape on a white background, so suggesting a snail's shell.

The Snake Charmer (French, *La Charmeuse de serpents*) Henri Rousseau, 1907, Musée d'Orsay, Paris.

Snakes slither darkly from the jungle as a sinister female figure plays the flute by the river under a moonlit sky, an exotic water bird by her side. In the artist's famous "jungle" pictures, the jungle itself is said to represent the unconscious, so that the snakes here are unwelcome or even harmful memories, brought forth by a subtle evocation. The French title, unlike the English, specifies the sex of the charmer.

Snake in the Grass Joshua Reynolds, 1784–8, Hermitage, St. Petersburg.

A young woman, breasts bared, peeps coyly from behind her hand as Cupid tugs at her sash. She is the "snake in the grass" of the title, and is thus being unfaithful in her alluring pose.

Snap the Whip Winslow Homer, 1872, Butler Institute of American Art, Youngstown, Ohio.

Barefoot boys, hands held in a line, play the game of the title in a mountain meadow after school. (In the game itself, also known as *crack the whip*, the players join hands in a line and rush forward together until the leader suddenly turns, causing the line to veer sharply or "snap," so that those at the end of the line are thrown off.)

Snare Paula Rego, 1987, British Council, London.

A girl on a beach leans forward to pull up a sick dog by its forepaws at it lies on its back. A crab is on its back nearby, feebly waving its legs in the air. The dog is thus held helplessly by the girl who is herself stranded on the beach, like the crab on its back. The original title of the painting was actually *Beached*.

Snow Storm J.M.W. Turner, 1842, Tate Gallery, London.

The scene is a snow storm at sea. The lengthy subtitle spells out the maritime maneuver and the artist's own involvement: *Steamboat off a Harbor's Mouth Making Signals in Shallow Water, and Going by the Lead (the Author Was in this Storm on the Night the Ariel Left Harwich)*. To "go by the lead" is to use the sounding lead to judge the depth of water.

Sod You Gits Sarah Lucas, 1990, Saatchi Collection, London.

The art object is a photocopy of a double-page spread from the November 11, 1990 issue of the tabloid newspaper *Sunday Sport*. The title is the spread's top headline, as the alleged retort of its feature, a midget model named Sharon Lewis (the "laugh-a-minute sex thimble"), to those who dub her a sick freak. The British invective phrase amounts to something like "Screw you, assholes."

Soft Construction with Boiled Beans Salvador Dalí, 1936, Tate Gallery, London.

The painting depicts a monstrous human figure, its face in agony, its limbs tearing themselves apart. One hand squeezes its breast, while

a foot rests on its lower torso. Since the torn flesh suggests the meat of a meal, it is scattered with boiled beans by way of vegetables. The picture's subtitle is *Premonition of Civil War*, and the artist liked to claim it proved his genius, since it was completed six months before the outbreak of the Spanish Civil War. *Cf.* **Dali-Christ**.

Solitude Frederic Leighton, *c.*1889–90, Maryhill Museum of Art, Washington, D.C.

A young woman draped in white, her head wrapped, her eyes downcast, is deep in thought as she sits on a rocky outcrop over a still pool of water. The reason for her isolation is uncertain. Perhaps she simply represents an individual human life, which is ultimately solitary.

Sollie 17 Edward and Nancy Kienholz, 1979–80, private collection.

The work is a re-creation of a small and seedy hotel bedroom. In it, a man lies on the bed reading a novel. The same man is also shown sitting on the bed, his head bowed, and standing at the window, where he patiently views the dull city scene. The impression is that he seeks to escape from his cramped and dreary surroundings. The title puns on the 1953 movie *Stalag 17*, about a German prisoner-of-war camp, with Sollie (a pet form of Solomon) presumably being the name of the depicted man, himself such an internee.

Solstice of the Sunflower Paul Nash, 1945, National Gallery of Canada, Ottawa.

The painting was apparently inspired by the ancient fertility rite of rolling a firewheel at the time of the summer solstice. The artist describes the work: "The spent sun shines from its zenith encouraging the sunflower in the dual role of sun and firewheel to perform its mythological purpose. The sun appears to be whipping the sunflower like a top. The sunflower tears over the hill cutting a path through the standing corn and bounding into the air as it gather momentum. This is the blessing of the Midsummer fire" (quoted in Wilson 1979, p. 156).

Some Comfort Gained from the Acceptance of the Inherent Lies in Everything Damien Hirst, 1996, Saatchi Collection, London.

The installation consists of 12 identical steel-framed glass cabinets containing parts of a vertically dissected cow preserved in formaldehyde. The title seems to imply that every object, however fragmented, inherently relates to all others of its kind, and that consideration of this fact is to some extent comforting. All disorder thus inherently relates to order, and all parts consistently make a whole. Put another way, an acceptance of our inherited human nature enables us to apply the same principle to everything and to be reassured by it.

Someone Waits Spencer Gore, *c.*1907, City Museum and Art Gallery, Plymouth.

A young woman in a hat stands before a window, through which a man is glimpsed walking by. It is unclear whether she is waiting for him to call or he is waiting for her to come out. Or possibly he is nothing to do with the woman, who is waiting for someone or something.

"Something Wrong Somewhere" Charles Green, 1868, Victoria and Albert Museum, London.

The proprietor of a grocery business and his wife puzzle over a ledger in the back room of their shop. The figures do not add up, and there seems to be "something wrong somewhere." The title is sometimes accompanied by an explanatory subtitle: *A Grocer and his Wife examining an Account Book*.

The Son of J.G. Lambton, Esq. *see* **The Red Boy**.

Song of the Aspen Bert Geer Phillips, *c.*1926–8, Eiteljorg Museum of American Indian and Western Art, Indianapolis, Indiana.

An Indian youth squatting on a rock plays a flute in an autumnal wood of golden aspens.

The Song of the Talking Wire Henry Farny, 1904, Taft Museum, Cincinnati, Ohio.

Returning to his camp with provisions, an American Indian brave has stopped to place his ear against a telegraph pole, where he can hear the buzzing and clicking of Samuel Morse's invention. He does not seem to comprehend its purpose or function, and to him it is simply a "talking wire." *Cf.* **Indian Telegraph**.

Song of the Wayland (German, *Wielandsgesang*) Anselm Kiefer, 1982, private collection.

The mixed media work depicts Wayland the Smith, the mythical being who, having been crippled by the king to prevent him leaving, forged his own wings to make his escape after raping the king's daughter and killing his two sons. He is seen here against the background of a scorched and desolate landscape.

The Sonnet William Mulready, 1839, Victoria and Albert Museum, London.

Seated by a stream, a girl places her hand to her mouth to suppress her laughter as she reads the poem that the young man beside her has given her. He is ostensibly tying his shoelace, but looks up slily to see her reaction.

SOS Starification Object Series Hannah Wilke, 1974–82, private collection.

The display is of eight photographs of the artist posing naked to the waist with petal-shaped blobs of chewing gum adhering to her skin like growths. Below the photographs are 15 smaller sculptures of gum, each molded into a fold. The title is based on a pseudomedical nonce word presumably intended to denote the "star-ring" or marking of the body by some kind of malignancy, the initial "SOS" serving as a warning. The artist's mother was battling with cancer at this time, and she herself would die from it in 1993 at the age of 53.

The Soul Attains Edward Burne-Jones, 1868–70, private collection.

For the story behind this final painting in the set of four in the artist's *Pygmalion* series, see The **Heart Desires**.

The Soul in Bondage Elihu Vedder, 1891, Brooklyn Museum, New York.

A naked angel-like figure, representing the Soul, sits in sad constraint, her body and wings bound, her hand and feet tied.

La Source ("The Spring") (1) J.-A.-D. Ingres, 1856, Musée d'Orsay, Paris; (2) *see* **Woman by a Spring**.

"A graceful, golden-haired girl stands nude in a rocky recess, her right arm passed over her head, and supporting the bottom of a vase held on her shoulder with the left hand. Streams of water fall from the vase into a pool at the girl's feet" (*Century Encyclopaedia of Names*, 1904). Both woman and water are the source of life.

Southern-mouthed Hounds Francis Barlow, *c*.1667, Clandon Park, Surrey.

The painting depicts a pack of baying hounds. They are "southern-mouthed" because they face south, and so do not see the hare running in the bottom right corner.

A Souvenir of Velázquez John Everett Millais, 1868, Royal Academy of Arts, London.

The painting is of a small girl in the style and costume of a portrait by Velázquez, an artist admired by Millais.

The Sower of the Systems George Frederick Watts, *c*.1902, Watts Gallery, Compton, Surrey.

The depiction is of God creating the universe, "sowing" the solar system with its planets and the planetary systems with their satellites.

The Spanish Singer (French, *Le Chanteur espagnol*) Édouard Manet, 1860, Metropolitan Museum, New York.

A Spaniard sits on a bench singing to his guitar. Hence the painting's alternate title, *Le Guitarrero* ("The Spanish Guitarist").

Spanish Tambourine Girl *see* The **Unwelcome Companion**.

Speak! Speak! John Everett Millais, 1895, Tate Gallery, London.

The painting is described by the artist's son, John Guille Millais: "A young Roman has been reading through the night the letters of his lost love … At dawn, behold the curtains of his bed are parted, and there before him stands, in spirit or in truth, the lady herself, decked as on her bridal night" (quoted in Ash 1998). The words of the title are thus those of the Roman addressed to the ghost of his lost lady.

The Specter of Sex Appeal Salvador Dalí, 1932, private collection.

The main object in the painting is a rickety propped-up human figure, its torso composed of sacks and wragged wrappings. A small boy in a sailor suit, representing the artist himself at the age of six, regards the Surreal scene, holding a hoop in one hand and an ossified penis in the other. (He appears similarly, as an even smaller figure, in The **Hallucinogenic Toreador**.) The "specter of sex appeal" is thus an unedifying one, and in this case, to judge by the amputated limbs, appears to be connected to cannibalism.

Sphinx Franz von Stuck, 1904, Hessiches Landesmuseum, Darmstadt.

The painting is not of the Sphinx of classical mythology, as in **Oedipus and the Sphinx**, but of a nude woman in a sphinx-like pose, her body raised on her forearms as she lies on a rug.

The Sphinx of the Seashore Elihu Vedder, 1879–80, Fine Arts Museum, San Francisco, California.

A figure of the Sphinx of Greek mythology lies on the seashore amid bones and parts of machinery. The artist himself explained the symbolism: "This figure of an all-devouring Sphinx stretched over the remains of Creation typifies the destructive side of Nature" (quoted in Wilton and Upstone, p. 185).

Spider on the Window, Monster in the Land — Edgar Allan Poe Steven Campbell, 1992, private collection.

A man is seated in a window reading a horror story to two children, a boy and a girl, while two nude women hold up hand mirrors as they recline in armchairs. A spider's web covers the window, through which people can be seen fleeing a giant beetle. As the title suggests, the scene is based on one of Edgar Allan Poe's *Tales of the Grotesque and Arabesque* (1840), in which a man mistakes a spider on a window for a monster far away on a hill.

The Spielers George Luks, 1905, Addison Gallery of American Art, Phillips Academy, Andover, Massachusetts.

Two young girls from one of New York's poor districts enjoy a gleeful dance together as "spielers."

The Spinstress George Romney, 1787, Kenwood House, London.

The depiction of a woman at her spinning wheel is said to have been suggested by the artist's sight of a a cobbler's wife spinning in her husband's shop. The lady portrayed is Nelson's mistress, Emma Hamilton, with whom Romney had long been infatuated.

Spiral Motif in Green, Violet, Blue and Gold: the Coast of the Inland Sea
Victor Pasmore, 1950, Tate Gallery, London.

The first part of the title is a factual description of the abstract painting, which in fact has a residual landscape reference, as suggested by the second part of the title. The artist was at pains to point out that this was only a reference. The work was one of a limited series of landscape themes developed by a free construction of pure form elements. Pasmore wrote: "In each case the title was suggested by the completed picture, in no instance was the picture a representation of an existing or preconceived image" (quoted in Wilson 1979, p. 165).

The Spirit of Our Time (German, *Die Geist unserer Zeit*) Raoul Hausmann, 1921, Musée National d'Art Moderne, Paris.

The Dada sculpture consists of a tailor's dummy head with an array of objects fastened to it, including a tape measure. It illustrates the artist's own comment that the average German "has no more capabilities than those which chance has glued on the outside of his skull; his brain remains empty." This was thus the vapid "spirit of our time."

The Spirit of the Dead Keeps Watch *see* **Manao tupapao**.

The Spirit of the Indian Thomas Moran, 1869, Philbrook Museum, Tulsa, Oklahoma.

An American Indian, a small figure brandishing a bow at the edge of a lake, challenges a spectral giant in the silvery mountains above him. The Indian is Hiawatha, and the giant is the Indian god Manito. H.W. Longfellow's *The Song of Hiawatha* (1855) tells how Hiawatha had to kill the god by shooting a lock of his hair. The "spirit" of the title is the god.

The Spirit of the Summit Frederic Leighton, 1894, Auckland City Art Gallery, New Zealand.

A full-breasted female figure in white sits nobly on a rocky mountain top, gazing up at the starry sky. The painting may have aimed to personify the Swiss peak known as the Jungfrau ("Virgin," "Maiden"), especially as the artist made studies for it in Zermatt. That would then be the "summit" of the title. The "spirit" is both the woman herself and the purity of the human soul that she embodies. The actress Dorothy Dene was the model for the figure.

Sponsa de Libano (Latin, "Bride of Lebanon") Edward Burne-Jones, 1891, Walker Art Gallery, Liverpool.

The painting is based on the biblical Song of Solomon and shows the North and South winds, as two wafting maidens in billowing robes, blowing upon King Solomon's bride of Lebanon.

Lo Sposalizio *see* The **Marriage of the Virgin** (1).

Spring (1) Frederick Walker, 1864, Victoria and Albert Museum, London; (2) (German, *Frühling*) Ferdinand Hodler, 1901, Museum Folkwang, Essen; (3) see **Apple Blossoms**; (4) *see* **Primavera** (1), (2).

Walker depicts a young girl parting the branches of a budding bush as she gathers primroses in the woods with her mother. Both she and the buds symbolize the season named in the title. Hodler's painting is devoted more explicitly to sexual awakening. In the left half of the picture a young girl kneels amid lush grass and blooming flowers, her hands poised, her eyes closed in ecstasy. In the right half, a nude youth sits awkwardly on barren rock, an expression of uncertainty on his face. (He was modeled by the artist's 14-year-old son.)

The Spring *see* **La Source**.

Spring Dance (German, *Frühlingsreigen*)
Franz von Stuck, 1909, Hessisches Landesmuseum, Darmstadt.

Three couples with linked arms perform a lively dance on a hilltop, their back to the viewer. Most are fully or partly clothed, but one woman is naked.

Spring Sale at Bendel's Florine Stettheimer, 1921, Philadelphia Museum of Art, Pennsylvania.

A horde of well-dressed women vie eagerly for bargains as they try on an array of extravagant costumes in the spring sale at Bendel's store, New York.

Springtime Lionel Percy Smythe, 1885, private collection.

A rosy-cheeked young girl struggles to part branches of pussy willow in a woodland glade. The painting evokes Frederick Walker's **Spring** and may have been meant as a tribute to it.

The Squatters George C.Bingham, 1850, Museum of Fine Arts, Boston, Massachusetts.

The squatters were a class of people who, following in the footsteps of such American frontiersmen as Daniel Boone, cleared the land, built rough log cabins, and usually lived by hunting rather than farming. The artist depicts a family of such squatters, the main figures being a seated young man and, leaning on a staff as he stands beside him, his elderly father.

The Squire and the Gamekeeper *see* The **Demurrer**.

Springtime Idyll (Italian, *Idillio primaverile*)
Giuseppe Pellizza da Volpedo, 1896–1901, private collection.

Children dance in a ring among flowering trees while in the foreground a small boy sets a garland on the head of a little girl.

Stag at Sharkey's George Bellows, 1907, Cleveland Museum of Art, Ohio.

The painting depicts a prizefight. A "stag" is a boxing match held in a private club. This one was at a seedy New York saloon run by an Irish crook named Tom Sharkey. *Cf.* **Dempsey and Firpo**.

Stages of Cruelty (1) Ford Madox Brown, 1856–90, Manchester City Art Gallery; (2) *see* The **Four Stages of Cruelty**.

A young woman gives a polite brush-off to a suitor while her little sister smacks a patient bloodhound with a spray of love-lies-bleeding. The artist presumably took his title from William Hogarth's The **Four Stages of Cruelty**, especially in view of the animal "torture." The painting's original title was *Stolen Pleasures Are Sweet*, quoting the old saying, itself a variant on the biblical words, "Stolen waters are sweet" (Proverbs 9:17). The title is hardly appropriate, although it may have been for an earlier version of the picture.

The Stages of Life Caspar David Friedrich, 1834–5, Museum der Bildenden Künste, Leipzig.

An elderly man, his back to the viewer, stands on the shore looking out to sea where ships are sailing. Between him and the sea a young man stands facing the viewer, while a seated young woman watches two children playing with a Swedish flag. The five figures represent the four stages of life. The children are childhood, the girl is youth, the young man is maturity, and the elderly man is old age. The five have been identified as the artist and his family. The elderly man is 60-year-old Friedrich, the children are his son, Gustav Adolf, and younger daughter, Agnes, the girl is his elder daughter, Emma, and the young man is his nephew.

The Staircase Group Charles Willson Peale, 1795, Philadelphia Museum of Art, Pennsylvania.

Two youths, one carrying an artist's palette, pause and look back as they climb a staircase. They are two of the artist's sons, Raphaelle and Titian, here portrayed lifesize. The original painting had a real step at the bottom and a real doorframe. Peale named all of his four sons after painters and they all became painters. The other two were Rembrandt and Rubens.

Standing Nude *see* **Nude Against the Light**.

Standing Woman Gaston Lachaise, 1912–17, Albright-Knox Art Gallery, Buffalo, New York.

The artist's most famous work is a sculpture of a massive female nude.

Starlit Waters Ian Hamilton Finlay, 1967, Tate Gallery, London.

The work consists of the two words of the title made of solid wooden letters standing on a base. It is painted green, the color of the sea, and

covered with orange fishing-net. The overall reference is thus to fishing boats, and the words form a short poem relating to this. (If it were not for the net the allusion would not be so specific, and could be simply to romance.) The artist in fact took the title from the name of an actual working fishing boat.

Stars in Snails' Sexes (French, *Étoiles en des sexes d'escargot*) Joan Miró, 1936, Museum of Modern Art, New York.

A black shooting star flies through a hooplike red circle, presumably representing a male sperm entering a female sex organ. But why a snail? The title of the Surrealist painting may have been suggested by words from a poem by the Dada poet, Tristan Tzara, translating literally as "a white very white light flee sun and stars snail."

State Hospital Edward Kienholz, 1966, Moderna Museet, Stockholm.

The sculpture represents an emaciated and naked mentally ill patient strapped to the lower bunk of a two-tiered unit while his self-image, encircled by a red nylon thought-balloon, lies strapped to the bunk above. A soiled bedpan lies on the floor. The artist had worked for a time in a California madhouse.

Still Life Willem Kalf, *c*.1653, National Gallery, London.

The title *Still Life* first came into regular use in the 17th century, and applied, as here, to a painting of an arrangement of inanimate objects, usually fruit, dead animals, glasses, bottles, and the like. The term itself derives from Dutch *stilleven*, and although now used for inanimate objects, must originally have applied to depictions of living creatures at rest. The French equivalent is *nature morte*, literally "dead nature," hence related Italian *natura morta* and Spanish *naturaleza muerta*. A Spanish "old master" still life, however, is usually titled *Bodegón*, the same as the word used today for a cheap restaurant. (Both display food and drink.) German *Stilleben* is related to the English. The title is found either on its own or, commonly, with a specification of the objects depicted, if only to distinguish one of the artist's still lifes from another. Examples, in chronological order, are: Juan Sánchez Cotán, *Still Life* (*c*.1600), Frans Snyders, *Still Life with Game and Fruit* (*c*.1613), Francisco de Zurbarán, *Still Life with Oranges* (1633), Giacomo Ceruti, *Still Life with a Pewter Plate, a Knife, a Loaf of Bread, Salami, Walnuts,*

a Glass, and Jug of Red Wine (1750–60), Paul Cézanne, *Still Life with Apples, a Bottle, and a Milk Pot* (1902), Juan Gris, *Still Life with Bottles* (1912), Giorgio Morandi, *Still Life with a Ball* (1918), Fernand Léger, *Still Life with Knife* (1950), John Bratby, *Still Life with a Chip Frier* (1954), Patrick Caulfield, *Still Life with Dagger* (1963). The Willem still life instanced above is in the Dutch style known as *pronk stilleven*, "showy still life" (*pronk* is related to English *prance* and *prank*), describing a lavish display. This one sports a huge red lobster shell on a pewter dish on an oriental carpet on a marble table supported by a cupid with his arms flung back. Its full title is *Still Life with the Drinking Horn of the St. Sebastian Archers' Guild*. The drinking horn is a silver-rimmed, silver-banded buffalo horn, used by the Archers' Guild for ceremonial drinking.

Still Sculpture (French, *Sculpture morte*) Marchel Duchamp, 1959, Robert Lebel Collection, Paris.

The work is a marzipan sculpture of vegetables being eaten by insects. The French title puns on *nature morte* ("still life"). See **Still Life**. Cf. **Still Torture**.

Still Torture (French, *Torture morte*) Marcel Duchamp, 1959, Robert Lebel Collection, Paris.

The work is a realistic plaster model of a human foot with its sole covered in flies. The French title puns on *nature morte* ("still life"). See **Still Life**. Cf. **Still Sculpture**.

The Stolen Child Charles Hunt, 1870, private collection.

In a dingy and dilapidated hovel, a fair-haired little girl looks terrified as she is held by two women, perhaps gypsies, who have taken her from her obviously well-to-do parents. As they begin to strip her of her fine clothes, the door opens and a uniformed police constable enters.

The Stolen Kiss (French, *Le Baiser volé*) Jean-Honoré Fragonard, *c*.1788, Hermitage, St. Petersburg.

A young woman has left the salon where her friends are still at cards in order to look for her silken scarf. Just as she finds it, a young man opens the door, draws her to him, and kisses her on her right cheek. She looks back apprehensively, fearful of being discovered.

Stolen Pleasures Are Sweet *see* **Stages of Cruelty**.

The Stolen Shift (French, *La Chemise enlevée*) Jean-Honoré Fragonard, *c.*1767–72, Louvre, Paris.

Cupid removes the shift of a young woman lying in bed so that she is entirely naked. The sense of "steal" in the title is thus more "take surreptitiously" rather than actually "rob." The French title less ambiguously means "The Shift Removed."

The Stone Breaker and His Daughter Sir Edwin Landseer, 1830, Victoria and Albert Museum, London.

An old man seated by the roadside cracks stones with a hammer while a young girl looks on with an expression of compassion. She is perhaps his granddaughter rather than his daughter, as the title suggests.

Stone City Grant Wood, 1930, Art Institute of Chicago, Illinois.

A small rural community, with farm and windmill, nestles among rolling fields in a valley. Stone City was an actual Mid West community built by a quarry owner (hence its name) and converted by Wood and a colleague, Adrian Dombush, into an art colony.

The Stone Pickers Sir George Clausen, 1886–7, Laing Art Gallery, Newcastle upon Tyne.

Peasant women prepare a field for plowing by gathering stones and piling them in a heap. The model for the young woman who is the central figure was not a real peasant but the artist's children's nursemaid, Mary "Polly" Baldwin.

The Stonebreaker (1) Henry Wallis, 1857, Birmingham City Art Gallery, (2) John Brett, 1858, Walker Art Gallery, Liverpool.

Wallis depicts a grim twilight scene of a stonebreaker who has died while at work on a heap of stones. Brett, by contrast, shows a young country lad cheerfully knapping flints for roadmaking in a rolling sunlit landscape on Box Hill, Surrey, England. The art critic John Ruskin praised both pictures, describing Brett's as "a boy hard at work at his heap in the morning" and Wallis's as "an old man dead on his heap at night" (quoted in Wood 1988, p. 15).

The Stonebreakers (French, *Les Casseurs de pierres*) Gustave Courbet, 1849, Gemäldegalerie, Dresden.*

Two laborers, one young, the other old, toil together to break large stones into small pieces. The painting, a harsh depiction of social injustice, was destroyed in 1945 in the final days of World War 2.

Stonemason's Yard Canaletto, *c.*1730, National Gallery, London.

A small square near the church of S. Vitale, Venice, is littered with blocks and pieces of stone, presumably for building operations nearby. (They may have been connected with the church itself, which was rebuilt in the early years of the 18th century.) The title is perhaps too precise for what is really just a general working area.

Storm in the Forest *see* **Tropical Storm with a Tiger**.

"Stormy" Charles Joseph Staniland, 1880, Victoria and Albert Museum, London.

The scene is best described, and the title explained, by the picture's subtitle: *Two Monks standing in a Road, the one rebuking the other.* The sky is suitably gray and threatening.

The Story of Aristaeus Niccolò dell'Abbate, *c.*1550, National Gallery, London.

The painting depicts several episodes from the classical story of the rustic god Aristaeus simultaneously. In the foreground he pursues Eurydice, wife of Orpheus (she is also shown lying dead, having been bitten by a snake), while to the right he consults with his mother, Cyrene. In the middle distance, Orpheus charms the animals with his lyre.

The Story of Psyche Harry Bates, 1887, Walker Art Gallery, Liverpool.

The silvered bronze triptych depicts figures and events from the Greek legend of Psyche, a king's youngest daughter who was so beautiful that the people ceased to worship Venus (Aphrodite) and turned to her instead. Venus resolved to punish her with various torments. In one of these she had to toil up a rugged mountain, where she expected to be dashed to pieces on the rocks below. She was rescued by Cupid (Eros), who called on Zephyrus, the South Wind, to come to her aid. The central and largest panel shows a young naked Psyche being borne gently away on the back of Zephyrus. The left panel has her sitting on a rock, and the right has Cupid kneeling. *Cf.* **Cupid and Psyche; Psyche Before the Throne of Venus**.

The Story of the True Cross *see* **The Legend of the True Cross**.

Stowing the Sail, Bahamas Winslow Homer, 1903, Art Institute of Chicago.

The painting, one of the artist's best known marine watercolors, depicts a seaman beginning to furl the mainsail of a skiff. (The jib has already dropped, ready for stowing when the main task is finished.) Homer sketched the scene from a dory off Nassau in the winter of 1903 during one of his regular winter holidays in the Bahamas.

The Strange Case of Monsieur K (French, *L'Étrange Cas de Monsieur K*) Victor Brauner, 1934, Alexandre Iolas Collection, New York.

The painting consists of nine panels depicting in each a different metamorphosis of the same character. The title evokes, and was perhaps suggested by, Joseph K, the persecuted protagonist of Franz Kafka's novel *The Trial* (1925).

Strange Fruit Alison Saar, 1985, Baltimore Museum of Art, Maryland.

The sculpture is a carved wooden figure of a nude woman suspended by a rope tied around her ankles. The title derives from the song by Lewis Allen made famous in Billie Holiday's 1939 hit. The song has a horrific description of black people who have been lynched and left hanging on trees, their bodies "swinging in the southern breeze." The woman's pose recalls that of the *Venus pudica* (see The **Birth of Venus**), and a cavity inside the figure's stomach suggests that the "fruit" could also be that of her womb.

The Strange Thing Little Kiosai Saw in the River John La Farge, 1897, Metropolitan Museum, New York.

The strange thing little Kiosai saw in the river was a severed head, here gruesomely depicted in a painting of Japanese inspiration.

The Strapper William Dobell, 1941, Newcastle City Art Gallery.

The portrait is of a young man holding a strap. "A strapper is a stable-hand. His job is to groom the horse, feed and water it, polish and tend the harness and, in general, see that his charge reaches the starting-line as glossy and pampered as a beauty queen" (Gleeson, p. 98). The subject was posed by a professional model at the art school where the artist taught.

The Strawberry Girl Joshua Reynolds, 1773, Wallace Collection, London.

The young girl with a basket of strawberries is a portrait of the artist's niece, Theophila ("Offy") Palmer, later Gwatkin. Her daughter was the subject of The **Age of Innocence**.

Strayed Sheep *see* **Our English Coasts**.

The Stream at Rest Richard Redgrave, 1848, Victoria and Albert Museum, London.

The painting is of an imperceptibly flowing river, the "stream" of the title being its current. When the picture was exhibited in 1849, the title was accompanied by a quotation from James Thomson's poem *The Seasons*, 'Autumn' (1730): "Why should the waters love / To take so far a journey to the hills, / When the sweet valleys offer their soil, / Inviting quiet, and a nearer bend?"

The Street (French, *La Rue*) Balthus, 1933–5, Museum of Modern Art, New York.

The painting depicts what the artist himself described as "a peaceful morning in a peaceful neighborhood in which peaceful citizens go about their business." Eight people are in a city street: two women, one carrying a child, a small girl playing with a racket and ball, a young boy, a workman carrying a plank of wood, and a youth grabbing a young girl between the legs. The innocent title gives no hint of this last assault. The street itself is the rue Bourbon-le-Château, Paris, where the artist had his studio.

The Street Enters the House (Italian, *La strada entra nella casa*) Umberto Boccioni, 1911, Sprengel Museum, Hanover.

A colorful and crowded street scene extends into the foreground of the painting where a woman leans on a balcony. The artist aimed to present the scene to the viewer as if he or she had just opened a window to be confronted by the noise and the spectacle.

The Street Singer (French, *La Chanteuse des rues*) Édouard Manet, 1862, Museum of Fine Arts, Boston, Massachusetts.

The portrait of a young woman with a guitar holding cherries to her mouth is actually of Victorine Meurent, the model for **Olympia**.

Strigils and Sponges Sir Lawrence Alma-Tadema, 1879, British Museum, London.

Three women bathe in a Roman plunge bath. One lightly scrapes the skin of her arm with a strigil (a type of curved blade), while another sponges her legs. The third leans forward to "shower" in the water from a fountain at the edge of the bath.

The Struggle (Italian, *La Sopraffazione*) Afro, 1951, Tate Gallery, London.

The abstract painting can be seen to depict two standing female figures, one of whom is trying to strike the other. The original Italian title

is a noun form of the verb *sopraffare*, "to over-whelm," "to overpower," but English has no exact equivalent of this.

A Student Daniel Maclise, 1862, Bury Art Gallery, Lancashire.

The painting was probably inspired by Gounod's opera *Faust* (1859), based on Goethe's verse tragedy of the same name, telling how the legendary ageing philosopher Faust sells his soul to Mephistopheles in return for eternal youth and the beautiful Marguerite. The artist depicts the scene in which Mephistopheles brings the rejuvenated Faust to the house of Marguerite to woo and win her. She holds a daisy ("mar-guerite") both to represent her name and to sym-bolize the jewels (the name means "pearl") with which Mephistopheles provides Faust as a means to tempt her. She is thus the "student" of the title, and he her "master."

A Studio at Batignolles (French, *Un atelier aux Batignolles*) Henri Fantin-Latour, 1870, Musée d'Orsay, Paris.

The painting portrays a group of artists and writers in Manet's studio in the Paris suburb of Batignolles. From left to right they are: Otto Scholderer, Manet himself painting, Renoir, Zacharie Astruc (seated), Zola, Edmond Maître, Frédéric Bazille, and Monet. The work's alter-nate title is *Homage to Manet* (French, *Hommage à Manet*), so that it is essentially a companion piece to the artist's earlier **Homage to Dela-croix.**

The Studio of Abel Pujol in 1822 (French, *L'Atelier d'Abel Pujol en 1822*) Adrienne-Marie-Louise Grandpierre-Deverzy, 1822, Musée Marmottan, Paris.

The painter Alexandre Denis Abel de Pujol (1785–1861) gives advice to one of the dozen or so female students in his studio as others con-tinue working from the elegantly dressed (fe-male) model. The artist was Pujol's wife and for-mer pupil.

Study of a Magdalen William Etty, 1845, Victoria and Albert Museum, London.

Many works of art are titled as a "study," usually meaning either a preliminary outline or sketch of something or else a finished represen-tation of a subject that has a particular appeal for the artist, perhaps because of its coloring or its specific nature. This painting is a study of a nude woman contemplating a crucifix, "Magdalen" being a term for a reformed prostitute.

A Study with the Peacock's Feathers George Frederic Watts, *c*.1862, private collec-tion.

A bare-breasted young woman wearing an amber necklace reclines in a setting of flowing draperies, her right hand raised to hold a spray of peacock's feathers behind her head. When ex-hibited in 1899 the painting was entitled *Fair Haired Girl*, and when sold at auction in 1934, *The Amber Necklace*. All three titles allude to at-tributes other than the obvious nudity.

Stuff Laurie Parsons, 1988.*

The work was a photograph of an outdoor tableau of natural material such as branches, rocks, and debris strewn on the road. The title is as laconic as was the original display.

The Stuff That Dreams Are Made of John Anster Fitzgerald, 19th c., private collec-tion.

A young girl dreams of her lover, attended by a strange gathering of sprites and fairies. The title is based on Prospero's words from Shake-speare's *The Tempest* (1611) "We are such stuff / As dreams are made on" (IV, i).

The Stumbling Block Jeff Wall, 1991, Marian Goodman Gallery, New York.

The work is a large-scale cibachrome trans-parency depicting a man lying on a city sidewalk waiting for pedestrians to trip over him. A girl is seen in mid-fall, a businessman sits on the ground after falling, and a boy sits on a nearby wall apparently having seen it all before. The title is a phrase normally applied metaphorically. Here it is used literally.

The Suicide's House (French, *La Maison du pendu*, "The House of the Hanged Man") Paul Cézanne, 1873–4, Musée d'Orsay, Paris.

The painting depicts a house in the village of Auvers-sur-Oise where a man had hanged himself.

The Suitors (French, *Les Prétendants*) Gus-tave Moreau, *c*.1853, Musée Gustave Moreau, Paris.

Ulysses (Odysseus) has returned after the Trojan War and now confronts and kills the un-wanted suitors of Penelope, his patient wife. The radiant figure of Minerva (Athene), goddess of war, appears like an apparition in the center of the picture to support him.

Sulamith Anselm Kiefer, 1983, Saatchi Col-lection, London.

The painting of a fire-blackened crypt is based on a Nazi architect's design for a "Funeral Hall for Great German Soldiers" built in Berlin in 1939. The depiction transforms the Nazi monument into a Jewish memorial, with a fire burning on an altar at the far end of the crypt symbolizing the Holocaust. The title quotes from Paul Celan's poem *Todesfuge* ("Death Fugue"), written in a German concentration camp: "Death is a master from Germany / your golden hair Margarete / your ashen hair Shulamith." Margarete is a blonde personification of Aryan womanhood, while Shulamith is a cremated Jewess. She represents the Shulamite, the young girl who is the "Beloved" of the biblical Song of Solomon: "Return, return, O Shulamite; return, return, that we may look upon thee" (6:16).

The Sulphur Match John Singer Sargent, 1882, private collection.

A young woman tips her chair back against the wall, her feet off the ground, while gazing idly at her companion, who lights a cigarette with a sulfur match. His action is presumably selected for the title, and as a focal point of the painting itself, because of its erotic charge.

Summer (1) Giuseppe Arcimboldo, 1573, Louvre, Paris; (2) (French, *Été*) Berthe Morisot, 1879, Tate Gallery, London.

Arcimboldo's painting represents the season not by a landscape but by the figure of a human head composed entirely of summer fruit and vegetables, such as pears, peaches, plums, and ripe corn. The figure's teeth are peas, its lips are cherries, and its nose is a cucumber. Morisot's painting depicts two young women in a boat on a lake on a summer's day. The women are professional models, and the lake is in the Bois de Boulogne, Paris. The painting was earlier known as *Summer Day* (French, *Jour d'été*).

A Summer Night Albert Joseph Moore, c.1887–90, Walker Art Gallery, Liverpool.

Four seminude young women prepare for sleep on a luxurious balcony overlooking a moonlit lagoon. As the title implies, the painting has no particular story or allegorical content.

Summer Scene *see* The **Bathers** (2).

Summer Shower Edith Hayllar, 1883, Forbes Collection, New York.

A tennis party has taken refuge indoors from a summer shower. A young man takes the opportunity to speak to one of the players as she sits demurely with her racket on her lap.

A Summer's Day William Stott of Oldham, 1886, Manchester City Art Gallery.

Three young boys play naked on the sands by the sea, one standing, one kneeling, and one reclining.

A Summer's Evening Philip Wilson Steer, 1888, private collection.

Three young women relax on a sandy beach after a summer evening swim. One stands and dries herself, one sits and dresses her hair, the third lies and relaxes. All are naked.

Summit Robert Ryman, 1978, private collection.

The minimalist painting is simply a square white canvas affixed to the wall with metal holders that themselves form an integral part of the composition. The title seems to imply that the artist has achieved a kind of perfection.

Sunday Edward Hopper, 1926, Phillips Collection, Washington, D.C.

A middle-aged bald-headed man sits dejectedly on a deserted sidewalk, dwarfed by the empty store front behind him, on what is for him the emptiest day of the week.

Sunday Afternoon Elaine de Kooning, 1957, Ciba-Geigy Corporation, Ardsley, New York.

The semiabstract painting depicts a stocky black bull. It was inspired by the bull fights that the artist saw (on Sunday afternoons) on a trip to Juárez, Mexico.

Sunday Afternoon on the Island of La Grande Jatte *see* La **Grande Jatte**.

Sunday Dawn (Italian, *Alba domenicale*) Angelo Morbelli, 1890, private collection.

A group of elderly folk make their way down the road to Mass in early morning sunshine. The English title has a punning effect (Sunday sunrise) that the Italian original lacks.

Sunday Morning Asher B. Durand, c.1850, New York Historical Society.

A little New Jersey family, all in their Sunday best, come out of their cottage to walk down a winding lane and over a stream to the church in the background. One of the community's elders is already stumping his way down the lane with his cane.

Sunday Morning in the Mines Charles C. Nahl, 1872, E.B. Crocker Art Gallery, Sacramento, California.

The artist presents an amalgam of the people and events that he saw during his time in the mining camps during the California gold rush. Among the dozen or so characters depicted are a young drunken miner about to throw away his purse of gold, some racing horsemen, a group brawling over a card game, a man on a keg reading the Bible while two companions listen attentively, and two more men preparing their weekly laundry. Inside a cabin a man writes a letter that begins: "Dear Mother, I have done well and I..."

The Sunflowers (French, *Les Tournesols*)
Vincent van Gogh, 1888, National Gallery, London.

The artist painted a series of seven pictures of sunflowers, of which three, including this one, have 14 flowers, two have 12, one has six, and one has three. In 1890 he told his sister and the critic, Albert Autier, that the canvases of sunflowers symbolized "gratitude." He also saw the individual flowers as miniature suns, so they justify their name.

Sunlight Sir William Orpen, *c*.1912, National Gallery of Ireland, Dublin.

A nude model is bathed in the sunlight that streams through the window as she pulls on a stocking while seated sideways in an armchair.

The Supper at Emmaus Caravaggio, *c*.1596–1602, National Gallery, London.

The scene is from the New Testament. Two of the disciples meet Jesus after his resurrection as they walk to the village of Emmaus and not recognizing him invite him to have supper with them. The painting depicts the moment when he blesses and breaks the bread and they realize who he is (Luke 24: 30–31).

Surprised! *see* **Tropical Storm with a Tiger**.

The Surrender of Breda Diego Velázquez, 1634–5, Prado, Madrid.

The historical scene is set in 1625. The Spanish commander, Ambrogio Spinola, receives the key of the town of Breda from his Dutch counterpart, Justin of Nassau, making a grand gesture of magnanimity as he does so.

Surrounded by Enemies (German, *Feinde ringsum*) Franz von Stuck, 1914, private collection.

The bronze sculpture depicts a naked warrior wielding a sword. Its title comes from a slogan coined by the German emperor, Wilhelm II, at the beginning of World War I. A similar warrior appeared on war bond posters in Germany at this time, but with different titles.

Susanna and the Elders (1) Jacopo Bassano, 1571, Musée des Beaux-Arts, Nîmes; (2) Artemisia Gentileschi, 1610, Louvre, Paris; (3) Anthony van Dyck, *c*.1621–2, Alte Pinakothek, Munich; (4) Sebastiano Ricci, 1713, Chatsworth House, Derbyshire.

The scene is from the apocryphal History of Susanna. Susanna, a young married woman, is desired by two elders. They conceal themselves in her garden, awaiting the moment when they can emerge as she is bathing and accuse her of the sin of adultery unless she gives herself to them (Susanna 19–21). The paintings depict their emergence, with a naked Susanna recoiling from the lecherous men. *Cf.* **Susanna and the Two Elders**, **Susanna Bathing**.

Susanna and the Two Elders (German, *Susanna und die beiden Alten*) Franz von Stuck, *c*.1913, private collection.

The subject is that of **Susanna and the Elders**, although here Susanna, her back to the viewer, holds a towel up to screen her body from the gaze of the lascivious old men.

Susanna at Her Bath (1) Albrecht Altdorfer, 1526, Alte Pinakothek, Munich; (2) Tintoretto, *c*.1565, Kunsthistorisches Museum, Vienna.

The depiction is of the moment in the apocryphal History of Susanna when the two elders spy on Susanna as she is bathing in her garden. (*Cf.* **Susanna and the Elders**.) Altdorfer's painting depicts not only Susanna bathing, attended by her maids, but the subsequent stoning of the elders (Susanna 62).

Susanna Bathing (German, *Susanna im Bade*) Franz von Stuck, 1904, Kunstmuseum St. Gallen, St. Gallen.

The subject of the painting is that of **Susanna and the Elders**. Here Susanna stands naked in the water, covering herself with her hands. However, it is the viewer who is the real voyeur, since she has her back to the two old men.

Susanna Lunden *see* Le **Chapeau de paille**.

Suspense Sir Edwin Landseer, 1834, Victoria and Albert Museum, London.

A large dog waits patiently by a door. The viewer is left to interpret the precise nature of the suspense. The dog may be merely hungry. However, a blood-stained feather lies beside him, giving a further clue. It has been suggested that he is a noble bloodhound, watching at the door for his master, a knight. The feather is an eagle plume torn from the knight's helmet in deadly combat. Dog and viewer are now thus held in suspense to learn if the knight still lives.

Suspicion Thomas Unwins, 1848, Victoria and Albert Museum, London.

A young woman sits on a terrace before a minstrel who plays a harp. Behind stands an elderly chaperone, her face expressing her suspicion. Can the minstrel be a lover in disguise?

Swans Reflecting Elephants Salvador Dalí, 1937, private collection.

The painting outwardly depicts three swans on a pond, floating on the water against a background of tree stumps. Yet their reflections in the water are clearly elephants. Furthermore, turn the picture upside down, and the swans (on the water) immediately become elephants, while the elephants (in the water) become swans. (The long necks of the swans double up as the elephants' trunks, and their spread wings as the elephants' ears.) A lifelike figure of a man stands on a rock nearby, his back to the water, no doubt reflecting on the swans that reflect the elephants and the elephants that reflect the swans.

The Swearing of the Oath of Ratification of the Treaty of Münster Gerard Terborch, 1648, National Gallery, London.

The painting is one of the few 17th-century Dutch representations of contemporary history. It is a group portrait of the signatories to the treaty that later that year brought an end to the Thirty Years' War. The full title ends with the date of the swearing, *May 15, 1648*.

Sweet Dreams, My Master Peter Howson, 1995, Angela Flowers Gallery, London.

The painting is the second in the series of seven inspired by Stravinsky's opera *The Rake's Progress* (*see* **Farewell, Farewell**). Here, Tom Rake has begun his downward progress and is clasped by a drunken prostitute in Mother Goose's brothel. The title quotes from the libretto.

Swimming Thomas Eakins, 1885, Amon Carter Museum, Fort Worth, Texas.

A group of men swim and dive nude in a river. The painting is based on photographs of the artist's own art students doing likewise. An alternate title is *The Swimming Hole*.

The Swimming Hole *see* **Swimming**.

The Swing (1) (French, *L'Escarpolette*) Jean-Honoré Fragonard, *c.*1766, Wallace Collection, London; (2) Pierre-Auguste Renoir, 1876, Musée d'Orsay, Paris.

The commission for Fragonard's famous picture of a fashionably dressed young woman kicking off her dainty shoe as she flies high on a swing was originally given by the Baron de Saint-Julien to the religious painter Gabriel-François Doyen. When Saint-Julien asked Doyen to paint his mistress on a swing with a bishop pushing her, and to portray himself looking up her skirts, the artist was scandalized, however, and rejected the commission. It therefore went to Fragonard. The painting's full French title is *Les Hasards heureux de l'escarpolette* ("The Agreeable Opportunities of the Swing"), referring to the patron's peeps under the petticoats. (It should be remembered that drawers had not yet been invented.) Renoir's painting is much more decorous, and depicts a young woman, a model named Jeanne Samary, being addressed by a young man as she stands by a stationary swing in a shady garden (that of the artist's studio in Montmartre, Paris).

Symphony in White No. 1: The White Girl J.A.M. Whistler, 1862, National Gallery, Washington, D.C.

The portrait of a somewhat disheveled young woman all in white standing on a wolf-skin rug with a white lily in her hand before a white curtain was originally called *The Woman in White*, echoing the title of Wilkie Collins's highly popular novel of 1860. When critics complained that the subject looked nothing like the novel's heroine, however, Whistler retitled it *The White Girl*. The subject is the artist's mistress, Joanna Hiffernan. The French critic Paul Mantz subsequently referred to the picture as a *Symphonie du blanc*. Whistler adopted the musical analogy, and in 1872 renamed the work *Symphony in White, No. 1*. Cf. **Symphony in White No. 2: Little White Girl**.

Symphony in White No. 2: Little White Girl J.A.M. Whistler, 1864, Tate Gallery, London.

This painting follows on from the one above. The woman in white here is again the artist's mistress, Joanna Hiffernan. The title does

not relate to the subject (she is not a "Little White Girl") but to the dimensions of the portrait, which is less than half the size of its predecessor.

Synchromy Morgan Russell, *c*.1913, Museum of Modern Art, New York.

The title refers to Synchromism, the abstract art movement founded by Stanton Macdonald-Wright and the artist in 1912. It literally means "colors together," from the Greek, and was described by Russell as "a piece of expression solely by means of color and the way it is put down, in showers and broad patches, distinctly separated from each other, or blended" (Chilvers, p. 518). Various other works of the artist incorporated the term, such as *Synchromy in Orange: To Form* (1913–14), one of the earliest purely abstract paintings.

The Syndics *see* The **Syndics of the Drapers' Guild**.

The Syndics of the Drapers' Guild Rembrandt van Rijn, 1662, Rijksmuseum, Amsterdam.

The painting is a group portrait of the sampling officers connected with the musketeers' company depicted in The **Night Watch**. It is sometimes known simply as *The Syndics* or by the longer and more explicit title, *The Sampling Officers of the Clothmakers' Guild*.

The Syracusan Bride Frederic Leighton, 1865–6, private collection.

The subject of the large canvas, whose full title is *The Syracusan Bride Leading Wild Beasts in Procession to the Temple of Diana*, was suggested by a passage in the second *Idyll* of Theocritus. The artist linked the scenario to the Syracusan tradition of sending betrothed young women to the temple of Artemis to appease the virgin goddess. The bride herself stands beside a garlanded lion as the central figure, with groups of 12 flanking her each side.

T

Ta matete ("The Market") Paul Gauguin, 1892, Kunstmuseum, Basel.

Five women are seated on a bench, with a fifth figure standing by. It is generally thought they are prostitutes awaiting clients in the mar-

ketplace, although the painting has the alternate title *We Shall Not Go To Market Today*, suggesting that the women, who wear their best dresses, are being urged to go by the standing figure.

Tahitian Pastoral *see* **Faa iheihe**.

Tahitian Pastorals (French, *Pastorales Tahitiennes*) Paul Gauguin, 1892, Hermitage, St. Petersburg.

A young Tahitian woman stands by a flowering tree under which a seated woman plays a flute. A dog lies in the foreground. The title is at bottom right. The artist said of his painting: "Exceptionally, I gave it a French title: *Pastorales Tahitiennes*, not finding a corresponding title in the language of the South Seas" (quoted in Bowness 1991, p. 102). "The importance of titles to all the works Gauguin produced in Tahiti should not be overlooked, especially since they were usually written prominently in large letters. These add a further dimension to his paintings and demonstrate his attempts to woo a Parisian audience with whimsical, allusive names that conjure up visions of an idyllic existence" (*ibid.*).

A Taint in the Wind Frederic Remington, 1906, Sid Richardson Collection of Western Art, Fort Worth, Texas.

Horses drawing a stagecoach through the night rear up in fear as they detect the unfamiliar scent of Indians and their mounts waiting in ambush. The strange odor is the "taint in the wind" of the title.

"Take Your Son, Sir!" Ford Madox Brown, 1857, Tate Gallery, London.

With the words of the title, a wronged woman holds her baby out to her seducer, who can be glimpsed in a mirror behind her. The (unfinished) painting was prompted by the passing of a new bill in England, in which for the first time women were able to sue for divorce.

Takka Takka Roy Lichtenstein, 1962, Museum Ludwig, Cologne.

The painting is one of the artist's comic-strip-style images, here a battle scene. The title, which appears in the picture itself, represents the rattle of machine guns. A 25-word caption adds an appropriate descriptive text.

A Tale from the Decameron John William Waterhouse, 1916, Lady Lever Art Gallery, Port Sunlight.

A group of young women, one crowned "queen" for the day, are seated by some steps in

a garden listening to a minstrel's tale. As the title indicates, the depiction is of a scene from the *Decameron*, a collection of tales by the 14th-century writer Boccaccio, in which seven young women and three young men flee the plague in Florence and tell one another tales over a period of ten days (hence *Decameron*, "ten days"). The painting shows one of the young men telling his own particular tale. *Cf.* The **Enchanted Garden**.

Tale of the Sea (German, *Seegeschichte*) Max Pechstein, 1920, private collection.

In what appears to be a seaside setting, a woman in a red dress leans forward to talk to a naked young girl (who has her back to the viewer) while another woman in a white dress looks on. The title suggests that the first woman is telling a story of adventure at sea. The subject may have been suggested by The **Boyhood of Raleigh**, depicting a similar sea tale.

Tamara's Dance (Russian, *Plyaska Tamary*) Mikhail Vrubel, 1890–1, Tretyakov Gallery, Moscow.

The painting is an illustration to Mikhail Lermontov's poem *The Demon* (1829–39), about the love of a demon for a mortal. It depicts Tamara, the mortal in question, dancing with her Georgian bridegroom at the foot of a carpeted staircase while an orchestra plays in the foreground. Behind her, in a dream image, the brooding Demon leans against a rock surrounded by desolate mountains.

Tanaquil, Wife of Lucomo Domenico Beccafumi, *c.*1520, National Gallery, London.

The painting depicts the legendary Etruscan prophet Tanaquil, wife of Tarquinius Priscus, originally called Lucomo, who is said to have been king of Rome from BC 616 to 578. She points to a tablet with a Latin inscription (beginning "*SVM TANAQVIL*") that identifies her.

Taperaa mahana ("Late Afternoon") Paul Gauguin, 1892, Hermitage, St. Petersburg.

A group of Tahitian women have gathered to sit under trees towards evening while, to the right of the picture, two other women continue walking as if paying a visit. The English title is the correct one for the work, which has also been known as "Approaching Evening."

Target with Plaster Casts Jasper Johns, 1955, Leo Castelli Gallery, New York.

A five-ringed target on a red background predominates beneath a row of nine boxes containing colored plaster casts of parts of the human body, among them a foot, a hand, an ear, a nose, and a penis. The title seems to imply that they are not an integral part of the work, but in some way complementary.

Tarquin and Lucretia Titian, *c.*1571, Fitzwilliam Museum, Cambridge.

The painting depicts a scene from the legendary early history of Rome. The virtuous Lucretia, wife of Tarquinius Collatinus, is about to be raped at sword point by Sextus Tarquinius, son of the tyrant Tarquinius Superbus. The dishonor led her to commit suicide.

Tarquinia Madonna Fra Filippo Lippi, 1437, Galleria Nazionale, Rome.

The artist's first dated work, a portrait of the Virgin and Child, was originally painted for the church of Sta. Maria de Castello at Tarquinia, central Italy. Hence its name.

Tauromaquia (Spanish, *Tauromaquia*, "Tauromachy") Frances de Goya, 1815–16, Metropolitan Museum, New York.

The set of 33 prints traces the history of bullfighting and depicts various famous moments in the Spanish sport. Almost all the scenes are shown from the point of view of a participant in the arena, and most have detailed descriptive titles. Examples are No. 20, *Agility and Daring of Juanito Apiñari in the Bullring of Madrid* (Spanish, *Ligereza y atrevimiento de Juanito Apiñari en la plaza de Madrid*) and No. 21, *Accident in the Front Seats of the Bullring of Madrid and Death of the Mayor of Torrejón* (Spanish, *Desgracias acaecidas en el tendido de la plaza de Madrid y muerte del alcalde de Torrejón*).

Te arii vahine ("The Noble Woman") Paul Gauguin, 1896, Pushkin Museum, Moscow.

A naked Tahitian girl lies beneath a tree around which a snake is coiled, suggesting she is a Polynesian Eve. She is actually the artist's 15-year-old mistress, Pahura. The fruit that lies before her on the grass has given the painting's alternate English title, *Woman with Mangoes*.

Te avae no Maria ("The Month of May") Paul Gauguin, 1899, Hermitage, St. Petersburg.

A Tahitian woman holds a posy of pink blossoms from the flowering tree beneath which she stands. Other blossoms lie on the ground. It is the month of May.

Te fare hymenee ("The House of Song")
Paul Gauguin, 1892, private collection.

Seated on the ground, Tahitians sing, joke, and gossip by firelight in the house that is their communal meeting-place.

Te nave nave fenua ("The Land of Delight") Paul Gauguin, 1892, Ohara Museum of Art, Kurashiki.

A naked young woman stands beneath a tree in a pose suggestive of Eve in the Garden of Eden, as the title suggests. Instead of a snake, however, there is a black lizard in the Tree of Knowledge, and the woman plucks a gaudy flower, not a fruit. She is Teha'amana (Tehura), the young girl with whom the artist was then living in Tahiti.

Te rereiva ("The Meal") Paul Gauguin, 1891, Musée d'Orsay, Paris.

Three Tahitian children are seated at a table on which lie bowls, a knife, and exotic fruit, including a hand of red bananas. The latter gave the painting its alternate title, *Bananas*.

Te rerioa ("The Dream") Paul Gauguin, 1897, Courtauld Institute, London.

A Tahitian couple squat on the floor of a decorated room. The woman is the mother of a child asleep in its crib. A horseman is seen through a window. What is the dream? The artist commented: "That is the title. Everything is dream-like in this picture; is it the child, is it the mother, is it the horseman on the track or better still is it the dream of the painter!!!" (quoted in Alley, p. 95). The painting is also sometimes known in English as *Day Dreaming*.

Te tamari no atua ("The Birth of Christ")
Paul Gauguin, 1896, Neue Pinakothek, Munich.

A young Tahitian woman lies on her bed. To the left behind her are two helpers, one a young mother holding a child with a halo around its head, while to the right is a manger with oxen and a dog. The painting is thus an unusual depiction, in a South Seas setting, of the Nativity.

The Tears of St. Peter El Greco, 1580–5, Bowes Museum, Barnard Castle, County Durham.

The painting depicts the moment in the gospel story when, after the second crowing of the cock, Peter realizes he has fulfilled Christ's prophecy and denied him: "And when he thought thereon, he wept" (Mark 14:72).

The Tempest (1) Giorgione, *c*.1506–10, Accademia, Venice; (2) Oskar Kokoschka, 1914, Kunstmuseum, Basel.

A fashionable young man and a partially nude woman suckling a baby are depicted in Giorgione's painting against the background of a gray and threatening sky, in which a flash of lightning indicates a fast approaching storm. The young mother and baby evoke the Virgin and Child, while the young man suggests a soldier or Christian angel. Perhaps the painting as a whole is designed to represent the cataclysmic event that was the birth of the infant Jesus. The original title is uncertain. The work was described in around 1530 as a "Landscape on canvas with storm, gypsy woman, and soldier," but in 1569 it was listed in the possession of the Vendramin family as *Mercury and Isis*, in which case the man should be Mercury. (X-rays have subsequently revealed that his figure has been painted over that of an old woman.) The current title alludes to the oncoming storm. Kokoschka's symbolic landscape, also known as *The Bride of the Wind*, is essentially an Expressionist portrait of the artist himself and Alma Mahler, widow of the Austrian composer Gustav Mahler, with whom he was in the throes of a tempestuous affair.

Temptation George Smith, 1850, Victoria and Albert Museum, London.

A hard-faced old woman sits by her fruit stall, warily eyeing the children who have gathered round it. They are tempted to try a fruit, but she will respond only to the touch of money. The painting is subtitled simply *A Fruit Stall*.

The Temptation of St. Anthony
(1) Hieronymus Bosch, *c*.1500, National Museum of Art, Lisbon; (2) Niklaus Manuel Deutsch, 1520, Kunstmuseum, Berne; (3) (French, *La Tentation de saint Antoine*) Félicien Rops, 1878, Bibliothèque Royale Albert Ier, Brussels; (4) (German, *Die Versuchung des heiligen Antonius*) Lovis Corinth, 1908, Tate Gallery, London; (5) Salvador Dalí, 1946, Musées Royaux des Beaux-Arts, Brussels.
Bosch and Deutsch drew their subject matter from the *Lives of the Fathers* and Jacobus de Voragine's *The Golden Legend* (*c*.1260), which tell how St. Anthony, living a solitary life of prayer as a hermit, was subjected to many temptations and trials of the flesh but overcame them all. Rops's painting shows the saint before the Cross of Christ on which a naked

woman has taken the place of the Savior. The inscription above her reads "EROS," not the expected "INRI." Corinth's work is closely based on an episode in Gustave Flaubert's prose poem *La Tentation de saint Antoine* (1849, 1856, 1870), in which St. Anthony is tempted by the Queen of Sheba, who appears before him with a train of exotic attendants. The work's original title was actually *The Temptation of St. Anthony after Gustave Flaubert*. Dalí's painting, based loosely and surrealistically on the panel in Grünewald's **Isenheim Altarpiece**, depicts a naked St. Anthony on one knee holding up a cross to an advancing caravan of animals on spindly legs led by a rearing horse. Behind it come four elephants, the first bearing a naked woman flaunting her breasts, the second with an obelisk on its back, the third carrying the remains of a temple (a woman's naked body visible inside), and the fourth bearing a column.

10—16 Gillian Wearing, 1997, Saatchi Collection, London.
 The work consists of a 15-minute video installation of seven films in which adult actors lip-synch the voices of children interviewed by the artist. The title thus refers to their age range.

The Tenant Restored to His Family *see* The **Benevolent Heir**.

The Tenderfoot Charles M. Russell, 1900, Sid Richardson Collection of Western Art, Fort Worth, Texas.
 The depiction is of a cowboy scene. A dude, possibly an Englishman, has arrived at a saloon about sundown. After buying several rounds, he and some cowboys go outside to inspect horses. One of the cowboys decides to have some fun. He trails the dude, then shoots at his feet with his six-gun. The Englishman hops. The wrangler shoots some more, making him dance a proper cancan. The title puns on the literal and metaphorical senses of "tenderfoot."

The Tennis Party Sir John Lavery, 1885, Aberdeen Art Gallery.
 Watched idly by a handful of spectators, two men and two women play a game of the newly fashionable lawn tennis. The picture was painted at Cathcart, Scotland.

The Tepidarium (French, *Le Tepidarium*) Théodore Chassériau, 1853, Musée d'Orsay, Paris

A tepidarium is a warm room between the cold and hot rooms of a Roman bath. In the one depicted here, a nude bather stands and stretches luxuriously amidst her female companions. *Cf.* **In the Tepidarium**.

Terrace at Sainte-Adresse (French, *Terrasse à Sainte-Adresse*) Claude Monet, 1867, Metropolitan Museum, New York.
 The bright and breezy seaside scene is set in the small resort of Sainte-Adresse, near Le Havre, northern France. The placename is probably a form of *Saint-André*, "St. Andrew."

Terror Antiquus (Russian, *Drevniy uzhas*, "Ancient Terror") Leon Bakst, 1908, Russian Museum, St. Petersburg.
 The painting depicts the destruction of some ancient civilization. Earth crumbles away under water and temples collapse, while in the foreground a statue of Aphrodite smiles fixedly. The Latin title matches the classical subject.

The Tetschen Altarpiece Caspar David Friedrich, 1808, Gemäldegalerie, Dresden.
 The painting depicts Christ on the Cross atop a rocky summit surrounded by fir trees and facing the beams of the rising sun. The work is so titled as it was bought by Count Franz Anton von Thun-Hohenstein for his castle at Tetschen, on the Elbe. This despite the fact that the castle had no chapel.

Text Painting Peter Davies, 1996, Saatchi Collection, London.
 The painting is a multicolor written text listing Davies's favorite artists and their importance to him. They include contemporaries such as Anthony Caro ("now he really is one mean badass M.F. S.O.B. ..."), Damien Hirst, Sarah Lucas, and Gilbert and George as well as Warhol, Beuys, and Matisse. The text begins: "Art I like is, Sean Landers the most important artist of his generation, ...". The laconic title hints at nothing of the content.

That Which I Should Have Done I Did Not Do Ivan Albright, 1931–41, Art Institute of Chicago, Illinois
 A battered and decrepit door is hung with a funeral wreath, while a woman's hand to one side holds a handkerchief. The title, representing the epigraph of a misspent life, echoes words from the General Confession in the Book of Common Prayer: "We have left undone those things which we ought to have done."

The Marcel Duchamp, 1915, Philadelphia Museum of Art, Pennsylvania.

The work consists of a handwritten Surrealist 18-line text in which the word "the" is replaced by a star. It is in English and begins thus: "If you come into * linen, your time is thirsty because * ink saw some wood intelligent enough to get giddiness from a sister."

Thel Beverly Pepper, 1976–7, Dartmouth College, Hanover, New Hampshire.

The outdoor sculpture, a turf-covered white pyramidal structure, takes its title from William Blake's poem *The Book of Thel* (1789), in which the maiden Thel laments transience and mutability by a river bank.

There's No Place Like Home Sir Edwin Landseer, 1842, Victoria and Albert Museum, London.

A little terrier looks up imploringly at its master (or mistress) as it waits next to an empty bowl at the entrance to its home, which is simply a barrel with a hole in it. The title quotes the familiar proverb, recently popularized by the line from J.H. Payne's song *Home Sweet Home* (1822): "Be it ever so humble, there's no place like home." Hadfield points out (p. 99) that the title might just as easily have been *Where Have You Been?* or *Why Are You So Late?* or *I Thought You Were Never Coming*, or *What's For Supper?* But these lack the resonance of the familiar saying and the pun on the two types of home.

There's No Reason Not To John Mc-Cracken, 1967, Nicholas Wilder Gallery, Los Angeles, California.

The work is simply a ten-foot high lime-colored wooden plank leaning against a wall. Can one call this a work of art? The title seems to suggest the artist's answer.

Theseus Recognized by His Father (French, *Thésée reconnu par son père*) Hippolyte Flandrin, 1832, École des Beaux-Arts, Paris.

The great hero of Greek mythology, having encountered many adventures and won many victories, returns to his father Aegeus, who does not recognize him. Aegeus is living with Medea, who is hoping her son Medus will inherit her throne of Athens. She does recognize Theseus, however, and persuades Aegeus, for the sake of her son, to allow her to poison him at a banquet. The painting depicts the moment when Aeneus recognizes the sword with which his son is about to carve the poisoned meat, and so realizes his

identity. Medea, seeing the failure of her ruse, turns to flee.

They Did Not Expect Him (Russian, *Ne zhdali*) Ilya Repin, 1884, Tretyakov Gallery, Moscow.

A gaunt and haggard revolutionary makes a dramatic and unexpected return from exile to his family. The painting depicts the moment when he walks into the room, his wife rising and turning from her armchair, his children's faces a mixture of joy and incredulity.

"They have seen better days" Jacob Thompson, *c.*1855, Christopher Wood Gallery, London.

A young mother and a grandmother, together with three young children and a dog, are gathered outside a farmhouse. The anecdotal title enables the viewer to deduce that the father has died, presumably in his prime, and that the rest of the family are now offered aid by a more prosperous neighbor, whose own child accepts a gift from the farmer's daughter.

They Work, Eat, and Go Home *see* The **Worker's Day**.

Thin Ice Kevin Sinnott, 1987, Bernard Jacobson Gallery, London.

One young man is about to fall into the arms of another as he slips while skating. The title alludes to the enforced intimacy that both will be obliged to experience. To "skate on thin ice" is to risk danger, and "thin ice" is often applied to a risky sexual liaison. (Compton Mackenzie's 1956 novel, *Thin Ice*, is the story of a homosexual relationship.)

A Thing of Beauty Is a Joy Forever Kate Hayllar, 1890, Forbes Magazine Collection, New York.

The painting is of a large decorative vase holding an exotic flowering plant next to an ornate parlor chair. On the wall behind them is a black-and-white framed print after Raphael's **Madonna of the Chair**. The title is the well-known opening line of John Keats's poem *Endymion* (1818).

The Thinker (French, *Le Penseur*) Auguste Rodin, 1880, Musée Rodin, Paris.

The famous bronze statue of a seated naked man brooding on the folly and sin of humankind was originally conceived as a seated portrait of Dante for the door of The **Gates of Hell**.

The Third of May, 1808 (Spanish, *El tres de Mayo, 1808*) Francisco de Goya, 1814, Prado, Madrid.

The painting depicts the mass executions that took place in Madrid the day after the riots depicted in The **Second of May, 1808**. Its full title is *The Third of May, 1808: The Execution of the Defenders of Madrid*. Both works were commissioned by Cardinal Don Luís María de Borbón, president of the regency council for the throne of Spain, to commemorate the insurrections that sparked off the Peninsular War.

37 Pieces of Work Carl Andre, 1969, Solomon R. Guggenheim Museum, New York.

The work consists of 36 square units, each six foot square, made up of 36 metal plates, each one foot square. These 36 "pieces of work" are all fitted flush together to make a 37th, now 36 feet square. The plates are differentiated as alternately light and dark, chessboard fashion, and the artist used six different metals: aluminum, copper, steel, lead, magnesium, and zinc.

This Is a Piece of Cheese (French, *Ceci est un morceau de fromage*) René Magritte, Menil Collection, Houston, Texas.

A realistic framed painting of a portion of French cheese has been placed inside a genuine glass cheese cover on its pedestal

This little piggy went to market, this little piggy stayed at home Damien Hirst, 1996, Saatchi Collection, London.

The work consists of a vertically bisected pig, its halves in two tanks. The tanks slide back and forth, so that although one always sees the external side of one half, one only periodically sees the internal cross-section of the other. At certain moments the two halves are exactly opposite each another, as if forming a whole animal. The title, quoting from the children's nursery rhyme, relates to the duality of the display: the pig is constantly in motion, as if going to market, yet at the same time remains at home in its two cases.

This, That, and the Other Richard Deacon, 1985, private collection.

The abstract sculpture consists of a steel blade passed through a belt or loop of laminated hardboard and canvas. The conjunction of the two disparate objects (this one and that one) evokes a new concept (the other).

"Thou Shalt Not Steal" John Singer Sargent, 1918, Imperial War Museum, London.

The well-known biblical commandment is quoted as the title of this war painting of two helmeted soldiers guiltily picking and devouring fruit in a French orchard. Stealing from local inhabitants was in fact regarded as a serious offence.

Thoughts of the Past John Roddam Spencer-Stanhope, 1858–9, Tate Gallery, London.

A prostitute stands by the window of her squalid London room. Her attitude is of hopeless despair as she reflects on her chaste past and the sordid state to which she has now sunk

A Thousand Girls (French, *Mille Filles*) Hans Bellmer, 1939, private collection.

Images of fruit and vegetables combine to form the depiction of a woman with her hair piled high on her head. The title presumably alludes to the mass of limbs and shapes, but the original French must surely also pun on *mille-feuilles* ("thousand leaves"), literally a type of layered cake made from puff pastry, cream, and the like, but also a slang term for a woman regarded as a sexual object (*cf.* English "crumpet," "cupcake," etc.).

A Thousand Years Damien Hirst, 1990, Saatchi Collection, London.

The installation comprises a steel-framed glass case containing flies, maggots, a cow's head and an electric insect killer ("insect-o-cutor"), together with a supply of sugar and water for the maggots and insects. The title seems to allude to the constant cycle of life and death. Maggots and insects (life) feed on the rotting cow's head (death), then themselves die and are killed. But any one moment's living and dying is also that of a thousand years.

The Threatened Swan Jan Asselijn, *c.*1650, Rijksmuseum, Amsterdam.

The artist's best known animal painting depicts a swan leaping forward from its nest where it has been threatened. Its wings are spread, its neck stretched, its beak wide open.

Threatening Weather (French, *Le Temps menaçant*) René Magritte, 1928, Roland Penrose Collection, London.

In a blue sky over a blue sea, three gray clouds loom in the respective shapes of a woman's naked torso, an inverted tuba, and a cane-bottomed chair. The "threat" appears to be sexual.

The Three Ages of Man and Death Hans Baldung, 1539, Prado, Madrid.

The painting actually contains four figures

as an allegory of the three ages of a human being. Infancy is a baby asleep on the ground, youth is a young maiden, and old age a haggard old woman. Behind them all stands death, as a skeletal figure holding an hourglass.

The Three Ages of Woman (German, *Die drei Lebensalter*) Gustav Klimt, 1905, Galleria Nazionale d'Arte Moderna, Rome.

A naked young mother with a child in her arms stands next to an older nude woman with bowed head. The latter was based on Rodin's 1885 sculpture *She Who Was Once the Beautiful Wife of the Helmet-Maker* (French, *Celle qui fut la belle Heaulmière*).

The Three Brides Jan Toorop, 1893, Kröller-Müller Museum, Otterlo.

The Symbolist artist's masterpiece is a ghostly scene depicting three brides, naked under their veils, attended by nude or seminude bridesmaids. The central figure, the Innocent Bride, stands bedecked with roses between the sensuous Hellish Bride and the sensual Nun Bride.

The Three Dancers (French, *Les Trois Danseuses*) Pablo Picasso, 1925, Tate Gallery, London.

Three anguished figures dance an agonized dance, the one on the left convulsively playing a guitar. The canvas complements the earlier and calmer *Three Musicians* (1921) and neoclassical *Three Graces* (1924). In 1965, when the Tate Gallery acquired the work from Picasso, he told the English painter and art collector, Roland Penrose: "While I was painting this picture an old friend of mine, Ramon Pichot, died and I have always felt that it should be called *The Death of Pichot* rather than *The Three Dancers*. The tall black figure behind the dancer on the right is the presence of Pichot" (quoted in Wilson, opposite Plate 13). The original painting of three ballet dancers was thus modified after the death of Pichot. Comparing the work to Les **Demoiselles d'Avignon**, conceived as a moral allegory, Lynton comments: "*Three Dancers* has no subject beyond that announced by the title" (p. 185).

Three Figures: Pink and Gray J.A.M. Whistler, 1868–78, Tate Gallery, London.

The three figures are three young women. The pink is that of a flowering shrub and plant, both in pots, and of the women's bodies, seen through their diaphanous draperies, while the gray is that of the wall before which they stand, and of the draperies themselves.

Three Flags Jasper Johns, 1958, Whitney Museum of American Art, New York.

The painting is a depiction of the American flag with two smaller identical flags superimposed. The flag is recognizably the Stars and Stripes but has 56 stars instead of the expected 50.

The Three Goddesses George Frederic Watts, *c.*1865–72, Buscot Park, Oxfordshire.

The three nude young women, one seen front view, one in profile, and one from the rear, are either the **Three Graces** or the goddesses Athena (known also as Pallas), Hera (Juno), and Aphrodite (Venus), depicted in The **Judgement of Paris**. The painting's exhibition history records the ambiguity. In 1876 it was shown under the title *The Three Graces*, then in 1878 as *Pallas, Juno and Venus*, then in 1881 as *The Three Goddesses*, then in 1888 as *Judgement of Paris* (although Paris is nowhere to be seen), then finally as now.

The Three Graces (1) Raphael, *c.*1501, Musée Condé, Chantilly; (2) Correggio, *c.*1518, Camera di San Paolo, Parma; (3) Peter Paul Rubens, 1639, Prado, Madrid; (4) *see* The **Graces Adorning a Term of Hymen**.

All three paintings are a group portrait of three nude women, the Three Graces of Greek mythology who are the daughters of Zeus and who personify beauty, charm, and grace. The subject has been popular with many artists, in some cases as a group sculpture. (An example of the latter is Antonio Canova's white marble neoclassical group of 1817.) Raphael's picture is also sometimes known as *The Three Hesperides*, since the women hold golden apples in their hands, evoking the three daughters of Atlas who guarded the garden of golden apples at the world's end in the far west.

The Three Graces Dancing (Italian, *Le tre Grazie danzanti*) Antonio Canova, 1799, Canova's House, Possagno.

The three bare-breasted Graces holds hands as they dance, the two outer women holding a flowery wreath over the head of the central figure.

The Three Hesperides *see* The **Three Graces** (1).

Three Ladies Adorning a Term of Hymen *see* The **Graces Adorning a Term of Hymen**.

The Three Nymphs (French, *Les Trois Nymphes*) Aristide Maillol, 1930–8, Tate Gallery, London.

The lead statues of three nude women are arranged in a group suggesting the traditional composition of The **Three Graces**. The artist prefered to regard them as nymphs, however, saying that the figures were too powerful to represent the Graces. The model for the central figure was a young woman who was an athlete.

The Three Philosophers Giorgione, *c.*1505–8, Kunsthistorisches Museum, Vienna.

The identity of the three men in a rocky landscape, one elderly, one middle-aged, one young, is uncertain. They could be astronomers, or even the Magi (Three Wise Men) waiting for the star to appear. If the title is accurate, they could represent three schools of philosophy: the young man the new Renaissance, the middle-aged man (who wears a turban) the Eastern, and the old man the ancient Greek. The young man may be a self-portrait of the artist.

Three Stages of Woman *see* The **Dance of Life**.

Three Standard Stoppages (French, *Trois stoppages-étalon*) Marcel Duchamp, 1913–14, Museum of Modern Art, New York.

The work is a carefully created assemblage. Three threads, each just under a meter in length, were dropped from a height of one meter on to a horizontal surface. Their resulting random shapes were glued on to strips of canvas, which were in turn fixed to glass panels. Each panel has a wooden ruler with a curve that follows the outline of the thread. The whole was enclosed in a wooden croquet box. The result: three standard but random measurements. The title puns on *stoppage* meaning both "stoppage" and "invisible mending" (with a thread).

Three Studies for Figures at the Base of a Crucifixion Francis Bacon, 1944, Tate Gallery, London.

The artist's key (and controversial) painting is a triptych that preceded many others. They all depict distorted figures that evolved from the traditional biblical figures who stand at the foot of the Cross in such works as The **Crucifixion**.

Three Women (Italian, *Tre donne*) Umberto Boccioni, 1910–11, Banca Commerciale Italiana, Milan.

The three women, one elderly, one mid-dle-aged, one young, represent the "three ages of woman," a typical late 19th-century theme.

Three Women Plucking Mandrakes Robert Bateman, *c.*1870, Wellcome Institute Library, London.

Three women are shown attempting to pull (rather than pluck) mandrakes from the ground. Mandrakes, long the object of superstition, are said to resist being plucked and when pulled from the ground are said to give a scream that will frighten the hearer to death. Those who attempt to harvest the vegetable thus resort to a system of lines and pulleys, as depicted here.

Throwing Off Her Weeds Richard Redgrave, 1846, Victoria and Albert Museum, London.

A young widow sits behind a screen about to change her mourning for the lighter dress held by her maid as the shadowy figure of a soldier appears in the doorway. A man's portrait can be seen on the wall above the screen, presumably that of her late husband.

Thursday Walter Dendy Sadler, 1880, Tate Gallery, London.

Monks fish by a river, keen to catch the food for the next day's dinner. A sequel painting, *Friday* (1882), shows them actually eating it.

Tiger in a Tropical Storm (French, *Tigre dans un orage tropical*) Henri Rousseau, 1891, National Gallery, London.

A tiger bounds through the long whispering grass as the wind and rain lash the trees overhead and lightning flashes across the sky. The painting was originally exhibited under the title *Surprised!* (French, *Surpris!*) and is occasionally known today as *The Storm in the Forest*.

A Tight Dally and Loose Latigo Charles M. Russell, 1920, Amon Carter Museum, Fort Worth, Texas.

Three Montana cowhands drive a small herd along a dry wash, but one of the men has gotten himself into difficulty. After attempting to lasso a cow, he finds that the latigo (the strap connecting the cinch with the "riggin'" that holds the saddle on his horse) has worked loose, while the lally (the half-hitch that the cowboy throws around the saddle horn to haul in the animal he has roped) holds tight. A cowboy with a tight dally and a loose latigo would be in serious trouble because as the cow pulls away, the cowhand's saddle would be jerked from beneath him and he could well be thrown from his horse.

He would then be in danger of being trampled under the frightened animal's feet. The other cowboys in the painting have recognized their companion's problem and, lariats at the ready, come to his rescue while he struggles to maintain his mount.

Time and Oblivion George Frederic Watts, 1848, Eastnor Castle, Worcestershire.

"The forms of Time and Oblivion, rising above the sphere of the terrestrial globe, are poised in mid-air betwixt the orbs of day and night. Time, as the type of stalwart manhood gifted with imperishable youth, holds in his right hand the emblematic scythe, while Oblivion, with bent head and downcast eyes, spreads her ample cloak and speeds swiftly towards the tomb" (artist's 1881 catalog description, quoted in Blunt, p. 62). Both Time and Oblivion are figures associated, sometimes jointly, with the allegorical figure of Death.

Time, Death, and Judgement George Frederic Watts, 1870s–1886, National Gallery of Canada, Ottawa.

The allegorical painting depicts three figures. A commanding young male Time, holding a scythe, stands hand in hand with a veiled young female Death. Behind them, seen rather hazily, is Judgement or Nemesis, her face hidden by her arm, which holds the scales that weigh human destiny. The painting was originally exhibited with the title *Time and Death*. Soon after, the artist added *Nemesis*, then *Judgement* to reflect the third figure.

Time Overcome by Hope, Love, and Beauty Simon Vouet, 1590, Prado, Madrid.

Two young women with pointed weapons threaten an old man who desperately tries to defend himself. The sickle that lies before him indicates that he is Time. The women are personifications of Hope (clothed, on the left) and Beauty (naked, on the right), and together with Cupid (Love), looking on between them, they triumph over Time. The painting implies that Hope, Love, and Beauty are eternal values, while Time in its very nature is transitory.

Time Transfixed (French, *La Durée poignardée*) René Magritte, 1938, Art Institute of Chicago, Illinois.

A steaming locomotive is suspended below the mantelpiece in a middle-class sitting room, as if emerging from a tunnel. A clock on the mantelpiece shows the time. The painting is thus, in cinematic terms, a "stop frame," arresting the movement of time and objects in motion.

Tinted Venus John Gibson, *c.*1851–6, Walker Art Gallery, Liverpool.

The marble sculpture of the goddess Venus carrying an apple was lightly tinted by the artist in imitation of the practice in ancient Greece. Hence the title.

Titian's First Essay in Colour William Dyce, 1856–7, Aberdeen Art Gallery.

With flowers strewn at his feet, the boy Titian sits on a chair in the garden and contemplates a statue of the Virgin and Child, wondering how he can best draw the figure and color it.

Titled (*Art as Idea as Idea*), (idea) Joseph Kosuth, 1967, private collection.

The work is a photographic enlargement, with white text on black, of the detailed etymological introduction to the first and basic dictionary definition of the word *idea*. The title puns on the many works entitled **Untitled**, while graphically echoing the dictionary's use of different typological devices for different purposes. The general message is that art as it is expressed in language is more important than its visual form.

To Be Looked At (from the Other Side of the Glass) with One Eye, Close to, for Almost an Hour (French, *À regarder (l'autre côté du verre) d'un œil, de près, pendant presque une heure*) Marchel Duchamp, 1918, Museum of Modern Art, New York.

The Surrealist work consists of two magnifying glass lenses joined by a wire at opposite ends of a balance-like figure supporting a circular aperture beneath a pyramid on a cracked glass support mounted between two glass panes in a metal frame on a painted wooden base. This lengthy description matches the lengthy title (inscribed on the crossbeam of the "balance"). The two lenses suggest that closer inspection may grant the viewer some sort of insight.

To Brighton and Back for 3/6 Charles Rossiter, 1859, Birmingham City Art Gallery.

The scene is an open railroad carriage. Passengers have taken advantage of a cheap excursion rate (3 shillings and 6 pence) to make a return day trip from London to the resort of Brighton.

To Fête Baby! (French, *Pour fêter bébé!*) Henri Rousseau, 1903, Museum of Art, Winterthur.

A young child stands in a park-like setting clutching his chemise full of wild flowers in one

hand and holding a brightly costumed puppet in the other. The title indicates the purpose for which the child's portrait was painted, and the child equally appears to be fêting himself.

To Pray Without Ceasing　Bill Viola, 1992, private collection.

The work is a video installation depicting on a television screen the cycle of life, from birth to life, from the explosion of the universe to total darkness, within a single 12-hour period. A disembodied voice recites excerpts from Walt Whitman's *Song of Myself* during the display. The biblical title (1 Thessalonians 5:17) suggests that the work has a devotional purpose.

Tobias and the Angel　(1) Filippino Lippi, *c.*1480, National Gallery, Washington, D.C.; (2) Giovan Gerolamo Savoldo, *c.*1527, Villa Borghese, Rome; (French, *Tobie et l'ange*) (3) Jean Charles Cazin, 1880, Musée des Beaux-Arts, Lille; (4) Paul Sérusier, *c.*1895, private collection.

The scene is from the Apocrypha. The elderly Tobit sends his son, Tobias, to his cousin Gabael to recover a sum of money left in Gabael's care. Tobias sets out with the angel Raphael to guide him: "So they went forth both, and the young man's dog with them" (Tobit 5:16). Lippi's painting depicts all three, Gabriel leading Tobias by the hand. Savoldo and Sérusier omit the dog and instead have Tobias landing a fish, in reference to a later episode in the same story: "And when the young man went down to wash himself, a fish leaped out of the river, and would have devoured him. Then the angel said, Take the fish. And the young man laid hold of the fish, and drew it to land" (Tobit 6:1–2). Cazin simply has the angel encouraging Tobias to continue his toilsome journey.

Today Is The Tomorrow You Were Promised Yesterday　Victor Burgin, 1976, private collection.

The work is a black and white photograph of a typical characterless British edge-of-town estate, a sparsely peopled street scene beneath a bleak sky with a lone dog crossing the road. The upper left portion of the picture is superimposed with lines of verse evoking an idyllic existence in which the reader can "wander down a winding path" to the sands and sea to gain "Total immersion. Ecstasy." The ironic title, in capital letters, concludes the verse.

Togetherness I　Evelyn Williams, 1996, Manchester City Art Gallery.

This painting and its pendant, *Togetherness II* (1996), depict a naked couple, their bodies entwined in a pose of post-coital lassitude. Although the lovers are physically entangled, their expressions suggest that emotionally they are separate entities, so that the title is ironic.

Toil and Pleasure　John Robertson Reid, 1879, Tate Gallery, London.

Workers in a turnip field pause to watch a hunt pass. Toil is the lot of the country folk, and pleasure the privilege of the gentry.

The Toilet of Venus　*see* The **Rokeby Venus**.

The Toll-House　(French, *L'Octroi*)　Henri Rousseau, *c.*1890, Courtauld Institute, London.

The artist was originally a tax collector in the Paris toll office, hence his nickname *le douanier*, "the customs officer," despite the fact that the toll office had no real customs functions. The painting thus depicts his place of work.

Tomorrow Is Never　Kay Sage, 1955, Metropolitan Museum, New York.

Strange steel structures rise from the clouds in this Surrealist painting, its title implying that it is impossible to envisage the future, for "tomorrow never comes."

Tomorrow Morning　Edward Wadsworth, 1929–44, private collection.

The Surrealist painting depicts a seaside scene that at first glance appears perfectly normal but that on closer inspection incorporates disturbing elements. A huge fishhook is caught in the jetty that forms the picture's centerpiece, a giant piece of seaweed hangs from a wooden pole nearby, and a star shines in what is otherwise a bright blue daytime sky. The title seems to suggest that "tomorrow morning" is always an illusory concept, that it will always differ in some way from the morning of today, of yesterday, and of other past days.

Too Early　James Tissot, 1873, Guildhall Art Gallery, London.

A party of three ladies and an elderly gentleman have arrived too early for a ball. That they *are* too early is apparent from their state of embarrassment as they stand awkwardly in the middle of the room and from the fact that the hostess is seen giving last minute instructions to the band. Two young maids peer giggling around a doorway.

Too Late William Lindsay Windus, 1859, Tate Gallery, London.

The painting is rather a puzzle. It depicts two young women, a young girl, and a young man, grouped together in a country field. One of the women has her arms around the other and is comforting her. The little girl looks up at the man, who hides his face with his arms. It is clear that he is the returned lover of the woman who is embraced by her friend (or sister). But why is he too late? The artist Ford Madox Brown interpreted the picture as follows: "It represented a poor girl in the last stage of consumption, whose lover has gone away and returned at last, led by a little girl when it was 'too late'. The expression of the dying face is quite sufficient — no other explanation is needed" (quoted in Hadfield, p. 53). More likely, it is "too late" for the lover to express his guilt or remorse at abandoning his beloved. Either way, it seems likely the little girl is the illegitimate child of their former passion.

The Tooth Puller (Italian, *Il cavadenti*) Pietro Longhi, *c.*1746, Pinacoteca di Brera, Milan.

The scene is set before the portico to the Doge's Palace. The tooth puller stands on a table and proudly holds up the tooth he has just pulled for the boy who sits below him holding a handkerchief to his mouth.

The Top Man Walt Kuhn, 1931, Huntington Art Gallery, San Marino, California.

The painting portrays a somewhat mournful-looking circus artist. The "top" is the circus tent in which he performs. The title may intentionally pun on "top" in the sense "best," here visually contrasting with the subject's dispirited and even degraded appearance.

Torchbearers of Christianity (Russian, *Svetochi khristianstva*) Genrikh Semiradsky, 1876, National Museum, Kraków.

Christian martyrs are burned alive on the orders of the Emperor Nero, who turned the fearful form of execution into a public entertainment. The title can be taken both actually and figuratively, for in their martyrdom by fire the victims were literal "luminaries of faith."

The Torn Hat Thomas Sully, 1820, Museum of Fine Arts, Boston, Massachusetts.

The portrait is of a young boy wearing a straw hat with its brim partly torn from the crown.

Torture of Women Nancy Spero, 1976, Jack Tilton Gallery, New York.

The work, a scroll 175 feet long, centers on the myth of the Babylonian god, Marduk, who cut the goddess, Tiamat, in half to form heaven and earth. This is told in 14 painted panels and is laid alongside the typewritten account of a Chilean model who was arrested and tortured by General Pinochet's secret police.

Totes Meer ("Dead Sea") Paul Nash, 1940–1, Tate Gallery, London.

A sea of crashed aircraft lies by a sandbank, their broken and crumpled wings resembling waves. Nash was an official war artist in World War II and the painting was inspired by the combat. (He based it on photographs he had taken at a dump for wrecked German aircraft near Oxford.) The title is in the language of the enemy, but also hints at the real Dead Sea, where no form of life exists. The work is also known by its English title, *Dead Sea*.

Tourists Duane Hanson, 1970, National Gallery of Modern Art, Edinburgh.

The Superrealist sculpture depicts a pair of fat, ageing, garishly dressed American sightseers. The artist says: "The subject matter that I like best deals with the familiar lower and middle class American types of today. To me, the resignation, emptiness, and loneliness of their existence captures the true reality of life for these people" (Chilvers, Osborne, Farr, p. 229).

Towards the Night and Winter Frank O'Meara, 1885, Hugh Lane Municipal Gallery of Modern Art, Dublin.

A young woman burns leaves on a bonfire by a pond as dusk falls. The title equates the time of day and time of year when all grows cold and dark. The somber mood is reflected in the gray tones of the sky, the smoke from the fire, and the woman's skirt.

The Toyseller William Mulready, 1835, Victoria and Albert Museum, London.

A black toyseller shows a toy to an alarmed child.

Tradition Kenyon Cox, 1916, Cleveland Museum of Art, Ohio.

The neoclassical painting depicts four allegorical figures, all female. Seated on the left is Past Art. She has handed the sacred lamp of knowledge to the central figure, Tradition, who in turn passes it on to Future Art and Literature, standing on the right.

Tragic Anatomies Jake and Dinos Chapman, 1996, Saatchi Collection, London.

The installation is a re-presentation of the figures seen in **Zygotic acceleration, biogenetic, de-sublimated libidinal model (enlarged × 1000)**. Here the girls are posed in a woodland scene as couples with fused torsos. Their bodies, though genderless, have the same mutant characteristics as in the earlier work. Hence the title, which also comments on their fate.

Train up a Child in the Way He should go; and when He is old He will not depart from It William Mulready, 1841, private collection.

Two young sisters encourage their little brother to give his alms to three beggars huddled by the wayside. The cumbersome biblical title quotes the entire verse of Proverbs 22:6.

The Tramp John Singer Sargent, *c.*1904, Brooklyn Museum of Art, New York.

The painting is a portrait of a down-and-out character, probably modeled by the Italian landscape painter, Ambrogio Raffele. The work was exhibited in 1907 as *The Vagrant*.

TRANSEXUALIS (decline) Matthew Barney, 1991, private collection.

The installation consists of a walk-in refrigerator in which a construction resembling body-building apparatus has been created from frozen petroleum jelly. Hooks hang from the ceiling. The suggestion as a whole, supported by the title, is of sexual deviance and moral corruption. (The upper and lower case lettering in the title presumably represent the work's theme and the artist's comment on it.)

Transfiguration (1) Fra Angelico, 1439–42, Convento di S. Marco, Florence; (2) Raphael, 1517–*c.*1520, Vatican Museums, Rome.

Fra Angelico's fresco and Raphael's great altarpiece, on which he was working at the time of his death, depict Christ's appearance in radiant glory to three of his disciples, as recounted in three of the gospels (Matthew 17:2, Mark 9:2–3, Luke 9:29).

Trap (French, *Trébuchet*) Marcel Duchamp, 1917, Musée National d'Art Moderne, Paris.

The work consists of a wooden board with four metal coat hooks nailed flat to the floor. It was a "trap" over which visitors to the artist's studio stumbled. The French title properly refers to a bird trap.

The Trapper's Bride Alfred J. Miller, 1845, Eiteljorg Museum of American Indian and Western Art, Indianapolis, Indiana.

An American Indian warrior sells his white-clad young daughter to a trapper. The painting is based on an incident witnessed by the artist as a member of Captain William D. Stewart's 1837 expedition from near present-day Kansas City along what would become the Oregon Trail to the annual rendezvous of the mountain men in the Green River Valley.

Traveler's Folding Item (French, *Pliant... de voyage*) Marcel Duchamp, 1916, Philadelphia Museum of Art, Pennsylvania.

The work is simply an Underwood typewriter cover, placed upright as if actually covering the machine. The French title can be understood to refer to a folding seat or campstool.

Traveling Companions Augustus Egg, 1862, Birmingham City Art Gallery.

Two identically dressed young women, presumably sisters, travel opposite each other in a railway carriage, one dozing, the other reading a book. The view through the window shows the coast near Menton in southern France.

The Treachery of Images (French, *La Trahison des images*) René Magritte, 1929, Los Angeles County Museum of Art, California.

The painting depicts a larger than life tobacco pipe, beneath which the artist has written, "*Ceci n'est pas une pipe*" ("This is not a pipe"). The title implies that the image of an object should not be mistaken for its reality. It can play false. The pictorial representation of a pipe, however recognizable for what it is, is not the pipe itself. The artist repeated the theme forty years later in The **Two Mysteries**.

A Treatise on Colour Harmony Tom Phillips, 1975, private collection.

The work has its origin in the artist's first visit to southern Africa (1973), when he was struck by the way in which the ideal of apartheid from the white point of view was reflected in the picture postcards he collected. These postcards became the basis of a group of works dealing with apartheid of which the one here is the largest and most elaborate. It consists of 16 separate square canvases hung in a block so as to form a narrative sequence, from top left, in the terms of the title. The first square has the title, artist's name, and date in the center with a text around the edge reading: "The greatness of a

nation consists not so much in the number of its people or the extent of its territory as in the extent and justice of its compassion." The quote is intended ironically, and was transcribed from the equestrian statue at Port Elizabeth. The second canvas explains that the work is "Based on excerpts of skin from postcards of South Africa and Rhodesia and South West Africa and of their land and skies." It also carries the titles and/or explanations of all 16 canvases, as follows: (1) "Title Piece" (2) "Introduction & Contents" (3) "Black is Beautiful" (4) "TGs of Above with GTG Surround" (5) "White Is Somewhat Lovely Too" (6) "TGs of Above with GTG Surround" (7) "4 & 6 Randomly Arranged with GTG" (8) "Ditto in Game Order with GTG" (9) "The Skin Game with SA Land & Skies" (10) "TGs of Above with Skin GTG Surround" (11) "GTGs of 9. Slogan in Land & Skies TG" (12) "All the Colours. Random Scattering" (13) "Imago Mundi. GTG Arrangement" (14) "Complete Colour Catalogue (FVZ)" (15) "Skin TGs Surround All the Skins GTG" (16) "List of Postcard Sources". Canvas (3) consists of 25 squares of color derived from black skins in the postcards. As such, it is a literal embodiment of its title. Canvas (4), also of 25 squares, is a mutation of (3), each of its squares made from a mixture of all the colors in the equivalent square in the preceding canvas. The artist calls these mixtures "TGs" ("terminal grays") as they were created by mixing together all the paints left at the end of a day's work to form a gray and to be used to paint part of another work. ("G" in "GTG" stands for "General.") Canvas (5), with its ironic title, introduces white skin extracts. Canvas (6) is its mutation. Canvases (7) and (8) combine the black and white TGs to form two abstract "harmonies" of 50 squares. The remaining canvases explore and develop the possibilities of the combination of black and white skin colors from the postcards. The work as a whole thus represents a political ideal and is a comment on the frustration of that ideal in South Africa. The overall title describes all of these functions.

The Trellis Gustave Courbet, *c*.1863, Toledo Museum of Art, Toledo, Ohio.

A young woman raises her arms to tend flowers on a trellis. The flowers themselves are of spring, summer, and fall, representing the three stages of her love life. An alternate title is simply *Girl Arranging Flowers*.

The Tribuna of the Uffizi Johann Zoffany, 1772–8, Royal Collection, Windsor Castle.

The crowded painting depicts connoisseurs and notables among the art treasures of the Tribuna, the room housing the masterpieces of the Uffizi. Some two dozen famous paintings and sculptures are faithfully represented, the most prominent being the **Venus of Urbino**.

The Tribute Money Masaccio, *c*.1424–8, Sta. Maria del Carmine, Florence.

The fresco depicts an event from the New Testament, the artist presenting three episodes in the one painting. In the center, a tax collector asks St. Peter for tribute money for the upkeep of the temple, and Christ directs Peter towards the lake. To the left, Peter takes the coin from the fish's mouth (Matthew 18:24–27). To the right, he pays the tax collector.

The Trinity Masaccio, 1425, Sta. Maria Novella, Florence.

The altarpiece depicts the Christian Holy Trinity of God the Father, Son, and Holy Spirit. God the Father supports the dead body of Christ on the Cross as if to raise him up. Above Christ's head is a dove, representing the Holy Spirit. The Virgin Mary and St. John stand either side of the Cross, and below them are two kneeling figures, probably those of Lorenzo Leni and his wife, who commissioned the painting.

Triple Alliance Vanessa Bell, *c*.1914, University of Leeds Art Collection.

Scraps of newspaper, a map of central Europe, and a check are used in this part-collage work to create a still life incorporating a lamp and two bottles. The title refers not only to the latter but to the recent rupture of the alliance between Germany, Austria-Hungary, and Italy, as implied by the torn pieces of map. Italy had broken the alliance by declaring its neutrality at the outbreak of World War I.

The Triumph of Bacchus and Ariadne Annibale Carracci, *c*.1595–1605, Palazzo Farnese, Rome.

The ceiling painting depicts the triumphant arrival of Bacchus (Dionysos), god of wine, riding in a gold chariot, and Ariadne, his wife, daughter of King Minos, in a silver one.

Triumph of Galatea Raphael, 1511–13, Villa Farnesina, Rome.

The Nereid (sea nymph) Galatea stands in her cockleshell chariot, drawn by dolphins. Hippocampi swim round her, and Tritons sport with the Nereids. Overhead, amoretti (cupids) aim their arrows of love at Galatea. She triumphs

solely in her stance, not because of any particular success. For this reason the fresco is often known simply as *Galatea*.

The Triumph of Samson Guido Reni, 1611–12, Pinacoteca Nazionale, Bologna.

The great biblical hero, depicted as a standing seminude figure, slakes his thirst after his victory over the Philistines, whose corpses litter the landscape below him.

The Triumph of Surrealism *see* The **Household Angel**.

The Triumph of the Innocents William Holman Hunt, 1876–87, Walker Art Gallery, Liverpool.

The biblical painting is essentially a reworking of The **Flight into Egypt**, with the Holy Family accompanied by the Holy Innocents, the young children who were slain by order of Herod and who were thus the first Christian martyrs (Matthew 2:16–18). The artist explained that here they ride into the picture from the Waters of Life.

Triumph of the New York School Mark Tansey, 1984, Whitney Museum of American Art, New York.

The monochrome painting at first sight appears to depict an army's surrender on a devastated battlefield. The "soldiers" on the left, however, can be recognized individually as modern French artists, Picasso, Braque, Matisse, and Léger among them, while those on the right are their American equivalents, such as Pollock, Kooning, Still, and Motherwell. The mock-history depiction thus represents the capitulation of Paris as world art center to New York. The title was ironically adopted from Irving Sandler's art history of the same name.

The Triumph of the Republic (French, *Le Triomphe de la république*) Aimé-Jules Dalou, 1879–99, Place de la Nation, Paris.

The great bronze sculpture is an allegorical group topped by a tall figure of Marianne, the personification of republican France. It was commissioned under, and celebrates, the Third Republic (proclaimed 1870).

The Triumph of the Victor Peter Paul Rubens, *c*.1614, Staatliche Kunstsammlungen, Kassel.

The victor is a warrior in Roman armor, who sits in the center of the painting with a corpse under his feet and a bound prisoner

kneeling to kiss his knee. Victory is personified by a winged woman, naked to the waist, who reaches up to place a wreath on the victor's head.

The Triumph of Venice Paulo Veronese, 1583, Doge's Palace, Venice.

The painting celebrates the glory of Venice in a depiction of well-fleshed allegorical ladies borne on clouds as they salute the equally solid personification of the Republic.

The Triumph of Venus (French, *Le Triomphe de Vénus*) François Boucher, 1740, Nationalmuseum, Stockholm.

Venus, goddess of love, is seated naked on a rock by the sea while all around her naked men and maidens disport themselves in the water. Cupids overhead join in the general celebration of physical flirtation and love. *See also* **Reclining Girl**.

Trouble Sir William Quiller Orchardson, 1896, private collection.

A young man bends in grief over a table, his face buried in his arm, as a young woman, presumably his wife, rises from her chair and walks away. The "trouble" of the title may thus be a marital disaster, for which the husband is reponsible, for which the wife has rebuked him, and for which she is now leaving him. However, the following conversation is recorded as occurring when the artist's daughter asked her father whether the man's distress was caused by disgrace or misfortune. "I think it is just money trouble." "Has he been cheating?" "No, just loss, I should say." "But how can money, mere money, cause such trouble?" "Well, he can't give to his wife as usual. That would cause him distress" (quoted in Hadfield, p. 69). But this may simply have been a toned-down account for the benefit of the daughter.

The True Picture of the Isle of the Dead by Arnold Böcklin at the Hour of the Angelus Salvador Dalí, 1932, Von der Heydt Museum, Wuppertal.

The Surrealist painting is based on the Symbolist work by the named artist (*see* The **Isle of the Dead**). However, instead of the tree-crowded island of the original there are now simply bare rocks, while to the left a rod rises high out of a bowl on a square block. The alteration is as enigmatic as the title, which additionally seems to hint at some religious interpretation.

Trust Me John Everett Millais, 1862, Forbes Magazine Collection, New York.

A middle-aged man dressed for the hunt confronts a a young woman in black who holds a letter behind her back. It is not clear which of the two speaks the words of the title. Indeed, it is not clear whether the man is the woman's father or husband, or who the letter is from.

The Truth Unveiled (German, *Die Wahrheit wurde enthüllt*) Egon Schiele, 1913, private collection.

The painting is either a dual self-portrait or depicts two different figures. The more prominent of the two wears a tunic and has his hands raised as if grasping or entreating. The second figure, not necessarily male, is semiobscured behind him. It is uncertain what the "truth" is that has been unveiled. Perhaps it is the artist's perception of his own dual image.

Try This Pair Frederick Daniel Hardy, 1864, Sotheby's, London.

A white-bearded rabbinical-looking spectacle salesman offers a farmer's or gamekeeper's family pairs of glasses from his bag.

Tu m' ("You ... Me") Marcel Duchamp, 1918, Yale University Art Library, New Haven, Connecticut.

The work is an amalgam of pictorial techniques. Shadowy images of "readymades" (a bicycle wheel, a bottle opener, and a hat rack) are projected on to a canvas on which various repetitive patterns and shapes have been painted. A bottle brush, directed at the viewer, emerges from a *trompe l'œil* tear in the center of the canvas that is "held together" with three (real) safety pins. It is up to the viewer to supply the missing word of the title. One possibility is *Tu m'agaces* ("You Annoy Me"). (The missing verb must begin with a vowel.)

The Turkish Bath (1) (French, *Le Bain turc*) J.-A.-D. Ingres, 1863, Louvre, Paris; (2) Sylvia Sleigh, 1973, private collection.

Ingres depicts a mass of naked women standing, sitting, stretching, and reclining around (and in) a Turkish bath as they gossip and drink coffee. Sleigh's picture is a feminist parody of this, with six naked men posed kneeling, sitting, standing, and reclining in an oriental setting.

Turning the World Inside Out Anish Kapoor, 1995, Rijksmuseum Kröller-Müller, Otterlo.

The cast metal sculpture is a smooth, organic piece resembling a giant silver apple. The title implies that it represents a world globe turned inside out, so that one merely sees the lining.

The Twa Dogs Sir Edwin Landseer, 1822, Victoria and Albert Museum, London.

A Newfoundland and a collie by a river face each other as if in conversation. They represent Caesar and Luath, the subjects of Robert Burns's poem "The Twa Dogs: a Tale" (1786), telling how two (twa) dogs discuss their respective masters. Luath was the poet's own dog.

Twilight in the Wilderness Frederick Edwin Church, 1860, Cleveland Museum of Art, Ohio.

The sun sets in glory behind the mountains in the wilderness of the American West, here an imaginary landscape entirely devoid of human presence.

The Twittering Machine (German, *Die Zwitscher-Maschine*) Paul Klee, 1922, Museum of Modern Art, New York.

Four fantastic bird-like creatures open their beaks in a stream of sound as they huddle together on the branch of a tree that is connected to a rod with a cranking handle. The title and the depiction itself imply that the song of the birds can be reproduced at will, like a record on a phonograph. A preliminary pen-and-ink drawing for the painting was called by the artist *Concert on the Twig*.

Two Children Are Threatened by a Nightingale (German, *Zwei Kinder bedroht durch eine Nachtigall*; French, *Deux enfants sont menacés par un rossignol*) Max Ernst, 1924, Museum of Modern Art, New York.

Two "children" (more like a grown man and woman) flee a bird in the blue sky, the girl running over grass, the boy balancing on the roof of a hut. The title of the Surrealist painting eludes exact interpretation, but the artist is recorded as saying that it was inspired by one of his own prose poems, beginning (in translation): "At nightfall on the outskirts of the town, two children are threatened by a nightingale." "The title, written unceremoniously on to the inner frame, adds its dimension of derangement. Derangement of values, even: is that the way to label a work of art? ... One almost forgets to ask oneself how a nightingale can threaten two 'children'" (Lynton, p. 173). "Why should a nightingale frighten anyone? And what kind of world could contain, as part of a casual narrative, the idea of a 'menacing' nightingale? What disturbs

the viewer, knowing the title, ... is the utter disproportion between cause, the bird's song, and effect, the terror it inspires" (Hughes 1991, p. 222). Ernst's teasingly mystifying titles played a key role in his art and were an integral part of his work.

Two Fried Eggs and a Kebab Sarah Lucas, 1992, Saatchi Collection, London.

The ingredients of the title have been arranged on a table to represent a woman's breasts and genitals. A standing photograph of the arrangement represents the figure's face, the eggs being its eyes and the kebab its mouth. *Cf.* **Au Naturel**.

2 Minutes, 3.3 Seconds Billy Apple (born Barrie Bates), 1962, Bianchini Gallery, New York.

The work represents three apples in painted bronze. The first is whole, the second has a bite out of it, the third is merely a core. The title presumably refers to the time taken to eat an apple. The artist took his name from his subject matter.

The Two Mothers (Italian, *Le due madri*) Giovanni Segantini, 1889, Civica Galleria d'Arte Moderna, Milan.

A young peasant suckles her baby as she sits in a lantern-lit stall by a cow and its calf.

The Two Mysteries (French, *Les Deux Mystères*) René Magritte, 1967, private collection.

The painting depicts the earlier picture **The Treachery of Images** placed on an easel within a larger picture containing a larger pipe floating in empty space. The latter is a reminder that the earlier pipe was not a real one. It is now no more real than the original, but is simply a two-dimensional depiction of it. Those are the "two mysteries" of the title.

The Two Princes in the Tower Charles Robert Leslie, 1830, Victoria and Albert Museum, London.

Two young boys kneel to say their prayers before going to bed. They are The **Princes in the Tower**, and the actual depiction is of a scene in Thomas Heywood's play *Edward IV* (1599) where the princes kneel to pray before going to bed and compare it to going to their grave.

Two Sisters (1) (French, *Deux Sœurs*) Théodore Chassériau, 1843, Louvre, Paris; (2) Susan Macdowell Eakins, 1879, private collection; (3) *see* **Piti teina**.

Chassériau's double portrait is of his own two sisters, Adéle and Aline, the latter 12 years younger than the former. They are dressed identically, have the same hair style, and look very much alike as they stand arm in arm, despite their age difference. The painting is also known in English as *The Sisters of the Artist*. Eakins similarly depicts her own sisters. Dolly (also called Mary) sits with an open book in her lap and watches Elizabeth as she sews.

The Two Trinities Bartolomé Murillo, *c.*1681, National Gallery, London.

The former altarpiece depicts Christ as a child between his parents, Mary and Joseph, while overhead is the figure of God the Father and a white dove, representing the Holy Spirit. Christ himself is God the Son, and he is thus the central figure in each of the two trinities of the title, earthly and heavenly. The subject of the painting was presumably taken from the New Testament story telling how Mary and Joseph searched desperately for Christ and found him preaching in the temple, whereupon he said to them, "Wist ye not that I must be about my Father's business?" (Luke 2:49). They did not realize that by his father, he meant God.

Two Women in an Aesthetic Interior Maud Hall Neale, *c.*1880, Sotheby's, London.

One woman plays the piano while another listens. The scene is set in an elegant Victorian room furnished with portraits of women, "Liberty" prints, pot plants, a lily, and a sunflower.

Two's Company, Three's None Marcus Stone, 1892, Art Gallery, Blackburn.

A young man draws his chair up to his beloved, who turns away demurely. A young woman, who had presumably been talking to the couple, looks back as she leaves the scene to the left. The painting depicts an episode in the artist's long-running serial of young love. Previous pictures were *In Love* (1888), *The First Loveletter* (1889), and *A Passing Cloud* (1891). The happy ending came with *Honeymoon* (1893).

U

Ubermensch Jake and Dinos Chapman, 1995, Saatchi Collection, London.

The work is a fiberglass sculpture of the disabled English theoretical physicist and

bestselling author Stephen Hawking (born 1942) seated in his wheelchair atop a rocky mount. He is thus the literal and metaphorical "superman" of the title.

Ugolino (French, *Ugolin et ses enfants*, "Ugolino and His Children") Jean-Baptiste Carpeaux, 1860–2, Musée d'Orsay, Paris.

The group sculpture depicts five nude figures in tortuous poses. As the French title specifies, they are Ugolino and four of his children. Ugolino della Gherardesca (died 1289) was an Italian Guelf leader who was betrayed by the Ghibelline leader Ruggieri degli Ubaldini and locked with his two sons and two of his grandsons in a tower, where they all starved to death. The story is told by Ugolino himself in Dante's *Inferno*, 33.

L'Umana fragilità ("Human Fragility") Salvator Rosa, *c.*1656, Fitzwilliam Museum, Cambridge.

The painting is an allegory of transience. A baby seated on a woman's lap is instructed by Death (a winged skeleton) to write: "*Conceptio Culpa, Nasci Pena, Labor Vita, Necesse Mori*" ("Conception is Sinful, Birth a Punishment, Life a Labor, Death Inevitable"). The words are from a poem by the 12th-century writer Adam of St. Victor. The woman is seated on a glass sphere, symbolizing fragility, and wears roses in her hair as a reference to the fleeting nature of love. Various other objects represent the tenuousness of life.

The Umbrellas *see* **Les Parapluies**.

Unconscious Rivals Sir Lawrence Alma-Tadema,1893, Bristol City Art Gallery.

Two young Roman women pose beside an azalea on an marble balcony overlooking the sea. They seem on friendly terms, but the title implies that unknowingly they share the same lover. This interpretation is confirmed by a statue of Cupid trying on a mask of Silenus and, to the right of the picture, by the feet of a statue based on the *Seated Gladiator* in the Lateran Museum, Rome. Gladiators frequently had passionate affairs with noble Roman women.

Under a Dry Arch George Frederic Watts, 1850, Watts Gallery, Compton, Surrey.

A poor woman cowers for shelter by night under the arch of a bridge by London's Thames River. The painting is sometimes wrongly referred to as *Under the Arches*. The correct title specifically indicates that the arch provides shelter from the rain and damp.

Under the Roof of Blue Ionian Weather Sir Lawrence Alma-Tadema, 1901, private collection.

Elegantly robed figures (a man and five young women) pose idly on a semicircular tiered Roman terrace. The title appears to have been suggested by a line in a letter from Shelley to Maria Gisborne, written in 1820: "We watched the ocean and sky together, under the roof of blue Italian weather" (Ash, n.p.).

Underneath the Arches Gilbert and George, 1969, various locations.

Dressed in business suits, their faces made up with metallic paint, the artists created their "singing sculpture" by repeatedly singing the old music-hall song of the title, written by Bud Flanagan in 1932. The pair performed the piece in various venues from 1969, and when they did so at London's Nigel Greenwood Gallery they did it continuously during the gallery's normal opening hours. The words of the song express a sense of pathos and of life's futility and evanescence: "Underneath the Arches, / I dream my dreams away, / Underneath the Arches, / On cobble-stones I lay."

The Unfortunate Tenant *see* **The Rapacious Steward**.

Unique Forms of Continuity in Space (Italian, *Forme uniche della continuità nello spazio*) Umberto Boccioni, 1913, Contemporary Art Museum, São Paolo.

The bronze Futurist sculpture is a visual analysis of a striding man. The title appears to have evolved from a statement by the theater director and critic Anton Giulio Bragaglia in his *Manifesto of Futurist Photodynamism* (1911): "To render a body in movement, I do not portray the trajectory ... but attempt instead to capture the form that expresses its continuity in space" (quoted in Tisdall and Bozzolla, p. 80).

Universal Prostitution (French, *Prostitution universelle*) Francis Picabia, 1916–17, Yale University Art Center, New Haven, Connecticut.

The painting depicts a standing "male" machine shooting out a string of words, "*convier...ignorer...corps humain...*" ("invite...ignore...human body"), while feeding an electric current to a "female" machine, labeled "*sexe féminin idéologique*" ("ideological feminine sex"), crouched over a traveling bag. The title seems to imply that prostitution is universal because the

female will always travel to be "energized" by the male.

The Unknown Political Prisoner Pietro Consagra, 1952, Tate Gallery, London.

The abstract bronze maquette was the Italian artist's response to an international competition for a monument so titled "to commemorate all those unknown men and women who in our time have been deprived of their lives or their liberty in the cause of human freedom." The competition was won by the British sculptor, Reg Butler, but his statue was never realized. (The maquettes were small-scale models from which larger works could be made.)

An Unknown Youth Leaning Against a Tree Amongst Roses *see* **Young Man Leaning Against a Tree**.

Unreal City (Italian, *Città irreale*) Mario Merz, 1968, Stedelijk Museum, Amsterdam.

The Italian words of the title are inscribed in neon lights within a triangular framework. The work appears to be an allegory on the artificial nature of contemporary city life.

Untitled Robert Gober, 1989, Tate Gallery, London.

The work is the model of a man's lower leg, complete with hitched-up trouser (revealing pale, hairy shin), sock, and shoe. In a sense the figure needs no title, since it is realistic and instantly recognizable for what it represents. *Untitled* is a common title in modern art, and especially in Minimalism. The reason for this can be appreciated when it is realized, as Archer points out (p. 53), that giving something a name renders it subordinate to whatever it is named after. Many works are not representative of something else, they are what they are. (Or as the artist Frank Stella put it, "What you see is what you see.") Even so, the title *Untitled* is often accompanied by a meaningful subtitle, serial number, or date. An example of the first of these is Barbara Kruger's *Untitled (When I Hear the Word Culture I Take Out My Checkbook)* (1985). Aside from Gober, the following examples appear in Hodge and Anson: Clyfford Still, *Untitled 1953* (1953), Donald Judd, *Untitled* (1972), Janis Kounelis, *Untitled* (1983), Cindy Sherman, *Untitled #122* (1983), Anthony Gormley, *Untitled (For Francis)* (1985), Keith Haring, *Untitled* (1989), Patrick Heron, *Untitled 10–11 July* (1992). The title has been exploited by the American artist Sherrie Levine, who in the early 1980s made a number of small photographs and wa-

tercolors called *"Untitled" (After …)*, with the blank filled with an artist's name, such as *"Untitled" (After Henri Matisse)* or *"Untitled" (After Willem de Kooning)*. The works are in the style of the named artist. (In these titles, "after" may mean either "inspired by" or simply "later than.") *See also* **Titled**.

The Unwelcome Companion John William Waterhouse, *c.*1873, Towneley Hall Art Gallery, Burnley, Lancashire.

Subtitled *A Street Scene in Cairo*, the painting depicts a young Egyptian woman looking resignedly at the (unseen) man who is presumably forcing his attentions on her. Until the partly obliterated label on the back of the picture was deciphered in 1977, it was known as *Spanish Tambourine Girl*.

USA 666 Robert Indiana, 1964, Stable Gallery, New York.

The work is a pentangular arrangement of highway route signs. All have "USA" in the upper half, and the center one has "666" in the lower half. The two top signs have "EAT" and "DIE" in the lower half, alluding to the American Dream of easy life and death. The two bottom signs have "ERR" and "HUG."

Utopia Juan Davila, 1988, private collection.

The work consists of groups of panels forming capital letters that spell out the title. The panels in the uppermost portion of each letter depict a serene mountainous scene, but as they descend show scenes that are increasingly random and disturbing. In other words, they depict the gradual disintegration of an imaginary or even an actual utopia.

Utopia — Reality —1 (Italian, *Utopia — realtà—1*) Gilberto Zorio, 1971, private collection.

An overhead neon sign in a blue-lit room spells out in capital letters, "*È utopia la realtà è rivelazione*" ("Reality is utopia is revelation"). The artist thus makes his statement on the nature of reality, the title emphasizing the equation between utopia and reality.

V

Vahine no te tiare ("Woman with the Flower") Paul Gauguin, 1891, Ny Carlsberg Glyptotek, Copenhagen.

The painting is the artist's first portrait of a Tahitian woman, here wearing a blue smock and holding an orange flower. The Tahitian title is inscribed at the top of the picture.

Vahine no te vi ("Woman with the Fruit") Paul Gauguin, 1892, Baltimore Museum of Art, Maryland.

A Tahitian woman in a purple dress poses for her portrait, holding a mango in her right hand. The Tahitian title is inscribed at the top of the picture.

Vairaumati tei oa ("Her Name Is Vairaumati") Paul Gauguin, 1892, Pushkin Museum, Moscow.

The portrait of a Tahitian nude represents Vairaumati, a mortal maiden seduced by the Tahitian war god, Oro, son of Tangaroa, here shown standing behind her. She bore Oro a child who came to be regarded as the ancestor of the Areoi, a privileged Tahitian caste.

Vairumati Paul Gauguin, 1897, Musée d'Orsay, Paris.

A nude Tahitian girl is seated on the ground. Beside her, a bird clasps a black lizard in its claw. Despite the different spelling, the subject is the same as that of **Vairaumati tei oa**.

The Vale of Rest John Everett Millais, 1858, Tate Gallery, London.

Two nuns are in their cemetery. One digs a grave while the other sits in contemplation on a tombstone. The painting depicts an actual graveyard in Scotland and implies the eventual death of the two nuns themselves in their "vale of rest," a poetic euphemism for a cemetery. The title was actually from a Felix Mendelssohn song with the line "the vale of rest where the weary find repose", which the artist had heard his brother singing.

Valentine Rescuing Sylvia from Proteus William Holman Hunt, 1850–1, Birmingham City Art Gallery.

The subject matter is from Shakespeare's *Two Gentlemen of Verona*, in which the two gentlemen are the friends Valentine and Proteus, who respectively love Sylvia and Julia. When Proteus in turn falls for Sylvia, he tries to desert Julia and take Sylvia from Valentine. He temporarily succeeds when he rescues her from a band of outlaws. The painting depicts the moment when Valentine, who has been captured by the same outlaws and made their captain, comes across Proteus as he is in the act of declaring his love for Sylvia. The scene is watched by Proteus' page, Sebastian, who is really Julia in disguise.

The Valley of Vision Samuel Palmer, *c.*1828, Yale Center for British Art, New Haven, Connecticut.

The view of farmland gently descending into a valley against a background of rolling hills was painted near Shoreham, Sussex. It has something of a dream-like quality, with ghostly white touches, and is thus part real, part visionary. Hence the title. The artist longed for the world of the Second Coming, which he felt could be glimpsed in nature but which could only be fully experienced in what he called the "Valley of Vision," existing in the mind: "The visions of the soul, being perfect, are the only true standards by which nature must be tried" (quoted in Geoffrey Grigson, *Samuel Palmer's Valley of Vision*, 1960).

The Valpinçon Bather (French, *La Baigneuse de Valpinçon*) J.-A.-D. Ingres, 1808, Louvre, Paris.

A nude woman sits by a bath, her back to the viewer. The painting is so named for the collector who originally bought it for 400 francs. It is also known (even by English speakers) as *La Grande Baigneuse* ("The Great Bather") and sometimes as simply *Nude from the Back*.

The Vampire Edvard Munch, 1893, Museum of Art, Gothenburg.

A nude, red-haired young woman seated on a bed bends over the neck of a man who kneels before her. The work was seen and aided in progress by a friend of the artist, Adolf Paul: "Another time in the same room [where **Puberty** had been painted] I encountered a different model, a girl with fiery red locks streaming about her like flowing blood. 'Kneel down in front of her and put your head in her lap.' he called to me. She bent over and pressed her lips against the back of my neck, her red hair falling about me. Munch painted on, and in a short time he had finished his picture, *The Vampire*" (quoted in Hodin, p. 64). The title of course alludes to the girl's vampiric kiss, her red hair suggesting the blood she sucks from it.

Various Cakes Wayne Thiebaud, 1981, private collection.

The painting depicts rows of garishly-colored cakes. The title puns on the two senses of "various": "several" and "different." The cakes differ not only from one another but from real cakes.

Veluti in Speculum Hans Hofmann, 1962, Metropolitan Museum, New York.

The abstract painting of juxtaposed rectangular colored shapes has a Latin title meaning "just as in a mirror." The shapes evoke space and seem to overlap the picture boundaries, as if "reflecting" a three-dimensional original arrangement.

Vengeance of Achilles Cy Twombly, 1962, Kunsthaus, Zürich.

The painting depicts a gigantic letter "A" with the apex colored an angry red. The "A" stands for Achilles. It also represents the bloody spear tip with which he has killed the Trojan warrior Hector in revenge for the latter's slaying of his close friend, Patroclus.

A Venus Albert Joseph Moore, 1869, York City Art Museum.

The portrait of a full-length female nude is just one of many worthy of the name of the goddess of love. Hence the indefinite article. The torso of this one was in fact copied from the **Venus de Milo**.

Venus and Cupid *see* **The Rokeby Venus**.

Venus and Mars (1) Sandro Botticelli, 1483, National Gallery, London; (2) Piero di Cosimo, *c.*1498, National Gallery, London.

Mars, the god of war, falls back in slumber, naked and bereft of his weapons. He has been conquered by Venus, the goddess of love, who reclines, alert and active, opposite him. (She is clothed in Botticelli's painting, naked in Piero's.) The depiction is an allegory of strife vanquished by love, or in hippy terms, "Make love, not war."

Venus Asleep *see* **Sleeping Venus**.

Venus at Her Mirror *see* **The Rokeby Venus**.

Venus, Cupid, Folly, and Time *see* **An Allegory of Love and Time**.

Venus de' Medici *see* **Medici Venus**.

Venus de Milo ?, *c.*100 BC, Louvre, Paris.

The famous marble statue of Aphrodite takes its name from Melos (Milos), the Greek island in the Cyclades where it was found in 1820. The identity of the sculptor is unknown. The statue came to the Louvre in 1821, six years after the return of the **Medici Venus** to Italy.

Venus Italica (Latin, "Italian Venus") Antonio Canova, 1812, Pitti, Florence.

The life-size marble stature of Venus depicts the goddess clasping her robe to her body to conceal her nudity. The work was intended to rival the **Medici Venus**.

Venus of Cnidus *see* **Aphrodite of Cnidus**.

Venus of Urbino Titian, *c.*1536, Uffizi, Florence.

A naked young woman, her left hand prudently positioned, lies on a couch as a personification of the goddess Venus. She was painted for Guidobaldo della Rovere (1514–1574), soon to become duke of Urbino. Hence the name. In a sense it is a misnomer, since the work is simply the portrait of a courtesan, whose clothes are being laid out by the women in the background. (The identity of *la donna nuda*, as the duke referred to her, remains uncertain. The fact that the painting entered his collection three years after it was completed would apparently rule out the formerly popular theory that she is his wife, Eleonora Gonzaga.) The work was based on Giorgione's **Sleeping Venus** and was later parodied in Manet's **Olympia**.

Venus on the Half-Shell *see* **The Birth of Venus**.

Venus Rising from the Sea Raphaelle Peale, *c.*1822, Nelson-Atkins Museum of Art, Kansas City, Missouri.

The painting, whimsically based on James Barry's picture of the same name (1772), is of a suspended bath towel (really a huge handkerchief) concealing the body of a naked woman after bathing. Only her foot, arm, and hair are visible. The work is subtitled *A Deception*, and is alternately known as *After the Bath*.

Venus Verticordia Dante Gabriel Rossetti, 1864–68, Russell-Cotes Art Gallery, Bournemouth.

The painting depicts a seminude Venus, holding a golden apple in one hand and an arrow in the other, a yellow butterfly poised on each. The Latin title means "Venus, Turner of Hearts," as an epithet of the Roman goddess who could

be invoked to "turn the hearts" of women to virtue and chastity. The apple refers to the first temptation, in the Garden of Eden. The arrow is either the one that killed Paris at the Siege of Troy (*see* **The Judgement of Paris**) or Cupid's arrow of love. The head, if not the body, is that of Alexa Wilding, a dressmaker that the artist "discovered."

Venus Victorious (French, *Vénus Victorieuse*) Pierre-Auguste Renoir, 1914, Tate Gallery, London.

The bronze statue depicts a nude Venus, the goddess of love, holding the golden apple awarded to her by Paris for her beauty.

Vernissage Howard Kanovitz, 1967, Museum Ludwig, Cologne.

A number of elegantly dressed men and women attend a *vernissage*, the French term for a private viewing of paintings before their public exhibition. The title, which literally means "varnishing," seems to hint at the superficiality of their talk, an impression enhanced by the uniformly blue background against which they stand.

Veronica Veronese Dante Gabriel Rossetti, 1872, Delaware Art Museum, Wilmington, Delaware.

A woman sits pensively before a violin and an open music manuscript book while a canary sings in a cage behind her. The Italian title means "Veronica of Verona," and the work itself is apparently based on a passage by Swinburne, telling how Lady Veronica is inspired by the singing of a bird to play and then write down the melody she seeks. At the same time the title evokes the Italian painter Paolo Veronese (1528–1588), whom Rossetti greatly admired and who seems to have influenced his method of coloring with shiny highlights. The model for the musician was Alexa Wilding, who also appears in **Sibylla Palmifera**. The companion painting for the work was **A Sea Spell**. Rossetti's original title for the picture was *The Day Dream*, and it was also known as simply *Lady with Violin*.

The Vertigo of Eros (French, *Le Vertige d'Éros*) Roberto Matta, 1944, Museum of Modern Art, New York.

The Surrealist painting depicts a number of biomorphic objects apparently floating in space amidst whirling lines. "The title relates to a passage in Freud in which he locates all consciousness as falling between Eros and the death instinct — the life force and its antithesis" (W.S. Rubin, quoted in S. Wilson, p. 124).

The Very Picture of Idleness Richard Rothwell, 1842, Victoria and Albert Museum, London.

A lazy but pretty young woman leans on her arms and looks at the viewer with a broad smile.

Vesper Edward Burne-Jones, 1972, private collection.

A young woman in a blue dress is depicted in profile floating above the earth. She is Vesper, or as the subtitle indicates, *The Evening Star*. The painting is also known as *Hesperus*.

The Veteran in a New Field Winslow Homer, 1865, Metropolitan Museum, New York.

At first sight the painting appears to show an old farmer scything his ripe wheat. The title, however, and his jacket and water canteen on the ground, together identify him as a former Union soldier. The field is "new" by comparison with the "old" field, the battlefield where many lost their lives. Some of the battles of the Civil War, moreover, were actually fought in wheat fields. The farmer, as a reaper, is thus a reminder of the Reaper that is Death.

Vexilla Regis ("The Banners of the King") David Jones, 1947–8, Kettle's Yard, Cambridge.

The watercolor of a wood takes its title from a Latin hymn that formed part of the Roman liturgy for Good Friday. The hymn has many allusions to the tree and the Cross, and the Crucifixion imagery is present in the three trees that dominate the depiction. The central one is the Cross, the one to its left evokes the good thief of the gospel story, and the one to its right, its base not rooted but supported by wedges, is crowned by a Roman standard as an emblem of wordly power.

Victorious Amor *see* **Amore Vincitore**.

Victory of Samothrace ?, *c.*200 BC, Louvre, Paris.

The famous larger-than-life marble statue depicts a winged Victory (the Greek goddess Nike) alighting on the bows of a galley. The figure was discovered in 1863 on the Greek island of Samothrace. Hence its name.

Le Vide ("The Void") Yves Klein, 1958, Galerie Iris Clert, Paris.

The work is simply an empty gallery painted white. Hence its title. Unsurprisingly, it

caused something of a sensation when it was first put on display as an "exhibition of emptiness."

La Vie ("Life") Pablo Picasso, 1903, Cleveland Museum of Art, Ohio.

A nude young couple stand in a sad embrace as they face a mother with a baby in her arms. The couple are the artist's fellow painter, Carles Casagemas, and his girlfriend, Germaine Gargallo. Picasso painted the picture out of feelings of guilt or compassion following Casagemas's suicide in 1901. (Unable to consummate an affair with Gargallo, he shot himself, having first tried to shoot her.) The nature of the confrontation between the couple and the mother is obscure, but it must tie in somehow with the title, which itself appears to imply that the painting is a statement about the meaning of life. Casagemas died without fathering a child. But another baby has been born and life goes on.

Vierge au diadème *see* **The Madonna of the Veil**.

The Village Bride (French, *L'Accordée de village*) Jean-Baptiste Greuze, 1761, Louvre.

Surrounded by his family in the one living-room of a simple village dwelling, an aging father gives his daughter's dowry in a leather bag to the young man who will marry her. French *accordée* is an old word for a bride or fiancée. The painting is also known in English as *The Village Betrothal*. Its original title was *A Father Paying His Daughter's Dowry*. (The French title is sometimes wrongly given as *L'Accordée du village*, which would mean "The Bride of the Village," *i.e.* the only one. A better English title might be simply *Village Bride*.)

A Village Choir Thomas Webster, 1847, Victoria and Albert Museum, London.

The artist's best-known work depicts a village choir singing and playing in their church gallery. Many of the men and women are clearly "characters." The subject was inspired by Washington Irving's *The Sketch Book* (1820), in which the writer relates how a village squire takes him to the local church and describes the individuals who make up the choir and band.

Violet John Singer Sargent, 1886, private collection.

The painting is a portrait of the artist's 16-year-old sister, Violet (1870–1955). A mauve flower at her breast points up her name and so also the title. In 1891 she married Francis Or-

mond, the son of a Swiss cigar manufacturer. She also appears in **A Morning Walk**.

The Violet Beast (French, *La Bête violette*) John Duncan Fergusson, *c*.1911, private collection.

The beast in question is an atavistic animal decorating a cloth that is the main object in a painting that is essentially a **Still Life**.

Violon d'Ingres ("Ingres' Violin") Man Ray, 1924, J. Paul Getty Museum, Malibu, California.

The artist has added a pair of *f*-holes (soundholes) to the photograph of the rear view of a seated nude woman, so that her back resembles a violin. The punning title, the French phrase for an artistic hobby, alludes to the painter Ingres, noted not only for his nude portraits but for playing the violin to visitors to his studio before allowing them to see his paintings.

Vir Heroicus Sublimis ("Man Heroic and Sublime") Barnett Newman, 1950–1, Museum of Modern Art, New York.

The canvas is a field of intense red broken only by five thin vertical lines. One is white and brighter than the rest, and is the artist's characteristic "zip." The Latin title seems to point to some immutable moral or spiritual message.

Virgil Writing His Own Epitaph at Brundisium Angelica Kauffmann, 1785, private collection.

The Roman poet Virgil writes his own epitaph as he lies on his deathbed in Brundisium (Brindisi, Italy) while two other poets and Calliope, the Muse of epic poetry, look sadly on. The words of the epitaph can be made out, with the poet's pen forming its penultimate letter: "Mantua me genuit, Calabri rapuere, tenet nunc Parthenope; cecini pascua rura duces" ("Mantua bore me, Calabria snatched me away, now Naples holds me; I sang of pastures, fields, and kings").

A Virgin Abbott H. Thayer, 1892–3, Freer Gallery of Art, Smithsonian Institution, Washington, D.C.

An innocent-looking young woman walks towards the viewer, accompanied by two children. She is the idealized virgin of the title, and is based on the artist's daughter, Mary.

The Virgin (German, *Die Jungfrau*) Gustav Klimt, 1913, National Gallery, Prague.

Figures of nude young girls and women lie

entwined on a bed of flowers. They represent the different stages of sensual awakening, and depict the girl becoming a woman.

Virgin and Child (1) Masaccio, 1426, National Gallery, London; (2) Fra Filippo Lippi, 1440–5, National Gallery, Washington, D.C.; (3) Jean Fouquet, 1450, Koninklijk Museum voor Schone Kunsten, Antwerp; (4) Dirk Bouts, c.1460–5, private collection; (5) Nicolas Froment, 1476, St. Sauveur, Aix-en-Provence; (6) Leonardo da Vinci, c.1478–80, Hermitage, St.Petersburg; (7) *see* **The Virgin of the Napkin**.

The subject of these and similarly titled works is the same as that of The **Madonna and Child**, although many of these depictions of Mary with the infant Jesus on her lap contain no other figures. Froment's painting, however, as the center panel of a triptych depicting Moses and the Burning Bush, includes Moses and an angel. Fouquet's Virgin is said to be a portrait of Agnès Sorel, mistress of Charles VII of France, who died aged about 28 in 1450, the year the painting is dated.

The Virgin and Child Before a Firescreen attrib. Robert Campin, c.1434–8, National Gallery, London.

The Virgin Mary sits with the infant Christ on her lap, one breast bared to suckle him. Behind her head, serving as a halo, is a large round firescreen of plaited cane. Hence the title.

The Virgin and Child with St. Anne

(1) Leonardo da Vinci, c.1501–12, Louvre, Paris; (2) Andrea Sansovino, 1512, S. Agostino, Rome.

The group in each case depicts the Virgin Mary with the infant Jesus on her lap and her mother, St. Anne, standing behind her. The composition of Sansovino's sculpture was based on Leonardo's painting (which itself has a cartoon version in the National Gallery, London).

Virgin and Child with St. Jerome and St. Sebastian *see* **Madonna della Rondine**.

The Virgin and Child with Saints

Pietro Perugino, c.1497, Pinacoteca Nazionale, Bologna.

The altarpiece depicts the Virgin Mary with the infant Jesus on her lap between two angels. Below her are the figures of four saints, each identifiable by his or her attributes: St. Michael the Archangel, St. Catherine of Alexandria, St. Apollonia, and St. John the Evangelist.

The Virgin and Child with Saints and Donors *see* **The Donne Triptych**.

Virgin and Child with SS. George and Anthony Abbot Pisanello, c.1445, National Gallery, London.

The Virgin Mary and infant Jesus appear as a vision "clothed in the sun" above the named saints. St. George is here a young knight in armor, a dragon at his feet, while Anthony Abbot, protector against the plague and leprosy, is an old man carrying a bell with a hog at his feet.

The Virgin in the Rose Bower Stefan Lochner, c.1440, Wallraf-Richartz-Museum, Cologne.

The setting of the painting, depicting the Virgin and Child, is the same as that of The **Madonna of the Rose Bower**, and the work itself is also known as *Madonna of the Rose Garden* (or *Rose-Garden Madonna*), as well as *Virgin of the Rose Bush* and *Virgin of the Rose Hedge*.

The Virgin of Chancellor Rolin Jan van Eyck, 1434–6, Louvre, Paris.

The Virgin Mary with the infant Jesus on her knee is seated opposite Nicolas Rolin (1380–1462), chancellor of Burgundy and Brabant, who kneels before her in supplication. The chancellor commissioned the work for the collegiate church in Autun.

Virgin of the Councillors Luís Dalmau, 1445, Barcelona Museum.

The altarpiece depicts the Virgin Mary, St. Andrew, and St. Eulalia together with the five councillors of Barcelona. The work echoes Jan Van Eyck's altarpiece *Madonna of the Councillors* at St. Bavon, itself named for the councillors who commissioned it. Dalmau studied with Van Eyck for five years from 1431.

The Virgin of the Napkin Bartolomé Murillo, c.1669, Museo de Bellas Artes, Seville.

The regular title of the painting, depicting Mary holding the infant Jesus in her arms, is simply *Virgin and Child*. No napkin appears, and the two stories that explain the name are recounted only in 1833. The first tells how one day, when Murillo was breakfasting with the nuns after mass at a convent, a napkin disappeared, much to the concern of the lay brother who was accompanying him. Some days later, Murillo offered the picture to the convent, painted on a similar napkin. The second account suggests that the lay brother wanted a picture of

the Virgin and Child for his private devotions and asked Murillo to paint it. The artist agreed on condition that he supply the cloth. Having no other canvas, the brother gave him the napkin, on which Murillo painted the present picture.

The Virgin of the Rocks Leonardo da Vinci, *c*.1483–5, Louvre, Paris.

The painting depicts the meeting in the wilderness of the Virgin and Child with the infant St. John and the archangel Uriel. The figures are posed before a rocky grotto. Hence the title, which has the alternate form *Madonna of the Rocks*. The later version of the work (completed *c*.1508) in the National Gallery, London, is equally known by either title.

Virgin of the Rose Bush *see* The **Virgin in the Rose Bower**.

Virgin of the Rose Hedge *see* The **Virgin in the Rose Bower**.

The Virgin Spanking the Infant Jesus Before Three Witnesses: André Breton, Paul Éluard, and the Artist Max Ernst, 1928, Mme. Jean Krebs Collection, Brussels.

The Virgin Mary holds down a naked boy Jesus across her lap and chastises him as described in the title. The three named Surrealist artists look on though a window. The punishment has no biblical precedent, unless one imagines it as a consequence of Luke 2:42–50.

The Virgin with the Diadem *see* The **Madonna of the Veil**.

The Virgin with the Veil *see* The **Madonna of the Veil**.

The Virtuous Comforted by Sympathy and Attention Edward Penny, 1774, Yale Center for British Art, New Haven, Connecticut.

A young invalid woman in an armchair is gently ministered to by solicitous attendants. The subject and title of the painting are in intended contrast to those of the pendant (companion piece), **The Profligate Punished by Neglect and Contempt**.

Viscount Lepic and His Daughters Crossing the Place de la Concorde *see* **Place de la Concorde**.

The Vision After the Sermon (French, *La Vision après le sermon*) Paul Gauguin, 1888, National Gallery of Scotland, Edinburgh.

A group of traditionally costumed Breton women pray after hearing a sermon and see a vision of the Old Testament story that the preacher took for his text. The depiction gave the painting's alternate title, *Jacob Wrestling with the Angel*, alluding to the account of Jacob's struggle against God (Genesis 32:24–30). Gauguin painted the picture after seeing Émile Bernard's **Breton Women at a Pardon**.

The Vision of Ezekiel David Bomberg, 1912, Tate Gallery, London.

The Vorticist painting, with its interlocking human figures, represents the Old Testament scene in which, following Ezekiel's prophecy (in the book named for him) of the fall of Jerusalem, the Jews combat the forces of Nebuchadnezzar (2 Kings 25).

The Vision of Father Simón Francisco Ribalta, 1612, National Gallery, London.

Father Simón, who died in 1612, the year of this painting, was a parish priest of Valencia famous as an ascetic. His vision, depicted here, was of Christ carrying the cross. Christ is shown surrounded by his executioners and followed by the Virgin Mary and St. John.

A Vision of Fiammetta Dante Gabriel Rossetti, 1878, private collection.

The painting depicts an auburn-haired woman in red, modeled by Marie Spartali, beneath an apple tree in full blossom. The portrait is of Fiammetta ("Little Flame"), the pet name of Boccaccio's lover, Maria d'Aquino, who died young. The artist later wrote a sonnet on the picture, beginning: "Behold Fiammetta, shown in vision here." *Cf.* **Fiammetta Singing**.

The Vision of St. Bartholomew (Russian, *Videniye otroku Varfolomeyu*, "The Apparition to the Boy Bartholomew") Mikhail Nesterov, 1889–90, Tretyakov Gallery, Moscow.

The painting depicts an episode from the boyhood of St. Sergius of Radonezh (1314–1392), born Varfolomey (Bartholomew) Kirillovich, in which he stands in awe, hands clasped, before the hooded figure of an old monk who has appeared to him under a tree on a hill.

The Vision of St. Bernard (1) Filippino Lippi, *c*.1480, Badia, Florence; (2) Pietro Perugino, 1489, Alte Pinakothek, Munich.

The alternate title of Lippi's altarpiece is *The Apparition of the Virgin to St. Bernard*, thus revealing the object of the saint's vision as depicted in both paintings.

The Vision of St. Eustace Pisanello, *c*.1435, National Gallery, London.

St. Eustace, depicted here on horseback in a stag hunt, comes across a stag with a crucifix between its antlers. It speaks to him and urges him to convert to Christianity. The legend dates from at least the 7th century AD.

The Vision of St. Francesca Romana
Orazio Gentileschi, 1615–19, Galleria Nazionale delle Marche, Urbino.

The painting depicts St. Frances of Rome (1384–1440), as she is often known, nursing one of her children. She is attended by her guardian angel, whom she continually saw in a vision.

The Vision of St. Jerome Parmigianino, 1526–7, National Gallery, London.

St. John the Baptist kneels on one knee before a sleeping St. Jerome and turns to point back and up at the radiant figures of the Virgin and Child, the object of Jerome's vision.

A Vision of the Past Eanger I. Couse, 1913, Butler Institure of American Art, Youngstown, Ohio.

Three American Indian braves stand back to back as if held together by unseen bonds. They are symbols of a captive race that has lost its independence but not its nobility or spiritual strength. In the sky behind them a celestial buffalo hunt can be seen. This is the "vision of the past" of the title, but so also is the inner vision in the mind of each brave. A young child sits at their feet staring at the green valley below. Perhaps he will become a farmer there, as white culture will have him be. This is therefore his own contrasting "vision of the future."

The Visit (1) (Russian, *Svidaniye*) Vladimir Makovsky, 1883, Tretyakov Gallery, Moscow; (2) Willem de Kooning, 1966–7, Tate Gallery, London.

Makovsky's painting depicts a peasant woman visiting her young son who has been "put out to work." He greedily eats the loaf his mother has given him as she looks sadly on. In de Kooning's semi-abstract painting the outline of a woman's naked body can be discerned, her legs splayed wide. The title was suggested by the artist's assistant, who was reminded of a medieval Visitation (Annunciation) scene. The woman is thus seen as the recipient of whoever or whatever is visiting her.

The Visit to the Child at Nurse George Morland, *c*.1788, Christie's, London.

The painting depicts the former practice among women of the English middle and upper classes of consigning their babies to wet nurses until weaning. A baby is thus shown being visited by his parents while he is "at nurse," on the lap of the nurse who is suckling him.

The Visitor Carel Weight, *c*.1952, private collection.

An elderly lady sits patiently on a chair in a drawing room awaiting a visit. The "visitor" of the title can be seen through the glass panels of the door as a skeleton, representing Death. The personification of Death as an unwelcome (or even welcome) visitor is quite common.

Vladimirka Isaak Levitan, 1892, Tretyakov Gallery, Moscow.

A rough track stretches across bleak plains towards the horizon. It is the Vladimirka, the track along which political exiles trudged under guard on their way to Siberia. It is so named because it passed through the town of Vladimir, 118 miles northeast of Moscow.

The Voice Edvard Munch, 1893, Museum of Fine Arts, Boston, Massachusetts.

A young woman stands with her hands behind her back amid a group of trees. Her mouth is tight shut, apparently repressing an urgent desire to speak. Her voice thus remains unheard.

Volga Boatmen *see* **Bargehaulers on the Volga**.

The Voyage of Life Thomas Cole, 1839–40, Munson-Williams-Proctor Institute, Utica, New York.

The work is a series of landscapes depicting the journey of a man through life from infancy to old age as he passes in a boat along a river and eventually reaches the sea. The four paintings are respectively titled *Childhood*, *Youth*, *Manhood*, and *Old Age*. The most popular was *Youth*, depicting a young man in a boat accompanied by angels as, one hand holding the rudder, the other raised aloft, he steers his way towards a "castle in the air" that can be seen in the background.

The Voyageurs Charles Deas, 1845, Rokeby Collection.

A family of fur traders in a dugout canoe traverse fast-moving waters as they prepare for a storm. Fur traders of French descent who made annual journeys on dugouts and canoes up and down river like this were known as *voyageurs*, literally, "travelers."

Vulcan Surprises Venus and Mars
Tintoretto, *c.*1555, Alte Pinakothek, Munich.

The scene is from classical mythology. Vulcan (or Hephaestus), the aged husband of Venus (or Aphrodite), has surprised a naked Venus and Mars in the act of intercourse. He now lays bare Venus' sex while Mars hides under the bed. Cupid, Venus's son, lies in his crib.

The Waefu' Heart Thomas Duncan, 1841, Victoria and Albert Museum, London.

A young woman sits sadly before the fire, a dog at her feet. She is Jenny, the heart-broken wife in Lady Anne Lindsay's popular ballad *Auld Robin Gray* (1772). The painting illustrates the lines: "I gang like a ghaist, and I carena to spin; / I darena think on Jamie, for that would be a sin. / I wish I were deed, but I'm no like to dee, / And why do I live to say, Wae's me." The Scottish title thus means "The Woeful Heart."

The Wafer Vendor (French, *Le Marchand d'oublies*) Gino Severini, 1908, private collection.

A traveling salesman has set up his stall on a Paris street to sell wafers. (The French word *oublie* comes from ecclesiastical Latin *oblata*, "communion wafer.") An alternate title is *Avenue Trudaine*, the name of the street, one formerly favored by such salesmen.

The Wait Edward Kienholz, 1964–5, Whitney Museum of American Art, New York.

An old woman sits waiting for death, her face represented by a miniature portrait, her arms and legs mere bones. Childhood memories hang in jars around her neck, and photographs of her loved ones fill the table beside her.

Waiting John Everett Millais, 1854, Birmingham City Art Gallery.

A young woman in a red bonnet sits on the steps of a stile over a wall as she waits for the lover who has apparently abandoned her.

Waiting: An English Fireside of 1854–55 Ford Madox Brown, 1851–5, Walker Art Gallery, Liverpool.

A mother, her young daughter asleep on her lap, sits sewing by the fireside as she waits for her soldier husband to return from the Crimean War. The subtitle dates confirm the subject.

Waiting for an Answer John Callcott Horsley, 1841, Victoria and Albert Museum, London.

A faithful retainer waits for the answer to his master's billet doux to the lady of the house while himself awaiting the reply to his own love note to his mistress's maid.

Waiting for the Verdict Abraham Solomon, 1857, Tunbridge Wells Museum, Kent.

The members of a closely knit family wait anxiously in the outer room of a courthouse to learn the outcome of a legal action against the father of the family. The artist painted a pendant (companion piece) entitled *The Acquittal*, also known as *Not Guilty* (1859), as a happy ending to the story.

The Waitress *see* **La Serveuse de Bocks**.

Walking Man I (French, *Homme marchant I*) Alberto Giacometti, 1960, Fondation Maeght, Saint-Paul-de-Vence.

The bronze sculpure is of elongated (and etiolated) figure of a man walking, his hands hanging limply by his sides. The figure's long legs form an inverted V that (perhaps intentionally) resembles the Chinese hieroglyph *rén*, "person," "man."

Walking to Bethlehem (German, *Der Gang nach Bethlehem*) Fritz von Uhde, *c.*1890, Neue Pinakothek, Munich.

A soldier helps his weary pregnant wife along a rutted road. The painting is a translation into modern idiom of Mary and Joseph's journey to Bethlehem (Luke 2:1–5). An alternate German title is *Schwerer Gang* ("Hard Going").

Walking Woman (French, *La Femme marchant*) Alexander Archipenko, 1912, Denver Art Museum, Colorado.

The bronze statue, with its holes and concavities, represents the woman of the title in the Cubist idiom.

Walking Wounded Alice Walker, 1861, Forbes Magazine Collection, New York.

Two young women stand in a hallway leading to a crowded drawing room scene. One has thrown down her gloves and fan, conventional symbols of flirtation and amorous rivalry, and is comforted by the other, a friend. In the drawing room itself a seated young woman glances up over her fan at a handsome young officer. The title clearly applies to the first woman, who has

been jilted and so emotionally wounded. But she is still "walking," and will recover. The usual military sense of the phrase is hinted at by the presence of the officer.

War (1) Anna Lea Merritt, 1883, Bury Art Gallery; (2) (French, *La Guerre*) Henri Rousseau, 1894, Musée d'Orsay, Paris.

Merritt's painting depicts a group of women on a balcony watching the triumphal parade of soldiers passing below. The artist herself described the subject: "Five women, one boy watching army return—ancient dress. It shows her respect for the classical tradition. It also shows the women's side of war—the anxieties, the fears & the long wait as opposed to the glorification of war" (quoted in Chadwick, p. 204). "War" this means different things to different people. The war in question was the 1882 British occupation of Egypt and its subsequent resistance. In Rousseau's picture a figure in white brandishing a flaming torch and a sword rides a black horse across a battlefield where black birds of death alight on the naked dead and dying as they lie on the burned earth. The horse is the bearer of war, and itself represents the crazed gallop of war.

The Washerwoman (French, *La Laveuse*) Honoré Daumier, *c.*1860, Louvre, Paris.

A washerwoman toils up the steps from the banks of the Seine in the evening sunlight at the end of her working day, leading her young child by the hand.

Washing in the Sun (Italian, *Panni al sole*) Giuseppe Pellizza da Volpedo, 1905, private collection.

The depiction is of laundry drying in the sun, either already hung out on a line or still in a basket on the ground. The English title, although accurate, is perhaps misleading, suggesting a person (or possibly an animal) performing ablutions. But "Laundry in the Sun" is no better.

Washington Crossing the Delaware (1) Emanuel G. Leutze, 1851, Metropolitan Museum, New York; (2) Larry Rivers, 1953, Museum of Modern Art, New York.

Leutze's best-known work depicts the historic occasion when Washington boldly crossed the Delaware to rout enemy forces at Trenton on Christmas night of 1776. Rivers based his Pop-art version of the event on Leutze's painting, and it also appears in Grant Wood's **Daughters of Revolution**.

Watching the Porpoises Alfred Downing Fripp, 1863, Bethnal Green Museum, London.

Perched happily atop a weed-strewn rock, three young boys watch porpoises sport in the sea.

The Waterfall (French, *La Cascade*) René Magritte, 1961, private collection.

A framed painting of a forest has been set on an easel and placed within dense foliage, so that it is a picture located within the object it depicts. The artist explained: "As for the title of the picture, *The Waterfall*, I merely meant to point out that the thought which conceives such a painting undoubtedly overflows like a waterfall" (quoted in Gablik, p. 97).

The Water-Lily Pond (French, *Le Bassin aux nymphéas*) Claude Monet, 1899, National Gallery, London.

The artist painted many views of the lily pond in his garden at Giverny, near Rouen, and created it initially by diverting a branch of the Epte River, building a "Japanese" bridge over it. The picture is also known as *The Pond with Water-Lilies*, keeping the French word order.

The Waterplash Henry Herbert La Thangue, 1900, Victoria Art Gallery, Bath.

A young girl drives a flock of geese to a stream ("waterplash"), where they drink greedily.

Wave, Beach Georgia O'Keeffe, 1928, Addison Gallery, Andover, Massachusetts.

A foam-edged wave spreads over the firm sand of a beach, while a lighthouse shines as a dot of light on the dark horizon between sea and sky. The painting depicts the artist's memory of a visit to a friend at York Beach, Maine, in 1920: "I loved running down the boardwalk to the ocean—watching the waves come in, spreading over the hard wet beach—the lighthouse steadily bright far over the waves in the evening when it was almost dark" (quoted in Jennifer Bright, *At the Sea*, 1996).

The Waves (French, *Les Vagues*) Arnold Böcklin, 1883, Neue Pinakothek, Munich.

A lecherous Triton seizes a distressed-looking mermaid amid the waves of the sea while other mythical sea beings dive, float, and rear up from the waves in the background.

Ways of Worldly Wisdom: The Battle of the Teutoburg (German, *Wege der Weltweisheit: die Hermannsschlacht*) Anselm Kiefer, 1978–80, Städtische Galerie, Munich.

The painting consists of 28 woodcut portraits grouped symmetrically beside and below two treetrunks, before which a fire is burning. They appear to represent the historical continuity of the named battle of AD 9 in which Arminius (German *Hermann*), chief of the Cherusci, vanquished the three Roman legions of Publius Quintilius Varus in the Teutoburg Forest. The artist had earlier used the subtitle in a 1976 painting entitled *Piet Mondrian*. He took the main title of the present work from that of a historical treatise by a Jesuit priest.

We Both Must Fade Lilly Martin Spencer, 1869, National Museum of American Art, Smithsonian Institution, Washington, D.C.

A lavishly dressed young woman holds a wilting flower as she stands wistfully beside a table on which a pearl necklace spills from an open jewel box. The painting, an allegory of the transience of youth, beauty, and life, is a portrait of Mrs. Fithian, a member of the family of Richard B. Connally, comptroller general of New York, who commissioned it. The title alludes to the mortality of both painter and subject.

We Shall Not Go to Market Today *see* **Ta matete**.

We Two Boys Together Clinging David Hockney, 1961, Arts Council, London.

The painting depicts two figures embracing. The title is written across their necks and comes from Walt Whitman's 9-line poem of the same name (1860), beginning: "We two boys together clinging, / One the other never leaving." Two lines from the poem are written to the right of the picture: "Power enjoying, elbows stretching, fingers clutching, / Arm'd and fearless, eating, drinking, sleeping, loving," while on the lips of one of the boys is the word "Never," from the poem's second line. An alternate title is also inscribed in the picture: *Two Boys Cling to Cliff All Night Long*, from a newspaper headline about a mountain accident. "Cliff" is a private reference to the pop singer, Cliff Richard, whom Hockney then idolized.

Weary Waiting Louise Jopling, 1877, Sotheby's, London.

A young wife sits sadly at a table while her little daughter sits at her feet nursing a doll. A small painting on the table of a ship immured in ice suggests that the woman's husband is an Arctic explorer and that his homecoming may be long delayed or even never happen at all.

Weatherbeaten Winslow Homer, 1894, Portland Museum of Art, Maine.

Waves pound a rocky shore on the Atlantic coast, where the artist himself lived from 1883.

The Wedding March Theodore Robinson, 1892, Terra Museum of American Art, Chicago, Illinois.

A veiled bride walks down a dusty road on the arm of her father, followed by other wedding guests. The title hints at the music traditionally played in a church on the entry of the bride. The picture was painted for the marriage of the American artist Theodore Earl Butler (1860–1936) to Suzanne Hoschedé-Monet, Monet's stepdaughter.

The Wedding of St. George and Princess Sabra Dante Gabriel Rossetti, 1857, Tate Gallery, London.

The painting depicts the "happy ending" of a popular medieval tale: St. George rescues the Egyptian princess Sabra from the dragon, then marries her. Here, the princess cuts a lock from her hair as she kneels before a seated St. George, who embraces and kisses her.

Wedge of Chastity (French, *Coin de chasteté*) Marcel Duchamp, 1954, private collection.

A wedge-shaped mold of galvanized plaster is set in a soft plastic casing. The actual "wedge of chastity" is thus itself hidden, as chastity itself often is.

Westward the Course of Empire Takes Its Way Emanuel G. Leutze, 1861, National Museum of American Art, Smithsonian Institution, Washington, D.C.

A group of weary travelers celebrate the first view of the golden land of California. The title quotes the well-known line from Bishop George Berkeley's poem *On the Prospect of Planting Arts and Learning in America* (1752): "Westward the course of Empire takes its way; / The first four acts already past, / A fifth shall close the drama with the day: / Time's noblest offspring is the last."

Westward the Star of Empire Takes Its Way Andrew Melrose, *c.*1865, private collection.

A train engine, its headlight blazing, rushes towards the viewer as it races through a forest on the American frontier, scattering deer. A pioneer homestead is seen to the left amid a mass of tree stumps like tombstones testifying to man's

destruction of the wilderness. The title adapts the famous line from Bishop George Berkeley's poem (*see* **Westward the Course of Empire Takes Its Way**). The "star" is the train's brilliant headlight.

Whaam! Roy Lichtenstein, 1963, Tate Gallery, London.

An American aircraft blasts an enemy plane to pieces. The painting, in comic-strip style, has a caption ("I pressed the fire control ... and ahead of me rockets blazed through the sky...") and the word of the title in huge letters to represent the force of the explosion.

What! Are You Jealous? Paul Gauguin, 1892, Pushkin Museum, Moscow.

The painting is a study of two nude Tahitian women, one seated, one lying. The import of the title has been the subject of much speculation. The following theories have been advanced: 1) It alludes to the imposition of Western morals on the Tahitians; 2) It is Gauguin's challenge to the viewer, to envy his exotic (and erotic) lifestyle; 3) It is his challenge to the viewer, to envy his art as a painter and rival his color harmonies; 4) It is addressed by one woman to the other, alluding to a third person. The artist himself offered no explanation and preferred the work to be known by its native title, which appears at bottom left: *Aha oe feii?*

What Could Make Me Feel This Way (A) Richard Deacon, 1991, Sprengel Museum, Hanover.

The huge sculpture is a mass of writhing, visceral coils created from bent wood, using screws and cable ties. The title could be statement or question, and leaves the viewer to decide which way is "this way," especially as the work demands to be looked at from all angles. "In the carefully considered, often witty, titles of Deacon's work, the language and sensuality of the forms draw the viewer in and invoke an emotional response to a new and layered expression of something familiar" (*The Times*, February 6, 1999). *Cf.* **Fish Out of Water, Let's Not Be Stupid**.

What Is Truth? (Russian, *Chto yest' istina?*) Nikolai Ge, 1890, Tretyakov Gallery, Moscow.

The painting depicts the moment in the New Testament when Pontius Pilate, in the trial of Jesus, poses the question of the title (John 18:38), as much to himself as to Christ.

What the Water Gave Me Frida Kahlo, 1938, private collection.

The Surrealist painting depicts the artist in her bathtub. Over her legs float the objects of her bathtime reverie, presenting images of death, pain, and sexuality. A real image is that of her deformed right foot, with its cracked big toe, the result of a road accident when she was 15.

When Logics Die Damien Hirst, 1991, private collection.

The work is a display of medical equipment with color photo closeups of suicides and fatal accidents. The title echoes the artist's statement: "I can't understand why some people believe completely in medicine but not in art, without questioning either" (Hirst, p. 24).

When Shadows Hint Death Charles M. Russell, 1915, Duquesne Club, Pittsburgh, Pennsylvania.

Seeing the silhouettes of a band of marauding Indians as shadows on the opposite canyon walls, two trapper-cowboy types make to silence their horses and draw them under the cover of a rock ledge. The title suggests a quotation or the opening words of a proverb.

When White Men Turn Red Charles M. Russell, 1922, Sid Richardson Collection of Western Art, Fort Worth, Texas.

A long-haired, blond American trapper and his Indian wives move down from the hills on horseback to camp with the women's tribesmen, whose tepees are seen in the valley below. The title implies that the trapper has "gone Indian," and evokes the artist's own short story *How Lindsay Turned Indian*, the tale of a trapper who married an Indian.

When Will You Marry? *see* **Nafea faa ipoipo?**

Where Are You Going? *see* **Ea haere ia oe?**

Where Do We Come From? What Are We? Where Are We Going? (French, *D'où venons-nous? Que sommes-nous? Où allons-nous?*) Paul Gauguin, 1897, Museum of Fine Arts, Boston, Massachusetts.

The artist made a lengthy analysis of this painting, which reads from right to left, and is an allegory of life from the cradle to the grave: "In the right foreground a baby lies asleep. Next, three women are sitting. Two (standing) figures dressed in purple exchange confidences. An intentionally large figure, which defies perspective, sits with an arm upraised and looks in amaze-

ment at the two people who dare think about their destiny. A figure in the centre gathers fruit.... An idol with both arms raised in a rhythmical movement seems to be pointing to the mysterious Beyond. Finally, an old (seated) woman on the point of death appears to be reconciled and resigned to her thoughts" (quoted in Raymond Charmet, *Paul Gauguin*, 1966). The painting's French title appears at top left on three separate lines. *Cf.* **Faa iheihe.**

Where Does It All End? Sarah Lucas, 1994–5, Saatchi Collection, London.

The work is wax model of a mouth chomping a cigarette butt. The title presumably alludes both to the "faceless" model and to the dubious fate of smokers generally.

Where to Next? Edward Frederick Brewtnall, 1886, Christopher Wood Gallery, London.

A well-dressed young couple, presumably on their honeymoon, pore over a map after breakfast on a sunny terrace somewhere by the Mediterranean. The question of the title will soon be answered and they will set off once again.

Whirlwind (Russian, *Vikhr'*) Filipp Malyavin, 1906, Tretyakov Gallery, Moscow.

Peasant women dance in a whirling revelry of red dresses and skirts.

Whispered Words (1) John William Waterhouse, 1875, private collection; (2) *see* **Parau parau.**

A Greek girl and her lover exchange private thoughts as they stand together. The depiction and title might have been made to evoke lines from Byron's poem *Parisini* (1816): "It is the hour when lovers' vows / Seem sweet in every whisper'd word."

Whistler's Mother *see* **Arrangement in Gray and Black, No. 1: Portrait of the Painter's Mother.**

White Azaleas or Black Net Romaine Brooks, 1910, National Museum of American Art, Washington, D.C.

The white azaleas and black net of the title are certainly prominent in the painting, whose main subject, however, is a slender, small-breasted female nude reclining on a couch.

The White Captive Erastus Dow Palmer, 1858, Metropolitan Museum, New York.

The neoclassical marble statue is of a naked

young girl who, the sculptor explained, has been captured by Red Indians but is sustained by her Christian faith. The work was inspired by **The Greek Slave.**

White Drawing (French, *Dessin blanc*) Mikhail Larionov, 1910, Tate Gallery, London.

The almost abstract painting depicts various white-colored objects on or above a white-colored table (or tablecloth). When asked what the picture actually showed, the artist replied that the subject was a still life with a goblet, a pear, a napkin, and a table.

White Flag Jasper Johns, 1955, Leo Castelli Gallery, New York.

The painting is a faithful reproduction of the Stars and Stripes, but all in white and utterly bereft of color. The work caused a scandal when first seen.

The White Girl *see* **Symphony in White No. 1: The White Girl.**

The White Horse (French, *Le Cheval blanc*) Paul Gauguin, 1898, Musée d'Orsay, Paris.

A riderless white horse lowers its head to drink in a pool. Two naked Tahitians ride brown horses in the background. The title was given the work long after the artist's death by his friend Daniel de Monfreid. "It is difficult to know exactly what Gauguin intended by the work, given the absence of his usual inscribed title, but the lush vegetation, rich colours and naked figures suggest an earthly paradise" (Bowness 1991, p. 120).

The White Knight Walter Crane, 1870, private collection.

A knight in shining armor rides a white horse through a broad valley with a winding stream. He is perhaps the Redcrosse Knight of Holiness from Book I of Edmund Spenser's *The Faerie Queene* (1590), here looking for Una after drinking from the enchanted water of the stream that caused him to lose his strength. However, he has no "bloodie Crosse" on his breast, not does he carry a shield with this emblem. (Spenser intended the Redcrosse Knight to be St. George, patron of the Anglican Church, while Una, who was taken from him by Archimago, and Duessa, the Roman Catholic Church, are "true religion.")

White on White (Russian, *Beloye po belomu*) Kasimir Malevich, 1918, Museum of Modern Art, New York.

The Suprematist composition, consisting of a white square on a white background, was one of a number of "white on white" works painted by the artist at this time. The white background represents infinity, while the square is both the purest form and the least natural.

"Who Can This Be?" Charles Robert Leslie, 1839, Victoria and Albert Museum, London.

A gallant approaches and bows low before a burly middle-aged man and the young woman who leans on his arm. The question of the title is that in the mind of the young lady. *Cf.* **"Whom Can This Be From?"**.

Who Shall Deliver Me? Fernand Khnopff, 1891, private collection.

The painting depicts the idealized head of a young woman with flaming hair and wide-staring eyes. The subtitle identifies her as *Christina Georgina Rossetti*, and the title is that of one of Rossetti's poems (1864), whose subject is her own worst enemy. The third verse runs: "I lock my door upon myself, / And bar them out; and who shall wall / Self from myself, most loathed of all?" The poem's own title, and therefore ultimately that of the picture, is presumably of biblical origin: "Who shall deliver me from the body of this death?" (Romans 7:24). *Cf.* **I Lock my Door Upon Myself**.

Who You Are and What You Do John Keane, 1986–7, Angela Flowers Gallery, London.

A crush of well-heeled faceless individuals fills a chic London cocktail bar. As the title implies, the painting is a parable of modern society, with its lust for sex, drugs, and money.

The Whole City (French, *La Ville entière*) Max Ernst, 1935, Kunsthaus, Zürich.

Exotic but fading plants lie at the base of a vast ruined city. Overhead, a large yellow sun hangs in an azure sky. Since it is ruined, the city is clearly not "whole," but perhaps the title implies that the whole of it was destroyed.

"Whom Can This Be From?" Charles Robert Leslie, 1839, Victoria and Albert Museum, London.

The painting is a pendant (companion piece) to **"Who Can This Be?"**. It shows a young lady eyeing a letter that has been given her by her servant, and is clearly an episode following on from the first picture. The letter is thus presumably from the gallant who greeted her and

her middle-aged companion. The title was subsequently altered to *Who Can This Be From?* but was then changed back following complaints from grammatical pedants.

Who's Afraid of Red, Yellow, and Blue III Barnett Newman, 1966–7, Stedelijk Museum, Amsterdam.

The solid red of the large canvas is relieved only by a single vertical band of blue at the left edge and a thin stripe of yellow at the right edge. The title adopts and adapts the line from Frank E. Churchill's 1933 song, "Who's afraid of the big bad wolf?", to reassure the viewer. One does not fear the modest blue and yellow, so why should one fear the dominant red?

Why Are You Angry? Paul Gauguin, 1896, Art Institute of Chicago, Illinois.

Two young Tahitian women are seated on the ground, one having turned her back on the other. A third woman walks by and regards the pair disdainfully. The artist preferred the painting to be known by its native title, *No te aha oe riri?*, which appears in the bottom left corner. Both title and subject are reminiscent of the earlier **What! Are You Jealous?**

Why Not Sneeze Rrose Sélavy? (French, *Pourquoi pas éternuer Rrose Sélavy?*) Marcel Duchamp, 1921, Philadelphia Museum of Art, Pennsylvania.

The Surrealist work, defined by the artist as a "mythological ready-made," consists of a birdcage containing imitation sugar lumps made of marble, a thermometer, and a cuttlefish bone (for the missing canary). Rrose Sélavy was the artist's female alter ego. The name evolved from the punning French phrase *Pi qu'habilla Rrose* ("Pi that Rose put on") representing *Picabia arrose* ("Picabia is watering"), which Duchamp wrote in a comment on Francis Picabia's **The Cacodylic Eye**. Two phrases then emerged from this: *aRrose Sélavy*, representing *art c'est la vie* ("art is life"), and *Rrose Sélavy*, representing *Éros c'est la vie* ("Eros is life"). Duchamp used the name for various poetical whimsies, such as: *"Rrose Sélavy et moi esquivons les ecchymoses des Esquimaux aux mots exquis"* ("Rrose Sélavy and I dodge the bruises of the Eskimos with exquisite words" (quoted in Richter, p. 90).

The Wilton Diptych ?, *c.*1395–9, National Gallery, London.

The painting, by an unknown artist, depicts King Richard II of England (reigned 1377–99) being presented to the Virgin and

Child by John the Baptist. With him are St. Edmund, king of East Anglia, and St. Edward the Confessor (reigned 1042–66). The representation of the three kings turns the work into an **Adoration of the Magi**. (Richard was born on January 6, the feast of the Epiphany.) The work is so named because it came to the National Gallery from Wilton House, Wiltshire. It is a diptych, painted in two separate panels.

Wind and Sun Laura Knight, *c.*1913, Pyms Gallery, London.

Two young women lie and sit in the sun and sea breeze on a grassy clifftop.

The Winders (French, *Les Dévideuses*) Eugène Carrière, 1887, Tate Gallery, London.

Two women sit opposite each other, one winding a ball of wool from the skein that the other holds. The two are the artist's wife and eldest daughter. *Cf.* **Winding the Skein**.

Windflowers John William Waterhouse, 1902, private collection.

A young woman walks through a windy meadow with anemones that she has picked gathered in the folds of her dress. The title refers both to the anemones (also known as windflowers) and to the girl herself, as a "flower in the wind." The artist painted many similar depictions of young women gathering or strewing flowers in an open meadow or parkland.

Winding the Skein Frederic Leighton, *c.*1878, Art Gallery of New South Wales, Sydney.

On a roof terrace, two young women wind wool, one making a skein from the ball of wool that the other holds. The painting was probably suggested by *The Skeinwinder*, a similar neoclassical depiction by the French artist Jean-Louis Hamon. *Cf.* **The Winders**.

Window or Wall Sign Bruce Nauman, 1967, Leo Castelli Gallery, New York.

The work is a spiral-shaped neon light resembling a shop sign. It was originally installed in the window of the artist's New York studio, and as such, amid a host of similar signs and displays, might have attracted little attention. A closer look, however, shows that the blue neon tubing spells out a personal statement about the role of the artist in society: "The true artist helps the world by revealing mystic truths."

The Wine of Circe Edward Burne-Jones, 1863–9, private collection.

The mythological sorceress Circe carefully prepares food and wine for the sailors of Odysseus which, when they eat and drink it, will cause them to be changed into swine.

A Wing and a Prayer Peter Howson, 1987, Collection Susan Kasen and Robert D. Summer, New York.

A down-and-out kneels by a city wall, his hands clasped in prayer. Around the corner is a church with lighted windows. The title quotes a World War II hit song about an aircraft's emergency landing: "Tho' there's one motor gone, we can still carry on, / Comin' In on a Wing and a Pray'r" (Harold Adamson and Jimmy McHugh, *Comin' In on a Wing and a Pray'r*, 1943). The expression was later used of the reliance on hope in a desperate situation.

Winged Domino Roland Penrose, 1937, private collection.

The head-and-shoulders portrait of a woman with butterflies on her eyes and mouth and birds in her hair has a title referring to these creatures, who here serve as a domino, or mask for the face. The painting is also known by its subtitle, *Portrait of Valentine*. It was inspired by the artist's first wife, Valentine Boué.

The Winnowers (French, *Les Cribleuses de blé*) Gustave Courbet, 1853, Musée des Beaux-Arts, Nantes.

Two women sift grain in a granary, one kneeling, the other seated against a sack, while a young boy looks inside a chest. The kneeling woman, her back to the viewer, was posed by the artist's sister, Zoé. The seated woman may be a portrait of another sister, Juliette, while the young boy is perhaps Désiré Binet, Courbet's son by his mistress, Virginie Binet. An alternate English title, translating the original French, is *Women Sifting Grain*.

Winsor 6 Robert Ryman, 1965, private collection.

The work consists of 35 horizontal bands of white paint, the artist creating each by loading a two-inch brush with pigment and drawing it steadily across the canvas from left to right until the paint ran out. The aim is to evoke the physical act of painting. The title comes from the name of the company, Winsor and Newton, that produced the artist's chosen paint.

Winter Harmony John Henry Twachtman, *c.*1890–1900, National Gallery, Washington, D.C.

A foggy river runs past scattered trees in a snow-covered valley. The artist has predominantly painted the scene in whites, grays, and blues, colors that readily blend and harmonize.

Winter Work Sir George Clausen, 1883–4, Sotheby's, London.

Farm laborers pull, cut, and pile turnips in a wet and muddy field as the hardest and most unpopular task of an English winter in the country.

With Back of Body Damien Hirst, 1983–5, private collection.

The work is an abstract mixed media collage in which the back of a guitar body appears. The title presumably alludes to this. There are other collages in the series with similar titles, such as *With Whites* (1983–5), including a white plastic bottle and white-painted objects, and *With Finger Plate* (1983–5), incorporating the named object.

With Hidden Noise (French, *À bruit secret*) Marcel Duchamp, 1916, Philadelphia Muesum of Art, Pennsylvania.

The work consists of a ball of string between two brass plates joined at the corners by four bolts. The ball contains a small unknown object which makes a noise when shaken.

With My Tongue in My Cheek Marcel Duchamp, 1959, Robert Lebel Collection, Paris.

A drawing of the artist's head in profile has a plaster protuberance added to represent his right cheek, which bulges because he has his tongue in it. He thus depicts the English idiom literally, and does so punningly, "with his tongue in his cheek."

With the Eye of the Mind Frederic Remington, 1908, Thomas Gilcrease Institute of American History and Art, Tulsa, Oklahoma.

Thee Plains Indian riders gesture excitedly at a group of charging spirit figures they think they see in the clouds. But the figures are imaginary, seen only "with the eye of the mind."

The Wolf and the Lamb William Mulready, 1820, Royal Collection, London.

A small boy, the "wolf" of the title, stands stockily with clenched fists by another boy, "the lamb," who cowers against a door, his arm raised to ward off a possible blow from the bully.

Woman at the Window (German, *Dame am Fenster*) Caspar David Friedrich, 1822, Nationalgalerie, Berlin.

A woman, her back to the viewer, looks out of an open window at tall boat masts and distant poplars. She is the artist's wife, Caroline, and the scene she sees is that of the Elbe River, where Friedrich had his studio.

A Woman Bathing in a Stream Rembrandt van Rijn, 1654, National Gallery, London.

A woman has discarded her rich robe and hitches up her shift as she gingerly steps into a stream. (She is not actually bathing in it, but paddling.) The painting is probably a portrait of Hendrickje Stoffels, the woman with whom the artist lived from about 1649 following the death of his wife, Saskia.

Woman Bitten by a Snake (French, *Femme au serpent*) Auguste Clésinger, 1847, Louvre, Paris.

A nude woman lies dead after being bitten by a snake. The model for the sculpture was the French society hostess, Madame Récamier (1777–1849).

Woman by a Spring (French, *Baigneuse à la source*) Gustave Courbet, 1868, Musée d'Orsay, Paris.

A nude woman, her back to the viewer, holds out her hand to catch the water from a spring as it falls into the stream by which she sits. The painting is also known as *La Source* ("The Spring"), a title given by the artist himself. *Cf.* La **Source**.

Woman Combing Her Hair Dante Gabriel Rossetti, 1864, private collection.

A woman looks up from her hand mirror to face the viewer as she combs her luxuriant auburn tresses. The descriptive title is almost certainly not the original one. Earlier sources give it as *Fazio's Mistress, Lady in a White Dress*, or *Lady in White at her Toilet*. The first of these refers to Rossetti's translation from the Italian of a sonnet by Fazio degli Uberti (*c*.1305–*c*.1367), glorifying his mistress as a beautiful temptress. *Cf.* **Fazio's Mistress**.

Woman Holding a Balance Jan Vermeer, *c*.1665, National Gallery, Washington, D.C.

A pregnant young woman standing at a table holds a pair of scales in her hand as she checks the weight of some gold coins. She is probably a portrait of the artist's wife, Catharina.

Woman in a Tub (French, *Femme au tub*) Edgar Degas, *c*.1885, private collection.

A young woman dries herself as she kneels naked in the tub in which she has just bathed. The painting is one of 10 exhibited by the artist in 1886 under the collective title *Sequence of Nudes, of Women Bathing, Washing, Drying, Wiping Themselves, Combing Their Hair or Having It Combed* (French, *Suite de nus de femmes se baignant, se lavant, se séchant, s'essuyant, se peignant ou se faisant peigner*).

Woman in Blue *see* **Young Woman Reading a Letter**.

Woman in the Setting Sun Caspar David Friedrich, *c*.1818, Folkwang Museum, Essen.

A woman, her back to the viewer, stands with arms half raised facing the setting sun. Like much of the artist's work, the subject has a religious symbolism. Here, the sinking sun represents God the Father.

A Woman in the Sun Edward Hopper, 1961, Whitney Museum of American Art, New York.

A middle-aged woman stands naked in a shaft of sunlight in her bedroom, a cigarette in her right hand. She was posed by the artist's wife, Jo, in fact aged 70 at the time.

Woman, Old Man, and Flower (German, *Weib, Greis und Blume*) Max Ernst, 1923–4, Museum of Modern Art, New York.

A female figure with a fan-shaped head and naked buttocks stands with its back to the viewer, while to the left an old man with large hands and no feet is seated with a small nude female figure in his arms. A flowering plant grows on what could be a sea wall to the right. The everyday reality of the title is perhaps intended to contrast with the unreal (or surreal) images of the human figures and the flower.

Woman on a Stair (French, *Femme sur un escalier*) Pierre-Auguste Renoir, *c*.1876, Hermitage, St. Petersburg.

The elegant young woman poised on a staircase is Marguerite Charpentier, née Lemonnier, wife of the publisher Georges Charpentier (1846–1905), whom she married in 1872. *See* **Man on a Stair**.

Woman Reading *see* **Girl Reading**.

Woman with a Parrot (French, *Femme au perroquet*). Gustave Courbet, 1866, Metropolitan Museum, New York.

The title does not reveal that the woman lies nude on a couch, and that she smiles as the parrot balances with outstretched wings on the fingers of her raised left hand. "Gustave Courbet … was the first important artist to abandon the pretense of giving names like Venus and Adonis to nude figures to make them acceptable to society" (Morse, p. 69). (*Cf.* **Reclining Woman**.)

Woman with Mangoes *see* **Te arii vahine**.

Woman with the Flower *see* **Vahine no te tiare**.

Woman with the Fruit *see* **Vahine no te vi**.

Women Asleep (French, *Les Dormeuses*) Gustave Courbet, 1866, Musée du Petit Palais, Paris.

Two women lie asleep on a bed, naked and entwined. The upper, red-haired one was posed by Joanna Hiffernan, Whistler's mistress. (*See* **Jo, the Beautiful Irish Girl**.) The painting has also been called *Idleness and Lust* (French, *Paresse et Luxure*) and *The Friends* (French, *Les Amies*). The latter title is more meaningful in French than it is in Englsh.

Women of Algiers (French, *Femmes d'Alger dans leur appartement*, "Women of Algiers in their Apartment") Eugène Delacroix, 1834, Louvre, Paris.

The longer original title gives a fuller idea of the depiction but does not explicitly state that the "apartment" is a harem. Three concubines sit in lazy luxury while their African servant leaves to carry out an order.

Women on the Banks of the Seine *see* **Young Women on the Banks of the Seine**.

Women Sifting Grain *see* **The Winnowers**.

A Woodland Flute Ian Hamilton-Finlay, 1990, private collection.

Five Latin names of trees are carved in capitals on an upright marble slab. The letter "u" that is common to each name is aligned below the "u" in the title, which heads the list. Below them are their English names. The whole thus reads as a type of concrete poetry, the "u" representing the flute "A Woodland Flute. Betula pendula, Carpinus betulus, Viburnum opulus, Populus tremula, Prunus. Silver Birch, Hornbeam, Guelder Rose, Aspen, Plum."

The Woodman's Child Arthur Hughes, 1860, Tate Gallery, London.

A robin and a squirrel look on as a chubby little girl lies asleep on the grass by the stump of an old oak. The child's father wields his woodman's ax in the background to fell another forest tree, while her mother gathers kindling.

The Woodman's Daughter John Everett Millais, 1851, Guildhall Art Gallery, London.

The depiction of a small boy offering a handful of wild strawberries to a little girl in a wood is based on an 1844 poem of the same title by Coventry Patmore. It tells of the relationship between Maud, the daughter of a woodman called Gerald, and the son of the local squire. Because of the social difference between them, they were unable to marry. The painting shows the beginning of their childhood friendship and illustrates the lines: "He sometimes, in a sullen tone, / Would offer fruits, and she / Always received his gifts with an air / So unreserved and free, / That half-feigned distance soon became Familiarity."

Work Ford Madox Brown, 1852–63, Manchester City Art Gallery.

The scene is a busy sidewalk in the fashionable London suburb of Hampstead. While laborers dig a trench for water pipes to be laid, the unemployed look on and the idle rich pass by. One young lady clutches a religious tract, while a figure on the right is recognizably that of the social historian Thomas Carlyle. The whole is thus a study of contemporary British society, and the title cites a leading Victorian ethic. The laborers are the real heroes, as manual workers, but Carlyle can also be regarded as a "brainworker."

The Worker's Day (Italian, *La giornata dell'operaio*) Giacomo Balla, 1904–7, private collection.

The painting is effectively a triptych, with the left side divided into two panels, upper and lower, depicting a construction site and its workers, and the right side a single panel showing another such site but with no human figures and at night. The picture was exhibited in 1907 under the title *They Work, Eat, and Go Home* (Italian, *Lavorano, mangiano, ritornano*) and in 1914 as *The Bricklayers* (Italian, *I muratori*).

World Peace (Projected) Bruce Nauman, 1996, Sperone Westwater Gallery, New York.

The installation consists of five video projections (hence the last punning word of the title) showing five people gesticulating and talking. Each continually repeats the same words: "I'll talk, you'll listen — You'll talk, I'll listen — I'll talk, they'll listen — They'll talk, I'll listen," or "I'll talk to you, you'll listen to me — You'll talk to me, I'll listen to you — I'll talk to them, they'll listen to me (etc.)". So much for the main title. World peace cannot be achieved by mere talking and listening, and the speakers do not mutually communicate.

Worn Out Thomas Faed, *c.*1860, Forbes Magazine Collection, London.

An exhausted father has fallen asleep in a chair by the bed of his sleeping child. He is too worn out to unlace his boots, too weary even to finish his supper. Possibly the child is sick, so that she, too, is "worn out."

The Worship of Mammon Evelyn De Morgan, *c.*1909, private collection.

A supplicant woman clasps the knees of the seated god of riches, Mammon, but he holds out beyond her reach the bag of gold that she requests.

The Worship of the Golden Calf *see* **The Adoration of the Golden Calf** (2).

Wounded Amazon (German, *Verwundete Amazone*) Franz von Stuck, 1904, Van Gogh Museum, Amsterdam.

A naked Amazon, one of the race of female warriors of Greek mythology, falls to her knees. Her left hand still holds a large red shield. Her right grasps her right breast, below which a spear wound gapes and bleeds. The Amazon was posed by the artist's model, Frau Feez.

The Wounded Angel Hugo Simberg, 1903, Ateneumin Taidemuseo, Helsinki.

A white-robed angel sits in pain with bowed and bandaged head on a litter borne by two little peasant boys.

The Wounded Leg Thomas Heaphy, 1809, Victoria and Albert Museum, London.

A soldier back from the wars has a leg wound treated by an old woman in her country cottage while a young mother and her children look on. The picture's original title was *The Village Doctress*, but the focus then shifted from the one treating to the one treated.

Wrecked Sam Taylor-Wood, 1996, Saatchi Collection, London.

The work is a large color print of a travesty of Leonardo da Vinci's **Last Supper**, with mod-

ern-day individuals posing as the disciples and a topless woman, apparently the artist herself, as Christ. As the title implies, the original image and its import have been wrecked.

Writing on the Sand Dante Gabriel Rossetti, 1859, British Museum, London.

A young couple walk hand in hand along a beach on a breezy summer's day. As they go, the man draws the woman's portrait in the sand with his stick.

Y

Yadwigha's Dream *see* **The Dream**.

The Year of the Cicada Grace Hartigan, 1970, private collection.

An array of plants, insects, and flowers, together with two human profiles, fills the canvas in a mass of multicolored forms. The dominant depiction is of a green cicada. The title presumably puns on that of Nathanael West's novel, *The Day of the Locust* (1939).

The Year's Youth Edward Stott, *c*.1898, private collection.

Chickens gather to feed on the grain that spills from the bowl of a young woman as she picks blossoms from a tree in an orchard. The title most obviously refers to the blossom, but could equally refer to the birds and the girl, who are yearly rejuvenated.

The Yellow Christ (French, *Le Christ jaune*) Paul Gauguin, 1889, Albright-Knox Art Gallery, Buffalo, New York.

Breton women contemplate (or envision) a crucifix with a yellow-painted figure of Christ. The artist copied the figure from a small 17th-century carving in the chapel of Trémalo, near Pont-Aven, Brittany. The painting is a pendant (companion piece) to *The Green Christ*, a version of the Deposition (*see* **The Deposition from the Cross**) dated that same year.

The Young Englishman Titian, *c*.1540–5, Pitti, Florence.

The subject of this portrait has not been satisfactorily identified. He was originally thought to be a member of the Howard family of the dukes of Norfolk. Hence the present title. He has also been given an Italian identity as either Guidobaldo III, duke of Urbino, or as a lawyer named Ippolito Riminaldi, or as Ottavio Farnese, whose family was often painted by the artist. An alternate title, and perhaps a better one in view of the uncertainty, is simply *Portrait of a Man*.

The Young Fortune Teller Joshua Reynolds, 1775, Huntington Art Gallery, San Marino, California.

A small girl reads the palm of an equally small boy. They are brother and sister, and the painting is a double portrait of two of the children of George Spencer, 4th Duke of Marlborough (1739–1817). The title intentionally echoes that of Caravaggio's The **Fortune Teller**, and the pose and costume of the children confirm this allusion.

The Young Generation (French, *La Jeune Génération*) Jan Toorop, 1892, Boymans-Van Beuningen Museum, Rotterdam.

The painting is highly allegorical. A baby in a high chair surrounded by newly-sprung shrubs represents the young generation of the title. The old generation is represented by a woman on the left, with a faded lily in her hand, some gnarled trees, and a crumbling brick doorway. Railroad tracks and a telegraph pole refer to the rapid passage of time, ushering in the new age, whose attributes, Faith, Beauty, and Life, are revealed in the Bird of Purity chasing out the Bird of Ugliness from the Wood of Beauty, in the figure of the Buddha, the emblem of Clarity of Thought, and finally in the colors pink, green, yellow, and turquoise.

Young Girls at the Piano (French, *Jeunes filles au piano*) Pierre-Auguste Renoir, 1892, Musée d'Orsay, Paris.

A young blonde girl plays the piano while a brunette of similar age stands beside her, one arm resting on the top of the piano, the other on the back of the player's chair. The identity of the two, presumably sisters, is uncertain.

Young Girls at the Seaside (French, *Jeunes Filles au bord de la mer*) Pierre Puvis de Chavannes, 1879, Musée d'Orsay, Paris.

Three young women, naked to the waist, pose languidly by the sea. One stands and dresses her long golden hair, one reclines in thought, and one leans back on her elbow. The three appear to be portraits of one and the same woman. The factual title seems to imply that the painting is simply a portrait, with no symbolic content.

Young Ladies on the Banks of the Seine *see* **Young Women on the Banks of the Seine**.

The Young Ladies' Subscription *see* **The Sailor's Orphans**.

A Young Lady's Adventure (German, *Abenteuer eines Fräuleins*) Paul Klee, 1922, Tate Gallery, London.

The almost abstract painting depicts an elegant female figure, the "young lady" of the title, who is confronted by an evil bird and about to be attacked by an arrow. The "adventure" may be her experience of the temptations that assail her.

Young Man Leaning Against a Tree Nicholas Hilliard, *c.*1590, Victoria and Albert Museum, London.

The well-known miniature has a formal title as *An Unknown Youth Leaning Against a Tree Amongst Roses*. The identity of the lovesick young dandy remains uncertain.

Young Man with a Skull Frans Hals, *c.*1626, National Gallery, London.

The young man with a long feather in his cap is traditionally said to represent Hamlet. However, the painting is more likely to be simply a Dutch *vanitas*, or depiction of an object (here, the skull) representing the transience of human life. The viewer is thus prompted to contrast the youth of the young man with the symbol of death that he holds. The painting is also known as *A Boy with a Skull*.

The Young Mother Charles W. Cope, 1845, Victoria and Albert Museum, London.

A young mother is seated on a sofa, her young child clasped to her breast.

Young Omahaw, War Eagle, Little Missouri, and Pawnees Charles Bird King, 1821, National Museum of American Art, Smithsonian Institution, Washington, D.C.

Despite its title, the apparent depiction of five Native American warriors is actually a multiple portrait of two Pawnee chiefs, Petalesharo and Peskelechaco.

The Young Photographers Frederick Daniel Hardy, 1862, Tunbridge Wells Museum and Art Gallery, Kent.

Young children play at taking photographs in a scene reminiscent of a Dutch interior. The real photographer's studio can be seen through the open door, while the photographer himself is out in the street soliciting passers-by for their custom.

Young Roebuck and Rough Hounds Sir Edwin Landseer, 1840, Victoria and Albert Museum, London.

A young roebuck lies dead among rocks, killed by the rough hounds that drove it there. One of the four that surround it licks up the blood that flows from a wound in its neck.

The Young Schoolmistress (French, *La Petite Maîtresse d'école*) Jean-Baptiste-Siméon Chardin, *c.*1740, National Gallery, London.

A young girl waits patiently for an answer from a small child puzzling out the words in a school book. The children are not likely to be the artist's own. His son was born in 1731 and his daughter had died in 1736 at the age of only three.

Young Spartans Exercising (French, *Jeunes Spartiates s'exerçant*) Edgar Degas, 1860, National Gallery, London.

The scene is set in classical times, but the nude boys and girls exercising do not look like ancient Greeks and were in fact modeled by contemporary "children from Montmartre." The title thus confirms their intended artistic identity.

A Young Teacher Rebecca Solomon, 1861, private collection.

A young child held in the arms of an Asian nursemaid is taught to read by her elder sister. The child looks keenly at the book before her but the ayah's gaze is directed elsewhere.

A Young Widow Edward K. Johnson, 1877, Victoria and Albert Museum, London.

A young widow in a shapeless black dress looks down sadly at the fine and frilly clothes that she holds but that she must now abandon.

The Young Widow (Russian, *Vdovushka*) Pavel Fedotov, 1851–2, Tretyakov Gallery, Moscow.

A young and pregnant widow leans in grief against a sideboard on which stands a framed portrait of her army officer husband, presumably killed in battle. The Russian title is actually a diminutive (of *vdova*, "widow"), denoting affection or sympathy.

A Young Woman Reading *see* **Girl Reading**.

Z

Young Women on the Banks of the Seine (French, *Les Demoiselles des bords de la Seine*) Gustave Courbet, 1857, Musée du Petit Palais, Paris.

Two young women repose by the Seine. The one nearer the viewer lies on her side in dishabille half asleep. The other, behind her, leans on her elbow, fully dressed and awake. The implication of the title coupled with the depiction itself is that they are prostitutes. Alternate titles are *Girls on the Banks of the Seine* and *Women on the Banks of the Seine*.

Young Woman Reading a Letter Jan Vermeer, *c.*1662–3, Rijksmuseum, Amsterdam.

The young woman reading a letter by a window is believed to be the artist's wife, Catharina Bolnes, whom he married in 1653. The painting has the alternate title *Woman in Blue*.

Youth Frederick Cayley Robinson, 1923, private collection.

At the edge of a pool in a barren landscape, a young male nude figure stretches as he wakes. He is not only *a* youth but Youth itself, waking into life, like the tiny leaves on the sparse trees around the pool.

Youth on the Prow, and Pleasure at the Helm William Etty, 1832, Tate Gallery, London.

An ornately decked sailing ship apparently going nowhere in particular is crewed by a single youth and a bevy of naked nymphs, some of whom sport in the sea. A cupid flies down to the masthead pennant. The pleasure is thus seemingly entirely hedonistic. The title quotes a line from Thomas Gray's poem *The Bard* (1757), more fully: "Fair laughs the morn and soft the zephyr blows, / While proudly riding o'er the azure realm / In gallant trim the gilded vessel goes; / Youth on the prow and Pleasure at the helm." The artist explained the subject as "a general allegory of Human Life."

Yvonne and Magdeleine in Tatters (French, *Yvonne et Magdeleine déchiquetées*) Marcel Duchamp, 1911, Philadelphia Museum of Art, Pennsylvania.

The Cubist painting is a portrait of the artist's two sisters, their profiles disjointed and on different scales.

The Zemstvo at Dinner (Russian, *Zemstvo obedayet*) Grigori Myasoyedov, 1872, Tretyakov Gallery, Moscow.

The *zemstvo* was an elected district council in Russia from 1864 through 1917. As such it comprised various representatives of society, from members of the nobility to the peasantry. These particular groups are depicted here. Inside the house, the nobility are presumably seated at table as they dine, for only a servant polishing a plate is visible through the window. Outside the house, the peasant members sit together eating bread and onions.

Zero Dollar Cildo Meireles, 1978–84, Galeria Luisa Strina, São Paolo.

The work comprises photographs of the front and back of a fake dollar bill. Its value is printed as "ZERO," its issue number is 00000000, and the familiar depictions of George Washington and the White House have been replaced by Uncle Sam and Fort Knox. The work is a satirical comment on the capitalist ideology of the United States. The artist introduced several worthless notes of this type into general circulation.

Zero Through Nine Jasper Johns, 1961, Tate Gallery, London.

The semiabstract painting presents the numerals zero through nine superimposed on one another in an arrangement of blue, red, and yellow shades and forms.

Zeus and Antiope *see* **The Dream of Antiope**.

Zeus and Io *see* **Jupiter and Io**.

Zim Zum Anselm Kiefer, 1990, National Gallery, Washington, D.C.

The monumental "earth painting" depicts a black and barren landscape stretching to a distant horizon. "The title refers to the moment before creation, as heaven and earth are about to cleave, as it is written in the Kabbala, the Judaic mystical text" (Richler, p. 214).

La Zingara *see* The **Fortune Teller**.

Zorrilla Reciting His Poems (Spanish, *Lectura romántica*, "Romantic Reading") Antonio María Esquivel, 1846, Museo Español de Arte Contemporáneo, Madrid.

The artist's best known painting depicts the Spanish poet José Zorrilla (1817–1893) reading his poems in Esquivel's studio to a gathering of leading literary and artistic figures of mid–19th-century Madrid. The work has the alternate Spanish title *Los poetas contemporáneos*, "The Contemporary Poets."

Zünglein ohne Waage Arnulf Rainer, 1975, private collection.

The work consists of drips and daubs of colored paint on a black and white photograph of a man putting out his tongue. The German title, meaning "Pointer without Scales," puns on the idiomatic expression "*Zünglein an der Waage sein*," "to be the pointer on the scales," *i.e.* to hold the balance of power. *Zünglein* literally means "little tongue," hence the reference to the grimacing man, although the precise relevance of the title as a whole is somewhat obscure.

Zweistromland *see* **High Priestess**.

**Zygotic acceleration, biogenetic, de-sublimated libidinal model (enlarged ×
1000)** Jake and Dinos Chapman, 1995, Saatchi Collection, London.

The sculpture is a tableau of naked prepubescent girl mannequins sporting wigs and wearing Fila trainers, all fused into a single body. The noses and mouths of some are transformed into sexual and excretory organs. It is *zygotic* because the melded work evokes a being that has developed from a zygote, a cell formed by the union of two gametes. It is an *acceleration* because it has fast-forwarded to its present biological phase. It is *biogenetic* because the figures appear to have evolved from similar living figures. It is *de-sublimated* because such an image is normally repressed, but this one has been overtly expressed. It is *libidinal* because it is associated with sexual desire, albeit desire gone awry. It is *enlarged ×
1000* because the minute original concept has been grossed up to a major physical realization. *Cf.* **Tragic Anatomies**.

BIBLIOGRAPHY

The Bibliography that follows is divided into two parts, General and Individual. The General listing is of works that are to a greater or lesser degree fairly extensive in their range, or that deal with a particular art school, such as the Impressionists or Symbolists, or that cover a particular country or region, such as American art or Italian art, or that review a particular gallery, such as the Louvre, Paris, or the Huntington, San Marino, California, or that treat a particular genre, such as works by women artists or with children as subjects. The works by Calvocoressi and Radice are here since they specifically relate their respective biblical and mythological subjects to art, literature, and music.

The Individual listing is of works devoted to particular artists. The listing may seem unevenly balanced, but this is because certain artists, as explained in the Introduction, produce more interesting titles than others. Hence the inclusion of some artists, such as Gauguin, more than once. It should be remarked that Penrose's work on Miró is one of the few that not only considers the titles of the artist in question but which sets them in the context of art titles in general. Such works are relatively rare.

It goes without saying that there are thousand of works on art, and that the listing is naturally selective. Even so, it provided helpful information on hundreds of works of art and their titles for the present book, and led to library loans and bookstore purchases that consumed both time and money but that more than a little enriched the life of this writer in the process.

General

Adams, Brooks, Lisa Jardine, Martin Maloney, Norman Rosenthal, and Richard Shone. *Sensation: Young British Artists from the Saatchi Collection*. London: Thames and Hudson, 1997.

Adams, Steven. *The Art of the Pre-Raphaelites*. London: New Burlington Books, 1988.

Alexandrian, Sarane. *L'Art surréaliste*. Paris: Fernand Hazan, 1969.

Alley, Ronald. *Tate Gallery: The Foreign Paintings, Drawings and Sculptures*. London: Tate Gallery, 1959.

Anderson, Janice. *Children in Art*. London: Bracken Books, 1996.

Archer, Michael. *Art Since 1960*. London: Thames and Hudson, 1997.

The Art Book. London: Phaidon, 1994.

Art Treasures of England: The Regional Collections. London: Merrell Holberton, 1998.

Baigell, Matthew. *A Concise History of American Painting and Sculpture*. New York: HarperCollins, rev. ed., 1996.

Bennett, Ian. *A History of American Painting*. London: Hamlyn, 1973.

Bindman, David, gen. ed. *The Thames and Hudson Dictionary of British Art*. London: Thames and Hudson, 1985.

Bonfante-Warren, Alexandra. *Country Life*. Leicester: Magna Books, 1995.

Bowness, Alan. *Modern European Art*. London: Thames and Hudson, 1972.

Brettell, Richard R. *Modern Art: 1851-1929*. Oxford: Oxford University Press, 1999.

Cachin, Françoise, intro. *Treasures of the Musée d'Orsay*. New York: Abbeville Press, 1994.

Calvocoressi, Peter. *Who's Who in the Bible*. London: Penguin Books, 1987.

Carr-Gomm, Sarah. *The Hutchinson Dictionary of Symbols in Art*. Oxford: Helicon, 1995.

Chadwick, Whitney. *Women, Art, and Society*. London: Thames and Hudson, 2d ed., 1996.

Cherry, Deborah. *Painting Women: Victorian Women Artists*. London: Routledge, 1993.

Chilvers, Ian. *The Concise Oxford Dictionary of Art*

and Artists. Oxford: Oxford University Press, 2d ed., 1996.

_____. *A Dictionary of Twentieth-Century Art*. Oxford: Oxford University Press, 1998.

Chilvers, Ian, Harold Osborne, and Dennis Farr, eds. *The Oxford Dictionary of Art*. Oxford: Oxford University Press, 2d ed., 1997.

Clay, Jean. *Le Romantisme*. Paris: Hachette-Vendôme, 1980.

Clement, Clara Erskine. *A Handbook of Legendary and Mythological Art*. New York: Hurd and Houghton, 1876.

Cumming, Robert. *Great Artists*. London: Dorling Kindersley, 1998.

Denvir, Bernard. *Post-Impressionism*. London: Thames and Hudson, 1992.

_____. *The Thames and Hudson Encyclopaedia of Impressionism*. London: Thames and Hudson, 1990.

_____, ed. *The Impressionists At First Hand*. London: Thames and Hudson, 1987.

Descargues, Pierre. *The Hermitage*, London: Thames and Hudson, 1961.

Dube, Wolf-Dieter. *The Expressionists*. Translated from the German by Mary Whittall. London: Thames and Hudson, 1972.

Forty, Sandra. *The Pre-Raphaelites*. London: Grange Books, 1997

Gale, Matthew. *Dada and Surrealism*. London: Phaidon, 1997.

Garb, Tamar. *Women Impressionists*. Oxford: Phaidon, 1986.

Gibson, Michael. *Symbolism*. Cologne: Benedikt Taschen, 1995.

Gombrich, E.H. *The Story of Art*. London: Phaidon, 15th ed., 1989.

Gordon, Dillian. *100 Great Paintings: Duccio to Picasso*. London: National Gallery, 2d ed., 1985.

Gowing, Sir Lawrence, gen. ed. *A Biographical Dictionary of Artists*. London: Grange Books, 1994.

Gray, Camilla. *The Russian Experiment in Art: 1863-1922*. London: Thames and Hudson, 1962.

Great Artists. London: Marshall Cavendish, 1987.

Hadfield, John. *Every Picture Tells a Story: Images of Victorian Life*. London: Herbert Press, 1985.

Hale, J.R., ed. *The Thames and Hudson Dictionary of the Italian Renaissance*. London: Thames and Hudson, 1981.

Hall, James. *Dictionary of Subjects and Symbols in Art*. London: John Murray, rev. ed., 1979.

Hardin, Terri. *The Pre-Raphaelites: Inspiration from the Past*. London: Tiger Books, 1996.

Heller, Nancy G. *Women Artists: An Illustrated History*. New York: Abbeville Press, 3d ed., 1997.

Higgonet, Anne. *Pictures of Innocence: The History and Crisis of Ideal Childhood*. London: Thames and Hudson, 1998.

Hilton, Timothy. *The Pre-Raphaelites*. London: Thames and Hudson, 1970.

Hodge, Nicola, and Libby Anson. *The A-Z of Art: The World's Greatest and Most Popular Artists and Their Works*. London: Carlton Books, 1996.

House, John, and Mary Anne Stevens, eds. *Post-Impressionism: Cross-Currents in European Painting*. London: Royal Academy of Arts, 1979.

Hughes, Robert. *The Shock of the New: Art and the Century of Change*. London: Thames and Hudson, updated and enlarged ed., 1991.

_____, *American Visions: The Epic History of Art in America*. London: Harvill Press, 1997.

Jacobs, Michael. *Mythological Painting*. Oxford: Phaidon, 1979.

_____, *Nude Painting*. Oxford: Phaidon, 1979.

Johnson, E.D.H. *Paintings of the British Social Scene: Hogarth to Sickert*. New York: Rizzoli, 1986.

Kroeber, Karl. *British Romantic Art*. Berkeley: University of California Press, 1986.

Kostenevich, Albert. *Hidden Treasures Revealed: Impressionist Masterpieces and Other Important French Paintings Preserved by The State Hermitage Museum, St. Petersburg*. New York: Harry N. Abrams, 1995.

Kuznetsov, Yury, comp. *The Hermitage Museum: Western European Painting*. Leningrad: Aurora Art Publishers, 1972.

Laclotte, Michel, and Jean-Pierre Cuzin. *The Louvre: European Paintings*. London: Scala Books, 1993.

Lambourne, Lionel, and Jean Hamilton, comps. *British Watercolours in the Victoria and Albert Museum: An Illustrated Summary Catalogue of the National Collection*. London: Sotheby Parke Bernet, 1980.

Levey, Michael. *From Giotto to Cézanne: A Concise History of Modern Painting*. London: Thames and Hudson, 1968.

Lippard, Lucy R. *Pop Art*. With contributions by Lawrence Alloway, Nancy Marmer and Nicolas Calas. London: Thames and Hudson, 3d rev. ed., 1970.

Lloyd, Christopher, intro. *A Picture History of Art*. Oxford: Phaidon, 1979.

Lucie-Smith, Edward. *Symbolist Art*. London: Thames and Hudson, 1972.

_____. *Sexuality in Western Art*. London: Thames and Hudson, rev. ed., 1991.

_____, Carolyn Cohen, and Judith Higgins. *The New British Painting*. London: Phaidon, 1988.

Lynton, Norbert. *The Story of Modern Art*. London: Phaidon, 2d ed., 1989.

McConkey, Kenneth. *British Impressionism*. Oxford: Phaidon, 1989.

Martin, Christopher, ed. *The Ruralists*. London: Academy Editions, 1991.

Mollett, J.W. *Dictionary of Art and Archaeology*. London: Sampson Low, Marston, Searle, and Rivington, 1883.

Morse, John D. *Old Master Paintings in North America*. New York: Abbeville Press, 1979.

Murray, Peter, and Linda Murray. *The Oxford Companion to Christian Art and Architecture*. Oxford: Oxford University Press, 1996.

Newall, Christopher. *Victorian Watercolours*. London: Phaidon, 1987.

O'Neill, Richard. *The Art of Victorian Childhood*. Avonmouth: Parragon, 1996.

Osborne, Harold, ed. *The Oxford Companion to Art*. Oxford: Oxford University Press, 1970.

Parkinson, Ronald. *Victoria & Albert Museum Catalogue of British Oil Paintings 1820-1860*. London: HMSO, 1990.

Paulson, Ronald. *Emblem and Expression: Meaning in English Art of the Eighteenth Century*. London: Thames and Hudson, 1975.

Pomeroy, Elizabeth. *The Huntington: Library, Art Collections, Botanical Gardens*. New York: Scala Books, 1983.

Pool, Phoebe. *Impressionism*. London: Thames and Hudson, 1967.

Potterton, Homan. *The National Gallery, London*. London: Thames and Hudson, 1977.

Radice, Betty. *Who's Who in the Ancient World: A Handbook to the Survivors of the Greek and Roman Classics*. Harmondsworth: Penguin Books, rev. ed., 1973.

Read, Herbert. *A Concise History of Modern Painting*. London: Thames and Hudson, new and augmented ed., 1974.

_____. *A Concise History of Modern Sculpture*. London: Thames and Hudson, 1964.

_____, consulting ed. *The Thames and Hudson Dictionary of Art and Artists*. Revised, expanded and updated by Nikos Stangos. London: Thames and Hudson, 1994.

Richler, Martha. *National Gallery of Art, Washington*. London: Philip Wilson, 1997.

Richter, Hans. *Dada: Art and Anti-Art*. Translated from the German by David Britt. London, Thames and Hudson, 1997.

Rose, Andrea. *The Pre-Raphaelites*. London: Phaidon, 3d ed., 1992.

Rossi, Filippo. *The Uffizi and Pitti*. Translated from the Italian by Richard Waterhouse. London: Thames and Hudson, 1966.

Sarabianov, Dmitri V. *Russian Art: From Neoclassicism to the Avant-Garde*. London: Thames & Hudson, 1990.

Schneede, Uwe M. *Surrealism*. Translated by Maria Pelikan. New York: Harry N. Abrams, 1973.

Schorsch, Anita. *Images of Childhood: An Illustrated Social History*. New York: Mayflower Books, 1979.

Sunderland, John. *Painting In Britain 1525 to 1975*. Oxford: Phaidon, 1976.

Sweeney, J. Gray. *Masterpieces of Western American Art*. Avenel, NJ: Crescent Books, 1996.

Swinglehurst, Edmund. *The Art of the Surrealists*. Avonmouth: Parragon, 1995.

Talbot Rice, Tamara. *A Concise History of Russian Art*. London: Thames and Hudson, 1963.

Taylor, Brandon. *The Art of Today*. London: Weidenfeld and Nicolson, 1995.

Tesch, Jürgen, and Eckhard Hollmann, eds. *Icons of Art: The 20th Century*. Munich: Prestel, 1997.

Thomas, Anabel. *Illustrated Dictionary of Narrative Painting*. London: John Murray, 1994.

Tisdall, Caroline, and Angelo Bozzolla. *Futurism*. London: Thames and Hudson, 1977.

Treuherz, Julian. *Victorian Painting*. London: Thames and Hudson, 1993.

Turner, Jane, ed. *The Dictionary of Art*. London: Macmillan, 1996. 34 vols.

The 20th-Century Art Book. London: Phaidon, 1996.

Vasari, Giorgio. *Lives of the Painters, Sculptors and Architects*. Translated by Gaston du C. de Vere with an Introduction and Notes by David Ekserdjian. London: David Campbell (Everyman's Library), 1996. 2 vols.

Vaughan, William. *Romanticism and Art*. London: Thames and Hudson, rev. ed., 1994.

Viney, Nigel, comp. *The Shell Guide to the Great Paintings of England*. London: André Deutsch, 1989.

A Visual Dictionary of Art. London: Heinemann / Secker & Warburg, 1974.

Waldberg, Patrick. *Surrealism*. London: Thames & Hudson, 1997.

The Walker Art Gallery Liverpool. London: Scala Books, 1994.

Walther, Ingo F., ed. *Masterpieces of Western Art: A History of Art in 900 Individual Studies*. Vol. I: *From the Gothic to Neoclassicism*, by Robert Suckale, Manfred Wundram, Andreas Prater, Hermann Bauer, Eva-Gesine Baur. Vol. II: *From the Romantic Age to the Present Day*, by Barbara Eschenburg, Ingeborg Güssow, Christa von Lengerke, Volkmar Essers. Cologne: Taschen, 1996.

_____, ed. *Impressionist Art 1860-1920*. Pt. I: *Impressionism in France*, by Peter H. Feist; Pt. II: *Impressionism in Europe and North America*, by Beatrice von Bismarck, Andreas Blühm, Peter H. Feist, Jens Peter Munk, Karin Sagner-Düchting, and Ingo F. Walther. Cologne: Taschen, 1997.

_____, ed. *Art of the 20th Century*. Vol. I: *Painting,*

by Karl Ruhrberg; Vol. II: *Sculpture*, by Manfred Schneckenburger, *New Media*, by Christiane Fricke, *Photography*, by Klaus Honnef. Cologne: Taschen, 1998.

West, Shearer, gen. ed. *Guide to Art*. London: Bloomsbury, 1996.

Wilson, Simon. *British Art from Holbein to the Present Day*. London: Bodley Head, 1979.

_____. *Surrealist Painting*. London: Phaidon, 3d ed., 1991.

Wilton, Andrew, and Robert Upstone, eds. *The Age of Rossetti, Burne-Jones and Watts: Symbolism in Britain 1860-1910*. London: Tate Gallery, 1997.

Wood, Christopher. *Paradise Lost: Paintings of English Country Life and Landscape 1850-1914*. London: Barrie & Jenkins, 1988.

_____. *Victorian Painting in Oils and Watercolours*. Woodbridge: Antique Collectors' Club, 1996.

Wood, James, intro. *Treasures of 19th- and 20th-Century Painting: The Art Institute of Chicago*. New York: Abbeville Press, 1993.

Wright, Christopher, comp. *Old Master Paintings in Britain*. London: Philip Wilson, 1976.

Wright, Susan. *The Bible in Art*. New York: Todtri, 1996.

Yenawine, Philip. *How to Look at Modern Art*. London: Chatto & Windus, 1991.

Zuffi, Stefano. *La pittura italiana*. Milan: Electa, 1997.

Individual

Adam, Peter. *David Hockney and His Friends*. Bath: Absolute Press, 1997.

Alley, Ronald. *Gauguin*. London: Spring Books, 1961.

_____. *Portrait of a Primitive: The Art of Henri Rousseau*. Oxford: Phaidon, 1978.

Alloway, Laurence. *Roy Lichtenstein*. New York: Abbeville Press, 1983.

Alpatov, Mikhail. *Aleksandr Andreyevich Ivanov*. Leningrad: Khudozhnik RSFSR, 1983.

Ash, Russell. *Dante Gabriel Rossetti*. London: Pavilion Books, 1995.

_____. *Lord Leighton*. London: Pavilion Books, 1995.

_____. *Sir John Everett Millais*. London: Pavilion Books, 1998.

Bindman, David. *Hogarth*. London: Thames and Hudson, 1981.

Blunt, Wilfrid. *England's Michelangelo: A Biography of George Frederic Watts, OM, RA*. London: Hamish Hamilton, 1975.

Bowness, Alan. *Gauguin*. London: Phaidon, rev. ed., 1991.

Bramly, Serge. *Léonard de Vinci*. Paris: Éditions Jean-Claude Lattès, 1988.

Callen, Anthea. *Courbet*. London: Jupiter Books, 1980.

_____. *Sir Lawrence Alma-Tadema*. London: Pavilion Books, 1995.

Fischer, Wolfgang Georg. *Egon Schiele*. Cologne: Benedikt Taschen, 1995.

Gablik, Suzi. *Magritte*. London: Thames and Hudson, rev. ed., 1985.

Gleeson, Kames. *William Dobell*. London: Thames and Hudson, rev. ed., 1969.

Gruitrooy, Gerhard. *Degas: Impressions of a Great Master*. New York: Todtri, 1994.

_____. *Renoir: A Master of Impressionism*. New York: Todtri, 1994.

Harrison, Martin, and Bill Waters. *Burne-Jones*. London: Barrie & Jenkins, 2d ed., 1989.

Hirst, Damien. *I Want To Spend the Rest of My Life Everywhere, With Everyone, One to One, Always, Forever, Now*. London: Booth-Clibborn, 1997.

Hobson, Anthony. *The Art and Life of J.W. Waterhouse RA 1849-1917*. London: Cassell, 1980.

Hodin, J.P. *Edvard Munch*. London: Thames and Hudson, 1972.

Hollmann, Eckhard. *Paul Gauguin: Images from the South Seas*. Munich: Prestel, 1996.

Jackson, Alan. *A Different Man: Peter Howson's Art, from Bosnia and Beyond*. Edinburgh: Mainstream, 1997.

Kilmurray, Elaine, and Richard Ormond, eds. *John Singer Sargent*. London: Tate Gallery, 1998.

Klossowski de Rola, Stanislas. *Balthus*. London: Thames and Hudson, 1996.

Licht, Fred. *Goya: The Origins of Modern Temper in Art*. London: John Murray, 1980.

Livingstone, Marco. *David Hockney*. London: Thames and Hudson, rev. ed., 1987.

McEwen, John. *Paula Rego*. London: Phaidon, 1992.

Mannering, Douglas. *The Life and Works of Gauguin*. Avonmouth: Parragon, 1994.

Mendgen, Eva. *Franz von Stuck*. Cologne: Benedikt Taschen, 1995.

Moure, Gloria. *Marcel Duchamp*. Barcelona: Ediciones Pol'grafa, 1988.

Néret, Gilles. *Klimt*. Cologne: Benedikt Taschen, 1993.

Penrose, Roland. *Miró*. London: Thames and Hudson, 1985.

Robinson, Duncan. *Stanley Spencer*. Oxford: Phaidon, 1990.

Rosenblum, Robert. *Ingres*. London: Thames and Hudson, 1990.

Sala, Charles. *Caspar David Friedrich: The Spirit of Romantic Painting*. Paris: Terrail, 1994.

Schmalenbach, Werner. *Fernand Léger*. Translated by Robert Allen, with James Emmons. London: Thames and Hudson, 1991.

Sugana, G.M. *The Complete Paintings of Toulouse-Lautrec*. London: Weidenfeld and Nicolson, 1973.

Spencer, Robin. *Whistler*. London: Studio Editions, rev. ed., 1993.

Swinglehurst, Edmund. *Salvador Dalí: Exploring the Irrational*. London: Tiger Books, 1996.

Sylvester, David. *Magritte*. London: Thames and Hudson, 1992.

Vance, Peggy. *Gauguin*. London: Studio Editions, rev. ed., 1992.

Wood, Christopher. *Tissot*. London: Weidenfeld and Nicolson, 1986.

_____. *Burne-Jones*. London: Weidenfeld and Nicolson, 1998.

INDEX OF ARTISTS

This Index gives the page(s) where titles of works by individual artists will be found. If more than one work appears on the page, the number of occurrences is given in brackets, as for Giovanni Bellini, the painter of two works on p. 192, or Frans Hals, who has three paintings on p. 207. A work credited to two artists will have their names listed separately unless they share the same surname. Thus Terry Atkinson and Michael Baldwin are indexed individually for their joint work Map to not indicate *(p. 157), but the brothers Jake and Dinos Chapman have a single reference for* Great Deeds Against the Dead *(p. 107). Attributed works, such as Andrea Landini's* Indecision *(p. 126), are indexed normally. Anonymous works, such as the famous* Venus de Milo *(p. 255), cannot of course be indexed at all. Where a single title belongs to several artists, as* The Last Supper *(p. 140), a slightly more detailed search on the page for a particular artist's name may be required. But such instances are the exception rather than the rule and normally it will be a matter of scanning less than a dozen entries to find the name of the artist sought.*

281

Kuindzhi, Arkhip 10
Kupka, Frantisek 15, 82
Kuznetsov, Nikolai 127

Lachaise, Gaston 228
La Farge, John 231
Lam, Wifredo 122, 133
Lambert, George 115
Lancret, Nicolas 61
Landini, Andrea 126
Landseer, Charles 157
Landseer, Sir Edwin 16, 53, 70, 72, 72, 75, 92, 114, 115 (2), 130, 136, 156, 166, 172, 179, 230, 240, 250, 272
Lanfranco, Giovanni 22, 164
Langlands & Bell 129
Langley, Walter 42
Lanyon, Peter 104
Larionov, Mikhail 265
Latham, John 72
La Thangue, Henry Herbert 24, 54, 139, 156, 262
La Tour, Georges de 68, 74
Lauderdale, Charles Dillem 110
Lavery, Sir John 203, 239
Lawler, Louise 119
Lawrence, Jacob 48
Lawrence, Sir Thomas 193, 206
Leader, Benjamin William 89
Le Brun, Charles 158
Lega, Silvestro 32, 94, 189
Léger, Fernand 8, 42, 45, 72, 108, 117, 141, 166, 176
Leighton, Frederic 15, 23, 28, 44, 51, 52, 60, 62 (2), 80, 88, 93 (2), 99, 113, 114, 122, 132, 135, 143 (2), 168, 187, 189, 190, 208, 225, 227, 236, 267
Leirner, Jac 56
Lely, Peter 223
Lemoyne, François 189
Leochares 18, 68
Leonardo da Vinci 9, 17, 31, 137, 140, 150, 151, 166, 196, 258 (2), 259
Leslie, Charles Robert 75, 99, 199, 251, 266 (2)
Le Sueur, Eustache 198
Leutze, Emanuel G. 262, 263
Levitan, Isaak 7, 84, 260
Lewis, Wyndham 29
LeWitt, Sol 95
Leyster, Judith 200
Lichtenstein, Roy 21, 75, 165, 236, 264
Lindner, Richard 161
Lippi, Filippino 245, 259
Lippi, Fra Filippo 9, 17, 56, 237, 258
Liss, Johann 65
Lissitzky, El 200
Lobley, James 68, 72
Lochner, Stefan 198, 258
Long, Edwin 12, 25

Longhi, Pietro 209, 246
Lorenzetti, Ambrogio 17, 105, 198
Lorenzetti, Pietro 68, 140
Lorrain, Claude see Claude Lorrain
Lotto, Lorenzo 17, 50, 136, 198, 212
Lucas van Leyden 45
Lucas, Sarah 24, 224, 251, 265
Luks, George 227

Macdonald, Frances 122
Macduff, William 219
Maclise, Daniel 232
Magnasco, Alessandro 212
Magritte, René 8 (2), 11 (2), 17, 21, 23, 34, 39, 45, 47, 51, 52, 53, 57, 59, 61, 66, 67, 68, 71, 73, 79, 80, 81, 83 (2), 84, 87, 91, 103, 104, 105 (2), 108 (2), 112 (2), 113, 114, 117, 119, 120, 123 (2), 124 (2), 127 (2), 128, 135, 143, 144 (2), 145, 147, 154, 159, 161, 162, 172, 174, 175, 177, 180, 182, 184 (2), 185, 188, 189, 190 (2), 191 (3), 203, 204, 205 (3), 206, 217, 219, 241 (2), 244, 247, 251, 262
Maignan, Albert 186
Maillol, Aristide 8, 243
Makovsky, Vladimir 26, 124, 260
Maksimov, Vasily 21
Malevich, Kasimir 81, 265
Malyavin, Filipp 265
Man Ray see Ray, Man
Manet, Édouard 7, 26, 27, 37, 38, 67, 84, 91, 146, 169, 172, 179, 180, 194, 219, 226, 231
Mantegna, Andrea 9, 11, 58, 63, 66, 151, 152
Manuel, Niklaus 132
Marc, Franz 88, 91
Marks, Henry Stacy 218
Marshall, Benjamin 214
Martin, John 27, 107, 132
Martineau, Robert Braithwaite 139
Martini, Francesco di Giorgio 56
Martini, Simone 17, 68
Masaccio 9, 58, 248 (2), 258
Masson, André 106
Matisse, Henri 26, 60, 66, 132, 149, 192, 224
Matta, Roberto 35, 256
Matteson, Tompkins H. 139
Max, Cornelius Gabriel 140
Mazo, Juan Bautista Martínez del 196
McCahon, Colin 20
McCracken, John 240
McTaggart, William 187
Meireles, Cildo 273
Meissonier, Jean-Louis-Ernest 79
Mellery, Xavier 9
Melozzo da Forlì 222
Melrose, Andrew 263
Memling, Hans 69, 73, 198, 214

Mercier, Philip 183
Merritt, Anna Lea 262
Merz, Mario 253
Metsu, Gabriel 168
Michallon, Achille-Etna 177
Michelangelo 26, 29, 57, 63, 67, 73, 76, 82, 139, 192
Michelino da Besozzo 171
Millais, John Everett 19, 24, 34, 35, 38, 40, 41, 43, 48 (2), 50, 60, 69, 78, 84, 90, 112, 119, 128, 131, 134, 142, 157, 158, 169, 175, 182 (2), 188, 193, 199 (2), 200, 208 (2), 211, 222, 226 (2), 249, 254, 261, 270
Miller, Alfred J. 247
Millet, Jean-François 16, 103
Milow, Keith 181
Milroy, Lisa 96
Miró, Joan 34, 56, 159, 178, 179, 191, 222, 229
Modigliani, Amedeo 206
Monaco, Lorenzo 56
Mondrian, Piet 41, 54, 84
Monet, Claude 67, 109, 112, 123, 239, 262
Moore, Albert Joseph 25, 75, 170, 233, 255
Moore, Henry 86
Morales, Luis de 73
Moran, Thomas 90, 227
Morbelli, Alessandro 51, 92
Morbelli, Angelo 94, 233
Moreau, Gustave 19, 98, 178, 232
Morgan, Evelyn de 24
Morisot, Berthe 57, 233
Morland, George 36, 53, 77, 165, 260
Morley, Malcolm 202
Morris, William 201
Moses, Alexander 216
Motherwell, Robert 130
Mount, William S. 43, 87, 118
Muckley, William Jabez 194
Mueck, Ron 64, 101
Müller, Charles Louis 210
Mulready, Augustus Edwin 207
Mulready, William 28, 41, 49, 55, 91, 92, 103, 127, 142 (2), 181, 219, 225, 246, 247, 268
Munch, Edvard 22, 33, 61, 63, 126, 130, 201, 217, 254, 260
Murillo, Bartolomé 17, 35, 153, 158, 213, 251, 258
Murray, Elizabeth 132
Myasoyedov, Grigori 273
Myron 71

Nadelman, Elie 156
Nahl, Charles C. 233
Nash, Paul 225, 246
Nauman, Bruce 97, 143, 267, 270
Neale, Maud Hall 251
Nesterov, Mikhail 259
Nevinson, Christopher 187

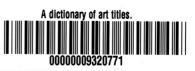